IDENTITY UNKNOWN

IDENTITY UNKNOWN

REDISCOVERING SEVEN AMERICAN WOMEN ARTISTS

DONNA SEAMAN

BLOOMSBURY

NEW YORK · LONDON · OXFORD · NEW DELHI · SYDNEY

Bloomsbury USA
An imprint of Bloomsbury Publishing Plc

1385 Broadway	50 Bedford Square
New York	London
NY 10018	WC1B 3DP
USA	UK

www.bloomsbury.com
BLOOMSBURY and the Diana logo are trademarks of Bloomsbury Publishing Plc

First published 2017

The profiles of Louise Nevelson and Ree Morton were previously published in somewhat different forms in *TriQuarterly* in 2008 and 2009, respectively.

ISBN: HB: 978-1-62040-758-5
 PB: 978-1-62040-759-2
 ePub: 978-1-62040-760-8

LIBRARY OF CONGRESS CATALOGING-IN-PUBLICATION DATA
Title: Identity unknown : rediscovering seven American women artists / Donna Seaman.
Description: New York : Bloomsbury USA, 2017.
Identifiers: LCCN 2016032067 | ISBN 9781620407585 (hardback) | ISBN 9781620407592 (paperback)
Subjects: LCSH: Women artists—United States—Biography. | Art and society—United States—History—20th century. | BISAC: BIOGRAPHY & AUTOBIOGRAPHY / Artists, Architects, Photographers. | ART / General. | SOCIAL SCIENCE / Women's Studies.
Classification: LCC N6536 .S42 2017 | DDC 709.2/2 [B] —dc23 LC record available at https://lccn.loc.gov/2016032067

2 4 6 8 10 9 7 5 3 1

Typeset by RefineCatch Limited, Bungay, Suffolk
Printed and bound in the U.S.A. by Berryville Graphics Inc., Berryville, Virginia

To find out more about our authors and books visit www.bloomsbury.com. Here you will find extracts, author interviews, details of forthcoming events and the option to sign up for our newsletters.

Bloomsbury books may be purchased for business or promotional use. For information on bulk purchases please contact Macmillan Corporate and Premium Sales Department at specialmarkets@macmillan.com.

For my loving, artistic, inspiring family,

Elayne, Hal, and David
And in memory of Claudia

CONTENTS

INTRODUCTION

TELLING THE STORIES OF SEVEN ARTISTS

The photograph is old; the quality of the black-and-white reproduction in the big, bulky book is poor, yet each artist in the group portrait is vitally present. Comrades and rivals, they are standing in front of a favorite café; they are gathered in a garden; they are lounging on a beach, looking pleased with themselves. Maybe they're seated around a table strewn with glasses and ashtrays, burning cigarettes in hands, heads tipped jauntily, suppressed hilarity making their eyes gleam. Or they've been rounded up, encouraged to dress in their best, then posed together, self-consciously formal, in a studio or gallery, uneasily marking an artistic moment and courting the eye of posterity. The captions name each in order from left to right. The group might include Thomas Hart Benton, Max Ernst, Marcel Duchamp. Jackson Pollock, Mark Rothko, or Franz Kline. And a woman. The reader leans in for a closer look, curious about her, only to find the tag: "identity unknown."

I used to come across such dismissive captions as an art student paging slowly and hungrily through art history surveys, intent on learning what the legendary modernist painters and sculptors looked like, where they hung out, how they interacted. As a young, aspiring female, I felt at once indignant and cynically amused at this failure to record a woman's name and connection to the men by her side. This seemingly blasé lack of interest implied that these anonymous women were of no interest, mere hangers-on, or some male artist's girlfriend-du-jour or taken-for-granted wife. If the anonymous female was an artist among artists, why was her name not documented along with the others? Not only is the phrase "identity unknown" disparaging, it even gives off a noirish chill, a tabloid shiver, as though we all agree that it's the woman's own fault that her name has been lost and that, most likely, she came to an ignoble end. "Identity

unknown" is what a weary clerk in a hospital or morgue would scrawl or type on a form that no one would ever look at again.

It's crushing enough if others don't know or care who you are, but it's even more abjectly demoralizing when you have trouble pinning down your own identity because your sense of self, of vocation, of your abilities and your need to express yourself, are at dire odds with what's expected of you as a female: selfless devotion to home and family. In times of rigid social structures, each woman artist must have felt like a lone traveler without papers traversing a hostile land as she struggled to live a freely creative life. Women had to fight for access to artistic training traditionally reserved for men. Many felt that they had to choose between being an artist or a wife and mother. Between being ostracized or embraced. And if a woman artist did manage to carve out time and space to paint and sculpt, she was confronted by yet more obstacles to being taken seriously as an artist, let alone being treated as equal to her male peers. Of course, male artists have also faced a discouraging battery of endless hurdles. The words *starving* and *artist* are legitimately paired. The percentage of artists recognized versus artists working in obscurity is crushingly low; the same holds true for artists who are able to make their passion their livelihood versus those who must relegate art to their "free" time. The entire enterprise is quixotic.

But women artists were suspect and disreputable, unwelcome aliens who managed to slip into the gated male art world. And if, by dint of fierce perseverance and good fortune, an artist did achieve renown, it was under-mined by reference to her sex and the inference that she was an anomaly. This was a maddening predicament because artists, like doctors, scientists, and writers, want to be identified according to their accomplishments, not their gender. None of the seven twentieth-century painters and sculptors portrayed here liked the designation "woman artist." Yet being female had profound implications for their lives and their work.

For millennia, women were visible as the subjects, not the creators, of art. It is still difficult for women artists to sustain critical attention and respect. They are routinely accorded less space in shows and exhibitions; their works are priced lower than those of their male peers, and some who teach art continue to be paid less than their male colleagues. Many women artists struggle with apprehension, insecurity, anger, depression, and guilt.

This makes the success of the seven artists presented here all the more remarkable.

Each of these exceptional artists, working in Chicago, New York, San Francisco, and Washington, D.C., were highly regarded during their life-times, if not nationally, certainly regionally. Their conviction and mastery did earn them encouragement and professional support from men: teachers, brothers, friends, lovers, husbands, sons, gallery owners, critics, and collec-tors. They exhibited regularly; their shows were reviewed; they posed for photographers and gave interviews to journalists, and they were honored with awards and grants. Collectors and museums purchased their work. But their renown was short-lived. All too soon their original, daring, and galva-nizing paintings and sculptures were forgotten, put in storage and neatly excised from the pages of art criticism and art history. Outside the art world, very few people now recognize most of their names or their work. We tell and retell robustly romantic tales of revered and delectably infamous male artists, while lore about women artists is scant and neglected. For decades, there seemed to be room in the American pantheon for only one iconic woman artist, Georgia O'Keeffe. There are many more stories to tell.

During the 1970s and 1980s, feminist art historians, critics, curators, and artists were on a mission to rescue women artists from the shadows. Linda Nochlin taught a trailbreaking course on women and art at Vassar College and Stanford University. Her controversial, now legendary essay, "Why Have There Been No Great Women Artists?"—first published in *Art News* in 1971—is an exacting and still bracing critique of the mythology of the "great" artist and the social institutions hostile or indifferent to all artists who fall outside the demographic of male and white. Nochlin concludes her meticulously presented, candid, disconcerting, and rallying argument with the observation that "while great achievement is rare and difficult at best, it is still rarer and more difficult if, while you work, you must at the same time wrestle with inner demons of self-doubt and guilt and other monsters of ridicule or patronizing encouragement, neither of which has any specific connection with the quality of the art work as such."

The outspoken, always riling scholar and writer Germaine Greer conducted extensive research into the fate of underappreciated woman painters working in the grand European tradition for her clarion history *The*

Obstacle Race: The Fortunes of Women Painters and Their Work, published in 1979. Greer writes, "The unreliability of the classic references when it comes to women's work is the consequence of the commentators' condescending attitude. Any work by a woman, however trifling, is as astonishing as the pearl in the head of the toad. It is not part of the natural order, and need not be related to the natural order. Their work was admired in the old sense which carries an undertone of amazement, as if they had painted with the brush held between their toes. In a special corner reserved for freaks they were collected and disposed of, topped and tailed with compliment."

As feminist art historians were making the case for gender equality in the arts, some women artists began making deliberately formulated feminist art. The most assertive and influential among them was Judy Chicago. Born Judith Sylvia Cohen, she took the name of her native city to free herself from the patriarchal surname tradition. Chicago left that flat, bricky Lake Michigan metropolis for California, enrolling at UCLA. In 1970 she taught the first feminist art course at Fresno State College. She then founded, with Miriam Shapiro, the first feminist art program at the California Institute of the Arts in Valencia. In 1974, Chicago began work on her enormous, complex, collaborative, and still controversial installation *The Dinner Party*, a work meant to symbolize women's contributions to Western civilization. As Gail Levin writes in *Judy Chicago: A Biography of the Artist* (2007), this was a bold variation on the Last Supper, based on the Jewish Passover Seder, a commemoration of emancipation (the Jews' escape from slavery in Egypt), as celebrated by the artist's grandparents. *The Dinner Party* was designed to elevate traditional women's crafts, such as needlework and china painting, to the level of fine arts. Constructed by nearly two hundred people, most of them women, *The Dinner Party* consists primarily of a grand triangular table and thirty-nine elaborate place settings designed to pay homage to mythic and historical women who struggled against sexist discrimination and tyranny. The most notorious elements of this elaborate installation are large ceramic plates representing such luminaries as Hildegarde of Bingen, Elizabeth I, Sojourner Truth, and Virginia Woolf, platters with audacious, explicit—some would say vulgar—variations on a butterfly/vagina motif. *The Dinner Party* opened at the San Francisco Museum of Art in 1979, immediately pulling in 100,000 people. Thousands

of people lined up at every stop along its national tour and the installation continues to attract viewers in its permanent home at the Elizabeth A. Sackler Center for Feminist Art at the Brooklyn Museum.

Chicago's installation has been an invaluable catalyst for consciousness-raising and zestful discussions about women, society, and art. But many woman artists recoil from such a brazenly dogmatic and reductively biological feminist approach. Germaine Greer wrote, "Feminism cannot supply the answer for an artist, for her truth cannot be political . . . The painter cannot expend her precious energy in polemic, and in fact very few women artists of importance do . . . The point is . . . to interest ourselves in women artists, for their dilemma is our own."

Nonetheless, many felt compelled to protest. A group of women artists came together in shared ire over a 1985 exhibition at the Museum of Modern Art in which only 17 artists out of 165 on display were women. Calling themselves the Guerrilla Girls, they took on the art establishment with wit and chutzpah. Adopting the names of deceased women artists as their noms de guerre and wearing gorilla masks in public to conceal their identity, they called attention to discrimination in posters, billboards, and theatrical, media-magnetizing actions. In 1989 they took a census of modern art at the Metropolitan Museum of Art in New York, and found that less than 5 percent of the artists were women, while 85 percent of the nudes were female. This inspired a poster asking, "Do women have to be naked to get into the Met. Museum?" The group conducted another tally in 2012 and found that very little had changed; the Guerilla Girls remain active.

Women sought equality by taking charge not only of the conversation but also of exhibition spaces. Art critic Lucy Lippard wrote about the initial convergence of feminism and art in her eye-opening book *From the Center: Feminist Essays on Women's Art*. Curator Marcia Tucker made waves as the founder and director of the New Museum, which opened in 1977. During the 1980s, Linda Lee Alter built a phenomenal collection of nearly 500 works of art by 181 women artists (including five of the seven portrayed here), which she generously donated to the Pennsylvania Academy of the Fine Arts. Women opened their own galleries, and women artists formed co-op galleries, including Chicago's Artemisia Gallery, founded in 1974 and named after the Italian Renaissance artist Artemisia Gentileschi (1593–1652).

In her foundational book *Women, Art, and Society*, currently in its fifth edition following its 1990 debut, Whitney Chadwick describes Gentileschi as "the first woman artist in the history of Western art whose historical significance is unquestionable." Artemisia Gentileschi's father was a highly regarded painter in the Caravaggio school who unwaveringly supported his extraordinarily talented daughter, though his good intentions went awry when he retained painter Agostino Tassi as a teacher for Artemisia. In 1612 Tassi was accused of raping his nineteen-year-old student, rescinding his offer of marriage, and taking paintings owned by the family. The case eventually went to court in Rome, and Gentileschi was tortured in a brutal effort to force her to drop the charges. Passing through the fire of this horrific ordeal seems to have given her even more stature and power. She married a wealthy Florentine, became a mother, and sustained a brilliant forty-year career. Gentileschi is revered to this day for her mastery and her triumphantly dramatic paintings of courageous women, including the ferocious and indelible *Judith Decapitating Holofernes* (circa 1618).

More than two centuries later, an American woman born to wealth and called to art, Mary Cassatt, took a more subtle approach to creative feminist dissent. Cassatt left Philadelphia for Paris in 1866 at age twenty-two, and her very proper family soon joined her there. She did not marry or have children, devoting herself to art during a time of now celebrated radicalism as the Impressionists gathered force. Cassatt made her name by painting mothers and children, which the male critics of the day deemed natural and appropriate subject matter for a woman painter. But Cassatt brought a sharply discerning eye to the nuances of domesticity, and she did venture beyond hearth and home to capture the irony of social interactions. In *Woman in Black at the Opera* (1880), a very proper woman in a front-row balcony seat leans intently forward, holding her opera glasses to her face and watching the stage with utter absorption, while a man seated farther along the balcony's curve trains his opera glasses on her. Since the inception of visual art, the female body, as seen through the male gaze, has been an archetypal symbol of longing, fertility, mystery, and beauty. What happens when this object of desire takes over as a keen observer and creator, scrutinizing and responding to the world from a freshly incisive point of view?

I grew up watching a woman artist at work: my mother, Elayne Seaman. I witnessed firsthand what it meant for an artist to perform the daily balancing act between caring for one's family and home and the demands of art. I understood early on that the need to create is deep, inexplicable, and persistent, and that it can be a source of both pleasure and angst. I saw that

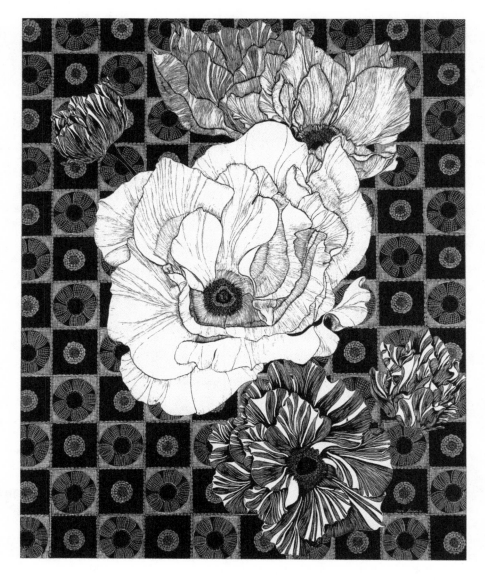

Elayne Seaman. Anemone Quilt. *1989. 20 × 24 inches. Incised ink painting.*

making art required solitary communion as well as communal support. My mother's intricately detailed incised ink paintings are created with an elegant and exacting technique she developed as a refined variation on an old illustration medium called scratchboard. Appreciation for this precise and challenging work began with her family, especially my father, Hal Seaman. An electrical engineer who can fix anything and an excellent photographer, he documented and framed my mother's paintings and help hang many exhibitions.

My parents grew up in the Bronx, and moved to Poughkeepsie, New York—hometown of the exceptional photographer Lee Miller—when my father took a job with IBM. There were few galleries or opportunities for artists to show their work in that Hudson River city, so my parents turned our home into a gallery, and my mother founded an artists' co-op, Summergroup, which has thrived for more than thirty years and is now called LongReach Arts. Art was part of our daily sustenance, our conversations, our way of engaging with the larger world. My parents are also generous and tireless community activists who have long been involved in good causes, including not-for-profit organizations dedicated to bringing art into the lives of people who might not otherwise have access to it. I grew up understanding that art has meaning, reach, and resonance that extend beyond private visions and small circles of kindred spirits. That art is universal, that it matters on scales personal and social. And that artists are smart, complicated, and fascinating.

I've chosen to write about artists whose work has deeply affected me. I was still a gangly girl when I first came under the midnight spell of Louise Nevelson's sculpture. I don't remember the particulars of my initial encounter with her great walls of painted wooden boxes and their strange, salvaged cargo, but however and wherever it took place, Nevelson's work spoke to me. I grasped in some intuitive way the language of its assiduously assembled fragments, its poetic enshrinement of the broken and discarded, its protective blackness, its secretive interiors, its provocative grandeur. Nevelson herself was a living work of art, resplendent in her many layers of colorful fabric and furs, her sculptural jewelry, her headscarves and turbans, her

theatrical false eyelashes. She was a star, glamorous and intimidating and avidly photographed, often in the company of other celebrities, looming large and bridging the gap between the rarefied art realm and popular culture. And yet this fierce art empress faded away after her death in 1988. When I looked for her in newly published art history books, I found, to my incredulity, that she was absent. It took twenty-seven years for a major posthumous retrospective exhibition to be mounted. This cycle of ascendance, erasure, and reclamation is part of the story of each of the artists I portray.

My interest in fiber art was sparked by a caring, no-nonsense arts and crafts teacher who inspired a small group of classroom-adverse high school students to help her restore room-filling nineteenth-century looms, on which we then learned to weave. This led me to the innovative, expressive, finely executed, and majestic woven forms of Lenore Tawney. One of the first great fiber artists—a weaver who boldly transformed a traditionally female craft into a fine art medium of tensile power—Tawney achieved international acclaim, yet was quickly relegated to the dim precincts of the forgotten. I learned about the clever, erudite, and inventive Ree Morton after I moved to Chicago, and heard about her brief stint at the School of the Art Institute of Chicago (SAIC) and its tragic end. I remain electrified by Morton's witty, shrewd, oddly beautiful constructions and paintings. As one of many admirers of Christina Ramberg, a nurturing, brilliant, funny, and generous painter and SAIC professor, I was entranced and intrigued by her exquisitely unsettling paintings. From the instant I first saw a spooky little dreamscape painting by an earlier Chicago artist, Gertrude Abercrombie, I had to know more about this enigmatic, autobiographical artist and her role as the city's Queen of Bohemia. I met the Bay Area artist Joan Brown on the pages of *The Art of Joan Brown* (1998) by Karen Tsujimoto and Jacquelynn Baas, and was immediately hooked. A visit to the Milwaukee Art Museum introduced me to Loïs Mailou Jones via her vibrant, jazzy, and uplifting painting *The Ascent of Ethiopia* (1932), the first of dozens of paintings I reveled in as I learned about the life of a master painter who faced not only sexism but also racism over her long, illustrious career as an artist, art ambassador, and art educator.

Each of these artists lived quintessential American lives. Born Louise Berliawsky in Kiev in 1899, and arriving in the United States with her

family in 1905, Louise Nevelson was part of the great wave of Eastern European Jews fleeing violent anti-Semitism at the start of the twentieth century. Her immigrant story is like so many others in her struggles as an outsider and concerted effort to be accepted, though her path forward was unique. Joan Beatty Brown was tightly knit into the history of San Francisco, with her Irish immigrant roots on her father's side and her Mexican heritage on her mother's, complicated by the tragic early death of her Danish grandfather in the aftermath of the catastrophic earthquake of 1906.

Loïs Mailou Jones had deep roots in the land by way of her Native American, African, and European heritages. Inspired as a student by the Harlem Renaissance, she ended up working as an illustrator for W.E.B. Du Bois and Carter Godwin Woodson, who were publishing the first black history magazines and books for young people. Jones also used her talents to support the civil rights movement, and helped forge connections to African nations as she traveled the continent, introducing African American art to Africans and bringing the work of contemporary African artists to America, ultimately creating an invaluable African art archive at Howard University, where she taught for many years. After marrying a Haitian artist, Jones filled a similar role in bringing Haitian art to the attention of Americans and vice versa.

As so many working-class Americans once did, Lenore Tawney worked in a factory after graduating high school. She then left her small Ohio town to seek her fortune in the big city, Chicago, where she waitressed, took art classes, and found security and advancement as a proofreader for a legal publisher. Tawney devoted herself to art after a brief marriage abruptly ended with her husband's death. Gertrude Abercrombie was born on the road as her charismatic parents traveled the country with a touring opera company. She cherished her ties to her father's small Illinois hometown, even after the little family settled in Chicago, where Abercrombie eventually presided over a famously vibrant, intrepidly interracial salon during the city's jazz heyday.

Both Christina Ramberg and Ree Morton had military families. Ramberg's father was an army colonel who served in Europe and Vietnam. She was born in Fort Campbell, a military base along the Kentucky-Tennessee border, and the family joined her father on assignments across the

country and overseas, including Japan shortly after the atomic bombings of Hiroshima and Nagasaki. Morton married a naval officer, had three children, and accompanied her husband on postings in Europe and the United States. After twelve years of marriage, she earned her bachelor of fine arts degree, separated from her husband, and quickly began showing her work.

I chose to write about deceased artists, and later realized to my dismay that this hampered my ability to write about more artists of color. Most artists discriminated against in the past for both their gender and race remain too far under the radar for the scope of this inquiry. The fact that many more American women artists of color—among them such luminaries as Judith Baca, Chakaia Booker, Barbara Chase-Riboud, Diane Gamboa, Carmen Lomas Garcia, Ke-Sook Lee, Hung Liu, Betye Saar, and Kara Walker—are thriving is an indication of some progress, however inadequate. Another criteria I assigned myself involved the artist's medium: I felt that it was important to profile artists who learned to handle brushes, palette knives, paint, canvas, wood, thread, steel, stone, papers, feathers. Artists who got dirty, and contended with gravity, dust, noise, and fumes. Artists who worked directly with materials, not with the clean, distancing mediation of a camera lens or computer. Artists who worked on a large scale and who therefore had to struggle to afford a studio.

The more "virtual" so many aspects of our daily lives become, the less sensuous our tasks. We learn through our bodies—our fingertips, muscles, senses. The smell, texture, and sound of materials and tools are evocative and instructive. The nimbleness, skill, strength, and stamina one needs to sculpt and paint develop through practice, and these abilities, this intimacy with materials, this whole-body mode of creating, have profound physiological, emotional, and aesthetical repercussions. And yet even as I advocate for the tactile, I've benefited incalculably from online access to digitized archives of images and old newspaper and magazine articles and catalogs. I was able to study at length and at all hours in my own home crisp, radiant photographs of artworks, beautifully detailed and illuminated on my flat screen. As profoundly moving and exciting as it was to be in the physical presence of the art of these seven artists, thanks to kind and patient curators, my immersion in their work was also deepened by time spent with Internet treasures.

The seven artists you will meet here share traits and diverge widely. Louise Nevelson, Loïs Mailou Jones, Lenore Tawney, and Gertrude Abercrombie were born before 1910. Joan Brown, Ree Morton, and Christina Ramberg were born between 1936 and 1946. For various reasons having to do with gender expectations, income, family, and temperament, Nevelson, Tawney, and Morton were late bloomers artistically, while Brown, Jones, and Ramberg began exhibiting work as students. All were married at some point, and all went through divorces except for Jones, who found true love in her forties and stayed happily married until her husband's death. Jones and Tawney did not have children. Motherhood was a joy for Brown, Morton, and Ramberg, and harrowing for Abercrombie and Nevelson. As girls, budding artists Brown and Ramberg made elaborate paper dolls and accompanying wardrobes, an activity that shaped their mature work. Brown, Jones, and Tawney were constant and fearless world travelers; Abercrombie, who played the piano as well as painted, became a recluse, rarely leaving her brownstone in Chicago's Hyde Park neighborhood. She hoped the world would come to her, and for a while it did. Abercrombie, Brown, and Morton infused their work with mischievous wit. Abercrombie and Brown painted so many self-portraits, they ended up creating boldly candid visual autobiographies. Ramberg was endlessly intrigued with the human body, but she rarely painted faces. Brown, Jones, and Ramberg supported themselves as full-time faculty members at prestigious art schools and universities, while Morton was an itinerant teacher. Brown, Nevelson, and Tawney created large-scale public sculptures. Nevelson and Abercrombie had drinking problems, and alcohol contributed to Abercrombie's fading away at sixty-eight. Ramberg suffered from a cruel disease that ended her life at forty-nine. Morton and Brown died in terrible accidents, Morton at forty-one, Brown at fifty-two. Brown and Tawney, both small, strong, and fit, became ardent followers of prominent Indian gurus. Tawney lived to be one hundred; Jones ninety-three, Nevelson eighty-eight.

Nevelson and Tawney made elegant, evocative, often enormous abstract sculptures out of myriad small components. Nevelson assembled her lavishly textured wooden columns and many-chambered walls out of hundreds of small pieces of reclaimed and repurposed chairs, staircases, packing boxes, musical instruments, even toilet seats. Tawney made her

"woven forms" out of thousands of strands of linen, wool, and silk, and put together intricate collages and assemblages with torn pages from old books, tiny corks, eggshells, and feathers. Ree Morton used twigs and branches and found objects in her sculptures, assemblages, and installations, which combined abstractions with images of plants, fish, and bows. Christina Ramberg ventured into figuration only to dismantle, bind, gag, sever, eviscerate, and flay the female body, creating exquisitely detailed, disquieting, and regal faceless figures of endurance and transcendence. Gertrude Abercrombie loved puzzles and riddles. Accordingly, she created a visual lexicon of objects and settings that she used in various combinations, while painting dreamlike tableaus in which she created highly stylized versions of herself as a searcher, a wanderer, a queen tethered to her castle. Joan Brown, earthy and cosmic and steeped in the art of ancient civilizations, looked herself squarely in the eye and painted herself forthrightly and with canny bemusement, portraying herself as an artist, lover, wife, mother, and spiritual seeker. Jones, a virtuoso colorist with an omnivorous eye and inquisitive intellect, loved to paint landscapes and city scenes, and she was also an evocative portraitist. Inspired by her travels, Jones created dynamic juxtapositions of Western, African, and Caribbean visual traditions.

This is not a book of art criticism. Nor is it a feminist polemic, though feminist I am. I wrote about these artists to learn more about their lives and spend more time immersed in their art. I wanted to discover what drove them, what obsessed them, what art meant to them, how they lived, and how they worked. I was curious about how their art embodied each artist's sense of self and experiences, what they hoped to achieve, how they were perceived and treated by others, and how they related to the world. I chose to write about women artists because I was raised by one, because I once dreamed of becoming one, and because there is still a severe deficit in the historical records when it comes to documenting the lives and accomplishments of women.

Elegies and biographies were the first forms of poetry and story, created to preserve memories, to tell the tales of the dead, to extract meaning from the paradoxes of human nature and randomness of life and

death. Ever since I was a bookish girl happy to be a member of my elementary school's library club, I've avidly read biographies about all kinds of people, books both sleek and massive. I treasure and applaud comprehensive, cradle-to-grave feats of scholarship, analysis, and narration, including such superb biographies of American women artists as Patricia Albers's *Joan Mitchell: Lady Painter* (2011), Cathy Curtis's *Restless Ambition: Grace Hartigan, Painter* (2015), Hunter Drohojowska-Philp's *Full Bloom: The Art and Life of Georgia O'Keeffe* (2004), Phoebe Hoban's *Alice Neel: The Art of Not Sitting Pretty* (2010), Gail Levin's *Lee Krasner* (2011), Nancy Princenthal's *Agnes Martin: Her Life and Art* (2015), and Laurie Wilson's *Louise Nevelson: Light and Shadow* (2016). I also ardently value "brief lives," succinct volumes that zoom in on the essentials, such as Francine Prose's *Peggy Guggenheim: The Shock of the Modern* (2015), a keenly distilled portrait of the influential art champion and collector. And I do love an illuminating and involving profile or biographical sketch, a form conducive to the blending of rigorous fact and personal interpretation. That is what I've attempted in the seven portraits that follow.

Each artist and her work, along with the wealth or paucity of available information, shaped my telling of her story. The well-documented Louise Nevelson evoked a descriptive and impressionistic response. The two self-portraitists, Gertrude Abercrombie and Joan Brown, engendered chronological narratives as I followed the progress of their painted diaries. Long hours spent scrolling through a box of microfilm reels containing Gertrude Abercrombie's papers induced me to scrutinize aspects of her private life and consider the sources of her depression. As solitary as making art can be, all of these artists were part of concentric circles of other artists, teachers, gallery owners, critics, and curators, and these associates became part of the narrative. Because Christina Ramberg was a key figure in Chicago's art world, I felt it was important to bring that rich context into sharp focus. So, too, with Joan Brown and her role in the Bay Area art community. Lenore Tawney's life is woven into the underappreciated history of the fiber art movement. Loïs Mailou Jones's extraordinarily active life leads to many facets of the African American experience, diverse art and social movements, and cross-cultural adventures and discoveries. I also took every opportunity to bring other women artists into these profiles, such

as Loïs Mailou Jones's mentor, sculptor Meta Vaux Warwick Fuller, and Lenore Tawney's close friend, the ceramic artist Toshiko Takaezu.

I began thinking about and researching these artists some years back because I felt that they were too little known and vastly underappreciated. I was not alone in my ardor. As I worked on this book, the artists' descendants, trusts, and foundations created invaluable websites. Photographs of the artists and their art have been posted on blogs and image-sharing sites, and galleries and museums have mounted exhibitions. I found myself riding a rising wave of rediscovery that affirmed my own long-term passion and curiosity, and made my inquiries all the more fruitful. Yet few people in the larger world are aware of these artists, with the exception of Louise Nevelson, and their enthralling creations. My hope is that by telling their stories of risk, dissent, independence, obsession, creativity, suffering, and transcendence, and showcasing select art works, *Identity Unknown* will bring Abercrombie, Brown, Jones, Morton, Nevelson, Ramberg, and Tawney to a diverse and widespread audience. Each of these artists lived a courageously self-directed, imaginatively improvised, disciplined, sacrificing, and questing life. Each body of work gives us a new perspective on what it means to be human. It seems that forgotten, dismissed, ahead-of-their-time artists resurface when we need them, when their art stops us in our tracks and stills the fizz and hurry of our days, when we have, finally, caught up to their visions and their art helps us make new sense of ourselves, our past and current predicaments, our fears and hopes for the future. These seven painters and sculptors and their art are ascending once again, now that we are ready to truly appreciate the significance of their struggles and dedication, their spirited and penetrating inquiries, and the transformative power of their creations.

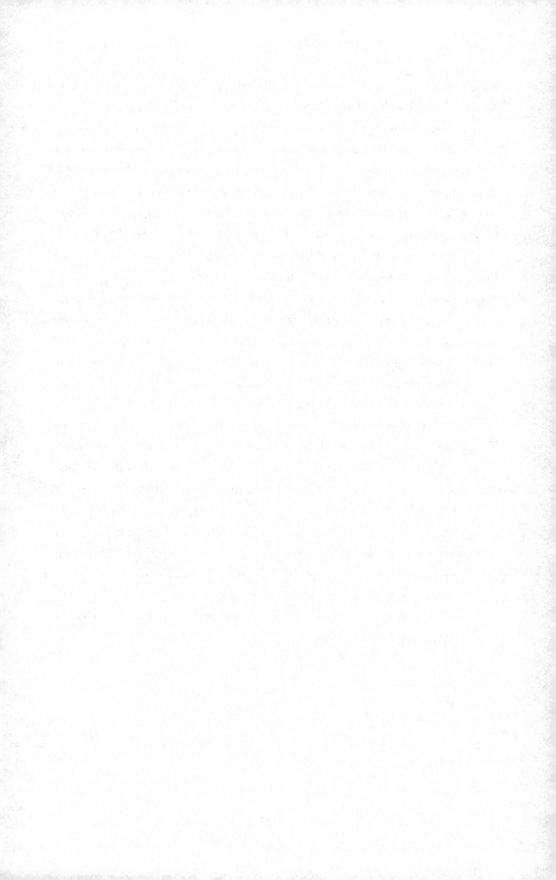

THE EMPRESS OF IN-BETWEEN
LOUISE NEVELSON

> My total conscious search in life has been for a new seeing, a new image, a new insight. This search not only includes the object, but the in-between places, the dawns and dusks, the objective world, the heavenly spheres, the places between the land and the sea.
> —Louise Nevelson

Louise Nevelson was a late bloomer, a mythmaker, and an art-world icon. Tall and fierce, she favored floor-length embroidered robes and furs, headscarves and hats, warrior-trophy necklaces, and daggerlike false eyelashes. With smoke rising from her ever-present cigar, she looked like an empress from a cold and distant land, a priestess of the steppes, a Siberian shaman. Indomitable, irascible, and fluently creative, Nevelson built large, complex abstract black wood sculptures that resemble the abandoned temples and shrines of a lost tradition. The artist was in her sixties when the mainstream media finally took notice of her striking assemblages and dramatic presence, and she held the spotlight until her death at age eighty-eight.

Nevelson could be *Vogue*-elegant, thanks to photographer Richard Avedon. She could also be campy, even grotesque, as one of the more grandiose of the self-appointed deities of the era of disco kitsch and cocaine decadence. Nevelson was photographed with Andy Warhol (but then, who wasn't?), New York mayor John Lindsay, and her friends Merce Cunningham and John Cage, who in one shot are laughing so hard their eyes slit shut. She looks demure as she shakes hands with President Jimmy Carter after receiving the Women's Caucus for Art Award, and radiant as President Ronald Reagan and First Lady Nancy Reagan present her with the National Medal of Arts. Recognition was long in arriving, and Nevelson eagerly

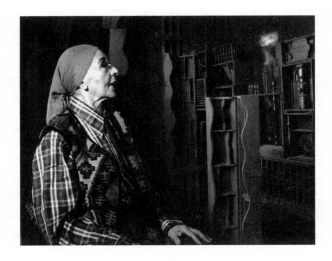

Louise Nevelson (Profile) with artwork. Pedro E. Guerrero.

wrapped herself in the shimmering cloak of fame like a shipwreck survivor pulling a blanket tight around her shoulders.

Nevelson courted the camera and the press, and was more than willing to ham it up. Photographer Hans Namuth cleverly combined two images to give the artist four arms, so that she looks like a magician, a card shark, an undercover incarnation of the fearsome goddess Kali, the dark mother. In other, far less flattering portraits, Nevelson looks like a sinister character out of such old films as *The Cabinet of Dr. Caligari* or *Metropolis*, a creepy look immortalized by Robert Mapplethorpe in 1986, two years before Nevelson's death. Cecil Beaton caught Nevelson in a vulnerable moment: her gray hair disarrayed, as though she had just stopped raking her hands through it in despair; her expression weary, sorrowful; the black sculpture behind her a post-apocalyptic ruin.

The most dismaying image appeared in *Life* magazine on May 24, 1958, with the trivializing headline "Weird Woodwork of Lunar World." The usually regal and impervious Nevelson crouches awkwardly behind her sculpture *Moon Garden* as a cheesy green light illuminates the ludicrous scene. In a peaked black hat that could be witchy but instead resembles a stubby dunce's cap, she looks for all the world like a colonialist in the stocks, humiliated and punished for some petty crime against propriety.

Photographer Pedro E. Guerrero observed that "Louise loved being provocative." He took many pictures of Nevelson in her ferocious prime, her late seventies, and created one of the most beautiful and revealing published portraits of the artist: a stunning work of chiaroscuro in which Nevelson, her skin golden, wearing a pale-blue paisley headscarf and silvery blue fur, leans her head on her hand on a black glass table in front of a black wall. She is a study in sun and moonlight, a graceful predator in repose.

Classical Western sculpture involved the liberation of the human form from great blocks of marble. Such master sculptors as Praxiteles and Michelangelo seemed to possess superhero X-ray vision that enabled them to peer into pearlescent stone wombs and discern figures of astonishing beauty awaiting birth via chisel and mallet. Mighty limbs, divine torsos, heads noble or monstrous, Olympian muscles, massive shoulders, lavish locks of hair, extravagant drapery, engraved armor—all enclosed in a fortress of whiteness, a mineral holdfast pried from the earth's clasp and turned malleable beneath the artist's sure hands. This miraculous metamorphosis from rough-hewn stone to finely carved and polished sculptures of gods and goddesses, men, women, and animals took place in a world that was all of a piece. In the atomic age, we see the world in pieces.

What a disconcerting childhood moment it is when the myth of solidity is exploded by the words *molecule* and *atom*. Suddenly your child's-eye view is recalibrated and the very school desk you lean on becomes a whir of tiny spheres, each containing its own spinning galaxies. Zoom in, zoom out, the cosmos is comprised of galaxies within galaxies, a continuum without end from the tiniest specks to the grand circle dance of planets and stars. The cosmos is a sea of choreographed particles and waves. All is in flux, even an imposing hunk of marble.

Yet subatomic awareness aside, marble is heavy, obdurate, and expensive. Far out of reach for a penniless middle-aged woman artist working out of a shabby apartment in mid-twentieth-century New York City. And besides, stone did not speak to Louise Nevelson. It was wood that called out to her. In her extemporaneous self-portrait-in-words, a torrent of observations, anecdotes, and pronouncements diligently recorded and transcribed by her assistant, Diana MacKown, and turned into a book titled *Dawns and Dusks* (1976), Nevelson explains, "I wanted a medium that was immediate. Wood

was the thing I could communicate with almost spontaneously and get what I was looking for . . . The textures and the livingness . . . When I'm working with wood, it's very alive. It has a life of its own."

But the sculptor began her long practice of visual expression as most artists do, by drawing and painting. As a girl, she composed remarkably vital interiors in which the furniture is about to shimmy and lift off the floor. Thick black lines revel in the illusion of perspective, bookshelves look ready to burst, and the curlicues of fabric and carpet designs refuse to be confined. An upholstered chair in the lower lefthand corner of a 1918 watercolor even has a molecular pattern. As an adult, Nevelson created free-flowing drawings, paintings, and prints, many depicting substantial female figures. One in particular, *The Lady Who Sank a Thousand Ships (Helen of Troy)*, offers intriguing clues to her feelings about womanpower.

But two dimensions were not enough for Nevelson. Captain of her high school girls' basketball team, she was vibrant, high-strung, and restless. She later channeled her physicality into dance and eurythmics, the art of expressive, improvised movements in response to music. These disciplines put her in closer touch with the creative force and helped her focus her energies. Nevelson used her entire body when she made art. Working quickly and intuitively, she was inspired and guided by the heft, texture, and shape of her materials. She needed to work with and against gravity.

When Nevelson speaks of wood, she isn't referring to freshly milled lumber like that produced in Rockland, Maine, where, as a young Russian Jewish immigrant, she came of age. No, she is praising used and discarded wood—cast-off wooden objects, fragments, remnants, rejects. Street debris. Scraps. All treasures for hand-to-mouth-poor Nevelson.

In the late 1930s the artist and her son, Mike, trawled through the streets of their Lower Manhattan neighborhood, collecting wood to burn in the fireplace to keep warm. But even as Nevelson struggled to keep body and soul together, she was stubbornly resourceful in her determination to make art. "I had all this wood lying around and I began to move it around, I began to compose. Anywhere I found wood, I took it home and started working with it. It might be on the streets, it might be from furniture factories. Friends might bring me wood." Nevelson later called herself "the original recycler."

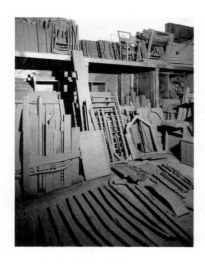

Louise Nevelson wood collection #4.
Pedro E. Guerrero.

Going out with a wheelbarrow in the dead of night, and later, in better times, riding around in a black Ford station wagon she dubbed Black Beauty, Nevelson collected battered and busted and thrown-away pieces of wood in great quantities. From this harvest of damaged goods and banished materials, she began to construct "wonder boxes" and "dream houses." Altars and wailing walls. Palaces and monuments. And as she constructed these mysterious works, she transformed junk into a precious substance through a simple alchemy: she painted everything black—profound, complete, irrevocable, mystical, holy black, the black of night, the underworld, silence, and blindfolds, of despair and death. But also the black of life's hidden ignition in a seed, an egg, pod, womb, the ocean depths, the nourishing earth. And the black of coal, obsidian, sable, velvet, tuxedoes, grand pianos, chess pieces, record albums, patent leather, caviar, the eye's pupil, ink, a crow, a panther. The beginning and the end.

For Nevelson, black was "the total color." She explained, "It means totality. It means: contains all . . . It contained all color. It wasn't a negation of color. It was an acceptance. Because black encompasses all colors. Black is the most aristocratic color of all. The only aristocratic color . . . I have *seen things* that were transformed into black, that took on greatness. I don't want to use a lesser word."

As for form, Nevelson credited Pablo Picasso with laying the groundwork for her sculpture: "Without Picasso giving us the cube, I would not

have freed myself for my own work." And like her contemporary and fellow assemblage pioneer, Joseph Cornell, Nevelson loved boxes. Boxes bring order to chaos. Boxes contain fear and conceal valuables. Open-faced boxes serve as little stages and dioramas, the precincts for fantasy. But while Cornell used boxes to preserve and showcase objects he collected and cherished in all their resonant detail and romantic allusion, Nevelson sought to obliterate all surface distinctions and cultural associations. As she filled her black boxes with strata of black forms, she emphasized their essence and sought to erase their former lives as banisters, bent-wood chairs, pallets and crates, bowling pins, wooden spools, guitars, even toilet seats. Each piece has been purified and born again; each curve and angle is sharply defined, caressed, revitalized. Nevelson then used these packed, open-faced boxes to build walls and towers, mysterious and sublime structures in many shades of black, harboring many shadows and secrets.

Nevelson's wood sculptures are at once archaic and innovative, imposing and elegant, brooding and witty. Intuitive and free-spirited, she was inspired by the art of Native North Americans and the Maya, and attuned to the realm of archetypes and dreams, to the very energy of the cosmos itself. Nevelson's titles convey her mysticism. The 1955 exhibition *Ancient Games and Ancient Places* included works titled *Bride of the Black Moon*, *Black Majesty*, *Forgotten City*, *Night Scapes*, and *Cloud City*. Her next exhibition, *The Royal Voyage*, featured *The King and Queen of the Sea* and *Undermarine Scape*. Later came *Moon Garden + One*, *Sky Cathedral*, *Sky Garden*.

How many clever quips, bad jokes, and tiresome remarks have been made mocking abstract art? Skeptics claim a child could do better, even a monkey. Abstract Expressionism has been dismissed as the visual ravings of a crazy person or an outright hoax, the artistic equivalent of the emperor's new clothes. Yet beginning with Wassily Kandinsky—whose concept of "inner necessity" and belief in the spiritual power of art inspired him to forgo representation and explore the deep resonance of abstraction—abstract artists, who trust spontaneity only after achieving technical mastery through traditional training, have been anything but glib. Carrying forward what art historian Frederick Hartt describes as "Kandinsky's imaginative legacy of form inflamed by emotion," the first abstract artists grappled with the boundary-dispelling perceptions of Impressionism, Freud and Jung's

theories of the unconscious, the free associations of Surrealism, Einstein's disconcerting revelations, and the shocking devastations of mechanized world war.

The initial Abstract Expressionist movement was dominated by male painters, yet women artists, including sculptors, kept abstract art alive and thriving in the ensuing decades. In the third and final edition of his influential magnum opus, *Art: A History of Painting, Sculpture, Architecture* (1989), Hartt observes that abstract sculpture was "more exciting than recent painting in the richness of its development and the multifarious shapes of its creations," and credits the ascendancy of abstract sculpture in great part to Nevelson, "who ranks as one of the finest artists of the twentieth century."

Abstract art is an invitation to imagine, to interpret, to reflect. Abstract art induces reverie. It liberates us from the literal and the everyday, and provides a bridge to the realm of the collective unconscious. Like jazz musicians—who begin with a deep knowledge of song and traditional composition, then venture out into new territory, making fresh connections and creating unforeseen variations on a theme—abstract artists improvise on line and form, light and dark, emptiness and presence. Abstract art is about mass and energy, being and nothingness, moods and correspondences. We absorb its emotional valence, its action or stillness, cacophony or silence. Our busy minds instinctively seek patterns and images in abstract art, just as we do when we gaze at clouds, fire, rain, and falling, whirling

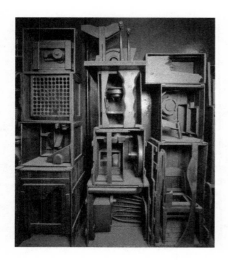

Louise Nevelson artworks #5.
Pedro E. Guerrero.

snow. The rigorous theorists and critics of the day who provided the intellectual framework for Abstract Expressionism—Hilton Kramer, Clement Greenberg, and Harold Rosenberg—would strenuously object, but much of the power of Nevelson's work resides in the way it evokes . . .

Oceans and oceanic forms, from waves to currents,
seaweed, fish, coral reefs, shells.

Landscapes, from hills and valleys to ravines,
rivers, oxbows, canyons, cliffs, deserts, forests.

Books open and closed. A rebus. Type cases. Musical scores.
Libraries, archives, punch cards, puzzles, mailboxes.

Cells. Hives and honeycombs. Pueblos.
Apartment buildings. Dovecotes.

Geodes. Fossils. Catacombs. Morgues.
Mausoleums, coffins, tombs.

Machines, motors, circuits, the insides of old televisions,
furnaces, factories, early mainframe computers.

Shadowboxes and tabernacles.
Stage settings and puppet theaters.
Secret nooks and crannies.
Cabinets of wonder.
Cluttered attics and basements.
Old dark rooms.

Laboratory slides. The periodic table.
Apothecary bottles and cases. Medicine cabinets.

Jewelry boxes. Safe depository boxes.
Wardrobes. Doll houses.

Toolboxes, sewing baskets.
Offerings. Reliquaries.
Arks. Scrolls.
Lost cities. Sacred ruins.
Temples, chapels, churches, mosques.
Treasure chests.
Prayers. Sanctuary.
Mindscapes and memory.
The genome.

Born in 1899, Nevelson was "a modernist down to the very core of her being," according to professor of Jewish history Michael Stanislawski. She came to art as a teenager just as America entered World War I and fully embraced mass industrialization. Nevelson tried to take advantage of the bounty of the robber baron era, and got slammed by the Great Depression. She took shelter in art during the life-altering horrors of World War II, and gradually benefited from the mad abundance of the postwar consumer frenzy. Nevelson knew displacement, exodus, exile, prejudice, and eviction; middle-class comfort and abject poverty. Her work was rooted in her faith in action, improvisation, and thrift. "I trained myself not to waste," she said; "I feel that if you know you're going to live your life as an artist, you steel yourself daily. You don't develop fancy tastes, fancy appetites." As for her approach to sculpture, she explained,

> During the war there was a shortage of materials, and I decided that creativity was the important thing and I would see things that I could use, everywhere. I always wanted to show the world that art is everywhere, except that it has to pass through a creative mind . . . In my environment as a child I was very aware of relationships. The injustices of relationships. And I suppose I transferred that awareness to material, what we call "inanimate." I began to see things, almost anything along the street, as art. I don't think you can touch a thing that cannot be rehabilitated into another life. And once I gave the whole world life in that sense, I could use anything.
>
> I feel that what people call by the word *scavenger* is really a resurrection. You're taking a discarded, beat-up piece that was of no use

to anyone and you place it in a position where it goes to beautiful places: museums, libraries, universities, big private houses . . . These pieces of old wood have a history and a drama that to me is—well, it's like taking someone who has been in the gutter on the Bowery for years, neglected and overlooked. And someone comes along who sees how to take these beings and transform them into total being.

Nevelson goes on to talk about what happens when she works with pieces of found wood: ". . . When you do things this way, you are really bringing them to life. You know that you nursed them and you enhance them, you tap them and you hammer them, and you know you have given them an ultimate life, a spiritual life that surpasses the life they were created for. That lonely, lowly object is not used any more for what it was—a useful object. It becomes a work of art. It transcends the third dimension and it too arrives beyond. It takes part in a great creative act *after* practically becoming ashes."

Her empathy for old, battered, broken wood, her sense of not only bringing wood scraps back to life but also elevating them to a better existence, is at once childish, poignant, grandiloquent, and mystical. And the psychological implications are compelling. Did Nevelson identify with used and abused wood? She, too, had been maligned, mistreated, rejected, dismissed, injured, and cast off. She came damn close to landing in the gutter herself, and she rose from the ashes of her severe depressions and setbacks resurgent and resplendent, a phoenix in brocade and fur.

How low did Nevelson go? She began life outside Kiev, Ukraine, as Leah Berliawsky. The Berliawskys lived next door to the Yiddish writer Sholem Aleichem's sister, and legend has it that when he visited and saw baby Leah, he declared she was "'built for greatness,' potent words Leah's mother, Minna, never let her daughter forget." But benediction aside, Leah's early years were difficult. Her father, Isaac, the son of a lumberman, immigrated to America a few years after her birth, seeking a freer life than the one they had in Pereyaslav, a small town fifty miles southeast of Kiev, in a region where pogroms, anti-Semitic restrictions, and epidemics ravaged Jewish

communities. His wife and two children joined him in Rockland, Maine, of all places, in 1905, and promptly changed their names to sound more American. Leah became Louise.

Curiously, Rockland, Maine, was also home to the poet Edna St. Vincent Millay, who fled from that town as soon as she could and, like Nevelson, found paradise in New York City. Few Jewish families lived in Rockland when the Berliawsky family was reunited there, and Louise later described it as a "WASP Yankee town," bluntly saying, "Look, an immigrant family pays a price." As outsiders they were not welcome, viewed forever after as alien or exotic. Her father's struggle to establish himself carried him so far from his roots and so deeply into a new life and sense of self, when his wife and children, now foreign even to him, so frightened, and so needy, arrived, he suffered a breakdown. But he recovered, and promptly put himself to work as a peddler, "scavenging bottles, paper, scrap metal, wheels, rags, old clothes, used furniture and other discarded items to sell from a junkyard near his home." As he regained his strength, optimism, and determination, he became successful enough to hold a stake in a lumberyard, work in construction and real estate, and own property. The parallels with Louise's up-and-down, junk-and-wood-centered life are intriguing.

But Louise was devoted to her lovely mother, who was terribly lonely, and often bedridden with elusive ailments and untreated depression. Minna suffered the hidden trauma of immigration, the shock of losing one's

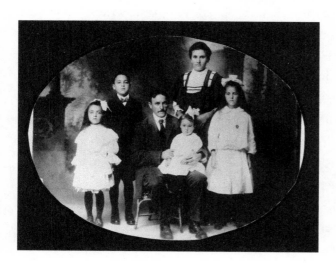

Berliawsky family portrait, ca. 1907. Unidentified photographer.

homeland and sense of belonging. Her very identity was erased, her standing in the world much reduced. To her new American neighbors, Minna, called Annie, would never be anything but an intruder. Immigrants have to re-create themselves to become part of their new community, and Minna wasn't able to effect this change. It was left to her eldest daughter to make the leap, and willful Louise had no trouble inventing an American persona, a personal mythology, and a world of her own.

In an effort to make a good impression, Minna dressed herself and her children in the finest clothes she could buy. But in this chilly Yankee town, frugality and plainness were virtues. Consequently, sensitive Louise was embarrassed by her mother's elaborate attire and makeup, and often felt conspicuously overdressed herself. Yet she loved her mother and understood that dressing well "was her art, her pride, and her job." She also described her mother as "a woman who should have been in a palace." In *Louise Nevelson: A Passionate Life*—the first and only full Nevelson biography for twenty-six years—Laurie Lisle quotes Nevelson saying, "My mother wanted us to dress like queens." Lisle believes that Nevelson sought to redeem her mother's life by transforming herself into a regal figure who ruled over her sculpture palaces and virtual empire with head held high.

But first Louise had to overcome her discomfort with English (the family spoke Yiddish at home, and Nevelson's English remained gnarly), the town's low-key but palpable anti-Semitism, and her dislike of everything at school except Shakespeare and art classes, in which she excelled. Energetic, olive-skinned, and curvy, she possessed, Lisle writes, "an extravagant dark beauty." Louise enjoyed her good looks and used them to her advantage. As she developed her considerable drawing and painting skills, which guided her all her life (in talking about sculpting, she later said, "Without drawing, you wouldn't *do* anything"), she also began to make her own eye-catching clothes, cleverly using aprons, cloth napkins, and draped fabrics. Her penchant for unusual getups became intrinsic to her identity.

At eighteen, Louise was working as a legal stenographer in a Rockland law office when she met and impressed Bernard Nevelson, one of four sons in a wealthy New York shipping family. He basically arranged her marriage to his younger brother, Charles. Their 1920 wedding pleased Louise's parents, and granted her a ticket out of the forested wilderness of Maine

and into the promised land of New York City. But Louise was soon bored by the plush and conventional life she had bartered her independence for. More alarming was her reaction when she became pregnant. She was absolutely traumatized. Terrified and appalled by the very idea of giving birth, she insisted on having a cesarean section. Myron, called Mike, was born in 1922, and Louise proved to be a miserable wife and a wretched mother. She spent so little time with her son that he had trouble learning to speak.

When the Nevelson fortune vaporized in the crash of 1929, Louise refused to curb her rebelliously lavish spending and impractical ways, and she continued to embarrass her husband and son with her flamboyant attire. Years later she told MacKown, "I was never married in the true soul sense." She remembers reading a newspaper article about a woman who pushed her husband out of a window during an argument and thinking, "There but for the grace of God go I." Equally alarming was her response to motherhood. "Here I had a son, and I didn't feel like living. I just felt like I was lost." Her depression was severe. She described what went through her mind: "I can't stay here because I'll do something desperate. I must get out of this. So I began working toward that end. The only thing that I felt saved my life was work because there was always a straight line there. I found that this was my stability."

After Nevelson began taking art classes, an epiphany at the Metropolitan Museum of Art affirmed her calling. And how fitting it is that her revelation was sparked by an exhibition of golden Noh kimonos. These exquisite ceremonial robes designed for classical Japanese theater moved her to tears. "I said, oh my God, life is worth living if a civilization can give us this great weave of gold and pattern." This was an abiding vision, made manifest in the elaborate robes she favored and the stage-set qualities of her sculptural installations, especially her late, still-controversial gold-painted assemblages.

Finally admitting that she cared not a whit for family life or material comfort or conformity, Nevelson enlisted her family's help (her brother Nate was a loyal and essential ally), and took off for Europe to further her art studies. Guilt over abandoning her son soon brought her back home, but she fled again a few months later in 1931, financing this trip by pawning the diamond bracelet Charles had given her in celebration of Mike's birth.

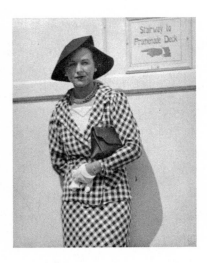

Louise Nevelson, 1932.
Unidentified photographer.

When she returned for good a year later, she rented a place of her own in Lower Manhattan and dedicated herself wholly to her art, declaring, "I am closer to the work than to anything on earth. That's the marriage." She was so absorbed in her struggle to survive and make art, she missed her son's bar mitzvah. When Mike tried to live with her, the steady stream of his mother's casual lovers soon sent him packing. Without a gallery, Nevelson could not sell her work, and so she scrounged, drank too much, plunged back into depression, and made art out of scraps.

Indomitable and gifted, Nevelson did succeed in exhibiting her work in group shows, though most of her relationships with other artists were thorny. She did, however, form a close and lasting bond with painter, then actor Marjorie Eaton. Newly separated in 1933, Nevelson needed a place to stay. Eaton introduced her to the master muralist Diego Rivera, who offered them both space in his New York studio and work as his assistants. Friendships developed between the two women, Rivera, and his wife, Frida Kahlo. Nevelson then had an affair with Rivera that she immediately regretted.

As much as she wanted admission into New York's now fabled abstract art circles, Nevelson didn't talk the talk or adopt the look. She simply refused to walk around looking like the starving artist she truly was. While other women artists dressed plainly and offhandedly, implicitly stating that they had more important things on their minds than fashion, Louise was

provokingly glamorous. When Alice Neel asked her how she managed to dress so beautifully, Nevelson replied, "Fucking, dear, fucking." Another woman friend (with friends like this, as they say, who needs enemies) described Nevelson as "slightly whorish." Brazen to the end, Nevelson told Lisle that "if she revealed all the ways she had survived during those financially difficult years, she would be arrested and put in jail."

Nevelson's confident, even aggressive appearance, coupled with her reluctance to theorize about her work, fueled the misogyny that ran rampant in the art world at the height of the Abstract Expressionist movement. Male artists and critics did not take her seriously, thus grievously underestimating her. But she stood her ground. When an obnoxious male artist tells her, "You know, Louise, you have to have *balls* to be a sculptor," she replies, "I *do* have balls." She kept her troubles to herself, and wore her glamour as armor.

After being forced to destroy many sculptures because she had no place to store them, after enduring poverty and despondency and rage, Nevelson, a hunter-gatherer in the urban jungle who refused to compromise or beg, finally insisted that gallery owner Karl Nierendorf come look at her work and give her a show. He looked, he liked both artist and art, and ended up representing Nevelson for seven years. She had her first solo exhibition in 1941, the same year she became legally divorced. The show was well received, but one egregiously sexist (or possibly jokey) anonymous review stands out by virtue of these jolting lines: "We learned the artist is a woman, in time to check our enthusiasm. Had it been otherwise, we might have hailed these sculptural expressions as by surely a great figure among moderns." It's enough to drive anyone to drink and fury.

Nevelson could be unnervingly confrontational, even atavistic and out of control. One of the more sad and shocking stories Lisle tells places a wrathful Nevelson at the lavish opening for a 1959 group sculpture show at the Museum of Modern Art. Enraged not to have been included, Nevelson slips behind a curtain concealing a stash of liquor and tubs of ice, lifts her long skirt, and pisses on the cubes.

Both Nevelson and the twentieth century were in their fifties when her work finally began to receive respectful critical attention. And she was well into her seventies and eighties when she began to work on large outdoor

sculptures. As much as she fought to be treated as equal to men artists, Nevelson believed that women did make art differently than men, and that this was a fine and wonderful thing. Furthermore, she said, "I think that if a woman is gifted and she's attractive she's going to have a great time on earth. Why would she want to be anything else? I don't think of myself as a strong woman. I never even heard that word about me until recently. I always thought bluntly that I was a glamorous goddam exciting woman."

When Nevelson wasn't hustling rich men, she liked to pick up stevedores who worked on the docks nearby. She got lucky in her relationship with one longshoreman named Johnny (last name lost), who for several years squired her around town and helped her with the heavy lifting in the studio. Too bad the injuries he sustained after being shot in a brawl with police ended up causing him "chronic stomach trouble." As Lisle so succinctly puts it, "Louise did not want to be bothered with the needs of a sick person." Heck, she had little patience with her own physical needs, although at seventy-six she chose to undergo breast-reduction surgery. She claimed her breasts got in her way when she worked. Maybe, but she also didn't want to look matronly or old. She wanted to be svelte and unencumbered and desirable.

As her fame increased, so did the quality of her clothing. The fashion designer Arnold Scaasi was quite taken with her unique chieftain/sorcerer style, her bold mixing of different prints and unexpected combinations of the opulent with the utilitarian—a flannel work shirt, for instance, with a sable coat. Scaasi designed lavish clothes fit for the "empress of art" that Nevelson adored, even as she refused to wear high heels because she liked to take long, free, and easy strides. She not only craved the attention her colorful, flowing garb attracted, she also, truth be told, felt shy and defenseless without her robes, hats, and amulets. And besides, her outfits were works of art. Nevelson told MacKown, "I love to put things together. My whole life is one big collage. Every time I put on clothes, I am creating a picture, a living picture, for myself . . . I like clothes that are upholstered. I like that you build up your clothes, and build up, and even the hat . . . I feel the clothes that I have worn all my life have been freedom, a stamp of freedom—because I have never conformed to what is being worn."

Nevelson was no hypocrite. She had "such esteem for the creative mind," she refused to stifle her artistic impulse and dress down to look like

everyone else. And why not flaunt her success? Hers is a tale of rags to riches, *schmattes* to fame.

Nevelson started making abstract free-standing sculptures in the heyday of Abstract Expressionism, and she began filling boxes with found objects in the Pop Art days, when a can of Campbell's soup was elevated to fine-art status. Nevelson couldn't have cared less about consumerism and mass culture, ensconced in her empire of castoffs. She was seeking a deeper level as she put together her intricate puzzles. By the late 1960s and early 1970s, Nevelson's attunement to the "livingness" of wood, passion for ancient cultures, and mysticism were in sync with hippie culture, and as were her flowing paisley thrift-shop clothes, her beads and bandanas, her love of Native American art, and her penchant for crazy-quilt juxtaposition and do-it-yourself handicraft.

The 1970s was also a time of renewed feminism and the women's history movement. Women critics were intent on reclaiming the work and life stories of forgotten women artists of the past, and on fighting for space in galleries and museums for women artists of the present. Women artists were also transforming art itself. Miriam Shapiro and Judy Chicago brought traditional women's crafts—sewing, embroidery, china painting—into the fine-art arena. Like her sister artists, Nevelson knew that the ordinary contains the extraordinary. In a 1976 interview with Arnold Glimcher, her most devoted and simpatico art dealer, she said,

> Well, don't forget that the lace curtain is not only a lace curtain. I am saying that it isn't just something to put on a window . . . It has a whole architectural structure of its own. It has its own life. It is constantly in movement. A breeze gives you new forms; and the glitter is like a river, or an ocean really. So we have to realize that when a mind is working in a medium, it means that you're using this kind of a medium to encompass into your consciousness all the creation that was put on this earth and also beyond.

Life on earth was at once too much and too little for Nevelson, who beneath her queenly robes was porous to the suffering of others, even as she was impatient with the needs of family and friends. She relied on the

discipline of art to channel her unruly emotions and tame her demons. She built an empire for herself out of "a thousand destructions of the real world," as a retreat, a hermitage, a sanctuary. And yet she did not work in isolation. She cultivated studio assistants and flourished in collaborations that allowed her to give full rein to her imagination while others took care of the technical challenges. Even her vivid autobiography was not written in solitude, but rather spoken aloud to trusted friend and assistant MacKown, who then turned ensorcelled talk into shaped prose. And in spite of her inability to maintain intimate relationships or to be social in the usual ways, Nevelson supported the efforts of other artists, especially women, and she never ceased to learn and grow. She never got stuck in ruts; she never closed doors to new adventures; she never permitted herself to be pigeonholed.

Once she was known the world over as the artist who painted everything black, Nevelson started painting her work white and gold. Revered for her adeptness with wood, she began to make sculptures out of glass and Plexiglas. When commissions for large outdoor sculptures began to pour in from across the country, she decided to explore the possibilities of aluminum and steel. As with wood, she composed with metal scraps and remnants to create what she called "sculpture-collage," remarkably buoyant landscape-scale studies in balance, shadow, and reflection. Penetrating and imaginative, Nevelson became fascinated with all the effort that went into manufacturing these adamantine manmade materials, conceiving of each substance as an "accumulation of thought." As with wood, she detected the life force in plastic and steel, and recognized that these materials profoundly altered our perception of the world.

Nevelson brought this same insightful understanding of how the things we invent and construct change not only the tangible and visual world but also our mindscape to her impressions of the then three-year-old World Trade Center:

> The World Trade Center is two giant cubes and the tallest cubes in the city. They stand there among the rest of the sculpture-city and they are fine. They're magnificent. When the lights go on at night they're touching beyond the heavens. But when you think of the concept of

building involved in the World Trade Center, it has set a precedent and challenge to the world that the human mind has encompassed the engineering of that space. From that point of view the World Trade Center is a landmark. And you can understand, if you want to tie it up with the evolution of humanity, how the human mind is going to have to move and expand to accept it.

Or not. Leave it to sibyl Nevelson to recognize the immense and problematic symbolic import of the World Trade Center, which, of course, led to its destruction. Naturally, she was thrilled to be commissioned to create an immense black wood wall relief for the towers. *Sky Gate, New York* was prominently displayed in 1 World Trade Center on the mezzanine facing the plaza until all was destroyed on 9/11, in a tragedy we've yet to fully wrap our minds around, let alone all the horrors, misery, and crimes that have followed.

The endlessly self-aggrandizing sculptor boasts about her handling of Cor-Ten steel: "I found that in my hands and in my way of thinking at this point, it was almost like butter—like working with whipped cream on a cake. I was using steel as if it was ribbon made out of satin. And somehow it gave me another dimension." Of course, Nevelson had the skilled assistance of metal fabricators. The tough gal who relished the company of longshoremen had a ball with the steel men, and there are photographs to prove it. Both MacKown and Guerrero documented Nevelson working at the Lippincott Foundry in North Haven, Connecticut, and these are the most vital and relaxed pictures of the artist available. Nevelson is in her element. You can just imagine her calling these guys "sweetheart" and "darling" and "dear" in her husky smoker's voice as she bosses them around, a slim cigar burning between her nimble fingers. Fake eyelashes jutting, headscarf snug, plaid and flower patterns in competition on her layered attire, Nevelson directs the men to do strange and marvelous gravity-defying things with curvilinear pieces of steel, resulting in the construction of tremendous sculptures of amazing lightness and beauty.

But creativity is no party. As Nevelson said, "The very nature of creation is not of a performing glory on the outside. It's a painful, difficult search inside." In spite of the fact that she worked with pieces, with scraps

and fragments, her search was for "the achievement of unity." Nevelson questioned all assumptions about reality, and thought a lot about how appearances deceive. She pondered the significance of the fact that everything that seems to be solid is actually a tenuous gathering of atoms, that everything is forever in the process of becoming something else. She also considered the conundrum that there is no such thing as nothing. She said, "I think often people don't realize the meaning of space. Space, they think, is something empty. Actually, in the mind and the projection into this three-dimensional world, space plays the most vital part in our lives. Your concept of what you put into a space will create another space . . . Space has an atmosphere . . . The whole body is in space. We are space." Lisle writes, "Near the end of her life, Nevelson's metaphysical sense of the insubstantiality of objective reality deepened."

Nevelson was even prescient in her anticipation of the lure of the virtual world. She riffs in her knotty, oracular way on the laws of nature. They are still necessary, she muses,

> But the thing is, the time may come, with computers, with technology, when humans will not need this manifestation, this projection into three dimensions. Even in sacred books, like the Indian philosophies, they don't feel—as long as you are laboring and working—that's the height. It's the place of contemplation, you see, that is where you don't have to make anything or do anything. But I, for my own needs, prefer to play the game with awareness, on earth, three-dimensionally. It's a choice I've made. I could easily have moved into an area of meditation and contemplation, and it is higher according to all philosophers. But I claim physical activity teaches me so much. My feeling is that there is great intelligence in labor . . . That living awareness moves me as I move it to an activity that encompasses the mind, the body, and the total consciousness. So I feel that I could not have projected my world only through contemplation. Since I *did* want to project a three-dimensional world for myself, it could not have been done without physical activity.

How could we wish it to be otherwise? We are creatures of the earth, members of one of the animal tribes. Our minds are fed by our senses. Our

bodies evolved, brain and all, to move through space defined by the planet's precious atmosphere and sculpted terrain with its lush and sustaining mantle of trees, shrubs, and grasses. We are wholly dependent on the many-stranded web of life, in which everything serves a purpose at each stage of its existence, cessation, and decay. Nevelson was no nature girl, yet she perceived the interconnectivity and cycles of life as she prowled the wild, secretive streets before dawn, her predator's eyes picking out hidden treasures. And she summoned the moon and the sun, oceans and trees, collective memories and shared dreams, as she worked the brilliant black, white, and gold magic of her art.

Yet during the years in which Nevelson built her imaginary empire, the gorgeous complexity and perfection of creation was being diminished by humankind's industriousness. Here and now in the twenty-first century, the entire living world is imperiled. Humankind has inadvertently put the glimmering, miraculous balancing act that is life at grave risk. We've assumed that nature can take care of itself while we, the planet's storytellers and inventors, tinkerers and garbage-makers, are held spellbound by the objects and machines of our own devising, oblivious to the cost of their manufacture, which is paid for with the irreplaceable currency of clean air and water, fertile earth, and all that keeps the fire of life ablaze. For future generations, the astonishment and bounty of a resplendent world teeming with countless, diverse, symbiotic species may become only a memory, the ultimate story of paradise lost.

Reading *Dawns and Dusks* nearly three decades after Nevelson's death, one is struck by her spirituality. The creator of *Dawn's Wedding Feast*, *Ocean Gate*, *Cascade*, *The Wave*, *The Forest*, *Tropical Garden*, *Sun Disk*, *Half Moon*, and *Royal Tide* was, in her way, a pantheist. In *Standing in the Light: My Life as a Pantheist*, nature writer and writer of conscience Sharman Apt Russell defines pantheism as "the belief that the universe, and all its existing laws and properties, is an interconnected whole that we can rightly consider sacred." She quotes Marcus Aurelius: "Everything is connected, and the web is holy." Surely Nevelson would have agreed.

A pantheist by nature, Nevelson didn't talk much about her Jewish heritage, but Judaism and the Diaspora shaped her life and her work. Her most intricately detailed constructions resemble historic Jewish art and artifacts:

elaborately filigreed Torah cases, carved arks that hold the sacred scrolls, and exquisitely patterned Kaddish cups, oil lamps, and candlesticks. Even more resonant in this context is her response to a broken world; her impulse to gather dispersed pieces and reassemble them to create a new unity. However subconsciously, Nevelson was enacting a ritualized form of *tikkun olam*, the Jewish call to repair the world. In 1964 she created two monumental Holocaust memorials, *Homage to 6,000,000 I*, which Lisle describes as "a massive black curved wall of immense dignity and grief, a sculptural kaddish," and *Homage to 6,000,000 II*; the first in Japan, the second in Israel.

Not only was space sacred to Nevelson, she also created works destined to grace sacred spaces, including the magnificent installation *The White Flame of the Six Million* (1970–71), for the Temple Beth-El in Great Neck, New York, one of several commissioned works for synagogues. She also completed a commission for the Chapel of the Good Shepherd at Saint Peter's Church in New York City.

Louise Nevelson was everywhere, and then she was nowhere. Would Nevelson have been able to draw on her sense of the mutable nature of reality and taken a philosophical view if she could have known how quickly and completely she was forgotten after her death? After Laurie Lisle's biography came out, there was silence. No one else in the public square was critiquing Nevelson and assessing her contribution to modern art. There were no major retrospective exhibitions. No one found her life alluring enough for fiction or film. Her work was rarely reproduced. Museums put her large installations in storage. Perhaps they are too difficult to maintain; imagine the tedium of dusting every edge and corner. New books about American art, modern art, abstract sculpture, assemblage, installation art—all spheres in which Nevelson was a pioneer and driving force—omitted her entirely, or relegated her to one inadequate, often condescending mention.

As Nevelson was eclipsed, Georgia O'Keeffe ascended. Book after book documented and analyzed her life and work, from the stunning nude photographs taken by her husband, Alfred Stieglitz, to lush reproductions of her paintings, to photographs of her desert refuge. Hunger for all things O'Keeffe sustains a veritable industry, and an entire museum devoted to

the sainted artist of the Southwest was erected in Santa Fe, New Mexico. O'Keeffe's sunlit paintings waxed; Nevelson's lunar sculptures waned. And Frida Kahlo had her revenge. Like O'Keeffe, she became a mainstream emblem of female creativity, albeit as a martyr to pain and betrayal. Her life of physical agony and psychological anguish, of great courage and trailblazing artistry, of audacious and indelible self-portraits, was celebrated in a torrent of beautiful and affecting books and in an acclaimed film. Like the forgotten Nevelson, Kahlo was a living work of art, with her crown of braids, elaborate earrings, embroidered blouses, and great ruffled skirts. But Kahlo is enshrined; Nevelson obliterated.

"She was a bird of rare plumage," wrote master playwright Edward Albee, a close friend of Louise Nevelson for more than twenty years. What did he think of Nevelson's erasure? In 2001, Albee wrote a play in homage to the sculptor titled *Occupant*, a work of exquisite empathy and dark, knowing humor. It's a duet for two characters: The Man, "40's, pleasant," and Nevelson, who is "much like the later photographs," and, as the stage directions explain, "encased in a costume 'cage.'" As the play begins, The Man starts to introduce her, and Nevelson interrupts, "Look, dear, everybody knows who I am." He demurs, "Time passes. You're not as . . . recognizable now as you were." Nevelson says, "You're kidding!" The Man then has the unenviable task of explaining that today few people know who she is. She bristles; she laughs; she exclaims "All right! So I'm invisible! Or I don't exist! Which do you want?" He tells her that more people know what she looks like than what she did: "You're a very famous image, Louise . . . You were."

Is Albee's Nevelson character devastated by the fact that her work has been forgotten? No, she's too resilient, smart, and cynical. She's been around; she knows how the world works. Sharp-tongued and at once combative and evasive, she banters and argues with The Man as he attempts to chronicle each phase of her life. The Man struggles to keep Nevelson honest. She balks and protests, at one point telling the audience, "Pay no attention to him." But as the duel continues, she recognizes that he is well-informed and well-intentioned, and she becomes almost grateful for a chance to reflect on her life. It's an interrogation, a reckoning, a therapy session. Finally, The Man asks her about her last days in the hospital. Her

name was initially on the door to her room, he reminds her, in capital letters no less. "As big as *death* maybe," she says. "Yes, there's no privacy anywhere." So she had them replace her name with "Occupant"—the brash and ironic final gesture of a self-made queen.

In keeping with the odd and inexplicable Nevelson blackout, *Occupant* began previews in New York City in 2002, with Anne Bancroft cast as the artist. But as Albee notes in the published version of the play: "Due to illness, Anne Bancroft was not able to continue in her role as Louise Nevelson, so the production never officially opened." Bancroft died in 2005, Albee in 2016.

A legal and financial debacle, rooted in the guilt and pain that burdened the relationship between Nevelson and her son, erupted over her estate after her death, keeping her work off the market. This anguished and protracted battle did contribute to Nevelson's banishment to the shadows, but all was resolved, and no court case can eradicate the power of her work or the profundity of her achievements. So why was Nevelson dismissed? Was she too flamboyant? Too strange? Did she become a caricature rather than an icon? Was she too intense, arrogant, cryptic, ornery, primitive? Too dramatic? Too contradictory? Too successful? Too on-in-years when she created her best work? Was she too flinty and rough with her cigars, her stabbing eyelashes, her gravelly voice, her mask and armor? Why was her work so quickly forgotten? Was it too decorative, too creepy, too female, too somber, too mystical? Even when she was alive, nearly everyone despised her gold sculptures. They were considered gaudy and crass. But their bold inquiry into our worship of wealth and status now comes through loud and clear, as does the artist's delight in opulence as power. Nevelson's romanticism is as misunderstood as her irony. Her gold sculptures reach back to her epiphany in the presence of the golden kimonos, and embody her belief that beauty is a precious and healing element.

Nevelson's entire oeuvre will be forever open to interpretation. Her sculptures ask to be read, and reread. Her great walls and towers are wooden poems, each box a stanza, each piece a word, yet they are not tethered to any one language. They speak to everyone. Her works alter the

spaces they occupy, and change those who stand before them. Nevelson's sculptures emit a mysterious force; they embody memory, dream, trance, and prayer. Nevelson's accumulations and compositions encompass loss, metamorphosis, and reclamation. Her sculptures make what was broken whole, and reveal that what we see as whole is the sum of infinite parts.

Nevelson's work makes us acutely aware of how blithely we throw things away. We churn out more products than we can possibly use, and we are profligate with our trash. Our garbage is amassed in gargantuan land-fills, which stand as our pyramids, our Great Wall. We can't seem to grasp that when we throw things "away," there is no away. There is only here, here on the glorious, spinning, orbiting earth. Our waste becomes more toxic and deadly with each generation of digital and nuclear devices. Nevelson discerned and respected the life force intrinsic to each and every made thing. We toss items when they're worn or broken or no longer stylish. We're losing the art of repair, and we're clotting the web of life with plastic bags and old cell phones and water bottles. A society that habitually discards so many objects so obliviously is at some deep level indifferent to life. How great a divide is there between trashing our belongings and seeing animals and other human beings as disposable? How different is the habit of waste-fulness from a lack of compassion? A reconsideration of Nevelson's art inspires us to reflect on what we value and cherish, how we live and die. What we hope for, and what we will leave behind.

It seems that when we need the vision and light of a lost artist, when we're ready to appreciate her perspective and discoveries, the veil is lifted, and the artist returns. How fitting it is that in this time of accelerating climate change, environmental crises, and unmanageable waste, an artist who perceived trash as treasure and found illumination in life's cycles has herself been reclaimed and resurrected. In 2000, the U.S. Postal Service issued commemorative stamps in Nevelson's honor. In 2007 a retrospective exhibition, *The Sculpture of Louise Nevelson: Constructing a Legend*, was organized and displayed by the Jewish Museum in New York, reassembled in San Francisco, and accompanied by an elegant catalog. Nevelson's archives are now available online as part of the Smithsonian Institute's vast and invaluable Archives of American Art. A new documentary film has been released; a Louise Nevelson Foundation has been founded; a new

biography, Laurie Wilson's *Louise Nevelson: Light and Shadow*, has been published, and Edward Albee's play has finally been produced. Long live the Empress of Art.

Intimate with paradox and contradiction, despair and triumph, Nevelson called herself Louise Neverlands in wry acknowledgment of her attempt to remain forever young, her preference for make-believe, and her longing for magic. For all her mastery of black and white, Nevelson knew that humankind lives in the gray zone. She understood that we are Earth's most conflicted beings. We dwell uneasily in dawns and dusks, the sea of ambiguity, the lost-and-found, the zone between emotion and intellect, the void between dream and reality. We all abide for better and for worse in the in-between.

GIRL SEARCHING
GERTRUDE ABERCROMBIE

I paint the way I do because I'm just plain scared. I mean, I think it's a
scream that we're alive at all—don't you?
—Gertrude Abercrombie

A girl walks across a barren yet somehow vital and stirring landscape
beneath an overcast sky marked with dark, winged clouds and illuminated
by a brilliantly bright full moon. Her arms are lost within a black blob of a
jacket; her green, knee-length skirt is brushy and in motion. She is wearing
black flats, and a little brimmed black hat perches on her brown, blunt-cut,
shoulder-length hair. She is leaning forward, left to right, as is a large forked
dead tree behind her. Its spare, dark, calligraphic limbs signal to the lone
traveler. Behind it is a small, boxy blue building with a black door and two
square windows. The building, the tree, and the young woman cast moon
shadows, while in the distance, the benevolent lunar light caresses a tightly
circled, even huddled grove of trees. The green of their clustered crowns
echoes the green of the girl's skirt. Her face is minimally indicated; her
large dark eyes predominate. The arresting simplicity and starkness, silence
and vigilance, of this small, dark painting invite the viewer to see this young
woman's solitary, meditative nocturnal walk as an archetypal journey, a
coming-of-age quest. Intriguing in its alchemical mix of the obvious and the
mysterious, *Girl Searching* is an essential piece in Gertrude Abercrombie's
unique and transfixing autobiography-in-paintings.

Abercrombie was thirty-six years old when she painted *Girl Searching*
in 1945. An established Chicago artist, a wife, and a mother, she was still
searching for clarity and freedom to be fully herself. Abercrombie did not
feel entirely comfortable in her own skin. She was not confident about
love, marriage, or motherhood. She was insecure, often blue, lonely, angry,

irascible, and narcissistic. She worked avidly, desperately, and defensively. Painting was her calling, her sanctuary, her armor, her therapy, her antidepressant, and her currency. Her reason for being. Her lifeline. Her promise of posterity. Abercrombie drank too much and altogether neglected her health. Her closest friends were gay men; she kept her distance from other women. She fed her cats more lavishly than her human friends. She had a sly, biting sense of humor and a zest for parties and mischief. She was musically gifted and wild for jazz. She hosted now-legendary jam sessions at her three-story Victorian brownstone in Chicago's lakefront Hyde Park neighborhood on the South Side near the University of Chicago. Over the fifteen years following her creation of *Girl Searching*, Abercrombie funneled joy and agony into hundreds of provocative paintings instantly recognizable as hers. She exhibited regularly, cruised the city in her vintage Rolls-Royce, and was featured in newspapers and magazines as journalists reveled in her enigmatic, even spooky art and her colorful life. Abercrombie's cherished title, Queen of the Bohemian Artists, was well-earned.

Artist, curator, and influential champion of Chicago artists Don Baum became a close and trusted friend of Abercrombie and, eventually, the executor of her estate. He described her as "very funny" and "grouchy" and "very introspective." He vividly remembers her house percolating with the energy of all kinds of people, jazz, art, and cats. Hers was a dynamic, unconventional household sustained by lodgers who ranged from University of Chicago students to renowned musicians and composers. "She played the piano, you know," Baum recalled, "and there was nothing she liked more than to sit down at the piano with somebody like Dizzy or Miles standing near her playing their instruments. It was pretty wild."

Abercrombie's daughter, Dinah, her one child, sounding pretty jazzy herself, remembered her mother during these sessions: "She was gay and radiant at these. Yes, she was the center. She was happy and expansive and had wonderful exchanges with all these people. She was blooming, she was flying . . . and the sound of her laughter would float over the music and carry the party into her sky . . . She would be sailing in her element and this was her glory and this was in her paintings, too."

Abercrombie's natural "element" also included a veritable fountain of booze flowing beneath a haze of tobacco and marijuana smoke. Among

Abercrombie's papers are photographs and letters documenting her close, loving friendships with frequent guests Dizzy Gillespie and Sonny Rollins. In his memoir *What Is What Was* (2002), Chicago writer Richard Stern records his University of Chicago colleague, Nobel laureate Saul Bellow, reminiscing, "It was wonderful then, good old Bohemian Chicago. I got in with Gertrude Abercrombie [the painter] and her crowd." Among the artist's papers is a note from the one and only Chicago-based oral historian and radio host, Studs Terkel: "To Queen Gertrude, You are regal—And we love you—Studs."

Photographs do not exactly confirm Abercrombie's regality. She does look thoughtful and self-possessed, and there are some elegant photographs of her and her handsome first husband, Robert Livingston. There are also some stylishly staged shots of the earnest artist seated before an easel, brush in hand, as though she's hard at work on a large self-portrait, in spite of being absurdly overdressed for the messiness of oil painting. And the painting is set within a large, showy frame; clearly it had been completed long before the photo shoot. No doubt impish Gertrude found this fakery hilarious. In other shots she looks shy, even apologetic. You can tell that she's rueful about her looks as she mugs and clowns for the judgmental camera. Pictures taken at parties capture her poised, attractive, camera-wooing friends looking splendidly at ease, while Gertrude stares at the camera with chagrin, curiously childlike in her reluctant compliance with

Gertrude Abercrombie on couch. Unidentified photographer.

the lens' demands. In one photograph she even lies flat on her back on the floor, ankles and wrists demurely crossed, while friends sit in a neatly composed group behind her, in perfect command of the situation while she, one assumes, pretends to have succumbed to way too much partying. Yet as fearful as she was of the pitiless camera, Abercrombie painted herself over and over again.

One of the most striking and seductive aspects of Abercrombie's oeuvre is her defining visual lexicon. Like a jazz musician improvising on certain rhythms, notes, and melodies, she riffs on a set of subjects, settings, objects, and colors that hold deeply personal and resonant meanings for her. Abercrombie created an incantatory repertoire of flatlands, the full moon, bare trees, white boulders, boxy little houses, paths, towers, windows, nearly empty rooms, paintings within paintings, letters, gloves, telephones, seashells, chairs, a Victorian chaise longue, vases, flowers, a pedestal, cats, owls, and horses. Her stark landscapes are occupied by tall, slender, and, yes, regal female figures clad in long, simple, even penitential gowns. These women have large, dark, deep-set feline eyes. Their stances and gestures are formal, as though they are onstage or performing a ritual or casting a spell or serving as witness or guide. These highly stylized tableaux, with their repeated symbols and magical motifs, give Abercrombie's paintings the look and aura of hieroglyphics or tarot cards.

Her moody palette was just as carefully defined as her imagery. And though her distinctive twilight colors express her moods and feelings, they also mirror the Great Lakes light that makes the evening skies of northern Illinois and Chicago so unexpectedly luminescent, a redemptive spectrum of dusky grays, coral pinks, and precious turquoises gracing the grit of the city and the monotony of the featureless land. But the focus of Abercrombie's paintings are the longings and fears aroused by complex psychological quandaries. Her self-assigned mission was to issue meteorological reports from a stormy psyche.

The enigmatic themes, dreamy atmosphere, and thematic continuity of Abercrombie's work inspired critics to call her a Surrealist or a magic realist. And she agreed. On a scrap of paper she wrote, "Surrealism is meant for me because I am a pretty realistic person but don't like all I see. So I dream that it is changed. Then I change it to the way I want it. It is

almost always pretty real. Only mystery and fantasy have been added. All foolishness has been taken out. It becomes my own dream. Others may or may not get it. Or dig it." And for all the mystery of her paintings, the artist talked about them in the most matter-of-fact manner: "I am not interested in complicated things nor in the commonplace, I like to paint simple things that are a little strange. My work comes directly from my inner conscious-ness and it must come easily. It is a process of selection and reduction." In 1952 Abercrombie told journalist Agnes Lynch, "I like to paint mysteries or fantasies—things that are real in the mind, but not real in the ordinary sense of the word."

No artspeak for Abercrombie. No manifestos, no abstractions, no pretension. She disliked such discourse, and there was nothing intellectual about her aesthetics. She did acknowledge that the artists Giorgio de Chirico, Max Ernst, and Salvador Dali might have "something to do" with her work. Then she said, "But the big influence was the Belgian painter, [René] Magritte. When I saw his work, I said to myself, 'There's your daddy.' And I've been working in that surrealist vein ever since."

When Abercrombie talked to Studs Terkel about her work, she said, "Everything is autobiographical in a sense, but kind of dreamy." She disingenuously played the role of the primitive and the unschooled, as in this passage from an article in *Chicago* magazine: "I always paint my face, I guess, when I paint people. It is the face I know best. And it's really the easiest for me because, you know, it is sort of like putting on makeup."

When Agnes Lynch interviewed Abercrombie at her home for the *Chicago Sun-Times*, she watched cats race around the artist's studio while the artist spoke about what Lynch described as Abercrombie's "restrained palette": "'I think it is foolish to lay out all the colors on the palette indis-criminately,' Miss Abercrombie said. 'To me each color has a special meaning and until I "feel" a color in an artistic sense, I just don't use it. Purple seems to be my new color, and I find it is getting into all my paint-ings.'" Lynch introduces the artist's nine-year-old daughter: "Dinah takes an active interest in her mother's work, and it was she who helped to intro-duce a new color note in her mother's paintings when she asked her some time ago to 'paint her a pink picture.'"

Abercrombie liked to tout her disinterest in technique as well as her lack of formal training. She never learned to properly use paints and other materials, and many of her paintings had to be painstakingly restored. As Don Baum observed, "She was no technician, believe me . . . She never really knew much about the craft of painting. It wasn't about that. It was about making her strange images." Abercrombie made the distinction between being a good painter and being a better artist, and it was the latter that she cared about. For her, making art was about emotion, perceptions, and ideas, not skill: "Something has to happen, and if nothing does, all the technique in the world won't make it."

As stylized and iconic as most of the far-from-lifelike figures in her paintings are, Abercrombie was in fact a gifted and expressive portraitist. Among her earlier works are lush, looser, more painterly, colorful, natural, and multidimensional paintings of friends and family. She captured the nuance of her subjects' temperaments, their living, breathing presence.

Abercrombie met writer Wendell Wilcox in 1934, when, as she wrote in her fragmented reminiscences, she was "recovering from a case of collapsed love." The two became friends, and he later wrote, "It is a great pity that she did not do more portraits of other people. She is a very remarkable portrait painter. Some she painted out of love and some for friendship and a few on order for the sake of money. They are all remarkably revealing— too revealing to the people who contracted to buy them and to be salable. Some rejected them. But Abercrombie felt that portraiture was not truly a branch of art and she disliked practicing it."

She was also, as others observed, just too darn self-involved to pay such concentrated attention to others. Even Abercrombie herself joked about her narcissism. She loved telling people, for example, about a postcard written by one friend, the artist Dudley Huppler, to another, the artist Karl Priebe: "Dear Karl, Took Gertrude to the Ballet last night. She didn't like it. She wasn't in it." The primary reason Abercrombie lost interest in painting others was because she needed to paint herself to survive her increasingly daunting life.

But early on Abercrombie did paint herself in that sensuous, assured style, creating a small oil-on-paper self-portrait in 1929, while she was attending classes at the School of the Art Institute. Art historian Susan Weininger establishes this image's unique place in Abercrombie's work,

noting that this painting of a "lovely" and "glamorous young woman, coquett-ishly turned toward us," is radically different from her other self-portraits, in which she "represents herself somewhere on the continuum from simply austere to truly forbidding." The inspiration for this small likeness was a photograph of Abercrombie's favorite movie star, Greta Garbo. Weininger writes, "Abercrombie's fascination with Garbo, a woman of beauty and mystery, was common knowledge among her friends." Wilcox concurs: "Garbo was her ideal woman, almost the only woman she ever admired."

Among a small group of vibrant woodcuts stored in a flat file at the Illinois State Museum in Springfield, the state capital, is *Cat and I*, a 1937 self-portrait of Abercrombie at her most jaunty in the company of a big, brash black cat. A proto-beatnik sorceress, she wears a striped turtleneck and black beret, her large, light-filled cat's eyes aglow. This is a far more animated and warmly human self-depiction than the curiously chaste and static figures that stand like oracles or the condemned in so many of her paintings.

Among Abercrombie's more formal depictions of herself—verging on traditional—is *Self-Portrait, the Striped Blouse*. She painted it in 1940, the year she got married for the first time. Here we see the woman the searching girl became. She stands beside a large window, the edges of her flat, brimmed black hat paralleling her strong, black eyebrows. She is at once elegant and raffish, with her sharp nose and chin. Her expression is solemn, preoccupied. Her lips are firmly closed; her large dark eyes look inward. Half of her face is in shadow, like the moon, which, seen through

Gertrude Abercrombie. Cat and I. *1937. Woodcut.*

the window, is nearly covered by an elongated black cloud—a hovering black slash. Her posture is aristocratic. The lustrous white blouse with black vertical stripes (Abercrombie often wore striped clothing) traces the curves of her strong body. The composition has a Renaissance feel, even a Mona Lisa echo, however modern it is in spirit. Behind her hangs a dark magenta velvet curtain, its folds voluptuous, a curtain more suitable to a stage than a window.

Beside Abercrombie is a white table on which stands a stemmed bowl filled with a bunch of grapes. The grapes are very dark, their burgundy glow coaxed out by the filtered moonlight. The dried vine reaches out into the landscape framed by the window. Abercrombie's right hand is poised to pluck a grape from the bunch, her curved fingers mirroring the blouse's stripes tracing her breasts. The grapes seem like a sacrament. Outside, an otherworldly twilight is underway, with that peculiar underwater feeling Abercrombie so often conjures, as though the world exits within a cosmic aquarium. This spellbound land is rendered in the colors of bruises. A thin line of light at the horizon mimics the line of light tracing the rim of the bowl. A tree stands stoutly alone like a giant stalk of broccoli, tufts of grass at its base, moonlight blessing its cruciferous head. The tree is torqued in a tornadic twist.

We see an alternative Gertrude in the poignant *Self-Portrait as My Sister*. Dated a year after *Self-Portrait, the Striped Blouse*, this is an under-loved only child's dream of an alternative self, more feminine, more lovable. Here the light is somewhat brighter than her usual gloom and more benign, though the sky is cloudy, at once quilted and watery. The imaginary sister, a glamorous variation on the artist, has Abercrombie's narrow face, prominent nose, firm, straight mouth, serious eyebrows, and large blue eyes, yet she is more delicate, more pliable, and prettier. Instead of black, her hat is azure, decorated with a turquoise flower and grapes that jut over the hat's brim while a stem corkscrews up into the air. Her neck is long and graceful. She's wearing a green dress with puffed shoulders and a blue ruffled collar that matches the hat, and her raised, eloquently posed hands are sheathed in long black velvet gloves. The right hand is extended toward her collar, a curled finger raised, while the left supports the right wrist—an elegant, ladylike gesture that echoes the curve of the

hanging grapes. But all this pretty refinement is belied by the concentration of her gaze. Abercrombie longs for beauty, but not at the expense of her artist's piercing powers. She referred to this painting as "Portrait of Artist as Ideal."

The pioneering modern art gallery owner, curator, and critic Katharine Kuh wrote, "No one looked less like the proverbial artist than Gertrude Abercrombie. Sharp-boned, 'hard-edged,' you might say, and a bit ungainly— even she was surprised to find herself a painter."

Abercrombie told Studs Terkel, "It's always myself that I paint, but not actually, because I don't look that good or cute." The tragic truth was that she suffered from a persistent and toxic ugly-duckling syndrome as the daughter of a celebrated beauty who turned out to be a chilly, critical mother. Gertrude's misery over her appearance was a deep, poisoned well that fed her insecurity, alcoholism, and craving for affirmation. And how confounding it must have been for this allegedly homely daughter of a gorgeous mother to become the mother of an exquisite daughter—whom Abercrombie almost never painted.

The all-the-world's-a-stage look of Abercrombie's dramatically flat landscapes and blank-slate interiors, the theatrical stances of her costumed figures and the use of props, may well be rooted in the lives of her resplendent opera-singer parents, Lula Janes and Tom Abercrombie. The couple was on tour in the South with the Aborn English Grand Opera Company during Lula's pregnancy. Lula made sure she was in Austin, Texas, with her older sister, Gertrude, a mother of six, when she gave birth to her only child on February 17, 1909. Baby Gertrude was named after her mother's sister, who became an adored aunt; her father's mother, Emma Gertrude; and his sister, Gertrude, who had died as a child. Abercrombie's family connections were precious to her.

Bedazzled, Abercrombie kept a cache of announcements, programs, and articles documenting the career of her formidable prima donna mother, who used the stage name Jane Abercrombie. Jane's appearances with a northern Illinois opera company brought the Abercrombies to lovely, wooded Ravinia, outside Chicago, and then in 1913 to Berlin, where she pursued her classical training. While Jane studied voice, Tom worked for the Red Cross. Only little Gertrude managed to learn German, an indication of the

linguistic gift that later enabled her to earn a degree in Romance languages at the University of Illinois at Urbana-Champaign. The family's German sojourn was cut short by the outbreak of World War I. They returned to Tom's hometown, Aledo, Illinois, which became a beloved place of refuge and inspiration for Gertrude. She enrolled in school and was ready to stay with relatives as her parents resumed touring, but their opera careers came to an abrupt and jarring end when a goiter permanently damaged Jane's voice and threatened her life. After her recovery, Jane and Tom became fervent Christian Scientists.

Susan Weininger writes, "Her parents, and her mother in particular, were conservative, frugal, and very proper. According to many friends and relatives, Abercrombie's parents, as strict Christian Scientists, considered smoking, drinking, and the generally wild lifestyle of their daughter inappropriate." As much as Gertrude stubbornly went her own way, however, she never cut ties with her parents, as trying as their relationships were and as harshly judged as she always felt.

Most of Gertrude's childhood photographs were taken in Aledo, and they capture a sturdy, uninhibited little girl. In one early picture, her pretty mother, wearing a light, finely pleated dress, looks down tenderly at her little daughter, who is swaddled in a frothy blanket and scowling vigorously, her large dark eyes staring, her lips clamped together. We see toddler Gertrude on a slide, experiencing the wonder of gravity, that childhood marvel, with her arms held up and opened wide, her legs wide apart, too, an expression of sheer joy on her face. In another picture at the same age she's naked, standing with her legs planted and throwing something with all her baby strength. Years later someone, possibly Gertrude, possibly her daughter, Dinah, wrote in now blurred blue ink: "Gertie already is a mean baby. April 1910." A mighty child with curly, unruly hair, she stands with her hands on bent knees, leaning toward the camera, mouth open wide in a rebel yell. She looks pugnacious and stubborn, a tough little tomboy. But the camera also recorded sweeter moments, such as Gertrude playing a tiny piano or hugging a cat. Cats were constant lifelong companions. In her later years she compiled a "cat list"—Jimmy, Monk, Davey, Daisy, Fancy, Joe, Leo, Mercy, Folly, Curly, Christine, Fitzgerald, and Tadpole. In other photographs she is cute and happy, hugging a teddy bear or cheek-to-cheek with

her handsome father. But she doesn't smile much, even when she's wearing a cowgirl outfit. And she looks very serious standing in the Tiergarten in Berlin.

The family settled in Chicago's Hyde Park neighborhood. Gertrude's father began working as a salesman, and the formerly artistic, worldly couple turned pious and conservative. Gertrude remained tough and daring. In 1919 she kept a little diary. The first entry on Wednesday, January 1, written in good schoolgirl cursive, reads "Virginia Bartlet had the mumps." On January 2 she records the temperature—4 above—and her trip to the hospital "with Mother" to visit friends. Friday's entry reads "8 below Elise and I played with our little ten cent dolls and made clothes for them." Saturday: "I went to take my dancing lesson and was the only one there. I rode on a street car the first one I ever rode on in my life."

Abercrombie continued to jot down notes about her experiences over the years. As her health declined in the 1970s, and pain rendered her nearly immobile, her world shrinking to one room in her castle of art and good times past, she began writing, on small pieces of paper, an episodic, casual, irreverent, sometimes furious memoir. Notoriously frugal, she wouldn't invest in a journal, or even full sheets of paper, instead filling odd scraps and little promotional notepads from a nearby car-leasing company edge-to-edge with tiny script. She recorded bits and pieces of her gritty city childhood:

> I was twelve when I began palling around with Tubby Dwyer. Her best friend was Fern Strong (also fat). I got into the magic circle because they took in Peggy Simons & four was better than 3. We carried sticks at all times & we yodelled [sic] constantly . . . I had to prove myself by pulling off glass drops that looked like swizzle sticks from the cheap chandeliers in the corridors of the St. George Hotel. We had those in our mouths wherever we went. We looked as if we had thermometers in our mouths . . . We would sit in the front seats of the double-decker buses, pay our dime, & ride all the way to Evanston and [blotted out] waving our sticks and hitting at trees & other buses & removing our swizzle sticks long enough to yodel.

December 10, 1921, marked the opening of a deep crevasse in the already divisive relationship between rough-and-tumble Gertrude and her decorous mother. Abercrombie remembered returning home from a movie theater, and, as she later wrote, "My seat felt sticky . . . it was all bloody. I thought I had sat on some glass at the theater. I cried and washed and my mother fixed me up with a big rag. She said if I didn't stop crying she would tell Daddy . . . Kotex came the next year. But it was too expensive . . . Bad year." Abercrombie was twelve. Her mother hadn't told her about menstruation. Gertrude never got over her mother's failure to prepare her for her first period, a watershed moment in every girl's life. Writer and alleged friend James Purdy purloined this incident in his excruciatingly explicit novel *Eustace Chisholm and the Works* (1967), one of three of his books in which characters based on Gertrude appear.

Another incident Abercrombie felt compelled to record happened in 1924, when she was "crazy about the boy next door." One night, she writes, she was studying algebra in her bathrobe, which she pauses to describe: "Flannel. Pink on gray—or if you turned it inside out, gray on pink." Two colors, one can't help but notice, that later become essential to her carefully selective palette. Young Gertrude glances out her window and into her crush's window, "and there he was waving his dong at me. That was the end of that romance. Too nasty."

The robust, lively, observant, intrepid girl grew into an intense and determined young woman with long ringlets. In college she bobbed her hair and displayed her good figure in fashionable clothes. But she never tried to emulate her beautiful and dignified mother's allure and polish. Instead, Gertrude accentuated her pointy chin and projecting nose by wearing pointed hats as part of her artist's garb, much to her daughter's embarrassment, embracing the role of witch, a figure of mystery and power in her mind, though it hurt her feelings when others described her that way.

Abercrombie returned regularly to Aledo, the wellspring for her moody prairie landscapes. Her gesturing trees are based on those in Aledo, and she painted, with rare naturalism, the eloquent ruins of the Aledo slaughterhouse. But she could not finish the meticulously precise painting of her beloved family home that she began in 1956. It is unlike any of her other place paintings in its realism, and how poignant it is that she began with

Gertrude Abercrombie.
Family Home in Aledo.
(*Unfinished*). *1956–1960.*
Oil on canvas. 20 × 25
inches.

the sky and worked her way down to the house's many-gabled slate roof. She could not address its foundation, nor walls, as though there were memories embedded therein that she could not confront. Dinah reported that her mother gave up because "she felt that she could not do it justice"—a ripple effect of Gertrude's sense that she failed to live up to her own mother's exacting standards.

Abercrombie was encouraged to become a writer while in college, but when she returned to Chicago, she began taking art classes at the School of the Art Institute of Chicago and the American Academy of Art instead. She found work as a commercial artist at a department store where she drew gloves—which became an elegant item in her painter's lexicon—for advertisements. She subsequently worked at Sears, Roebuck & Company, a foundational Chicago firm famous for its immense mail-order catalog, as a "revamp" artist, finalizing the drawings of various products for publication. But she was also creating her own pieces, and exhibited her paintings in a gallery for the first time in 1932. She truly blossomed when she began showing in Chicago's burgeoning no-jury open-air art fairs. Abercrombie found her artistic milieu in these populist outdoor gatherings. When she spoke with Studs Terkel forty years later, she was still grateful for these experiences: "I met all kinds of people, classes, colors, creeds, everything . . . which I hadn't known before. I was twenty-four . . . and it was just beautiful to meet all these people that I had never met. I had never met any colored people and

very few Jewish people and there were so many odd people . . . I mean odd to me . . . and everybody loved each other."

Abercrombie became a celebrated regular at the Hyde Park Art Fair for decades, leaning her paintings against her vintage Rolls-Royce and sitting beside them, basking in the sun and the attention. She loved hanging out with other artists and the crowds of art lovers or the merely curious. Her daughter told Weininger that Abercrombie found in this "dream of community and love among friends . . . compensation for feelings of loneliness within her family." The connections she forged at the fairs led to cherished friendships, one-woman gallery shows, and sustained sales of her work.

Another big step for Abercrombie was her employment with the New Deal's Federal Art Project (FAP) of the Works Progress Administration (WPA) in 1935. This appointment made her calling as an artist official, and provided a full-time job that enabled her, at age twenty-six, to move out of her parents' house and into her own apartment. This was also the year that she met two mainstays in her life, artist Karl Priebe and writer James Purdy. And she began a series of affairs.

"It makes me so unhappy, not hearing from you," writes Karl Priebe, Abercrombie's closest, most loyal friend. A much adored Milwaukee artist, Priebe was also a blues and jazz aficionado and, according to curator and art historian Robert Cozzolino in *With Friends: Six Magic Realists, 1940–1965* (2005), a "smooth socialite," a "brilliant conversationalist," a bird lover, and a

Gertrude Abercrombie sitting on steps with her artwork, 194-?. Unidentified photographer.

tireless correspondent. His Milwaukee home was full of Abercrombie's paintings, works embraced by his circle of Wisconsin artist friends, a group that, like Abercrombie, went against the prevailing tide of Abstract Expressionism. As Cozzolino observes, they created neither Abstract Expressionist works nor Midwest regional paintings along the lines of Thomas Hart Benton and Grant Wood. Instead they "developed personal iconography in response to the complexity of modern life" and "made art that explored the irrational and revealed the fantastic in the everyday. Their work was often a means to understand the self and its relationship to an unstable world." Cozzolino concludes, "They established a tradition of the absurd, magical, and introspective that persists in the region." Their figurative yet freely imagined and provocative paintings and drawings comprise an overlooked yet compelling facet of twentieth-century American art.

Handsome, confident, and outgoing, Priebe, of German descent, met self-conscious yet ambitious Abercrombie while he was studying at the School of the Art Institute in Chicago, frequenting blues and jazz clubs on the South Side, and developing an abiding love of black art and culture that inspired many of his works. He won the Prix de Rome, a distinguished arts scholarship, in 1941 at the age of twenty-seven, was featured in *Life* magazine in 1947 as a "fantasist," and led a very busy professional and personal life. Even so, over the course of their thirty-plus-year friendship, Karl sent Gertrude a continual stream of postcards, a barrage of affection, news, and encouragement. Most were graced with a fluent, animated drawing, usually a portrait of a man or a woman or a bird, with the message flowing along the edges of the card.

Priebe also sent daily postcards to the prominent, in-the-know photographer Carl Van Vechten, with whom he had an intense relationship. He was friends, too, with such stars as Pearl Bailey, Duke Ellington, Dizzy Gillespie, Billie Holiday, poet Langston Hughes, and choreographer and dancer Katherine Dunham. Priebe's great love was Frank Roy Harriott, an associate editor for *Ebony* magazine and an African American writer who received a Rosenwald fellowship to write a novel, Cozzolino tells us, "loosely based" on Billie Holiday's life. A photograph from 1946 shows Holiday in radiant good form, smiling broadly, seated at a nightclub table with Priebe, who is mugging cheerfully for the camera and holding a Chihuahua that Holiday is petting. Harriott sits to his left, cigarette in hand, also smiling

Gertrude Abercrombie and friends, ca. 1950. Unidentified photographer.

brightly. A gleaming array of empty glasses covers the small table. Karl and Frank lived together for much of their then radical gay and interracial ten-year relationship, which culminated sadly with Priebe nursing Harriott through a long illness to his early death in 1955.

Exuberant, affable, charismatic, generous, and energetic, Priebe got along with everyone and joyfully hosted uniquely eclectic, socially daring Friday salons for many years. One photograph captures Priebe, in a white shirt, a wine bottle in hand, leaning on Harriott's shoulder, while Abercrombie sits knock-kneed on Harriott's other side. As Curtis L. Carter, a professor of philosophy at Marquette University, recalls, "It was the closest thing to a real art salon, in the Parisian sense, that Milwaukee ever had. Literally there were no social barriers. Everyone was welcome of any social standing or race or ethnic background. So it was fun to go to." Abercrombie instigated this same renegade form of multicultural socializing and synergy in Chicago.

As close as Karl and Gertrude were, and as much as they shared an artistic passion for portraits, landscapes, and still lifes, their focus and styles were very different. Abercrombie's paintings are flat, angular, static, and stagy, her palette strictly specified, her lines spare, her compositions static. Priebe's paintings are fluid, organic, and full of movement, jazzy and jeweled in polychromatic splendor. While Abercrombie paints ruler-edge horizons, Priebe blurs and blends land and sky, a response to southern

Wisconsin's rolling terrain. Abercrombie aims for a uniform surface and limited dimension; Priebe revels in texture and transparency.

Abercrombie was painting the story of her inner life even when she depicted trees, the moon, and owls, for Gertrude associated totem animals with magic, myth, and wisdom. When Priebe painted birds, he usually did so based on his keen birdwatcher's observations, rendering each as a distinct living being, not a symbol. And while he did create some self-portraits, he most often painted other people, primarily African Americans within expressive, dreamy, even mythic compositions.

Abercrombie shared Priebe's love of jazz and deep admiration of African American culture, and they both defied the rules of 1940 and 1950s racial segregation. Abercrombie's black musician friends visited and lodged in her home, and her sensitivity and objection to racism and racial violence and injustice inspired one of her very few political paintings, the ominous *Design for Death* (1946), which was renamed *Charlie Parker's Favorite Painting* in honor of its most ardent admirer. A scorching full moon presides over a bare black tree with branches like onyx lightning. Against the tree leans a dark ladder. A bright noose dangles from a limb. A wooden crate stands below. Everything is in place for a lynching.

In spite of Priebe's obvious identification and empathy for minorities, which James Purdy also shared, Abercrombie's narcissism induced her to record these thoughts on January 27, 1972:

> The sight of a young black man walking down the street with his *head held high*. & his feet & his body swinging and after so many years of having been stepped on and stomped on—he is saying, "Fuck you, Whitie—I AM ME. I am *somebody*. I am ME!"
>
> A more beautiful thing I have never saw. I wonder if anybody else ever saw that. As clearly as I do. I doubt it.

A cheerful gag photograph shows the affectionate art duo, Karl and Gertrude, standing on either side of an Abercrombie portrait of a rather haughty woman wearing a very feminine, flowery hat. Each artist wears a similarly showy millinery. Karl holds a finger coyly by the corner of his mouth, imitating the snooty pose in the painting. Gertrude, shy and

awkward, has one arm bent with her hand behind her head, pinup style, but her expression is guarded and hesitant rather than flirtatious, her fear of the camera evident as always.

Letters from Priebe appear often in Abercrombie's paintings as emblems of friendship and trust, comfort and strength. Priebe's actual cards and letters reveal how much he worried about Gertrude. He often offers succor and advice, and always expresses love. How bereft she must have been when Priebe died at age sixty-two on July 5, 1976. Abercrombie would die a year later, almost to the day: July 3, 1977.

Abercrombie met Llewelyn Jones, literary critic for the *Chicago Post*, at the mammoth—three-hundred-artist-strong—outdoor art fair held in Grant Park along Lake Michigan in 1933. He, in turn, introduced her to writer Thornton Wilder, who was teaching at the University of Chicago. Wilder had received his first Pulitzer Prize for *The Bridge of San Luis Rey*, and went on to win two more for his now classic plays *Our Town* and *The Skin of Our Teeth*. Wilder met the avant-garde expat writer Gertrude Stein in 1934, when she returned to the States in triumph after her clever memoir *The Autobiography of Alice B. Toklas* became an international bestseller, and her only commercial success. Stein and Wilder joined forces, and Gertrude met Gertrude in 1935, when Abercrombie attended one of their joint lectures at the University of Chicago. Surely she knew about (and perhaps even dreamed of emulating) Stein's enormously influential Paris salon, where Stein reigned as the stalwart champion of such revolutionary painters as Pablo Picasso and Henri Matisse as well as such young expat writers as Ernest Hemingway and Sherwood Anderson, both with Chicago connections.

Stein's *Tender Buttons: Objects, Food, Rooms*, published in 1914, is an avant-garde work in sync with Abercrombie's sensibility. Stein creates word jazz in which she seeks to subvert established definitions and stale usage via surprising juxtapositions. This leads to an out-of-context-ness not unlike Abercrombie's enigmatic groupings of her talismanic objects. Stein penned a form of light-touch surrealism: "A seal and matches and a swan and ivy and a suit." An art devotee with an eye for essentials, Stein turns painterly: "Light blue and the same red with purple make a change. It shows there was no mistake. Any pink shows that and very likely it is reasonable." She seems to reach into the same inventory as Abercrombie: "A peaceful life to

arise her, noon and moon and moon. A letter a cold sleeve a blanket a shaving house and nearly the best and regular window"; "A table means does it not my dear it means a whole steadiness."

At some point, Abercrombie showed Stein her work. Did Stein visit her studio? Did Abercrombie bring work to the University of Chicago campus? The story Abercrombie told brings us Stein, age sixty-one, telling the twenty-six-year-old artist gruffly, bluntly, perhaps teasingly, "They are very pretty but girl you gotta draw better." Abercrombie remembers, "I knew I could. I went right home and painted a painting that won a big prize at the Art Institute." This was *There on the Table*, an intriguing work depicting a strongly built woman seated in a bentwood chair facing to the right but seen only from the collarbone down. She's wearing a black short-sleeved blouse with a large, lunar button in the center. Her bent arm extends along a greenish-blue tablecloth on which we see an earthen bowl holding three ripe bananas, a small, crouching black cat, a hammer with its wooden handle extending over the front edge of the table, a screw, a ball and jacks, a folded-up measuring stick, and a white toy top.

Decades later, Abercrombie told *Chicago* magazine a story about this painting: "Everyone sees something different in my work. I remember one of the first times that my work was hanging in the Art Institute. I was so proud to arrive and discover someone was standing there and lecturing about my painting, which showed one half of a body and a bunch of bananas on a table. The man said, 'This painting by a Mr. Abercrombie shows the contents of one of his son's pockets.' That sure surprised me because I never had a son. I have a daughter, Dinah, who is happily married in Costa Rica!" She offers no comment on the lecturer's assumption that the artist was a man.

As a side note indicative of nothing but coincidence, both Gertrudes were born in February—February 3 for Stein, February 17 for Abercrombie; and both died in July—July 27 for Stein, July 3 for Abercrombie.

In March 1936, Abercrombie wrote Stein that she had been trying "to use my head as you said and to quit doing sloppy thinking, and so of course my drawing isn't so sloppy." Stein returned to Paris, and Abercrombie and Wilder became friends, though in *The Letters of Gertrude Stein and Thornton Wilder*, Thornton writes to the other Gertrude in 1936, "Do you remember Gertrude Abercrombie, the painter with the thin sharp face and

the disheveled hair and Wendel[l] Wilcox the too-perfect story writer? They are coming here for a home-made spaghetti dinner Wednesday night. Forgive me, but I can't like them." Yet Wilder continued to see the two friends, and at some point he became very fond of Abercrombie.

On June 7, 1935, Wilder wrote, "Here's the cheque—for a portrait, me or Davis or anybody. Don't shilly-shally about it; you're a very good artist and worth many times that, so come across with a sample of your gifts." The Davis he refers to was Robert Davis, a newly graduated University of Chicago philosophy major and one of Abercrombie's lovers. Wilder often filled the role of patron and mentor, and he took a "special interest" in this brilliant working-class scholar. He funded a year abroad for Davis, and they traveled all across Europe together.

Once Abercrombie took a bus to New York, in part to see Wilder, a harrowing trip she wrote about in her episodic memoir: "A man thinking I was asleep reached his hand into my bosom." When they stopped the next morning, he treated her to breakfast: "I had grapefruit and eggs and bacon and coffee & I felt that I had been paid for the grope." Once safely in Manhattan, Abercrombie and Wilder attended a performance of *Aida* "with a real life elephant." This is typical Abercrombie sangfroid, accepting the slime and the sublime.

Although she took creative risks and abused her health, Abercrombie always sought security and safety. An entrenched homebody, she repeatedly painted enclosures, holdfasts, places of refuge. Yet she also felt isolated and entrapped, turning her ivory towers, blocky houses, and empty rooms into cells for solitary confinement. Sharply aware of the flimsy divide between exterior and interior—hence the crumbling walls in her interiors—Abercrombie was also concerned with how one's inner turmoil distorts one's perception of the world. This inspired her to paint windows looking out on her characteristic landscapes as well as rooms with paintings on the wall in which paintings-within-paintings serve as windows onto the artist's psyche. She painted horses standing with their noble heads reaching into rooms through open windows, perhaps signifying the continual presence of the past, of nature's constant infiltration in spite of our attempt to seal ourselves

off from the wild. She also painted scenes in which furniture is set outside on plains of twilight enchantment, turning the earth into a stage set for enigmatic human drama. And she loved to create compositions featuring "demolition doors," old wooden doors taken from demolished buildings and lined up side-to-side to form fences around construction sites as Chicago's aggressive urban renewal movement transformed the city. These doors to nowhere comprise a quintessential Abercrombie symbol and joke.

Abercrombie painted portraits of seashells as images of female sexuality. But she also cherished them as the beautiful carapaces they are, evolved to protect vulnerable creatures who can't survive without armor, soft beings like herself. Abercrombie maintained a flinty, joshing, good-time facade, but she was pierced and wounded by every slight and disappointment, every loss and lie. She needed protection, and her house became her fortress, her paintings her shields, her persona as queen her jeweled shell.

Here's how Abercrombie describes meeting her good-looking, well-off, kind first husband, the attorney Robert Livingston: "I met Livingston next to a fire plug at 57th & Blackstone (where 20 years before I had had a green river). He consented to marry me and he did and we had a beautiful [crossed out: ½ Jewish girl] child Dinah. I wish I still had her. She is having a romance with a motorcycle man in Seattle."

All in one scrawl we find a jocular dismissal—a fire plug couldn't be less dreamy—of what may have been a whirlwind romance, conflicted thoughts about marrying a Jew, and sadness over her troubled relationship with her daughter. There is also a neat bit of Chicago history here: a city brewery began making Green River, a lime-based soda, in 1920 when Prohibition made beer illegal. Abercrombie would have been eleven when Green River first appeared.

The Christian artist married the Jewish attorney in 1940, and their daughter and only child, Dinah, was born in 1942. Photographs record a striking couple. Nontraditional to the core, Gertrude loathed and despised all housework, so Bob took care of it for awhile, then hired a cleaning woman. It was he who gave their baby her nightly bath.

In her ragtag reminiscences, Abercrombie examines her leap away from her parents' faith and her close connections to Jews.

Jewishness
My first lover was Jewish (Benny Sabbath Aug 10 1932)
"'buyer of art'" (Goldbergs, David 1934)
My first show was at Katharine Kuh's gallery 1935 Jewish
My first prize I won at Art Institute—Eisendrath 1938
My first & only real husband was Jewish 1940
Now can you not see why I love the Jewish people?
And even had these things not happened I would still somehow have a
 big feeling for the Jews. Funnier, more musical, more . . . brighter,
 tenderer. I wept 6,000,000 tears for the 6,000,000 killed in W.W. II.
 Of course I wept more than that for those people.

In what appears to be a draft for a letter or a letter never sent, she writes, "My husband was Jewish. And so of course one of the first presents I received was the *Settlement Cook Book* [a bestselling Jewish "charity" cookbook written by Lizzie Black Kander, of Milwaukee, Wisconsin, who established a settlement house based on Jane Addams's work with immigrants and the poor in Chicago. The cookbook has been in print since 1901]. I wanted to try to emulate the culinary . . . of the Glencoe cook." Glencoe is the wealthy North Shore suburb in which the Livingstons lived.

Abercrombie made asparagus with Hollandaise sauce:

It had all to do with egg yolks . . . The trouble started then. I am a non-waster. I had the egg whites. I had to find use for them. Back to the *Settlement Cook Book*. (Which by the way has always failed me by saying "cook until tender," or "cook till done." Awfully nerve-wracking advice for the novice.) Under "egg whites" it said "Kisses." I said grand! I remembered those white sweet candies that were like fudge without the chocolate.

 I went to it hammer & tong (The hammer was to emerge later as an important implement in this story). I followed the recipe carefully. When it was time to spill the Kisses into the pan, they splattered out like pancakes.

Abercrombie added flour until the batter was stiff. When she pulled them out of the oven,

They didn't look very good. I decided to taste one. I couldn't bite into it. So hard! The hammer finally came into play. I hit one with it. The hammer neck came off. Naturally, I threw the pan of kisses across the room.

I have now stuck to osculation.

Love and kisses,

G

How many people could come up with "osculation" for kissing? Abercrombie's facility with languages engendered an abiding love of word puzzles and puns. Among her papers is a 1969 letter from Thomas Middleton, a well-known word puzzle and acrostic creator for the *Saturday Review, Harper's*, and the *New York Times*. Impressed with her submission of a double-crostic, a tricky crosswordlike puzzle involving lettered clues and numbers, he sent her the official construction rules. If she did succeed in having a puzzle published, there is no evidence of it in her papers. Her ardor for puzzles shaped her aesthetics: she set out her assorted symbols in compositions that function as visual acrostics based on her own hermetic set of clues and meanings.

Abercrombie's enjoyment of wordplay also underlies the "jokes" she collected, and inspired friends and family to send her many of the funny postcards she saved. In her later years she began assembling her "Joke Book," which one imagines was a distraction from the terrible pain, immobility, and isolation so cruelly delivered by her scourge, arthritis of the spine. Yet in 1972 she told *Chicago* magazine, "When I'm not painting I'm doing Double Crostics. And I'm also inventing some. I'm also writing a joke book. I didn't plan it to be a joke book. It is just some of the things that have happened in my life. And many people seem to think they are very funny."

Poor, dear, sad, brave Queen Gertrude. She kept her shell so polished, her crown so bright, that her pain remained concealed even when that wasn't her intention.

A letter from Abercrombie to Thornton Wilder, dated June 1, 1943, offers a rare glimpse into the realities of the early days in Abercrombie's eight-year marriage to Livingston.

My Dear Thornton,

While Dinah is asleep I must tell you how much Bob & I enjoyed *Shadow of a Doubt* [Wilder wrote the screenplay at director Alfred Hitchcock's request] last night. The first movie we've been to together for a year! Great Preparations were made in getting someone to stay with the baby . . .

Our life is pretty dreary now mainly because Bob has taken a war job making bullets and fixing the machines from 4 to 12 at night. He gets home at 1 and sleeps till 9 and away he goes to the office to practice law until factory time. I see him practically not at all . . .

I keep real busy with Dinah most of the day and get in an hour or two of painting. The evenings are the worst for I am tied down with Dinah and never get out.

She writes about a New York art dealer who "has never done much" for her. But, she explains, "The Museum of Modern Art came to her & asked to see my work. I was so pleased. Even if the museum doesn't show anything maybe the dealer will give me a big show next season. I have a lot of new things and want to show there. K. Kuh has closed her gallery here for the duration so Chicago hasn't much to offer in the way of exhibiting space."

She concludes, "Dinah is such a fine baby. Very good, healthy, strong and easy to care for. Do you think you'll ever be coming through here and can stop off so we can show her off to you?"

In 1944, Abercrombie's status was boosted considerably by her one-person show in the Chicago artist room at the Art Institute of Chicago. This is the year the little family moved into the three-story Victorian brownstone at 5728 S. Dorchester, the commodious abode destined to be hangout and home for so many stellar jazz musicians and the all-seeing, tell-all writer James Purdy—the cluttered, hectic kingdom in which Queen Gertrude would spend the rest of her life for better and for worse.

During her first marriage Abercrombie painted many walking or fleeing paintings, including *Girl Searching* and *The Stroll* (1943), featuring an elegant lady in a long black gown with a train, long, black gloves, and a marvelous large-brimmed black hat resembling a slender flying saucer, a shape echoed in the one black cloud and two dark green clouds snagged on

the raised, forked limbs of a tree. The grass is, for Abercrombie, unusually vital. The full moon casts what looks like sunlight, and the distant horizon seems to demarcate the surface of a great lake rather than a prairie. A white boulder sits beside the wide, straight road, and a jaunty black cat—head lifted, ears perked, tail out straight, mirroring the arrow of the woman's train—prances a few steps ahead. But for all the liveliness of the scene, the woman's expression is tense and preoccupied; her arm hangs heavily at her side.

Contrast this with *The Ivory Tower* (1945), in which a large stone structure resembling a rook in chess, a game Abercrombie enjoyed, stands alone on a rolling landscape bereft of life, a pale road running from its dark entrance across the rising land until it curves out of sight around a high hill. It is very dark, in spite of the full moon, toward which a fragile, leafless little tree tilts. At the top of the tower, in an open, arched window, a woman stands, one hand on the sill, the other lifted to a canvas on an easel, which repeats the larger scene. Is she an artist queen enjoying contented solitude, or is she a captive? Is her tower a variation on Abercrombie's beloved three-story home, or does it represent the confines of marriage and motherhood?

The Bride (1946) depicts a woman in a long, traditional lace wedding dress, with an even longer veil pouring down her back onto the ground, marching resolutely across a vacant landscape on a very narrow black road. A bare black tree, a mere trunk narrowing up to a point, gestures back toward where the bride came from. In the far distance stands a tiny white building, perhaps a church. A large, gauzy pink-and-peach cloud, dawn-hued or twilight-touched, hovers above. Again, Abercrombie has composed a tableau that should be joyous but instead seems to portray a bride on her way to an execution.

Is *Flight* (1946) the next in a series? Abercrombie's stand-in, attired in a wedding dress and long white gloves, is running down a path on which she has dropped a white bouquet. She is fleeing from thick woods, an unusual feature in Abercrombie's work, from which an indistinct yet nonetheless menacing male figure in formal black is emerging. The wildness of the setting is somewhat belied by the presence of an exceedingly large park bench. What does this say about Abercrombie's marriage?

Even more poignant are two paintings of Abercrombie as a new mother, carrying baby Dinah on her emblematic road. Dated 1942, the year Dinah was born, one depicts a young mother in a dark skirt carrying a baby wrapped in a white blanket and walking tensely down a desolate road in a blighted land. A blocky white building stands far behind her; it may be a hospital. The other painting, dated 1943, portrays a hooded woman clutching a swaddled baby, who is facing the viewer. Abercrombie's archetypal grove of trees stands huddled along the horizon, and the full moon floats wanly above a narrow river as the woman tentatively crosses a wood-plank bridge that rests precariously on either shore. She is heading toward four robust trees and a stump. Both of these new mothers seem nervous and frightened, as though they've been cast out and are now grim refugees on their way to an uncertain future alone in a vast, silent world—hardly the images one would associate with a young mother married to and cared for by an indulgent, wealthy, responsible husband.

Abercrombie continued to paint images of solitary nocturnal vigils, of divergence, doubt, and rupture. After seven years, her marriage to Livingston was beginning to come apart. In her piecemeal memoir she wrote, "Bob let me slip through his fingers and I let him slip through my fingers. Juicy, eh?" In 1946, Livingston was clandestinely seeing the woman who would become his second wife, while Abercrombie was also smitten with another. She remembers "the day in 1947 when Wendell caught me and Frank holding hands on a bench on Wooden Island." Wooden Island is in Jackson Park, where, as she often recalled, she met Clarence Darrow as a child.

Don Baum remembered seeing Frank Sandiford for the first time when he went with Abercrombie to the Commons, the main dining room at the University of Chicago. Baum told an interviewer, "I think the real reason she wanted me to go was to look at Frank, who worked there in the food service. So there was this tall skinny guy. Kind of funny looking actually." Frank, as Baum discovered, had been a "society burglar" who "burglarized mainly North Shore homes." Ah, love, crazy, blind love. What appealed to Abercrombie when she gazed at this gangly, big-toothed former burglar and ex-con? The exact opposite of her dashing, upright, successful husband, whose wealthy family's house in Glencoe was just the sort of place Sandiford robbed?

Her paintings express her quandary, an inner tug-of-war between Livingston and Sandiford, between a sheltered life with the father of her child and an unpredictable alliance with a marked man of shaky morals and dim prospects. In the exceptionally graceful painting *Reverie* (1947), a nocturne, a very bright full moon presides over a hilly landscape with a bit of blue water visible between two plateaus. Two choices? On top of the higher of the two risings is a bulky rectangular brick structure, glowing crepuscular pink, without door or window. The other plateau holds a huddle of trees wreathed in a green fizz. Convention and security versus wildness and vibrancy? Rigidity versus suppleness? Closed up versus open and growing? Down below stands a bare tree, its one limb pointing toward the moon, which is bathing the scene with munificent radiance. Abercrombie's avatar, neatly clothed in a long-sleeved, lunar-white blouse and a narrow black knee-length skirt, is stretched out on the ground, leaning on her right arm, her legs extended in the direction of the tree, while she faces the moon and the water. Also on the ground lies a moonlit sheet of paper, its creases those of a letter. Letters appear in many of Abercrombie's paintings, usually from her dearest friend and most faithful correspondent, Karl Priebe. But in this case, it's most likely one of Frank's illicit love letters.

Sandiford wrote to her while she was still married and visiting her beloved family seat, Aledo, Illinois, the inspiration for her dreamscapes. A small town in a tornado-frequented region—the source of her leaf-stripped, leaning trees—Aledo is just a short drive away from the Mississippi River, which may well be what is flowing between the facing bluffs in *Reverie*.

In one letter, Frank declared that he

felt that long flutter of Romantic longing we two know so well. I could feel your hand in mine and your cheek against mine for a second. But you are gone and my hands are empty and my eyes are wet.

In your house I see your dress on a chair. It has your smell and your presence. I pick it up and hold it tenderly to my face and sigh. I see your tape recorder and wish I could turn it on and hear your voice.

Yes, Gertrude, I will wait. I'll wait, with a little impatience at times, a few feelings of frustration and anger at times, but I'll wait with a determinism and always with an understanding.

Please be with me darling, even where you are, be with me and let me be with your thoughts. I will go to bed now to be with you "closer" than during the waking hours.

I love you so

F—

After "waiting and yearning for it so much it hurt," Frank finally received a reply from his beloved. But he was disappointed: "Perhaps I expected too much. It was not much. Write soon again and tell me all about yourself. What you do for kicks—about Bob—about Freddie—about the moon in Aledo—anything!" After describing a night out with friends, he tried for romance and ended with a more crass, though, who knows, perhaps endearing detail: "Darling I am so lonely. I have a heady sadness, a deep longing, an ache that hurts. I go to sleep feeling your arm around my neck and your shoulder under my head and I push my face into your breast and wake up with the pillow all out of shape and large spots on the sheets."

In September 1947, Frank was visiting Karl Priebe in Milwaukee when he wrote, "My dear Gertrude, I miss you so. I had moments of deep depression and would have run home to you but for the knowledge that it would have been no good with Bob as he is and Dinah there."

In a scattershot diary entry Abercrombie wrote, "Sunday nite. The big moment. I said to F. when he kissed me I'll die if you ever sleep with me & he said I'll die if I don't."

It appears that Abercrombie was giving Sandiford money, and that she found him a place to live. How she agonized over the decision to leave Livingston for Sandiford! In 1947 she painted the pristine and evocative *Two Ladders*. At just twelve by sixteen inches, it's a beautifully refined work depicting two elegantly tapering black ladders reaching up from an amphibian plain—itself a manifestation of betwixt and between. This wash of greens and blues lifts to a gently undulating horizon that meets a delicately modulated, dusky, purplish sky. The ladder in the foreground reaches to, or holds, a large, radiant white crescent moon. The ladder in the distance supports a large, scrolled pink cloud. Which should she choose? The waxing and waning moon, or the ephemeral, floating, shape-changing cluster of water crystals? Moon and cloud are each a symbol of change, but the moon,

her guardian, is reliable in its phases, while clouds are forever mutable and bring storms and chaos.

In 1948 the intensifying pressure of infidelities and marital discord finally blasted the marriage apart. Abercrombie and Livingston divorced. Abercrombie and Sandiford got married. And Abercrombie painted her way through all the trauma and upheaval and realignment.

In *Indecision* (1948), Gertrude's alter ego stands on the shore of a river in a long, deep rose gown. Her hands are encased in white gloves. At the center of her right hand is a stigmata. With her left hand she points to the sky. She wears a black blindfold. She is a fairy-tale figure of deliberation and justice. Behind her a gray door levitates. Across the river, a tower stands on a cliff. Thin white clouds and a large, low, pink full moon bear witness.

The Chess Match (1948) is one of Abercrombie's most overtly theatrical compositions. The black-and-red grid of the people-sized chess board is partially enclosed by two parallel brick walls, each ending with a column crowned by a spherical finial, which looks just like a pawn. Between the columns we see the horizon and a pink, curling cloud. A wan crescent moon drifts above. Clad in a somber gray gown and holding a red carnation, the artist's alter ego stands, as though in a trance, on a black square at the lower left-hand corner. On the red square in front of her is the base of an old-fashioned telephone; the earpiece, attached by a snaking cord, is on an adjacent square. This telephone makes frequent appearances in Abercrombie's work as a symbol of broken communication and unwelcome news. A large key lies on a red square near the oft-depicted round tripod table holding her signature stemmed dish. A green-eyed black cat sits on the closest black square, gazing intently at us. A record album lies on a red square. On the corner stands a squat tree occupied by an alarmed owl. From here on out, owls—nocturnal and solitary birds of prey associated with wisdom, sorcery, and ill omens—appear in many of Abercrombie's paintings. Another truncated bare tree stands in the far left corner, and to its right stand a man and a woman, facing each other on separate squares. The man wears tight black pants, a white-and-black-striped tunic, and a short orange jacket. He looks like a dancer or acrobat or harlequin. His arms are folded. The woman facing him, in a black gown, has thick orange hair. What is being enacted here as the lone woman with the flower watches

this encounter on a chessboard strewn with evidence of disorder? Seduction? Betrayal? Theft? "Abercrombie claimed," writes Weininger, "that she was the last thing that Sandiford, a small-time criminal before their marriage, ever stole." The veracity of that quip remains open to interpretation.

There is no mistaking the players in *The Courtship* (1949), a mischievously funny and coyly romantic tribute to the illicit nature of her relationship with Sandiford and a teasing allusion to his criminal past. An owl, a man, and a woman stand on a beach at night. The man is tall and slim. He's wearing a long-sleeved black shirt, white pants with the cuffs rolled, sandals, a black cap, and a black bandit mask. He is turned toward the woman with his arm extended and his hand cocked like a gun. His expression is stern but not threatening. A crescent moon floats low in the sky, and a giddy pink cloud sails above, its rose madder hue repeated on the woman's clinging gown, which reveals a far more feminine and voluptuous figure than that of Abercrombie's other alter egos. Her body faces forward, and she's holding her hands up as one does when a gun is pointed at one's heart. Her head is tilted toward her assailant, and she looks alert and foxy-sly. A suggestively feminine conch shell sits near her feet, while a phallic lighthouse stands gleaming on an island. This may be Abercrombie's most confidently sexy painting, her most ebullient rendering of attraction, seduction, and risk.

According to Abercrombie's friend Marian Despres, who bought *Between Two Camps* (1948), this very different painting represents the artist's two marriages. A small deep crimson tent topped by a sagging white flag, a sign of surrender, indicates her first marriage. Her second is represented by a black tent pressed against the side of a massive, free-standing alabaster white staircase on top of which stands a woman holding a pink flag aloft. A green kite hangs in the air, its taut string pegged to the ground and marking the divide between the two camps. The kite is flying toward the left, the flag toward the right, representing the two directions in which the woman is pulled. In this study of ambivalence, the stairs, which resemble those leading to her house, signal Abercrombie's potential liberation, but they actually lead nowhere. This is a stairway to futility, or, worse, a plunge into the abyss. And those little marriage tents offer provisional shelter at best.

All the stress and exhaustion brought about by Abercrombie's epic need to paint while trying to care for her daughter and meet the demands of a new marriage, which must have felt like a new world, underlie perhaps her one and only overseas landscape, *Search for Rest (Nile River)*, of 1951. The narrow river, fringed here and there with reeds, snakes across a rolling plain. Along the horizon a line of desiccated black-and-white trees, straight out of Abercrombie's Aledo landscapes, reach toward an immense full moon like a troupe of dancers or supplicating fugitives. A giraffe stands near the river, facing a distant white tower. Gertrude stands near a large, dark old leafed tree. Her long gown is coral; her deep-set eyes are severely shadowed by fatigue; her left arm is extended, hand palm-up, asking for succor, reaching toward a curvy blue Victorian chaise longue, the one she so often painted. Here it's a symbol of rest and comfort. Beside it is Abercrombie's tripod table, another emblem of home in a strange land, its round marble top so luminous with moonlight that it becomes a second moon, a moon mirror. But this bewitching dreamscape seems to promise not the rest the weary wanderer so desperately needs but only further psychic demands.

Abercrombie's father died in 1948, the same year she divorced Livingston and married Sandiford. Abercrombie's mother, whom Don Baum describes as "quite a *grande dame*" who "tried to not know a lot of things that Gertrude did," died in 1961. Livingston wrote his ex-wife a sympathetic note; Chicago's mayor Richard J. Daley sent his condolences to one of the city's best-known artists via telegram.

Sandiford shared Abercrombie's love for jazz and jazz musicians, and he had some minor play as a jazz critic. The *Chicago Sun-Times* photograph of Gertrude and Frank's New Year's Eve wedding captures the couple standing next to a piano, surrounded by friends. Beret-wearing, goateed beatnik Sandiford is smiling broadly. Gertrude has her lips drawn together in a tight line with a faint hint of a smile as she looks down toward Dizzy Gillespie at the piano. The caption reads "'Be-bop' newly-weds given musical toast."

After this rousing sendoff, they did embark on a time of exhilarating mutual creativity. During the 1950s Abercrombie produced somewhere around 450 paintings, and exhibited regularly in galleries and museums in Chicago, Milwaukee, and New York. While she painted nonstop, except

while hosting her storied parties and jam sessions, Sandiford was writing about his prison experiences. *Next Time Is for Life*, his shockingly graphic autobiography, which includes then rare descriptions of homosexual acts, was published under the pen name Paul Warren in 1953. Though he had grand ambitions for a writing career, this was his only book and biggest claim to fame, aside from marrying the Queen.

One can detect Abercrombie's feelings about her life in her many images of captivity and in two themes she identified as "Snared" and "Snagged." In this series of paintings, her avatar's long dress or blindfold with scarflike ties serves as a restraint or leash. Take *The Queen* (1954), for example. It portrays the lovely monarch wearing a large gold crown and carrying a gold-and-black scepter, while the long, narrow train of her turquoise gown is held firmly in the beak of an owl perched behind her on a shelf high up on the wall. A queen tethered; her powers curtailed.

Gertrude's feeling of being pulled in two directions at once is expressed with a trickster's glee in *Split Personality* and *Strange Tree*, both from 1954. In the former, the lower half of a woman stands in a long blue skirt while her upper half hovers in the air nearby, her hair and the frayed edges of her toga-like top in motion, as though she's just been torn in two. The shadow on the far wall, however, shows the woman whole. In the second painting, the figure closest to us is half woman, half tree. Nude and human from the navel up, her legs have been replaced by a tree trunk. Behind her, beneath a white cloud, stands a figure comprised of the woman's fleshy legs and a tree-torso replete with bark-covered breasts and raised tree limbs.

Art columnist Ron Offen recognized the jazzy wit of Abercrombie's paintings, which, he writes, "project the same feeling as an ironic Gillespie run of flatted fifths and thirteenths. The obliqueness is there, the elfin humor, the eldritch detachment." Abercrombie's bebop jokester side arises in humorous paintings in which she parodies her own symbolic lexicon, just as a jazz musician may transform a melancholy tune into a fast-breaking, exuberant composition that turns sorrow on its head. Dizzy Gillespie himself said, "I want to make an unequivocal statement that Gertrude is the first bop artist. Bop in the sense that she has taken the essence of our music and transported it to another art form."

In *Strange Shadows (Shadow and Substance)* from 1950, a white sign

hangs on the wall: LATER. The female figure stands on a red plank stage floor in a long gray gown, her arm and hand outstretched, palm up, a gesture of seeking or giving. A star-shaped clock sits on the floor, as does a white column with a goblet on top and a small owl. A patch of plaster has fallen away from the wall, as it does in so many of Abercrombie's interiors. What's "strange" is that the woman casts the shadow of a tree with an owl on its armlike branch, while the column's shadow is in the shape of a woman, holding the goblet in her outstretched hand.

But this brain-teasing painting had serious inferences, according to Dinah. In her curiously disassociated essay, "For Gertrude," which appears in the catalog for the 1991 retrospective exhibition at the Illinois State Museum in Springfield, Illinois, of her late mother's work, she writes that in this painting Gertrude "stands with her second husband, represented by the white pedestal; shadows of herself and her past husband, the bare tree, are reflected on the wall. The clock in the foreground points to 11:28, the moment of my birth, showing that I stayed with her after the divorce."

Abercrombie played up her witchy, hermetic aura. She painted herself as a fortune-teller, seated at a table with a crystal ball and facing an open window through which a white horse has nosed his large, regal head. The two appear to be communing. *Untitled (Ballet for Owl)* of 1952 presents a stage covered in what appears to be artificial grass. An owl perches on a stump, its eyes wide with dismay as a barefoot woman in a magenta blouse and a floor-length black skirt slit open to the hip holds a wand in her outstretched hands. In *Levitation* (1953), a woman levitates beneath a full moon, floating horizontally, her arms, long hair, and the train of her long pink dress hanging down, creating a shadow that looks like a dark horse.

Dinah remembered Abercrombie "playing solitaire each afternoon, thinking up new ideas for her paintings while she played." When columnist Ron Offen visited Abercrombie's studio, he gawked at her "occult" work: "Where the hell does all this stuff come from? Has Gertrude been dabbling in the Black Arts? 'No, nothing like that,' she reassured us. 'They just . . . come. I can't explain it. But the strange thing is, once I paint something, it usually turns up in real life. For example, that marble-topped counter there.

It popped in a painting I did. Then, a few weeks later I saw it in a shoe-maker's shop. Naturally, he had to sell it to me. After all, I had painted it.'"

This dream-inspired acquisition gave rise to the 1960s Marble Top Mystery series. Abercrombie painted another levitation tableau in which a man wearing a very tall black magician's hat and a black suit stands behind the marble-topped counter, while a woman floats serenely above it. These escapes from gravity may attest to the uplifting power of art, or the artist's need to visualize her ability to rise above her trials and tribulations.

In *The Magician*, she stands behind the marble-topped table, on which are arrayed instruments of her dark art: an owl, a black cat, the large-brimmed black hat she wears in many paintings, the white pitcher she often painted. But as in other, more disconsolate Marble Top Mystery paintings, large holes have been cut into the marble. In some cases, the woman stands within a hole, sometimes topless, always dejectedly captive, reduced to the status of a creature under a male magician's control. The artist has been stripped of her powers. Who or what brought her down?

It's still possible to purchase copies of Paul Warren's *Next Time Is for Life*. The title blares garish yellow on the noirish cover of the small, pulpy, 25-cent Dell paperback, published in 1953; smaller type declares, "The true, shocking story of a two-time loser." The bold-strokes cover illustration depicts a chiseled man, much handsomer than the buck-toothed author, shadows accentuating his gaunt but still rugged if pensive face, dark eyebrows arching over big blue eyes turned away from the viewer as he clutches the bars of his prison cell. An awkwardly drawn cop in brass-button blues and a snappy hat with a badge seems to sneer at him, while farther in the distance a sketchy chain-gang convict in stripes pushes the long wooden handle of a broom. A quote from the famed mystery writer Erle Stanley Gardner, of Perry Mason renown, slashes across the lower right-hand corner: "A remarkable book. He knows the Inside."

Gardner even wrote the foreword, a brusque two-page essay focused most on the failings of the prison system of the time: "The story has the ring of truth. The author knows the inside of prisons and he knows the confusion and frustrations that are the inside of a convict's mind." Gardner writes of

how unjust punishment "doesn't make inmates better. It makes them worse." He then observes, "This book should do some real good," following up with a quick lash of criticism: "I think there are places where the thing is over-done." This mix of authenticity and exaggeration seems to be a key to Warren's—a.k.a. Frank Sandiford's—modus operandi.

Nonetheless, the back cover warns readers, *Dragnet* style, "THE BOOK YOU ARE ABOUT TO READ IS TRUE." And indeed the book is deeply unnerving when read with Abercrombie in mind.

Next Time Is for Life is a gritty confessional with no attempt on the author's part to make himself look good, save for how he managed to endure the physical and psychological brutality of prison life. Warren/Sandiford writes that he was born in London in 1916, and that he arrived in the United States when he was eight. He was a misfit in school, mocked for his accent, scrawniness, and thick glasses. He starts shoplifting and joins a gang. Finally he feels accepted, and he discovers that he loved taking risks. He justifies his slide: "I knew I would never be able to be as good as my parents wanted me to be anyway." Then one day he has the bright idea of showing his sister dirty pictures. Aroused, they take off their clothes and their parents catch them "examining each other." He runs away and gets in worse trouble.

Jailed at seventeen, he serves two years, navigating the power hierarchy, viciousness, and corruption of penal life as well as inmate camaraderie and circumstantial homosexuality. He becomes an ardent reader in prison and finds purpose and satisfaction in reorganizing the prison library. He hates and resists all forms of authority, including the self-appointed bosses among the convicts. To prove his independence, he befriends a much-maligned "punk," or homosexual, and gets into fights to defend his freedom to do as he wishes even behind bars. He is beaten, sent to the Hole, and put on the harshest work detail, shoveling coal. His self-destructive behavior baffles prison officials who recognize that he's smart and know that he comes from a solid, upstanding family.

When he gets out, he finds a decent enough factory job in Chicago, and begins frequenting South Side jazz clubs. But he cannot stay out of trouble and seems not to want to. He admits that he's uncomfortable with "the honest people, the ones that didn't understand me, the ones I didn't

understand." He describes in painful detail his failure to have sex with willing women, his spell as a weed-smoking hipster, and the relief he feels when he completely abandons the world of the squares, stops being what he calls a "phony," and resumes his ill-fated life as a "society bandit" or "gentlemen burglar," as the newspapers tag him. His escapades are ballsy and inept, and he seems almost happy to be locked up again.

In the Statesville prison he meets the despised thrill killer Nathan Leopold (Richard Loeb, Leopold's partner in the murder of young Bobby Franks in Chicago in 1924, has himself been murdered behind bars by another prisoner). Leopold brings Warren/Sandiford books, and tries to enlist him as a teacher. All the anxieties stoked by Warren/Sandiford's anger, fear, sexual confusion, and inability to imagine a viable future lead to a mental breakdown. In spite of this period of hospitalization, he serves the maximum sentence, and is released in 1944. Just a few years later, he and Abercrombie begin making eyes at each other.

In her reminiscences, Abercrombie writes, "Connections with the Loeb–Leopold case. As a girl of 10 or 12 I used to walk with Clarence Darrow [He defended the killers] in the park. He would always say 'Hello, Little Girl.' Then—they almost took Bobby Livingston (my 1st husband) instead of Bobby Franks. Because the two boys played together—same age—and L & L didn't care whom they got." She describes attending a service at the 5th Church of Christ Scientist in which Mrs. Franks gave testimony. "Then my second (sick) husband spent time in Statesville with Leopold. His story about L & L he wrote about."

Abercrombie and Sandiford had been married for going on five years when *Next Time Is for Life* came out in 1953. This explicit tale of crime and punishment, this sensational exposé of prison violence and sexuality among incarcerated men, hit with the power of a sonic boom. It even attracted the attention of Eleanor Roosevelt, the "First Lady of the World," who wrote incisively about the book and her meeting with its author and his artist wife in her *My Day* column datelined January 16, 1954.

CHICAGO, Friday—I had an interesting talk in Chicago with a man and his wife who live in a suburb of the city. She is an artist. He is an ex-convict who is now trying to become a writer. His one book in print is

called "Next Time Is for Life," by Paul Warren. You may read this book
and feel as I did that it is rather hard to be interested in every step of a
criminal career. How you come to stealing and how you carry on becomes
eventually repetitious, but the psychological development from the time
that he felt rejected by his family as a boy, and in the detention home
found a little circle of which he could be a part, that is most interesting.

In the end, though he came to it by many steps, it was four years of
talking with a psychiatrist that brought him to an understanding of
himself. He could no longer hide behind the old defense mechanisms.
He had to face his own responsibility and he is now out of prison, has
a home and a child and friends. He hopes to help by his writing the
understanding which might improve our chances of doing a rehabilitation
job in institutions, but also he might help many a family to keep their
youngsters from the many temptations that he succumbed to.

He has been fortunate I think because he told me that whenever he
went to look for a job, he honestly told his future employer that he was
an ex-convict and he found understanding and a helpful attitude. I am
afraid this is not the universal experience, but perhaps there was
something in his own attitude which helped him, and those reading his
book may get an understanding of what that attitude is.

Sandiford wasn't the only Chicago writer Roosevelt met who was inti-
mately acquainted with the city's underworld. In 1950 Roosevelt presented
Nelson Algren with the first National Book Award for fiction for his Chicago
novel of poverty, drugs, and desperation, *The Man with the Golden Arm*.
Algren was born the same year as Abercrombie, and he was writing as furi-
ously in his poor North Side neighborhood as she was painting to keep her
life on track on the South Side. Sandiford the burglar and his cohorts were
just the sort of lowlifes Algren was fascinated by.

While Queen Gertrude was painting in a house full of cats and jazzmen,
supporting Sandiford, raising her beautiful daughter, and cruising around
town in her Rolls-Royce, she had a twin of sorts in New York City known as
the Jazz Baroness. But in her case the title was authentic.

Kathleen Annie Pannonica Rothschild de Koenigswarter, called Nica, was born to vast wealth and high social status in 1913 as part of the British branch of the Rothschild international banking dynasty. Her entomologist father, Charles, met Nica's formidable mother while butterfly collecting in the Carpathian Mountains in the region of Hungary known in Latin as Pannonia, the source of her unusual name. And like a butterfly, she escaped her gilded-cage childhood, which was shadowed by her father's suicide and her beautiful mother's coldness, by taking flight as a skilled pilot in the open-cockpit era. She met her future husband, Baron Jules de Koenigswarter, a French widower ten years her senior, on a runway in France, after they each landed their private planes. They married, sent their children to America at the start of World War II, and served in the French Free Forces. Nica worked bravely as a translator, decoder, radio broadcaster, and battlefield jeep and ambulance driver, attaining the rank of lieutenant and receiving the Médaille de la France Libre. The mother of five dutifully fulfilled her role as a diplomat's wife when Jules was posted in Norway, Mexico, and the United States. But, as in her cosseted girlhood, she found herself confined and pining, and this time she flew away on a zephyr of jazz.

Enthralled by the freedom and genius of this bodly inventive American music, Nica abandoned her family at great and lasting psychic cost to all involved and became a glamorous and mysterious regular at New York City's jazz clubs. Like Abercrombie, she had a thing for Rolls-Royces, though she was able to purchase hers new, and she also hosted now-legendary after-hours jam sessions. These began in her hotel accomodations, mixed-race gatherings that outraged the management, especially after Charlie Parker died in her Hotel Stanhope suite. Nica then bought her own place in New Jersey, with a view of Manhattan. There the master pianist and composer Thelonious Monk lived and eventually died. The Baroness's home, like the Queen's in Chicago, was a hangout not only for jazz cats but also for a burgeoning population of felines. Everyone called it the Cathouse.

Nica provided sanctuary, food, Chivas Regal, and a sharp, appreciative ear for such jazz insurgents as Charlie Parker, Thelonious Monk, Art Blakey, John Coltrane, Charles Mingus, and Abercrombie's friend Sonny Rollins. Nica was also an artist, though not on Abercrombie's level, and created the

book *Three Wishes*, a collection of her photographs and her interviews with three hundred musicians who answered her challenge: If you could make three wishes, what would they be? For all her flamboyance, Nica was shy and self-effacing, as well as generous and brave in her stand against racism. The Jazz Baroness died in 1988.

Queen Gertrude made a list of the jazz musicians who spent time in her castle:

> Adorable musicians been here. (inc. lived here:
>
> John Lewis
>
> Percy Heath
>
> Milton Jackson & Ernst Krenek [Krenek was a classical Czech composer who lived in Vienna and came to the United States in 1938 to escape persecution by the Nazis for writing "degenerate music," namely a jazz opera about a black jazz musician, a work Abercrombie would have deeply sympathized with. Apparently the two found each other mutually inspiring; Krenek wrote another opera while renting her entire second floor.]
>
> Ted Friedman
>
> Cyril Touff
>
> Bob Baker
>
> Dizzy Gillespie
>
> Wardell Grey
>
> Charlie Parker
>
> Sarah Vaughn
>
> George Treadwell
>
> Eddie Baker
>
> Bud Freeman
>
> Bill Harris
>
> Dorothy Donegan
>
> J. C. Heard
>
> Max Roach
>
> Miles Davis
>
> Tommy Potter

Luke Jordan
Karl Shapiro
Paul Goodman
Lou Levy
Tiny Kahn
Irv Craig
Al Haig

Abercrombie wrote down some funny jazz anecdotes:

Dizzy Gillespie saw my black cat & said, "What kind of a cat is that?" I said "spayed." He said, "Yeah, I can see that."

Ted Friedman came into the library where I was adjusting the tape recorder in preparation for Sarah Vaughn's coming to sing. He said, "What kind of dog is that?" I said, "I don't have a dog—that's a cat." He went out and came back and said, "No, that's too big to be a cat." I said, "Well our cat is real big." He went out and came back & said "man is that a big cat!" I went out & there was Sarah with her Great Dane.

During the 1950s and early 1960s, Abercrombie's life appeared to be richly creative, productive, and contented. As the years went by, she created fewer portentous self-portraits in austere tableaux embodying her emotional dilemmas and fears, and began to focus more often on objects. She painted a coffee grinder, a shaving brush and mug, peanuts, an egg in an egg cup with a chick hatching out of the shell. She painted ostrich eggs and an ostrich. And many shells. More empty rooms. Her technique grew a bit more nuanced and refined, her compositions less probing and more formal, even formulaic. She seemed to be placing elements drawn from her visual lexicon in her compositions like cards in solitaire or pieces on a board game, seeking combinations that clicked instead of striving to express deep, complex feelings and concerns. These are pleasing professional works created by a painter certain of her skills and her audience.

Her daughter, Dinah, observes, "In the 1950's, her paintings were lighter in tone and less symbolic in content, the gloomy dark greens and blacks clearing to the cheery pinks and pale grays of her second marriage.

These paintings are happier, but also more superficial, displaying more trivial concerns, more casual social engagements."

But her wily mother, gambler that she was, may have been holding her cards close to her chest as long as she could, rather than laying them out on the table for all to see. And some of these works are among her most painterly and lush. In *Pin Point* (1958), a beautiful snail shell—its subtly modulated pearlescent colors falling within Abercrombie's signature spectrum of grays, purples, pinks, and gorgeous turquoises—sits on pink sand or perhaps a tablecloth in front of a deep gray wall with a piece of plaster gouged out of it, to which is neatly pinned a deeply green and alive leaf with two nibbled-out holes. This is a feint toward classical trompe l'oeil painting, but it is more fluid and expressive than clinically realistic. It is a work of close observation and sensuous interpretation, and there is nothing trivial about it. She also created works expressing her impish sense of humor as well as an abundance of exquisite miniatures, some small enough to be mounted as brooches and pins. None of these are superficial; all are amusing and lovely paintings, perhaps made to dispel and camouflage her pain.

Abercrombie had gallbladder surgery in 1959, and her health continued to fracture under the onslaught of her drinking, self-neglect, and hidden sorrows. As Don Baum recalls, they all drank "jug sherry . . . I think back and wonder how anyone of us survived. That stuff was so lethal. It was terrible. Italian Swiss Colony sherry. Oh God!" Baum comments, "Probably killed her."

She left this record of one very bad day in an unidentified year; the habit, one assumes, is her drinking:

8:30 *all at once* Thurs Apr 16
I just woke up
Hadda go to toilet
Doorbell—Cristina came
Cats hollered like crazy
Telephone—Ida
Frank came downstairs swearing at me.
Supposed to go to dentist.

I flipped. I was trying SO hard to kick my habit and *that many* obstacles were too many today

Baum reported, "Her relationship with Frank Sandiford was very complicated . . . there was an undercurrent of darkness, of depression, strange troubles." If even a fraction of what Sandiford describes in his book was true, from the thrill he felt as a criminal to the fear, abuse, and bloodshed he suffered in prison, would he be free from rage and the impulse to deceive, lie, and take what he felt he needed, consequences be damned? How did he feel about Abercrombie supporting him with her hard-earned income while they lived in the house she owned thanks to the generosity of her first husband? Did he resent the Queen's fame? The love jazz musicians had for her, even as they extended their affection to her second husband?

A battle of some sort precipitated this abject letter in 1952, while Frank was away, a letter he may or may not have seen, since it resides in Abercrombie's archive:

Tuesday, 2 PM

Dearest Frank—

I know now that the trouble with me has been a complete selfishness. Even this panic & hysteria I've been having is like that of a pampered spoiled child. I'm going to do everything I can to retrieve myself. I go to see Dr. Alexander Friday at 10. How I wish you were here to go with me as far as the building. I want you to see & help me. I really need you and I have much faith in you. I know I must have inner faith in myself & quit relying on you for the wrong things. I *will* get well. I want to so terribly. I want to get rid of this horrible selfishness I have had for all these years. How could I ever have caused you my dear husband to suffer so along with me. But I know you will be all right and I know I will too.

A nice letter came from your folks to us. Just saying that they know it will be all right. I'll write to them they are so sweet.

Waiting for you is just hell. But telling you this and feeling so sorry for myself is all part of the selfishness which I *will* get rid of. All the props are out & it is terrifying but I'll make it.

You are so fine and I love you so.

Gertrude

Dinah is here & is so well & happy. I worry about you out there. Shall I send money or check?

Even my asking you to hurry back is so selfish. But I do want you here so terribly much.

G

They stayed together, and life continued much as it was. Abercrombie painted and painted and sold her work at galleries and art fairs and got her name in the papers. Sandiford, Baum remembers, "did most of the cooking," and kept writing though not much came of it. Eleven years later, Abercrombie penned this stream of addled consciousness:

March 22, 1963

Dear Diary, =

I don't know. He says if I don't now I never will . . . He be high—maybe that's it.

I done it all even made a pretty picture . . .

Ah yes I know now what is wrong. The love. He doesn't. Oh dear all you got is yourself. And it is never easy.

So . . . I'm finally sleeping & the boy Frank is screaming at the cat & the cat is screaming and I say "hey—can you keep it quiet (or some such & he says F U & shut up & I am mortified & no amelioration helps & so Don't say NUTHIN!

He hates me so much

he loves me too

could you please be more quiet?

There is only one way to get along with Frank. Now I'm saying several ways. 1. *Agree* 2. Bolster ego. 3. Listen. 4. Don't express your opinions. 5. Don't *do anything*

me: 1. I do love Frank. 2. I wish he'd accept invitations because whatever would be would be sweet.

O.K.? No for you. Yes for me.

Keep MUM!

Among her papers are undated, scrawled, furious notes. Howls of rage.

Frank you are a
Fairy and a
Fag and a
Fruit and a
FOOL

This is a peculiar and hateful rant given Abercrombie's close friendships with gay men, but her fury is understandable if she was grappling, reluctantly, with Sandiford's concealed homosexuality.

James Purdy quite explicitly addresses the sort of sexual conundrums Abercrombie may have faced in his three novels featuring Gertrude-inspired characters. Born in Hicksville, Ohio, in 1914, Purdy weathered a rough childhood. He graduated from Bowling Green State University, then arrived, penniless and friendless, in Chicago in 1935 to attend graduate school at the University of Chicago. Purdy quickly found his way to Abercrombie and her circle of artist and musician friends. She provided him with shelter, employment as a babysitter (oh, what a crazy childhood Dinah endured), friendship, and a writer's dream material.

Like Karl Priebe and Abercrombie, Purdy was deeply affected by African Americans and African American culture. Black characters appear so often in his work that many readers assumed that Purdy was at least part black. He wasn't, but he did belong to a despised minority as an openly gay man who had the audacity to write overtly about homosexual relationships, a subject so taboo no American publisher would sign him. Instead, he found a champion in England, poet and critic Dame Edith Sitwell. When his books did begin appearing in the United States, he garnered high praise from such literary exemplars as Dorothy Parker, Gore Vidal, Tennessee Williams, Susan Sontag, and Edward Albee, who brought Purdy's first novel, *Malcolm*, to the Broadway stage.

Purdy's sexually explicit, emotionally intense, and nearly hallucinogenic novels and short stories of torqued families and tormented outsiders, forbidden lust and poisonous marriages, were inspired in large part by

*James Purdy and Gertrude Abercrombie,
ca. 1945. Unidentified photographer.*

Queen Gertrude and her art- and jazz-enlivened enclave. But there is a deeper dimension to Purdy's fascination with Abercrombie. In the article "James Purdy's *Gertrude*," Paul W. Miller asserts that the writer perceived the painter as an "alienated, self-starting artistic genius like Purdy himself, rejected by family and society alike." Furthermore, Miller suggests, Purdy saw Abercrombie as an alter ego and channeled aspects of himself into his Gertrude-like characters. Both painter and writer created unique forms of "autobiographical surrealism grounded in realism."

An early photograph shows them standing close together. Purdy is tall, attractive, and tousled, looking like a poet in a jacket and open-collared white shirt. Gertrude is plucky and glowing in a striped blouse with a plunging neckline and her jauntily angled black hat. She's looking up and away, her lips sealed, her expression bemused. Purdy gazes into the camera, about to smile or smirk. Two other photographs catch them in bed. Gertrude is on her back, under the covers. Purdy, in a white shirt and dark vest and trousers, sits on the side of the bed and leans over her, one hand on her hair as he kisses her cheek. Her eyes are closed; her mouth is open; she may be laughing. It's playfully intimate. In another photo Purdy pets her face. Is he wiping away a tear? Waking her up? He seems like a kid jumping in Mommy's bed. Who took these pictures?

Having benefited immeasurably from living in Abercrombie's home and from her steadfast friendship and support, Purdy repaid her cruelly in the fiction he published during her lifetime, exposing her troubles, taking

swipes at her paintings, and disparaging her looks. Yet she professed to be pleased with, even proud of, her resemblance to Eloisa Brace.

Malcolm (1959) is an arch and campy urban fairy tale, a bohemian Mark Twain–esque coming-of-age tale infused with a touch of Chicagoan Frank L. Baum's Wizard of Oz magic, and Flannery O'Connor's dark moral calculus. Naive and trusting young Malcolm, an autobiographical projection of Purdy, has been either abandoned by his wealthy father or orphaned. He is a beautiful, disarming boy every adult desires, even though he disconcertingly says whatever is on his mind. When Mr. Cox, a meddling astrologer, comes across this dangerously passive naïf, he takes charge, sending Malcolm, in classic fairy-tale style, to various addresses where each open door leads to an indoctrination into a mysterious facet of life.

Malcolm arrives at the basement door of a three-story house in which a jazz concert is underway: "Malcolm was listening to the sound of the alto sax which was coming from upstairs, but his glimpse of the strong chin and fierce blue eyes of Eloisa Brace stopped him a little. He had never seen such a strong-looking woman." He enters and "a young man with a beard and thick glasses hurried down the back staircase." Malcolm is astonished to learn that this eager fellow is Jerome, Eloisa's husband. Jerome directs Malcolm's attention to his wife's paintings: "They were portrayals of a woman wandering at night, a woman with long hair and a strong chin, but with a soft, kind, even moony expression, garbed in a long flowing robe. The different women depicted in the paintings, Malcolm decided, both were and were not Eloisa. The real Eloisa was so much crosser and older in everyday life."

Jerome brags that he's famous for being a burglar and for serving ten years in the "state pen." He eagerly hands Malcolm a copy of his book (taken from a stack in a closet), titled *They Could Have Me Back*, a snide dig at Sandiford's more macho *Next Time Is for Life*. Jerome plies Malcolm with alcohol and keeps touching him in increasingly inappropriate ways. Malcolm drinks so much he passes out.

Malcolm wakes up the next morning in a very narrow bed with a dark-skinned man beside him who is so distinguished-looking that Malcolm asks him if he's royalty. Unperturbed to find a strange boy in his bed, the gentleman explains that he's a piano player. Eloisa bustles in with coffee,

and informs Malcolm that she is going to paint his portrait. While at her easel, she tells him, "I can't help being interested in jazz musicians any more than a fish can keep out of water." When Malcolm asks, "Doesn't Jerome interfere?" Eloisa replies, "Jerome knew everything about me when he married me. We both knew the chances we were taking . . . I gave up a rich husband for Jerome . . . But I've never regretted it. Not that we're happy, Jerome and I. We've never known a day of rest. While with my first husband, I was *outwardly* happy, you see—had nothing but rest. But with Jerome, well, I don't have a thing, and not really a happy moment. Get poorer every day—he can't find work because of what he is, and we do nothing but quarrel. But, Malcolm, it's *life* with Jerome."

Did Purdy discern that Abercrombie's nagging sense of unworthiness precluded happiness? Or did she feel stifled by her lawyer husband? Or did he pull away because of her drinking and self-absorption? Did Sandiford's neediness give her a sense of mission? In their marriage she was the provider, not the recipient. Surely the Queen wanted to be in charge. But Sandiford, who was seven years younger, was boiling with ambition and not about to settle into passivity.

When Mr. Cox tells rival artist Kermit, a midget, that Malcolm is living with Eloisa while she paints his portrait, he says, "All of Eloisa's portraits, whether they are of her or others, look just like Eloisa." But Kermit believes, "This one will be different . . . She can't paint, and she can't draw, and she can't even see. But . . . she does have a definite feeling for young men like Malcolm, and that feeling will triumph in this case and produce a good painting, perhaps a masterpiece. That often happens to painters without talent—they do one fine thing."

Wealthy Madame Girard, vying for Malcolm, tells Eloisa, "You are too ugly to appear in public." Then: "How beautiful you were before your *second* marriage . . . And now look at you. You have allowed that burglar to defile you, to *common* you, that's what . . . And you've gotten a pot on you from drinking with him."

When Jerome becomes angry at Eloisa, Malcolm "saw her former character of dominance . . . changed now to dependence, almost panic." Jerome and Eloisa argue bitterly over the very lucrative painting commission Madame Girard's husband has initiated to please his overwrought wife.

"'Must my life *always* be heroic?' Eloisa said with routine bitterness. 'Is there to be no rest anywhere, no oasis in the . . .'" she trails off.

Then she loses her temper: "'You're all of a pack!' Eloisa cried out suddenly, looking at all of them. 'You're all fairies, that's what. All a pack of fairies. And you let women carry the burden, while all you do is talk. Damn all of you! Fairies! Fairies!' she cried, weeping, and seizing the brandy bottle, she ran out of the room."

What happened at 5728 Dorchester? Abercrombie left behind this horribly disturbing indictment of Sandiford, accusing him of acts that are in no way commensurate with the course his life took after they broke up or the tone and content of his letters to her from New York. The wounded Queen raves in painfully fragmented, spit-out sentences:

No woman ever loved a man as much as I loved you

It is very sad that I have found out about all of your sexual aberrations. The homosexuality I knew about. I saw the sodomy. I pretended you were just drunk. When our friends knew you had gone forever they told me the other things. I knew that you had been seen exposing yourself in windows. Arrested once. I tried to understand. Two other times friends saw you do it and didn't report it because they had so much respect for me they didn't want to have you arrested.

But when I learned that you sexually molested Dinah for 4 years— at the age of 9—till 12

Some of the people whom you think of as your good friends:

"He treated you like a big piece of shit."

"I always wiped my mouth after he kissed me. Knowing what he had done."

"I never felt he was in your class."

"He can't win. He hasn't got it."

Diz: "Write him a letter with just 2 words 'Fuck You.'" He also told me how you with John Pratt tried to get him into the homo act.

"Good riddance."

The trouble is that I remember the sweetnesses of you. If I had known of your aberrations I'd have spent every cent I have to help you. Now I am spending it on myself. The ambivalence of love & hate.

"He is just a hustler."

"He said he doesn't know why he hasn't been caught after the wild sexual things he has done."

The tape recording tells it.

I don't think any of these things are terrible, except the child molesting. But it certainly shows that you are very sick. I hope you get *help*. I never want to see you again. I'm having a lot of trouble forgetting the big love I had for you. I think you had it for me, too.

I was not right either. Not at *all*.

I nagged and I was mothering you and I emasculated you and you went along with it until you HAD to leave. But I never dreamed you wouldn't pick up and come back and be a MAN.

So now you'll live off another woman.

No woman ever loved a man more than I loved you.

You worked for 6 years out of the 16 we were married. I met you 2 years. Before that. I have all those letters and notes saying that I was the one who showed you everything. You did a lot. You planted pansies. (Snide) Yes you did all that a husband is supposed to do. Almost.

6 yrs. Of support out of 16.

You should be doing it now & then I would be like a woman.

Didn't work.

For the whole month of January 1964 you were sick. I went up to the 3rd floor very many times each day. Your thank yous were feeble. Jesus how I wanted a real one. No woman ever loved a man as much as I loved you.

You forgot my birthday. You wanted money from me. It is any wonder I told the bank to cut you off?

You DUMPED me.

Abercrombie's accusation of Sandiford sexually abusing her daughter is the most appalling sentence in her entire archive, a horrified, guilt-ridden statement. Is it true? If so, how did she find this out? Nothing else seems to substantiate this hideous charge, though Dinah's deep and corrosive anger at her mother surfaces in people's recollection and what appear to be her furious annotations to the Abercrombie photo albums.

As bohemian as Abercrombie was, as beyond ordinary as she envisioned herself to be as queen of the realm of art and jazz, she was still acutely sensitive to traditional gender roles and blamed herself for taking on the allegedly masculine position of income earner. Her supposition that her financial support and "mothering" of Sandiford somehow emasculated him is also mired in convention and cliché.

In 1965 Sandiford was ensconced in Yaddo, the famed artist's community in Saratoga Springs, New York, thanks to a recommendation from Saul Bellow. Sandiford wrote to Abercrombie, complaining that his fellow residents criticized him for his perceived "innocence and naïveté" regarding art and literature, or so one assumes. "They are so sophisticated these people and are so secure, or should be, but I guess I get into their skins somehow."

They were separated at this point, and while Sandiford walked away scot-free and began his ascent to a new, healthier, more conventional and fulfilling life, poor Abercrombie, grievously wounded, withdrew more deeply into her shell.

Here's her resigned retrospective reckoning:

May 28 71
 I had 3 big blows in the 60s. They didn't blow good. 1st was not
too bad. The nutty husband left. But it did leave me companionless.
And riddanceless. Then the other nut took my 20 grand & killed
himself. I thought it was a good investment. 10%. It wasn't. Then I got
pancreatitis and nearly died & wished I had. Two good anagrams for
pancreatitis:
 Trace its pain—& can't praise it.
 I weather the storm.

Dear Gertrude never could resist clever word play or funny malapropisms. In her notes she wrote, "I saw a sign on Wentworth (when I was a child). It said 'Special today PORK LIONS.'"

In a perhaps never sent June 7, 1971, letter to her psychoanalyst, James Alexander, she elaborated on those "three big blows":

The husband Frank went to Yaddo (through Saul Bellow) to write. He ran away with a younger prettier lady: I am glad he left. But of course it is lonely.

A man with whom I invested 20,000 dollars (because he said I'd get 10% interest) well he killed himself so I AINT GOT NO MONEY

Then I got pancreatitis. You know what that is. Odd that you asked. It hurts mightily. 2 surgeons worked on me for 6-1/2 hrs. They saved my life—which—I wonder maybe they shouldn't have.

Livingston had been living in New York with his second wife for two years when he died unexpectedly in 1967. He was only fifty-two. Abercrombie kept his death notices, and wrote in her notational memoir, "Three years ago Dinah's father died of a heart attack. This still kills me." She continued,

Dinah is in Costa Rica—some kind of a commune. She is following the pattern of young people—drugs—then vegetarianism—next Jesus & God. I hope she makes it. She was very dear to me after the operation.

The 20,000 was partly what I saved & partly what my mother left me. Isn't that a devilment?

I'm really spilling my guts tonight. Afraid to send . . .

Now I am NOT asking for help. And yet I am crying for it. In an effort to find peace for the mind I am destroying the body. I drink sherry & it HURTS . . . Then there is the terrible loss of a sex life . . . What to do. Lordy Lordy Lordy. Forget it?

I am by design destroying myself. I'll try not to. I have a thousand friends and 2 darling cats. But no lover.

Sick, lonely, and alcoholic, proud and self-loathing, Abercrombie was not able to keep painting at the pace she used to, nor could she get out much. Eventually she couldn't even manage the stairs in her home. As her life shrank, Sandiford's expanded. He was anxious to remarry and extremely frustrated by how slowly their divorce was proceeding and how little information he had been receiving. On November 14, 1965, he used stationery

from Columbia University's School of General Studies, Office of the Dean (how did he come by this?), scribbling through the printed letterhead and writing above it a saying of Abercrombie's:

JOKES WILL WIN OUT IN THE END.
G. A.
I suppose it is naïve of me, but I just don't understand why you have to hide behind legal dodges. I must have been all wrong about you, but still, in spite of all you have, or haven't done, I don't believe you are purposely being mean to me. I don't for instance believe that you could have given my precious records away. But then I couldn't get myself to believe it when I found out you had taken my name off our joint bank accounts . . . I have been living like a pauper while you have been spending dividends from money, some of which I earned. Well it all sounds completely unfair to me, and I can't understand why it doesn't to you. Why, oh why did you not show some of this avarice toward Bob, the millionaire? Why only me?
. . . Am I all so rotten to you? Don't you think that I have some pretty serious complaints with you and your conduct at all? Just because you are a woman, with the law on your side should not mean that you are not a lady painter, and all that that implies . . . [And what might that be? That a "lady painter" is somehow disreputable?]
I am going to be a volunteer counselor for addicts.

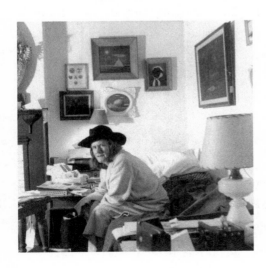

Gertrude Abercrombie in her bedroom. Unidentified photographer.

Their divorce was finalized in 1966.

When Sandiford wrote to Abercrombie in January 1974, he was living in Brooklyn and keeping up with their jazz friends, particularly Sonny Rollins and Max Roach. He provided her with the address of a literary agent to whom he had recommended her "Joke Book." He hoped that she would include "the one about when someone asked you what you thought of Jackson Pollock and you said, 'He's a big drip,'" and claimed that Arthur Miller had some of his work, and that Dustin Hoffman had his book but returned it to his agent "with thanks (but no thanks)." He sounds confident, chummy, completely on the up-and-up—giving no hint of his criminal past or the damage it may have done.

Abercrombie's happy ex wrote again from the Red Hook section of Brooklyn in July 1974. Francis (Frank's official name) had married Frances from Milan, a tiny village in upstate New York. They had two children, a son and a daughter. He described seeing Dizzy Gillespie at a Carnegie Hall concert, and hanging out later at a jazz club with Horace Silver and Art Farmer. "Nowhere could I go but that your name didn't come up." He bragged about how fit and strong he was, how he had "cut out the hootch," now barely smoked, and exercised and wrote every day. He reported that things were going well with his book (a book that never materialized): "I think I am going to hit it big on this one." Then his letter turned cruelly manipulative. He informed Abercrombie that he and his second wife "are down to a bit over eleven hundred in the bank . . . I know I'll make it, but Frances is worried." After writing about how much pain he was in after an accident he apparently had on a job—he had received some workman's compensation and was due for more—he had the unmitigated gall to write this:

> Meanwhile I want to move from here. I think of that house on Dorchester that we both loved, of the back yard I took care of, of the neighborhood with its fine school and I wonder what's to become of it. Could you, as you used to put it to people you'd give paintings to, "put it in your will"?
>
> I doubt Dinah would want it. Chicago pulls me back. Frances loves it and so did the kids. I would keep it up in memory of you. I know this sounds morbidly greedy but I think you know I'm not that. I would just love to live my life out at 5728 with the cats and the garden.

Here are some pictures of the kids. Please take care of yourself and, if you can, or feel like it, write to me. "Can't we still be friends"?
Courage!
Frank

Among the puzzle pieces of Abercrombie's life is this undated response which, given further correspondence, must be a first, angry, spontaneous draft of a letter she did send:

Frank—
forget the friend bit. I have many true and faithful friends and to one of them my house shall go. Anyway what makes you think I'll die first? Of all the nerve and crassness & greediness.
You did not even send the prints I asked for. Anything you may think would interest me. You might get into some *grace if you do.
Indifferently,
*or Grace as the case may be. (about $80,000 for house)
Prints of all my cars & 18 prints of me & Diz of me & Sonny. Whatever else & my Rolls. Send NOW.

On August 28, 1975, the *Gazette Advertiser*—published in Rhinebeck, New York, a beautiful old town one hundred miles or so up the Hudson River from New York City—ran an article about a woman named Frances Sandiford. Readers learn that she graduated from nearby Bard College and earned her library degree at Western Reserve University. She had been a librarian at Red Hook Central School in Brooklyn. Now living in Tivoli, she has a new job. A photograph captures Frances in summery attire, her long, dark hair swept off her forehead, crouching beside a little girl and boy. The caption reads: "Frances Sandiford of Tivoli chats with her children, Veronica, 8, and Paul, 4, at home. Mrs. Sandiford will be the teacher at St. Paul's Nursery School in Tivoli this year." The article promises that "Hearing and telling stories will be a special delight for a dozen tots in Tivoli this fall." Her husband, the reporter notes, is publicity director for Manpower, an employment services agency, in Poughkeepsie, New York.

Sandiford wrote to Abercrombie again at the start of 1977, still not

having sent her the photographs she'd requested several years back. After a long, self-congratulatory description of his latest encounter with her old friend and boarder Max Roach, followed by a bit of music criticism, a smug reference to an article he wrote for the *Village Voice*, and his preening description of himself as a "stage-Johnny" when it comes to "jazzmen," he claimed that he was "still on the hunt for those negatives," which, he reported, were in storage "in some box or other" at his mother-in-law's house in Milan. He assured Gertrude that he'd have them printed and bring them along when "we stop off at Chicago on our way to Wisconsin to see my mother." In closing he wrote, "We will probably see you toward the end of August."

Gertrude Abercrombie died on July 3.

Frank Sandiford would outlive her by sixteen years, the length of their marriage.

In 1980, Frances Sandiford began working as the prison librarian at the Green Haven Correctional Facility in Stormville, New York, a position she held until she retired in 2000. What led her to work in a prison? The prison library saved her husband when he was incarcerated. Did his experiences influence her? Did she keep Frank's past to herself? Surely she read his book, of which he was so boastful. Surely they talked about his past.

On June 12, 1986, the *Gazette Advertiser* ran a notice of an exhibition at the Hotel Rhinecliff of photographs of the Hudson River taken by Frank Sandiford.

Frances Sandiford became a book reviewer for *Library Journal*, and in 2011 she published an essay there titled "Reflections of a Retired Prison Librarian." Reading this, no one would imagine that she had married a man who served time and whose salvation was the prison library.

"I had never intended to be a prison librarian," she wrote. "I had worked in college libraries. After having two children, I had taken off some time. When I wanted to go back to work, the best job to come my way was at Green Haven Correctional Facility in Dutchess County, NY, a maximum-security facility for men and a drivable distance from my home. I hesitated at first because I didn't know what a job at a prison would entail, but I finally decided to give it a try."

Sandiford described the strict security protocols and many rules, including a ban on chewing gum "because it could be used to jam locks."

Though she admitted to never fully adjusting to these restrictions, she did come to feel that she was "doing a vital service for a population in need." She explained, "Here is the real difference between prison libraries and libraries in the free world—prison libraries are lifelines for the inmates, their one contact with the outside, a small taste of freedom."

She continued, "It sometimes sent chills down my spine to know that the men I dealt with in the library had such sordid pasts. I felt the contradiction of providing intellectual freedom in the midst of prison security. It was a potentially dangerous environment." After addressing various professional aspects of her job and noting what the men enjoyed reading, she mused, "Of course, there was a dark side to the library: it was a meeting place where inmates could collaborate, where plots could be hatched and contraband sold or bought, but I prefer to concentrate on the positive. It was in prison libraries like mine that Malcolm X turned his life around. Reading presents new horizons, and I like to think that I contributed to the inner growth of many prisoners."

Having "learned a lot about the American justice system," Frances became a board member of New Yorkers Against the Death Penalty.

James Purdy's *Malcolm*, a campy fable of innocence lost with an Abercrombie-inspired character, Chicago painter Eloisa Brace, came out in 1959, the apex of Gertrude's life as an artist. His novel *Eustace Chisholm and the Works* is a far grimmer, even devastating tale. Grueling in its depiction of poverty and sexual torment and violence, it features a bawdier, boozier, and more embattled and despairing variation on the artist, Maureen O'Dell, a character Abercrombie, no matter how resilient and well-armored she was, had to find excruciatingly painful to confront—especially since Purdy's book was published in 1967, soon after her divorce from Sandiford and around the time of her first husband's unexpected death. Abercrombie's health was poor and her spirit was flagging when her longtime friend betrayed her, albeit, it must be said, in a novel of graphic intensity that courageously addresses the suffering of homosexuals at a time in which they were subjected to vicious prejudice, resulting in debilitating shame and necessary secrecy.

The novel is set during the Great Depression in Chicago's Hyde Park neighborhood, where Eustace Chisholm "had been caught up in two tragedies, the national one of his country's economic collapse, and his failed attempt to combine marriage with the calling of narrative poet." Amos Ratcliffe, seventeen, is a beautiful boy in the Malcolm mode, though poor and struggling. He is in love with his landlord, Daniel Hawes, who insists that he's adamantly opposed to sex between men. The two meet for the first time at Maureen's studio. On her way to see Eustace, she runs into Amos, whom she has been kind to, giving him money and counsel. Now she chides him for stealing Daniel, her "fellow." Here is what Amos sees: "Her face, from which jutted a nose like Pinocchio's and a vermilion line of mouth, contained a pair of large blue eyes red and puffy from crying."

"Old Maureen is knocked up," she tells him. She "studied Amos's face carefully," then says, "Talk about pearls for teeth . . . you got 'em. No wonder the boys go for you, because I could too and if I had something to push between those pearly teeth I'd be the first in line." She begins "kissing him inside the mouth industriously" and with "professional speed" unbuttons his pants and fondles him. Then she asks him for a terrible favor: to accompany her when she goes for an illegal abortion.

On the appointed day, Amos arrives at her small apartment and examines her paintings, "unsold oils whose subjects ranged from Maureen herself at midnight to scenes of ruined slaughter-houses, pool-room interiors, prairies and corn fields, skies and lawns without depth or perspective."

Eustace, Maureen's "mentor for sexual freedom," frees "her from her Christian Scientist mother, and from the deadly existence she had led in virginity up to the late age of 23. But perhaps she would have been happier as an old maid." He tells her that her "personal tragedy" actually has nothing to do with her mother, but rather is due to the fact that she "had been born with the face of a gargoyle on the body of a sylph." To overcome this "she must give herself unstintingly to the sexual experience and work at it just as she did her painting, in order to discover its secrets." The result of her epic promiscuity is that at twenty-seven she feels old and defeated. Eustace now smugly calls her "yesterday's queen." She has already had several abortions and says that this time she hopes to die. And she nearly does.

The illegal abortion scene is horrific—crude, gory, dangerous, and torturous. Maureen screams and screams and vomits; Amos passes out, then retches. One line is enough to give a sense of the agony and grotesqueness Purdy describes: "her abdomen and pubic hair so stained with blood they resembled a huge wreath fashioned out of torn pieces of entrails."

But Maureen is tough, stoic, and blunt. She tells her brave young friend, "Be glad you're a man, Amos, even though you don't go for women. Be glad you got a man's thing. There's no future in being a woman after a certain time."

Is Karl Priebe referring to an in-progress version of *Eustace Chisholm and the Works*, or is he referring to an earlier work in this postcard, dated October 21, 1964? "Dear Gertrude, Well, I read James' book and of course fiction ain't fact so don't feel abused."

Yes, we should remember that "fiction ain't fact," but Purdy was every bit as autobiographical a writer as Abercrombie was a painter, and his novels are to a great extent romans à clef. Purdy freely admits that fact greatly shaped his fiction in a letter to Abercrombie dated July 17, 1965, but he was either unconscionably oblivious to Abercrombie's feelings or blinkered by his own creative vision:

Dear Gertrude,

You will like my new book—the one I am writing now—it has the old real you in it—describes your first abortion and your gay life before you married those dumb men. You must be *you* again. You're too great for men. Come back, Gertrude, come back! You can!

I haven't heard from F. and I *won't* . . . I won't see F. I was never interested in him except as one of your mistakes. You're not a mistake—be your old self again. Be Plumy, o Gert!

My new novel is called EUSTACE CHISHOLM AND THE WORKS.

Love, love. Cheer up! You're great. James

Abercrombie's decline upset and worried her friends. Purdy sent her letters into the 1970s, trying to rally her spirit. On March 2, 1971, he wrote, "Don't

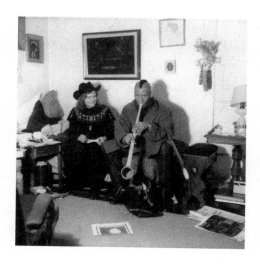

Gertrude Abercrombie and Sonny Rollins. Unidentified photographer.

give up for a long while: You have lots to do & accomplish . . . You must eat well. Are you eating the proper food?" He closes a letter dated June 24, 1972, "Write to me soon, get well, don't leave me."

Jazz giant Sonny Rollins was among Abercrombie's most loyal and loving correspondents, writing to her often and urging her to take care of herself and to return to painting. Abercrombie's papers include an incredible set of letters from the brilliant, famously disciplined and devoted saxophonist, who cherished his visits to 5728 Dorchester, and deeply admired Abercrombie's paintings. An undated photograph shows them seated next to each other beneath one of Abercrombie's paintings. She is in black, with a band of brightly patterned embroidery on her blouse, a black cowboy hat on her head. She is turned partly toward Rollins with a close-mouthed smile, her eyes bright with affection. Rollins has on a coat and scarf, his hair shaved away except for a low-riding Mohawk. He's blowing into a rudimentary long, straight horn with a bowl-shaped bell, gazing intently ahead, either at the photographer or into an inner distance. His letters among the painter's papers provide a remarkable window onto his creative evolution as he shares, in the hope of offering inspiration, his own efforts to improve his physical and psychic well-being in order to become a better human being and artist.

Rollins's early missives are addressed with great warmth and enthusiasm to both Gertrude and Frank. Five pages into a letter dated March 21,

1962, he writes, "Oh yes, Gertrude dear, I too like the spectrum of color. Like unto the musical scale, it is another of Nature's masterpieces, isn't it? And how can anything or anyone halt or mar her plan?"

Rollins is cosmic. He writes of his Rosicrucian studies, his isometric exercises, and his striving for a higher plane of consciousness and creativity. Acutely aware of the essential role the body plays in making art, and increasingly spiritual about its care, he wrote to Abercrombie and Sandiford on July 12, 1962,

> Dear Friends,
>
> I certainly hope that you both are enjoying the best of life's offerings. I hope also that you Gertrude have stuck to your guns and minimized your drinking. I've still not been able to completely stop from taking a cigarette occasionally, but I am steadily working at abolishing this insidious habit once and for all.
>
> I can't begin to tell you how pleasant the visits to your house were and how much they contributed to the success of my trip. Outside of the tapes which I still haven't gotten around to hearing—I gained so much in the way of inspiration and incentive as a result of association with you both again. I hope you both realize that I really mean this. Naturally there is an open invitation to you both to visit us whenever either or both of you get to this part of the country.

On September 7, 1962, Rollins writes, "Gertrude (Precious stone that you are) How are you faring with your battles and struggles? I am still fighting and regardless of what I ever do—I will always be striving for my self-development."

On December 20, 1962:

> So how are things? Have you conquered that over-indulgence hang up? I have not smoked in many months now and don't intend to *ever* again . . . It demoralized me both mentally and physically . . .
>
> That's for me. But for you Gertrude the fact that you have picked up the brush is in itself tantamount to victory, and I am deeply happy about it.

Also I have not forgotten that I asked you to paint something for me. My walls are waiting to accommodate it patiently!!!!

Post-Sandiford, he writes in an undated letter on music paper,

And Gertrude yes I Love Gertrude very much!
Are you turning out more beautiful MEANINGFUL WORK? Your paintings are treasures which one could quite naturally fall in love with . . . And yet and still the greatest painting which you've ever done for me personally is the image which your person has etched upon my consciousness—Giving as it does LIFE to my Soul.

A letter from 1972:

Dearest Gertrude,
It is good to know that you are alright . . .
You say you have been deserted but are just as happy for it. Well, as long as you are happy to some extent because after all Gertrude you are the salt of the earth, and deserve some pleasure out of this thing called life.

An undated missive:

Dear Gertrude—
It was distressing to hear of your having to be hospitalized. You must try to *heal yourself* through the various ways available. Will Power and Diet are the ways which I have in mind . . .
It is also good that your daughter is coming back from South America. I know you'll be glad to see her.
P.S. Happy Mother's Day

A rare convergence of Abercrombie's passions for music and painting is found in her design for an album cover for her dear friend, composer and musician Orlando Murden. A Chicago singer, harpist, and pianist, he wrote the music for the hit song "For Once in My Life," which was made famous

by Tony Bennett and Stevie Wonder. The back of the album sleeve for *Orlando! . . .* , released in 1970 by Super Star Records on Chicago's North Side, carries a quote from Abercrombie: "You have heard over one hundred recordings of 'For Once in My Life.' Here it is; sung and played by its composer. Ah, so tenderly. (Painting on cover titled 'For once in my life' created by Miss Abercrombie.)"

On the front cover, against a black background, floats a photograph of Orlando, a harp, and, on a stand, Abercrombie's framed painting, one of her very last, and an image of remarkable revelation. On a barren dreamscape, a large snail shell, lushly painted, rests not as it would on a snail's back but on a naked woman's abdomen as she lies flat on her back, her legs inside the shell, her arms at her side, her long dark hair arcing across the ground. A full moon beams, a white cloud drifts, and a harp stands at the horizon. Here Abercrombie reveals herself as a shell woman, prone and helpless.

James Purdy, who began a June 8, 1976, letter to his loyal friend "Dear Painter Woman," and concluded with "your old-time playmate," cut Abercrombie to the quick when he looted her life to create his character Maureen O'Dell. Yet Abercrombie kept the rave reviews *Eustace Chisholm and the Works* received, along with ads and playbills for Edward Albee's stage adaptation of *Malcolm*. She must have been proud of Purdy in spite of the misery she suffered over his savage fictionalized portrayals. But then he dealt the final blow. For all his protestations of love, Purdy inexplicably abandoned Abercrombie during the closing act of her terribly diminished life, compounding his literary assaults by a complete withdrawal of his decades-long friendship when she needed his support the most. Not only did he not attend her crowning achievement, the 1977 retrospective exhibition at the Hyde Park Art Center, at which she reigned supreme from a wheelchair, he also refused to loan her the portrait she painted of him in 1936 for inclusion in the show. Abercrombie could not understand why Purdy had severed communication. Did he envy her this major recognition? Or, given his profound connection to her, could he not bear to see her dwindle away? Perhaps the very thought of her imminent demise terrified and shattered him.

Twenty years after Abercrombie's death, Purdy attempts to make amends in his novel *Gertrude of Stony Island*. Dedicated primarily to "Miss

Abercrombie," it is an imaginative and restorative elegy for the woman who rescued, inspired, and haunted him. Intriguingly, Purdy writes from the point of view of his fictional Gertrude's mother, Carrie, who is grieving for her recently deceased daughter. Carrie admits, "We never got on, Gertrude and I. Yet I believe we loved one another." Her musings continue:

> She was not a beautiful girl. Her chin was too pointed. I even once thought of plastic surgery, for the rest of her face was quite lovely . . . It was her body that attracted the men . . . I sometimes think she had so many fellows because it was her way of spiting me.
>
> Her paintings have always frightened me. No, not exactly frightened. They unhinged me.

Carrie discovers that Gertrude's diary "was not like any diary you have perused or peaked into . . . It was not a diary at all. It was well, why not say it, a book of codes." Carrie's husband, much to her surprise, encourages her to use the diary to "go in search of my lost Gertrude." Carrie is guided on her quest by Cy Mellerick, a handsome young attorney (shades of Abercrombie's first husband?) who knew Gertrude but who tells Carrie that "no one knew Gertrude very well." Cy gallantly takes Carrie on a journey into the artist's world, a realm so strange and unsettling for her mourning mother that Purdy turns to mythology for the equivalent, aligning Carrie's quest for Gertrude with Demeter's search for her daughter Persephone.

Ultimately Cy and Carrie end up at Gertrude's now condemned brownstone studio. There Carrie has a vision: "I saw I knew Gertrude at last in all her shimmering grandeur and squalor, in all her triumph over her poor parents, and her effulgent incarnation as herself and only herself. For her art had given her a new birth and being which owed nothing to me or you, Daddy. She had created herself and in her death was forever free of us both."

Purdy has orchestrated a rapprochement between the at-odds mother and daughter, and recast Gertrude as a transcendent artist whose work lives on in all its moody glory after her death. Purdy may well have been seeking to ameliorate his guilt by paying fictional reparations for the very real pain he caused Abercrombie. He himself did not have an easy time of it. As

prolific and critically championed as he was by the likes of Susan Sontag and Fran Lebowitz, Purdy, due to his wrenching and disturbing subject matter and uncompromising style, remained poor and marginalized as a cult writer until his death at age ninety-four in 2009. He had a bit of a resurrection with *The Complete Short Stories of James Purdy* (2013). On the cover is the portrait of Purdy painted by his muse, Gertrude Abercrombie. This substantial volume allows readers to take full measure of Purdy's daring originality, unflinching realism, and full-blown strangeness. In his introduction, filmmaker John Waters, the devilish and benevolent maestro of weird, urges readers to perceive the book as "a ten-pound box of poisoned chocolates . . . fairy tales for your twisted mind . . . gracefully disquieting stories for the wicked." Purdy, Waters avers, is not a fringe writer, but rather one who's "been dead center in the black little hearts of provocateur-hungry readers like myself."

Purdy felt that Abercrombie had not yet been given the credit she deserved, writing, "Her radical American vision will take some time to be fully understood and appreciated." For all her recognition, Abercrombie herself suspected that this would be the case. She purposefully held on to many of her strongest paintings, and even tried to buy back other works to be sure that upon her death her best paintings could be given to museums and other institutions that would preserve her work and make it available to the public. Yet she also nearly thwarted this reach for posterity. Her cavalier approach to technical considerations meant that many of her paintings were fragile, and required major restoration. Similarly, one of the cruel ironies of her life was that she drank to excess to anesthetize her feelings of being unworthy and unloved because of her alleged homeliness; yet it was alcohol that ravaged her looks as it destroyed her health.

Critic and curator Dennis Adrian reviewed Abercrombie's 1977 retrospective exhibition in the *Chicago Daily News*: "Her work itself is painstaking, exacting and personal; it is perhaps more privately mystical than surrealist . . . There is a special quality of her personal artistic statement, her involvement with contemporary American art other than her own field, and her confident commitment to our city's rambunctiously active culture. Because of all these

things, Gertrude Abercrombie deserves the fullest respect as one of our greatest painters."

Abercrombie's friend and the executor of her estate, Don Baum, carried out her wishes and gave a phenomenal collection of her work to the Illinois State Museum in Springfield. In 1991 the museum mounted the definitive retrospective Abercrombie exhibition and published an invaluable catalog. To this day, Abercrombie is always included in books that survey Chicago art. The Art Institute of Chicago owns five of her paintings, including the recently donated and central work *Self-Portrait of My Sister,* though as of now none are exhibited.

Abercrombie is the high priestess of Chicago's rogue figurative tradition. The renegade painters in the morphing groups known as the Hairy Who and Chicago Imagists—first exhibited at the Hyde Park Art Center in the 1960s, thanks to Don Baum—shared Abercrombie's focus on the human figure, however stylized or wildly imaginative, and her proclivities for surrealism, stagy interiors, and flat, open landscapes, and the rendering of psychological states, though their work is far more animated, visually complex, cartoony, and brash. Chicago artists such as Roger Brown, Art Green, Gladys Nilsson, Jim Nutt, Ed Paschke, Christina Ramberg, and Karl Wirsum found inspiration in everything from advertisements in pulp magazines to thrift-store junk, underground comics, tabloid newspapers, local performance posters, and other forms of street art.

The Chicago women artists who followed Abercrombie and her staid or regal, quaint or timeless, dreamy and symbolic, theatrical and jokey images were far more liberated personally and artistically, and much more worldly and politically engaged, yet such painters as Suellen Rocca, Barbara Rossi, Nancy Spero, Hollis Sigler, and Phyllis Bramson do emulate Abercrombie's use of a personal visual lexicon while extending her pioneering investigation of female roles and the predicaments and paradoxes of women's lives. And, despite their training, they share her appreciation for and identification with self-taught or outsider artists.

But Abercrombie's renown was always primarily local and short-lived. As often as she exhibited and as well as her paintings sold, she never had a major gallery. And her paintings were so out of step with the radical trends in New York, the world's art capital, from Abstract Expressionism to Pop,

performance, and installation art, that her work had no traction and little resonance. Even in Chicago, Abercrombie was quickly overshadowed by the more confident, brash, and articulate artists who followed, intrepid and mischievous painters associated with the School of the Art Institute of Chicago who filled the city's hippest galleries, including Phyllis Kind and Allan Frumkin, which soon opened second spaces in New York's SoHo district. Abercrombie slipped back inside her shell and was pulled under by the onrushing tide.

We walk down a long and winding road across a vast prairie dreamscape with Abercrombie as the searching girl becomes a questing woman, the ebullient queen of the bohemian artists and the lonely queen trapped in her arthritic body—her shell become cage, her castle a prison. Abercrombie takes us to her promised land, the prairies of Illinois and her heart's home, Aledo, and to the stark rooms of her inner Chicago. Our eyes widen when we encounter an Abercrombie painting. We lean forward to take in every detail and tip into an altered state. We find ourselves in a nocturnal realm, a theater of the psyche, a magician's arena. We see a flatland, an open-air stage under the moon's eye. We see a gesturing woman, signaling trees, a chaise longue, a table. As Abercrombie's avatars search for love, direction, understanding, and fealty, we search for clues to the meaning of her twilight and shell-glow colors, her clouds and owls, cats, and horses, her towers and tents.

Abercrombie's paintings create an episodic one-woman show illuminating the artist's struggles with the perplexities of the self, love, marriage, motherhood, captivity and freedom, inheritance and independence, loneliness and abandonment; her pursuit of beauty and magic, her guiding dreams, and the refuge she found in humor. Abercrombie's paintings are bewitching, enigmatic, elegant, awkward, eerie, funny, clever, sad, anguished, teasing, and playful. She was hardworking, diligent, and ambitious, famously social and generous, musical, warm, and witty. She was also depressed, irritable, self-conscious, self-deprecating, self-destructive, angry, sharp-tongued, stingy, and reclusive.

Her paintings depict emotional deprivation and isolation, but also bold

exploration and confident autonomy. Her self-portraits as witch, magician, and queen generate transcendent personae, women of extraordinary powers. This is how she wanted to be seen and remembered, and knowing the true story of her life only strengthens our sense of her artistic vision, determination, and triumph.

"Chicago Artist Abercrombie Is Dead at 68." So reads the headline on a brief newspaper article in Abercrombie's Archives of American Art collection. Clipped and photographed without source or date, it floats on the dusty microfilm frame like a scrap from Abercrombie's mishmash memoir. The notice claims inaccurately and carelessly that "Miss Abercrombie . . . was at the top of her career in the 1930s and 1940s." Though, on a more positive note, the reporter marvels, "In one year alone, she staged five one-woman shows." The closing line is slicing: "No services are planned."

Decades later, Gertrude Abercrombie's paintings are alive and magnetizing and enigmatic, just as she envisioned. Abercrombie did not write about why she painted, or how she felt with a brush in her hand, or what she hoped people would glean from her work. Now her dreamscapes and stage sets cast their spells on the walls of museums in Illinois, Wisconsin, Pennsylvania, and Washington, D.C., and on the pages of books. They await our searches online, rising up to fill the screen so that we can bask in their otherworldly iridescent light, amphibian atmosphere, and transfixing magic. Queen Gertrude rules; long live the queen.

BEHIND THE MASKS
LOÏS MAILOU JONES

> I discovered that not only being black, but being a woman created
> a double handicap for me to face.
> —Loïs Mailou Jones

At ninety years of age, Loïs Mailou Jones is poised, charming, and candid. Resplendent in a richly hued silk jacket patterned with mask-like faces, she is every bit "The Grande-Dame of the Art World," as *Ebony* magazine honored her. The writers for *Good Morning America*, by contrast, were way off the mark with their title for Jones's segment, "A Portrait of the Artist as an Elderly Woman." Unfazed as always, Jones took control of her story, graciously and firmly. She told her white male interviewer, Joel Siegel, that she was warned as a young artist that she wouldn't be able to make it at home in America because "the establishment in this country was not interested in the work of black artists." She was advised to go abroad, where her talent would matter, not her skin color. Jones devoted herself to her arts education and career, became a professor at Howard University, and attained her first sabbatical in 1937, which made possible her first voyage to Paris. She thrived in the City of Light, forging a lifelong friendship with French painter Céline Tabary, creating more than forty paintings and exhibiting her work in galleries and museums.

Jones described what happened when she returned home and brought her work to galleries in New York City, only to find that, indeed, in that harshly segregated milieu, artistic excellence did not transcend racism: "I went to 57th Street with my impressionist works, street scenes, beautiful paintings of Paris. And they said, 'Your work is excellent, but you know, we can't show it. We can't take you on.' And so I decided to put my work in crates and ship them to the national museums. They all made the shows.

And I would go to the openings and see my work hung and feel happy about it." In Paris, her paintings had been accepted without question in the prestigious annual Salon de Printemps exhibition at the Société des Artistes Français at the Grand-Palais. In her own country, the same artworks were deemed unacceptable because she was African American. Only when she submitted paintings without revealing her identity was her work accepted on its merit.

Jones was a skilled basketball player, though she was nowhere near tall. Her quickness, precision, and fortitude in dodging and overcoming obstacles and aggression served her well as she held her own with dignity and grace in a world dead set against people of color and independent, creative women. How far Jones came in spite of discrimination is evident in the photographs she saved. In one, the artist is standing beside President Bill Clinton and First Lady Hillary Clinton as they hold up one of her watercolors. In another, President Jimmy Carter presents the artist with an Award for Outstanding Achievement in the Visual Arts. Jones presents President Léopold Sédar Senghor of Senegal with her portrait of him. French president Jacques Chirac stands between the artist and his wife, his arms around them. The artist stands with President Paul E. Magloire of Haiti, who commissioned portraits of himself and his wife, and presented Jones with Haiti's Diplôme et Décoration de l'Ordre National Honneur et Mérite au Grade de "Chevalier" (Chevalier of the National Order of Honor and Merit). Proud and confident, the artist worked diligently to reach the summit where heads of state enthusiastically recognized her accomplishments and her contributions to culture. Boston-born, Loïs Mailou Jones became a citizen of the world, and her paintings reflect her deep immersion in the diverse places she called home.

Consider this series of watercolors:

Fishing Shacks, Menemsha, Massachusetts (1932). Menemsha is a three-hundred-year-old fishing village on the island of Martha's Vineyard. Jones has painted several simple huts in reach of the surf, and a fleet of humble fishing boats with their sails rolled up, tied to a wooden dock and pulled on to the sandy shore before a vibrant green bulkhead of beach shrubs.

Negro Shack 1, Sedalia, North Carolina (1930). Here Jones depicts a log cabin in the woods, with smoke lifting slowly from the chimney; patches of red and yellow wildflowers growing in the tamped-down dirt; tall, leafy trees; a large tub leaning against a log; a wooden chair set in the shade of a tree with a white cloth draped over the back; a red ball waiting on the ground; and a clothesline festooned with a red shirt and a white shirt stretching between trees, while in the two doorways stand children and an adult in bright clothes, looking out.

Harlem Backyard (1930). Clothes hang on an array of clotheslines stretching over the pavement between two buildings. On this golden day, a tree softens the city's hard edges, its narrow, close-set leaves glowing in the sun, while a striped cat stretches out blissfully on a wooden back-porch step. Jones has revealed a hidden, homey, serene bit of Harlem life.

Pêcheurs sur la Seine, Paris (1937). Small fishing boats, one with two men holding long poles, mingle with houseboats in a classic Parisian bridge-and-river scene rendered with a sure, light touch and palpable pleasure.

Quartier du Fort National, Haiti (1954). Our eyes are drawn down a steep, dusty road bleached bright by a full-on sun as it runs to the sea and a knot of fishing boats. Along the way we see a patched-together shanty on the left with a tipping front porch on which a woman sits, working on something in her lap. Similarly roughly built homes, one against the other, line both sides of the steep path to the shore, with large-leafed trees presiding, while small figures walk in the distance, bundles and vessels balanced on their heads.

Nigeria (1970). A woman stands, balancing, with lifted hands, something tall on her head, while she looks out to sea, where a fishing boat sails. Beneath a thatched palm-leaf roof, held up by slender trees turned into slightly bent poles, other women are busy among pails and bowls. A child walks by.

These watercolors document the places that inspired Jones over her long, disciplined, yet adventurous life. Her profound gifts for color and

dynamic compositions were evident right from the start. But her perception deepened and her techniques and skills developed steadily, while her delving appreciation for nature—for that master painter, the sun; for those living mirrors, rivers and seas; for breathing, gleaming trees and plants—was a constant, stirring, inspiring force. So, too, was her avid appreciation of the visual impact of humankind's constructions, from simple homes and working boats to the architectural splendor of Paris. Jones painted in awe. But she was also vigilant in her effort and determination to achieve recognition, and had no qualms asserting that she deserved it. Attention and renown she did receive, though not on as large a scale as merited, for reasons that seem all too deplorably obvious.

Jones's story is one of focus and perseverance as much as creativity and daring, and her step-by-step success does not yield the sort of tumultuously romantic drama we seem to prefer when it comes to artists' lives. For all her eagerness to be noticed and rewarded, and for all her unapologetic, clearly necessary self-promotion, Jones was scrupulously private. She maintained a personal archive scrubbed so clean of any hint of emotion, personal conflicts, or sexuality that the CIA would be impressed.

A fairly well-off and well-behaved girl much loved by her industrious parents, Jones became a formidably rigorous young woman who kept herself extremely busy on many fronts, way too busy for trouble. Not to say that Jones didn't wrestle with anger and frustration over social ills, especially racism and sexism, reductive, loathsome forms of systemic prejudice and discrimination that hobbled her personal freedom and her career. In an ideal world, Loïs Mailou Jones would have immersed herself joyfully and gratefully in the glorious beauty of the natural world and painted out of wonder, curiosity, and gratitude. Her only sense of duty would have been to the refinement of her translation of what she saw and felt into the language of line, form, and color. Instead, though she grew up privileged and surrounded by prominent men and women, there was no ignoring the harsh facts of extreme segregation regulated by the so-called Jim Crow laws, and outrageous violence against blacks, including a virulent outbreak of lynchings in the South. But as Jones attended the High School of the Practical Arts and the School of the Museum of Fine Arts in Boston, during the 1920s, the Harlem Renaissance was underway, ensuring that African

American art, literature, music, and dance flourished to profound and lasting effect. Jones, like most of her peers, felt summoned to create works that offered uplifting and progressive perspectives on the black experience. She could not paint purely for her artist self, who swooned over the caress of sunlight on a field of wildflowers. Instead, she felt compelled to paint as a member and representative of her cruelly maligned and attacked race and as one of many African Americans calling for equality and freedom.

Yet no political or social or academic agenda or demands kept Jones from freely and intrepidly exploring diverse painting styles, subjects, and perspectives. Refusing to be categorized as simply a watercolorist or portraitist or landscape painter, designations that may have led to a more commercially viable career, especially as a black woman artist, Jones changed her approach at will, just like the artists who inspired her. A photograph of Picasso adorned her studio wall, as did a cow's skull right out of a Georgia O'Keeffe painting. Throughout her long life, Jones developed her own forms of figuration, Impressionism, patterned abstraction, and imaginatively collaged compositions. Her colors, inspired by her close study of the living world, were always lustrous and powerful; her lines, guided by both nature and the human-built world, were both supple and ruled. With pencil, pen, palette knife, and brush in hand, on paper and on canvas, Jones was liberated and in command.

Jones's parents steadfastly encouraged her artistic talent and provided her with all the materials she needed. Jones remembers drawing as early as three years old; at seven, she received her first watercolor set. "As a child, I was always drawing," she said. "I loved color." According to Chris Chapman, who became Jones's confidant and adviser during the last decade of her life and wrote the richly illustrated tribute *Loïs Mailou Jones: A Life in Color* (2007), the artist's "ethnic heritage included Native American, Scotch African, and Dutch. Her parents could speak Dutch, and her Aunt Rachel had Native American features with black hair that was so long and straight she could sit on it."

Her parents, Thomas Vreeland Jones and Carolyn Dorinda Adams, grew up in Paterson, New Jersey. Seeking better opportunities, they moved

to Cambridge, Massachusetts, after marrying in 1896, and their son, John Wesley, was born there. A few years later they moved to Boston, and in 1905 they had Loïs, giving her the lovely middle name Mailou, which was frequently bestowed on the Moseley branch of her maternal grandmother Phoebe Moseley Adam Ballou's family tree. Since her brother was nine years older, Loïs usually played alone after the family moved to the top floor of a downtown office building owned by the Society of Universalists of Boston. There they would live for thirty years. Thomas served as building superintendent, while Carolyn established a brisk business as a beautician, and later earned quite a reputation for making colorful and lively women's hats. Thomas attended Suffolk Law School at night, earning his degree at age forty in 1915 and becoming a successful real estate lawyer and agent. Jones said, "I think that much of my drive comes from Daddy—wanting to *be* someone, having an *ambition*." Her handsome and accomplished parents were popular members of Boston's African American upper-class society.

During the summer, the Joneses were among the black elite who gathered each year on the island of Martha's Vineyard. Jones's grandmother, Phoebe Ballou, worked as the housekeeper and nanny for a family named Hatch. Jones said that Phoebe "was really a very, very important person in the household. That influenced me because as a child they accepted me as a member of the family . . . and encouraged me very much in my art." Hardworking (a family trait) and thrifty, Ballou bought property in Oak Bluffs, an enclave for the island's prominent African Americans, which became Jones's most cherished refuge.

Jones describes her Boston childhood, "I was rather a lonely child living down there in School Street. My playground was the roof of the building. And I can remember going up ladderlike steps to my playground, and looking over all the big buildings, the City Hall, and those office buildings all around the city, and seeing the smoke and . . . sort of duskiness, the grayness of all of those surroundings." Then they would take the ferry to Martha's Vineyard: "What a joy it was to see the buttercups and the fields of daisies and the beautiful blue of the ocean. Indeed it was a great inspiration. I just fell in love with nature. That island is greatly responsible for my love of nature and for art as a career." There, Jones mused, "My life in art really began."

In a 1991 interview Jones reminisced,

My mother loved flowers, and in our summer house at Martha's
Vineyard, the Portuguese vendor would come by in the morning with her
little wagon, pulling it, full of flowers, and mama would buy them all.

Flowers were everywhere, and that carried over into designing hats
which she did for friends and for children for Easter. I always admire her
ability to design those hats, and it probably did something to instill in me
an appreciation for color . . .

Even though my mother wasn't an artist, she was an artistic person.
And she was interested in my work. So many parents in those days
discouraged their children from going into art, saying, "You can't make a
living at it." . . . But my parents just encouraged me. My mother would
say, "Set your goal, and if that's what you want to be—you want to be an
artist—just work, and don't let anything interfere." And she would help
me to that end."

Jones would accompany her mother to the art-filled homes of wealthy
clients, and "they would invite little Loïs to come and make a watercolor of
their garden, or to come and see their art books. That exposure had a lot to
do with my development as an artist." But "little Loïs" also took note that at
white family residences her mother had to enter by the side door and could
only eat in the kitchen. Nothing kept her proud and resourceful mother
from celebrating her talented daughter's accomplishments, however. She
would even hang Loïs's watercolors on a clothesline to create informal
outdoor exhibitions. At seventeen, the artist had her first official solo show
on the Vineyard. Years later, when Jones was working as an illustrator, she
drew herself as a serious young girl seated demurely on the ground, wearing
a plaid dress and a large bow in her hair, contentedly painting the seascape
with a sailboat that we see behind her.

Flowers and the ocean weren't the only spurs to Jones's burgeoning
creativity. She and her neighbor, the future writer Dorothy West, became
lifelong friends, and the longest-living members of the Harlem Renaissance,
dying within months of each other in 1998. Jones also found two essential
early mentors on the island.

The remarkably gifted performer, educator, and composer Harry T. Burleigh wrote more than two hundred songs, including many spirituals, among them "Go Down Moses," "Swing Low, Sweet Chariot," and "Sometimes I Feel Like a Motherless Child." He befriended and advised a group of the Vineyard's aspiring young people, and was the first to encourage Jones to do as he did, and go overseas to study.

The talented and resilient sculptor Meta Vaux Warwick Fuller concurred. She was an even more significant figure for young Jones. Destined to become a key member of the Harlem Renaissance, Fuller, born in Philadelphia, won a scholarship to attend the Pennsylvania Museum and School for the Industrial Arts, which is now the Philadelphia College of Art. In return, she was required to make a work of art for the school's collection. The result was her triumphant *Procession of the Arts and Crafts*, a bas-relief featuring thirty-seven figures. Her senior exhibition included a metal sculpture, *Crucifixion of Christ in Anguish*, which, as art historian Lisa Farrington writes, "struck viewers as especially morbid in its gruesome details, to which the artist responded, 'If the Savior did not suffer, wherein lay the sacrifice?'"

Fuller traveled to Europe to continue her sculptural studies, landing in Paris, the home of a family friend, the African American expatriate painter Henry Ossawa Tanner. A student of Thomas Eakins, Tanner was the first African American artist to achieve fame in the United States and Europe; his portrait of a man and a young boy, *The Banjo Player*, is one of his best-known works. Fuller was fortunate in having Tanner as a guardian angel in the city. When she arrived at the American Girls' Club, where she had reserved a room, she was refused entry: no women of color were allowed. The staff had assumed that they were corresponding with a white woman. Fuller nonetheless made her way into the city's art world. When she met the master sculptor Auguste Rodin and showed him her work, he said, "My child, you are a sculptor—you have a sense of form!" Unconcerned with her skin color, Rodin became her mentor.

Back in the States, Fuller became the first African American woman to be commissioned by the federal government to create a public sculpture. A set of figures celebrating "the achievements of African Americans since their arrival in Jamestown in 1619," it was displayed at the Jamestown

Tercentennial Exposition in Virginia. Fuller married, moved to Massachusetts, and continued to create politically sensitive art, fulfilling a commission from W.E.B. Du Bois to honor the fiftieth anniversary of the Emancipation Proclamation. Two very different sculptures of black women embody Fuller's groundbreaking vision and impact. *Mary Turner (A Silent Protest against Mob Violence)* of 1919 is a haunting condemnation of the horrifically brutal murder in Georgia of a pregnant black woman who had protested the lynching of her husband. *Ethiopia Awakening* (1914) portrays a graceful Egyptian woman emerging from the tight wrappings of a mummy. Fuller explained that the figure is "awakening, gradually unwinding the bandages of [the] past and looking out on life again, expectant, but unafraid."

Loïs Mailou Jones. The Ascent of Ethiopia. *1932.*
Oil on canvas. 23 1/2 × 17 1/4 inches.

Buoyed by Fuller's friendship and galvanized by *Ethiopia Awakening*, Jones created her first Africa-themed painting, *The Ascent of Ethiopia* (1932). A study in blues spiked with gold, it is anchored to a portrait of a powerful and attractive dark-skinned woman shown in profile and wearing an intricately patterned headdress from which, at the center of her forehead, a serpent arcs. In the background, two small pyramids stand on a smooth, bright, dune-like mountain, on top of which balance two skyscrapers, one an inverted pyramid. Beside it and beneath the letters MU, for *music*, a man plays a grand piano while another stands and sings. Behind them is a glowing yellow full harvest moon, and in the concentric celestial bands surrounding it we see the masks of comedy and tragedy, an artist's palette and brushes, and a man at an easel painting a figure standing on a pedestal. Beneath the capital letters DRA, for *drama*, two figures perform a scene. Black figures also climb a long staircase beneath a beaming sun with a dark star at its center, their ascent symbolic of the liberating power of art.

This is a keystone work for Jones, presaging her later explorations of African cultural motifs and reflecting both her fluent sense of design and her attunement to the zeitgeist. The Harlem Renaissance and its celebration of black culture was in full swing, and Jones spent a lot of time in New York in the thick of it, deeply moved, in particular, by Aaron Douglas's Africa-influenced murals at the 135th Street public library, which is now the Schomburg Center for Research in Black Culture. Jones may also have been intrigued by the art deco movement and its embrace of not only sleek new technology but also the art of Egypt, which had become all the rage after the 1922 discovery of King Tutankhamen's tomb. This stylized and stylish painting was the young artist's declaration of devotion to her calling and her allegiance to, pride in, and excitement about her African American heritage.

Thanks to her artistic precocity and her supportive parents, Jones attended Boston's High School of Practical Arts. An outstanding student, she formed a close, lasting bond with guidance counselor Laura F. Wentworth, who followed her career closely, always worrying that Jones would imperil her health by working too hard. In the meantime, Jones won a scholarship to attend vocational drawing classes at the Museum of Fine Arts. After her regular school day ended at two o'clock, she would "take the long walk" to the museum and draw until four thirty, maintaining this

demanding schedule for four years. At the same time, she managed to become an apprentice to Grace Ripley, a costume and stage designer and professor at the Rhode Island School of Design. In her Boston studio, Ripley was busy creating costumes for the Ted Shawn School of Dance. Shawn was a trailblazer, elevating American modern dance to the status of a true art form by celebrating dance as a universal and sacred art form and drawing on diverse cultures in his revolutionary choreography. Jones worked at Ripley's studio on Saturdays and in the evenings. The designer would hand her a quick sketch to work from, and Jones would complete the design and make the costumes, including those involving batik and tie-dyeing. Jones also made papier-mâché masks based on African art. African masks would become enormously significant to her mature work and worldview.

What did Jones do when she wasn't in art class, the studio, or the museum? She attended Sunday school and church, and volunteered for community activities, thus setting the course for her life as a humanitarian as well as an artist. In an interview with Kathleen Ayers of the United States Information Service (USIS) in 1955, Jones explains that her mother and teachers emphasized and encouraged her "artistic bent" when she was a child, "but for some time I thought I wanted to be a social worker so I could do something for people. When I was 12 I used to visit a Boston community center to tell stories to the younger children." While in college, drawing on her burgeoning love for dance and drama, Jones founded the Pierrette Club for Girls under the auspices of the League of Women for Community Service in Boston. "Pierrette" is the female version of Pierrot, the central character in commedia dell'arte, and Jones's large (thirty members) and ambitious theater club met weekly and produced plays. She was president and her mother was club mother, in addition to being "her most intimate and steadfast personal supporter," offering "constant affirmation and praise." She ran the club for ten years, and said that she loved "working with those girls." This impulse to help others also kept Jones teaching for forty-seven years, and motivated her remarkable outreach work as an art ambassador, especially in Africa, as well as her work organizing and overseeing student trips abroad. Her interest in others and her compassion infused her paintings.

Ayers notes that Jones's paintings were tagged as "happy art"; "For joie de vivre, a warm friendliness and instinctive belief in the goodness of people and

the world are salient characteristics of this talented Negro artist." In spite of this now jarring racial designation in a piece written a decade before the civil rights movement, Ayers's is a respectful and laudatory article, one that Jones carefully saved. In 1968 she told *Ebony* magazine that she was still comfortable with the "happy art" description. "Even though I sometimes portray scenes of poor and struggling people," she says, "it is a great joy to paint."

Irrepressible and energetic Jones loved to swim and play tennis, even participating in tournaments, in addition to playing basketball and serving as team captain. As she observed, "All of these activities made my life so full and helped me to be a very healthy person." These extracurricular activities also helped Jones win a coveted scholarship to attend the School of the Museum of Fine Arts, Boston, as one of only two African American students. Practicality ruled when she decided to major in design, and she graduated in 1927 with honors. In addition to her coursework, Jones spent long hours in the museum, where she particularly loved studying the textile and ceramic collections. She also simultaneously attended evening classes at the Boston Normal Art School (now the Massachusetts College of Art), where she earned a teaching certificate. Yet another scholarship enabled her to attend graduate school at the Design Art School of Boston, from which she received a diploma in 1928. Fully certified, Jones began working as a freelance textile designer for the F. A. Foster Company in Boston and New York's Schumacher Company, creating fresh and intricate patterns for cretonne, a strong cotton or linen cloth with a dull finish that is used in curtains and upholstery.

Loïs Mailou Jones. Design for Cretonne #13. *ca. 1932. Tempera on paper. 27 x 21 inches.*

Jones's lushly patterned textile designs from the late 1920s and early 1930s, rendered in watercolor and tempera with pizzazz, are ravishing. The details are entrancing and exuberantly inventive in their intricate forms, fresh themes, and skilled color dynamics. Some designs are botanical (palm trees, birds of paradise, leaves), some jazzily abstract. She achieves a Navajo look and Caribbean and African auras. In analyzing Jones's textile creations, curator Lowery Stokes Sims writes, "references to a multiplicity of cultural and media phenomena seemed to flow effortlessly and copiously from the well of Jones's creative impulses." Jones's superb design sense is detectable in all her paintings, no matter their subject or style.

But as gorgeous as her textile designs were, and as successful as this young designer became, there were serious drawbacks to this endeavor, beginning with racial prejudice. Cautious about revealing herself to white art directors, Jones had a white friend take her designs along as part of her portfolio. Jones's work sold, while her friend's did not. Once her designs were in production, Jones decided to visit one of her best customers in New York and introduce herself. When she arrived, she saw that one of her motifs, titled *Ganges*, had been used to upholster an entire set of showroom furniture.

Jones, a master at understatement, was in for another jolt on a trip to Martha's Vineyard: "During the drive to the island, I saw my designs draped in the show windows of interior decorator shops. What a good feeling it was to know that I had designed them! But only the name of the design, printed on the borders of the fabric, was known, never the name of the artist who created it. That bothered me because I was doing all this work but not getting any recognition. And I realized I would have to think seriously about changing my profession if I were to be known by name." Jones was quite clear about this. She later reiterated, "As I wanted my name to go down in history, I realized that I would have to be a painter. And so it was that I turned immediately to painting."

The frustrations continued. Seeking employment in keeping with her decision to change her focus from applied to fine art, Jones went to see the director of the Boston Museum School, where she had excelled, hoping for a position there, as had been offered to other outstanding students. But instead of a job offer, she received this bit of barbed advice: "He very kindly looked at me and said, 'Loïs, we don't have any opportunities here, but have

you ever thought about going South to help your people?' That was a shock to me, because here I was a young Boston lady exposed to Radcliffe and Simmons and Harvard and Tufts and all of the big schools . . . to be told to go South was something I really didn't anticipate." Again, her scorching, matter-of-fact irony.

But Jones was a quick study and a resolute individual with a gift for turning adversity into opportunity. Soon after this appalling exchange, she went to a party at a friend's place and met a professor from Howard University, the preeminent, historically African American institution founded in Washington, D.C., shortly after the Civil War. Bostonian Jones knew little if anything about Howard, but the professor impressed her, and with his encouragement, she decided to apply for a teaching position there. She was told that she would be considered, but they hired one of their own, the newly graduated James A. Porter, who went on to have a distinguished and influential career there. Jones would have to wait. But she never stayed still. As part of her pursuit of continual education, she attended Sunday lectures by black scholars at a Boston community center. One week, she listened closely when educator Catherine Hawkins Brown, then director of the Palmer Memorial Institute, a black elite prep school and junior college in Sedalia, North Carolina, told the audience, "We *need* you young people in the South."

Jones marched up to Brown and asked if the school had an art department. It did not. Jones told Brown that she would like to come down and build one. "She thought I was too young and would not be able to do it." Jones prevailed. People would be wise not to underestimate this pretty, sweet-voiced, petite yet mighty woman. In Brown, however, she had a formidable opponent.

Brown wrote to Jones on July 23, 1928, "You understand that you will have to do pioneer work here. We have nothing but a blank room, but will fix it up on your suggestion." Brown made many demands, beginning with her reaction to the "snappy little sports-car" Jones bought herself for the solo journey from Boston to Sedalia. "She warned me that my car was going to be kept in the garage and that I was only to leave the campus when she gave me permission. You can imagine how my feathers fell because I was thinking of North Carolina A & T College in Greensboro and how nice it was going to be to drive up for the football games."

Then Brown made sure Jones had no free time whatsoever. "On learning that I was quite athletic, and had played on the basketball team in Boston, Charlotte Hawkins Brown made me coach of the basketball team at Palmer. Then she learned that I could play the piano, so on Sundays she had me playing the piano for the Sunday school, and she also had me teaching folk dancing. She had not only brought me there to build an art department: she had made me into the jack-of-all-trades. It was a challenge, but it was fascinating."

As frenetically busy as Jones was, she did make time to paint a series of inquisitive watercolors depicting the campus and the area around the school and portraying students and others who caught her eye. Her naturalistic Sedalia drawings and watercolors are freely worked in vital, lustrous colors, rich in contrast and vigorous in composition. Jones readily made the switch from fabric design to art. A photograph shows the young, lithe teacher lounging on the steps of a wooden building with a flapper-style headband around her cropped hair, a long, patterned coat or robe over a white dress, white stockings, white ankle socks, and lightweight, laced athletic shoes. She is relaxed, gently smiling, bemused yet spring-loaded.

Here is her account, related decades later, of how she parlayed her success at Palmer into the position she truly desired. Note her unabashed and indisputably deserved self-praise and her daring, though coyly underplayed, strategy (emphasis added): "I built up an excellent art department. One of the things I did was to invite James Vernon Herring (the founder of the Department of Art at Howard University) to come down to give an art lecture to my students. *It so happened*, just as he arrived, I put up a very excellent exhibition of the students' work."

Jones's inspired invitation to Herring set the course for close to five decades. She reports that Herring told her, "We need you at Howard, and I want you there in September." Jones had a two-year contract with Palmer, but somehow Herring convinced Brown to release Jones, who was immensely relieved to leave behind the brutal racism of the South, and perhaps the ire and histrionics of Brown herself. A two-page typed letter from Brown to Jones reveals the friction between the two women. Brown writes, "I am free to admit that I have not been able to fathom fully the difficulties involved, and have failed utterly to hide my annoyance; things

that I might have ignored, I have been sensitive toward." She eventually offers anemic "belated thanks" to her hardworking art teacher, coach, and so much more, though she also bossily reminds Jones that the highest attainment for everyone involved with the school is to realize their mission "to elevate the masses, thereby increasing their racial self-respect." Jones left little trace of whatever pain and anger she may have felt over Brown's imperial treatment; she was clearly grateful to have escaped as soon as she did, and to have found a position at such a prominent and exciting institution. Howard University was a haven, a nurturing community of innovative scholars and artists. Jones soon realized, though, that while Washington, D.C., was a step up from the Deep South, it still lagged behind Boston as far as race relations. Nonetheless, she would make Washington her primary home and headquarters for the rest of her life, no matter how much time she enjoyed in other lands.

The groundbreaking Harmon Foundation was founded in 1922 by white real estate magnate William E. Harmon to honor and support African American achievement in the arts, humanities, and sciences, and it mounted the first national competition for black artists. By the time Jones participated, more than four hundred entries had been displayed. The artists were interested in creating "sympathetic and dignified" depictions of African American life, according to Howard University art history professor

Loïs Mailou Jones. Negro Youth. *1929.*
Charcoal on paper. 29 x 22 inches.

Tritobia Hayes Benjamin, a colleague and friend of Jones who became her biographer; "Jones and others employed the portrait as a means of conveying profound respect for their race." Jones won an honorable mention in the 1930 Harmon Foundation Exhibition for her Sedalia charcoal drawing *Negro Youth* (1929); *The Ascent of Ethiopia* (1932) appeared in the 1933 show.

In a letter dated February 11, 1937, Valerie E. Chase, the principal of Washington, D.C.'s Terrell Junior High School, wrote,

> My dear Miss Jones:
> Our gratitude to you is boundless. Your presentation of the art achievements made by persons of our race and heritage lent an atmosphere of culture and refinement in true simplicity of style. Even your dress and voice, if such personal reference is condoned and pardoned, blended with the idea of simple beauty which your talk suggested.
> Our artistic appreciation has been increased greatly. The students are inspired and hopeful of their own small efforts.

Jones, impeccably and stylishly appointed, gave her all in her outreach to students and other artists, and always impressed everyone she met. She continued to evolve as a teacher at Howard, where she taught design and watercolor. Her credo was "Talent is the basis for your career as an artist—but hard work determines your success." She also told her classes, "You must love your art as though you were married to it"—an intriguing bit of wisdom from a lovely, vivacious, and serious woman who remained single until she was forty-seven. Benjamin observes that when it came to her students, "Jones was zealous in her efforts to provide practical experience." She invited professionals to visit her classes to lecture or demonstrate techniques, and she arranged for her students to attend design clinics and workshops at various state-of-the-art companies. She also continued her own education, taking summer courses at Columbia University, a choice that proved momentous for both professional and personal reasons. Then Jones launched her career as an illustrator.

Her Howard colleague Dr. Carter Godwin Woodson, the son of former slaves and the second African American to earn a Ph.D. at Harvard,

founded the *Journal of Negro History* in 1916; in 1921 he founded an organization, the Associated Publishers, to bring out periodicals and books about African Americans, a subject utterly neglected by mainstream presses; and he founded the *Negro History Bulletin* in 1930. Woodson eventually became known as the "Father of Black History" and of Black History Month. Jones, whose passion for drawing never waned, took up illustration under Woodson's direction in 1936. She created the drawings for *The Picture Poetry Book* by Gertrude Parthenia McBrown, an actress turned writer and editor, with whom Jones also coproduced four plays. Jones's illustrations are all vigorously detailed and animated, but she worked with particular intensity on *African Heroes and Heroines* (1939), conducting the research and creating the thirty drawings for the book while in Paris, where one would think she had more than enough to handle.

Woodson also helped establish the Association for the Study of Negro Life and History, for which educator Mary McLeod Bethune served as president. The only one among seventeen children born to former slaves to get an education, Bethune devoted herself to helping others. She founded a school for African Americans in Florida, which became Bethune-Cookman University. She was an adviser to President Franklin Roosevelt and Eleanor Roosevelt, and she founded the National Council of Negro Women, for which Jones served as an officer, associate editor of the organization's journal, and graphic designer, winning the organization's award in 1946.

Historian Arthur Schomburg also worked on groundbreaking black history publishing projects with Woodson and Jones, becoming a friend of the artist's. Born in Puerto Rico, Schomburg filled many roles once he arrived in New York, from law clerk to journalist to library curator to activist. He is best remembered for his landmark collection of artworks, manuscripts, rare books, and many other artifacts related to black culture and history, a foundational archive acquired by the New York Public Library by way of the Carnegie Corporation. The now more than five million items are housed in the Schomburg Center for Research in Black Culture. Schomburg, Chris Chapman writes, even "gave Loïs advice on the preservation of her legacy as she began her career."

Jones made the dream of studying abroad that was instilled in her by her Martha's Vineyard guiding lights Harry Burleigh and Meta Vaux

Warwick Fuller come true. After teaching at Howard for seven years, Jones was able to take her first sabbatical, and in her typical high-achiever mode, she won a fellowship to study in Paris at the Académie Julian, alma mater to John Singer Sargent, Childe Hassam, Henri Matisse, and Henry Ossawa Tanner. Off to France Jones went in high style and high spirits, booking passage in September 1937 on the nearly new SS *Normandie*. Schomburg and Woodson saw her off with flowers and a fruit basket. Jones later described "the wonderful feeling that I had the minute I got on the boat: it was 'French soil.' I was treated so beautifully. The courtesies that were afforded to me and the whole atmosphere was conducive to an absolute freedom. How good it was to be 'shackle-free.'"

Jones immediately began making shipboard sketches and watercolors, portraying her fellow passengers and the crew. She had had a year of French, but her fluency was tentative. Fortunately, upon her arrival in Paris after the luxurious seven-day voyage, she stayed with the distinguished family of a Howard colleague, then lucked into a dream studio near the Jardin du Luxembourg. It was in the penthouse of a sleek, modern building, and boasted a skylight, a balcony facing the Eiffel Tower, two-story-high wall space perfect for hanging paintings, and a rooftop garden—her second rooftop "playground." Jones said, "It was something that was just

Loïs Mailou Jones, in her Paris studio. 1938.

unbelievable, a Negro girl being offered this beautiful studio." Feeling liberated in every way, Jones was phenomenally productive in this ideal setting.

Jones had looked forward to meeting Tanner, hoping that he would offer her guidance, as he did for Fuller. Sadly, the painter died a few months before her arrival. "But," she related, "the spirit in me and the feeling of how he was accepted . . . gave me the strength and the courage to work very, very hard. Believe me, I worked from morning to night while I was there that first year in France." This was a life-changing juncture, and Jones intended to get the most out of it.

She ended up meeting another expat artist, Albert Alexander Smith, the first African American to study at the National Academy of Design. Though he received a Harmon Foundation Award, Smith's etchings and paintings of musicians and racial injustice were not well received in the United States. In Paris, he was able to both work as a jazz musician and exhibit his art. He and his wife were very warm to Jones; later he wrote to her, "Now, my dear Loïs, keep the pot a-boiling, we will hit the bull's-eye one of these days. Best of luck to you Loïs and always feel that I am as ever your silent partner along this unusual road we have both chosen."

The Académie Julian, where students studied with a different professor each month, was divided into men's and women's divisions, and an instructor Jones particularly wanted to study with was in the men's division. Chapman notes, "It was ironic that in Paris Loïs enjoyed freedom without prejudice from the color of her skin yet encountered prejudice as a woman artist in an art school." But the academy redeemed its gender restrictions by assigning the American a French interpreter and guide, fellow student Céline Tabary, whom Jones described as "a very fine artist, who turned out to be really like a sister to me." The two women bonded quickly. On their school holiday, Tabary, the daughter of an architect, brought Jones home to stay with her family, who, in Jones's words, "practically adopted" her. The Tabarys lived in the north of France, in the village of Houdain in the Pas-de-Calais, a region Jones came to love and paint with great fervor. When they returned to Paris, Tabary moved into the studio with Jones. "Céline and I were very, very serious about our careers to the extent that we painted from morning to night," Jones recalled. Inseparable, they painted outdoors together, which

is how they met the painter and cofounder of the French Symbolist school, Émile Bernard, an associate of Vincent van Gogh, Paul Gauguin, and Paul Cézanne.

Jones and Tabary were painting by the Seine when Bernard approached Jones and began to praise her painting. Jones called Tabary over to translate. Impressed with the talent and gumption of the two women, who hauled their large canvases and heavy boxes of paints and brushes across the city each day, he invited them to store their canvases and paints overnight at his nearby studio. They were astonished that evening to find themselves in what Jones described as a "magnificent" studio, "with paintings on the walls, a huge fireplace, and antique furniture. He showed us his hundreds of Japanese prints and told us that the studio had previously belonged to the English painter, J.M.W. Turner." Bernard set out three paintings and asked them who they thought the artist was, and they both answered, "Gauguin!" Jones remembered, "He was furious, because they were his; he said that Gauguin had stolen his style and gone to Tahiti and gotten famous."

Bernard took a great liking to Jones and Tabary, and invited them to his salon, where they met other artists, musicians, and poets. He and Jones talked at length about aesthetics and painting styles and techniques, and Jones treasured a long letter he sent to her in January 1939 once she was back in the States. Bernard wrote,

> You are a remarkably gifted artist and I hope that you will have the power to fully mature and achieve your own style without letting yourself be influenced by fashion. That would be a terrible tragedy for you and I would deplore it heartily. The little that I saw of you inspires great faith in me and I am certain that if you discover your milieu you will succeed and will enjoy great success . . . I have but one bit of advice to give you: Continue always in your own path, that is the only way to perfect one's work.

Along with fond wishes to see her again soon, Bernard penned this report: "Presently we have nothing very artistic happening in Paris. Since everyone has started painting there are lots of people who claim to be artists, but there is not a single painter among them. We really need to pass

a law to keep so many idiots and ignoramuses from dirtying canvasses with their graffiti. Happily, the Louvre Museum and nature are still here to console us in the face of so much ugliness."

Bad art would be the least of anyone's worries once the Nazis, who condemned the work of modern masters as "degenerate," invaded France. The war made it impossible for Jones to return to Paris to see Bernard again; the artist died during the Nazi occupation on April 19, 1941.

Most of Jones's Paris works were impressionistic in style and technique. She used a palette knife to create lushly textured still lifes and portraits, and worked outdoors on cityscapes as often as possible, finding "Paris so mystic, so beautifully silvery-gray." What distinguishes her first Paris scenes (she would paint many more over the years) is her acute sensitivity to light and dark and to the clash and harmony of colors, from the sun-kissed or shadowed stone of the buildings to the brilliance of flowers and produce. Even more thrilling is her ability to capture the complexity of overlaying patterns, the intense simultaneity of city life. Buildings press against each other, jutting and angling; windows reveal interiors or reflect the outside scene. In *Rue St Michel, Paris* (1938), the street is hushed and empty in the early morning. On the sidewalk, a café owner sets out chairs near an enticing display of reds, greens, and whites indicating open bins of fruits, vegetables, and blossoms. *Déjuener, Place du Tertre, Montmartre* (1937) is bursting with energy as a group of men in white shirts cluster around a small table beneath a red umbrella in a crowded sidewalk café. Around them, the little plaza is abloom with other fringed umbrellas as people enjoy lunch, overseen by slender trees, potted plants, and storefronts golden with sun. Everything is vibrating and touching and humming. Edge-to-edge, this electric painting is as lively as one of Jones's vivid textile designs, but here she captures fully dimensional life.

Bernard's influence can be discerned in *Marché aux Puces, Rue Médard, Paris* (1938), a painting of Paris's famous flea market done in a style that anticipates Jones's future works. Here the brushstrokes are more contained, the colors more solid, the use of line firmer as Jones depicts a market scene in which women dressed in dark tops and skirts and aprons examine a bolt of white cloth beside a table displaying dishes and a picture frame. A large white umbrella with red fringe offers a bit of shade;

Loïs Mailou Jones. Marché aux Puces, Rue Madrid. *1938.*
Gouache on board. 15 x 18 inches.

buildings stand protectively in the background; a man holds a red mesh bag
behind his back. Market scenes would prove to be one of Jones's favorite
subjects.

While researching her illustrations for the book *African Heroes and
Heroines*, Jones immersed herself in the African collections at the Musée d'
Homme. Paris galleries were also exhibiting African art, which comprised
another great wave of multicultural influence, following the clamor for
Japanese prints. Fascinated by masks since her apprenticeship to costume
designer Grace Ripley, Jones made sketches of the masks and sculptural
figures she saw on display in Paris, and then painted *Les Fétiches* (1938),
one of her most striking and most frequently reproduced works. A bold and
dynamic modernist composition in earth tones punctuated by red, white,
and green, it depicts five masks, including a Kifwebe mask of the Songye
people in Central Africa, and, in the center, a large mask that resembles the
Kpelie, or Guru Dan, ancestor mask of the Senufo people in Ivory Coast,

Loïs Mailou Jones. Les Fétiches. *1938. Oil on canvas. 25 1/2 × 21 1/4 inches.*

along with a charm, or fetish, and a small ritualistic statue. Squiggled and jagged lines accentuate the crown of the Guru Dan mask, referencing a traditional striated hair arrangement, while also indicating the energy radiating from this sacred object. The masks, figure, and charm are all floating in dark space as though taking part in an otherworldly dance animated by a mystical force. Chapman writes, "A keynote work of her career, *Les Fétiches* is a poetic synthesis of the spirit and meaning of Jones's ancestry." Jones's professors at the Académie Julian were baffled by this departure from the street scenes and still lifes Jones had been painting. The artist bluntly informed them that "if white painters such as Picasso, Matisse, and Modigliani could use African art, then she certainly had the right because it was her heritage."

Inspired as Jones was by the Harlem Renaissance, she was also buoyed by the French equivalent, a parallel movement known as Négritude, in which artists, as art historian Lisa E. Farrington elucidates, "proclaimed the existence of a 'mythic' African soul that was sensitive, sensual, and spiritual." These artists and thinkers also protested "the global oppression of African people," a stance Jones would increasingly embrace.

Did Jones partake of Paris's scintillating nightlife? She did attend the legendary cabaret music hall Folies Bergère, where the talented, athletic, sexy, and exuberant expat performer Josephine Baker danced in her shocking little banana skirt. Jones and Baker became friends. In her *Good Morning*

America appearance, Jones recounts, "I was rather young, and, may I dare say, attractive, in those days. I went to a French restaurant and the garçon kept looking at me, and finally he came over and said, 'Pardon, mademoiselle, je suis Josephine Baker?' I said, no, but I know her."

Given all that she accomplished during her first Paris stay, Jones couldn't have done much carousing. Everything seems to indicate that she kept to the straight and narrow, wholly focused on her work. Certainly she was no bohemian. That sort of rebelliousness and abandon, risk-seeking and hedonism, were far too dangerous and damning for a woman of color. Indeed, even white women artists had far more to lose in terms of respect and reputation by flaunting convention than male artists. As an African American woman artist, Jones had to be above reproach in every way. She had to be impeccable and immaculate, professional and proper, steely in her resolve. But then again, Jones was both fun-loving and exceedingly circumspect. So who now knows exactly how she spent those enticing Paris nights?

In no hurry to return home, Jones requested and received an extension of her fellowship. She and Tabary traveled throughout Italy. After her return to the States, she spoke with the *Vineyard Gazette* about her experiences there. The Italians "simply must know all about you," she said. "When I walked down the streets to paint I had a crowd of people following step for step. They can't understand the American Negro at all, and they wouldn't believe I wasn't Ethiopian. But they had to know what I was doing in Italy and why I wore such modern clothes." In France, Jones reported, "I was asked a lot of questions, too. They all thought I was from India."

In each place she visited, she painted, extending her command of color and form, her fluency in Impressionism and Postimpressionism, her skill with watercolors and oils. Reluctant to give up this precious creative and personal freedom, she asked for another year abroad, but Howard University said no. Upon her arrival back in the States, the *Vineyard Gazette* wasn't the only publication to cover her homecoming. After all, in 1939 transatlantic voyages were still considered glamorous, and the press eagerly covered the arrival of the most impressive ocean liners. Jones saved her clippings. Two lack all source information, but one or both may have been (let us hope)

from the magazine published by her sorority, Alpha Kappa Alpha (AKA), given the (hopefully) teasing tone:

> Howard U. Art Instructor Back After Study in Paris
>
> A little brown woman who looked and acted very continental returned to America last Tuesday on the *Ile De France* from Paris. She was Miss Loïs M. Jones, instructor of art at Howard University, who was returning to her duties there after a year abroad where she won the plaudits of European art critics and teachers.

Another clipping from February 1939 reads,

> The artist is a Boston girl. She possesses the rare combination of innate ability, an intense love for her work, and the soul of an artist and exceptional training.
>
> She has been the recipient of many honors here and abroad, and is still the sweet brown girl that we always knew and could be mistaken for the artist's model instead of the artist that she is.

Expat artist and jazz musician Albert Smith worried that Jones would experience the same indifference and outright rejection he experienced on home ground, but at first it seemed that Jones would avoid that fate when,

Little Paris Group in Lois Jones's studio. 1948. Unidentified photographer.

just a few months after resuming her American life, she had a solo exhibition of her Paris works in Boston's Robert G. Vose Gallery. But then she ran into the great wall of discrimination.

Tabary came to visit Jones in December 1938, and then became stranded in Washington, D.C., as World War II broke out in Europe. She ended up staying for seven years. To help her friend support herself, Jones created the Saturday Morning Art Class for young people, which she held in her apartment and team-taught with Tabary, though her commitment to community giving kept her from collecting tuition from many of their students. Jones then paved the way for Tabary to secure a teaching position at Howard University. The dynamic duo also hosted weekly meetings of what they called the Little Paris Studio, a salon meant to help the city's public-school-system art teachers develop their skills by critiquing each other's work. The group held annual exhibits, which were a real boon for artists who lacked access to mainstream galleries due to racial discrimination. Jones was motivated by her belief that it was essential for art teachers to do their own work in order to stay artistically vital and committed.

The Corcoran Gallery of Art, a public institution in the nation's capital, did not accept submissions to its annual juried exhibition from African American artists. So Jones, covert rebel, had her white friend, trusty Tabary, bring her painting in. Sure enough, *Indian Shops, Gay Head, Massachusetts* (1940) was not only accepted but also won the Society of Washington Artists' prestigious Robert Woods Bliss Prize for Landscape. To maintain her camouflage, Jones asked the gallery to mail her the award. "Unbeknownst to the gallery officials," Benjamin writes, "Jones broke the color barrier." Jones revealed the truth two years later, but it took fifty more years for the artist to receive a public apology.

Jones kept painting with the adroitness and vigor she displayed in Paris. She created a series of portraits, including an affectionate watercolor of Tabary in a lavender coat and a jaunty beribboned and veiled hat, no doubt one of Loïs's mother's creations. Jones paid further tribute to her mother's creativity in the lush and lovely oil painting *My Mother's Hats* (1943), a joyfully chromatic still life depicting several hats and a bursting floral arrangement on a table beside a curtained window through which the

sun filters and glitters. Similar opulent beauty is found in portraits of two other women Jones much admired.

The subject of *Madame Lillian Evanti as Rosina in "The Barber of Seville"* (1940) is among the many individuals in Jones's life whose name, like her own, may be preceded by the designation "first African American." Evanti, a 1917 graduate of Howard University, is known as the first professional black lyric soprano. Unable to break through racial barriers in America, Evanti joined European opera companies and performed to acclaim in both Europe and the United States. She also cofounded the National Negro Opera Company. Jones met Evanti, who had just returned from abroad, on Martha's Vineyard the summer after Jones's year in Paris, and the two felt an immediate rapport. Evanti, who was fluent in seven languages, culturally sophisticated, and well connected to the Washington elite, regularly threw exciting dinner parties that reminded Jones of Bernard's Paris gatherings. Jones decided that she wanted to paint Evanti in full regalia, dressed for her role in Rossini's opera. You can hear the artist's delight in her description of Evanti's attire: "It was a beautiful costume. The mantilla was of gorgeous lace, and the bodice, the little bolero jacket, was a brilliant crimson." The life-size painting, on which Jones worked for long hours each day for three weeks, using a palette knife, is an aria of golds and reds. Jones's dazzling portrait is on par with similarly sumptuous works depicting elegantly appointed women painted by Mary Cassatt, Matisse, Edouard Manet, Berthe Morisot, and Sargent. Evanti glows not only due to Jones's gift for color but also because of a marvelous convergence: *The Barber of Seville* came on the radio while Jones was painting, prompting the diva to sing. This painting was one of Jones's personal favorites.

Among others Jones knew well who achieved firsts was the African American Arctic explorer Matthew Henson, who voyaged in search of the North Pole with Robert E. Peary. Henson could speak Inuit and was an adept hunter and dog-sled driver. He broke the trail for Peary and ultimately calculated that he was the first to reach the highest point north on April 6, 1909, though Peary received all the credit and fame. Henson wrote about his Arctic adventures in *A Negro Explorer at the North Pole* (1912). He ended up working as a clerk in a federal customs house in New York for three decades, summering on Martha Vineyard's at Jones's mother's place.

Loïs Mailou Jones. Self Portrait. *1940.*
Casein on board. 17 1/2 × 14 1/2 inches.

Jones kept a photograph in which Henson stands tall in the sunshine, his straw hat in his hand, next to Jones in a flowery blouse and white slacks, while behind them a large pine tree and a leafy shrub mirror their stance. In 1974 a Washington businesswomen's association commissioned Jones to create a painting of Henson planting the American flag at the North Pole.

Sports lover Jones was also good friends with athlete Althea Gibson, the first African American tennis player to compete in the U.S. National Championships and at Wimbledon. Gibson won over fifty championships, and eleven major professional international titles, becoming the first African American to be designated Female Athlete of the Year by the Associated Press. She then became a professional golfer and the first African American member of the Ladies Professional Golf Association.

In 1940, the same year she painted her gracious portraits of Tabary and Evanti, Jones painted the poised and thoughtful *Self-Portrait*, which can be interpreted as a study in conscience. The artist stands at her easel, an unbuttoned blue smock revealing a red blouse and a shield-shaped pendant. Her dark hair is cut short and curled away from her face; a gold hoop gleams in her ear; her lips are pressed together, her eyes serious. She is in her studio, but its rendering makes it appear strangely ambiguous. It has a curious backstage aura, even a churchlike atmosphere. Behind her are two small, dark, slender figures that resemble carved wooden African

sculptures. They could also be two young Africans standing in the doorway, looking in. The painting seems to suggest that the artist is acknowledging responsibility to a larger community, to her ancestors, perhaps, and to future generations. One senses that she would prefer to paint more personally and freely, but that pressing human concerns command her attention and generosity of spirit.

Upon her return to Howard University after her transformative year in France, Jones met Dr. Alain Locke, chair of the philosophy department, the first African American Rhodes scholar, and a catalyst for the Harlem Renaissance. Locke believed that by claiming their African heritage, American blacks would reaffirm their self-respect and independence. Locke's inquiry into black consciousness led him to write about African American art, and to call for African Americans to create "a vigorous and intimate documentation of Negro life itself." He told Jones that he admired the work she had done in Paris, but, in her words, "he insisted that black artists have to do more with the black experience and, especially, with their heritage." Jones soon painted *Jennie* (1943), a portrait of a young black woman in a yellow blouse with a bow and an apron, at work cleaning fish in a well-appointed kitchen. The model was one of Jones's Saturday Morning students, and Jones's biographer, Tritobia Hayes Benjamin, tells the story of how, fifty years later, Jennie, whose married name, aptly enough, was Fisher, saw the painting in an exhibit at the Corcoran and recognized herself with great excitement. She made an appointment with Benjamin and asked, "Can I have my painting?" Benjamin gave her a reproduction.

In what Jones referred to as her "Locke Period," she also painted *Mob Victim (Meditation)* (1944), her most dramatic portrait. A handsome brown-skinned man with gray hair and a gray beard wearing a white shirt, yellow suspenders, and dark pants stands beside a tree, beneath a dark sky and moon-bright clouds, with rolling green hills and a white, cross-topped church in the distance. His hands are tied together with rope in front of his waist, and he gazes up, his expression meditative, even serene, possibly prayerful. Jones explained, "I was very much disturbed by the many lynchings that were taking place in the Unites States, and I felt I had to make a statement on canvas about lynching." On the lookout for a suitable model,

she was out walking in Washington on U Street when she saw "this tall, black gentleman. I remember he had two guitars on his back and he was rather a clochard-looking type with a slouched hat and a long black overcoat, a curious looking individual. But under that hat, I caught the expression of his eyes." Jones walked up to speak with him, and even though he didn't seem to understand that she wanted to paint him, she confidently gave him her address. Two days later he arrived at her door. When she started to explain how she wanted him to pose "as a man about to be lynched," he told her, "But daughter, you know I worked in the South, and my master took me and the other workers in the wagon to see one of our brothers lynched." Jones responded, "Well, tell me about it. How did he look?" "Well," the man said, "he just had his hands tied and he fastened his eyes on the heavens."

Jones ended up working with this man many times. She said, "He was one of the best models that I had."

As much as Jones was committed to painting the black experience as Locke encouraged her to do, she never lost her passion for landscapes. "I have to paint what I feel. I mean, I wasn't just limiting my work to black subjects . . . If I see something beautiful in nature, I will paint it. I am a lover of nature. I have to paint from within. It might be a black subject, but whatever I do has to be in the direction of my best statement: 'Excellence.' As I used to tell my students, anything I do must be of a caliber that will live after me. That is really my credo, even now." Jones was in her early eighties when she made this statement.

Jones left no hints about her state of mind during World War II, but surely she and Tabary worried constantly about Tabary's family. Jones returned to France right after combat ceased, and traveled there often during the next two decades, painting in Paris and in the countryside, sharing Tabary's studio on her family's property when she went north. Jones's landscapes became more robust, more animated, more panoramic, with a pleasingly rich depth of field. Her exploration of the contrast between the organic and the human-built generates a vital tension in each composition as she revels in the verdant beauty of trees and the solidity of red-tile roofs. In the 1950s

her landscapes and cityscapes come into ever crisper focus as she uses more sinuous, darker, and defining lines. There is motion in these paintings, certainly in the figures in her street scenes, but also in the massing of clouds, the breathing and stirring of trees, the play of wind and sunlight on water. These are exuberant works by an artist skilled in pinpoint observation and receptive to nature's spell. Jones worked rigorously even as she swooned with pleasure.

The stronger linear, more illustrative elements and the move into more modern facture in both her watercolors and oils, from the fluidly zesty street scene *Florence, Italy* (1953) to the jazzily hard-edged and geometric *Paris Rooftops, Montmarte* (1965), are traceable to a profound change in Jones's orderly life: her marriage to a remarkable graphic artist with the impressive name of Louis Vergniaud Pierre-Noël.

As Jones advanced into her forties, her mother and closest confidante told her, "Loïs, don't let anything interfere with your career . . . But I'm afraid you're getting too many paintings and one day you're going to have all these paintings around you, and you're going to be sitting very lonely in your studio. I think you had better be thinking about getting married." Jones laughed as she told Charles Rowell, a professor of English and founder and editor of *Callaloo*, a journal dedicated to African American literature and art, this story. "It jarred me a bit. I'd always been admired by nice gentlemen and, as a matter of fact, I'd always been very popular. But one of the gentlemen had asked me, 'Can you cook?' That kind of discouraged me." Clearly Jones had very deliberately avoided the trap of mid-twentieth-century domesticity, in which women were expected to put husband, children, and household first. No way would this university professor and ambitious, adventurous, and prolific artist ever put her work second. Not after all the effort she had made to get where she was.

But at this point, her mother's frank projection of a possibly empty future made an impression on Jones. On her next trip to Paris she met Eric Feher, a Hungarian who had become a French citizen, "a well-educated man" who was "very serious as a painter." Feher proposed, and Jones accepted, though not altogether confidently. "At that time the prejudice in Washington was horrible. You couldn't eat at any of the restaurants; you couldn't go to any theaters, or, if you did, you had to sit in the balcony, in

the very back. I related to him the unhappy situation we would have. But he said, immediately, 'Well, I don't care. You'll be my wife and I know all about that, that wouldn't make any difference.' But it worried me very, very much to the extent that I felt the only way we could marry was for me to give up my teaching at Howard University and to come and live in Paris. We were engaged and I returned to the States."

Jones first met the Haitian artist Louis Vergniaud Pierre-Noël in 1934, when they were both taking summer graduate design courses at Columbia University. Jones remembers their first conversation: "He didn't speak much English but he was very much admired by all of us. He was tall, very keen featured, rich brown complexion, and a sort of crew hair cut and he wore very gorgeous white linen suits with a little black string tie and he was really a very handsome fellow. I remember him coming over to my desk looking at my designs and remarking finally that what I was doing was 'very good, very good.' And then he went on to say, 'I am living at The International House here and I have been asking for someone to take me to Harlem and they have been advising me not to go and that the people are very bad and there is much sickness and that I must not go to Harlem. But I see that you have a little car . . .' (because I had a little T-model Ford), and he wondered if I would take him."

Jones, who had cousins living in Harlem, was happy to: "I took him to meet my family and then we got to be very good friends because we had so much in common. We went to the art exhibits and we danced together because he loved to do the tango and he taught the tango to me and we went to the theaters and we studied together. And so we had a wonderful summer. At the end of that summer school, that was in 1934, I went back to my work at Howard University and we corresponded for quite some time and then finally sort of broke off because I discovered that I needed an escort locally here in Washington, D.C., to carry me to the AKA parties and events. [AKA was Jones's sorority, Alpha Kappa Alpha, which strongly supported her art career, sponsoring an exhibition and commissioning her to design a stained glass window commemorating the group's founders.] So I had a very nice gentleman who was head of the Department of Physical Education to be my escort, Professor Arthur Waller. And so I didn't hear any more from Vergniaud Pierre-Noël."

Page forward to 1953 and a scene right out of a romance novel. Her mother was visiting Jones in her Washington, D.C., home. Jones was upstairs, packing for Paris, where she was going to marry Eric Feher, when someone came to the door. Her mother called up to her to say that a man with an accent who seemed like someone from the Haitian embassy, where Jones had good friends, was asking for her.

"And there stood Vergniaud Pierre-Noël. The first thing he said after he embraced me was, 'Have you married yet?' I said, 'No, have you?'" In one version of the story, Jones continues, "And that was it. That year (1953) we were married in France. It was a lovely wedding. We married at Céline's home in Cabris." But in a later interview, she revealed that there was a bit more to this encounter. She told Pierre-Noël not only that she was engaged but that she was about to leave for France to get married. He asked her to "think about it a little bit more." He went to New York to see her off on her voyage, and when she arrived, she told Feher that "she couldn't go through with the marriage, that things had changed."

While Jones's mother worried about her daughter marrying someone they knew nothing about from a place they had no direct knowledge of, Pierre, as Jones called her husband, sought his prominent family's consent to marry a foreigner. Then, as they booked their trip to France, he encountered visa troubles. Fortunately, well-connected Jones had the perfect contact: she and Congressman Adam Clayton Powell Jr. knew each other well from their summers on Martha's Vineyard, where they went horseback riding and swimming together. Powell quickly intervened. The happy couple married twice in France in August 1953, once "civilly" at Tabary's Cabris home, as Jones explains, the other "religiously" at a Methodist church in Grasse.

In another sequence of striking convergences, Jones was invited by Haiti's President Magloire "to be his guest in Haiti and to do a series of paintings depicting the beauty of the landscape and the people." These works were then to be exhibited in Washington, D.C., at the Pan American Union, during President and First Lady Magloire's visit as guests of President Eisenhower. Jones told Haitian officials that she had just married Vergniaud Pierre-Noël, and that this trip would be their honeymoon. "They said, 'That's wonderful. Bring him. We'll give you the suite at the Ibo-Lele Hotel.' And so it was that I went to Haiti." While on this working

honeymoon, the indefatigable Jones also taught at the Centre d'Art in Port-au-Prince.

When the happy couple arrived in Haiti, Jones was delighted to see that Pierre's impressive family home was well staffed with servants and surrounded by flowers and palm trees. She acknowledged in an interview that his family would have preferred that he married a Haitian, but felt that her fame as an artist and, as she said, "my love for painting in Haiti and my great love for the Haitian people . . . made up for it."

There's one more extraordinary facet to this love story. The newlyweds were traveling around Haiti so that Jones could paint various vistas and towns: "I was doing a painting en route to Cape Haitian in a little small village called Carries on the Caribbean, and as I was doing this painting, I had a very unusual feeling as I looked up through the clouds, up to the sky, and out over that indescribable blue of the horizon and the blue of the ocean. It just seemed like the heavens opened up and there was a sort of a glow of something that just came over me. I learned later that it was at that time that my mother had passed. And all of this went into that painting because of that sensitive feeling that I had in portraying the color, a sensation that I will never forget as a truly religious experience while working, while painting."

Was her mother's sudden concern about her daughter's future loneliness a presentiment of her own early death?

During the two decades when Jones and Louis Vergniaud Pierre-Noël were apart—while Jones was painting, teaching, traveling to France, exhibiting her work, and accruing awards—Pierre-Noël, five years her junior, had been working as an acclaimed graphic designer and illustrator for governmental and nonprofit organizations in Haiti and the United States. Pierre-Noël won prizes for his postage stamp designs, including one marking the twentieth birthday of the United Nations. Jones remembered that when they were grad students at Columbia, Pierre was called "the man with the microscopic eye because of those beautiful pen and ink drawings that he did which were handled with such detail." He used his visual acuity to create exceptional entomological drawings for the American Museum of

Natural History, the Columbia University Department of Zoology, the Entomological Society of America, and the Department of Entomology at Harvard University. In Washington, D.C., where they made their permanent home, Pierre-Noël worked as a designer for the Pan American Union and the United Nations World Health Organization, and became assistant professor of graphic art at the Washington Technical Institute. An article in *Ebony* in November 1968 tells us that "marriage to Pierre-Noël brought personal happiness to Loïs Jones—she discovered that a 'career isn't everything for a woman,' she says—and it also gave new direction and inspiration to her art." Not only was she buoyed by her husband's love and companionship but her work was transformed by her sojourns in his homeland. The couple spent part of each year at their Port-au-Prince home and studios situated "high on a mountainside overlooking the ocean and the city." Jones responded to the island's blazing tropical sun, varied terrain, and roiling street life by using brighter, more opaque colors, leaving her brushy, impressionistic approach behind as she explored a robust naturalism, especially in her watercolors. Then, in a thrilling departure, she invented a potently patterned and rhythmic style. She painted market scenes, landscapes, seascapes, harbor scenes, and symbols and images derived from the beliefs and rituals of Haiti's indigenous religion, Vodou.

In these syncopated paintings, one feels the press and whirl of life on a populous Caribbean island, where the sea is always in sight, and people spend much of their time outside. With her artistic calling anchored to a northern island, Martha's Vineyard, Jones was sharply attuned to Haiti's sea-caressed beauty. She was also happy to be part of a black society, in spite of its class inequities and political tyranny. Haiti was a wellspring that sustained Jones for the rest of her life.

Les Vendeuses de tissus (1961) is an elegant frieze-style painting depicting a line of women fabric vendors, each holding up sheets of brightly colored cloth, with more samples folded on their held-high heads like peaked roofs or open books or mortarboards. They stand close together, their limbs and wares interlocking as though they are part of a woven pattern, while behind them on a strip of blue sea white sails echo the shape of their dresses and the sheets of cloth they hold outstretched as though they were living masts.

In the complex, vertical painting *Marché, Haiti* (1963), a troop of vendors carry their wares on their heads and in their arms as they march down a narrow street to the marketplace. Simple rectangular forms suggest buildings; the sea, punctuated by a sailboat, is rendered as a free-floating plane of blue. The dynamic scene is framed by bands of red and black, with a border of yellow and blue depicting a worn, plastered wall through which the lathing is visible, while the word *Haiti* appears like graffiti. This is a commanding and colorful tribute to the power and resiliency of the island's people.

These lithe, midsize paintings were followed by the large, bold *Street Vendors, Haiti* (1978), in which a street scene resembles a stage set. Two fabric vendors stand and display their wares in front of a bright red building with a simply rendered white lattice balcony and tall arched windows filled with panels of yellow and green, blue and black, that may indicate interior walls or shutters. A young shirtless boy in blue shorts walks by with a large bowl, holding several bottles balanced on his head, one hand raised to steady it, while a man in dark trousers and a white shirt walks in the opposite direction, pushing a Fresco, or snow-cone, cart sporting an array of bottles of syrup in many colors. In this focused and flattened cityscape, the sea stretches along the top of the painting, carrying a sailboat in full sail; pale mountains hover in the distance.

Jones's increasing urge to simplify yielded *The Water Carriers, Haiti* (1985). Three large-eyed, watchful children stand in an abstract space of flat rectangles of reddish clay brown, mango, Prussian blue, new-leaf green, turquoise, and jade. Each holds a round clay vessel on his head, arms raised. Two are wearing shorts and no shirts. The smallest is clad in a little pink V-necked shift, and may be a girl. She is only using one hand to hold the pot on her head; in her right hand she holds a ball beside her thigh. They look like young dancers or acrobats.

"After all the impressionistic feeling of Paris, my life in Haiti was decidedly different: the marketplace with the people in bright colors, the voodoo ceremonies that I went to. I made sketches of the fire dancers and the voodoo symbols. I encountered much excitement resulting from the drumming. All this changed my palette entirely. The colors changed, and the style changed . . . Going to Haiti changed my art, changed my feelings, changed me."

Jones was fascinated by every aspect of the Vodou ceremonies, including the creating of the *vévé*, intricate drawings made with cornmeal portraying the various *loa*, or spirits. She painted her own variation in *Vévé Voudou* III (1963), a floating still life of Vodou symbols, similar in approach to the array of African masks and charms in *Les Fétiches*. The central figure here is the *loa* Le Grand Bois (great wood), a fundamental force of nature associated with trees, plants, and herbs. For many years, Jones wore a treasured pendant that Pierre-Noël gave her in the shape of Le Grand Bois, who continued to appear in her paintings.

Was Jones religious? She was raised Protestant, and she and her brother attended Sunday school and "that was a very serious thing . . . that carried over into my later life to certainly have a deep feeling, a deep religious feeling which has certainly come out in my work."

Jones spoke to the spiritual aspect of her love of landscape painting: "I'm a great lover of nature and I commune a great deal with nature. Especially during those days when I was doing much out-of-door painting, on-the-spot painting, landscape painting, quietly in the hills or mountains and enjoying the beauty of the skies and the color . . . I would throw my thoughts out and review things that I had done, my life at that moment, and just commune with nature and get a great satisfaction from that feeling. Then all of that came certainly into play in my work, the beauty of the portrayal of nature, the colors, the textures and feeling that I put into those paintings, especially during the period of impressionistic expression."

She loved hearing the church bells in France and Italy. "It kept me in a very good spirit, in a very highly keyed religious feeling, a feeling of love for my work, the love for people, because I love people, people of all walks of life. And as I've gone through my career, painting, especially out-of-doors whether I'm painting in France or Italy or in Haiti or Africa, to be close to the people, especially the peasant folk, the poor people, means so much to me and it has affected my whole being and my whole life in making me, as some say, a very sensitive person, a very sensitive painter. And to me, that's religion."

In Washington the couple ended up living in the former Haitian embassy, a three-story, fifteen-room house that was, as all of Jones's homes were,

tastefully decorated, filled with art, and always guest-ready. A Washington, D.C., newspaper article about her artistic success in Haiti ventures into marital territory, noting that her husband "concentrates on the more technical and illustrative aspects of art, and is well known as a designer of postage stamps for the government of Haiti . . . Mr. Pierre-Nöel now has his own studio here and is giving his wife a bit of competition in the D.C. art world. He has been doing illustrations for publications of the Pan American Union and the Pan American Sanitary Board."

What was her marriage like? Betty LaDuke, who studied with one of Jones's best-known former students, Elizabeth Catlett, met Jones in 1986. During their interview, the artist told her that when she and her husband were in Haiti, "I preferred to work after midnight, because it was so quiet, and Noël would say, 'Aren't you coming to bed?' 'No, cheri,'" Jones would answer, "'I'm working,' and he understood." Their relationship was unusual, Jones admitted: "Not only was Noël always interested in my work, but almost to the sacrifice of his own."

Chapman writes that their marriage was "close and happy," and photographs of the couple do have that aura. Jones's friend and colleague Edmund Barry Gaither is an art historian, educator, and curator; he put together Jones's retrospective exhibition *Reflective Moments* (1973–74) at the Museum of Fine Arts, Boston, the museum's first showcasing of an African American artist. Gaither writes that Pierre-Noël "was especially well-suited for Loïs because, in addition to the fact that he was handsome, refined, and spoke impeccable French, he was able to completely submerge his ego as an artist, and lavish on Loïs the praise and attention that she cherished. He was always at her side but just a little in the background, willing to take her where she needed to go, whether hauling a carload of paintings and watercolors from Washington, D.C., to Martha's Vineyard, or attending a diplomatic opening at an embassy." Though Pierre-Nöel towered over petite Jones, she was in charge. Yet more than twenty years into their marriage, a Haitian journalist notes that Jones talked about her husband with pride and "girlish excitement that has only increased over the years."

As their tenth anniversary approached, devoted educator and passionate traveler Jones, as though she didn't have enough to do, gamely

organized and directed the first trip to France for Howard University students. This 1962 inaugural adventure was the first of many, ever-more-extensive student tours, including trips to Africa and Hong Kong.

Jones also felt compelled to write about art and artists and conduct original research. Interested in helping Haitian artists exhibit in America, she sought and received a research grant from Howard in 1968 to travel to Haiti to interview Haitian artists and document their work, thus initiating her groundbreaking Black Visual Arts project.

Just as Jones was part of the Harlem Renaissance, she also was an early and essential figure in the 1960s Black Arts movement that blossomed in sync with the Black Power movement, with its "Black is Beautiful" rallying cry and irresistible anthem, James Brown's 1968 "Say It Loud: I'm Black and I'm Proud." No longer content to look to Africa from afar for inspiration and validation, Jones wanted to see the land for herself, experience historical African art in context, and meet contemporary African artists. In 1970 she secured a second, even more substantial research grant from Howard University to travel to Africa and document the lives and work of as many African artists as she could find.

Jones put together a challenging itinerary that took her to eleven countries between April and July: Congo, Dahomey (now Benin), Ethiopia, Ghana, Ivory Coast, Kenya, Liberia, Nigeria, Senegal, Sierra Leone, and Sudan. Ultimately, she took thousands of carefully documented slides of African art, building a unique archive for the university. She also brought along slides of artworks by African American artists, which she was eager to share. As she arrived in each major African city, Jones checked in with the local U.S. Information Services office (now the U.S. Information Agency), and was promptly invited to lecture. A press release announced her program in Accra, Ghana: "This talented American Negro artist and educator, known in France and Haiti, as well as in the United States, has through her personality, as well as her art, contributed to international understanding and mutual appreciation." In Ghana, she marveled, "art is everywhere."

Jones's avidly attended presentations brought her into contact with the very artists she had hoped to meet and interview. Stepping gamely into the role of art ambassador, Jones talked to African artists about why and

how African American artists looked to traditional African culture for inspiration, thus tracking the ongoing ripple effects of the African diaspora. For her part, Jones was struck by how many connections she found between the art of Haiti and that of Dahomey and Ghana, transatlantic reverberations many Africans were surprised and moved to learn about. Jones took particular pleasure in visiting art schools, where she met with teachers and students and spoke with directors about exchange programs.

Jones's visit to Ethiopia was warmly recounted on the women's page of the *Ethiopian Herald* on April 19, 1970. The article quotes "the distinguished American artist" saying, "My first visit to Ethiopia was overwhelming, the colorful countryside and the handsome and interesting faces of the country people offers much inspiration to the artistic mind." In Ethiopia's capital, Addis Ababa, Jones attended a cocktail party and met a photographer working for *National Geographic*. He warned her against going to Sudan, her next stop, where he'd had a harrowing time, nearly getting his cameras and film confiscated. Alarmed, Jones's hosts suggested that she fly to Tanzania instead. She agreed, but when she arrived at the airport, she was told that there wouldn't be any flights to Tanzania for a day or two. Not one to waste time, she asked if there was a plane bound for Sudan. One was just about to depart. She boarded it without hesitation.

In Khartoum, she was instructed to fill out a "Photographic License," on which she had to specify the camera and lens she would be using. More significantly, she had to agree not to photograph "military zones, bridges, drainage situations, broadcasting station and public utilities such as water, gas, petrol and electricity work," as well as "slum areas, beggars and any other defaming subjects." This restrictive "license" notwithstanding, Jones had a splendid time. She was impressed with Khartoum's School of Fine Arts, and when she met Sudan's top woman artist, Kamala Ishag, she made a long-term friend. Jones even ventured out into the desert, where she was welcomed by a woman living in a mud hut who promptly sent one of her children out to get their esteemed guest a cold bottle of Coca-Cola, even though he had to walk more than a mile. That's hospitality. Jones believed that she had a far more positive experience in Sudan than the photographer because she was African American.

She fell in love with Kenya, and had a fantastic time in Nigeria, where

she and her husband participated in the second World Black and African Festival of Arts and Culture in Lagos, which she described as "an international event of mammoth scope." The most important thing to do in each city or town, Jones believed, was to go to the marketplace: "It's there where you really see the people and get a true picture of the country." Jones loved painting markets, and she loved the sea. In Dahomey she stayed "at the edge of the sea" in the coastal city of Cotonou, where, she recounted, she "had the view from my window of that magnificent ocean where I could see the peasant women carrying things on their heads standing so erect; they were beautiful as they walked along the beach with their little children. It was really a pageant as I looked from my hotel window . . . I made many sketches, and that is something I did everywhere, to build up my research for the paintings that I would carry out in my studio in Washington, D.C."

A consummate professional, Jones, wearing African attire with panache, looks every inch the diplomat in newspaper photographs that caught her striding along with African dignitaries, in conversations, and at state affairs. Jones felt a deep bond during these encounters: "I'm not an African, but frankly when I went to Africa I felt something so warm between myself and some of those people. I was completely relaxed with them. I enjoyed the exotic design and the color, I felt akin to it."

Africa precipitated the third wave in Jones's ever-evolving oeuvre, following the tidal changes catalyzed first by Paris, then by Haiti. In Africa she made vivid on-site watercolors that capture the vitality and beauty of each scene, as was her habit wherever she went. But what fired Jones's imagination in Africa was not nature or landscape but rather art, craft, and spiritual symbols and objects. As a gifted fabric designer, Jones was entranced by African textiles, which inspired her to fill her canvases with painted versions of their robust, colorful, geometric patterns. To achieve the necessary sharp demarcations and opacity needed for these motifs, Jones began using acrylic paints, which she mastered just as thoroughly as she had watercolors and oils. These textile designs became the foundational theme and grid for her African paintings, works that verge on hard-edge abstraction, with all

evidence of brushstrokes concealed in the flat surfaces accented by black lines and borders. But as dazzled as Jones was by the textiles, it was the masks that most entranced her.

Art historian Cheryl Finley writes that for Jones, the mask was "a lifelong muse." The artist was "enamored with its spiritual significance, theatrical expression, cultural importance, and emotive possibilities." Not only did the mask inspire one of her best-known early paintings, *Les Fétiches*, it was also part of Jones's educational mission. When she was on the editorial board for the *Negro History Bulletin* in the late 1930s and early 1940s, she created the "Children's Page," which offered creative activities for young readers, including designs and instructions for making masks to be used in performances. Jones wrote, "I feel that the mask project is twofold in its purpose in that it not only affords an excellent opportunity to feel the emotions and absorb the spirit, customs, and experiences of various people; but it will also give the student the training in constructing the mask."

Now Jones found herself in a world of evocative masks rich in timeless significance. She remembered, "what I marveled at was the beauty of the mask . . . I found in many of the masks the importance of the eye." The eye: the painter's most precious conduit to the marvels of life.

Jones's wonderment over all that she observed during her first African journey is elegantly expressed in one of the more buoyant of her early African paintings, the adroit watercolor *Magic of Nigeria* (1971). Much like the floating masks in *Les Fétiches*, this composition is an aerial still life in which floating swatches of patterned textiles back an airborne Owo ram's head and two Ibo masks. Jones has given two of the masks surprisingly expressive eyes, while a single large eye, from a mask fragment, also hovers. Each gleams with life and consciousness.

At the center of *Moon Masque* (1971) is a round lunar Kwele mask from Zaire with very expressive long, arching eyebrows and large, sloped, halflidded eyes from which descend three white lines like the tracks of tears. The mask is surrounded by concentric circles of orange, brown, and gold that mesh with horizontal stripes, and it is flanked by the heads of two young men shown in profile against a red background, while all around them pulsate brilliantly colored patterns based on Ethiopian fabric motifs.

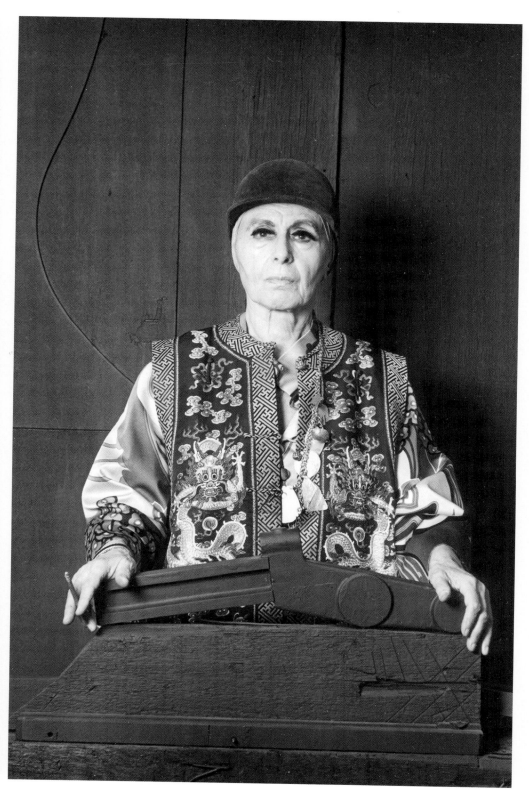

Lynn Gilbert. *Louise Nevelson* © 1967.

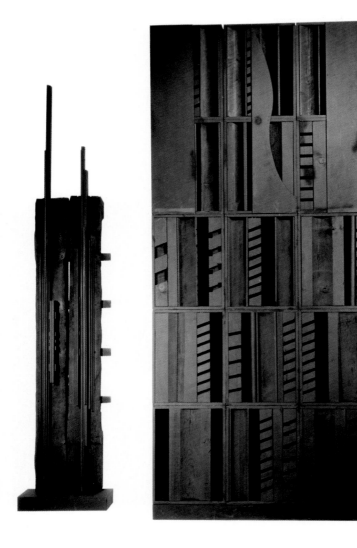

Louise Nevelson. *The Endless Column.* 1969–1985.
Painted wood sculpture. CENTER: 128 1/8 x 59 1/16 x 11 1/6 inches. LEFT: 109 7/8 x 22 x 9 1/8 inches.
STAND: 4 x 25 1/8 x 6 inches. RIGHT: 114 13/16 x 21 1/2 x 5 1/4 inches.
STAND: 4 x 18 x 6 inches.

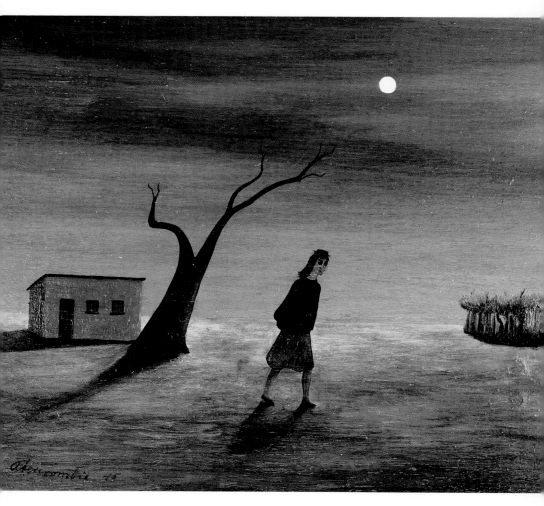

Gertrude Abercrombie. *Girl Searching.* 1945. Oil on Masonite. 8 x 10 inches.

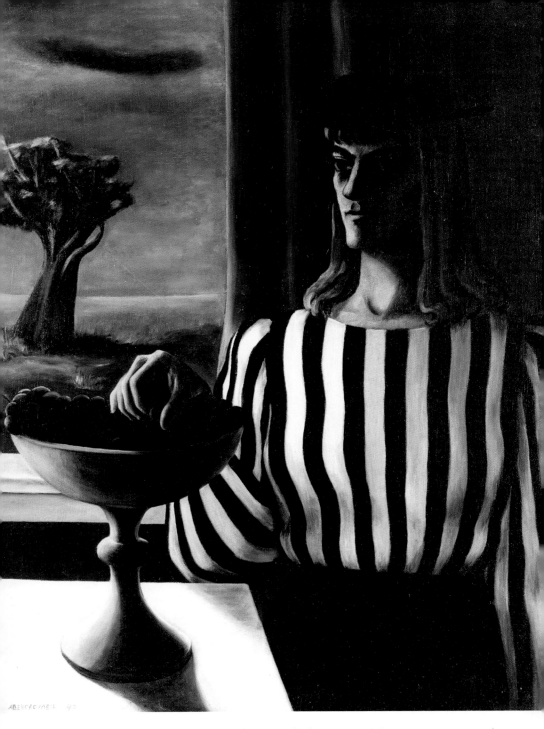

Gertrude Abercrombie. *Self-Portrait, the Striped Blouse.* 1940. Oil on canvas. 36 x 30 inches.

FACING PAGE: Gertrude Abercrombie. *The Parachutist.* 1945. Oil on Masonite. 16 x 20 inches.

Gertrude Abercrombie. *Reverie.* 1947. Oil on Masonite. 12 x 16 inches.

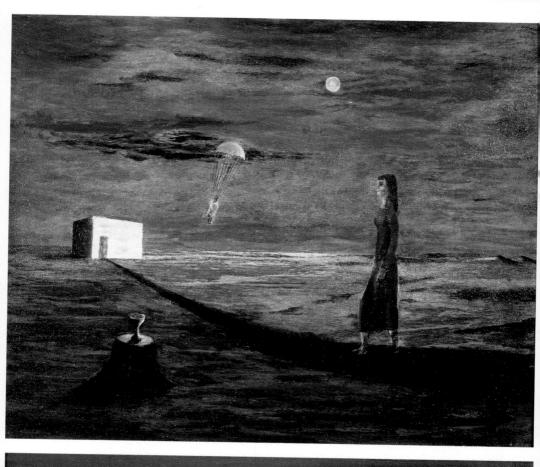

Gertrude Abercrombie. *The Chess Match*. 1948. Oil on canvas. 20 x 24 inches.

Gertrude Abercrombie. *Two Ladders*. 1947. Oil on Masonite. 12 x 16 inches.

Gertrude Abercrombie. *Untitled (Ballet for Owl)*. 1952. Oil on board. 12 3/4 x 15 inches.

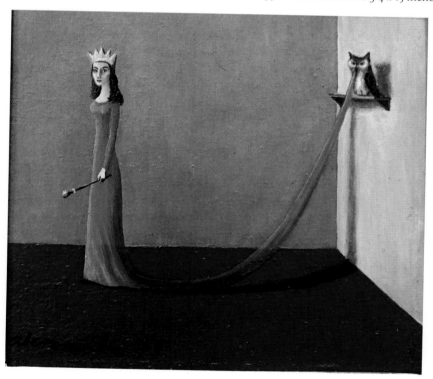

Gertrude Abercrombie. *The Queen*. 1954. Oil on board. 5 x 4 3/4 inches.

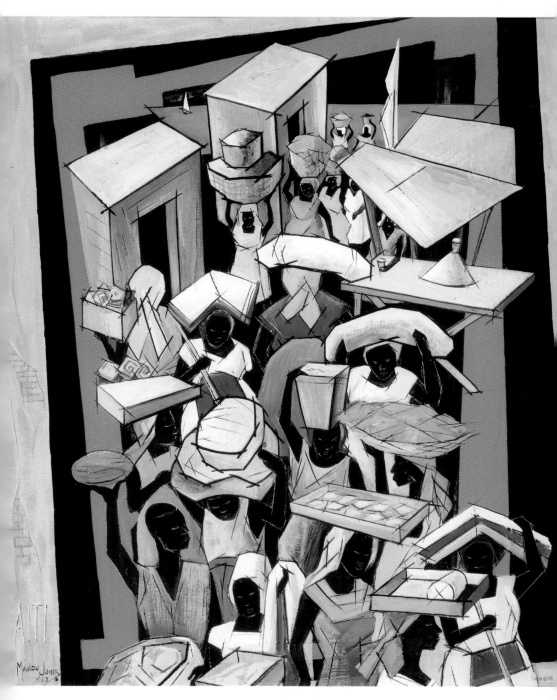

Loïs Mailou Jones. *Marché, Haiti.* 1963. Acrylic on board. 24 x 20 inches.

FACING PAGE: Loïs Mailou Jones. *Madame Lillian Evanti as Rosina in "The Barber of Seville."* 1940. 42 x 32 inches.

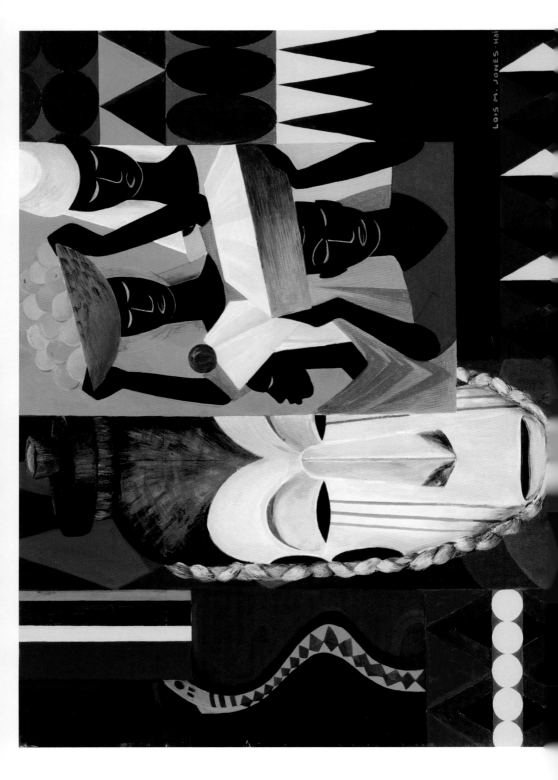

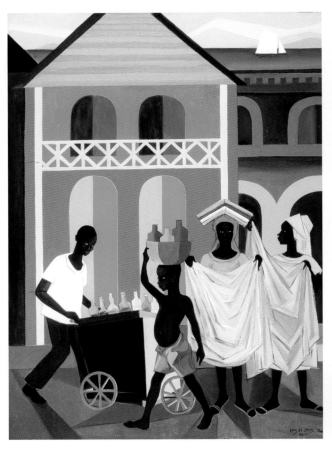

PRECEDING PAGES:
Loïs Mailou Jones.
Damballah. 1980. Acrylic.
30 x 35 1/2 inches.

Loïs Mailou Jones. *La Route
à Spéracédès.* 1989. Acrylic.
23 1/2 x 29 1/8 inches.

THIS PAGE:
Loïs Mailou Jones. *Street
Vendors, Haiti.* 1978. Acrylic.
53 x 40 1/4 inches.

Loïs Mailou Jones.
Bouquet. 1996. Watercolor.
17 x 23 inches.

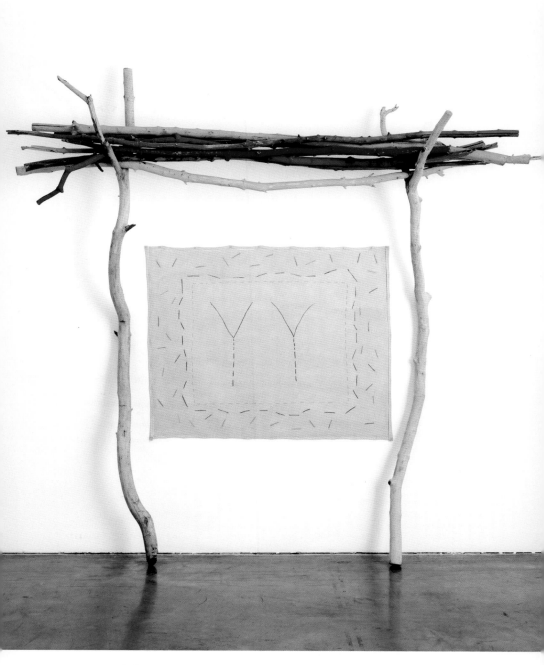

Ree Morton. *Untitled 1971–1973*. Gouache, pencil, and crayon on canvas; gouache on wood. 93 x 66 x 18 inches.

FOLLOWING SPREAD: Ree Morton. *Sister Perpetua's Lie*. 1973. 15 works on paper and canvas: acrylic, ink, crayon, and pencil on paper; chalk on paper; acrylic on canvas; watercolor on paper; chalk, wood, and acrylic on wood.

Ree Morton. *To Each Concrete Man*. 1974. Acrylic, pencil, wood, paper, rawhide, vinyl, canvas, metal, light bulbs, and electrical fixtures. Photographer: Markus Wörgötter.

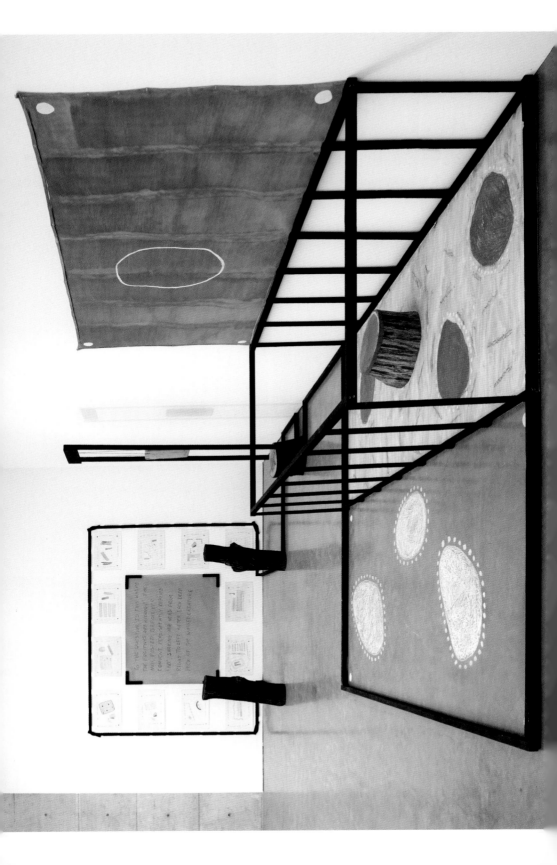

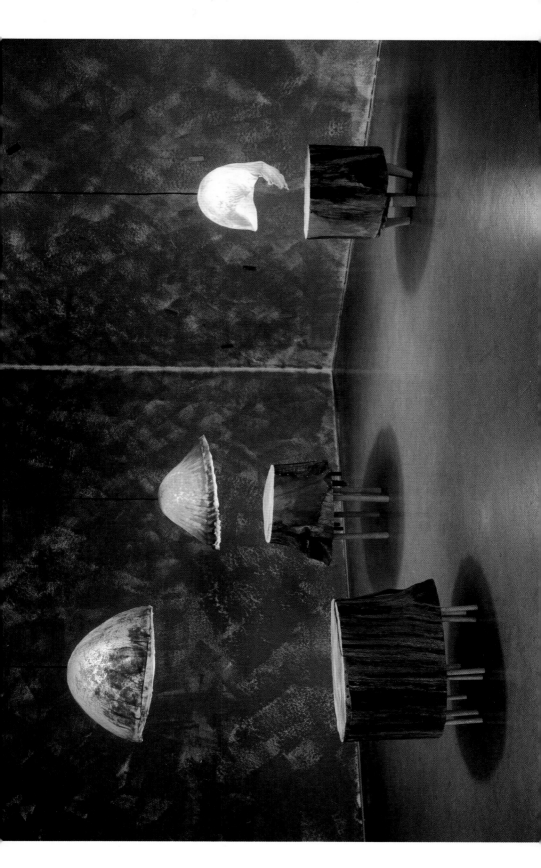

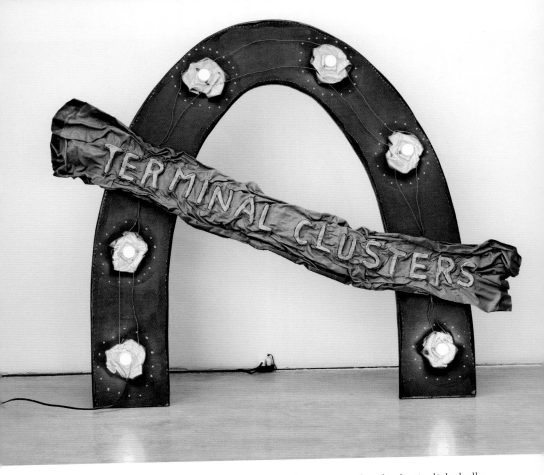

Ree Morton. *Terminal Clusters*. 1974. Enamel and glitter on wood and celastic, light bulbs.
48 x 48 x 8 inches. Photographer: Markus Wörgötter.

Ree Morton.
One of the Beaux Paintings
(#4). 1975. Oil on wood
and enamel on celastic.
24 x 24 inches.
Photographer: Joerg Lohse.

Ubi Girl from Tai Region (1972) is one of Jones's largest paintings, an acrylic on canvas measuring 60 by 43¼ inches and containing a magnificent combination of African elements. A carved head shown in profile dominates; it is derived from a decorative Ivory Coast heddle pulley, part of a narrow loom used to create the strips of patterned cloth Jones found so beautiful. Jones has also painted outlines of masks from Zaire and blocks of textiles patterns. Reaching out into fuller dimensionality is the realistically portrayed head of a young woman participating in an initiation ceremony, the top half of her face painted white with a large red X, much like the tracing of a mask. This marking signified protection.

"I was so interested and fascinated by this girl from Tai Region in Nigeria," Jones told the USIS in 1973. "She was wearing the painted design on her face for a special ceremony. There was something about the deep look in her eyes that impressed me as being symbolic of Africa—so much so that I combined in that painting two masks from Zaire and also the profile of a huge fetish from Ivory Coast."

Jones deliberately combined masks, sculptures, and patterns from different African regions and cultures in her paintings. She did this, she explained, in order to "explore on canvas a sense of the underlying unity of all of Africa" and to create "an overlapping and bringing together of ideas." Jones also forged an evocative union between Africa and the West when she paired African design and symbols with Western-style portraiture, as in *Ubi Girl from Tai Region*, and several later works inspired by Jones's interest in African braided hairstyles. In *Deux Coiffures d'Afrique* (1982), Jones juxtaposes a realistically painted young girl with her hair in tufted braids with an ethereal blue rendering of a carved woman's head with an intricately braided and coiled coiffure and beaded headband. *Petite Ballerina* (1982) portrays the same lovely girl wearing a beautiful white cowrie shell and feather headdress, while beneath her float two masks and beside her stands a large carved female figure. *Mère du Senegal* (1985) portrays a mother tenderly braiding her child's hair in an open coil pattern.

There is motion in Jones's paintings, flowing from her perpetual energy, drive, and joy in the act of creation. In her Haitian and African paintings we sense Jones the fleet tennis and basketball player, covering the canvas

the way she darted across the court. Here, too, is Jones the swimmer, immersed in color and rhythm. Jones also brought her theater production experience to her paintings. Not only did she produce plays with the Pierrettes back in the 1920s, and coproduce plays with Gertrude Parthenia McBrown, she also worked with Asadata Dafora, a Sierra Leonean choreographer, drummer, composer, and performer who brought African dance, drumming, and culture to the American stage in the mid-1930s in productions he termed dance-opera, which combined African rituals and ceremonies with European theater traditions.

The work that made Dafora famous in the United States was *Kykunkor* (*Witch Woman*), which was based on a folktale about a bridegroom who is cursed by a jealous rival. A rave review by a *New York Times* dance critic, John Martin, launched sixty-five sold-out performances that dazzled audiences with every aspect of the percussive production, including the dancers' elaborate headdresses, which were designed by none other than the intrepid Ms. Jones. Once Dafora's African Dance Troupe became part of the Works Progress Administration's Federal Theater Project, the group performed in Orson Welles's production of *Macbeth*, which was set in nineteenth-century Haiti and featured Vodou priestesses. Dafora led the way for African American dancers and choreographers to draw on their African heritage in their work, most prominently the soaring, innovative, and scholarly Pearl Primus, whose career Jones followed with high interest and great pleasure, and the extraordinary Katherine Dunham, who, like her friend Loïs Mailou Jones, was destined to become a "grande dame."

Dunham was Jones's next-door neighbor in Port-au-Prince. After earning her Ph.D. in anthropology at the University of Chicago, Dunham had conducted ethnographic studies in the Caribbean, especially in Haiti, where she was initiated into the practice of Vodou. Her multicultural and unabashedly sexual choreography was extremely controversial. She was also a teacher, writer, and civil rights activist of great valor. Dunham was ninety-six when she died in 2006.

In *Damballah* (1980), Jones explicitly yokes together African and Haitian symbols and images. In using a grid layout, much like that of block printing on fabric, she presents a vividly patterned snake, the symbol of Damballah, the Haitian deity of creation, beside a large, elongated,

expressive Afikpo Igbo (an ethnic group in southern Nigeria) monkey mask ringed with cowrie shells, on which three stripes or grooves run down the cheek from each eye. The mask is partially overlaid by a painting-within-the-painting of the brightly attired Haitian vendors Jones so loved to portray, their wares on their heads.

In 1977 Jones painted *La Baker* (1977) in tribute to her Paris friend Josephine Baker, who had died of a stroke two years earlier in the midst of her long-sought comeback. Jones added to her newly forged synthesized style a touch of Matisse in this jazzy painting, which places the expat performer turned decorated French war hero firmly within the African culturescape. Jones presents three dancing images of Baker—one nude, two with ostrich tail feathers for teasing adornment—along with classic African female figures, masks, and eye-popping African designs, all on a cosmic stage on which Baker embodies nothing less than the African diaspora.

Pride in her heritage and commitment to documenting and disseminating accurate black history not only propelled Jones's career as an illustrator but also inspired her to create a 1966 portrait series in which she paid tribute to such African American pioneers as Phillis Wheatley, Sojourner Truth, and George Washington Carver. Jones's skill and interest in commemorative portraits later turned personal. In 1981 she received an honorary doctorate from Suffolk University, where her father earned his law degree as one of the law school's first African American graduates. Family and friends celebrated Jones's recognition by establishing the Thomas Vreeland Jones Scholarship for African American law students. In 1991 Jones presented the university with her loving and thoughtful portrait of her father, who died when she was twenty-nine. By then she had already succeeded as a textile designer, exhibited her work in various shows, including a Harmon Foundation exhibit, and begun teaching at Howard University.

As committed as Jones was to freedom, equality, and unity, and as keenly attuned as she was to the violence and transformations of the civil rights movement in the States and the epic battles for independence in Africa,

she was not a political artist. Yet she did make one overtly political piece, *Challenge-America* (1964). A collage in which images of historic and contemporary black leaders are juxtaposed with newspaper headlines, it pays tribute to the 1963 March on Washington. When Edmund Barry Gaither curated the 1969 exhibit *Afro-American Artists: New York and Boston* for the Museum of Fine Arts in Boston, he invited Jones to participate. At sixty-five, she was the oldest of the featured artists. The two pieces she chose to exhibit were the superb Haitian painting *Vendeuses de tissus* and *Challenge-America*. Gaither admits that he loved the first choice and was not happy with the second, but had to comply because "Loïs argued that *Challenge-America* was a key expression of her affirmation of the civil rights struggle and its meaning for the nation. For her, it was a very important work." Jones took a similar approach in a 1988 watercolor commissioned by the *Washington Post* titled *We Shall Overcome*. It's a jumbled jigsaw puzzle of portraits of Martin Luther King Jr., Bill Cosby, Michael Jackson, Desmond Tutu, and various sports figures floating above a tableau of three white-hooded KKK members, the word *cocaine*, and two drug dealers, one with white dollar signs marking the lenses of his shades.

Her husband advised her, "Don't get into politics; you can lose your head! You're an artist." Jones's Haitian paintings did not address the suffering of the island's tyrannized people until the brutal and corrupt dictator Jean-Claude "Baby Doc" Duvalier was finally ousted by a citizen uprising in 1986, followed by the harrowing exodus of Haitians who attempted to reach the United States on flimsy boats. By then, Pierre-Noël had died. In the brooding *Haïti Demain?* (*Haiti Tomorrow?*) of 1987, Jones's palette has darkened. Shadowed reds and blues form a background pattern not of symmetry and strength but rather of jagged edges and harsh collisions. At the painting's center is a worried woman in a turban, cradling an infant gazing up imploringly, while a group of undernourished children stand in the foreground, their eyes lifted to a meager trickling-down of cash and coin. An inset image depicts a ragged boat against a fiery sky and sea. This is a painting of hunger and hopelessness, of life and the future betrayed.

Jones returned to Haiti in 1989, 1991, and 1993. The island nation continued to influence her work, all the way to the swirling, splattered

Expressionist watercolor *Simbi, Haiti* (1994), an homage to the Snake *loa* painted when she was nearly ninety.

Jones's innovative and dynamic African acrylics are unique in their cultural resonance. Not only do they exemplify the black arts movement and its embrace of African traditions, but these distinctive works are also in sync with the multiple art movements of the up-for-grabs 1960s and 1970s, from Abstract Expressionism to Pop Art, Op Art, hard-edge, color-field, and pattern and decorative art. Jones felt that every style was hers to explore. She once said, "As an artist I am very free thinking, free feeling."

Some of her more expressive and abstract Haitian paintings, such as the whirling winged and feathered *Cockfight* (1960) and her electric *Vévé Voudou* series (1963), loosely resemble works by Arthur Dove and Adolf Gottlieb. Her linearly patterned African paintings are similar to Frank Stella's swooping geometric creations, while her referencing of textile designs aligns with Miriam Shapiro's fabric and acrylic collages.

While Jones was venturing into abstraction combined with figuration, her celebrated former student Alma Woodsey Thomas was fully embracing abstract painting, turning her love for nature and enthrallment with space exploration into brightly colored, scintillating compositions of strokes, dashes, daubs, arabesques, and swoops. The first to graduate from Howard University's fine arts program in 1924, Thomas earned a master's degree in education from Columbia University, then taught at a Washington, D.C., junior high school for thirty-five years. She attended Jones and Tabary's Little Paris sessions, which gave her the impetus to pursue her own work, though she had to wait until she retired to paint full time. This patient late bloomer then achieved great success as "the first African-American woman to receive national critical acclaim as a nonfigurative painter." Thomas had her debut show at her alma mater in 1966; in 1972, she had a solo exhibition at the Whitney Museum in New York, followed by a retrospective at the Corcoran Gallery back in Washington, D.C.

But for all these crisscrossing ripples in the art continuum, Jones's African paintings are rare in the deep-down power of their emotion and

intrinsic mission as they span centuries, cross the Atlantic, and connect spirit and flesh, individuals and communities. Jones was in her seventies when, with ever-replenishing vigor and authority, she created these striking, original, evocative works, paintings enthusiastically acclaimed in the United States, Haiti, France, and Africa. Jones's scrapbooks were bursting with show announcements, invitations, and newspaper and magazine reviews and articles in the 1980s and 1990s. The journalists who met with Jones, especially the women, loved to comment on her dynamism, sense of style, and youthfulness.

In an article in *Museum & Arts Washington*, Nancy G. Heller wrote,

She leads me up the stairs of her art-filled, three-story house, chatting all the while. As I pause on the top landing to catch my breath, I find it difficult to believe that my guide—now briskly opening doors and turning on lights—is 82 years old. Loïs Mailou Jones doesn't seem a day over 55. Her youthful looks and her energy are almost as remarkable as her accomplishments . . .

This intimating figure is small, with fashionably cut, short blonde hair and beige-framed glasses. She dresses elegantly—today in black trousers and a turquoise-and-black print jacket. Her voice sounds soft but intense and she uses her hands gracefully as she speaks.

Loïs Mailou Jones could easily be the subject of one of her own canvases, with her cream-brown skin and short-cropped tawny hair that frames her forehead. Her deep-set eyes look straight at you and sparkle with laughter when she smiles.

Jones was charismatic, vivacious, and tough. Her colleague and biographer Tritobia Hayes Benjamin, who curated the traveling retrospective exhibition *The World of Loïs Mailou Jones*, first met the artist as a student in her watercolor class in 1965. She was majoring in art history, but James A. Porter, chairman of the art department, believed that art history majors should experience the making of art to acquire "a well-rounded insider's point of view." In 1970 Benjamin joined the Howard faculty and was assigned an office next door to Jones. They became friends. Benjamin went on to earn her Ph.D., and when it came time to choose a subject for her

dissertation, she decided to write about Jones's mentor, sculptor Meta Warrick Fuller. But when Benjamin met with Jones to talk about Fuller, Jones said, "You know I think I would really be a better topic than Meta Warwick Fuller." As Benjamin told curator Carla Hanzal in 2009, "That was Loïs—she didn't pull any punches on anything; she always spoke her mind . . . Loïs was the quintessential self-publicist, if I may say so." Jones did make a convincing case, explaining that she maintained an impeccable archive containing every article written about her and every announcement and program for her exhibits along with many photographs. She was also willing to talk in depth, assuring Benjamin, "I . . . would be at your disposal." Benjamin took her up on it, and her dissertation paved the way for her biography, *The Life and Art of Loïs Mailou Jones* (1994).

Jones told fellow artist Betty LaDuke that she "put [her] whole feeling from within" when she painted. Works as complex as *Ubi Girl from the Tai Region*, LaDuke writes, "first appear . . . as 'an idea of a dream,' that she jots down then develops as a color sketch. A well-thought-out, precise sketch is transferred to canvas, and colors and forms are adjusted as she paints. 'I work fast when I'm keyed up, and I stay with it.' Her large canvases seldom take more than a week to complete." Gaither writes that during the school year, Jones "reserved her weekends for painting." Jones didn't retire from Howard University until 1977, when she was in her seventies. During her long academic career, she played "a leading role in creating what would become one of the most important training grounds for black visual artists of the 20th century." Finley notes that Jones "was at the forefront of designing and implementing Black Studies curricula in the visual arts." Jones was, in fact, an interdisciplinary pioneer, combining music and performance with visual arts. And she expected her students to set standards for themselves as demanding and lofty as her own. Jones's commitment to her work was absolute. Artist David Driskell writes, "As students of Loïs Jones, we were taught that art must be the central focus of our lives. She often spoke of the importance of being 'married' to one's art, and the devotion and discipline she brought to bear in her own career left a lasting impression on us."

And Jones didn't use the word *married* lightly. Not only did she keep suitors at bay throughout her twenties and thirties, determined to avoid the conflicts over her art that marriage and motherhood would bring, she also maintained a disciplined routine, ensuring that everything in her life served her art and professional standing, from her polished and stylish appearance to her showcase homes. Jones didn't even relent during her "summer idylls on Martha's Vineyard," as Chris Chapman recalls. "The Vineyard was the place where Lois could really relax, though not too much. She still required her *New York Times* every Sunday. When we went out to eat, she made me wear a tie, and I would be the only person in the restaurant wearing a tie."

Jones did not mince words when critiquing her students. She spoke forthrightly because she wanted to toughen them up, knowing all too well the difficulties they would face as black artists. And she insisted on respect, which women academics had to cultivate more actively than men. But Jones was also nurturing and supportive; some students even called her "Mom." Her maternal side was certainly evident in her role as international tour guide, where sympathy and authority were both required to keep students from being overwhelmed or too impetuous.

On the subject of motherhood, LaDuke writes that Jones and Pierre-Noël were "physically" unable to have children. "Noël reassuringly told Jones, 'Your paintings will be our children.'" Indeed, Chapman writes, "She felt that her paintings were her children and was very particular about who adopted them." This explains one of Jones's quirks in interviews; she often praises her own work, calling her paintings "beautiful" or "outstanding" and "important." Such remarks can sound self-aggrandizing, but Chapman's insight reveals just how deeply she cared about her creations and how she saw them as entities independent from herself that would outlast her. She was proud of her paintings, and wanted them to be valued.

Jones's decades on the Howard faculty, teaching watercolor painting and diverse design courses, traveling abroad, and conducting ground-breaking research, were deeply satisfying and essential to her creativity. Looking back soon after her retirement, she mused, "I might say it's been really a rich career and I'm still enjoying it and I just hope that I can continue . . . because, as I tell my students, a career calls for work. The

greater part of it is work along with what talent you have." As for no longer teaching, "I just have a fear of leaving those young people because they have kept me young and I think the spirit of working with them, the exchange of ideas, has been greatly responsible for at least my well-being, as you see me today."

Yet for all her success and delight in teaching as a veritable fountain of youth, Jones coped with immense frustrations. As LaDuke reported, "the art department chairman wanted her to stay with the more 'lady-like' watercolor painting, since oil was the preserve of men, and the university already had an oil painter on the faculty—James Porter." Jones was also poorly paid and passed over for promotions: "It was many, many years before I ever realized an adequate salary. I think being a woman had something to do with that." Other women faculty suffered the same discrimination. This was, no doubt, another reason for Jones to make sure she succeeded in the wider world as an artist on her own terms.

Jones visited and spoke at many schools and colleges in Africa, Haiti, and across the United States, and her scrapbooks bulged with thank-you letters from principals, department chairs, faculty, and students who were uplifted and encouraged by her good counsel and pleasing presence. In spring 1967 she participated in the annual festival of art at Philander Smith College in Little Rock, Arkansas, a private, historically black Methodist liberal arts college dedicated to social justice. After her time there she heard from Carlon Winston Pryor, a faculty member of the biology department: "I write to tell you that my life is by far richer for having met you. Your visit here for even its brief period was totally refreshing. It has given me the desire to go even further with my own endeavors. I thank you most kindly. To some of us you have given that kind of 'divine glow' which makes us wish we could associate with you more and more."

Pryor had particular reason to be grateful to Jones, given his creative "endeavor" as a male scientist with a passion for fine crocheting. The previous fall an AP wire story had gone out from Trenton, New Jersey, with the headline "Crocheting Contest Prize Goes to Male." The brief article explains, "A man from Little Rock, Ark., won first prize for crocheting over 24 women at the New Jersey State Fair on Saturday." Pryor submitted his entry by mail, providing a funny, ironic little echo of Jones's strategy

when she shipped her work to museums and galleries to avoid racial discrimination.

In 1979 the busy retiree had a solo exhibition at the Phillips Collection in Washington, D.C., and in 1980, President Jimmy Carter presented her with an Award for Outstanding Achievement in the Visual Arts.

Two years later, Jones's husband died. Among the condolence cards and letters she saved was a warm, handwritten note from friends who wrote, "Pierre was a beautiful man. He touched everyone that knew him with his special grace. I don't think I have ever known a man so gentle and so kind and so thoughtful."

Jones also received a sympathy letter on letterhead from the Anacostia Neighborhood Museum, Smithsonian Institute. This experimental museum, set up in an old repurposed theater, was designed to connect with the African American community, especially with young people, to entice them to visit the Smithsonian's larger museums on the National Mall. It was eventually relocated and renamed the Anacostia Community Museum. Minister, educator, and civil rights activist John R. Kinard, museum director from its inception in 1967 to his death in 1989, wrote to Jones in May 1982:

Dear Loïs:

Please allow me to express my heartfelt sympathy to you regarding the passing of your devoted Pierre.

I remember so well on occasions when I was fortunate to visit in your home that there existed between the two of you endless love and reciprocal devotion. Aside from the design work that he did so well he was a gentleman of the first magnitude.

. . . You have always been a pillar of strength to me, not only encouraging our efforts here but participating and giving of yourself and your talents whenever asked.

I am appreciative and grateful to you and Pierre for all of your affection and encouragement given so willingly and freely to so many people like myself.

Jones's quiet activism and generosity were ongoing.

Speaking with Rowell six years after her husband's death, Jones said, "Ours was a marvelous companionship of thirty years: we travelled together, we worked together, and we had joint studios . . . I know his one wish is, 'go on with your career, Loïs; do the things you want to do.' I constantly go back to Haiti because he is buried there, and I feel very close to him, and my studio is there. It's there that I do most of my creative work."

Jones painted with undiminished energy throughout the 1980s, into her own eighties, showing her work in solo exhibitions and receiving a stream of awards, including an honorary doctorate from Howard University. In 1989 she traveled to both Haiti and France, where she visited her dearest friend, Céline Tabary. While there, she completed a set of eight paintings, mostly en plein air landscapes executed in a spirited Postimpressionist style, alive with bold lines and strong color contrasts that echo her geometrically structured Haitian and African paintings. But this exciting and productive year was interrupted with a thunderbolt when Jones suffered a heart attack on her eighty-fourth birthday. She underwent triple-bypass heart surgery and, as determined as ever, bounced right back. There was no way this dynamo was going to miss the opening of her major retrospective exhibition, *The World of Loïs Mailou Jones*, at the Meridian House International in Washington, D.C. Jones even accompanied the show as it traveled cross-country, speaking at each of the seventeen venues. And this indefatigable grand dame was honored and written up everywhere she went.

When the exhibit landed at the Schomburg Center for Research in Black Culture in New York, a venerable institution bearing the name and carrying forward the mission of her old friend Arthur Schomburg, Jones was honored with an eighty-seventh-birthday party. Not to be outdone, the Terra Museum of American Art in Chicago presented her with a cake decorated with her painting *The Ascent of Ethiopia* to celebrate her eighty-eighth birthday. Perhaps the most meaningful celebration took place on her eighty-ninth birthday at the Corcoran Gallery of Art, the institution that had once turned away works by African American artists. The deputy and chief curator publically apologized for the museum's past racist policies, and, in

1996, the Corcoran School of Art presented Jones with an honorary doctorate of fine arts, "In grateful recognition of your talent, your lifetime contribution to the arts, and your perseverance in breaking down what separates us, one from another." Jones, in turn, ensured that her rightful place was held in perpetuity by donating to the Corcoran *Indian Shops, Gay Head, Massachusetts* (1940), the very painting her friend Céline Tabary brought to the museum in her stead to circumvent the color ban.

Jones kept painting. *Edgartown Beach* (1994) is a sumptuously bright and exuberant watercolor, a playful Martha's Vineyard scene in which Jones delights in the luxurious beach foliage, colorful beach umbrellas, sunbathers, and sailboats out on the azure blue sea. At ninety, Jones painted *Bouquet* (1996), a jewel-beautiful watercolor still life alive with the artist's endless joy in seeing and painting. The flowers and fruits are voluptuous, while the wooden-handled paring knife is sharp, a symbol, perhaps, of the artist's still acute vision and steady hand.

On June 9, 1998, Chapman writes, Jones "gracefully passed away" at her home.

In the *New York Times*, art critic Holland Cotter wrote,

> Ms. Jones was an iconic figure, and an important historic link in a path-breaking generation of black American artists. Her eclectic, academic work, in a career spanning nearly 70 years, ranged from impressionistic landscapes to political allegories, and from cubistic depictions of African sculptures to realistic portraits.
>
> She was influential as a teacher, not only for her exacting standards and the encouragement she gave students, but as an example of persistence in a climate unfavorable to black and women artists.

The more successful Jones became, and the more attention she received as a black woman artist, the more she had protested against this reductive identity. She was in her early eighties when she told Betty LaDuke, "Although I still feel interested in shows that feature black artists and am happy to contribute works that are strong, I don't feel restricted to black

shows or themes. I feel that I can do or express anything that I want. I'm tired of being considered only as a black painter. I'm an American painter who happens to be black."

In a tribute to Jones after her death, her former student, artist David Driskell, observed, "Although she considered herself first and foremost an American artist, she understood and graciously accepted the role affectionately bestowed upon her as 'Queen Mother' of African-American art." Yet, as Benjamin candidly revealed in a 2009 interview, behind Jones's mask of cordial acceptance, she "was never fully satisfied about her place in American art history and felt the need for accolades continuously. In many instances, as some of her peers' and former students' lives and artistic recognition appeared to loom larger than hers, she would have feelings of enmity toward them . . . While she enjoyed immensely recognition in mainstream artistic circles, Loïs continued to feel unappreciated, and in many instances determined that she needed to break out of the categories in which she had been placed. Hopefully, history will provide for her, as she so coveted, her rightful place without gender or race bias—but as an American artist."

Jones was born during a socially rigid, virulently racist and sexist era—hence her abiding love for the respite and refuge she found in the African American enclave on Martha's Vineyard, an oasis of accomplishment and mutual respect, and in the countries she visited on her constant travels, lands where she was lauded simply as an artist. Later generations of African American women artists have had a slightly easier time earning respect and success as society slowly grows fractionally more flexible and inclusive. There was something both affirming and bittersweet about having Faith Ringgold present Jones with the Outstanding Achievement Award in the Visual Arts from the Women's Caucus of Art in New York in 1986. Born in 1930 in Harlem, Ringgold is an African American artist, activist, and author of an award-winning children's book, *Tar Beach*. Ringgold's often shocking paintings directly confront racial and sexist conflicts and inequality. In *Of My Two Handicaps*, a painting in her 1972 *Feminist* series that incorporates quotes from black women, she embraces a statement made by Shirley Chisholm, the first African American congresswoman: "Of

my two handicaps, being female put more obstacles in my path than being black." Ringgold was profoundly appreciative of Jones's trailblazing courage, achievements, and painful predicament: "We are deeply impressed by your illustrious life's performance. This award is only a small token of what is due you. Like the more than 45 other awards you have received, this one is not enough, for you have done what no Black woman in America has done before you. We would hope that it would cause the New York art world to stop their business as usual and see you, Loïs Jones, for what you are: An American Artist, an American Woman Artist, Black, highly accomplished and proud, of singular creative strength and beauty, young and vigorous at 80 and getting better."

Indeed, Jones did live on to receive many more awards and mount a remarkable number of prestigious exhibitions during the last dozen years of her long, productive life. After her death, a series of exhibitions have introduced new audiences to her virtuoso and sparkling body of work. *Full Spectrum: The Prolific Master within Loïs Mailou Jones* opened in Washington, D.C., on November 3, 2014, which would have been her 109th birthday.

No amount of praise made Jones forget the need for her unwavering tenacity. Consider this small sampling of newspaper and magazine headlines found among Jones's archives:

"Paris Offered Artist Her 'Chance to be Free'" (*Ebony*, November 1968)

"Art: Lois Mailou Jones at the MFA—Finally" (*The Real Paper*, April 11, 1973)

"Achievement against the Odds: Now Lois Jones Can Pick Up Her Prizes in Person" (*Montgomery Journal*, July 5, 1978)

"Jones Illustrates the Plight of the BLACK ARTIST" (*Suffolk Journal*, October 23, 1980)

"Lois Mailou Jones: An Indefatigable Black Woman Artist" (*Washington Post*, February 23, 1983)

"Overdue Applause Greets Black Artist" (*New Directions for Women*, March/April 1985)

"The Never-Ending Struggle" (clipping without attribution, 1987)

Jones refused to stay within the narrow confines American society established for black women. She inherited a mingling of bloodlines from distant places; her island paradise pointed her toward an endless horizon, and art is by its very nature a quest for freedom. But Jones was not content to simply break free on her own. She felt compelled to educate and liberate others, to foster opportunities and recognition for all artists of color. Jones was always aware of the larger, communal picture. She was inspired, as artists everywhere have always been, by the glory of nature, the life force itself, as well as by the timeless power of African masks. Jones's abiding fascination with masks was artistic, cultural, intellectual, and profoundly personal because she played many roles, faced adversity in many forms, and, yes, wore many masks.

Jones's beauty both opened doors and led to ludicrous underestimations of her talent and intensity. Her gender was a mask not of her choosing, as was her skin color. Her task was to turn these maligned traits transparent so that her true identity shone through. Conversely, a mask, well chosen, can serve as armor and camouflage. A mask can protect, disguise, disarm, and charm.

Determined to exhibit her work in spite of racial barriers, Jones used Tabary and other white friends as proxies to mask her identity. To succeed professionally, Jones was scrupulous in maintaining a professional, unflappable public facade, diligently concealing her private, more vulnerable self. Donning the mask of imperturbability allowed her to excel as a demanding teacher and adventurous art ambassador. Jones drew strength from the protection and empowerment masks provided. And the mask, a symbol of the spiritual realm, a conduit to the ancestors, and a vehicle for transcendence, served as an expressive emblem of her African heritage, the wellspring for her most original paintings.

Jones may well have heard the sociologist, historian, educator, journalist, and civil rights activist W.E.B. Du Bois lecture in Boston at those formative Sunday forums. Du Bois, like Jones, was born in Massachusetts, and shared her Dutch-African lineage on his mother's side. He also lived and worked into his nineties. The first African American to earn a Ph.D. at Harvard, Du Bois wrote seminal and transformational books, including *The Souls of Black Folk* (1903), which made him famous. The book begins with

the story of how, as the sole black child in a "wee wooden schoolhouse," he abruptly became aware that he "was different from the others; or like, mayhap, in heart and life and longing, but shut out from their world by a vast veil." This is followed by one of Du Bois's most resounding passages:

> After the Egyptian and Indian, the Greek and Roman, the Teuton and Mongolian, the Negro is a sort of seventh son, born with a veil, and gifted with second sight in this American world—a world which yields him no true self-consciousness, but only lets him see himself through the revelation of the other world. It is a peculiar sensation, this double-consciousness, this sense of always looking at one's self through the eyes of others, of measuring one's soul by the tape of a world that looks on in amused contempt and pity. One ever feels his twoness,—an American, a Negro; two souls, two thoughts, two unreconciled strivings; two warring ideals in one dark body, whose dogged strength alone keeps it from being torn asunder.

Is not this veil, this "double-consciousness," this "twoness," embodied in the mask? And as a woman, Jones was born with two veils; she had to navigate two forms of "double-consciousness," learn to overcome two "handicaps." Jones was a warrior of "dogged strength" on both fronts, and

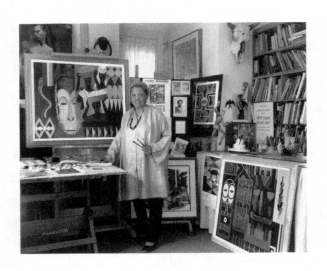

Loïs Mailou Jones in her Washington, D.C., studio, 1983.

she held fast to the safeguard of the mask, even as she longed to cast it aside. Jones's greatest ambition was to be seen not as a black artist or a black woman artist, but as an artist. Free and clear. And the truth is, as compelling as her story of perseverance against racial and gender discrimination is, it would not be told and retold if we were not first drawn to and exhilarated by the virtuosity, creativity, evolution, and radiance of her paintings. In their light, we do see Jones as an artist—singular, sublime, incandescent.

"THE REBELLIOUS BRAVO"
REE MORTON

Thinking about art and other artists—feeling an affinity with other artists,
and that this is a good way to do your life. The important thing is that
we are here. And trying to make a difference, and giving a damn. There
aren't any ultimate answers, only now and what can be done with that.
Very liberating notion.
—Ree Morton

The artist speaks to us through a cosmic dust storm, a comet's tail, the
mist of time. The screen contains a whirl of pixels shimmering and shad-
owing in many shades of white and gray. The sound booms, muffles, and
echoes. There is scratch and static. The artist is trapped, tightly framed
within the camera's pitiless lens, the space capsule window. She is pale,
late-night puffy, tired, reluctant. Ghostly. Polite. Her voice is gentle, with a
slight Southern intonation. Her dark hair is long, mussed; she wears no
makeup. She sits still, as though for a photograph, and while she valiantly
holds the video camera's gaze, she can't help but look yearningly, every so
often, over her shoulder toward her studio. Her garden, her paradise. This
interview, this interrogation, is the price of readmittance to that realm of
possibility, that arena of creativity, that small place of freedom. The artist
listens intently to each question and responds thoughtfully, weighing her
words, counting the minutes. The sad truth is, she hasn't many left.

The year is 1974. The artist is Ree Morton. Black-and-white video is the
cutting-edge medium of the time, however bulky the equipment, however
foggy the result. Morton is a sculptor who brings both wit and metaphysics
to her installations, which at this point in her intensely fertile and tragically

Ree Morton in kindergarten, ca. 1941.
Unidentified photographer.

brief spell of art-making are constructed out of humble bits of wood, from found pieces of lumber to branches and twigs and sawed logs. Morton's sculptures are linear in their marking of paths and dotted-line mappings of space, and archaically architectural in their evoking of thresholds, roofs, and huts. Her works suggest the sacred in their allusions to altars, shrines, and gravestones, prayer sticks and sand drawings. Attuned to dichotomies, Morton is at once pictorial and sculptural. She loves forked branches and other Y shapes, an emblem that suggests division, a choice of direction or options—a symbol of life's continual branching off, of evolution. Or ambivalence. In the December 1973 issue of *Artforum*, art critic Lucy Lippard describes Ree Morton's work: "The spaces are compact but welcoming, like little shelters for the expanding imagination, the legendary door in the wall."

The second of five children, Ree Morton was born Helen Marie Reilly on August 3, 1936, in a New York town that also changed its name. It was originally called Sing Sing, a variation on Sint Sinck, the name of a branch of the Mohegan tribe, which translates as "stone upon stone" in tribute to this Hudson River settlement's large beds of limestone. But by 1901 the town was anxious to distinguish itself from its infamous Sing Sing prison, and so became Ossining. Helen became Ree, plucked from Marie, while attending Skidmore College, then acquired her new last name when she dropped out at age twenty to marry Tom Morton, a naval officer. Her father was a doctor, and her mother, also named Helen, was a nurse, although she devoted herself to caring for her family. The Reillys talked their daughter into enrolling in the nursing program at Skidmore. On video

Ree Morton with her children, ca. 1964.
Unidentified photographer.

Morton ruefully describes her romantic idea of caring for others as "cool hands on a warm head." She was happy in her science classes, she says, and she "loved studying," but once she began working in a hospital ward as part of her training, she discovered that she was "totally unsuited for nursing." She laughs uneasily as she describes how she was always certain that she had every symptom she learned about, and how she became much too emotionally involved with the patients. Feeling guilty about her dislike of the work she was supposed to be committing herself to, Morton got married in 1956 and quit her job.

She and Tom moved to Jacksonville, Florida, and she had three children. Linda was born in 1957, Sally in 1961, and Scott in 1962. During this time, the family spent five months in Europe, moving from port to port, following the aircraft carrier on which Tom was stationed. Back in Jacksonville in 1960, Morton was ironing with the television on when she heard about art classes at the museum. She signed up, thus launching what became a serious immersion. For the next eight years, as the family moved to Georgia and Virginia, Morton took art classes wherever she could. During a brief stay in Los Angeles, she taught children in the art program associated with Watts Towers. When the family moved to Rhode Island, Morton took a giant step and enrolled in the University of Rhode Island, taking classes at night and working on her art at home. Marcia Tucker, the brilliant and gutsy art historian, critic, and curator who founded and directed

the New Museum in New York City, was one of Morton's teachers, and became her mentor and friend.

Morton earned her bachelor of fine arts degree in 1968, and separated from her husband. She moved to Philadelphia with her three children (her daughters aged eleven and seven, her son six). She set up a rudimentary studio in the basement of their house behind the washer and dryer, and managed to earn her master's in arts at the Tyler School of Art in 1970. Morton became part of the city's thriving creative community, taught at the Philadelphia College of Art, and began making innovative and energetic work, including curiously ritualized and theatrical sculptures, as a colleague at the school helped care for her children. Morton rose quickly, commanding a spot in the prestigious *Contemporary American Sculpture* exhibition at the Whitney Museum of American Art in New York. Month by month, she created a phenomenal number of sculptures, drawings, and paintings, continually trying new materials, riffing on wildly diverse inspirations, and commanding the attention of critics, gallery owners, curators, and art teachers. Her early work is earthy, talismanic. It looks casual, but it is powerful. It has mojo. Morton wrote in a notebook, "Art can be a way of viewing the world, rather than merely an object to be viewed."

Wood Drawings (1971) is a set of sixteen small wall pieces comprising found wood scraps, worn and weathered strips and boards that Morton has drawn on and embellished with screws, hinges, and nails. Her markings look like the lines on a ruler, or some sort of tabulation. They are humble, cryptic pieces given weight and resonance by the simple act of hanging them on a wall. Although they weren't made as a single work, displayed together, they look like a collection of ancient objects the significance of which has been forgotten; like shards and fragments excavated from archeological digs, puzzle pieces to a lost civilization. They possess a quiet beauty. They are funky. Morton is at once deeply serious and slyly witty.

Another untitled piece from this time consists of two tall forked branches leaning against a wall, holding up a precariously balanced horizontal stack of entwined branches delicately painted yellow, pink, green, orange, and purple. This sculpture frames a large drawing of two Ys

Ree Morton. Untitled. *1972. Paint on paper, tape, felt, flour, and wood; studio of the artist.*

surrounded by a border of hatch marks. Another untitled piece consists of two large brown triangles leaning against the wall, and painted with a line of white dashes. The dotted line (reversed, however, with short sticks making dark dashes on a white line) extends onto the floor to create a semicircle, connecting the outer corners of each triangle. At the center stands a thick, gracefully curving forked branch. It feels like an altar, a sacred place.

Morton's interest in architecture is intriguing, even poignant, given how often she moved as a navy wife, how mobile the idea of home had to be for her. Morton never settled anywhere; she was always pulling up stakes and heading off to new terrain. Accustomed to the nomad's life, she became an itinerant artist, accepting guest teaching gigs all across the country, and making art in each setting that reflected her quick impressions of each new locale, its landscape, ambience, and the personalities of the people she meets. Morton was a performer on tour, a roaming jazz musician improvising on local songs, a magician working with whatever materials are at hand, a wandering storyteller weaving in bits and pieces of native folklore. She wrote in her notebook, "My work is directly related to the transmission of a sense of place." She worked hard as a teacher wherever she landed, maybe too hard. She chided herself for being "too damned conscientious." She needed

to devote more time to her own work, she realized. A late bloomer, she felt pressured to produce. Her mind fizzed and boiled with artistic visions.

Morton's notebooks are sketchbooks for ideas, drawings, and diagrams for installations, as well as a place to tot up to-do lists, keep a journal, debate with herself, note inspirations (pueblos, rock paintings, theater) and copy down quotes from her extensive reading, which encompassed T. S. Eliot, Gertrude Stein, Gaston Bachelard, author of *Poetics of Space*, and architectural historian Christian Norberg-Schulz. Pencil in hand, she questions and cajoles herself. On this page, she moves from thinking about how to balance teaching with art-making to pondering how awkward it can be when people respond to her art:

How to deal with that kind of reception that looks like adulation? Here you are making work that is important to you, wanting people to like it—right?—of course —? And then the whole freak out of seeing them liking/hating you because of it?—A mystery . . .

The whole problem of art-STAR—people really want to do that to you. The problem is staying with yourself and your work and the more honest you get, the more you get these RESPONSES—Eyes—. ugh.

Later she ponders the response to her work in a gallery show in Chicago in December 1974:

The misinterpretations continue to bewilder me, and the reactions from the show in Chicago that are now filtering in, seem to be suspicious . . . isn't that weird . . . of what? Is it the old paranoia that the artist is, after all, trying to put a good one over in the public? . . . The work has always been a way at getting to answers to questions that present themselves, seem interesting, provocative. Poets aren't asked to defend their subjectivity, so I wonder where the idea came from that art at this time needs defending, justifying. How do you go about justifying your own existence, for Chrissake? If what you want is not to present graphically a resolution of a theory, but to lay out all that wild input of sensations, complications, contradictions, and the old, already dog-eared word, ambiguity, that continually comes rolling in off the beach, then why does that meet so

much resistance? . . . The responsibility of the artist . . . to be free, and while in that freedom to look, and to see while looking, and to feel, and to respond while feeling, and to be romantic and to love the romance. Analysis may be better suited to the couch. Goddamnit, never explain what you're doing.

Morton also jots down wry and mischievous mottos and aphorisms. She gives herself instructions. Sometimes they look like poems:

> The point in all cases is that
> the deities must be made
> to laugh.

Beneath a series of quirky drawings of dark rectangles with stick figure legs and feet she writes,

> Drawings based on the mating habits of lines.
> myth is the best detergent for a dirty history.

A lively, colorful drawing fills an entire page. It looks like a bright, flirty marquee, all magenta and goldenrod yellow with penciled words traced in red:

> Work of art has a unique
> quality—it is that of
> clarifying & concentrating
> meaning contained in
> scattered & weakened
> ways in the material
> of other experiences.

Another page:

"What a nice thought"—I've been saying that a lot lately. Thoughts can give pleasure in a way that approaches the sensual—warm and reassuring—that you try and hold, rather than challenging or dealing

with in an analytical way—Like a small frog in your hand, it will be gone soon enough, but what a wonder while it is willing to be still.

A drawing of a pink horseshoe-shaped banner with green squiggles indicating a ruffle or lace carries this declaration:

REALITY IS BAD ENOUGH WHY SHOULD I TELL
THE TRUTH

These are excerpts from an unusual and beautiful publication, a large spiral-bound book with cardboard covers titled *The Mating Habits of Lines: Sketchbooks and Notebooks of Ree Morton*. Originally published as a catalog to accompany an exhibition of Morton's drawings at the Robert Hull Fleming Museum at the University of Vermont, Burlington, on display from October 1999 into January 2000, it is a precious record of Morton's creativity and temperament. And the only record. A chronicle of seven years of intense artistic exploration, it should have been the first chapter in a long saga of exploration.

Morton's last visiting artist gig was at the School of the Art Institute of Chicago during the 1976–77 winter semester. She charmed everyone within her radius, and created a bold and animated exhibition of paintings inspired by architect Louis Sullivan. Then on April 30, 1977, Ree Morton died from injuries sustained in a car crash. She was forty years old. She'd been a full-time artist for not quite a decade. The significance of her work has yet to be fathomed. Her name is known primarily to other artists. But through some strange stirring of the collective unconscious, her presence is resurgent some forty years after her death.

Morton's metamorphosis from wife and mother to artist was rapid and dizzying. In a 2009 catalog of her work, published by the Generali Foundation in Vienna on the occasion of the first major Morton retrospective since the posthumous traveling exhibition of 1980–81 curated by the New Museum, two photographs mark her two lives. One is a classic black-and-white, all-American portrait circa 1963, in which a demure mother and

her adorable children form a tight group, all neat and shiny, dressed in their proper middle-class best. The other is a sunny color photograph taken in 1976, capturing a fit, tan Morton in tank top and shorts, standing like an explorer by the river, hand on hip, one foot up on a rock. Morton is at Artpark in Lewiston, New York, where she has assembled a group of students to help her with a large outdoor installation, which includes a thirty-five-foot ladder with brightly colored, ribbon-like rungs.

Morton of the forked branches and roads was keenly aware of the apparent dichotomy in her life as mother and artist. In her video interview with Lyn Blumenthal and Kate Horsfield, she talks about this conundrum in her soft, wondering voice as amusement and sorrow pass across her expressive face like sun and clouds. Even after earning her degrees and receiving prestigious invitations to exhibit her work, Morton says, "I still was not able to call myself an artist. I mean, I was a housewife right? I was a mother; I had children; I had a family to take care of." Many women felt stretched on the rack between family and profession. The second wave of feminism was just cresting. *The Feminine Mystique* by Betty Friedan came out in 1963 and lifted the veil on the repressiveness and frustrations of most women's lives. They had been told that their identity resided in that of their husband and children; that they should dutifully put their family's needs before their own, and sublimate any interests beyond the domestic. The first issue of *Ms.* magazine hit the newsstands in July 1972, just as Morton moved to New York and rented a studio in Greenwich Village. Erica Jong's daring novel of female sexual freedom, *Fear of Flying*, came out in 1973. When Morton received her B.F.A. in 1968, she was still living with one foot in the military, one of the most conservative facets of American society, and the other in its most experimental and least understood realm, the art world. Yet even there, women were still relegated to the backrooms, not yet welcomed on the main stage.

Art, Morton says, "was something I did in my extra time. It was taking up a lot of time by then, but still . . . The teachers would talk a lot about commitment, being committed to your work, and somehow that word had a lot of implications that I couldn't accept, the kind of lifestyle that I didn't think I wanted; that somehow if you are an artist you have to behave in a certain way, you had a certain way of looking at the world that I didn't think has anything to do with me, so I would just never be committed, I would

never say I was an artist." But Morton overcame her reservations quickly, and took to the artist's life as naturally as a fish to water.

In her 1976 grant application to the John Simon Guggenheim Memorial Foundation, Morton took a jaunty approach when she described her leap from domesticity to art:

Previous Accomplishments:

My career probably began when at the age of three, when I took up watching ant hills and protecting lady bugs. This caused a long interruption in my artistic progress, because my family read it as an interest in science, and directed me to nursing.

These days, almost anyone would be able to say that keen perceptual skills and patience are sure signs of an artist, but in 1939 the mistake was easily made.

As soon as I realized the mistake, I started studying art, but it was already 1963, and I had a Naval Officer husband, three children, and a house in a middle-class neighborhood in Norfolk, Virginia.

The story from there resembles the feminist classic, "Out of the Kitchen, and into the Studio." I started watching art the way I used to watch ant hills. I got a BFA and an MFA. I learned to use power tools and know the difference between needing help and just thinking I did. I got a teaching job in Philadelphia. I moved to a loft in NYC. I learned to take myself seriously. I learned not to take myself THAT seriously.

I did some good work, got some shows, and some reviews.

Not bad, for a girl.

Morton's irreverence in addressing this august institution is bold and dazzling.

On camera, she becomes more animated when she talks about Marcia Tucker and other intelligent women art scholars and artists she met as a student who were "very serious and very involved in what they were doing. That was kind of a revelation." Morton talks about wanting to be systematic in her work, about her shaped canvases, and her desire to move paintings

onto the floor. Finally the camera pulls back, and we can see into her loft, catching a glimpse of an old bicycle and a great assortment of sculpture-ready materials leaning against the walls. The camera swings back to Morton, who is talking about how she likes to work with her hands, directly in contact with materials. She works fast, she says. Morton pulls her gaze away from her stash. "You can see how I collect just junk—over there. I have things around, and then I work, it's almost a kind of drawing process. It involves picking something up, placing it over there, looking at it, putting something else with it, seeing how they relate to one another, bringing a third thing in, taking it out. It's really physical manipulation."

As the interview proceeds, the volume of the city soundscape rises and Morton has to compete with the churn and honkings of traffic and the calls and whoops and screeches of children playing, as though a school has just turned its students loose into a playground. She talks about the immediacy of working with materials, how tactile it is, how sensual. She is emphatic about the visual experience, about how she wants her work to have a visual impact, and no, she replies to a query, there isn't one way for the viewer to respond. The work must speak for itself. "It should trigger associations that you have because of who you are and where you come from. I would have no idea about that. And that's cool. I don't want it closed, I want it open."

She breathes the word *cool* like smoke, with a distinctly 1970s inflection. It is an era when the doors of perception are open wide, a time of radical new approaches to everything. A back-to-the-land movement is underway, which inspires renewed respect for craft and for folk art. Morton says, "I really dig grassroots artists." Fascinated by the inventiveness and compulsion of naive or self-taught artists, she sees their work as "an affirmation of how important the act of making something is, art that is outside of any knowledge of what a whole art system involves." Morton mentions having met outsider artist Joseph E. Yoakum, in Chicago, and buying some of his drawings.

Yoakum, of African, Cherokee, and French descent, led an even more nomadic life than Morton, and his fantastically patterned and sinuous land-scapes were rooted in his world travels and interest in geology. It makes sense that Morton responded so strongly to Yoakum's drawings because they summon up an archetypal form of landscape, rather than recognizable, earthly vistas. Yoakum described his work as "spiritual unfoldment," and his

vibrant, archetypal landscapes do seem to channel the very life force itself—an act of channeling Morton was also engaged in.

Although Morton's work can appear eccentric, improvisational, and humble (given her use of wood scraps and linoleum), it couldn't be further from naive. Take her large and complex 1973 installation, *Sister Perpetua's Lie*, a series of drawings and wall pieces that extend out onto the floor, one resembling a cage, another a guillotine, emulating the stations of the cross, while also sanctifying the acts of framing and demarcating, key motifs for Morton. The impetus for *Sister Perpetua's Lie* is the hypervisual 1910 novel *Impressions of Africa* by the French writer Raymond Roussel, an avant-garde book that deeply influenced Marcel Duchamp and the Surrealists. Much like his far more renowned Parisian neighbor Marcel Proust, Roussel was peculiar, hermetic, and gifted. Jean Cocteau called him "the Proust of dreams." Poet and art critic John Ashbery writes, "There is hidden in Roussel something so strong, so ominous and so pregnant with the darkness of the 'infinite spaces' that frightened Pascal, that one feels the need for some sort of protective equipment when one reads him."

Morton felt no need for armor. Quite the contrary. Roussel was a kindred spirit who spoke to her directly and sublimely in his dizzying mix of serious intent and high-dudgeon absurdity, and she responded sculpturally. One can read the exhaustively visualized *Impressions of Africa* as a set of instructions for a sculptor, so exacting are Roussel's descriptions of structures, statuary, and pageantry, including an open-air theater, paintings, and objects, some of which are rather horrifying. The novel's impact on Morton's work can be gleaned from reading the very first page, on which the narrator looks out over Trophies Square, where "everything appeared to be ready for the coronation of Talu VII, Emperor of Ponukele and King of Drelshkaf." The narrator's tour of the square includes this description:

> . . . two stakes, each fixed to one corner of the platform and joined by a
> long slack string which sagged under the weight of three objects,
> hanging in a row and clearly displayed like lottery prizes. The first of
> these objects was nothing more or less than a bowler hat with the
> French word "PINCÉE" printed in white capitals on its black crown;
> the next one was a dark grey suede glove with the palm turned outwards

and a large "C" lightly marked on it with chalk; lastly there dangled from the string a fine sheet of parchment, covered with strange hieroglyphics.

A group of French citizens have been shipwrecked in this macabre coastal kingdom and are now witnesses to and participants in odd processions, ceremonies, and performances. The passage most relevant to Morton's piece reads, "Then came a sculptured group, which featured a stirring scene. A man on horseback, with the fierce face of a myrmidon of the law, appeared to be questioning a nun, who was standing before the door of her convent. In the background, in low relief, other men at arms, mounted on fiery horses, awaited an order from their leader. On the base, the title, engraved in hollow letters: *Sister Perpetua's Lie*, was followed by the question: 'Is this where the fugitives are hiding?'"

After several pages of descriptions of paintings, bizarre enactments, a beheading, and acts of torture, Roussel returns to Sister Perpetua: "To the question: 'Is this where the fugitives are hiding?' the nun, posted before her convent, persistently replied: 'No,' shaking her head from right to left after each deep peck of the winged creature, who looked as though he was scratching for food."

Sister Perpetua is a mechanized statue.

When asked about the novel by the off-screen interviewer, Morton replies, "*Impressions of Africa* was a book that just sort of invaded my life for nine months. I just couldn't think of anything else . . . and finally incorporated it into a piece."

Morton paid homage to a very different sort of book a year later. Drawing on the pleasure she took in watching ants as a child, a possible impetus for her love of dotted lines, Morton explored the border between nature and artifice, object and symbol, while playfully bridging the divide between art and science, and venturing into theatrics and games. With all this in mind, she delighted in the informational drawings and text found in a guide to wildflowers titled *Weeds of the Northeast*. Her notebook contains carefully copied facts about jack-in-the-pulpit, swamp cabbage, and the figwort family, and her own botanical illustrations, harking back to her love of science classes. But she also drew a pretty tree-size daisylike flower in a fenced pasture, writing, "IT IS IMPOSSIBLE NOT TO BE DEALING WITH CLICHÉ WHEN DRAWING

FLOWERS. HOW TO DO IT AND LET THAT SHOW?" Morton wanted to slip inside sentiment, mine its essence, and revel in its schlock.

But for now, she created a series of zestful and mischievous plant taxonomy drawings framed in knotty wood and hung on splendidly ugly wood-grain wallpaper, a gift from a student. The down-home look resembles grade-school assignments painstakingly drawn and printed on Big Chief tablets, or the work of a self-taught artist. In another set of drawings devoted to plants and their properties, Morton pursued her love affair with banners and flags, drawing pedants and flags around plant names and positioning them over simply rendered, rustic landscapes, as though they were being pulled across the sky by small airplanes. Morton relished plant names—the broom-rape family, bitter buttons, forget-me-not, snake grass, trumpet weed—and she extracted descriptions from another cherished book, *Wild Flowers Worth Knowing* by Neltje Blanchan, first published in 1917. By drawing words instead of the plants themselves, Morton calls our attention to the perverse fact that humans are more enamored of categorizing and naming the living world than of directly experiencing nature. The naming animal, we are compelled to corral, label, anthropomorphize, domesticate, and commodify the wild, and bestowing names is the first step toward domination. The landscape is a grand stage for human folly, and our habits of labeling and designating boundaries distance us from nature. We pretend to revere the living world, even as we map it, then destroy it.

Morton's rapid ascent in the art world didn't blind her to its contradictions and paradoxes, pretension and competitiveness. She poked fun at the business side of art by drawing little framed landscapes in her notebook and instructing herself: "DO SOME PAINTINGS THAT HAVE RED DOTS ON THEM." The red dot, of course, indicates that a piece has been sold.

Although she was conversant in art theory, Morton distrusted overly conceptualized work. As high as her aspirations were, she was firmly grounded on the earth and loved to work spontaneously, while following nature's lead by forswearing straight lines and machined corners. She was bored and irritated by the rigidity, austerity, and intellectual chill of minimalism, the prevailing style of the time. Morton declined to conform to trends and instead trusted her wit and élan, her impiety and audacity. She wanted to have fun, and wanted others to loosen up.

Morton's toying, topsy-turvy perspective is camouflaged within the beauty and mystery of an installation titled *To Each Concrete Man* (1974). Arranged in a dark room, it consists of a low platform edged with a serrated railing and placed against a wall. Out in the open stand four rough-hewn tables or pedestals built out of tree stumps, balancing on the slenderest of legs, made of crooked branches of different lengths in asymmetrical groups. Skins of irregular dimensions are stretched over the stump tops, not quite covering the wood, suggesting drums. Above each low, tilting table, each an experiment in mass and buoyancy, hangs a tipped lamp, suspended from the ceiling, yet seemingly floating in space. Made of rawhide so that the light glows golden, they're shaped like mushroom caps or simple flowers. They hover like jellyfish in a dark sea. It's an organic piece, vital and atmospheric. Subterranean. But Morton isn't content with creating ambience. There's more going on here. Each pedestal and lamp frames space, spotlighting a small, circular stage, an empty platform. Mischievous Morton has made bases and lights for exhibiting sculptures, but has supplied no sculptures. She thwarts our expectations. She draws our attention to absence. She subverts tradition. She skewers pretension. She writes, "It seems to me that as a result of making the object less precious and turning to the surrounding space, the space has been having its turn at being revered."

Lest this sound just as esoteric and excessively intellectualized as the minimalist work she finds sanctimonious, let it be said that encountering *To Each Concrete Man* is a wholly sensuous experience. You aren't thinking about abstractions; you are giving yourself over to the strange intimacy and promise of a mysterious environment. Writing for the *New York Times* on April 14, 1974, art critic Peter Schjeldahl playfully observes that the lighting and placement gave "the ensemble somewhat the air of belonging in a nightclub for forest gnomes."

But before you imagine a Disney cartoon, consider the source of the title *To Each Concrete Man*; it's from the Spanish philosopher and writer Miguel de Unamuno y Jugo. Morton wrote in her notebook:

Unamuno—proclaimed creed of ideophobia—ideas were not to be worshipped nor followed blindly, but were to be spent, by using them as shoes are used: they were to be subordinated to and made part of life, the

basic reality. Not life in a general and abstract sense, but the life of each individual [*each concrete man*] of flesh and bone, who in Unamuno's view, is the subject and supreme object of all philosophy . . . The novel was to Unamuno chiefly a medium of expression for a philosophy which could not be systematized—a method of vitalizing thought.

"Vitalizing thought" was this artist's mission as well.

Morton was a book lover and a quotation gatherer, and words are a crucial part of her visual lexicon in word-centric drawings and word-emblazoned banners and ribbons. In her notebooks she quotes another of her chosen mentors, the enigmatic and scandalous Belgian artist James Ensor. Unlike wandering Morton, he lived his long life in the attic above his family's house and souvenir shop in the seaside town of Ostend. But there is nothing homey about his macabre, diabolical, and satirical paintings and drawings. His most famous work is the enormous (eight and a half by fourteen feet) *Christ's Entry into Brussels* (1888), a grotesque, clamoring scene embracing a vast mob of people and a profusion of banners and signs. Other paintings feature puppets, carnival masks, and skeletons engaged in various ordinary and disturbing endeavors. Ensor's artistic mastery was matched by a weird, burlesque sensibility that was every bit as cryptic, idiosyncratic, surreal, theatrical, and taunting as Roussel's. Ensor was also a musician and composer, and expressed himself well in words. Morton copied this swoon-inducing passage from Ensor's writing in her notebook:

I love to draw beautiful words, like trumpets of light . . . I adore you, words who are sensitive to our sufferings, words in red and lemon yellow, words in the steel blue color of certain insects . . . subtle words of fragrant roses and seaweed, prickly words of sky-blue wasps . . . words spat out by sands of the sea . . . discrete words whispered by fishes in the pink ears of shells, bitter words, words of fleurs-de-lis and Flemish cornflowers, sweet words with a pictorial ring, plaintive words of horses being beaten, evil words, festive words, tornado and storm words, tornado and storm-tossed words, windy words, reedy words, the wise words of children, rainy, tearful words, words without rhyme or reason, I love you! I love you!

Morton's children went to live with their father in Alexandria, Virginia, when she moved to New York in 1972, an arrangement that lasted for two years (though she and the kids vacationed together during the summers). While in Manhattan, Morton would most likely have seen the work of Saul Steinberg, who described himself as a "writer who draws," on the pages and covers of the *New Yorker*. The brilliant, mordantly witty artist hid the full weight of his virtuosity and vision behind the blithe airiness of brilliant cartoons and clever drawings, potent visual commentary. He and Morton share a sensibility and aesthetic ground. Both felt compelled to illuminate the overlooked and the absurd. Steinberg also loved literature and created arresting word images of arch philosophical and social insight, including drawings featuring banners and signs mocking authority and gullibility. He also, like Morton, created faux maps that chart human attitudes more than earthly geography. Both exposed the ludicrousness of self-aggrandizement and our penchant for delusion. Both artists were masters of the line, and had a profound sense of the line's mysterious vitality. Both sought to charm and disarm, then drive home sharp truths.

Morton responded artistically to every place she traveled. Her 1974 visiting artist stint in Bozeman, Montana, at Montana State University,

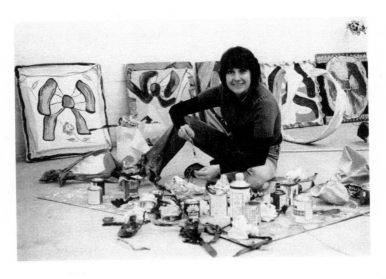

Ree Morton in studio with Beaux paintings. 1974. Photographer: Becky Cohen.

proves to be particularly liberating. While there, she went fishing whenever possible, and pursued an insouciant passion for decorative bows. It amused Morton that the word *bows* not only rhymes with the first syllable of *Bozeman* but also offers punning variations on *beaux*, women's lovers or dandies. By painting big, glossy, showy, flowerlike bows, Morton mischievously explored and subverted stereotypical femininity. She painted portraits of bows that she feels have "personality, i.e. a life force—a way of looking at the world. They see. A lot of my work has that quality—able to see."

At the same time that Morton was busy bringing bows to life, Judy Chicago was directing the communal creation of her feminist installation *The Dinner Party*, saying it loud and proud—women are men's equals and deserve their place at the table, in the historic record, and on museum walls. Morton, who disliked and distrusted stridency, took a more covert approach to protesting sexism. She turned the bow, a girlish item if ever there was one, into an image of radiant power.

In her notebook, Morton wrote,

Women artists tended to be seen as another's wife, or girl, or as a dilettante.

Women are not any more "part-time" than anyone else. Very few artists of any sex do not work at something other than their art to earn a living, though it's true that women often have three jobs instead of two.

Feminist movement instrumental in breaking down the stereotype of the personal in art as "trivial."

UNTIL:

Women artists have been taught by women

Turned on by women's art

become aware & unashamed of the peculiarities of their own sensibilities—

until then I don't think anything definitive can be said.

How inevitable and touching it is that at the bottom of the page, immediately following this gentle feminist manifesto, Morton notes, "Wrote a long letter to the kids . . . Don't lose sight of them and their needs.

Sometimes I think I've blown the whole thing, and then again, it seems to work alright. There's no certainty sometimes. Change is consistent."

As are worry and guilt.

Morton turned away from constructing ceremonial and organic installations out of wood and other natural materials and began working exuberantly with bright colors as she created such decorative objects as flags, banners, ribbons, swags, and garlands. She found the perfect (if hazardous) material: celastic, a fabric impregnated with plastic. When celastic is immersed in acetone, it becomes soft and malleable, a sort of cloth clay. It will stick to anything and hold any shape. As the acetone evaporates, the fabric hardens and maintains a durable surface. Celastic enabled Morton to riff on "fakeness" as she created sculptures that resemble gooey cake decorations or the sets for low-budget community theater productions. Morton fashioned striking works that fool the eye with their frozen drapery, and manifest the dichotomy between ostentatious display and commemoration, as in garish funeral floral arrangements and Victorian funerary monuments, which fascinated her in their elaborateness and mix of elegance and morbidity.

Thanks to her published notebooks, we have access to Morton's thoughts about artificial surfaces, imitation, stage lights, memory versus memorial, pretension versus feeling, and ambiguity versus contradiction. Scattered across the page are the phrases:

Embossed Words—Importance of Edge.
OXYMORON.
Giving special significance to ordinary things.
Things that have to do with ways of commemorating, affirming.
What happens when you put words on an object?
the importance of drawing. To draw with objects
Slogans convince us politically, and phrases from old songs shape us
 sentimentally.
Kaleidoscopic view of life—a new arrangement of signs, an unexpected
 set of formations which may cast new lights and shadows in life but
 without thereby deciphering it.

Morton made celastic wall hangings pierced by lightbulbs and carrying the inscriptions: "Solitary, or Rarely?" or "The Plant That Heals May Also Poison." She built free-standing horseshoe shapes, emblems of good luck that resemble cartoony headstones. These also featured lightbulbs in flowerlike fixtures, and sported crinkly celastic banners that read "Antidotes for Madness," "Of Previous Dissipations," "Terminal Clusters," "Fading Flowers." You laugh, you shudder.

Slim and youthful, Morton stands in a bright Los Angeles studio in what looks like an old factory building. Sunlight splashes against large glass brick windows. The walls, wooden floor, ceiling, and poles supporting the ceiling are a creamy if worn off-white. Morton, her hair cut breezily to collar length, stands in a cheerleader pose, one leg bent, toe to floor, both arms raised, one holding a pole with a long, curving yellow celastic flag. She's smiling. It's a jubilant pose, but her eyes are thoughtful. Like her sculptures, Morton is a study in light and dark.

It could not have been easy, working so intensely on uncharted waters while worrying about her children and longing for love. But in autumn 1975 she landed a one-year appointment as a guest professor in San Diego and brought her two younger children, Sally and Scott, along as Linda began college in New York. She was happy during her sojourn in California. In a remarkably warm, funny, and generous 1976 essay titled "Places: Ree Morton," she declares "since i came to California in september, i've stopped smoking, gained five pounds . . . i sleep more and cry less than i did in New York." She also writes about the irony of her girlhood intention to forever live down the street from her family's house, when instead she's roamed far and wide. She asks herself if any of the places she's passed through have shaped her work, and responds,

> You see lots of good stuff when you keep moving around, although it
> doesn't always register right away. delayed reactions allow for the
> Fermentation Theory. i have this theory that the hot stuff goes into a
> storage bin labeled Good Visual Information, cooks around awhile, and
> jumps on out whenever it is damn good and ready. some of the best

Ree Morton. Study for Signs of Love. *Black sketchbook, 1976–1977.*

visual information i have gotten (excluding very distant memory, which i think happens in a different way) has been from camp sites, construction sites, roadside stands, traffic jams, horticulture schools, tidal pools, victorian cemeteries, scenic overlooks, race tracks, and regattas.

During her California dreaming interlude in 1976, Morton whipped up a circuslike installation titled *Signs of Love* at the University Art Museum in Berkeley, California. This dazzling, room-filling work brought together many of her signature objects and symbols in what Allan Schwartzman and Kathleen Thomas, curators for the posthumous Morton retrospective exhibition that opened at the New Museum in New York in 1980, described as "a veritable rococo feast of colorful celastic ladders, curtains, swags, roses, ribbons, and small panel paintings." Words rendered in large, animated black letters float on the walls like incantations: *Poses, Pleasures, Objects, Moments, Gestures, Symbols, Atmospheres, Settings.* A pair of iconic paintings of a prince and princess evoke fairy-tale romance. It's antic, kitschy, sentimental, and droll. Schwartzman and Thomas cite the French painter Jean-Honoré Fragonard, a master of the rococo style, as a precursor, looking specifically to his love cycle. This series of his large, lush, sensual, even erotic panel paintings of lovers in gardens gone wild replete with cascades of flowers and statues of mythical figures was commissioned by Madame

du Barry, the "official" mistress of Louis XV, only to be summarily rejected and returned to the artist. Fragonard's sumptuous, risqué style quickly fell out of fashion. He later died in obscurity.

Antoine Watteau, another of France's rococo geniuses, may also have been of interest to Morton. His fine line, acute attention to architectural detail, shrewd psychological insights, and embrace of dichotomies could be seen as even more aligned with Morton's forked sensibility. Art critic Jed Perl, in his delectable and incisive book *Antoine's Alphabet: Watteau and His World* (2008), characterizes Watteau's masterpieces as expressing "a mingling of velvetiness and steeliness that constitutes one of the miracles of art." He goes on to explicate Watteau's "delicious artifice" in which his "hiding or veiling or theatricalizing strong feelings becomes a way of revealing the complexities of those feelings," as well as "the gathering contradictions of his world." The French artist and Morton share another trait. Watteau died young, succumbing to tuberculosis at thirty-six in 1721.

In *Making Their Mark: Women Artists Move into the Mainstream, 1970–1985* (1989), Judith E. Stein and Ann-Sargent Wooster include Morton in their discussion of artists forging the "new decorativeness." Work by Miriam Shapiro, Joyce Kozloff, and others evinces a rich spectrum of patterns, textures, and colors. These "decorative" artists embraced "such devalued materials and techniques as mosaics, weaving, fabric, needlework, and wallpaper." Morton's bows and ribbons, flowers and banners, fit right in. But Morton, they note, "produced a powerful and strangely original body of work," one that is far more poetic and searching.

Just as she lived a peripatetic life, Morton did not stay with one artistic mode for long. Following her rococo inquiry into artifice, Morton resumed her contemplation of nature and our perception of it. She tapped into old-fashioned American romanticism in a series of beautiful paired paintings titled *Regional Piece[s]*. Each large, horizontal oil-on-wood panel is draped with a celastic swag. The top paintings depict dramatic sunsets over seascapes; the bottom paintings are portraits of fish underwater, each prismatic fish carrying the radiance of the sky within the ocean deep. Morton's lush and evocative "seasets and sunscapes" form a yin-yang of the cosmos above and the cosmos below. But by framing each painting with a curtain,

like a proscenium, Morton is reminding us that these are cropped and staged views—nature tableaux. The faux drapery brackets and cages nature. By capturing the beauty of sky and sea, sun and fish, then reminding us that this is merely an artist's simulacrum, Morton, as always, is having it both ways.

A clue to her stereoscopic vision is found in her *Journal* essay: "i watched the other day while the horizon line softened, and the ocean and sky turned the same pink, in almost no time at all this big orange ball fell back behind the water, courtesy of California Special Effects."

Morton first came to the School of the Art Institute of Chicago as a visiting artist in 1974. She returned to teach for another semester in the winter of 1976 and spring of 1977, once again living without her children. As always, she responded with lightning-fast accuracy and inventiveness to place, rekindling her architectural ardor in the presence of Chicago's world-famous Louis Sullivan edifices, which include the magnificent Auditorium Building and the gorgeous Carson, Pirie, Scott and Company Building, just blocks away from the Art Institute on Michigan Avenue. Sullivan is remembered for his paradigm-establishing skyscrapers, elegant, organic ornamentation, and the dictum "Form follows function." Morton created a series of drawings and paintings based on his book *A System of Architectural Ornament* (1924), which contains highly detailed diagrams and notes. Morton improvised on a plate titled "Manipulations of the Organic," a schematic based on fourteen leaf shapes that serve as templates for an array of increasingly complex designs. Morton consequently painted fourteen panels, each a variation on Sullivan's forms, and breathed life into them, just as she animated her "seeing" bows.

On February 1, 1977, Morton wrote,

It seems to me that things have to be more serious—that the lightness and joyousness of the last three years has been a good thing, but now it is time to clarify, and to find the meaning . . . It's nice doing this work from Sullivan—RM x LS—Ree Morton loves Louis Sullivan. Looking at his work, thinking his thoughts, and then making them my own . . . it

seems now that the ability to be light and free has been learned, and now it becomes necessary to use that toward some end, in order not to be totally frivolous and irresponsible. Light and ironic on serious subjects, without frivolity. The joy is there. I don't know where it's going, but I can feel the alteration in substance . . . the spirit is working—the drawing is breaking—I'm sure it is art.

Ree Morton died in Chicago on April 30, 1977.

The art critic Peter Schjeldahl was in Chicago to present a lecture at the Art Institute on the day of Morton's death. As he writes in a 1993 essay, he hadn't seen Morton since he met her in Philadelphia while she was still in art school, "an ex-Navy housewife in her mid-thirties with three children . . . She seemed a nice, warm person bedraggled with care and possessed, it quickly emerged, of intense artistic ambition all the fiercer for blooming late. She showed me some works. She may have fished them out of her pockets: scraps of wood with patterned markings. I remember being caught by them. They had something, a fetishy quality offset by sober formality. But the vulnerably eager Morton struck me as an unlikely type to become an important artist. Actually she was a new type."

Impressed by her "ever more self-confident work," Schjeldahl was looking forward to seeing her again: "I had a distant crush on Morton for a while. I think many people did. While being as toughly independent as a woman artist had to be, not to be patronized, she radiated a lovely combination of the maternal and the childlike." Schjeldahl was struck by how passionately Morton wanted to be an artist, how ardently she searched for meaning. He detected a spiritual dimension in her ritualized approach to art.

These were not easy sentences for the sensitive critic to write: "She was expected at a party after my lecture. At the party I heard she was dead. The shock of that evening has not worn off for me."

The artist has been cornered. She's being interrogated by authorities who think they can help her. She's not so sure. She is tense, all but holding

her breath between questions. She listens hard to each query, worried that her answers will make things worse. Suddenly a phone rings. Loudly. Repeatedly. Like an ominous call in an old film noir. Like a dame in distress told to sit tight and do nothing, the artist doesn't move, enduring each prolonged, urgent trill like a slap. The strange, roiling molecular mist thickens and thins. The phone finally falls silent. The inquisitor asks another question. The artist suddenly brightens as she talks about hunting for materials. This is a subject she's comfortable with. "I look a lot." She relaxes a bit, then turns ruefully confessional as she talks about her drawings. She says she wishes she hadn't used such poor-quality paper. When she is asked about the possibility of selling her large sculptures, she lifts an eyebrow and laughs. Her pieces, she says, "need a whole lot of space around them." They're not for living spaces, she observes, they're not "household objects."

Someone or something is pounding on something somewhere out of sight. The artist talks about Stonehenge; she "loves the mystery of it." She loves Japanese gardens. "The relationship scale-wise to the landscape I think is fantastically subtle and really beautiful." The pounding grows louder. It sounds portentous. The artist valiantly ignores it. When her interlocutor asks her if she has anything else to say, if there is anything they haven't covered, she shakes her head instantly, with a pained, tight-lipped smile, like a child held hostage by a displeased adult looking for an apology. The scene turns a bit surreal. Doesn't she want to talk about one more aspect of her work? "No way!" she replies. Her bemused and slightly insulted inquisitor imitates her: "No! No! Get out of here!" We've been transported back to Raymond Roussel's *Impressions of Africa*, where the nun is asked, "Is this where the fugitives are hiding?" Standing protectively before her convent, she repeatedly says, "No," shaking her head from right to left after each deep peck of the winged creature . . . The artist has become Sister Perpetua. She will not tell. Not now, not ever.

The blue haze intensifies, the video hum ratchets up a notch, like an insect swarm. The artist slips back into thought. Her posture eases. She mustn't squander this opportunity. This is important. She summons up new strength, and surprises her discouraged questioner by saying dreamily, "The use of color is extremely important in all the work. A sense of color." She

pauses. "I'm very involved with camouflage." The word makes her smile secretly, as though she's thinking of a lover. "And tracking, marking." Emboldened, the interviewer quickly asks "What are you working on now? Do you have any projects that you're getting into?" The artist has already drifted back into reverie and is startled by the question. She looks around blankly, and answers slowly, "No, not specifically. I'm just sort of resting a while. Just waiting." She falls silent. She sits still, as though waiting to be dismissed, pensive. The pounding resumes, accompanied by banging and crashing.

The catalog's covers are a deep, solid, lipstick red. The title—*Ree Morton: Retrospective, 1971–1977*, printed in black—hovers high in the upper right-hand corner, its placement tacitly acknowledging the void left in the wake of Morton's sudden death. In her preface, Marcia Tucker, teacher, friend, founder and director of the New Museum, where this definitive exhibition originated, explains that although the New Museum "was founded in order to present the work of lesser-known living artists," they chose to make an exception for Ree Morton. Her death "cut short an important and influential career," Tucker avers, yet the "ideas and energies found in the extraordinary body of work she left behind are a living, vital force, continuing to make a real difference to all who come in contact with them."

It's fitting that this retrospective of the work of a wandering artist traveled for a year. The exhibit left New York City in April on the third anniversary of Morton's death and journeyed to Houston, Texas, followed by a showing in Boulder, Colorado, where Morton planned to move with two of her children and teach full time in her first attempt at permanence. Next stop Buffalo, New York, and finally, in the spring of 1981, four years to the month after her death, the retrospective came to Chicago, the scene of the fatal accident. It was a beautiful, mysterious, indelible exhibition, surrounded by a nimbus of awe and tragedy that, sad to say, reflected the duality inherent in her aesthetic: presence and absence.

With the forked stick as her divining rod, Morton mapped paths that connected disparate realms. A mother and an artist, warm and determined, she united the personal with the artistic, the funny with the serious, the

fleeting with the timeless, the joyful with the sorrowful. She yoked together language and image, nature and artifice, romance and isolation, kitsch and grace, teasing and profundity. Herself a connoisseur of words, Morton and her art inspired cascades of vivid interpretations that yield a Mortonesque lexicon: eccentric, playful, rococo, prescient, idiosyncratic, funky, quirky, allusive, enigmatic, feminist, decorative, open, generous, crude, theatrical, hermetic, canny, bumptious, cartoonish, festive, poetic, childlike, tender, saccharine, sad, sweet, vulnerable, disciplined, literary, formal, ritualistic, punning, metaphysical, and pivotal.

When Ree Morton, divorced mother of three, entered the art world in 1970, she found herself in a rollicking realm of anything goes. The do-it-yourself, back-to-basics, power-to-the-people, counterculture approach to life was transforming art-making and art, and Morton became one of the most inventive, intuitive, liberated, and liberating of the make-it-new artists. With her curving, doodled dotted lines, she redrew the boundaries between the psychological and the formal, the cerebral and the sensual. Exuberant and mischievous, she took a boldly theatrical approach to what came to be called installation art, whipping up stage sets and altars meant to alter our perceptions and expectations. An improviser with limited time and means, she sensed that any materials at hand, no matter how worn or ordinary, were valid, precious, and rich in potential. Morton knew that a weed is a glorious manifestation of life, that one's feelings can be monumental. That

Ree Morton. (Blank billboard) Sketchbook, 1976.

art is a collage of past and present, body and mind. She knew that the quest for meaning and expression is an exalted calling, demanding rigor and daring. A cartographer of our uncharted feelings and thoughts, Morton marked the trail for all who follow her into the wilderness of the imagination.

We crave mystery and surprise. We often feel boxed in and shackled. We are so often under the spell of illuminated screens, we become oblivious to the fully dimensional and sensuous world. As our visual sensibility is jacked up by aggressive, hyperactive digital special effects, as machines mediate so much of our experience, contemplation of Morton's vibrant, tactile, dreamy, intelligent, hunter-gatherer creations, even when viewed in photographs, ushers us into a more nourishing, graceful, provocative realm, one that reminds us that we are part of nature, that grand, complex, and secretive living spectacle. Morton's platforms and sticks and guiding lines and bows and banners cue us to the immensity of what we don't know, all that we haven't even noticed, let alone fathomed. Although her tragic death stokes our awareness of life's brevity, randomness, and cruelty, Morton's brimming, adventurous life and celebratory and inquiring art renews our sense of beauty, mystery, possibility, and wonder.

SWIMMING IN LIGHT

JOAN BROWN

My work has dealt with introspection . . . I'm constantly trying to pull out new information from my intuitive self, which results in the surprises that I discover in my work, and which keeps me stimulated.

—Joan Brown

A steep San Francisco street pitches down to the small, pier-bordered beach of Aquatic Park, facing the magnificent, treacherous, busy San Francisco Bay. From this sandy stretch patrolled by gulls, cormorants, and pelicans, one sees the soaring, bright span of the Golden Gate Bridge and the grim hulking rock of Alcatraz. The park's streamlined beach house was built by the WPA in 1936, two years before Joan Vivien Beatty was born to reluctant, unhappy, and inept parents in this city of high hills and expressive nonconformists. Aquatic Park became a refuge for young Joan, an only child seeking escape from a peculiarly miserable family life. On the beach and in the bay she could breathe deeply and move freely as she reveled in the ever-mutable light and bracing breeze. This intersection of the wild and the human-made was a dynamic place of possibility in which Joan could test her resolve and resilience, her courage, buoyancy, and strength.

Joan was a sweetly pretty girl, small and perfectly formed, almost doll-like. Yet she harbored a restless, intrepid spirit. She swam in the frigid water as though the bay possessed healing properties, as though it could cleanse her of her parents' traumas. In the bay she tested her mettle, preparing for a life of her choosing. In those rough yet tonic waters, she learned to rely on herself—on her endurance, her instincts, and her ability to navigate tricky situations. Once she became the artist Joan Brown, the bay was often her subject. She painted its grand expanse dotted and dashed by tiny swimmers in bright caps and dark goggles, their arcing arms flashing

rhythmically, frothing and bubbling the dark water as they propel intently forward, dwarfed by ships, piers, the distant scrubby hills, the resplendent bridge, the hazardous waves. Brave, perhaps reckless individuals pitching themselves against the world, holding course, surging ahead against great resistance and peril. Perhaps inspired by the expanse of the bay, Brown worked on an enormous scale, creating canvases large enough to enter. At Aquatic Park, clouds bright and dark sail by; the clinging, rolling fog is pulled and shredded by the insistent wind; the water changes color and texture as the sunlight switches from tentative to blazing, casting wavering reflections on the hulls of ships, sunbeam calligraphy, as the distant, mammalian hills turn from brown to deeply shadowed blue. Here are big ships docked at the Hyde Street pier, determined swimmers, and the press and hum of the roller-coaster city looming at your back. To stand here is to occupy the capacious and vital living theater of Joan Brown's imagination.

Vivien Beck never wanted children. Her grandmother was born and raised in Monterey, Mexico, one of eighteen offspring and part of the mighty Castro clan, which was prominent on both sides of the border, though in the Bay Area the Castros attempted to elevate themselves above their relatives in Mexico by describing themselves as "California Spanish." When Vivien's maternal grandfather died, her grandmother supported the family, according to Joan Brown, by "taking in washing during the day and then dancing at the fiestas at night . . . so she must have been tough"—a quality her descendent would inherent. Vivien's mother met the love of her life when she was sixteen, Brown recounts: "This is a very romantic story—she was on the beach in Monterey, and met a sailor, who was a Dane, from Denmark, and he didn't speak English, and she didn't speak English, and they got together and got married . . . Now this Danish sailor that my grandmother had married was an adventurer. He was a wild guy, and he was always going off looking for gold and mines and things like that, so he was gone most of the time. So in 1906 he and another guy decided they were going to strike it rich in Salinas." While her husband was off prospecting, Brown's grandmother decided to go to San Francisco with their young daughter to visit her brother, who ran a laundry. The devastating,

now legendary earthquake hit early in the morning. Brown shares the story she was told:

> Everybody was screaming, "It's the end of the world!" and, "Get on your knees!" and all this sort of thing. Streets were splitting open, really ugly kinds of stuff going on, just hideous—and so the firemen came to the door and they said, "We'll give you ten minutes. We're dynamiting this block to try and stop the fire from spreading. We'll give you ten minutes to get out, get your valuables." At that time people didn't keep their money in banks, or a lot of people didn't, they kept it in their homes. But she didn't know where her brother had his money and jewelry, so in a panic she just grabbed things like dirty laundry and my mother. They went out in the street, and that was it.

Mother and daughter ended up camping out, with other displaced and terrified San Franciscans, in Golden Gate Park. They were finally reunited with her brother, who had lost everything. Fortunately another brother lived in the city, and his house, on Market Street, near Castro Street, a house Brown would later inherit, was undamaged. The family regrouped there. But the catastrophe wasn't over:

"Meanwhile, the husband, the Danish sailor, down in Salinas, hears of the earthquake. He knows his wife and daughter are up in San Francisco," said Brown. No passenger trains were allowed to enter the city, only trains carrying relief supplies. So Brown's grandfather, then in his early twenties, decided to hop a freight train bound for the devastated city. But he "missed," Brown said, and "he fell under the wheels, and he was killed." When her grandmother learned of his death, the shock was overwhelming. She took ill, and remained an invalid, often bedridden, for the rest of her life.

Brown's mother's fractured childhood left her determined to avoid having a family of her own. Vivien wanted to attend college and become a teacher. Instead, she had to care for her incapacitated mother. Vivien went to work at a bank, where she met a San Franciscan of Irish descent, John William Beatty. After they married, they lived for years in a tiny apartment with Vivien's mother before their only child was born, when Vivien was in her late thirties and John was in his forties. They knew they had to find a larger

*Joan Brown at age 5. 1943.
Unidentified photographer.*

place. The apartment was so small it had no bedrooms. They put a down payment on a house, moved in, and after a week moved out and returned to their wretchedly cramped apartment. They went through the same helplessly demented process yet again with another house, this time retreating back to their holdfast permanently, in spite of its obvious inadequacy for a family of four. The Beattys had plenty of money, but somehow Vivien could not bear the thought of owning a house. "It was all attitudes and emotions," Brown said, as though living in a proper home would seal Vivien's unwanted fate in a way that having a child hadn't already. Consequently Joan grew up under utterly baffling and aberrant circumstances.

"There was a wall bed in the living room. Every night my mother and father would disarray the living room and sleep in that wall bed. Every night they'd push the dining room table over—we never even used the damn dining room other than at Christmas, and out would come the wall bed, and I had a little studio couch. So I shared this dining room with my grandmother all these years, and I absolutely hated that environment. It was dark, I mean dark in the psychological way, and it was crazy." And as if life wasn't psychologically crushing enough in the cramped Beatty household, Vivien developed epilepsy.

Brown's paternal grandfather was born in Ireland. He immigrated, during the potato famine, to New York, then made his way to San Francisco. There he worked as what Brown described as a "pointer, a guy who did this

fancy work with gingerbread . . . houses." He built his family a house in the Mission District that withstood the catastrophic 1906 earthquake. Nonetheless, his son John, Brown's father, was ashamed of coming from what was then a very poor neighborhood.

After his father's early death, John dropped out of high school (he eventually earned his diploma in night school), lied about his age, enlisted, and served in World War I as a member of the American Expeditionary Force in Siberia. Decades later, a San Francisco gallery owner, Charles Campbell, gave Brown a photograph taken in Vladivostok of her father and his post's baseball team. By some strange chance, Campbell lived in Siberia as a boy at that time while his peripatetic parents mined gold. The soldiers made him the team's mascot.

John Beatty was a small man, apparently overwhelmed by his vehemently neurotic wife. He also had a problem with alcohol. Brown frankly describes the grim Beatty family dynamics:

> He drank himself into a stupor almost every night, which I don't blame him for one single bit. My dad and I were always very close; I was very sympathetic, very protective. My mother would fight him up and down and I'd jump in . . . He was rather helpless in any situation that needed action, and my grandmother was bedridden most of the time, crippled with arthritis. So very often I would have to take over a situation when my mother was sick, you know, with the epileptic attacks, and that would happen any time during the night. It's only been in the last five or six years that I can sleep soundly at night, because I was always alert, waiting for this.

Joan's well-off parents wouldn't replace torn window shades or worn-out furniture; they were so stingy, they cut paper napkins in half. Yet they were willing to buy their lovely daughter expensive clothes, and she acquired lots of pricey items, including cashmere sweaters. The bizarre contrast between her fancy wardrobe and her shabby home cued Joan to the perversity and absurdity of human nature.

The Beattys also paid their daughter's tuition for Catholic school, which she loathed. Joan found all the rules and rituals dull and meaningless.

She was aware that while her parents attended church, they were not actually religious. They were simply doing what was expected of them. It was a social act, a mere gesture toward community. Joan fumed over the lack of coherence in her parents' thinking and lives. Looking back, she observed, "It was wacky, there was no consistency, no point of view that you could put your finger on as a child."

Joan craved certainty, and wholesome domesticity. As a girl and teenager, she was "very, very angry, extremely angry," but she was also "resourceful." Concealing her weird and troubling home life, she made lots of friends and became quite the little ringleader, involving her pals in her enthusiasms. She was devoted for a while to making paper dolls, and "all kinds of clothes for them." She made her own because the manufactured ones "were all the same age and type. And I would have both male and female paper dolls, and all different ages. I used to have one I really liked called Aunt Agatha, a woman in her fifties. And I'd have little kids, and create all these stories and all these clothes for these particular people." She made enough dolls and wardrobes for her and her troupe to enact paper-doll dramas, which she directed, stipulating the personalities of each character. Joan's paper-doll productions were a clear precursor to her narrative art. Many of the figures she would later paint have the flatness of paper dolls, and clothes and textiles are important elements in her work. Her paper-doll plays were an early strategy for gaining perspective on her smothering circumstances, bringing order to chaos, and finding meaning in experience and purpose in life.

Joan's quest for a world wider and more nurturing than her home life also led to her love of reading and her habit of spending many hours in the public library:

> I would go to the library, which was right up on Octavia and Union, and I loved going to it. It looked like a ship, with portholes, a beautiful building, and I spent a lot of time there. I used to set a goal, and I did this for both myself and my girlfriend—again, giving orders, telling people what to do, and we read maybe fifteen books a week or more. It was all about ancient history, mostly having to do with Egypt but some Greek and Roman stuff. Then, too, I would wander around the library

(a lot of times I'd go up at night, it was only about seven or eight blocks away), and would browse around and pick what I wanted.

This self-directed immersion in ancient Egyptian history would resurface in her painting to profound effect.

Swimming was also a significant involvement for Joan; she swam all year round in the frigid, inhospitable San Francisco Bay, in fog and sunshine, serenity and storms, days short or long. Somehow this decisive, bossy, resourceful girl knew how to train herself for a future life radically different from that of her parents, a life of self-definition, self-determination, and self-sufficiency. As toxic as her relationship was with her angst-ridden mother, and as harsh and demanding as it was to have to endure her parents' burdensome eccentricities and shoulder family responsibilities far beyond her years, Joan was brightly curious, creative, active, and unsinkable, pursuing whatever interested her, and fully embracing life. Becoming the one functioning member in her woebegone household empowered her to be herself. Brown reminisced in her frank way,

> It was tense, and I had made up my mind very early that as soon as I got the opportunity I was going to get the hell out of there. And I was always optimistic; the world was a big, exciting place. I didn't feel, as maybe certain kids do, being raised in the slums, that this is all there is. I kn[e]w that this was just one tiny bit of what there was, and that I just had to get through this . . . The home life was so crappy . . . I thought . . . I'm gonna fly this coop. And I hated my mother. We never got along; she didn't like me either.

Her parents tried to be strict and protective, but they couldn't prevent her from secretly running wild. Joan stayed out late, walking home at three in the morning, then climbing over the fence and in through the back window. "So on the one hand I was restricted as hell and on the other hand I just had this insane kind of freedom where I should have been clamped down a bit."

Joan would slip twenty-dollar bills out of her mother's bureau drawer and eat dinner out on her own to escape her dreary family. Like her father

before her, she lied about her age, in her case so she could work during the summer, beginning her ruse at fourteen. She was happy to have a job and liked earning her own spending money. At school she was so smart and self-possessed, she was advanced to the first grade after only a week in kindergarten. She said she "pushed" herself through high school, hating most of her classes and faking it. "I was a little con artist." Joan knew she had to grow up quickly to survive. "I just picked up very fast on what was going on around me."

She didn't know exactly what she wanted to do, but one thing she felt certain she wanted to avoid was getting married: "I hated the guys that I knew. I thought they were real stupid." Instead, she said, "my immediate goal as a young person was to seek a more sophisticated, worldly group of people who in turn would teach me and allow me these experiences outside of the damn Catholic San Francisco environment—as well as my own home." She thought she might become a fashion buyer or designer, and later had no qualms about telling Paul Karlstrom, the West Coast regional director of the Smithsonian's Archives of American Art, that she could have been very successful in that sphere. "I like the fantasy world of clothes . . . I have an intuition as to what will be popular . . . As a kid I was a pacesetter, if you can imagine, in Catholic schools in San Francisco. I was the first to have the very short hair, kind of cut like Napoleon's."

As with Catholic school, her otherwise miserly parents were willing to cover all her college expenses, and Joan was set to attend a girls' Catholic institution, Lone Mountain College. But a week before she was supposed to register, she saw an ad in the newspaper, which she remembered years later as stating: "Be an artist, go to the California School of Fine Arts." Intrigued, this intrepid seventeen-year-old went on her own to visit the campus. Founded in 1871, and built on Russian Hill in a Spanish architectural style, the school offered a grand view of the bay. Although it was only six blocks from the Beattys' squalid little apartment, it was an entirely different realm: an oasis, a sanctuary, a place of realization. Brown said, "I loved the environment when I walked in. It was a whole new world for me, and I was just ready for it, it was just right." Joan saw "this brick patio with the tile fountain, and there's all these guys playing bongo drums around the fountain . . . to me these guys were really sophisticated, really exciting . . . these guys in

sandals with turtlenecks and long hair and beards." She went to the office to find out about admittance requirements and procedures, and then style-conscious Joan promptly headed downtown to buy "more arty attire."

It was easy for her to get the arty look right, but with nearly no knowledge of art or experience making it, she was on her own when it came to creating a portfolio as part of her application. Always resourceful, she used typing paper to create a set of drawings of movie stars. She was accepted and enrolled in the fall of 1955. It was at the California School of Fine Arts (CSFA) that Joan Beatty found her true family, and became Joan Brown.

The first year was daunting. Joan liked her fellow students, many of whom were Korean War veterans whose tuition was covered by the GI Bill. But her design classes made her feel inept and overwhelmed, and she was stunned and unnerved by her first life drawing class when she found herself in a group of primarily men gazing at a naked woman. When her parents saw her drawings, her mother "was going to call the police on the school, because she thought it was some kind of orgy situation." By the spring semester, Joan was deeply discouraged. Her grades were poor, and she was convinced that she had no talent or aptitude for art. She thought, "I'm in the wrong area here. I'm going to get the hell out of this school." Then she met William H. Brown. From Oakland, he was seven years older than Joan and far more educated. At the University of San Francisco he had concentrated on philosophy and literature; he learned Chinese at Yale before serving in the Korean War, and he studied art in New York before returning to his home turf and enrolling in CSFA. Brown remembers, "Gee, he was the ultimate in sophistication to me . . . He wasn't so far out that I couldn't relate to him. He had been to the Catholic schools . . . So he was more or less from the same kind of environment as I was . . . yet he was really sophisticated and traveled . . . I just fell madly in love with him."

Joan was seriously considering dropping out at the end of the spring semester, but Bill not only encouraged her to keep at it but also convinced her to enroll in a summer landscape painting course taught by Elmer Bischoff. This proved to be a crucial decision, bringing Joan together with her greatest mentor.

Although Joan dove into art school as bravely as she plunged into the bay, it took awhile for her to find her pace and acquire agility. Her first

artistic epiphany had been about the promise of an exciting, free-spirited, and cutting-edge life. With her eye for trends and innate hipness, Joan intuited that those long-haired bongo players were onto something new, zestful, and impactful. When she encountered Bischoff at the moment when she was asking herself if she should stay or go, she experienced her first full aesthetic awakening to what it truly meant to live life as an artist instead of just looking the part. Other teachers had opened her mind to the world around her, Brown later mused; "But down deep, psychically, I never got the kind of energies or connections that I got from Elmer . . . I hated lectures, I hated talks. I'd never listened to anybody, or had any respect or paid any attention to anything anybody had said in a lecture situation . . . and here's somebody talking about art in a way that really touches and connects to me."

Berkeley-raised, Bischoff studied art at the University of California, Berkeley, earned a master's degree, and taught at a high school until he enlisted in the air force during World War II. He became a lieutenant colonel in intelligence services, and was stationed in England, near Oxford. Upon his return he began teaching at the California School for Fine Arts and, along with Mark Rothko, Clyfford Still, and Ad Reinhardt, seeded Abstract Expressionism in San Francisco. But in the early 1950s Bischoff resumed painting people, objects, and places, bringing the energy, freedom, and love of thickly applied paint to representational art. He wasn't alone in this fresh, expressionistic approach; Richard Diebenkorn and David Park were also working in a similar mode, thus engendering the movement that became known as Bay Area figuration.

Brown wasn't Bischoff's only grateful student. In 1963 he began teaching at the University of California, Berkeley, and he continued well into the 1980s as a much beloved and notably influential professor recognized with numerous awards and honorary doctorates. Bischoff was admired for his integrity, visual intelligence, close and supportive attention to individual students, and unflagging passion for painting.

Bischoff himself had had an extraordinary mentor, Margaret Peterson, the only woman among the "Berkeley modernists." Born in Seattle, Peterson, like Bischoff, was first a student, earning a master's degree, then a teacher at the University of California, Berkeley, from 1928 to 1950. Peterson's

inspirations included Hans Hoffman, Picasso, Georges Braque, and the Mexican modernists Carlos Mérida and Rufino Tamayo. But she looked beyond modern art for creative sustenance, traveling the world, studying mosaic techniques and Romanesque and medieval paintings, and conducting extensive inquiries into the nexus of art and spirituality, particularly as expressed in the art of indigenous peoples in the Pacific Northwest and Central and South America. Peterson was also unusual in her use of the exacting medium of egg tempera. Many of her jazzy, archetypal paintings are rich in reds and yellows and animated by strong, kinetic black lines and whirls, totemic and iconic compositions featuring figures, faces, and floating symbols, and graced with titles of cosmic implications: *The Gemini, The Birth of Fire, The Gods of Intertidal Waters, Sky Gods in the Dance of Contradiction*. Intriguingly, Brown was to follow a similar path in her life and her art.

Peterson also proved to be a person of principle. During the hysteria of the Cold War and the "Red Scare," fears of a Communist apocalypse led to the establishment of the U.S. House Committee on Un-American Activities and its investigations of private citizens, particularly influential artists, entertainers, educators, and writers. Her university joined in by asking faculty members to sign a loyalty oath. Margaret Peterson refused. In a letter to the university president she wrote, "I believe all political tests to be abhorrent to the principles of our Bill of Rights. My conscience does not admit compromise with these principles." She was subsequently brought before the university's own "Un-American" committee, which ruled that it could not "recommend continuation of employment." Peterson promptly resigned her cherished university position and ended up living in Canada for the rest of her life.

In the summer of 1956, Joan Beatty blossomed in the light of Elmer Bischoff's teachings. From him she acquired the philosophy, mission, and "critical standard" necessary for becoming an artist, bolstered by crucial, life-shaping lessons: "Work hard, respect the validity of your own imagery, take chances, and accept the struggle of the creative process regardless of material or financial success." Brown said that Bischoff gave students

confidence by letting them "make a lot of mistakes." Most essentially for her, "He taught me to see . . . He had us painting things around us, to describe the essence of a chair, of an animal, a simple studio situation, a cup of coffee on a table, things like that. Also the freedom to paint large, which I liked." Joan found her way as she followed Bischoff's advice and permission to be intuitive and spontaneous. She also, wrote curator Karen Tsujimoto in the only book devoted to the artist, *The Art of Joan Brown* (1998), "delighted in the sensuous manipulation of thick, rich oil paint or the soft velvety track of her pencil as she coaxed it across a sheet of paper."

This aesthetic awakening was only the start of the summer's transformations.

Although Bill Brown and Joan Beatty were, according to Tsujimoto, a "vivid study in contrasts"—he was "quiet and soft-spoken while Joan was a petite fireball of energy and feistiness"—they decided to get married. But before the ceremony, in one of those strange interventions of the body when one is under stress and pushed to the limit, Joan became ill:

> I got sick. I got mononucleosis. I was working terribly hard; I got very excited about painting. I got very skinny, down to eighty-nine pounds. I was very sick. (I was still living at home during this time.) So Bill gave me a bunch of books on painting, on the Impressionists, Rembrandt, Goya and Velázquez. While I was recuperating I went through all these books, and I was just knocked out. I'd never seen any of this stuff, and I felt this tremendous surge of energy. And it was a tremendous sense of humanity in these damn things. So I thought that these people, at the end of their lives—whatever they may be, whenever their lives were cut off—must feel a tremendous sense of accomplishment and wonder at having put this all into form, all these feelings. And even then, at seventeen years old, I had a very clear idea, I think, of what went into these paintings, in terms of putting forth this sense of humanity and feeling. I thought, "This is really what I want to do. I could do this. This is what life's all about." It was like in the Bible where God comes out and strikes Paul and he falls off his horse and [the interviewer cannot resist jumping in to say, "And the scales fall from his eyes; he's blind, and then he can see again." Brown resumes] . . . Yeah, I really

felt that way. It was a tremendous change in my whole being which has always affected me.

In August 1956 Joan married Bill, the man who guided her through the choppy waters of her fears and discouragement to the open sea where she would thrive.

After only six months of undergraduate courses, in winter 1957, this young artist who so dramatically "saw the light" exhibited her work for the first time in a small two-person show in the funky co-op Six Gallery, the very space where Allen Ginsberg read his epoch-catalyzing poem "Howl" on October 7, 1955. Brown's work was also being accepted in large group shows. She was working with an earthy palette, applying the paint thickly and zealously in broad, overlapping strokes, layering and mixing colors on the canvas so that different hues and tones show through in a robust play of light and shadow. Some of these physical, urgent works were abstract, such as *Brambles* of 1957. This exuberant jumble of lush impasto in piney greens, browns, and whites won a prize at the Richmond Art Center. But Brown focused most on representational works, using the spontaneity and slashing speed of action painting to indicate the figure in a muscular shorthand in works such as *Portrait of Flo Allen* (1957). Allen was a famous actress and model who posed for many major West Coast painters, including the visiting Diego Rivera, and created the Model's Guild to ensure that models were fairly paid.

In photographs from this time, Brown is often smoking and paint-spattered, and there is no doubt that she threw herself into her work. As Tsujimoto writes, "Her reputation for always being covered with paint from head to toe, because of her uninhibited and exuberant way of working with oil paint, became legendary among CSFA faculty and students."

One of the most effective of Brown's early paintings is *Feb. 13, 1958* (the title refers to the date of her twentieth birthday). A woman stands off to the right with quiet poise and grace, submitting to our gaze, willing to be tested in some unspecified way. She wears a dark dress with a deep red patch catching the light at her groin and right hip; her arms hang down, the sleeves rendered in cascades of blues, greens, and turquoises. Her head is at a slight angle; red shadows surround her eyes and run down the

right side of her face, while a yellow dash hovers above her bright, questioning left eye. The atmosphere is at once somber and expectant, formal and timeless. One can sense the pressure of banked feelings, an inner fire waiting to flare.

As a preternaturally gifted student, Brown took up what became the dominant theme of her work: self-portraiture, a demanding line of intimate inquiry she pursued over the course of many dramatic changes in her painting styles and her life. Tsujimoto writes, "Undoubtedly inspired by Rembrandt's lifelong preoccupation with self-portraiture, Brown claimed herself as primary subject matter for her art. Her emphasis on self-portraiture, like Rembrandt's, was a necessary process for introspection, self-awareness, and ultimately self-definition."

In 1958 the twenty-year-old artist had her first solo exhibition. She also landed in the epicenter of San Francisco's percolating art scene when she and Bill moved to a building on Fillmore Street and became next-door neighbors and close friends with the artists Jay DeFeo and her husband, Wally Hedrick.

An exceptionally versatile and adventurous artist, DeFeo is known best for *The Rose* (1958–66), her legendary mega-layered painting and, in the words of critic Michael Duncan, "whopping metaphor." Weighing in at nearly 2,000 pounds, *The Rose* now resides at the Whitney Museum of American Art in New York.

Born at the start of the Great Depression, DeFeo, like Brown, was an only child forced to cope with a difficult childhood. Her doctor father, of Italian origin, and her mother, of German Austrian descent, did not get along and did not stay together. But early on, she and her mother had accompanied her father on his rounds all across Northern California as he treated people serving in the Civilian Conservation Corps, a public relief program created as part of Franklin D. Roosevelt's New Deal. DeFeo herself suffered many childhood illnesses, and was often left with her paternal grandmother. She even spent one year convalescing in a rest home. After DeFeo's father took up with another woman and started a second family, her mother became a nurse and worked nights to support herself and her daughter. Art became a sustaining passion for the often lonely, isolated DeFeo. When she enrolled at the University of California, Berkeley, her

father's alma mater, she, like Brown's mentor Elmer Bischoff, had been profoundly inspired by Margaret Peterson.

DeFoe's husband, Wally Hedrick, like Bill Brown, was a Korean War veteran. Outgoing, creative, and radical in his approach to art and collaboration, he was a musician, an artist (one of the first to make sculptures out of metal scrap and junk), one of the half dozen cofounders of the Six Gallery, and a counterculture ringleader. DeFeo and Hedrick's Fillmore apartment and studio, situated in a neighborhood of coffee shops, little galleries, and jazz clubs, became a gathering place for the burgeoning Bay Area Beat movement, which drew together artists, writers, and filmmakers who actively opposed the rigid conformity and insistent consumerism of the 1950s. Among this circle were the poets Robert Duncan, Philip Lamantia, and Michael McClure. The artists included Wallace Berman, Manuel Neri, and Bruce Conner.

As pale-skinned Joan and olive-skinned Jay became fast friends and a gorgeous and formidable duo, the two artist couples broke open a wall between the two apartments to let the good times flow freely as they threw marathon parties featuring Hedrick's home-brewed beer, music, crazy dancing, drugs, and general rambunctiousness. The group's antiestablishment irreverence and lack of cash engendered their innovative, liberated, nose-thumbing use of scavenged and ephemeral objects and materials in their art, including Berman's assemblages and Conner's elaborate baroque collages. Joan was making eloquently delicate, cleverly constructed, and witty mummylike sculptures out of "ragged bits of fabric, string, cardboard, wood, or tattered fragments of an old fur coat," creating human, animal, and bird figures. DeFeo and Neri were working with plaster.

Brown remembers, "It was really exciting and highly charged energy-wise, lots of psychic energy or whatever fancy terms you want to give it, or I want to give it, was going on. We charged each other up constantly . . . It was kind of like a big burst of energy, a rebirth in a sense. For a very short period of time." Drugs, especially marijuana and at times peyote, helped stoke this whirling atmosphere, but Brown wasn't into that: "I don't like any drug but alcohol frankly."

The year 1959 was one of even more accelerated propulsion for Brown. She earned her bachelor of fine arts degree, and decided to stay at CSFA to

work toward a master's. She "accidentally" acquired representation at a New York gallery when, at the urging of her friends, gallery owner George Staempfli surprised her by showing up at her studio and immediately purchasing two paintings. But Brown, true, for once, to her roots, was so skeptical, she worried that the check Staempfli handed her was "phony." She brought it to the bank where her father worked, and he initially shared her suspicion. Neither could believe such good fortune. But they were wrong. Staempfli proved to be totally on the up and up, and another life-changer for Brown. Not only did he return and buy six more paintings, he also included Brown in a two-artist show scheduled in New York the following year, and arranged to pay her a monthly stipend in the interim. At twenty-one, Brown had achieved the sort of success most painters can only long for.

Buoyed, she extracted herself from two untenable situations. She felt that she had to separate from Bill. Looking back, she admitted, "Right away the marriage started going to hell." Not only were they opposites in temperament, but Joan was also very young, and this was her first serious relationship. But the primary reason the marriage didn't take was that she was so intensely dedicated to her studies and to making art. Brown reflects, "So I worked like hell that first year, just went one hundred percent into it"—to the detriment of her marriage. Still, she affirms, "Bill and I were very good for each other in those early years. We both learned a lot, and parted friendly, and have remained friendly."

She also knew that she had to get clear of the Fillmore Street scene:

After a point it really got too damn hard to handle it. It was out of control and it was interfering . . . There were too damn many parties. Although I was younger and I was strong, physically and psychologically and could withstand a lot more than I can now . . . even then I had a very private kind of introverted side to me. Which, of course, I had developed strongly as a child and had nurtured and protected over the years. And after a point that started to get a little invaded. And although I couldn't put it in the words that I'm saying now, I could put it in simple terms. I got sick of people coming over. And I got sick of a party every time I turned around. I got sick of drinking so damn much gin, which, of

course, is my own fault and responsibility. No, it made me crazy and wilder . . . I just got damn fed up with it. I realized it was cutting into my privacy, which I very much need. So I got the hell out of there. I left. Bill and I split up, which was really my doing. I wanted to get out of there to go on my own. So I moved out and Bill remained.

It wasn't total solitude Brown sought, however, but rather a quieter and more productive life with an artist with whom she was more in sync. She had a "special rapport" with sculptor Manuel Neri. They "each brought to their work a similar personal attitude—an attitude that prized high energy, speed, and spontaneity and working with unpretentious, low-brow materials." She and Neri began living together and sharing a studio on Mission Street close to the Embarcadero, "a move that marked the beginning of an intensely satisfying period of creativity and partnership for the two artists."

Manuel Neri was born in California's Central Valley in 1930, after his parents fled Mexico. He tells the story:

Well, my family was from a little village in the highlands near Guadalajara, and the name of it was Arrandas. And my father . . . had gone through university in Guadalajara. Was, you know, trained to be an attorney . . . He met my mother and married. And he was working for the revolutionary government . . . That revolution of 1924 in Mexico was really against the church. And unfortunately, my mother's family was pro-church. And at one point, one of my uncles on my mother's side set out to kill my family. And my family could have just easily had him hung or shot with no problem. And my father did a fantastic thing, which was go to Mother and say, "Dear, I can't, I can't do this. We'll never be able to have a family together if this happens. It's not a matter of just killing one of your brothers. It's a matter of killing all the males in your family because these family things, feuds, are like that." And so my father said, "Instead of that, I'm going to go to America and then send for you." And so he came here to this country and got a job. Fortunately, he spoke a little English . . . and was able to get along in this country and later sent for my mother.

Neri's father went to night school, studied auto mechanics, and began fixing cars for a living, but this was during the Great Depression, and he just couldn't earn enough money. He ended up working in a vineyard, and died when Neri was only nine. As World War II got underway, Neri's mother moved to Oakland, where she found work. Neri went to high school there, then enrolled at the University of California, Berkeley, intending to be an electrical engineer. He'd barely begun his coursework when, during the summer, he attended San Francisco City College "to make up some math classes I needed and an English class. And just out of dumb luck, I decided to take an art class for an easy grade. And I met a wonderful man who changed my life."

Roy Walker encouraged Neri to visit different art schools and sit in on classes. Sure enough, Neri decided to abandon engineering for art and transferred to the California College of Arts and Crafts, in Oakland. There he began painting in an Abstract Expressionist mode and making sculptures—primarily in plaster because it was inexpensive, required little equipment, and enabled him to be spontaneous. Neri got along well with teacher and painter Richard Diebenkorn, so he followed Diebenkorn to his new teaching position at the California School of Fine Arts.

Neri met Brown for the first time in Elmer Bischoff's CSFA class, and remembers her as being "wild as hell." He describes their interaction:

> For me, it was a very comfortable relationship, and that was because I liked what she was doing, I trusted what she was trying to do . . . and we talked. We exchanged ideas a lot and got along great on that. You know, we felt free to . . . walk in the studio and say, "Hey, I don't like the way that arm is going. Can I change that?" And just go over and do it . . . And nobody thought anything about it, you know. I mean, she might change it back again afterwards but no big deal.

Brown said, "Manuel and I always influenced each other a great deal, way before we were ever together. When we first met we were sympathetic and responsive to the same kind of work and attitude behind the work that each of us did. We automatically clicked in terms of work."

It's a profoundly intimate act, to share a studio, almost more so, in

some ways, than sharing a living space. And you can see the synergy in their work. Both Brown and Neri were involved in active and expressionistic interpretations of the figure; both used material lavishly and actively, working with speed and emotion, intuition and trust in the process. Neri created his evocative *Windows* paintings and began the work he is best known for, female figures of complex energy and resonance. Brown began the new decade by stepping away from abstract painting for good, in spite of the phenomenally positive reception her Abstract Expressionist paintings had garnered. This refusal to be trapped by the expectations of others would always be her modus operandi. As she found the peace and harmony she needed in her new, cozy home with Neri and Bob, their bull terrier, Brown began painting her private world with zest and wit, working on large canvases with brilliantly bright and contrasting colors thickly and athletically applied.

The expansive diptych *Model with Manuel's Sculpture* (1961) celebrates the vibrancy of their mutual studio life. It is large enough to make the viewer feel that she can walk into its highly animated space, a fizzing realm of luminous rectangles and other geometric shapes gleaming against a layered, darkly shimmering void. Two of Neri's roughly textured white and beige female figures, one standing ramrod straight, the other half perched on a yellow-and-red stool, anchor each panel, while the living, fleshy, dark-haired model, seen from the back and rendered in pinks and peaches and blues, stands in blue high heels. In the lower right corner of the larger panel Bob the watchful dog looks out at the viewer with bemusement. It's a stop-action mise-en-scène reverberating with collisions between light and dark, the living and the manmade, and capturing the charged atmosphere of the studio and the current that flows and sparks between life and art.

Brown addresses the domestic side of her new life with Neri and Bob the dog in *Family Portrait* (1960). A red easy chair is at the center, and on it a dark-haired, dark-eyed, mustachioed man is squarely seated, his legs in dark brown pants parted, one arm resting on his thigh. A woman is perched on the arm of the chair, her legs crossing over his left leg, her hands in her lap. Her red dress, with its bold pattern of black slabs, clashes with his bright green-and-yellow plaid shirt. The dog, gleaming white, forms a canine triangle, seated with his front legs straight, his head facing

protectively forward, eyes looking at the viewer, ears perked attentively. The man's eyes look to the side. The woman's face, her eyelids bright, her lips deep red, is tilted toward him, but she, like the dog, looks out steadily, even stoically, at us. She has a beauty mark on her left cheek, as did Brown on her right. The three figures present a unified front. On a flaming orange table stands a heavy ceramic vase in which long-stemmed flowers arc. In the upper left corner a tulip-shaped, golden hanging lamp serves as the room's flowery sun. The floor is a pool of dark blues and black. The figures are rigid; only the flowers are unconcerned as they gracefully absorb the light. So staid is this painting in its composition, the figures' expressions so serious, brooding, and guarded, it stands in intriguing counterpoint to the bohemian life the couple, who were not yet married, were actually living. Given Brown's fascination with the subversive aristocratic portraits of Diego Velázquez, is she aggrandizing a humble American home? Perhaps she's parodying the conservative, buttoned-down, orderly mid-twentieth-century definition of the American nuclear family? Or is she portraying the intensity of their personalities and the strength of their bonds? Whatever her intentions, when a collector purchased it, Brown wrote to Staempfli, "I'm glad you sold *Family Portrait*. I hope he appreciates it because it's the most personal painting I've ever done. I'm sure he does or he wouldn't have bought it. Sound pretty sentimental, don't I."

Neri was teaching a course at CSFA. Brown had her gallery stipend, and she was teaching art at a private school run by an older woman, a situation she described with her usual bluntness: "I was teaching at . . . oh, God, this is hideous. I was working at a private school for rich children, earning $117.00 a month. Teaching five days a week, although the teaching time was maybe only two or three hours. It took time to get there and time to get back. But I was painting before I left and painting when I came back. It was very intimidating. The old woman was an alcoholic. Again, it was a very bizarre kind of situation, absurd. As absurd as the situation that I was raised in as a child."

Later she said that for all its challenges, the experience was instructive. Establishing the pattern of exceptional productivity that was to characterize her entire life, Brown was also exhibiting regularly at this time, receiving positive reviews and the occasional prize. In 1960 she made her

first New York appearance in a two-person show, and she had work in two prominent traveling exhibitions, including *Women in American Art*, which also featured Lee Bontecou, Helen Frankenthaler, Grace Hartigan, Georgia O'Keeffe, and Louise Nevelson. Brown also received her master's degree, making this yet another banner year in her remarkably fruitful, young art life. It was high time to celebrate.

In 1961 Brown and Neri went traveling. First they spent three weeks in New York. "Then we got on a boat and went to Europe," Brown recounted. "And I loved that boat. I went crazy on that boat, just absolutely wild for the five days that it took us to cross. I had a wild romance on the boat, and was absolutely obnoxious. I won a dance contest and stuff like that." Kalstrom asked, "A wild romance with Manuel?!" Brown replied,

> Oh no! No! With somebody else. I had just a marvelous time. It was the first time I hadn't painted, or wasn't in an art situation for the number of years since I'd started. And there I was on the high seas. Just eating, drinking, sunning, and swimming . . . Great fun. So anyway, we got to Europe. And one of the goals was George Staempfli's place, the art dealer in New York, who had a house on the Costa Brava . . . a very fancy house, right near Marcel Duchamp and Dali and, who was it? Max Ernst? Man Ray, that was the guy. He had a house there. So we went directly there from the boat. We took a train into Barcelona, some overnight deal. Finally we got to Cadaques on the Costa Brava. We stayed at Staempfli's very fancy place, where you pressed a button for the maid to come in and pick up your towel off the bathroom floor. That's how fancy, how rich it was. And we were waited on hand and foot.

Neri remembered calling Staempfli from Madrid, asking if they could come visit. He told Neri, "Okay. Come on over. We're going to have a party for you." Neri continued,

> So we arrived late in the day, went straight to the party, walked in. The list of the people who were there were just a knockout . . . Man Ray was there. [Marcel] Duchamp was there, and . . . all these others that I

probably don't even know who the hell they were . . . [Salvador] Dali was there. He lived close by . . . All I could do was like back up into a corner and sit down, and . . . a funny thing happened. Duchamp's girlfriend came on to me, this big, tall beautiful knockout redhead. She wanted me to go hiking with her, and I kept looking at Duchamp and saying, "Oh, my God." And I said, "I'm sorry. I can't go." Anyway, I was with Joan. And he was kind of laughing over in the corner. And then he said, later toward the end of the evening . . . "Hey, join me for coffee in the morning." . . . We were there about four days, and Duchamp and I would have coffee every morning.

Brown and Neri subsequently traveled all over Spain. Brown was ecstatic over seeing paintings by Francisco Goya and Velázquez in the grand Museo del Prado in Madrid, describing the experience as "unbelievably moving."

When Brown and Neri took a train from Barcelona to Rome, their luggage was accidentally left at the Spanish border. So when they were invited to join a friend that night at the opera to see a performance of *Aïda*, Brown insisted that they splurge on tickets and clothes. Brown's love of costumes, spontaneity, and passionate embrace of life are all on display in this episode:

Because it was spectacular and extravagant, all the elephants and all this with *Aida*. So that was great fun, spending and wasting all that money. For me it was just a luxuriant experience of going up these tiny steps to one of those marvelous beauty salons where they have little busboys who are like the old Phillip Morris guys with the little hats, wearing mandarin clothes and bringing drinks and all. So I had the whole works. I had my hair dyed and set, my eyelashes dyed, a makeup job, the whole thing. Everything, which took half a day. Then I went to all the shops, the boutiques. You go in and have dresses shown to you. You just sit in a room like this and people come in and model the dresses. You say, "I like that." If they don't fit, they tailor them right there; went to a shoe shop and a lingerie shop, and just spent a hell of a lot of money. It was great fun. And all of us decked out like celebrities and going to the opera.

London was their last stop. Brown loved the city and was floored by a major Rembrandt exhibition they had the good fortune to see. Brown's remarks about the show presage her approach to her own work going forward: "It had some of the best art I've ever seen. And I liked some of the worst; it just showed this guy never took a middle road. It was either all the way or nothing. He either fell flat on his ass or excelled. It had that whole set of self-portraits in all these far out and very straight get-ups. And there was the tremendous exchange between the self and what he was portraying of himself on the canvas."

Two contemporary painters also excited Brown. She very much admired the daring British painter Francis Bacon. Brown talked about what spoke to her in his work and why:

> His hardness and his unyielding imagery. And his simplicity for me is the utmost in simplicity. There's nothing there that isn't necessary. You don't have to wade through a lot of stuff to get through to me what is the core. That doesn't mean that is the core. Someone else, someone sitting next to me, may see the core of his work as something else. The core to me is his connection, his sympathy, his anger, his understanding, etc. You know, of humanity, of the world about him. And it doesn't necessarily take place in the imagery that he represents. Because I really believe imagery is a vehicle for all these feelings and insights and thoughts and ideas that we have about the world around us. His imagery happens to be the particular world that he deals with. It certainly isn't my world. But he hits on many of the things that I feel and want to hit on myself.

The other living artist Brown revered was Willem de Kooning, particularly his acidly controversial *Woman* series; ferociously angry, seething, jarring, toothy, busty, violent, archaic yet atomic-age portraits of women that boil with the might, allure, and terror of female power. Many consider these images to be hotly misogynistic, but Brown saw them differently:

> I was very interested in slopping paint around (I don't see it as slopping paint around, but that's an easy term to give it). But I love his surfaces.

It's beautiful. And his combination of light. I like a lot of technical things. I like the way he described things, fought with the surface, and this kind of thing. This goes back to when I first saw reproductions of de Koonings in the late '50s. And boy, he was a hero to me. As time has gone by, since the late '50s, gradually I've been very much less interested in his surfaces.

I can still find them sensual, sexual, exciting, but not with the same enthusiasm that I did years ago. What stands out, what I like as much, or perhaps more so, was the earlier paintings of the women series which I connected strongly with . . . There's a marvelous humaneness in those. It's a whole complex of emotions that I get from them . . . They're angry, on one hand they're put-downs, and yet they're terribly sympathetic to the image that he's dealing with. He put a vast array of dimensions within the emotions.

Upon Brown and Neri's return from their European adventures in September 1961, Brown began teaching at her alma mater, and launched a feverish wave of new paintings clearly influenced by the places and master-pieces she'd steeped herself in overseas. She painted a flamenco dancer. She painted an opulently loving portrait, *Bob, Sultana, Guard* (1961), based on a photograph she and Neri posed for in Alhambra, Spain, all decked out in Arabian costumes. In the painting, Brown brought their dog into the tableau and achieved a deftly distilled approach to the figures and the architectural and textile patterns that inspired Matisse in his Moroccan paintings.

Brown also created tempestuous compositions in homage to Rembrandt's portraits of women. *The Day before the Wedding* (1962) is an eruptive, prismatic, and very intriguing variation on the Dutch painter's subtle and haunting *Susanna and the Elders*. In Rembrandt's at-the-time daring interpretation of the biblical story of lechery and coercion, strength and faith, beautiful Susanna, wearing a veil on her hair and partially wrapped in a white cloth, is leaning forward, one hand raised, as she steps gingerly into a shallow pool in a grotto. She looks at the viewer with poised alarm, while two extravagantly attired, turbaned men crouch threateningly behind her, one grasping the pristine cloth that preserves her modesty. In her version, Brown has concentrated on a resolute Susanna, turning her

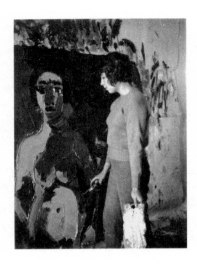

Joan Brown painting. 1962.
Unidentified photographer.

pose into one of decisiveness, more like that of a diver about to plunge into what looks like the turbulent bay, with hills and a fireworks sun in the background. Brown's is a provocative image of a woman ready to leap into a new life, a new marriage. Brown has yoked together the past and the present, tracing the common thread of human vulnerability and resilience.

In a year in which she already had solo shows in San Francisco and New York, this young artist ascending had her first one-artist exhibition in Los Angeles. She worked and worked and worked.

Two months after her return from Europe, Brown became pregnant. At the start of 1962, she and Bill Brown got divorced, and she and Manuel Neri got married in Reno, Nevada. Impending parenthood transformed their lives and their art. Brown began painting female nudes, an inquiry generated, perhaps, by the changes to her own body. *Girl Sitting* of 1962 depicts a woman seated at the right edge of the canvas, filling it nearly from bottom to top. Her face is roughly modeled out of green, scarlet, and cadmium yellow. The crown of her head glows with wriggling lines of pink, a caress of floral light. Another pink swath covers her right shoulder; her dark hair is gathered at her neck. Her right arm, in pinks and reds, rests protectively over her round white belly, while her other arm, glowing yellow in the same beam that catches her forehead and nose, reaches out over the painting's edge. Her white breasts have bright red nipples; the same red forms the triangle indicating her pubis. A patch of buttery cadmium

yellow heats up her left thigh. Dark-blue lines shadow her neck, and wide dark-blue strokes cross her collarbone and slant down to meet between her breasts. The background is a corduroy of madder and Venetian-red strokes with black and olive-green shadows. The woman's large, dark Coptic eyes look entranced and inner-directed.

Similar anonymous, multihued, timeless female figures stand in a tumultuous sea of paint beneath a wild sky in the mural-like *The Moon Casts a Shadow on a Midsummer Night*, also of 1962. Artists had been painting nudes beside or in bodies of water for centuries before Matisse and Cézanne brought fresh vigor to the classic juxtaposition. When Brown weighed in, she created a night of moonlight and shadow as a scene not of tranquillity or enchantment but rather of fierce, crashing, primeval turbulence. One wide-eyed female figure stands at the left edge of the canvas. Much of her body is in shadow, but her strong-featured face, large-nippled breasts, and target-like belly are illuminated as a great, seething crest of golden yellow covers her legs and collides with similarly bounding waves of red infiltrated with tracings of black and green and foamed with white. A second female figure is more deeply submerged, the rocking, jumping moon-lifted water reaching her belly. The moon is both a source of reflected radiance and the gravity that pulls forth the tides. Here light and water are one. The sky is a bedlam of blues and blacks slashed with yellow and red, and sky and sea meet in a smash of spray and sparks. The chromatic women stand calm and still amid the turmoil, steadfast beings born of this roiling sea.

Neri became permanently enthralled by the "archetypal female figure." As a father, he recounts, "all of a sudden, the woman became . . . this life-giving source for me. And I started using the female form as the vehicle to carry my ideas." He constructed life-size sculptures out of wire and wooden armatures, then slathered them with plaster that he gashed, scraped, notched, and doused with paint. Brown was muse, model, and mate as the two artists encouraged and supported each other, "each vitally stimulated by the other's work." Tsujimoto writes, "For these two young artists, unburdened by concerns of material success, and overflowing with uncontained energy, there was a tremendous sense of shared creativity and freedom." As Neri combined painting with sculpture, Brown, bewitched by "a purely hedonistic love of her medium" and driven by a tidal sense of urgency, built

up sculptural surfaces on her canvases out of pigment as thick as two to three inches. She was working so frenetically that she didn't wait for layers of paint to dry, resulting in sections sliding slickly right off the canvas splat onto the floor. Part of her impetus for this was "feeling very strongly about the background not just being a background, or backdrop for the figure, but believing that it was every bit as important physically as [the imagery] in the foreground."

When their son, Noel, was born, Brown, twenty-four, was suffused with "immense happiness." She did not cease her perpetual creativity to accommodate this profound change in her life, but rather moved her studio into her home to stay close to her young son. She painted at night, and continued working on a mammoth scale by using smaller panels that were later hung together as diptychs and triptychs. Appreciating anew her mentor Bischoff's advice to paint the world around her, Brown did so with avid pleasure. She created ebullient still lifes and interiors, such as *Refrigerator Painting* (1964), a luscious kitchen scene with raucously patterned wallpaper in yellow and green, a bulky black clock, and an orange-breasted, red-beaked bird, actually a sculpture Brown made, standing on top of the big, friendly appliance, while a large emerald-green houseplant reaches in from the left.

Brown also joyously painted scenes from her son's childhood, sunny, swirling, expressionistic paintings radiant with wonder and love. *Noel on a Pony with Cloud* (1963) is a sweet, bursting, bright carnival of color and happiness. *Noel on Halloween* (1964) portrays the boy standing in a red room filled with immense houseplants. He's wearing a cat or leopard costume and holding a white-and-black bird, presaging Brown's future darkly amusing human and animal pairings. Her robust impasto conveys the energy of both the child and his artist mother, who is pushing herself to keep house and studio humming. The daunting complexity and affectionate comedy implicit in this challenge is hinted at in *Noel in the Kitchen* (1964), in which a tippy stack of dirty dishes projects precariously over a counter's edge. Two large dogs flank little Noel, who may be turning a knob on the stove, while his pants have slipped down to expose his cute little buttocks.

During a retrospective exhibition of his mother's work at the San Jose Museum of Art in late 2011 and early 2012, Noel Neri, himself an artist,

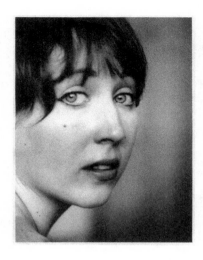

Joan Brown. Close-up. 1964.
Unidentified photographer.

spoke about Brown with sweet enthusiasm and humor. "She was really a good mother. She was also an artist, and she had to kind of keep that separate, and that was quality time for her. And occasionally she would share that with me. She liked to have me in her studio as she was painting and comment on her work and I have very fond memories of that. That was really special."

Beginning with *Family Portrait*, and including the paintings in which Brown so contentedly records her son's childhood, her work was coalescing into "a vividly colored and grandly sized family album." This marks an important shift in Brown's work as she began to purposefully and candidly chronicle a woman's life, a subject rarely considered worthy of high art. Ultimately, Brown took this interpretive documentary approach in surprising, even audacious directions.

Her larger-than-life family album includes *Portrait of Lupe* (1962), a paean to her mother-in-law, "whom Brown greatly loved and admired." Perhaps Neri and his mother kindled a new appreciation in Brown for her own Mexican heritage, a bond reconfirmed when she inherited the house once owned by one of her Mexican great-uncles, the small Victorian that survived the 1906 earthquake. The family moved in, and Brown set up her studio in the basement. Brown's depictions of her son's warm, happy, coherent childhood stand in confident opposition to her own oppressive upbringing, a contrast that infuses these paintings with a triumphant

delight. These images of youth, innocence, and promise also arise from Brown's abiding sense of the universal human condition.

As cozy and productive as this time was, Brown was always up for adventure and perpetually open to change. When she and Neri were invited to teach for the summer at the University of Colorado at Boulder in 1964, she let this fresh environment guide her toward a different medium. Working quickly in this new, temporary space, she created free-flowing black-and-white drawings and broadly sketched, loosely painted, roughly layered collages, some as large as six by seven feet. After she attended a Beatles concert that was part of the group's inaugural American tour, she made portraits of the Fab Four and of the Rolling Stones. Her exploratory, transitional Boulder works pointed forward to Brown's growing interest in line, even as her rock-and-roll portraits look back to her first drawings of movie stars. Then, in one revealing piece, *Couple with Dog* (1964), Brown reprises and revises her *Family Portrait* of 1960. In this much more informal, nearly cartoony composition, a man in stripes sits on a dark chair, one leg crossed over the other, his right elbow on the chair's arm, his head resting on his fist. It's Ringo Starr. A big-footed dog stands nearby and seems to be frowning. Brown, in a dress and clunky high heels, sits on her indifferent companion's lap, her expression tense, even sad. Brown was on the brink of a seismic shift.

A selection of Brown's large collages were on display in the show she and Neri had in Los Angeles that following winter. When her paintings of her son were shown at the Staempfli Gallery in New York, for the first time critics were less than captivated by her heavily sloshed surfaces. And they weren't the only ones "questioning and doubting her work." Brown herself was concerned that her painting technique has lost its force and meaning. It was time, she felt, to move away from impasto, the style that had brought her such early and resounding renown. Brown's marriage to Neri was also losing its electricity and depth. Having learned as a girl to watch out for herself and to extricate herself from detrimental situations, she wasn't the sort of person to cling to a faltering relationship or domestic arrangement purely for security's sake, or to please others. She and Neri separated in 1965. Brown also put an end to her profitable affiliation with the Staempfli Gallery, a brave and risky step that potentially jeopardized her future as an

artist. But success breeds demands, and this was making Brown wary. "When the pressure got heavy, I refused to maintain anything in my work that bordered on product. I decided in '65 that I was bored with what I was doing and there was a lot more to be learned. So I stopped painting heavy expressionistic paintings and did a lot of studying—I became my own teacher, a student of myself."

Brown immersed herself in the paintings of Giorgio Morandi, an Italian still life painter who had just died the year before, and whose contemplative style was as far from the molten vehemence of Francis Bacon and de Kooning as one can get. Focusing on objects with simple forms and quietly eloquent presence—vases, bowls, pitchers, and bottles, placed in the sparest of settings—Morandi depicted his evocative arrangements with a subtle, poetic palette, exploring nuance, balance, and opposition. Morandi's contemplative still lifes, with their metaphysical aura, lean toward abstraction and are considered to be precursors for minimalism—the antithesis of Brown's large, surging, aggressively chromatic canvases. Morandi's intimate, understated paintings and meditative approach directed Brown toward a new way of working.

She reflects, "I . . . decided to work very subtle, very small, to be much more conscious of what I was doing. The gallery flipped out, of course. I was also showing in L.A. at the time, and I said the hell with it and I went underground for three years—exploring and studying these new areas, and painting new pictures. I realized that in that gallery situation I was in there was no room for change and I just couldn't handle that so I got out when I became aware."

"I felt a tremendous sense of freedom," Brown later said. "I didn't have to answer to anyone . . . I really did feel that art is one of the few things where you are one hundred percent free, where you don't have to answer to anyone but yourself. I'm never going to give that up. I won't lose that again." In yet another conversation, she said,

> I got the stars out of my eyes much earlier than a lot of people do, and I had a choice to either really turn out products and be "successful" or to follow my own interior. Therefore I had to go underground for a number of years and give up the outside success, which I have never regretted. I

push other people to do that, too, to go to a higher place . . . It was difficult as hell. I thought, "Am I doing the right thing or not?" I sort of stumbled around. But I found when it was getting monotonous, when the inspiration and struggle was no longer there, that no amount of success and money and fame would influence me to give up the freedom.

While speaking with *Artbeat* in 1981, Brown shared a key insight into her feelings about living life as well as making art: "I really don't like staying in one spot; I don't like repetition. It seems like the minute that I'm comfortable, I move into an area that is more challenging for me." Interviewer Claudia Steenberg-Majewski asks, "Do you think you are finding out about how far you can go?" Brown replies, "Oh yes, I like going over the edge. I like really going into areas which one used to call the unconscious and the subconscious. Or I call them the super conscious. Higher levels of oneself. Yes, I like exploring past what I know, past what my body can do, past what my rational mind, imagination, is hooked into."

Brown never played it safe; she never held back.

The habitually productive painter spent much of 1965 struggling with one painting, a humble still life comprised of two eggs and a cucumber on a table and a larger cucumber or squash on a countertop in the upper left corner. *Still Life #1* is a study in beige, browns, and greens in which the artist was using "thin layers of oil paint and limiting her palette to subtle colors." This was a transitional work, entirely personal in its mission, and it isn't very exciting to look at; yet, as curator Karen Tsujimoto writes in *The Art of Joan Brown*, it "was vitally important to the artist, for in the process of working on it she rediscovered the freshness and energy for painting that she feared she had all but lost." Brown committed herself to this intense focus and the discipline of learning an entirely new technique while she was raising a three-year-old son and adjusting to single motherhood after she and Neri divorced in 1966. He moved some forty miles away to Benicia, and began teaching at the University of California at Davis. She began therapy "after I'd been married twice and thought, 'What the hell's going on?'"

Brown began spending long, inquisitive hours at the newly opened Asian art collection at the M. H. de Young Memorial Museum in Golden

Gate Park. Arriving early in the day before the crowds, she studied the varied acquisitions of industrialist and collector Avery Brundage, art ranging from a gilded bronze Chinese Buddha dated 338—the oldest such work on the planet—to Chinese and Korean ceramics, Indian sculptures and miniatures, and Japanese scroll paintings. Here was an entirely different world, far from the canvases of Rembrandt, Goya, and Velázquez in outlook and expression. While the impact of this Eastern submersion was only intermittently detectable in a new body of work that would soon occupy Brown and baffle friends and critics alike, its influence would flower fully and dramatically later on.

During this time of personal and aesthetic transition, Brown made some funny, funky cutout sculptures, variations on the giant, cartoonish, rock-and-roll collages she made in Colorado. These pieces initiated what became a deep and abiding theme in her work: a mythic, even mystical pairing of animals and humans.

Her wry wit is evident in *Untitled (Tiger)* of 1966, a small poster-board cutout of an openmouthed tiger standing up like a man, wearing a fake leopard-skin shirt. *Rock and Roll Rat* (1967) is a thirty-one-inch-high painted plywood figure: a rat-headed musician in a wildly patterned blue-and-green shirt that clashes rowdily with equally hectic pink dotted and dashed pants, accessorized with a wide yellow beaded belt and platform shoes. An electric guitar with an STP sticker juts out from his side as he stands with his arms folded. These teasing flat, frontal figures reach back to Brown's childhood passion for paper dolls, and forward into her evocative explorations of self, nature, and the cosmos, though she never gives up her impish forays into the absurd. Brown offered a glimpse into the source of her humor and its place in her work throughout its many metamorphoses:

> From my childhood I got a very strong sense of the absurd, and all the dimensions that happen within the absurdity—happiness, humor, gentleness, violence—all this stuff that can go into absurdity. W. C. Fields is a great example of this and one of my very favorite artists of all time. This thread of what I call absurdity, and I could mention some actual situations going back to my past, has been a real main thread throughout the work I've done, almost from the beginning. And this,

again, I feel is a great connection and a gift from my own past and something I really express, and I feel that maybe the main communication I have in what I do that other people can relate to.

After her long, solitary struggle, a veritable penitential retreat, with *Still Life #1*—its two large eggs signaling an impending rebirth—Brown began painting in a mode so radically different from her rambunctiously expressive impasto paintings that her new creations seem to be the work of another artist. And it was during this sea change that animals became essential and evocative presences in ways far more mysterious than her rock-and-roll rat or the companionable dogs in her earlier family portraits. In *Lion in Fake Environment* (1967), for example, a realistically rendered male lion with a regal mane fills the frame, his expression questioning, wary. Brown widens the lens to capture a strangely glowing, stylized landscape in *Great Cat with Madrone and Birch*, circa 1968. A range of cloud- and snow-wreathed mountains runs along the right edge at a slant, overlooking a vast, flat, featureless desert on which stand two slender, leafless pole birches, a red, valiantly twiggy and leafy madrone (a West Coast evergreen with peeling red bark), and a burst of green, branchy shrubbery, all emitting an otherworldly, syrupy light. At the center, a large gray cat sits up straight and attentively, ears perked, yellow eyes wide and staring, whiskers alert, and long, white-tipped tail extended along the sandy ground. The scene is at once somber, mysterious, and theatrical—a dreamscape. In *Grey Wolf with Red Clouds and Dark Tree* (1968), a huge, sky-filling cloud hangs above a gawky, splay-footed wolf, who looks like he wants to play. Or be rescued. *Buffalo in Golden Gate Park*, of the same year, is an affectionate portrait of an impossibly cute buffalo facing the viewer and chewing meditatively on a stick, his widely spaced eyes high up and close to his small curving horns. His hoofs are as shiny as dancing shoes. A pine tree stands beside him, a branch reaching above him in spiky benediction, the red ground thick with pine needles, the pinking sky serene; a patch of peachy light crowns his hump. These paintings possess an aura of fantasy, of childhood wonder as perceived by an adult, specifically an artist enthralled by her young child and his innocent receptivity to the world.

But Brown was not only painting from the heart, she was working as a serious artist steeped in the work of her forerunners and contemporaries. So

what else inspired such dreamy works? Such tenderness? Such mischievous humor? In her quest for fresh ways to see and to paint, Brown was closely studying the luminous, meticulously realized fantasies of the self-taught French painter (and civil servant) Henri Rousseau. Championed by Picasso, Rousseau became a guiding force for the Surrealists, Max Beckmann, and countless other artists and poets. He is known far and wide for his ubiquitously reproduced masterpiece *The Sleeping Gypsy* (1897), a desert tableau beneath a full moon in which a peacefully curious lion stands over a sleeping woman in stripes, her lute and water jug beside her. Brown seems to have responded deeply to the magic spell of Rousseau's compositions, in which humans and animals meet, and his heightened attention to every detail. After creating her slapped, sloshed, slashed, layered, kinetic canvases with few lines, let alone fine details, Brown was seeking control, precision, stillness, and flatness: a more forthright and direct form of expression. With an eye to Rousseau, Gauguin, and others who worked simply, even what some called primitively, Brown was not only shaking off her own whirling-dervish approach but also defying, as Tsujimoto suggests, "either deliberately or disinterestedly, the classical standards of traditional figurative painting that are based on conventional subject matter, draftsmanship, and illusionistic perspective and modeling." Not to suggest that Brown in any way compromised her standards, skill, or intensity. She made numerous drawings and sketches of the animals she carefully observed day after day at the San Francisco Zoo and Golden Gate Park, and thought hard about what she was hoping to achieve.

As a teacher, parent, and artist, Brown was sharply observant of and receptive to her environment, including San Francisco's Haight-Ashbury district, the epicenter of the hippie movement in 1968, the year these paintings were made. With psychedelics, rock and roll, and Eastern religions providing inspiration and guidance for those seeking alternatives to postwar consumerism and conformity, the city was kaleidoscopic with all things bohemian, rebellious, irreverent, mystical, outlandish, and exalted. The counterculture was seeking liberation on all fronts, from attire to sexuality to citizenship, while calling for peace and a return to nature and more holistic, more organic ways of being and knowing. Brown was painting her visionary, even hallucinatory animal paintings, with their peculiar distortions,

supernatural colors, and soulful animals, at the height of this frenetically experimental, intoxicating, and intoxicated time of acid trips, outdoor festivals, underground comics, and frenzied recklessness. Yet in the midst of this upwelling of unchained expression and celebration of altered states of consciousness an atmosphere in harmony with Brown's trippy new paintings, the profit-focused art world did not welcome her radical artistic transformation. Instead, her new work was summarily dismissed as genuinely naive and unintentionally primitive, an absurdly cavalier characterization Brown hotly protested. Clearly, her approach was an aesthetic and philosophical choice, a deliberate exploration. She asserted, "I feel that my paintings are very sophisticated and much more intellectual than people realize." This would not be the last time critics viewed her work reductively, inducing Brown to speak out and correct them.

As her work changed, so did Brown's appearance. Photographs and self-portraits document chameleonic changes in her hair color, texture, length, and style. Blonde, red, brown. Short, long, smooth, curly. Did she tinker with her looks as though she herself were a work of art? Did painting self-portraits lead to self-image experimentation? In a 1979 video interview, Brown sports a dark, frizzed perm cut into a white-gal Afro. Smiling sardonically, the pain still palpable, she says that her late 1960s work was "absolutely panned." Staring off into the distance, she remembers, "Even friends of mine said, boy, you lost everything you had—you never should have given up that old way of working. But I knew this was a good change for me. [She raises her eyebrows.] Scary but necessary. So after that one show in '68, I went underground again [she laughs] and didn't show again until 1971. I didn't have a gallery again until 1974."

To step away from a sure thing, from success in the trendy and fickle art world, required bedrock conviction. Or, as Brown would have said, it took guts.

In a carefully lit black-and-white photograph circa 1962, four men and one woman stand with almost military attention in two rows in a high-ceilinged space with shadowed brick walls. Each gazes at the camera with serious intent. Though they're dressed comfortably in sweaters and pullovers, they

clearly mean business. This is one artists' group portrait in which the woman is resoundingly identified. The setting is the studio of Alvin Light, a California School of Fine Arts student who became a longtime faculty member, and a painter who became a sculptor working primarily in wood. He is the only male artist in the photograph who will not marry the woman. The other three men are William H. Brown, her first spouse; Manuel Neri, who will become her second husband and the father of her child; and Gordon Cook, destined to be her third.

This resolute photograph documented the four's collaboration as a drawing group that met regularly to keep each other on track, and to pool their resources in order to hire a model. Just as Joan and Manuel already knew each other when she married Bill Brown, Gordon Cook was part of her circle all along. Eleven years older than Brown, and at least a foot taller, he was from Chicago. He earned his B.F.A. in 1950 at Illinois Wesleyan University, then he studied intaglio with the influential teacher and printmaker Vera Berdich at the School of the Art Institute of Chicago. In 1950, Cook went to the University of Iowa in Iowa City, where he studied with the singular Mauricio Lasansky, who grew up in Buenos Aires, the son of immigrant Eastern European Jews. Sustained by Guggenheim fellowships, Lasansky left Argentina in 1943 and became an American citizen. When Cook joined him in Iowa, Lasansky was establishing the country's first M.F.A. printmaking program. Cook studied with this pioneering and influential master, then moved to San Francisco, where he parlayed his printmaking expertise into a paying gig as a printer's apprentice in the International Typographical Union. Married with two sons, Cook supported his family as a journeyman typesetter, working on his art and eventually teaching printmaking during his off hours. He and Brown met when they were both part-time faculty members at the San Francisco Art Institute. They got to know each other better when Cook began talking with her about his desire to learn to paint.

Curator Barbara Janeff described Cook as "a large, handsome man, very direct with a sly sense of humor. He was open to the world but critical of fancy art world nonsense and pretentiousness in general." Versatile artist Don Ed Hardy, most famous as a tattoo innovator and founder of the arty apparel brand Ed Hardy, studied with Cook at the San Francisco Art

Institute. In a vividly illuminating tribute to his mentor, Hardy eloquently describes Cook's "magnetic and singular personality," far-roaming erudition, gravitas, and wit. He writes, "Gordon's aesthetic was absolutely unique. His extreme seriousness about making art (though he disdained such a loaded term) was balanced with a great wildcat humor." Cook, Hardy explains, maintained a blue-collar perspective and mocked the romanticizing of art and artists, valuing, instead, "the demands of the craft of printmaking and painting." It was through this rigorous practice, Cook told his students, that one experienced spontaneous transcendence. Cook's credo was "Get it right."

Friends could not understand how feisty, "firecracker" Brown and "quiet, somber, and introspective" Cook could be a good match, but in fact the two were remarkably simpatico when they married in 1968. Both despised pretension; both were ardent, inquisitive readers; both loved animals; both were passionate about music and dancing; both had sons; and they shared "a certain mystical sense about life." They were also passionate about swimming in the San Francisco Bay's thrashing waters, which Cook believed were "restorative and magical." These soul mates would profoundly inspire and buoy each other at critical conjunctures throughout their mutually creative time together.

Brown explained her feelings about matrimony: "See, I've been married three times. I get married. I prefer family life. If some crazy catastrophe again happened and I was alone again, either through being a widow or divorced, or what have you, I'm sure I would marry again . . . I like the structure of family life, I like the growth and the exchange that can take place with a close relationship. I'm very much a focused or channeled kind of person."

Cook was unique in his full support of the new direction Brown was taking in her work, and she encouraged him as he underwent his own artistic change, setting aside the exacting technical rigors of printmaking and picking up the brush. Cook's fascination with Morandi was deeper and more lasting than Brown's, and he began drawing and painting dignified and vital still lifes featuring coffee cups, glasses, tins, boxes, bowls, and pitchers, paying particular attention to reflections and shadows. He also painted hats, books, and other objects in a palette weighted toward grays and browns,

taking obvious pleasure in investigating the interactions of light and dark; color, line, and mass.

Before their wedding, Cook gave Brown a book about Henri Rousseau, which electrified her, replicating the impact of Bill Brown's prenuptial gift of books about Rembrandt, Goya, and Velázquez. For Brown, love and art were inextricably intertwined.

In 1969 Brown painted a mammoth two-panel celebratory portrait to add to her evolving "family album": *Gordon, Joan and Rufus in Front of S. F. Opera House*. Her source was a handsome photograph of the two of them all decked out for a night at the opera, a picture Brown transformed by working on a grand scale with saturated color and touches of the inexplicable. The couple faces forward formally, even stiffly. Cook is tall, powerful, and debonair in his black tux, black tie, and white shirt, his dark mustache trimmed, his black-framed glasses bright with reflections while his dark eyes look to the side. His right hand clasps his left as Brown stands beside him, her right arm in the crook of his elbow, her midnight-blue sleeveless gown starred with a beaded pattern along the décolletage, her left arm stretched at her side, a patterned silver clutch purse in hand. Her eyes are the lightest, most beaming blue. The couple's gleaming shoes seem not to be touching the blue swirl-textured sidewalk (or is it a carpet?) edged with red brick and running along a raised-bed allée planted with lavish greenery and trees. Are they levitating with happiness? On the left sits Rufus the dog. His dark, white-speckled coat looks appropriately dressy; so, too, his red collar with its silver disks. His long, bright red tongue hangs down. The cerulean sky is threaded with rosebud pink; the tumbling, balloonlike fair-weather clouds are subtly indented to form hearts. The Rousseau glow and stylization are undeniable, but this capacious diptych is also in accord with the colorful, similarly posed portraits David Hockney was painting in Los Angeles. Brown's is the Bay Area side of the same shiny new portraiture coin. This is a breakthrough painting for Brown, a tribute to her third marriage and the start of a new, extraordinarily fecund and exciting time of "prodigious creativity."

The woman painter most famous for chronicling her life in self-portraits—and what a life of epic suffering and resilience it was—is the Mexican

artist Frida Kahlo. There are some formal and thematic parallels in the work of the now iconic Kahlo and underappreciated Brown. Brown's portrait of herself and her new husband, for example, echoes Kahlo's folkloric double portrait *Frieda and Diego Rivera* (1931). Kahlo used the German spelling of her name in this composition, which she painted in Brown's hometown, a work that at once celebrates and subtly satirizes her relatively new marriage to the famous, soon to be heatedly controversial muralist. The couple came to stay in the city in late 1930, while Rivera worked on his commission for the San Francisco Stock Exchange. Left to her own devices, Kahlo avidly explored San Francisco, entranced by its beauty, and particularly fascinated by the Chinatown neighborhood. Kahlo met photographer Edward Weston, who wrote about the couple in his diary, describing her as "a little doll alongside Diego, but a doll in size only, for she is strong and quite beautiful, shows very little of her father's German blood. Dressed in native costume even to huaraches, she causes much excitement on the streets of San Francisco. People stop in their tracks to look in wonder." Kahlo, charismatic in character as well as appearance, smart, well educated, and fluent in three languages, struck up other friendships in San Francisco, including one with a crucial supporter of Rivera's, the insurance broker and art collector Albert M. Bender, who made it possible for Rivera to enter the United States after his visa was denied because of his standing as an outspoken Communist. As Rivera gave lectures, worked on his murals, and, in keeping with his chronic infidelity, vanished for days in the company of another woman, the tennis champion Helen Wills, Kahlo began painting.

In *Frieda and Diego Rivera*, the couple stands side by side, facing forward, as do Cook and Brown in *Gordon, Joan and Rufus in Front of S. F. Opera House*. Rivera, as in life, is nearly twice Kahlo's size. He is wearing a dark suit, blue shirt, wide belt, and large, sturdy shoes, and he holds the classic emblems of the painter, brushes and a palette. Kahlo, in a long, dark, full-skirted dress and tiny sandals, demurely holds his other hand with her left as her right clasps her patterned and fringed red rebozo. A rosy bird with blue-tipped wings flies above, carrying a banner that reads: "Here you see us, Me Frieda Kahlo, with my dearest husband Diego Rivera. I painted these portraits in the beautiful city of San Francisco California for

our friend Mr. Albert Bender, and it was in the month of April of the year
1931." At a glance, this seems like a sweet, tender tribute. But for all his
monumentality, Rivera's expression is guarded, while tiny Kahlo, a feather-
like ribbon in the braided crown of her hair giving her an aura of buoyancy,
has her head tipped to the side and a droll and challenging look on her
pretty face, as though cueing the viewer to the hidden complexities of their
union. Kahlo's biographer, Hayden Herrera, writes that the artist seems
almost to float "in the air like a china doll . . . Yet Frida's penetrating gaze
has a note of demonic humor and gritty strength, and for all the solicitous-
ness and 'femininity' of her pose and dress, she is self-possessed." Kahlo
presented the painting to Bender as a gift, and he subsequently donated it
to the San Francisco Museum of Modern Art in 1936. Might Brown have
seen it?

Beautiful and photogenic Kahlo, in her elegant and elaborate tradi-
tional dress and jewelry, crown of dark braids, dramatic eyebrows, and
dignified poise, would ultimately paint dozens of arresting, unnerving, and
unforgettable self-portraits in which she imaginatively, forthrightly, even
surreally chronicled her life, from pain and anguish to her depthless
capacity for sensuousness and love and her profound appreciation for beauty
and tradition. Horrifically injured at age eighteen in a bus and trolley-car
collision, Kahlo underwent many medical miseries and was often encased
in a back brace, which made everything, including painting, difficult. Yet
Kahlo pressed on, surrounding herself with beauty and turning the act
of dressing and ornamentation into an art form and political statement
in her embrace of indigenous Mexican textiles and jewelry. In her self-
portraits, Kahlo created settings with symbolic implication. Animals appear
often in Kahlo's paintings, as in Brown's, from dogs and cats to monkeys,
parrots, doves, and an eagle. Herrera explains that Kahlo loved animals
as companions and perhaps as substitutes for the children she could not
have. Through animals she felt connected to life in spite of the cruel isola-
tion caused by her injuries. She painted animals to affirm "her feeling of
oneness with all living things." Even so, Kahlo recognized that animals
embody a force beyond our understanding and control. They can be
menacing as well as wondrous. Brown perceived this, too: "They might
be domesticated, and they might have human characteristics . . . But

nevertheless there is the sense of unpredictability, of wildness. Even a pet poodle or Chihuahua . . . My dogs are unpredictable. And there's a sense of tension, anxiety, which we all feel around animals to one degree or another, whether it's a bird or a bunch of fish in a tank."

In *The Little Deer* (1946), Kahlo painted a hybrid human-animal figure (as Brown did, decades later), placing her head on a stag's body, which is pierced by nine arrows. As in all her self-portraits, even while in pain, Kahlo remains stoic and calm, gazing steadfastly at the viewer. Brown, too, in her infinitely more fortunate circumstances, painted herself with a similarly collected expression, creating a paradoxical dynamic of self-scrutiny, self-revelation, and self-possession even in the act of self-portrayal and self-exposure. The artist remains in charge. Any disclosures are carefully considered, calibrated, and formalized. Both artists boldly, sometimes humorously, and, in Kahlo's work, tragically addressed female sexuality, female images, female creativity, and female power. In their potent, disconcerting self-portraits, both artists covertly affirm and assert the significance of women's lives and the legitimacy—indeed, the necessity—of art about women by women. Brown said, "I feel most of my work, if not all of it, is like keeping a diary." As practiced by Kahlo and Brown, self-portraiture is also a conduit through the precincts of the self to universal concerns.

In spite of receiving acclaim during her lifetime, at least in major art centers, Kahlo was still little known in most of the United States by the time Brown became an art student. It wasn't until the feminist art movement gathered steam in the 1970s, and a retrospective exhibition of Kahlo's galvanizing work appeared in six cities across the United States in 1978 and 1979, that Kahlo and her piercing images of mythic resonance, cultural pride, sexual unconventionality, and profound suffering began to be fully appreciated. In the early 1980s she became a figure of veneration and inspiration, one of few women artists the public was aware of and enthralled by. Though Brown's thoughts about Kahlo are not on record, she must have become cognizant at some point of Kahlo's figurative, autobiographical, iconographic paintings. Brown, with a Mexican branch on her family tree, and who had married a Mexican American with whom she had a son, would eventually become utterly fascinated by ancient Mayan culture and art, a wellspring for Kahlo's creativity.

During the summer of 1969, Brown was invited to be a guest instructor at the University of Victoria in British Columbia. There she discovered a Chinatown quite different in atmosphere from San Francisco's, and full of much more intriguing art and objects. She was "struck by their vibrant color and design," and inspired by their "curious duality between 'funky' roughness and elegance." This introduction to another facet of Chinese culture, after her close scrutiny of the classic Brundage collection and growing appreciation for her new husband's deep fluency in Asian thought, instigated a fresh inquiry for Brown into the role of art in society past and present.

The couple made a bold move in late 1969: they left San Francisco, the only place Brown had ever lived. Cook was frustrated with changing attitudes at the San Francisco Art Institute, and concerned, as a teacher and father of two young teenage sons, about the increasing presence of drugs at their school and in their neighborhood. So the family of five humans— Brown and her son, Noel, and Cook and his sons, Matthew and Paul—along with two dogs and an ever-expanding clan of cats (the count rose to sixteen), relocated to the peaceful Sacramento River delta, some sixty-five miles north of San Francisco. They found a house in a very small town with the appealing name of Snug Harbor, on Ryer Island, but it wasn't snug for long: a flood forced them out of their new home. This disaster proved providential in the end; in nearby Rio Vista they acquired a property even more conducive to art-making, consisting of two acres with two houses and a barn, which became Brown's studio. She took a leave of absence from teaching, and fully immersed herself in her new world.

This momentous separation from her hometown for the first time may also have been precipitated, however subliminally, by two jolting losses. In January 1969, just two months into her marriage to Cook, her father died of a heart attack. In spite of his drinking, he'd been healthy, so his sudden death at Brown's parents' apartment early one morning was a complete shock. Brown said, "I felt a big, big loss, 'cause as I say, he was a nice, nice guy. I really liked him."

Then, six weeks after her father's death, Brown lost her mother too:

She hung herself in that apartment . . . All the talk, "I'm stuck with this goddamn drunken husband, I'm stuck with you, you brat, I'm stuck with

my mother." [She was always fighting with her mother, whom she chose to take care of rather than put in a rest home.] She was a very unhappy woman . . . But what was ironic was that when she did have the opportunity to make a new life, once my grandmother was in the rest home, I'd been long gone, my father dies, she has plenty of money on her hands, six weeks later she hangs herself.

Finally her chance came, what she'd always talked about, but she couldn't cut that. It was very interesting, when she died I didn't cry. As somebody said, "Maybe you shed all your tears years before," which I had. But as time passes, I feel sympathetic; I feel sorry. But I don't feel that connection, that so-called love you're supposed to feel for your relatives. That had been long gone.

Brown talks tough in this interview, but she knew her mother was even more depressed than usual after her husband's unexpected death. Brown had been calling her twice a day, and went to see her often. Concerned about her mother living alone, since she blacked out during epileptic seizures, she'd looked all over the city for the ideal assisted-living arrangement, finding a

real neat condominium, they have a doctor and nurse on call all the time, all safety devices, a nice social room. Geez, you couldn't have a nicer setup. I would have moved in in two minutes if I was, you know, old, and decrepit, and had the money. Hell, it was nice. We were just about to get her to get out the cash. The attorney said, "Aw, this is terrific, it's just right for her, blah blah blah . . . " She said no, she wouldn't do it; she wanted to go back to that goddamn bleak apartment . . . I was concerned . . . So I called her that night, and she was alright, and she said she'd made her will out. I called her early that Friday morning. She sounded really depressed, really out of it. But it wasn't much of a switch from how this had been for thirty years, on and off. She'd always talked of suicide when I was a kid, constantly referring to suicide—she was going to go off the bridge, all the time she was going to jump off the bridge. She'd say, "Oh, look, here's another one off the bridge. Well, I'm gonna be next." . . . Yeah, which scares the hell out of you when you're a

little kid. Geez, it was terrifying. So anyway, that evening I called and she was out, probably at the neighbors'. That morning I called and there was no answer. She was due at a bridge club, she had some screwy bridge club, and they called and said she didn't show up. I said, "Gordon, something's wrong."

So we went over . . . oh, this was odd. I woke up that morning and I felt different, before I called my mother. I felt different, I felt a burden was off me, to tell you the truth. At first I had a hard time explaining it, it was like missing an arm or a leg, I felt different. It was like a hum, a noise was gone. I believe very strongly in this kind of communication between people, psychic energies, whatever you want to say. I'm not trying to be far out. I think at some point science will prove all this stuff the same way as electricity was. But I felt like a loud noise had stopped. I felt freer, I felt better . . . I paid no attention to why, but I felt different.

When they arrived at the building, Brown, sensing something dire, insisted on going to the police station instead of going inside the apartment. They returned with a police officer, and he and Cook entered the apartment and found Vivien's body. Brown wasn't surprised: "This had been in the works for so damn long, by personal choice." She concludes her recitation of these hard facts, "So that was the end of that, that was the end of family life."

But she had her own family. And this abrupt end to her constant worries about her parents, along with her inheritance—her parents "left, in cash, close to a quarter of a million dollars, which I blew most of in about a year and a half or two years"—enabled Brown to enter a golden zone of creativity.

In the Sacramento River delta—in a new, rural environment and a new studio—Brown began working in a new style with new materials. She had been seeking paints that would dry as quickly as acrylic, but that would retain the opulence and depth of traditional artist's oils. She discovered the perfect solution when she ran out of paint in her delta digs,

far from any art-supply outlets. She headed to the local hardware store to see what she could find and returned to the studio with gallons of oil enamel house paint in a variety of colors. To her delight, she found that the sumptuous oil enamels gave her precisely the surface she wanted, while drying rapidly. She reported, "I find it very, very durable; I can get a very flat, opaque surface that will look like a refrigerator surface, or I can use many layers of transparency." And she loved the bright, shiny colors. Eventually she began adding glitter to the paint to give it "another kind of texture and to reflect light in a different way." Brown also used glitter "to designate cheapness, vulgarity, things like that." She began painting on Masonite for its uniformly smooth, hard surface, using full sheets that measured four by eight feet. These enormous sheets ultimately proved to be too heavy to work with, so she switched back to canvas, achieving the slick surface she wanted by heavily priming the canvas with rabbit-skin glue.

While Cook, inspired by the flat, humid delta and its trees and grain elevators, painted contemplative landscapes of muted hues and peaceful, humble beauty, Brown developed a controlled, linear, richly prismatic approach. Brown elucidated her intentions:

> And as the years have gone by I want more of the clarity and the simplification, especially in dealing with figures . . . I have this need to paint people and paint things in general. In a way, for the past three years, finally it's coming into focus. And it's a very pleasing, very thrilling and a very scary kind of situation because it's starting to take form. I'm getting rid of a lot of the excess baggage, a lot of old ideas about what works and what doesn't, what art is . . . And I've been getting down to painting things clearly that are important to me, which are usually incidences, either symbolic or literal, that have happened in my own life and experience. And doing it without . . . the trappings, and the fancy paint work. Not to say there isn't a response to the materials. There's a definite tactile thing . . . There's a speed to enamel and it's right there, you have it. If you're particularly impatient, it's [a] great medium. You don't have to add oil, you don't have to add thinner. If you're brushing, you can put it on and it's right there. You can take it off if you don't like

it. But nevertheless, it's sensual. I like the look; I like the smell . . . So yes, that is important. I don't mean to say I'm just doing the imagery and that's all I care about. No. I like the two things to go hand in hand. I like to be brought back to the fact that this, after all, is only paint on canvas, aside from the other things that go on.

In the hilly, busy, cacophonous city, Brown practically swam in a sea of thickly applied oil paint. She painted with great swooping energy, creating dense, layered, ridged, grooved surfaces, images pressing forward into space, toward the viewer. Now that she was in the country, where everything was quiet, open, and flat; where she lived beside a serene, fish-filled river and worked in a stand-alone studio surrounded by greenery and trees, a place where farm animals once lived and where wild-life still thrived, Brown became more interested in detail, in smoother surfaces, in more defined subjects, in more narrative works. She began using smaller brushes along with the more liquid, quick-drying paints. While in the hard-edged, human-built cityscape she had felt the need to create lushness and action on the canvas, on the delta the living world around her was so sensuous and saturated with hidden life, she sought to capture and counter that ambience with precision and stillness, developing a visual iconography and meticulous style rooted not only in close observation of nature but also in her deepening study of mythology and sacred texts.

So there they are, in a blue-collar world, an hour's drive away from Haight-Ashbury, which was losing its love-in glow as harsher drugs prevailed and the cashing-in on the counterculture grew more cynical and cutthroat. After the shock of her parents' deaths, and the unshackling of the chains that bound her to their unhappiness, the delta must have felt Edenic to Brown, a place of rebirth and renewal. Certainly a feeling of natural abundance is evident in the astonishing flowering of her art in 1970, a year of her own personal renaissance as she followed her brush into a new realm of symbolism and allegory, dream and quest. Alone in her barn turned studio, far from the pressures of the art world, she worked steadily, creating a profusion of startlingly original and compelling paintings.

At the center of *In Memory of My Father, J. W. Beatty* (1970), set against a deep red background, stands a sturdy wooden box with metal braces at the corners with this inscription painted in black:

SGT. JOHN W. BEATTY /(887214) / A.E.F. SIBERIA / FEB. 5, 1897–JAN. 21, 1969

Brown explained that while her father was stationed in Vladivostok, during World War I, he befriended some of the German prisoners of war being held there, "and when he left, they made him that wooden box as a gift." In her painting, the box is guarded by an alert white dog with black spots, black ears, and a black patch around his right eye. On the other side of the box sits a watchful dark gray cat. Above the box flies a seagull with a shamrock in its beak, an acknowledgment of Beatty's Irish heritage. The painting has a black border within which silvery salmon swim to form another sort of honor guard. Fish are symbolic of fertility and life's regeneration. The river delta where Brown was living and painting was prized for its abundant fishing, and fish began to appear regularly in her work. The gull and its bit of greenery also allude to the dove that returns to Noah's ark with an olive leaf in its beak, thus signaling the abatement of the flood waters. This biblical tale of safe passage and renewed life had multiple meanings for Brown. She had navigated the flood of loss and painful memories in the wake of her parents' abrupt deaths, only to have the first sanctuary she and Cook found in the aftermath rendered uninhabitable by a flood. In a photograph taken of the deluge, Allen, the dog in the painting, stands in water beside a bed on which belongings are stacked, including Brown's father's wooden box.

Brown painted nothing comparable in memory of her mother.

The Flood was not the only biblical theme Brown explored in her watershed year. She painted imaginative Garden of Eden scenarios that accentuate the paradoxical nature of life, the fact that even in paradise, one entity must die for another to live. In *Seascape in the Garden of Eden*, a dynamic scenario of nature's web of consumption, creatures from two elements, air

and water, collide. Against a sky of oblong, neatly ordered clouds, large waterfowl dive from above, beaks open, as fish leap from the water in a convergence of prey and predator. The scene is framed by a border containing a great serpent.

Brown said, "I prefer to paint my figures life-size. I feel I can identify with them." And often her figures are larger than life, and otherworldly, as in a quartet of "paradise" paintings from 1970.

In *Paradise Series #1: Eve with Fish and Snakes*, Brown's Eve is a dark-skinned woman with long dark hair, dark eyes, and a somber expression. She is standing naked before a great yellow mountain, behind which rises a green peak. The black triangle of the woman's pubic hair inverts and echoes the mountains' shape. Her feet are planted on a black slab, and all around it writhe fat snakes in livid patterns of green, red, black, and white. One ringed serpent has its long apple-red forked tongue extended toward her, a bolt of blood lightning. Eve clutches a large dappled red fish, its open mouth close to her right nipple. While the painting of Eve is somewhat natural-istic, *Devil Standing on Fish* is a highly stylized and theatrical piece. The naked devil is half red and half black, his legs and feet marked with yellow dashes. His eyes are large and searchlight white; his horns are brown, as are his feathery, glinting wings. He stands triumphantly on a very large red fish, the same sort of fish that Eve cradles at her breast, and he holds a gigantic serpent over his head, its diamond-patterned body draping down on both sides past his knees. The black void behind them sparkles with a blizzard of stars.

In *The Mermaid* Brown reaches into myth, folklore, and fairy tales to portray the alluring half-human, half-fish siren of the sea. Her mermaid is thoroughly human in her relaxed pose and frankly assessing expression. She has lustrous dark skin; large, light eyes just like the artist's; a plush body; and a scaly tail made elegant with glitter and sequins. Behind her a red sea churns with white-capped waves and many colorful, leaping fish. A being of both air and water, she is emblematic of the artist, who loves to swim and who dwells in both the earthly world and the deep, mysterious inner ocean of dreams and creativity.

Her cardinal year of 1970 also gave rise to some of Brown's most striking self-portraits. *Self Portrait with Fish and Cat* presents the artist, her blonde

hair in a side-parted bob, standing in a bright red room on a floor of reflective red tiles edged with white. She is clad in a paint-spattered shirt, pants, and shoes so vigorously painted they form an expressionistic painting-within-the-painting and a patch of aesthetic autobiography as Brown reminds us of her earlier impasto work. By subtly combining her first approach to painting with her new style, she announces, "I'm the same artist, just trying new things." Brown is also wearing transparent white gloves, which seem to beg for some sort of symbolic interpretation, but which are merely accurate: Brown wore them for protection because she was allergic to some of the paints she used. Her right arm is extended down along her side, and she holds a wide paintbrush in her right hand. In her left arm she clasps a large fish against the side of her body. Gold and silver with a proud forked tail, the robust and glorious fish is arcing back as though in mid leap, or as a child might arch away from his mother's embrace in a bid to be set down. Meanwhile, a dark cat walks by, his gaze on the floor. The artist is wrestling with the life force, with creativity, while drawing on its surging power.

Self Portrait is a small, square (a shape Brown rarely used) painting unique in its galaxy of autobiographical iconography. We encounter the artist's head and shoulders at front and center. She's wearing a red blouse. Her hair is blonde, shading to brown and cut chin-length. Her large light-green eyes are beaming bright, surrounded by coronas of yellow, white, green, and blue, with shadows beneath her eyebrows. Her rosebud lips are closed; her expression is inwardly directed, almost entranced. A rat crouches on her left shoulder, its tail stroking her neck. All around her float a jumble of creatures and objects, each rendered with vibrancy, affection, and humor. There are many different breeds of dog, a cat, lots of fish, and birds. Donald Duck, Mickey Mouse, Minnie Mouse, a teddy bear, and a Chinese doll all float like little astronauts cut loose from their capsules. We spy a bride who resembles Brown, holding her bouquet at her waist; a man in a fancy black jacket and white slacks—the groom? A matchbook, a sugar jar, a pitcher, a chicken, a pig, a camel, the head of a tiger, the legs and tail of a lion, a red high-heeled shoe, a cow. Symbols of romance and art, marriage and motherhood, sustenance and power, inspirations and responsibilities. All are suspended in the space around the artist's head, as though they've escaped the precincts of her memory and thoughts. Slightly cartoonish and

ebulliently emblematic, influenced, perhaps, by the Chinese zodiac, this is a painting about how one can feel at once elevated and overwhelmed by one's passions and the demands of one's life. It is also a boldly inventive approach to self-portraiture.

"Many people have asked me why I do so many self-portraits," Brown said. "There are two reasons why. One: It is so much handier to use myself as a model than to hire someone. I do not like having another presence about when I am working. I prefer solitude, and the self-portrait affords me that solitude. Two: The self-portrait is really an inquiry, an introspective process of asking myself where I am coming from. For me, it is being able to stand back and look at myself as a spectator. That's all."

Frida Kahlo, often bedridden, is widely quoted as having said, "I paint self-portraits because I am so often alone, because I am the person I know best."

Brown's year of metamorphosis also brought forth *The Bride*, a colossal, topsy-turvy work in which many of her key themes, icons, and lines of inquiry coalesced to provocative and profound effect. The voluptuous bride faces forward in the classic folkloric stance. She is wearing a full-length, long-sleeved, full-skirted white lace wedding dress (the pattern painted in dark calligraphic squiggles and dashes), with a border of orange ribbon bows. She holds a pink, sexually suggestive bouquet at her waist with both hands. As womanly as her body is, the bride's large, proud head is feline. Her big blue cat's eyes are almond-shaped, her whiskers long, her lustrous fur that of a black-nosed, striped brown tabby with elegant black markings. From her right wrist cascades a long orange leash that matches the ribbon trimming her dress; it is attached to the collar of an enormous rat. Cat bride and rat groom, their fur aglitter, stand on black, hillocky ground from which red and orange poppies and white and blue morning glories bloom. Filling the clear turquoise sky is a festive flotilla of large, brilliantly hued, richly patterned, various shaped fish. This chromatic dreamscape—with its ocean sky, field of poppies promising visions, and totemic cat-woman and her tamed rat cohort—vibrates with mischievously sexy wit, magic, mystery, and implication, goading and bewitching us into questioning assumptions about our place in nature, gender roles, and hierarchies of power.

Though many animals are essential characters in Brown's paintings, dogs hold an especially emotional place. Brown said that she was hugely

influenced by the dogs Velázquez painted in his portraits of the aristocracy. By granting equally inquisitive attention to dogs and people as individuals dwelling together, she felt that the great painter expressed "a tremendous humanity . . . a sympathy and connection to these people and very much so to the animals."

Man Drinking at Bar with Dog (1972) is painted from a bartender's perspective. We see several shelves of glasses and bottles on the inside of the bar. A thoughtful, even worried gray dog with soft ears, a boxy muzzle, and a pink nose sits on a stool at the shiny red bar, its head just clearing the top. Beside him sits a man, seen from the side, in a blue suit jacket and white shirt, his elbow on the bar as he drinks happily from a tipped glass. The room behind them is in dark shadow. Brown said, "It's one of my very favorite paintings. I would never sell it, and people have offered to buy it. I really love that painting."

Brown wasn't allowed to own a dog as a child, and so she walked the neighbor's dog. Many of her father's drinking buddies were dog owners:

> All these men would meet down on the Marina, on Chestnut Street. They would bring their dogs into the bar and would sit them up on the bar stool, or get them a plate of beer on the floor—until they were all kicked out, then they used to tie them up outside to the parking meters or the telephone poles. But I remember that, as a kid, going in to look for my dad, on a Sunday afternoon, or in the evening sometimes, and there would be these dogs sitting there. And the dogs looked so wise, like they really knew where everything was at. The people, of course, looked absurd. This was very moving, very touching to me.

Dogs seem aligned with the men in Brown's life, from her father to her second and third husbands to her son. Dogs are family members, companions, guardians. Cats, on the other hand, are closely aligned with the artist: alter egos, avatars, familiars. Like Brown, cats can seem delicate even though they possess a seething force of will backed by agile strength and speed. For most of human civilization, cats were not considered cute and desirable as pets. Instead, they were viewed as the predators they are, sneaky, smug, self-preening, cunning, aloof, and deceptive, concealing a killer's

watchfulness behind studied indifference. They are sleek hunters of the night with the spooky ability to see in the dark, to move in elegant, deadly silence. Red in tooth and claw, they are a touch alien with their vertical pupils. Given their beauty, sensuality, and mystery, Brown adored them as femaleness incarnate. She also appreciated the fact that cats were sacred in ancient Egypt. Bastet, the cat goddess, underwent several transformations over the millennia, beginning as a lioness and solar deity and becoming the hybrid figure of a woman with a cat's head, a lunar deity associated with dance, music, joy, love, and protection. Bastet was most often depicted holding a sistrum, a sacred, rattle-like musical instrument; Brown often painted herself holding a paintbrush. The mutability of Bastet over time would have appealed to Brown, herself ever morphing in life and in art.

The Bride presents two figures essential to Brown's iconography: a half-animal, half-human entity and the rat. When asked about her hybrid figures, Brown replied, "I think that comes from my interest in belief systems of ancient cultures. The idea of the lower part of man, the lower self and the higher self, which is supposedly what the Sphinx is all about, interests me. . . . It was always very poignant, that play between half animal and half human."

Two years after she painted *The Bride*, Brown stripped her cat-headed figure down in *Woman Wearing Mask* (1972). Instead of a genuine cat-woman hybrid, this is a woman claiming the powers of a big cat. According to the Chinese zodiac, Brown was born in the year of the tiger, a designation that identified her, and rightly so, as confident, courageous, strong, competitive, stubborn, charming, and indomitable. In this brash painting, the woman, the artist, is wearing a large, tigerish, vaguely Asian purple cat mask with strong white markings. The woman's body is athletic in its muscled leanness. She stands in red ankle-strapped, open-toed high heels, with bows above her painted toenails. Her only garments are a tiny, transparent black lace bra and bikini panties. Her feet are apart; her right fist is against her right hip; her left thumb is tucked into her lace panties as though they're a holster, the rest of her large hand extended along her thigh. It's a gunslinger pose, playing in provocative counterpoint to the bewitching delicacy of the sexy lingerie and shoes—alluring attire that, of course, has its own firepower.

Rats play an unnerving role in Brown's paintings. Creatures of the shadows in alleys, basements, sewers, and tenements, rats are associated with poverty, pestilence, decay, neglect, and the underworld, with dirt and death. Rats are also associated with the forbidden and the obscene, sexual voracity or depravity. Rats in a maze denote helplessness. Rats and all their connotations morbidly fascinated Brown. In 1959 she made a series of furious ink drawings titled *Rat Dream #1, #2, #3*. They resemble her vigorous, dense paintings of the time in their expressive intensity, but they are unique in their creepy, smeary, obliterating darkness. Brown recounted the dream that precipitated these images: a rat "appeared to her on the kitchen sink, its luxurious pelt extending to a long, bushy tail. Only when she stroked the tail in the dream did she discover the sharp nails concealed within the soft fur."

Brown confided,

I trust the unconscious very, very strongly. And I don't trust my conscious, my mind is a mess . . . It's just filled with nonsense, sidetracking, garbage and crap. But in my unconscious are the ideas I get for painting, from nothing very clear or precise—my dreams. I'm a great believer in dreams. I pay a great deal of attention to them, and listen to them, and follow them in my everyday life very strongly. Which again comes from what we think of as the unconscious state. It's very clear, absolutely to the point . . . And my dreams are absolutely orderly, fantastically orderly, very clean, very clear, very bright in color. They look just like my paintings as a matter of fact.

Brown closes 1970, her year of artistic amplitude, with an entrancing addition to her "family album," *Christmas Time 1970 (Joan and Noel)*, a double portrait radiating motherly love and protection in an idyllic woodland scene. The two figures face the viewer. The light is benevolent, projecting from a dramatic sunset and glowing golden leaves on a tree branch that hovers above mother and son. Brown—her large, pale eyes open wide and gazing off just a bit to the side, her expression self-contained, proud—stands behind her eight-year-old son, her strong hands, in her see-through white painting gloves, resting on his shoulders. Noel, his dark eyes

shadowed by the bill of his San Francisco Giants cap, engages the viewer. Donald Duck animates his red T-shirt. Noel has one hand in his pants pocket; from the other dangles a disgruntled teddy bear. A large gray cat lies sphinxlike by their feet; a big dog sits off to the side, his sturdy head in profile, and one sizable front paw enter the frame. The ground is covered in fallen autumn leaves. It's an intimate peaceable kingdom, a vision of an idyllic world that would take on increasing spiritual significance for Brown.

Brown never glossed over the grim aspects of her childhood, but after long reflection, she managed to find aspects of her early life to be grateful for.

I think my life with both my mother and father was a very gift-giving kind of situation, as painful and as negative as it may sound on the tape. I don't mean this in any patronizing way; it's something I've thought a great deal about, and it's developed over the years. Naturally I just felt anger and hatred as a kid, all the way around. But my father taught me a great deal about gentleness, which is something that did not develop that much in my own personality. I felt you always had to come out fighting. And I did, during those early years. I survived that way, fighting my mother. Hell, I held her down for a number of years from imposing too much upon me, for my own survival.

In her father she perceived

a natural, innate kind of gentleness that has been very impressive to me . . . I see it in my son . . . Maybe it's inherited, I don't know. But it's something I'm very touched by . . . For me this was a great gift. The other gift, from my mother's side, I feel, is that I knew I didn't want to either live like that or end up like that, wanting something and yet thinking I couldn't do a damn thing about it. Her failure gave me, in a sense, the go-ahead that, hell, you can do anything you want to do, if you work at it. But you don't sit around waiting for it to happen. Her utter failure in coping with her goals, fantasies, desires, and more important, her actual situation, was a great gift to me, in terms of being able to take action.

In 1971 Brown painted a unique portrait of herself as a child, a no-doubt necessary look back to her earliest years as she continued to process the loss of her parents. For the magnificent *Portrait of a Girl*, Brown took elements from several photographs of her young self to create the girl in the painting, who stands in the center of the four-by-eight-foot panel, facing the viewer with both trepidation and determination. A thin pink ribbon with a bow holds her pretty curled hair in place. She wears a collared empire-waist pink dress with tiny white polka dots, puffy short sleeves, and a high pocket on her right side, an outfit completed by white anklets and pretty red strapped shoes. She holds her right hand behind her back as though to prevent an adult from taking hold of it, or perhaps she's concealing something. Her left arm extends down as she holds a pink rose, an offering of love and gratitude. Her eyes are large, light, and gazing, her mouth set. She is both present and absent, lost in thought or perhaps channeling—or even projecting—the enormous blue, red, and yellow dragon that looms behind her, fangs exposed, claws extended. The beast gleams and writhes with an electric current. Behind the dragon is a red wall arrayed with black Chinese characters. The bright glittery patterns of the dragon's scales and fins are reflected in snake-like forms on the shiny black floor, as though other dangerous creatures thrash below. But Brown stands firmly, and while the dragon is threatening, a manifestation of all the perils a young girl must face as she goes out into the voracious and cruel world, there is also the sense that this mighty creature is protecting her. The dragon, Brown said, was "the symbol of wisdom." Tsujimoto writes, "In Chinese culture the dragon is a positive symbol signifying happiness; in ancient times it was frequently used decoratively to ward off evil spirits. The color red symbolizes joy, celebration, and good fortune." Tsujimoto translates some of the Chinese characters as "old," "woman," and "west," and suggests that they may refer to the death of Brown's mother or "the artist's own maturity and newfound strength and vitality." This reclamation of her child-self is a declaration of survival and tenacity.

Pair this resounding painting of youthful resilience and coming into one's power with *The Birthday Party* (1971). At thirty-three, the artist has painted herself in a corner, a dead end or a place of safety and renewal. She wears a long, sleeveless, deeply V-necked floral-print dress with a high split and red beaded shoes. Pensive, not celebratory, though she also appears

Joan Brown. The Birthday Party. 1971.
Oil enamel on Masonite.
96 x 41 ½ inches.

confident and poised, she holds up a martini glass in a toast, her nails painted red. The dark rug she stands on has a dragon pattern, and the walls converging behind her are festooned with pink and blue yin-yang symbols surrounded by pulsing lines. In Chinese cosmology, yin is the feminine principle, associated with darkness, cold, and wetness, while yang is the masculine aspect of nature, found in light, heat, and dryness. Together these two opposite yet complementary forces make life possible and influence destiny. The dashes surrounding the yin-yang symbols resemble the trigrams of the *I Ching*. Here is the dragon-backed girl all grown up, her dragon now a foundational source of power, a deep well from which to draw.

Next to the artist sits a gray wolf, his long bright red tongue hanging down. This is a new totem animal for Brown, a creature portrayed as evil incarnate in folklore and fairy tales and feared, loathed, and hunted to near-extinction in America. Yet in many traditions the she-wolf is revered as an embodiment of fertility and maternal vigilance, and the wolf, creature of the night and the moon, is in fact a highly intelligent and brave animal,

by turns cooperative in the pack and an independent wanderer. The wolf could be Brown's far-roaming creative spirit, the part of her that always remained free and daring, even as she was zealously protective of home, family, and the sanctity of her studio.

The wolf appears in a very different self-portrait also painted in 1971, *Girl with Gorilla and Wolf.* Here the artist, looking rather student-like, sits in a patterned red-and-black armchair. She's dressed casually in a forest-green-shaded-to-sage velour pullover, blue slacks, white socks, and moss-green Wallabees, one knee crossed over the other and supporting a sketchbook to which she applies a pencil. Her eyes, as always, are large and staring, her expression thoughtful. The wallpaper behind her is a riot of bright red poppies, almost like flames, their green stems like fuses as they glow within an intricate web of smaller patterns. The wall looks like a densely starred and planet-filled sky, emblematic, perhaps, of the universe of her imagination. The rug is equally elaborate and alive in a crystalline pattern of blues, purple, and greens. Everything fizzes and pops and shimmers; the very molecules of the air seem visible and in motion in a wholly alive interior space as dense and redolent as those painted by Édouard Vuillard. But this is no ordinary domestic scene. Behind the artist stands an enormous black gorilla, one robust, fingered paw on the back of the chair, his eyes wide and bright, his expression sweet-tempered, self-conscious, kind. A regal gray wolf stands mid-stride in the lower righthand corner, his ears perked, his eyes sharp. Gorilla, woman, and wolf appear to have been interrupted during a private consultation. This is an evocative variation on Brown's previous family portraits anchored to an easy chair. Here she honors her creative kin in all their mysterious, mystical wildness.

In *Wolf in Studio* (1972), a large and imposing black wolf stands on a paint-swirled floor, guarding the doorway to a studio with a blue gridded floor and a red wall: a place of order and intensity. The wolf is an emissary from a hidden realm, a sentry, and the artist herself, watchful, powerful, elusive.

Brown didn't often explicate her use of images or symbols. She once said, "I like to leave my paintings open enough and enigmatic enough that people come to them at whatever level they want."

After living on the river delta for two intensely productive years, during

which she created a substantial and phenomenally striking body of work that redefined her as an artist, Brown returned to San Francisco in the fall of 1971. As inspiring and astonishingly productive as her delta interlude was, Brown had had enough of the rural community's isolation and stifling conservatism, so antithetical to her open-mindedness. She and Cook bought a "modest, unassuming" house on Cameo Way in the middle-class neighborhood of Diamond Heights, where she set up a studio in a back room that she would use for the rest of her life. She was ready for a fresh immersion in the complexity, diversity, and surprise of the city.

Brown scrutinized herself in a series of tightly focused 1972 self-portraits, piercingly observed headshots that illuminate two sides of the self: one harboring deep, timeless animal needs, instincts, and responses; the other the intellect, discipline, demands, and boons of civilization.

In *Self-Portrait with Fur Hat*, Brown stands before a yellow-and-black-checkered wall, wearing a paint-smeared brown shirt with a pocket over each breast. Her tiger self is manifest in a large, unruly yellow-and-black fur hat, from which strands of red hair escape. Her expression is composed, inwardly directed; she looks healthy, strong, attractive, unpredictable, even dangerous.

In *Self-Portrait in Knit Hat*, the artist is seen against a background vertically divided into red and blue. Brown is glamorous here, carefully made-up, and deadly serious. Her mauve-and-black knit hat is a close-fitting turban that becomes a coiled cobra at the crown. Her dark-blonde shoulder-length hair streams down behind her. She is polished, contained, and capable of sudden, decisive action. In *Untitled (Self-Portrait in Turban with Eskimo Dog Pin)*, a pink-and-violet background sets the artist's stressed visage in high relief, a starkness further accentuated by the white line around her jaw and forehead. This is a naked face, tired, worried. But her dark jade shirt picks up the lighter green of her eyes, and her plain black turban is adorned with a pin depicting a husky, his tongue out, a figure of strength and resilience.

Around the same time Brown and her family returned to the city, she also had a major solo exhibition at the San Francisco Museum of Art. In talking about this exhibit, Brown touched on what drove her to work so incessantly:

All of a sudden that painting show came along at the Institute . . . quite unexpectedly. Here I had done on and off this whole series of paintings. And I was never thinking in terms of showing them or getting feedback. It's funny. I don't know why, well, I guess I do know why that's so. It's the internal need that is so strong to put things into form . . . I know that if I don't work for a period of time, I'm extremely uncomfortable. I can do without a lot of things but I can't do without making pictures of my own. And I don't know why this is so. But it's true. And I get very crabby and moody and all kinds of things. I just don't feel right. I don't feel alive. And then if I paint too much I feel crazy as hell, but it's something that I need to do.

So that's probably why it's not so important to show and things like that. When I'm feeling good about what I'm doing it's fun to show and I like to see them all together. They look kind of neat.

"Kind of neat" is such a humble understatement, given Brown's colossal, radiant, disquieting, complexly conceived, and exactingly executed new paintings—works that delve deeply into myth and the psyche, paintings generated by questions metaphysical, existential, and spiritual. Works that draw on the artist's deep knowledge of and attunement to the art of the past and her own resolute independence. Works that prompted the critic Thomas Albright to write in the *San Francisco Chronicle*, "These are among the most extraordinary portraits ever painted."

After teaching at the Sacramento State College (now California State University, Sacramento), Brown took a position at San Francisco's Academy of Art College (now Academy of Art University). After making all those meticulously rendered, static self-portraits and iconic images, those towering, formal, glossy works of great control and specificity, Brown, having returned to an urban environment, looped back to a looser, quicker, more animated, even cartoony expressiveness, leaving Edenic scenes behind for a more sensual, riskier subterranean realm.

Curator Brenda Richardson observes, "Brown was a child of the 1940s. After a day in the studio, she loved to dress up in satin and chiffon and go

out dining and dancing (and drinking) in grand style." Cook shared her pleasure in swanky entertainment, so they would deck themselves out and go downtown and party. Brown's delight in the lush life of posh restaurants, ballrooms, and nightclubs, as well as her insights into the thornier realities behind the good times, inspired her exuberant, cutting, ultimately macabre *Dancers* series.

In *The Dancers in a City, #2* (1972), a man and a woman are dancing on a red-tiled deck gridded with white, San Francisco's skyline behind them in dusky purple, the blue sky about to turn black. Seen in profile, the woman looks straight ahead, tense in spite of her pretty dress, which is made of actual fabric. Brown explained that she painted that dress "maybe fifty times and I didn't like it. I said, 'the hell with it, I'm just going to cover it up.'" She used some material she had "laying around," cut out the shape of the dress, and glued it on. It shimmers in luminous detail, in contrast to the scrubbiness of the rest of the canvas. The dress also gives the dancer more substantiality compared to her perhaps imaginary partner, a man with a mustache in formal attire who is rendered only in outline, his gaze off to the side. They barely seem aware of each other. Is he perhaps the ghost of a lost lover or husband? A fantasy? Hovering just above their feet is a musical staff with clefs and notes, a fluttering ribbon of music. And in the lower-left corner stands a sturdy dog, looking at the viewer with wide-eyed, wry, and conspiratorial amazement, as though to confirm that something very strange is afoot.

The enormous canvas *Dancers in a City, #4* (1973) is infused with a madcap, frenzied energy. Two couples cavort across a ballroom with floor-to-ceiling windows looking out onto a golden sky and the San Francisco skyline, which is reflected neatly in the bay. The dancers are flying through the air above a pool-table-green floor, their legs spread wide in great, zestful leaps, their arms raised. The couple on the right looks joyously abandoned in their wind-milling flight, while the other couple has a combative aura. The man wears a blue cap, heavy laced work boots, and blue-and-red striped garments that look like a prisoner's uniform. His right arm and fist are raised as though he's about to strike his dance partner, who wears a nebulously painted pink dress and mismatched high heels, one red, one yellow. Her left arm is raised high as she leans away from him, though

they're holding tightly to each other with their opposite arms. At the bottom of the painting we see a floating piano keyboard, much of it in red, and two spooky hands in white gloves pounding away. This frenetic painting sparks with joy and peril, ecstasy and rage, expressing Brown's awareness of the perpetual dualities of existence.

The underworld wells up in *The Last Dance* (1973), a grotesque and brusquely, even crudely painted scenario set in some dark hell of lust gone wrong. Pairs of men and women are identically dressed—the men in black jackets outlined in white and white pants, the women in long pink dresses dotted with white ovals with red centers. Two couples are embracing tightly, one elegantly, the other suggestively, while another couple dances facing each other without touching, grinning broadly. Large rats outlined in red scurry forward from the bottom of the painting, while one, monstrous, whale-like rat rises up, an upside-down couple clamped in its sharp yellow teeth. In the background, a skeleton in a dark suit and brimmed yellow hat dances in a close clutch with a rat, whose tail extends obscenely along the floor. This is a lurid tableau of the timeless pairing of sex and death.

Brown's audacious *Dancer* series caught the attention of the intrepid and influential art collector and dealer Allan Frumkin. Born in 1927 in Chicago, Frumkin, a graduate of the University of Chicago, opened his first gallery there in 1952. An avid collector of Matisse drawings and Max Beckmann prints, he was among the first to bring work by the Surrealists, including Joseph Cornell and Roberto Sebastian Matta, whom he met in Italy, to Chicago. Frumkin opened a second gallery in New York in 1959, and developed an affinity for Bay Area artists, exhibiting Richard Diebenkorn, William T. Wiley, and Roy De Forest. After admiring one of her *Dancer* paintings in a national group exhibition at the Krannert Art Museum at the University of Illinois in Urbana-Champaign, Frumkin sought to contact the artist through Brenda Richardson, sending the curator a letter in which he wrote, "There was a very interesting and strange painting by an artist who turned out to be Joan Brown . . . The most interesting surprise for me in the whole show." Her subsequent solo exhibition at the Frumkin gallery in 1974 was her first in New York in a decade, and it garnered high praise from *New York Times* art critic Hilton Kramer, who observed, "She has taken the Bay Area heritage in a surprising direction—into a robust style in which the

macabre and the grotesque live on easy terms, with an immense energy and authority." Brown was to stay with Frumkin until the end of her life.

The return to the city seems to have revved Brown up, and she may also have been feeling less on guard as Noel grew out of the first phase of childhood. She was going out dancing, painting her edgy *Dancer* paintings, and, while her new studio was being renovated, making funky, funny, romantic, clever, and colorful cardboard sculptures of glitzy paper-doll-like dancing couples swinging and whirling on a chunky ocean liner and the roof of a big, bulbous yellow taxi. She and Cook joined Elmer Bischoff in a weekly drawing group. She was also back to swimming in the bay, though with more focused intent. Cook was a longtime member of the men-only Dolphin Swim and Boat Club in Aquatic Park. There were no swim clubs for women, although Brown found a group of female swimmers who provided encouraging, high-spirited camaraderie. As she became more committed to long-distance swimming, she also became involved in the battle over beach facilities for women. While the men had a clubhouse with showers and lockers, the women had to use public restrooms that were closed in the winter, forcing them to resort, at times, to changing their clothes under the piers. This predicament became urgent when one of the swimmers was raped in a public bathroom in 1974. Brown was a powerful presence in the group, which brought a sexual discrimination class action suit against one of the clubs closed to women. In 1977 women were finally granted access to all the clubhouses on public bay-front property.

The men and women who braved the bone-chilling water, hazardous currents, and perilous boat traffic ranged from factory workers to teachers, restaurant owners, psychiatrists, bankers, and housewives—hardy individuals who found the exertion and the challenge enrapturing and empowering. For Brown, it was a way to immerse herself in a vast, fluid, mysterious realm, the sensuous and liberating opposite of the flat, measured surface and hard edges of her paintings. She found swimming in the bay restorative, meditative, and inspiring. Ideas came to her in the water. She swam at the end of the day, enthralled by the beauty and peace of twilight. Her creative energy was recharged by the bracing cold, the blood-pumping effort, the buoyancy, the cleansing. By plunging into the sea, the place where life began, the fluid that sustains life, and pitting herself against its unfathomable pull and push,

surge and crash, Brown gave herself over to the earth and its rocking, salty, watery mantle, submerging consciousness in the rhythms of breath and limbs, waves and wind, and the slow revolution of the planet.

But for all her enthusiasm and fortitude, Brown came in last—eighty-fifth out of eighty-five—in one of her first organized swims. She decided she needed a trainer to improve her technique, and began working with Charlie Sava. A demanding and exacting Swimming Hall of Fame coach then in his seventies, Sava was famous for coaching women swimmers, including national and world record-setters and an Olympian, Ann Curtis. Brown adored him, and her swimming skills sharpened. She had her picture taken holding up a photograph. In it, Sava is seated between two women at a dressy event. Empty wineglasses crowd the tabletop. On the left, Brown, looking pixieish with short, shiny hair in a checked, sleeveless dress, leans against her teacher, her chin on his shoulder, one slender arm reaching across his chest, her hand on his collarbone and shoulder. The other woman holds Sava's other arm and presses close. Both women are smiling widely; Sava looks at once shyly pleased and acutely uncomfortable.

Brown paid tribute to Sava in several paintings, including *Charlie Sava and Friends (Rembrandt and Goya)* of 1973, in which her three mentors sit behind a low red wall, as though at a viewing stand. Before the wall stands a dark trophy depicting a woman swimmer with knees bent, arms swung out behind her, waiting for the signal to dive in. Sava is, again, in the center, wearing black-framed glasses and glowing with incandescent silver hair and a white T-shirt. On either side of him sit dark, barely discernible shadow forms of the old masters, who seem to have barely materialized after their long journey from beyond. This is a witty homage in the form of a holy trinity. But how can a swimming coach be so elevated? Brown explains:

> Charlie Sava, the swim coach, has been a tremendous help in directing me to where the paintings are right now. All this started going through my mind when I met up with him, about economy, about getting rid of all this extra stuff. Jesus, that's exactly what he teaches in swimming. It's not to waste, not go off this way or that way with your arms or your feet or whatever, when you breathe, just get right down to the basics. Which is one of the most difficult things to do in the world. It's so hard not to sidetrack.

As Sava's training put Brown in touch in a new, clarifying way with her body, the efficiency and directness she acquired as a swimmer carried over into her creative life. She brought her new athleticism and understanding of the body in motion to her paintings, creating the *Acrobats* series: streamlined, silhouetted, flatly painted figures of swimmers in midair. These simplified, brightly hued animated figures have much in common with the fluid, gestural, colorful figures of Matisse's buoyant cutouts.

Brown said about this time of extreme transformation in her work, especially her strange Acrobat paintings,

> It's been very hard to come by. I've really worried about (God, during last summer) what I was doing with the paintings . . . Some of them came out pretty good, some were crappy. Some were very important and obviously got me in transition which is where I want to be right now. But Jesus! That was like pulling teeth. God, I'd be so exhausted after painting. Weeks would go by and nothing. I just couldn't think of anything. I'd start with something and something else would happen. It was just an awful kind of thing that makes you want to give up painting. [laughter] It was really tough for about five or six months.

While she was struggling toward yet another new phase in her painting in 1974, Brown's professional standing rose. She had solo shows at the Charles Campbell Gallery in San Francisco and the Allan Frumkin Gallery in New York. At age thirty-six, she was the subject of a major retrospective exhibition, containing 122 works, at the University of California, Berkeley. That same university also appointed her lecturer, then assistant professor; ultimately Brown earned tenure and a full professorship.

Brown was living in a vital California city and teaching at a major university, a hotbed for progressive thought and action in the turbulent 1970s, yet there is no evidence of her feelings about or perspective on the larger world. No record of any response to the Vietnam War or Californian Richard Nixon's presidency, Watergate disgrace, and resignation. No indication of any interest in the rise in environmental awareness and governmental action, subjects of great concern in the Bay Area. These topics may have come up in her classes, though Brown was a strict and focused teacher,

but in the studio and in recorded lectures and interviews, Brown concentrates wholly on art.

There was one issue, however, that she could not avoid: sexism in the art world. The American feminist art movement coalesced in Southern California, when Judy Chicago taught the first feminist art course at Fresno State College in 1970, and then founded, with Miriam Shapiro, the first feminist art program at the California Institute of the Arts in Valencia. In 1974 Chicago began work on her enormous, complex, collaborative, and still controversial installation *The Dinner Party*. Chicago's biologically tethered, programmatic approach did not in the least appeal to Brown, who deplored the deliberate emphasis in feminist art on female anatomy and allegedly female colors:

> I think it's a goddamn fraud. I can't stand it. I think it is very, very self-conscious and a totally exterior motivation for working. But again, I will say that if this is a help—either to these women, or to younger women and to up-and-coming students . . . if this is helpful to them, to recognize and deal with their own identity and their relations to the world around them, to men and other people . . . great! But objectively I think it stinks. I think it's absolutely contrived.

Brown didn't need to adopt a heavy-handed approach. As a woman artist painting her life for all to see, she was implicitly asserting the equality of women and their experiences. She told journalist Andrée Maréchal-Workman, "In terms of living my life, I am totally a feminist, and you probably are, too. I feel I am absolutely equal and do not put up with a lot of nonsense about women's inequality, or anything like that. But in things like words, for example, jumping down someone's throat because they use the word 'girl' or 'lady' or even 'mankind'—again, that is all so superficial. It does not mean anything. How someone lives really shows where they are coming from, not what they say."

Brown was absolutely comfortable with being a woman, and with flaunting her good looks. In her interview with Paul Karlstrom, she repeated a compliment she'd received at a pool party where she was wearing one of her many bikinis. A male guest said, "I hope you won't think I'm a sexist

saying this, or I hope you won't mind . . . But, you have one of the best bodies I've ever seen." Brown replied, "That's the nicest compliment I've had in years. The hell with the paintings." Feminist heresy! Unconcerned with what came to be called political correctness, Brown delighted in this affirmation of her womanly beauty and didn't consider the comment at all demeaning. Her husband, however, thought it was crude. She responded, or so she claimed, by telling him, "Bullshit! I loved it!"

As an art student Brown was supported and encouraged by men, she said, both faculty and fellow students. She insisted that their positive feedback was genuine. "They were never patronizing. I was supported like hell, and yet I wasn't patted on the ass." She did say that she felt that opportunities for advancement were withheld at the Art Institute due partly to her personality: "I was a little abrasive or suspicious of the people involved." And why wouldn't she be? It became apparent that her colleagues, including other women, were jealous of her early success. Brown describes the attitude:

> "Goddamn it! How does she get to show in New York? And after all she is a girl . . . She's probably sleeping with that gallery dealer." Which was utterly untrue. I mean it doesn't matter whether I was or I wasn't. It has nothing to do with anything. I wasn't and if I had been, it would have had nothing to do with the fact that I was showing there or not. And I was always surprised when these things would come up, because they had never occurred to me . . . It pissed me off . . . Yeah, and it made me a little snottier or nastier than I might have been."

There was no question in Brown's mind that sexism kept her from being offered a well-paying teaching job. As she told Maréchal-Workman,

> The reason I taught in so many places with so many diverse groups of people was that, as a woman, I couldn't get a job. Although I had the credentials and the requested exhibition record and all that, women were not hired. So, for thirteen years, twelve months a year, I taught anywhere I could, including my kitchen for some time, for group critiques. It was tough at the time, but I would never have had the experience of working with all those different groups of people if I had been able to sail from

school into—like many of my male peers did—a university or college job . . .
For me it was a very enlightening experience, without which I would not
have become conscious of my deep-seated belief that the creative spirit is in
everyone, that it belongs to everybody.

On the subject of motherhood, Brown told Claudia Steenberg-
Majewski in 1981, when her son was nineteen,

I've always wondered why nobody has ever asked me how I did it and
what I thought about raising a child. I know women come up to me all
the time and ask me, "I'd like to have a child. What do you think?" I say
absolutely. But again, I'm a person first who is a woman who happens to
be an artist. And as a person and as a woman I have thoroughly enjoyed
family life.

It's been tough from time to time. Sometimes there's an
overcompensation; sometimes I put too much energy into one area and
not enough into the other. It's really hard to keep that balance but, boy,
everything really feeds into the other, just like with the swimming and
the studying of ancient civilizations. I find that the work is a by-product
of myself as a person and therefore it's much richer because I have lived
and have been involved in other dimensions.

As far as the practicality of it and getting down to time slots, I
really believe that when there's will, there's energy. When my son was
little I used to work at night. In the beginning I'd be tired but then it's
very stimulating and you go past that . . . Whatever's important, you
discipline yourself, but the richness that came from that I would
never trade.

Brown was living at warp speed, and speed was her element. She took
up charcoal, oil pastel, and graphite, media that allowed her to work quickly
and directly. In 1975 she created some keenly satirical, cartoony "skeleton"
scenarios, interior scenes in which the walls and doors are designated with
thick, black, ruled lines, and the neatly articulated figures are actually skele-
tons with remarkably animated and expressive body language. Not only are
her black skeleton figures strange but the settings are provocative, even

disconcerting, in their racy, edgy wit. Take *The Gynecologist's Office*, for example. The drawing depicts a large, stark room. The only colors are the red of a jacket on a hanger on a hook on the far wall and the yellow of the light-bulbs. At the lower edge of the painting the simply drawn examination table juts into the frame. On it lies a skeleton, seen from the collarbone down. Her bone-legs are spread, her long-toed bone-feet in stirrups. The doctor, with a large light strapped to his head, stands beside the table as the light beam—rendered in a shower of little black dashes—illuminates the patient's pelvis. Behind the doctor stands another skeleton, taking notes on a pad.

Brown's skeletons arouse thoughts of mortality and the afterlife. Her dancing skeletons in various paintings, among them the gruesome *Last Dance*, resemble the festively attired skeletons associated with the Mexican Day of the Dead ceremonies, which inspired Frida Kahlo to include skele-tons in her paintings. But Brown, as always, preferring to emphasize the simplest aspects of her work, spoke about her bone men in strictly formal terms, noting that like her sketchy *Acrobats*, "they're very quick . . . Speed is very necessary to me." She continues,

> So the skeletons again, are just a vehicle . . . I don't put in the eyes, nose, fingers and all that stuff. I just get the general gestures with this very quick kind of routine that I've rigged up. You know, three ribs and all this and that. I'm right to the point where I can get all kinds of gestures . . . Because people's gestures absolutely fascinate me. So I can do it that way very, very quickly, and I don't have to worry about it, therefore I can do anything that comes into my head . . . I get a lot of ideas when I can work very quickly like that . . . It stimulates me. I don't care if they end up in the garbage can. It's the process that's important."

While Brown's struggles in the studio to find solutions to profoundly personal inquires required dedication, integrity, and a sense of mission, her drive to improve her skills as a long-distance swimmer placed her in mortal danger. In 1975, for the first time, she joined the annual women's Alcatraz Swim, which involved swimming a mile and a half from Alcatraz Island to the Aquatic Park cove, a route challenging under the best of circumstances. After all, the federal government had built a maximum-security prison on

that rocky island in the belief that the cold, treacherous waters would foil all escape attempts. Brown was "very nervous" about the swim, she said, because the water "can be rough as hell." She expressed her hope, doubt, and fear in a magnetizing painting that at once reached back in its refinement to her delta panels and anticipated a new blend of fluid figuration and crisp visual narration conveyed through patterns, saturated colors, and compelling personal candor.

In *The Night before the Alcatraz Swim* (1975) we see the artist/swimmer from the side as she sits in a black wooden chair, facing left. Composed but brooding, she wears a black blouse with a white grid pattern and black-and-white-checked pants, an outfit embodying order and clarity. She holds a steaming white cup in her left hand. The floor is bay blue; in the wall's loosely evoked orange-and-black woodgrain pattern, large knots look like eyes or targets. Through a picture window, or in a painting-within-the-painting, we see the bay at dusk, the water and sky deep rose. The hills beyond are dark and secretive, and Alcatraz is a black hulking silhouette, the great X of its water-tower structure visible, the only light a dot of yellow atop the guard tower. It is a somber scene.

On the day of the swim, twenty-three women dove into the San Francisco Bay from a boat on the east side of Alcatraz Island. Only fourteen reached the shore on their own. When Brown spoke with Paul Karlstrom only three weeks after the swim, the terror of the experience is palpable: "But this Alcatraz thing, this hideous experience, this swim (not so very hideous, just moving). It really shook up not just my physical being but my psyche, my soul, my emotional being and my spirit."

What happened? In a torrent of words, Brown explained, "We were all very tense, but we were optimistic." The swimmers dove off the boat in pairs at two-minute intervals. They were told to follow the "pilots" in rowboats, and that, depending on their speed, the swim would take between forty minutes and an hour. They were informed that the water nearby was rough, but that after five minutes they would find themselves in a calm sea. "Jesus, what misinformation that was!" Brown said. Instead, they ran into what people who know the bay well call "freaky" waters, a stretch of unpredictable back-eddies and powerful, whirling currents. They tried to stay on course and together, but, as Brown relates,

We all got lost, and lost each other in this water . . . This is a real literal situation of isolation. We all feel it and experience it somewhat on a day-to-day basis. But here you really are. You're out in the middle of a goddamn ocean! And you're isolated! The San Francisco Bay is a rough damn body of water, especially there. I can see why they picked that to put that prison on. You know, it scares the hell out of anyone . . . And seeing that the city is so small and so far away. The city, the skyline, that I love so much, that I paint over and over again during more optimistic moments, looked so foreign and far away . . . It scared the hell out of me . . .

We didn't just encounter swells. We encountered these huge giant waves and this goddamn freighter went by in the middle of all this swimming, 'cause the coast guard screwed up somehow. It scared us to death and made even bigger waves. I was never afraid of drowning. I was very aware that I could die, not that I have a death wish or anything. But death wasn't the fear at all. The fear was this real sense of isolation.

Brown was terribly seasick, and she kept swallowing water as she battled against the waves. She was in such distress, she began to hallucinate. She thought she saw Hawaiian Islands and palm trees—mirages stemming from her memories of a recent trip. In a sketch of her vision, *Gate Swim with Hallucinations* (1975), the span of the Golden Gate Bridge tilts dangerously close to the panicked swimmer, while behind her tall palm trees seem to beckon from low hills.

The always determined Brown kept swimming. "I didn't want to get out. I wanted to make that swim, damn it!" Finally one of the pilots, bolstered with "fins and stuff," swam up to her and asked, "'Are you in trouble?' And I said, 'No, I'm not. I'm doing just fine thanks. How far are we?' He says, 'About a quarter of a mile from the opening.' I said, 'Fine. I can make that.' He said, 'Let's see you swim.' And as it turned out I was swimming in circles. I wasn't worth a damn. I was just horrible, just out of it, just gone—the cold, feeling sick to my stomach, being in the water. He said, 'You've been in the water an hour and a half.' I didn't believe him. If someone had asked me how long I had been in, I would have said twenty minutes at the most. You lose track of everything."

Brown doesn't remember being pulled out of the water—"apparently I

was stiff as a board"—or being transferred from a small boat to a larger one and finally to a cruiser. She was "frozen inside and out," and too sick to drink the coffee with brandy they offered, which, she observed, was not at all typical of her.

This frightening near-disaster haunted Brown, who promptly picked up her brush: "After the swim I painted a number of paintings because I couldn't say everything I wanted to in one." Her *After the Alcatraz Swim* series was an attempt to cordon off and reduce her lingering fear, each painting a calm, cool, and collected self-portrait in a serene, civilized, safe setting, the trauma of the nightmare swim carefully confined to a painting-within-the-painting.

In *After the Alcatraz Swim, #3* (1976), a woman with large blue eyes and neatly combed earlobe-length dark hair sits with one leg crossed over the other in an orange straight-backed chair at a red wooden table on which stands a solid black telephone with a white dial, the kinked cord reaching off to the left, a lifeline. She is wearing a demure dress with an alarming pattern of looming boats. Brown describes them in a video interview in which the camera is focused very tightly on her face as "very stylized, kind of art-deco-type freighters" that represent "the ship that came through." As she says this, a wave of anxiety rises, causing her to take a deep breath, then laugh wryly, nervously. The memory still rattles her several years later. In the painting, the wall behind the seated woman is sunshine yellow with thin, widely spaced blue vertical lines evoking prison bars. The avidly patterned black floor features pink and blue triangles, each with a thin line down the center, and a larger motif of open-winged white and blue butterflies, which Brown may have used as symbols of the soul or of psychological, even spiritual transformation after the ordeal. A large canvas leaning against the wall behind the seated woman in the freighter dress and yellow pumps depicts, with whirling, cresting, white-capped turbulence, the "freaky" bay waters and the flailing, exhausted, freezing, disoriented swimmers, small figures among massive, spearing waves. In two tiny rowboats, figures reach out to take hold of swimmers' extended hands. Sinister Alcatraz hulks darkly with its yellow Cyclops eye in the background. The contrast between the calm, orderly room and this bayscape disaster is galvanizing. Brown has captured the duality of our outer and inner lives, our ability to live with a harrowing

memory by reducing its undertow pull through the transmutation of art. A terrifying close call becomes one image among many in one's life album.

In a particularly stylish canvas in the series, *After the Alcatraz Swim #1* (1975), a painting of menacing waves and an imperiled swimmer hangs over the mantelpiece above a comforting, well-behaved fire in a fireplace, though its confined flames echo the shapes of the waves, suggesting that if they escaped the hearth, they too would be a threat. Brown portrays herself standing nearby on a boldly patterned carpet in a long, form-fitting, sleeveless gown with a line of beads running to the hem and topped by a gold anchor, a symbol of having reached safe harbor. She leans one arm on the mantel and rests her other hand on her hips as she gazes off to the side—the perfect image of glamorous nonchalance were it not for the fright in her large, staring eyes.

Brown's output is phenomenal in quality, quantity, and variety, and the simultaneity of her diverse artistic inquiries is downright kaleidoscopic. As her son later said, "She painted like 30 paintings in a good year. I mean, most artists are lucky if they get one or two. When she worked hard, she really worked hard. She came here to do something and she did a lot. She never stood in one spot for too long."

Brown's Alcatraz paintings are extremely large and meticulously wrought, and yet they are but a fraction of the complete count of her mid-1970s creations. Brown continued to paint solitary figures in rooms and other interiors, creating scenes of rumination, limbo, and other forms of psychic incarceration. A Brown interior is like a chrysalis in which her avatar awaits transformation.

In a set of five paintings, one of many such groups that Brown created in 1975, two feature a small red bench. In *Woman in Room*, the black-and-white-checked floor takes up most of the canvas. A woman sits on the bench, her legs crossed. She's wearing green dress shoes and a lacy, see-through bra; a white fringed towel is wrapped, turbanlike, around her hair. In front of her face she holds a hand mirror, while in her other hand a cigarette burns, its smoke lifting toward the window, through which we see a slightly swirled midnight-blue sky, an empty black car, and a streetlight. In *Woman Waiting in a Theatre Lobby*, the floor again dominates. Here

the carpet, patterned in a demented, clashing herringbone, is nearly hallucinogenic. A woman seen in profile sits alone on the red bench, hunched forward, anxious and hopeful.

The flirty yet reflective compositions *The Room (Part 1)* and *The Room (Part 2)* display more exacting control than the two red-bench paintings. In this pair, Brown depicts a plain room in gray. In each we see from the side, or from the back at a three-quarters angle, a scallop-topped easy chair, dark pink with dense patterns of red flowerlike crosses. In *(Part 1)*, all that is visible of the occupant is a leg, clad in a white anklet and yellow shoe, draped over the chair's arm. In *(Part 2)*, we see a bare arm, the hand holding aloft a lit cigarette. Each otherwise hidden sitter appears to be gazing at a traditional Chinese painting on the facing wall.

The fifth painting, *The Captive*, is inspired by Brown's affinity for the paintings of Francis Bacon. Here she has rendered a stark, empty room in which a white dog with a long, bony tail stands tensely and uncomfortably, its head down, a grimace on its face. The dog is held fast by a large-linked, brutally short chain attached to a rectangular pedestal on which rests the hand and arm of a black skeleton standing outside the frame. It's a chilling scene of imprisonment and torture.

Each of the brooding, solitary figures in these five paintings generates a provocative vibe, especially in light of a remark Brown made at the time: "Hell, if I lived by myself somewhere in a room in a studio, and that's all I did, my art would just die. I'd just back myself into a corner and my art would go to hell."

Patterns are essential to so many of Brown's paintings, especially checkerboards, a proclivity she addressed with characteristic brusqueness: "Well I've asked myself, 'What the hell interest do I have in checkerboard squares?' I've always liked checks. Even as a child, any item of clothing that was checked or dotted. I think with checks there is some kind of satisfaction from imposing order in a chaotic situation. There's something methodical, there's something that goes on within that ordering process that strongly moves me."

For a professor in the art department at a major university, Brown had a remarkable aversion to artspeak and any form of intellectual pretension.

Joan Brown and son, Noel Neri. 1976. Unidentified photographer.

At age thirty-eight, with a fourteen-year-old son, Brown was about to go through another metamorphosis. In 1976 she received a Visual Art Fellowship in Painting from the National Endowment for the Arts. She used that windfall and a grant from the University of California, Berkeley, to travel across Europe with Noel during the summer. In August, she bravely overcame her lingering fears and tackled the all-women's Alcatraz Swim again, this time coming in sixteenth in a field of seventeen. Noel said many years later that she "was a terrible swimmer!" What she had, he averred, was "incredible determination."

Then, in September, after nearly eight profoundly inspiring years with Gordon Cook, Brown sought a divorce. Tsujimoto writes, "Some have suggested that the divorce was due, in part, to the professional and commercial success that Brown was then enjoying, while Cook was less successful in his own artistic endeavors." In an article that appeared eight years after Brown's death, the author Abby Wasserman reports that while she "was outgoing and optimistic, [Cook] was introverted and critical and, according to friends, sometimes cutting toward her in public." If so, the intrepid, invincible Brown wasn't about to curb her effervescent energy or artistic verve to mollify a resentful spouse. Better to cut free than feel like a dog on a short chain shackled to a post in a locked room.

At some point that decisive summer, Brown shared an interlude in Italy with Modesto Lanzone, an old friend, restaurateur, and art collector

supportive of Bay Area artists who shared Brown's passion for bay swimming. A member of the Dolphin Club, Lanzone "rowed beside her during arduous swims and helped her overcome her fears." He told Wasserman, "Everyone said she was too skinny to do it, and she was intimidated . . . But she was a fighter." For both Lanzone and Brown, "water was a mental therapy." When the two were in Italy together, visiting Lanzone's family on the northwest coast, Brown observed a couple in a public plaza and was inspired to paint *The Kiss* (1976), which is also an homage to Rodin's famous sculpture, which she saw earlier that summer in Paris. Executed in the stripped-down style of her *Acrobats*, this enormous painting depicts a deck with a red-hot floor and simple black railings overlooking a golden scribbled mass of grasses and shrubs tinted by the sunset in a mauve sky, purple mountains in the dusky distance. On a white bench supported by thin black legs, a stylish couple is tightly wrapped together in an erotically intimate embrace and deep kiss. So heated is their passion, they seem to have torched the deck red and ignited the surrounding ring of flaming gold.

The Kiss sparked the romantic, jet-setting *Journey* series of 1976, paintings that seem to chart Brown's release from a poisoned marriage, her embrace of personal freedom, and the launch of a fresh, new, curious, insouciant engagement with the world, albeit not without addressing the shadow side of pleasure. In *The Journey #2*, a dressy woman and a suited man are on a strange white, tapering staircase rising into the sky, the San Francisco skyline in the background. Wide-eyed, he descends carefully. She is confidently ascending, her posture perfect, her smile assured. This jazzy and intriguing canvas now hangs in the San Francisco International Airport.

The Journey #3 depicts another elegant couple on a balcony or deck or rooftop, overlooking a green hill dotted with boxy white houses and an azure sea. The man half sits on the red railing, facing the viewer; the woman stands, gazing off into the distance. They seem at ease and in sync in their mutual pursuit of luxurious diversion.

The Journey #4 is the breeziest of the series. Here the couple is on a red scooter. The man is driving, his expression one of concentration, while the woman sits at ease behind him, her back against his, her legs crossed as

she holds a cigarette up in one hand and tilts her head back to exhale a curling snake of smoke. Alcatraz crouches off in the distance, reflected benignly in the calm bay waters, its menace contained.

In *The End of the Journey*, the woman, with her gamine haircut and perfectly placed beauty mark, wears a black-and-white-striped coat and red slingback heels. She is carrying a white suitcase festooned with stickers naming foreign cities, all of which but "New York" and "San Fr . . ." have been crossed out. Behind the pink patio or rooftop she stands on looms San Francisco's mostly dark skyline at twilight. She is looking over her shoulder, her expression sad and weary. Behind her looms a black, smoky cloud in which one can discern the shape of a man.

This sexy series about the romance of travel and sexual passion also charts the path of a newly divorced woman facing, once again, the vagaries of attraction, seduction, and abandonment. But two large paintings from early 1977 seem to carry the sequence into a more esoteric dimension.

In the dramatic, dreamlike *The 1st Encounter*, the left side of the canvas is dark. In that void a man in a suit and tie sits comfortably in an easy chair, his face a blank. The rest of the painting shades from orange to yellow. Just to the right of center stands, in silhouette, a woman, the same artist avatar as in the *Journey* paintings. The top of her dress is red, but from the waist down it is transparent, outlined with thick black slashes. She has her hand in a large pocket, and she is striding toward the brightest section of the painting, in which a barely detectable male figure covered in Egyptian hieroglyphics stands facing her. Behind him is an in-progress canvas on an easel. An image of transition?

The End of the Affair is also divided into dark and light. On the dark side, a man rendered in expressive brushstrokes, with fluid white lines and red and pink accents, stands facing a full-length mirror, tying his tie. In the orange glow on the right side of the painting, the woman, in a transparent lace peignoir, her hair covered with a scarf, sits, her face turned toward the viewer, on a bed covered with a striped cloth with black hieroglyphics. Beside her sits a man covered with red hieroglyphics. She has made her choice. She has left the dark for the light, the earthy for the mystical.

Brown addresses her fascination and identification with ancient Egypt without the scrim of romance in *The Search*, also painted in 1977. Here,

against an impressionistic skylike blue-and-white background, the artist stands before us, wearing a transparent Egyptian-style dress in reddish purple with black stripes, her body beneath it rendered in detail. A scarf tightly covers her head, and she wears an Egyptian-style necklace. She holds in one hand a lit cigarette, from which a long stream of smoke rises to the heavens. In the other she grasps a long, thin paintbrush from which bloodred paint drips to the ground. Both smoke and the paint seem like offerings, one to the sky, the other to the earth, one of the spirit, the other of the body. An easel stands beside her, holding a half-finished painting of an Egyptian queen. The monarch and the artist possess similarly regal demeanors. "As if by some alchemy—reincarnation perhaps—the two seem connected as spiritual sisters," Tsujimoto writes. But for all the painting's underlying mysticism, it is also mischievous in its teasing, irreverent style. Tsujimoto pegs it: "Yet in spite of the earnestness of Brown's mystical quest, she never abandoned her keen wit and often disguised the seriousness of her interests in the humorous and caricaturelike quality of her work."

Part of Brown's profound attraction to Egyptian art was her sense of its intrinsic humor and humaneness, especially during the reign of Akhenaton, a reformist pharaoh who may have established the first monotheistic religion in worship of the sun god, Aton. Akhenaton appears to have valued and respected women and their role in society, with particular regard for his primary queen, Nefertiti. He even encouraged the making of more lifelike art as opposed to standardized iconography, and the names of his chief artists have been preserved, including the sculptor Bek. Brown talked about what she found exciting about the art created during Akhenaton's brief, peaceful rule, which she described as "the most humane and touching art of all times":

There was the utmost kind of simplicity. But yet, my God, it would catch people in certain kinds of gestures. What the art described were very common everyday things that we all witness and experience and feel, and which somehow, for me, are some of the most moving. There'd be two people, perhaps a husband and wife, talking, playing. Here's the king and the queen . . . offering each other a cup of wine or whatever. The woman Nefertiti caught just for a second watching her children playing off in the courtyard. Marvelous descriptiveness of animals, of

cats and dogs. Just an everyday kind of family life and situation. It was very beautiful.

In 1977 Brown realized her lifelong dream and traveled to Egypt. She went alone, and was awestruck to finally find herself in the potent presence of the ancient monuments she'd been reading about her entire life. This journey was a genuinely transformative experience, a momentous epiphany that freed her to forthrightly address the true nature of her artistic and personal search in new paintings of undisguised spiritual iconography. Her Egyptian sojourn also catalyzed a passion for travel that would shape the rest of her all-too-brief, if fully lived, life.

After participating in the no-doubt-frigid New Year's Day Alcatraz Swim, Brown had two one-artist exhibitions in 1978: one at the University of Ohio in Akron; the other at the Hansen Fuller Gallery in San Francisco. There she displayed large, refulgent, mystical Egypt-inspired canvases conveying metaphysical messages. The title of one inordinately huge canvas, *No Excess Baggage*, was a joke. After using that phrase in her interview with Karlstrom for the third time, Brown laughs and exclaims, "God, my favorite cliché!" Six and a half feet high and fifteen feet long, this is a work of humor and metaphysical intent. The left half is an atmospheric whirl of luminous blues in which a large, all-seeing hieroglyphic eye hovers. Below it is a stack of four large suitcases, outlined in radioactive yellow and orange, which the artist is leaving behind. She stands in slender silhouette on a narrow boat piloted by the Egyptian god Ra. According to the ancient sacred stories, Ra traveled on two boats. One was the sun or morning boat, which carried him across the sky; the other, the night boat, took him through the underworld to the east, where he would reunite with the rising sun, the sign of rebirth. That is the boat Brown evokes as it takes her away from her "baggage," and all material and prosaic preoccupations, into the other half of the painting, a realm of brightening lavender, a new dawn, a new life. Beneath the boat, Brown has painted in white cursive, "He for whom this is accomplished, his soul shall live in eternity and he shall not die again in the Underworld."

The San Francisco show in which this gigantic "message" painting appeared was roundly condemned by the critics, including the erstwhile admiring Thomas Albright of the *San Francisco Chronicle*, who described

her new work as "distressingly vapid, corny, and strained." Surely she was stung, yet Brown never had painted to please gallery owners or critics, and she wasn't about to start now. Besides, she was preoccupied with more urgent matters than the art market. Not only was her head whirring with Egyptian gods and thoughts of reincarnation but her outlook also grew increasingly spiritual. Inspired to become more actively concerned with the plight of her less fortunate neighbors, she prepared meals for the homeless, worked with mothers and children at an abused women's shelter, and gathered and distributed supplies for the disabled at the historic Laguna Honda Hospital. She even carried pet food in her car to feed stray cats and dogs. For Brown, an essential aspect of the art of living was giving.

Brown turned forty in 1978, and subtly celebrated that landmark with an allegorical self-portrait unlike any other she had made. In *The Cosmic Nurse*, she imagines herself in an old-fashioned nurse uniform and cap, carrying a white case emblazoned with a red cross, the symbol of medical care, especially during war or other disasters. As she heads out to fulfill her mission to help others, a transparent yellow cat clamps down on the hem of her dress with its teeth. Brown is mocking herself, her zeal, and the obstacles she faced. But she is also responding to a key book of the time. Her waylaid nurse is in a realm of shimmering, strobing light, air made visible in a welter and swarm of small squiggles and daubs in white, red, green, and blue. This scintillating atmosphere was inspired, in part, by physicist Fritjof Capra's bestselling, enormously influential *The Tao of Physics: An Exploration of the Parallels between Modern Physics and Eastern Mysticism* (1975), in which he elucidates his perception of the correlation between perpetual subatomic collision and whirl and the Eastern spiritual understanding of the cosmos as one grand unified whole, forever in motion. To read Capra's original preface, still fresh and affecting four decades after the book's initial release, is to instantly comprehend Brown's fascination:

> I was sitting by the ocean one late summer afternoon, watching the
> waves rolling in and feeling the rhythm of my breathing, when I
> suddenly became aware of my whole environment as being engaged in

a gigantic cosmic dance. Being a physicist, I knew that the sand, rocks, water and air around me were made of vibrating molecules and atoms, and that these consisted of particles which interacted with one another by creating and destroying other particles. I knew also that the Earth's atmosphere was continually bombarded by showers of "cosmic rays," particles of high energy undergoing multiple collisions as they penetrated the air. All this was familiar to me from my research in high-energy physics, but until that moment I had only experienced it through graphs, diagrams and mathematical theories. As I sat on that beach, my former experiences came to life; I "saw" cascades of energy coming down from outer space, in which particles were created and destroyed in rhythmic pulses; I "saw" the atoms of the elements and those of my body participating in this cosmic dance of energy; I felt its rhythm and I "heard" its sound, and at that moment I knew that this was the Dance of Shiva, the Lord of Dancers worshipped by the Hindus.

Capra also wrote that the "highest aim" of Eastern mysticism "is to become aware of the unity of and mutual interrelation of all things, to transcend the notion of an isolated individual self and to identify themselves with the ultimate reality." For physicist Capra, it was an epiphany to apprehend that modern physics could "be in perfect harmony with spiritual aims and religious beliefs." For artist Brown, her deepening study of Eastern mysticism would affirm the ancient bond between art and religion, and allow her to join this intrinsically human continuum.

That summer the ever-adventurous Brown set out on an even more ambitious solo expedition to ancient and sacred sites. This time she traveled in South America, down the Amazon River, to Machu Picchu in Peru, and even to the Galápagos Islands, off the coast of Ecuador. The more Brown saw and the more she read, the more uplifting her recognition of the unity of the universe became. She saw how interpretations of life's duality—dark and light, life and death, male and female, creation and destruction, present and past—are woven into Chinese, Mayan, and Indian traditions. She marveled over the prevalence of the pyramid in Egypt and the Yucatan, and noted similarities as well in sculptures and images. She was finding her way ever more deeply into the realm of archetypes and the collective unconscious.

To further pursue her spiritual quest, Brown became a member of Ananda Community House, the San Francisco headquarters for Paramahansa Yogananda's Self-Realization Fellowship. Paramahansa Yogananda, who arrived in the United States in 1920, was one of the first gurus to teach yoga practices to Westerners in person, and his *Autobiography of a Yogi*, first published in 1946, is now a spiritual classic. Yogananda's teachings celebrate the unity of all religions, a perspective in harmony with Brown's inquiry into the universality of art. Classes in meditation and other techniques for developing and enhancing spiritual awareness were taught at the community house, which was where the artist met a police officer who was also an attorney, whose many degrees included a master of art in philosophy and religion. They were both raised Catholic, fascinated by archaeology, and committed to spiritual inquiries. Michael Hebel had been involved with Hinduism and the community house for a dozen years when he and Brown began seeing each other in late 1979. This was Brown's first serious relationship with a man who wasn't an artist. In the spring of 1980, they were married in a Hindu ceremony at the San Francisco Museum of Art, Hebel in a suit, Brown in a lovely sari, beads, and a ring of flowers in her hair. Their guests were artists and other art-world denizens, police officials and lawyers. Brown quipped, "Your friends aren't going to arrest my friends, are they?"

Hebel moved into Brown's Cameo Way house, which they extensively remodeled. The upper floor was opened up to accommodate a library and a meditation room that led to a rooftop solarium centered around a small mosaic fountain Brown designed. Theirs was a positive and harmonious bond. Hebel said, "I was a good balance for her because she had a bucketful of tenacity and a thimbleful of patience; I have a bucketful of patience and a thimbleful of tenacity."

The couple's honeymoon was a month-long spiritual pilgrimage across India, during which Brown and Hebel visited temples and shrines venerating saints, sages, and gods. They went to two of Hinduism's seven sacred cities, Mathura, Krishna's birthplace, and Varanasi, with its many ghats—broad flights of stairs, many used for cremation ceremonies, leading down to the holy river Ganges, in which pilgrims wade and bathe, washing away their sins, cleansing their spirits. Varanasi is a colorful, crowded, ardent place of water and fire, life and death, the earthy and the divine. Considering

Brown's contemplative immersions in the San Francisco Bay, this ritual river submergence must have been extraordinarily moving for her. She and Hebel also traveled to the Himalayan town of Ranikhet, at the base of the holy mountain Nanda Devi, sometimes translated as Bliss-Giving Goddess, the second highest peak in India. There Brown was photographed seated at the mouth of a meditation cave. In the months preceding their marriage and Indian sojourn, Brown had painted enormous, dreamy, nearly abstract anticipatory tributes to the sacred mountain, imagining the energy and power of this vast, heaven-reaching edifice of stone and ice. She also painted an intimate mandala, *Untitled (Eight Symbolic Trigrams)* of 1979. Against a black void coheres a disk of red dashes, a round force field. At its center is a circle rimmed with similarly active marks of blue against a pink background; along its edges, like numbers on a cosmic clock, pulse eight yellow *I Ching* trigrams. Within the central circle is a burst of light and this quote, neatly written, from T. S. Eliot's *Four Quartets*: "The end of all our exploring / Will be to arrive where we started / And know the place for the first time."

What would prove to be the most consequential stop on their honeymoon pilgrimage was unplanned. Brown was reading *Sai Baba: The Holy Man and the Psychiatrist* (1975) by Samuel H. Sandweiss, a psychiatrist from San Diego. Sandweiss describes his 1972 trip to India, during which his skeptical curiosity about the power of gurus was washed away by an encounter with Sai Baba, which precipitated a sudden surge of faith. So affected was Brown by Sandweiss's story of his instant spiritual awakening that she and Hebel decided to visit Sai Baba's ashram near Bangalore.

Sathya Sai Baba, born in 1926 in the village of Puttaparthi, reputedly began exhibiting mystical abilities as a teenager, materializing food out of thin air and reciting Sanskrit texts that he could not possibly have studied. He declared himself to be the incarnation of Sai Baba of Shirdi, or Shirdi Sai Baba, a spiritual master who lived austerely and believed that all faiths were one. His self-proclaimed reincarnation took a very different path. Sathya Sai Baba, a strong-featured man with a large, bushy Afro who habitually wore long orange robes, steadily gained enough followers and funds to become an extraordinarily powerful and extremely wealthy and showy spiritual leader, clairvoyant, and healer. Revered as a living god by nearly forty million followers, he opened dozens of centers around the world, developed

close ties to prominent individuals, and applied his massive fortune to large-scale philanthropic efforts, building elementary schools, lavish universities, clinics and hospitals, and drinking water facilities that brought clean water to millions of Indians. He also constructed a veritable theme park honoring his own life. As with so with many rich, worldly gurus, Sai Baba also aroused much suspicion and distrust. Over the years, he was accused of fakery and fraud, and, far worse, the sexual molestation of young boys.

But in 1980, when Brown and Hebel arrived at his ashram, Sai Baba was at the peak of his powers. The blessing ceremony the newlyweds attended proved to be an electrifying experience. As the guru walked through the crowd of devotees, he briefly made eye contact with the artist, who, as she later discovered, and as witnessed by Hebel, spontaneously "developed a red, third eye on her forehead," that is, a mark known as a *tilaka*, a symbol of religious commitment. From that mystical event forward, Brown, like the psychiatrist Sandweiss before her, became an ardent disciple. Her passionate commitment to Sai Baba and his projects radically changed her life and her art, and led to her death.

Brown painted *Self-Portrait at Age 42* during the year of her marriage to Hebel and the inception of her cosmic connection with Sai Baba. Rather than paint a stylized silhouette or glamorous or comic stand-in, Brown

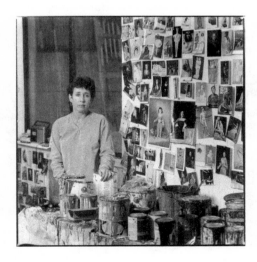

Joan Brown in studio,
San Francisco. 1986.
Unidentified photographer.

returned to the expressive figuration of her mid-1970s self-portraits, depicting herself with exacting lines and carefully chosen details. The artist stands facing forward against a flat, featureless slate-blue background, gazing with large, luminous eyes into time and space far beyond the mere here and now. Her face is lovely, glowing, and serious; her red hair forms a flame-like nimbus. She wears gold hoops in her ears. Her blue shirt is dabbed and streaked with white, pink, and green paint, indicating her artist's calling while also wrapping her in a swatch of the starry, galaxy-punctuated cosmos. Her pose seems formal, even ritualistic, with her left arm held behind her back, her right crossing over her waist, her hand, in a sheer painter's glove, clasping her other arm. Around her neck she wears four necklaces of descending lengths on which hang symbols of her spiritual quest. The lowest is a long beaded strand with a white tassel or crystal. The rest are on gold chains and clustered close together. In ascending order, they are a yin-yang symbol, the head of Nefertiti, and a lotus flower, signifying Sai Baba. In a photograph of Brown standing beside this painting in her studio, she gestures toward her shoulders, as if to say, "Yes, it's me." Unlike her self-portrait, she offers a wide, toothy, dimpled smile.

In 1980 Brown received her second Visual Arts Fellowship from the National Endowment of the Arts. In spring of 1981 she taught at the University of Hawaii at Oahu; during the summer she conducted a master painting workshop in Port Townsend, Washington, and in the fall she had a show of her brand-new Indian paintings, startling in their bright hues and simplified Hindu iconography, at the Allan Frumkin Gallery in New York. She based her pared-down palette on the symbolic use of color in many traditions, and eagerly embraced by New Agers: blue, for spirituality, inspiration, understanding, and inner peace; red, for energy, passion, and strength; pink, representing unconditional love and balance; and yellow, associated with creativity and intellect. As Brown's intensifying spirituality began determining every aspect of her art, she told the story of her embrace of Hinduism in a series of 1981 vignettes.

She updated her perennial theme in the octagonal canvas of *Family Portrait*. Against a blue background, Brown and her new husband face each other. Each is wearing a deep-rose robe (hers also covers her hair) patterned with large yellow four-petaled flowers with white centers, which resemble

the wildflower Himalayan clematis. Each holds a cat, so that the cats are also in profile and facing each other. The cat that Hebel holds up is large and white with spare black stripes; it could be a white tiger cub (white tigers live in India). Its eye is blue, its nose pink. Brown holds a slender black cat with a yellow eye. This is a loving portrait celebrating the couple's spiritual bond and shared passion for the living world.

In *The Indian Initiation*, the artist, wearing a blue, gold-trimmed sari that covers her from head to toe, accepts a scroll from a tall and attractive, somewhat Egyptian version of the Hindu monkey god Hanuman, a figure of courage, loyalty, and perseverance.

The seeker and the god meet again in *The Observation*. Here the sari-clad artist—this time in red, strands of curling hair escaping around the edge of her veil, and a curious beam highlighting her eyes—stands at the left edge, on a purple stone, in profile, looking attentively at a white-furred, white-bearded Hanuman. The god, sitting cross-legged on a purple stone pillar with a jeweled scepter by his side, faces away from her, a sweetly contemplative expression on his face. He is wearing strands of beads and an elaborate bejeweled, filigreed gold crown, a strand of red gems hanging over his forehead.

In the somewhat more painterly and expressive work *The Vigil*, the monkey god and the artist face the viewer. The background is blue, lighter on the muscular god's side. Hanuman has a red face with enormous, staring black eyes, long black hair falling behind his shoulders, a red cap, and hoops in his ears. His tall, upright body is yellow. He holds his hands before him in the Namaste pose; oddly, his feet are also shaped like human hands. Over his right shoulder hovers the sun, with a mane of rays and a man's face with a long, curving mustache. The sun looks all-knowing and bemused. The artist sits on a blue-and-white boulder, wrapped in a hooded black sari with white trim. She has a red *tilaka* on her forehead; her expression is tense and tentative. Above her is the full moon, a gentle, benevolent entity with a stylized human, feminine face. Brown expresses more emotion and uncertainty here than in the others in this religious sequence.

Brown created a new variation on her cat-and-woman hybrid in *Harmony* (1982), which consists of two tall adjacent panels with curved top outer corners. On the left, we see one-half of the standing artist,

bright-eyed in her pigment-splotched blue painting clothes, holding a broad paintbrush. Behind her the saffron-yellow background glows, as does the orange sun with its serene if watchful face. On the other panel, the colors are reversed. The furred cat half of the body is rendered in yellow and orange brushstrokes. Her eye is large and open wide; her paw is on her hip; her very long tail extends down at a sharp angle. The cat-woman stands against a blue field on which rides a white quarter moon with a sensuous face. Here Brown is celebrating the harmony rather than the dichotomy between her human and animal selves, day and night, East and West, intellect and instinct, conscious and unconscious, art and mystery.

In October 1981 Brown competed in a Golden Gate Swim and came in seventy-third out of seventy-nine. To her, it was being there and making the effort that counted. All of Brown's pursuits were sustaining and inspiring her. When Steenberg-Majewski asked her that same year, "Where do you see yourself going from here—any new directions, materials, themes?" Brown replied:

> Searching as usual, continuing the journey, going deeper inside. I don't mean in terms of being a recluse at all, just more examination. As each little bit of awareness starts coming into focus then I try to get deeper into that, more introspective. I'm very much into meditation these days, things like that which have actually resulted from the many years of painting, being involved in that particular kind of space. I find myself more involved and getting more enjoyment in teaching and working with other people than I have before though I've been teaching 21 years. It's a very exciting time.

In the summer of 1982, Brown and Hebel traveled to the Yucatán and experienced the grandeur and mystery of an astonishing number of archeological sites, from Chichén Itzá to Uxmal and Tula, and Bonampak and Palenque in Chiapas. These ancient Mayan and Mesoamerican pyramids, ziggurats, totems, and murals stoked Brown's burgeoning ideas about making large-scale public art.

Brown continued to chart her spiritual quest in mural-size canvases, including *Homage to Sathya Sai Baba* (1983), in which she stands before a

schematic blue rendering of Sai Baba's temple and residence, which is supported by a kneeling elephant and lion. The artist holds up a painted copy of her small ink drawing, *Self-Portrait with Monkey Mind* (1983). "Monkey mind" refers to the incessant inner chattering and capriciousness one experiences when one is attempting to achieve inner stillness and quiet in meditation. It is a vivid metaphor for the distractions and prosaic preoccupations that block the way to higher levels of consciousness. Brown held up her sketch on a visit to Sai Baba's ashram, hoping, as she explained in a 1985 slide lecture to other Sai Baba devotees, to catch his attention. She wanted him to affirm that she was on the right path, even though her thoughts and feelings were "scattered and racing." Brown said that he answered her unspoken questions without actually talking to her.

Brown created two immense paintings in 1983, each a primer of symbols and icons, each a declaration of Brown's evolving beliefs. In *Year of the Tiger*, the artist stands in three-quarter view in her painting clothes, with her characteristic deep-space stare, a pointed brush in hand. Two black cats flank her, each perched on a colorfully patterned column. All around her, against the serene, cobalt-blue skylike background, are symbols of her spiritual quest. Flowing from the tip of her brush is a tracing in yellow of Nut, the Egyptian goddess of the sky. Nut is most often depicted nude with stars on her body, arcing protectively over the world, her feet and hands on the ground, her supple body elongated, facing the earth. Brown has reversed this ancient image. Her goddess of the sky is doing a full back-bend, facing the cosmos, her heart open to the celestial powers, her long hair rippling down. Above her spins a colorful Chinese zodiac. The painting's title refers to Brown's sign in that system, the tiger. Brown has also painted several constellations, including Aquarius, the water bearer, her Western birth sign. Aquarius people are destined to be independent, original, energetic, deep-thinking, and caring. Brown, along with many other New Agers, believed that the current Piscean Age, a time of misery and conflict, would soon give way to the Age of Aquarius, in which people would live in planetary harmony, trust, peace, and love.

By contrast, the busy, narrative, satiric *Questions and Answers, #1* frankly confronts the artist's doubts and contradictions, and the pull of the body versus the purity of transcendence. Brown, usually reluctant to

elucidate her symbolism, did explain that *Questions and Answers* "was metaphorically based on the seven deadly sins of gluttony, greed, sloth, wrath, pride, lust, and envy."

Brown has painted herself standing and facing the viewer in paint-spattered clothes and her sheer white painting gloves, holding a paintbrush and a small paint-filled dish. The background is divided, one half in green, the other in pink, signaling Brown's investigation into life's duality, a theme picked up throughout. Reading the cartoony painting's elements from left to right, we find a drawing of Lewis Carroll's Cheshire Cat, captioned with Alice's question, one perfectly attuned to what Brown had hoped to ask Sai Baba: "Would you tell me which way I ought to go from here?" A strange bearded, turbaned reptilian figure sits before sacks of gold. A Janus-faced head, one side smiling, the other frowning, floats above the artist. Brown said that she saw this two-faced image in a temple she and Hebel visited near the headwaters of the Ganges River. In the painting's upper righthand corner, on the pink side, Brown has painted a ceremonial Egyptian scene, including hieroglyphics. Below it is a seated Mayan jaguar in profile, holding a red heart. Two cats are eating out of a double bowl. Other cats have "thought-forms" or prismatic vibrations floating above them, phenomena Brown learned about in the writings of two clairvoyant theosophists, Annie Besant and C. W. Leadbeater. A small Santa Claus stands in the lower corner, indicating Brown's love of that family holiday. She painted in white cursive:

> "I have always thought of Christmas," wrote Charles Dickens, "as a good time; a kind, forgiving, charitable time; the only time I know of, in the long calendar of the year, when men and women seem by one consent to open their shut-up hearts freely."

Brown's belief in a coming golden era in which suffering would cease, and her conviction that she could contribute to its blossoming via her art, inspired a number of paintings. The idea for *A New Age, #1* (1983) surfaced in Brown's mind while she was meditating. In a letter to Sai Baba, Brown noted that this was the first time a painting came to her in that trancelike state. The lower two-thirds of the painting is deep red with a pattern of cascading fish painted in white outlines. A paisley-shaped sea, rendered in

spangled blue and white, seems to part the red swathe. A tiny man in orange with a round black Afro floats on the waves. This is meant to represent the end of the Piscean Age. The small figure in the little blue boat is Sai Baba, ushering in the Age of Aquarius. In *A New Age: Transformation (The Bolti Fish)* of 1984, a vast work that makes viewers feel as though they were walking beneath the sea, the tiny artist in her painting gear stands between the open jaws of a gigantic, seemingly kind and gentle rainbow-scaled fish. Brown explained the origin of this vision: in Egypt, during the reign of Akhenaton, "there were fish in the river, in the Nile, called Bolti. And these fish hatched their eggs in their mouth. It was looked upon as a symbol of reincarnation and of transformation . . . And this was a sacred image." Here Brown painted her own rebirth.

Brown's vision of an idyllic, peaceful new age inspired paintings of animals who were ordinarily enemies, predators and prey, coming together in gentle tranquility, such as in the Mayan-inspired *The Golden Age: The Tapir and The Jaguar* and *The Golden Age: The Deer and The Wolf* (both 1985). Brown became a grandmother as she neared fifty, and she brought her sweet view of a paradisiacal future to *Portrait of Oliver Neri* (1988), in which she lovingly paints her adorable little grandson standing and facing the viewer in a white T-shirt and red overalls. He wears two pendants, one a yin-yang symbol, the other a miniature of Sai Baba. Little Oliver holds a small lotus blossom in his hand, a symbol of purity, rebirth, and divinity. A young jaguar is at ease to one side of the boy; on the other rests an antlered deer.

Brown spoke with Zan Dubin of the *Los Angeles Times* in 1986:

"One of my main interests is archeology and anthropology," said Brown, 48, "and in the last 10 years I've traveled to archeological sites in Egypt, India, South and Central America and the Orient. In the art I saw, the thread running through all the ancient cultures is the symbolism of a golden age—whether represented by the yin and yang or by men and women shown as the sun and moon.

"Every ancient culture, throughout the ages, had a golden age," said Brown, a soft-spoken redhead with clear blue eyes, "a time, always foretold to reoccur, when all creatures lived in peace and perfect

harmony. It was perhaps like our Eden. And we are now entering a golden age, the Aquarian Age. We are moving into a time of peace."

If only.

These tranquil, idealistic paintings suggest that the hard-driven Brown was now contentedly anchored to home and studio, dedicated to meditation, painting, and family. Nothing could be further from the truth. This restless dynamo traveled continually and arduously. In the spring of 1983 Brown went to China, touring the legendary Yellow Mountain, with its unique granite peaks and famous vistas and sunsets so often depicted in Chinese art; Hangzhou, with its beautiful, historic temple- and pagoda-ringed West Lake, a cherished inspiration for classic Chinese poets; and Xi'an, an ancient city in the Yellow River Basin, home, in its outlying plains, to the famed terra-cotta warriors of the Qin dynasty. Brown also went to India that spring, visiting the site for Sathya Sai Baba's new ashram and the astounding Ellora Caves, where between A.D. 600 and 1000, thirty-four temples and monasteries devoted to Buddhism, Hinduism, and Jainism were carved out of a high basalt cliff, the caves themselves filled with reliefs and sculpture. Brown also visited the even older, breathtakingly elaborate Buddhist Ajanta Caves. Both of these magnificent complexes, ancient technological and aesthetic marvels of religious art, became UNESCO World Heritage Sites the year Brown was wowed by them. She went on to the Mahabalipuram monuments, temples in the shape of chariots cut into massive rocks. That summer, not yet sated, she returned to Mexico, embarking on an extended journey that included a stop at the Great Pyramid of Cholula, the largest in the Americas. These sanctuaries, these artistic and sacred sites, had to be as profoundly humbling as they were inspiring for Brown. They certainly made painting, even on Brown's room-filling canvases, seem small, confining, and isolated. Saturated by her encounters with these monumental ancient carvings, temples, reliefs, sculpture, murals, ziggurats, and pyramids, Brown was ready for an entirely new approach to art.

Meanwhile, the tireless artist continued to show her new work at galleries on both coasts, racking up some lacerating reviews. Her visual diary of her spiritual discoveries and her simple, illustrative style struck

critics as childish, preachy, even kitschy. While other artists, primarily male, were praised for deliberately adopting a naive or unschooled approach to art to reach back to the essentials of seeing and expression, or for embracing kitsch with rebellious intent, Brown, whose nimble, self-deprecating wit is always on display, was condemned for what was taken as flat-footed sincerity. The chorus of negative reviews includes a write-up by William Wilson in the *Los Angeles Times* that reads, in part, "Her slightly faux-naif sideways approach has something in common with Indian miniature painting, but it is comparatively undeveloped and devoid of its complexity, poetry and metaphysics. Brown's work is charming and professional and as superficial as those suburban vestals who used to swoon over Ravi Shankar."

It's true that Brown was using a painterly shorthand. She was not channeling her ideas and visions into the intricate detail found in ancient Indian art; she was a twentieth-century American artist built for and enamored of speed. She worked hard and incessantly, but she stroked and rolled and swam across the great expanses of her canvases quickly, flowing in a torrent of thoughts and emotions, her fluency in form and color propelling her forward. Brown was seeking a more meaningful role for art and a far larger audience than that commanded by the intrinsically elite commercial art world. So wide was the gap between her intentions and the critical response accorded her work that she decided to speak out in a bold letter to an arts magazine, *Images & Issues*:

> In past civilizations and at various times in history, there was a coming together or unity of art, science, and religion . . . The ancient civilizations believed that the reason for their art was to put into form the beliefs, discoveries, and customs of their particular cultures. The artists were considered useful and respected members of their societies, and the role of an art historian or critic was unnecessary . . . Why can't art historians and critics learn the difference between knowing about and knowing? Probably because they cannot empathize with the content of a work. The critics and historians seem endlessly caught up in the "style" of art and how it can conveniently fit into a safe niche in art history . . . There is nothing really new in the content or the meaning of a work of art, as the spirit itself does not change but is

expressed differently according to the style and materials of the artist and of the time. If the art historians and critics would abandon their rational, linear thinking and make an attempt to connect to their feelings and intuitions, they may discover a clue to the real meaning behind a work of art.

After the first wave of success in her twenties, Brown pushed back against the gallery system and its preference for consistent, marketable work, declaring that an artist's entire quest is based on being free to follow the course of her own inner promptings, sales be damned. Now in her forties, and long sustained by her teaching and her gallery shows, Brown continued to maintain perfectly cordial and supportive relationships with Allan Frumkin and other gallery owners and museum curators, but once again, she chose to take full advantage of her freedom as an artist able to support herself by teaching, refusing to bow to either the marketplace or harshly negative reviews. This time she would liberate herself not only by making art of her choosing but also by enacting her vision of art as a force for good in the world, taking a giant step into a new realm and channeling her considerable talents and energy into the creation of large-scale public sculptures.

Brown stepped out of her home studio and away from her devotion to personal, private art-making into a world of commissions, committees, regulations, and construction crews. Just as she found happiness and love when she joined the spiritual community at the Ananda Community House and as a disciple of Sathya Sai Baba, Brown now flourished as a public sculptor. The fervor of her artistic commitment, her ready skills, and her fertile imagination enabled her to achieve rapid success in this new arena. In just six years this painter, whose previous sculptures had been small and constructed out of cardboard and other ephemeral materials, built eleven public art commissions in shopping malls, parks, and plazas in locations reaching from San Francisco to Los Angeles, San Diego, Washington State, Ohio, and Texas.

In a 1986 article in the *Los Angeles Times*, Brown explained,

These days I'm more excited about public art than anything else . . . Again, that stems from my awe of ancient cultures where art was a part of everyone's life and a collaborative process.

Public art demands the participation of several people—architects, artists, laborers, engineers, landscapers—and that process is important to help us become a more integrated society. We aren't islands unto ourselves.

Designing and constructing her outdoor sculptures were the ideal ways for Brown to revel in her love of bright colors, animal and nature imagery, bold geometric patterns, and deep affinity for ancient monuments. The form she chose to work with was the obelisk, a tapering square or rectangular stone pillar with a pyramidal top. The ancient Egyptians' obelisks, so finely crafted of polished granite, honored the sun god, Ra, their towering shape meant to resemble a mighty sun ray. Brown built obelisks that reached forty feet in height and were sheathed in chromatic ceramic-tile mosaics, with motifs mirroring each tower's location. Just as she discovered the qualities of oil enamel house paints in a pinch, Brown acquired her passion for tiles while she was remodeling her kitchen.

In 1984 Brown installed a ten-foot-tall obelisk, featuring a large, expressive tiger, in Akron, Ohio, at the Ocasek Government Office Building. In 1985 she had a solo exhibition of her paintings at California's Monterey Peninsula Museum of Art. In the spring she traveled to archaeological sites in Guatemala, Honduras, and Mexico; in the summer she journeyed throughout Egypt, Israel, Turkey, Jordan, and Greece. That same eventful year she installed *Black Mustangs*—a seven-foot-high, forty-seven-foot-long mural on concrete, accompanied by four-foot-wide, eight-foot-tall columns—in a junior high school in Kent, Washington, and created a magnificent thirty-six-foot obelisk in San Diego. On the Horton Plaza Obelisk, six feet in diameter, three levels of imagery depict three layers of life: at the bottom, a school of fish in the sea; above them a jaguar on land; and at the top, white birds on the wing, overseen by the sun and half-moon, each depicted with a face. That fall, Brown took a sabbatical leave from her teaching duties at Berkeley.

Brown rejoiced in her new form of monumentality and the integration of her art with the living world. Every element in her radiant, glinting obelisks is perfectly scaled, beautifully animated, and vividly patterned. She felt freshly liberated and inspired. As with everything she did, Brown threw herself passionately into her life as a public sculptor, quickly learning

complex new artistic, technical, and managerial skills while securing and completing an astounding number of commissions. She all but proselytized to journalists:

> Subjectively, I am most interested in public art because I don't like the elitism which is happening in the art world these days. I am really for bringing the art back to the people. Maybe I'm a socialist at heart, I don't know. But it seems to me that most people will not take an elevator up one, two, three or four floors to a gallery. They are afraid of being asked questions; they don't know anything about art; they are afraid of being pressured into buying; or they don't have the leisure time to go to a gallery. Even working people don't have the time, or they feel too intimidated to go to a museum.
>
> So I'm really excited about this "percentage for the arts" that is happening around the country, bringing art back to the people. In all the ancient cultures and civilizations—and this, incidentally, is one of my main interests—the arts and society were integrated. And they no longer are. Since the Renaissance they have become more and more separated and isolated . . . People today buy art for all the wrong reasons. The majority—I don't mean all the people, but those I've come in contact with, at least—buy for investment, in order to make a buck. They deal with it as if it were a Cadillac or a Rolls Royce or whatever. It's not that. Art has a soul and a spirit, and those things are ignored. People buy art because they can lord it over their friends with better, more trendy, more extensive collections. I find this absolutely appalling. I really feel that regular people might not like what they see out there, but they should have the opportunity to say so. They should have the right to like or dislike it. They should have the option to interact with art.

The 1980s was a particularly aggressive time financially. After the economic crises of the 1970s, there was a rush to rebuild, amass, and secure wealth. This was the Masters of the Universe decade: the stock market was newly resurgent; gentrification accelerated and spread; cocaine gave the up-and-coming the illusion of invincibility as they dressed for success and embraced conformity. The art world touted collecting as a brinksmanship

pursuit, all about trophy-hunting and prestige investments. New, savvy galleries opened, displaying art suitable for commodification. All this was anathema to Brown's inner-directed need to create, her reverence for sacred monuments, her turning to art as a path to communion, empathy, compassion, and connection to the living world. Joan Brown was a New Ager seeking peace, kindness, and love at a time when the art market was catering to Me-Firsters looking to make a killing.

On the upside, the 1980s real estate and luxury booms made money available for community improvements and arts organizations. The "1 percent for art" initiative in San Francisco, for example, was part of the booming city's 1985 Downtown Plan, which required developers of new buildings, or large expansions to existing sites, to set aside at least 1 percent of their construction costs for public art in privately owned yet publicly accessible open spaces, such as the outside walls of San Francisco's Performing Arts Garage, where Brown created a large bronze relief inspired by the figures on classical Greek pottery: a dancer and two graceful musicians—a flutist and a lute player—in motion, each twelve feet high and five feet wide.

In 1986 Brown completed the Center Obelisk, a spectacular commissioned work for a Beverly Hills office complex. Rising eighteen feet, it's covered in bright, scintillating ceramic tiles depicting native species of palm trees and far-larger-than-life hummingbirds. That May, Brown received an

Joan Brown. Pine Tree Obelisk. *Sydney Walton Park, San Francisco, 1987. Ceramic tile and steel. 12 x 5 1/2 feet.*

honorary doctorate of fine arts from the San Francisco Art Institute. The ever-intrepid, inexhaustible artist, now Dr. Joan Brown, celebrated by returning to Mexico for more archaeological visits.

Brown built several public towers for her hometown. Pine Tree Obelisk stands in Sydney Walton Park, vibrant with seagulls, crabs, and lobsters. A twenty-foot-high tower with porpoises joyously swimming around its facets graces the Rincon Center in the Embarcadero, and the Four Seasons Obelisk enlivens a rooftop garden in the city's financial district, its animal and plant motifs representing the four cardinal directions and the four annual seasons.

One of Brown's most challenging, lively, and eye-catching obelisks was built for a brand-new shopping mall in Arlington, Texas, between Fort Worth and Dallas. The plaque reads:

> The City's History
> a commemorative sculpture by Joan Brown
> Acclaimed California artist, Joan Brown, created this sculpture that depicts the rich history of the city of Arlington. Measuring forty-two feet tall and five feet wide, the brightly colored obelisk has been displayed in The Parks Mall at Arlington since its completion in January 1988.
> Brown uses rich symbolism to honor the city's past. The lion's head, spouting a stream of water, represents Arlington's historic mineral water well that was the focal point of the city's nineteenth century town square. The black birds are indigenous to the area. She pays homage to Texas with prickly pear cactus, a map of the state and the famous Texas lone star. At the base of the monument, the well water forms a pool with brightly colored fish, a representation included in many of Ms. Brown's works.

Twenty-six years later, a post went up on a Facebook page titled "Arlington, Texas—Proud to Call it Home," with the heading "Beautiful obelisk in the center of the Parks Mall. 42' high. Awesome piece of public art." A series of photographs show Brown's obelisk in full and in detailed close-ups, confirming that it still stands in all its prismatic delight in spite

of major renovations to the mall. The post elicited comments that would have made Brown very happy. One woman reports that her little sister took her first steps near the sculpture in the early 1990s; another remembers running around the obelisk while playing with her brother. A man remembers seeing it under construction when he was ten. Another writes that he picked up a half-priced book about Brown some years ago because he liked her paintings, and was "very surprised" to discover that she was the artist who made the Parks Mall sculpture.

Brown spent much of 1988 traveling in Hong Kong, Bangkok, Singapore, India, and Burma. She took a leave from teaching, returned to Mexico, and traveled in Belize. In 1989 the wandering artist went back to India and to Malaysia, followed by a research trip to Berlin and Assisi, Italy, where she studied the life of Saint Francis, whose love for animals resonated profoundly with Brown. The saint inspired some of her last paintings. She returned to Italy in 1990, the same year she completed an installation in Sacramento's Arden Fair Mall, *The Peaceable Kingdom,* in which two six-foot tiled benches shaped like cats stand on a six-thousand-square-foot mosaic floor alive with portraits of animals indigenous to Northern California.

Brown's mosaics and obelisks are colorful, ebullient, sparkling, soaring, and cheering. In talking about public art commissions, she observed, "There's certainly less money in it; the monetary benefit for the artists is much less than selling to collectors or through a gallery. But I find it very exciting and rewarding—a wonderful way of sharing."

What better way for the artist to express her gratitude to her guru in celebration of his sixty-fifth birthday than to create an obelisk? At the time, Sai Baba was building the Eternal Heritage Museum near his ashram, Prasanthi Nilayam (Temple of Peace), outside Puttaparthi, his birthplace. The museum is but one of many grandiose structures in the sprawling complex, which ultimately included a music college fronted by a colossal drum, horns, sitars, and guitars; a hospital; a boldly designed planetarium; a sports facility; and a museum devoted entirely to Sai Baba's life. The array of gaudily decorated edifices and garish sculptures resembles a religious Disneyland or a spiritual Las Vegas. The Eternal Heritage Museum, also known as the Sanathana Samskruti Museum and the Museum of the

Religions of the World, was built in the style of a Hindu temple with three high, elongated domes. It celebrates a central teaching of Sai Baba's, the unity of all religions, by illuminating each tradition's teachings and the lives of spiritual masters and saints. Brown and Hebel were on the steering committee responsible for planning the museum's U.S. exhibition.

Brown planned to erect her elaborately detailed thirteen-foot-tall, five-sided obelisk in the museum's three-story-high, open central hall, then under construction. She poured all her artistic and spiritual passion into its design, working on it in San Francisco with several assistants. On the bottom tier, against gleaming turquoise tiles, Brown set out fresh variations on one of her favorite themes—animal adversaries coexisting in peace and harmony—creating encircled, paired portraits of an eagle and a mouse, a peacock and a snake, a lion and a lamb. Above these vibrant, gracefully rendered images are plaques, each in the form of a temple and bearing one word in both beautifully formed Sanskrit and English: "truth," "righteousness," "nonviolence," "peace," and "love." Beneath these tablets are rectangles containing a text explicating each word according to Sai Baba's teachings. One reads, "To lose peace is to lose one's mainstay in life. Peace within you is the very nature of yourself and it is attained by abstaining from egoism, attachment and desire." Above word and scripture is another section of encircled peaceful-animal images, topped by bright flying birds and butterflies. Instead of coming to a pyramidal peak, the top of the obelisk is crowned with "a golden globe etched with a map of the world, symbolic of the universality of Sai Baba's teachings."

The obelisk was carefully packed up and shipped in enormous crates, according to one account, to Mumbai on the west coast of India. The crates were then trucked nearly six hundred miles south and east to Puttaparthi. Brown, Noel, and two assistants, Lynn Mainrec and Michael Oliver, traveled to Bangalore in September 1990. The plan was to reassemble the sculpture and oversee its installation in the museum in time for Sai Baba's November birthday and the inauguration of the new building. Brown was upbeat and excited as they waited at the ashram for the obelisk's arrival, writing to Hebel about an "extraordinary" session she and Noel had with Sai Baba, during which she felt they were drenched in his love. The sculpture's arrival was delayed so long that Noel returned home; Brown, Mainrec,

and Oliver continued to wait. When the crates finally arrived, Brown and her assistants began working with tremendous zeal.

Brown was exhilarated by her encounters with Sai Baba, who was very complimentary and encouraging as the obelisk came together. The trio was determined, as late in October as it was, to finish on time. The artist and her assistants were so intent on completing their work, as others present at the time have chronicled in online recollections, that they chose to ignore warnings that the building was unsafe: one of Sai Baba's engineers had apparently reported that the museum's immense central dome was too heavy for the structure, and in danger of collapse. The building was closed, and everyone was warned to stay away, but Brown, Mainrec, and Oliver persisted, assuring those who tried to dissuade them from entering the museum that they needed less than an hour to finish. At around 2:00 p.m. on October 26, a loud crack was heard outside the building as the massive middle dome gave way, instantly killing Brown and Mainrec and severely injuring Oliver, who later died after being rushed to a hospital in Bangalore.

Although Joan Brown was only fifty-two when she died, she had accomplished more in her shortened life than most people ever even imagine attempting. She had the fortitude, intelligence, and imagination to survive an emotionally impoverished, peculiarly and unnecessarily deprived childhood and live life with passion, integrity, and gratitude. Quickly finding her stride as an artist while still in art school, she worked consistently at a feverish pitch with such proficiency and vision that she created hundreds of paintings, many of them exceedingly large. As Brown evolved both artistically and spiritually, she valiantly and daringly charted her struggles and revelations in her self-portraits for all to see. Rather than perpetuate the misery of her parents and her upbringing, she lovingly cherished her family life, thriving in her marriages and deeply and happily loving her son. She had more than fifty solo exhibitions during her lifetime, along with many two-artist shows, and she exhibited in dozens of prestigious group exhibitions. Brown was awarded major grants and fellowships; she had a distinguished teaching career, and she traveled the world. She

took risks at every turn in her life, in every relationship, in every swim in the treacherous San Francisco Bay, in every journey, in every painting, in every change in artistic style, and in every refusal to conform to the demands of the art market, ultimately giving herself over to a faith anchored in a distant land and culture. Joan Brown never held back. She never stopped pushing herself; she never ceased exploring or creating or caring or giving.

There was another element to Brown's frenetic activities during the last years of her life. Michael Hebel told Karen Tsujimoto that in 1987 and 1988, while Brown was building her joyful obelisks and conducting extensive international research journeys, she was also dealing with breast cancer. This frightening experience added new urgency to her already high-energy ardor to live life to the fullest. Hebel said that she sensed that her life would be cut short, and "frequently talked about wanting to 'speed things up' in order to accomplish all that she could in her lifetime."

The summer before her death, Brown wrote a letter to Sathya Sai Baba, which reads, in part,

> Words cannot properly express the great joy and gratitude that I feel within my heart, the heart that you began to open in 1980 . . . Because my heart opened up my consciousness started changing and over the ensuing years some destructive and useless habits began to drop away and were gradually replaced by good ones such as service and compassion. I became aware that I was no longer a separate entity asking "what could I get from society," but instead started asking "what could I give?" . . . From the bottom of my heart I thank You for the great opportunity that You have given to my family and myself and all Your devotees to be together with You at this time in history, knowing that You are the Divine Master bringing in the Golden Age. I remain a soldier in Your army at Your Lotus Feet.

Looking back to the last time he saw his mother in India, Noel Neri said, "Before I left, when we said goodbye, I realized that her life had changed. She was living a spiritual life and our relationship was going to change, her relationship with her husband was going to change. I felt she

couldn't end her life in a better time. So many people are sad and bitter when they die. I think she had a very glorious end."

Every element of Brown's life and art would seem to secure her a place in the history of American art, and yet for years Brown went missing. Her art-world afterlife reversed the night-to-day direction of her cosmic autobiographical paintings as the bright light of recognition faded and she was relegated to the dark cave of neglect. Hers is part of the long story about underappreciated women artists, but Brown was also overlooked because her perpetually changing art made her impossible to pin down and categorize. Worst of all was what critics damned as the unforgivable gaucheness of her message-laden spiritual paintings. Brown was spectacularly out of sync with art-world trends, and consequently excised from the discourse. And yet her paintings have proved to be buoyant, resurfacing from the deep like reclaimed sunken

Joan Brown, cat, monkey. ca. 1988. Unidentified photographer.

treasures, as dazzling as gold, as entrancing as silver. In recent years, her rediscovered work has been exhibited with celebratory enthusiasm in galleries and museums in diverse locations, and a new understanding of and appreciation for her candor, wit, warmth, virtuosity, and dynamic genius is gathering strength. Joan Brown and her prodigious and radiant visual diary documenting her daring, propulsive, and profound quest, her fusing of art and life, will long intrigue and enliven all who find a way into her beaming presence.

FREEZE AND MELT
CHRISTINA RAMBERG

The point is: my aim is to make from my obsessions and ideas the
strongest, most coherent visual statement possible. Before I can make
them strongly stated I need to fully understand what those ideas are.
Only then can I really struggle.
—Christina Ramberg

Christina Ramberg stood out. Her height was exhilarating, her bright
eyes expressive, her smile radiant and gentle. With her glossy hair, lanky
poise, keen attentiveness, and readiness for fun and laughter, hers was an
open beauty. She had a melodic voice, strong, long-fingered hands, and an
irresistible gravitational force. Ramberg was alluring and private, quirky and
rigorous, original and knowledgeable. And this lovely, charming, witty, and
warm woman, this masterful artist, drew and painted erotic, taunting,
disturbing, and mysterious images of bound, broken, disintegrating, ampu-
tated, and reassembled bodies. These images were the start of an exacting,
formal, and provocative inquiry into the human figure as an icon of all our
vulnerabilities and strengths, secrets and paradoxes, wounds and resilience.

In the painting *Black Widow* (1971) a woman stands facing right,
though apart from a rolled ponytail of black hair with blue highlights, her
head is concealed by the garment she is either taking off or putting on. Her
arms are up, and she is trapped in the hooding cloth, caught at that awkward
moment when, if someone else is present, he or she can gaze at your
exposed body without having to meet your eyes—an everyday action that,
when witnessed, can make one feel excited or panicked as the article of
clothing blocks sight, restricts breath, and leaves one exposed and
hampered. But this figure is voluptuous and powerful; her flesh is flawless
and firm. She is wearing a delicate black-beaded necklace and the tight

Christina Ramberg. Black Widow. *1971.*
Acrylic on Masonite. 31 x 18 1/2 inches.

black satin and lace corset known as a "merry widow." The lace is patterned
with little fish or tadpoles or leaves. Her black satin panties have a fetching
little appliquéd rose; the one visible leg is clad in a shiny, thigh-high
stocking, and she is standing in a wave of the same black lace, as though
she's stepping out of or into a skirt. There is tremendous tension here as her
assertive breast points right, her buttocks left; her arm reaches up, and her
leg thrusts down. So statuesque is this figure, one must assume that if some
sort of submission or voyeurism is going on, it is lustfully consensual.

Black Widow is a quintessential Ramberg painting. She has used her
favorite materials, acrylic paint on Masonite. A precision painter, she loved
the hard, polished surface of Masonite and acrylic's quick-drying proper-
ties. In pursuit of a smooth-as-porcelain finish, Ramberg would even sand
her paintings down when she reworked them, to achieve a perfect surface.
She also had a penchant for assertive black outlines, a technique lifted from
comic books, one of Ramberg's enduring inspirations and the source for her
method for painting hair with patterned highlights. Her 1970s paintings are
so immaculately crafted, one cannot detect a single brushstroke, not in the

ominously neutral backgrounds nor in the intricate textures of her figures' attire. Here, too, are Ramberg's signature muted palette, freeze-frame stillness, pitiless light, and central motif: the body depicted from neck to thigh, often anchored to the painting's edges.

The most unnerving aspect of Ramberg's partial figures is the absence of a face. In her earliest works she does provide glimpses of a chin or forehead. But before and after painting *Black Widow*, she repeatedly drew images of women struggling with garments that cover their heads and bind their raised arms, exploring this vulnerable position as awkward, funny, flirty, and terrifying. Many of Ramberg's works stand on the axis between enticement and entrapment, sexual power and sexual exploitation.

Ramberg collected comic-strip panels in a scrapbook she made with her husband, fellow artist Philip Hanson, paying particular attention to "damsels in distress," crying women portrayed with their heads dropped into their hands, their hair falling protectively and fetchingly forward. She repeatedly drew prone women, facedown and crying, their faces shrouded by their long hair.

Ramberg created mystery portraits, depicting heads from the back. In 1968, as a student at the School of the Art Institute of Chicago (SAIC), she created intaglios of loose, cascading hair of different lengths. Certainly this was a time when hair was wild and free and electric with overt social, political, and sexual connotations, but Ramberg was most interested in

Christina Ramberg. Untitled (Crying Women). 1968. Felt-tip pen on paper (double-sided). 6 x 3 1/4 inches.

depicting elaborately constructed and rigid hairdos involving braids, rolls, twists, and knots. Some seem derived from European and Japanese traditions. Some resemble vegetables; one drawing of a particularly twisty configuration has the helpful caption "plastic bag." Others seem entirely alien. Even more unnerving are Ramberg's drawings of rows upon rows of small, disembodied heads that are wrapped, gagged, and blindfolded; bandaged, muffled, and masked; identities erased, senses shut down, breath choked. These bound and bulging heads are more object than human. Her drawings of variations on this theme could have been ripped from a torturer's handbook or a mad scientist's lab notes.

Ramberg also drew hands, lots and lots of gesturing female hands with long fingers and red nail polish. Hands arranging hair. Hands performing a private sign language. Hands masturbating. Hands doing dance moves. Hands forming mudras. Hands performing strange private magic tricks. Hands wrapped prophylactically in white cloth, images likely derived from the comic-book images she saved of crying women clutching handkerchiefs. Graceful hands, hands like claws, hands so oddly rounded they resemble weird heads. Hands wrapped with cords. Ramberg took lots of photographs, primarily slides, to use as references for her drawings and paintings, including shots she set up of Hanson and their friend, the artist Karl Wirsum, in which their hands are tied and bound. As often as Ramberg drew hands early on in her creative endeavor, hands, like heads, are

Christina Ramberg. Untitled *(Hands). ca. 1971. Felt-tip pen, graphite, and colored pencil on graph paper. 8 1/2 x 6 1/2 inches.*

conspicuously absent in her later torso paintings. The binding, cloaking, and severing of hands in Ramberg's work evinces a persistent engagement with helplessness and loss, states that would afflict anyone whose hands were endangered, but especially an artist.

Ramberg also drew women lashed to chairs, and bulbous women's feet crammed into very high high heels. In some depictions the foot is bound to the shoe, adding to the misery of being hobbled and hampered. These images summon up thoughts of foot fetishes, including the Chinese tradition of foot-binding. Shoes actually were a torment for Ramberg, who had extremely large feet and had to contend with depressingly limited choices in footwear. How much did her struggle to find feminine shoes for her unusually long feet shape her obsession with the binding of body parts? Her visual inquiry explores both the eroticism of bondage and, more clinically, the strange shapes flesh takes when a person is tied up or tightly wrapped. *Black Widow* is one in a series of darkly alluring paintings that depict female torsos squeezed into tight, sexy undergarments, stylishly erotic images that brought Ramberg critical attention, exhibits, and sales even before she earned her M.F.A. These paintings leave viewers wondering: Was Ramberg commenting on the peculiar ordeals women subject themselves to in order to achieve body shapes deemed desirable and fashionable? Did she see women as captives of a sexist society? Or could it be that her female torsos are fitted with impregnable corsets as armor that mocks the iconography of sexual invitation? Could her bustiers and girdles function as implements of self-control? Are these female figures being repressed physically and emotionally by others? Or are they choosing to conceal their true selves with protective camouflage? Are they combating social tyranny by proudly flaunting their female beauty and power?

Whatever the nuances of her intentions, Ramberg was obsessed with corsets. One definition of *corset* is "a tight-fitting medieval jacket," and fitted jackets do appear in many of Ramberg's later paintings. As a verb, *to corset* means "to restrict closely: control rigidly." The corset holds and molds, constricts and, perhaps, protects the body. Does it do the same for the self, for the soul? Ramberg not only dressed her figures in sexy, meticulously detailed corsets but also drew and painted free-floating corsets, improvising on the basic form until it morphed into a vessel, which she referred to as an

urn. Urns are often used to hold the ashes of the cremated dead. What to make of that? Are Ramberg's corset-urn images studies in the unbreakable bond between life and death? Her corset-urn drawings and paintings resemble the famous, often reproduced face-vase drawing first used as a figure-ground perception test in 1915 by the Danish psychologist Edgar Rubin. Face-vase, corset-urn, bondage-armor, submission-domination, life-death. The corset-urn illusion never stopped resonating for Ramberg, and her images will always induce us to look and look again.

There is a sinister dimension to much of Ramberg's work, yet Ramberg herself was engaging, kind, and wholesome. Her mother always described Christina as "sunny," Christina's sister Debbie remembers. And many of her paintings and drawings are witty and teasing, coy and fetching, though if you pay close attention, you can detect a shadow and feel a chill.

Consider *False Bloom* (1971). It appears to be one of Ramberg's gentler paintings, almost pretty in its femininity. The torso is seen from just below the ribs to the mid-thigh, and it is clad in a lovely, flirty little terra-cotta-hued wraparound skirt-like girdle, with a pattern of small black roses and garters holding up shiny black stockings. From its waistband waft pieces of black mesh, and a hand, its fingernails painted red, holds a black rose hovering near the figure's crotch. But what is false? And what does a black rose signify?

In *Probed Cinch* (1971) we see a woman from the back, standing against a putty-colored nowhere background. Her long brown-black hair hangs past her shoulder blades; a shiny black undergarment wraps her waist and the top of her hips, plunging down between her buttocks. Beneath this corset white fabric is pressed and folded into a leaf-veined pattern, with a bit of fabric poking out from the top, while a large hand with red nail polish reaches around, one finger inserted naughtily into the waistband.

Ramberg stands beside this painting in a rare piece of film footage, now seen in the documentary *Hairy Who and the Chicago Imagists* (2014). She is lovely, casually elegant, even demure, in a deep red blouse, and she is laughing shyly, and a bit mischievously, as she looks around the room.

Shady Lacy (1971) offers the same posterior view. This lady is wrapped in a floral-patterned lace bodyshaper with a band of exposed flesh above the waist. A hand reaches up to hold her long, black coiled hair, one thick strand of which slides down into her panties.

Christina Ramberg. Waiting Lady. *1972. Acrylic on Masonite.*
22 3/4 x 34 1/4 inches.

One of the most suggestive paintings in Ramberg's body of work is
Waiting Lady (1972). A woman, seen from the side and rendered with
thick, shaded black lines and colors much like those of photographic
negatives, stands with her knees bent (though we only see one slender
leg) while she bends over from the waist, her long dark hair falling
forward and completely covering her face, while her arm (again, we only
see one) is lifted and angled behind her as though her wrists are tied
and perhaps hoisted up. A slender black-beaded choker looks like a
"cut here" line around her neck, and her armpit is covered with a lacy
antiperspirant shield. She is also wearing a pointy strapless black satin
bra, a patterned corset clasping her midriff, patterned black bikini panties,
black stockings, and high black boots: a classic sadomasochistic pose and
outfit.

An entry in a journal kept in 1970 and 1971 reads,

Since I last wrote, I finished the bent-over figure I'd begun, named it Delicate Decline, & took it to Phyllis [owner of the Phyllis Kind Gallery, which handled many Chicago Imagists], designating it the one to go to Dennis Adrian's Canadian show. I expected it wouldn't sell for that reason and that it should be in the next show but a lady named Jane Abramson whisked it away. That put me under pressure to finish the next bent-over lady in time for Phyllis' show. I called it Waiting Lady because she appears to either be waiting on someone or waiting obediently to have something done to her.

Ramberg writes about her waiting ladies as though she knows no more about them than we do. No one claims to understand why Ramberg painted figures that ventured into the pornographic, the fetishistic, the sadomasochistic. Her sister Jane recalls,

She surprised all of us! I can remember my poor mother walking into the gallery and she just didn't know what to make of what Christina was doing. She was certainly interested in the grotesque, wasn't she? We all have many sides. I think there was a lot going on in Christina's life. Our life growing up wasn't perfect. There were things going on, and we often don't know each other that well. But I never felt that there was something really dark at the core about Christina at all, she just really wanted to explore whatever it was that intrigued her.

My parents knew Christina wanted to spend her life making art, and they were concerned that she wasn't going to be able to support herself, so they really pressed her hard when she was in high school and then in college to get credentials to be a commercial artist. Christina was adamant that she would not do that. She was going to figure out a way to make it work, and so she was very pure about what she wanted to do. She was going to make it happen, and she did.

No matter how puzzled by and uncomfortable with her work her family was, they all adored Christina, and her parents never wavered in

their support, or failed to take pride and pleasure in her accomplishments. And there was much to celebrate. By the time Ramberg completed her M.F.A. in 1973, she had been in eleven group shows, including the coveted Whitney Biennial in New York.

Ramberg's parents and siblings weren't the only ones who struggled to comprehend her paintings. Out in the world, her sexy corset paintings were interpreted as both obscene and feminist. Baltimore's *Sun* put together a special editorial section for its July 4, 1976, bicentennial issue, which included commentary by Isaac Asimov, Margaret Mead, and political journalist, writer, and professor Norman Cousins. How did Ramberg feel when the paper used a large reproduction of *Shady Lacy* (misspelled "Lacey") to illustrate Cousins's editorial? Perhaps she was, initially, honored because Cousins was a dedicated advocate for nuclear disarmament and world peace, causes Ramberg would later take up with zeal. But his essay, "We Have Swept Away Too Many of the Old Taboos," is a screed against sexual explicitness. Cousins identifies the increasingly open discussion of sexuality in the public square, the relaxing of objections and laws against pornography, and the "advent of the pill" as lamentable forces loosening "moral standards" and fostering "anarchy." He writes, "The society has gone from a condition in which almost nothing was allowed to a society in which anything goes . . . What we have is not freedom but an assault on human sensitivity and privacy." He objects to the deplorable spread of pornography to newsstands and mainstream movies because it "leads to desensitization." It subtracts love from sex. It also "tends to produce impotence" because it "makes sex boring." Worse, he extrapolates, it fosters "the decline of respect for life." What would Cousins, who died in 1990, have had to say about today's ubiquitous sexual imagery and the cyber porn explosion?

He raves on a bit more poetically, "Art proceeds out of an exquisite awareness of life." And idealistically, "Finally, there is the need to endow government with the kind of sensitivity that makes life and all its wondrous possibilities government's most insistent concern."

Yes, "an exquisite awareness" is a graceful and insightful term, but pairing the government with sensitivity? That is pure fantasy. And how on this spinning earth did Ramberg's elegantly sexy, strangely formal, and teasingly restrained painting of a woman's lace-covered torso earn the caption "People who insist on seeing everything and doing everything run the risk

of feeling nothing"? There is nothing crass about Ramberg's image. She was certainly not the enemy. Ramberg's work actually does exactly what Cousins believed art could and should do: it lures us into thinking deeply, in this case, about our complex, contradictory perceptions of and feelings about our bodies, gender stereotypes, sexuality, and objectification.

Ramberg rarely talked about the eroticism in her work or wrote explanatory artist statements, and she often recoiled when people felt free to bring up voyeurism, fetishism, and other sexual topics with her. Even artist Rebecca Shore, a student of Ramberg's who became her closest friend, says that Ramberg never talked to her about her risqué subject matter:

> I remember having trouble squaring the dark sexual side of her work with her; I always thought of her as very wholesome. But that's the complexity of human beings: she had both sides. She had a very playful thing going on but also dark stuff inside. And sometimes I think actually her playful side drew on the dark stuff. I remember she had these little handmade gag gift potholders that she would get at the Value Village Thrift Store. There was a female and a male. You lift the skirt and there's pubic hair made of fake fur. And on the guy you lift this flap and there's a little stuffed penis. She thought they were hilarious.

In considering how Ramberg's work has been interpreted as visual commentary on the subjugation of women and of women reduced to sex objects, Shore says, "I think that's recontextualizing. Not that Christina wasn't a feminist, but I don't think she saw her work as taking control of sexual imagery. Or sexist imagery. I don't think that intention was even there. I think it was much more about an expression of her subconscious." There was nothing overtly political, declaratory, or strident about Ramberg's work. She was far too subtle and nuanced for that. And, as Shore puts it, "She had plenty of self-doubt."

Ramberg's instant success was at once gratifying and overwhelming. Her diary entry about *Waiting Lady* continues,

> Jim Speyer [an Art Institute curator] announced at the opening that he liked it and I thought that was his way of saying that he wasn't going to

buy it, that he was relinquishing his hold on it and waiting for another. But then he said he was buying it and that it was baroque (?) (Because it twists & turns?). It has happened too breathlessly fast lately that I hardly have time to look at the paintings before they're gone and that really isn't good. When I want to remember how I handled a particular problem in the last picture I have to refer to a slide.

Ramberg was so accomplished, it's easy to lose sight of the fact that when she was painting *Waiting Lady* and other sexually daring works, she was in her early twenties. In a catalog essay for Ramberg's 1988 retrospective exhibit at the Renaissance Society at the University of Chicago, Carol Becker, a professor, author, and prominent academic administrator, wrote,

> There is no real naughtiness in these paintings. They do not represent the release of repressed fantasies which have become distorted as a result of being constrained. Nor does the implied voyeur in any way appear lascivious. The flat comic-like portrayal, the gorgeousness of the garments, present these half-dressed women as voluptuous and adored, but not necessarily sexual. They are painted so lovingly, so tenderly, so innocently, that I begin to suspect that the implied voyeur of these strong and complex paintings might not be an adult at all, but rather a young girl, perhaps sitting on the edge of the bed, watching her mother dress.

Two years after her retrospective, Ramberg, who had been on the faculty at the School of the Art Institute of Chicago since 1973, granted an interview to a graduate student, Kerstin Nelje, in which she confirmed Becker's insight with a key memory of an early awakening to sexuality:

> My father was in the military and I can remember sitting in my mother's room watching her getting dressed for public appearances. She would wear these—I guess that they are called 'Merry Widow'—and I can remember being stunned by how it transformed her body, how it pushed up her breasts and slendered down her waist. Then she put on these fancy strapless dresses and went to parties.
>
> I think the paintings have a lot to do with this, with watching and

realizing that a lot of these undergarments totally transform a woman's body. Watching my mother getting dressed I used to think that this is what men want women to look like, she's transforming herself into the kind of body men want. I thought it was fascinating . . . In some ways, I thought it was awful.

Girls coming of age in the 1950s and 1960s were confronted by a torpedo-breasted, small-waisted, round-hipped, high-heeled female role model, by perfect, obedient women squeezed into and reconfigured by "lift and separate" bras and "Heavenly Bodies" girdles, including the "Waist Whittler." There was nothing out of place on these curvy, unflappable women's bodies or in their spanking-clean homes. Their hair was teased and sprayed into helmets. Their clothing, at once fetching and wifely, was starched and properly coordinated. This sanitized, controlled, armored, and standardized mid-twentieth-century ideal American lady-of-the-house was lauded in movies and on TV, in glossy and pulp magazines, in advertisements and commercials, and in comic books. Sinners or saints, women were reliably nurturing. They were supposed to play dual roles: ever-willing corseted playmates and lace-wrapped vixens as well as cheery and accommodating full-time homemakers and moms. When girls, reveling in the ready freedom of their preadolescent bodies, caught their first glimpse of the undergarments that made possible that cookie-cutter style of womanhood, they might have been shocked by the contraptions involved, the pinched, creased flesh and the misshapen feet. This revelation must have struck keen-eyed Christina with particular sharpness. Not only was she an unusually tall and angular girl, hence an unlikely candidate for the requisite plush look, she was also already scrutinizing everything around her and preparing herself for the life of an artist.

Her sister Debbie, who was two and a half years younger than Christina—the four Ramberg children arrived at neat two-and-a-half-year intervals—remembered, "Christina always excelled. She won a coloring contest when she was little. It was in the Sunday newspaper. We were living in Fort Leavenworth, Kansas. We lived there for one year. I was in third grade, so she must have been in fifth grade. She was always good at these things. If you had to color a picture of a woman, she would put a plaid dress

Christina Ramberg. Paper dolls.

on her, not just a plain-colored dress. She always had an eye for that kind of stuff."

The sisters, Debbie recalled, would "spend hours and hours doing paper dolls." Commercial paper dolls were favorite playthings in the mid-twentieth century, and even in the digital age they remain popular as toys and collectibles. Inexpensive and fun to play with, they fed children's imagination and fascination with fashion. Many featured characters in fiction, comic books, movies, and television shows, but the Rambergs made their own, constructing dolls out of manila folders. The dolls and outfits Christina created were extraordinarily well made and vibrant. Her dolls' faces were expressive, and their stylish clothes evince great command and inventiveness. Top book and fashion illustrators designed manufactured paper dolls and their clothes; had Christina been interested in commercial art, she would have excelled.

In 1963, when Ramberg was a junior in high school, Betty Friedan's *The Feminine Mystique* appeared. Now designated by the Library of Congress as one of the "books that shaped America," it remains an arresting critique of the lives of suburban women, including Friedan's own as a mother of three with a psychology degree who was writing freelance articles for women's magazines. These publications, when she first began to work as a journalist, had published serious fiction and covered the full spectrum of news, science, and culture; but they had shifted to peddling fluff,

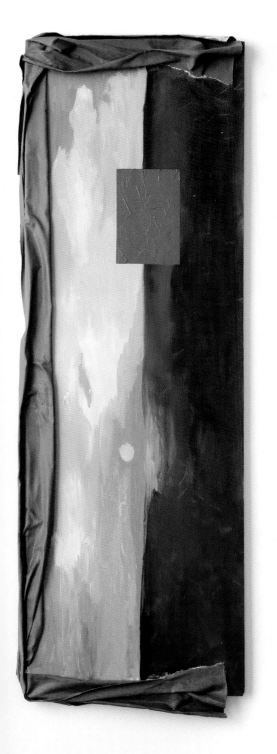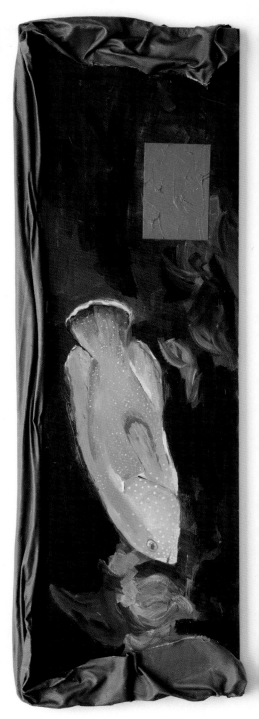

PRECEDING PAGE: Ree Morton.
Regional Piece. 1975–76. Oil on wood
and enamel on celastic in two parts.
Each: 17 x 50 inches.
Photographer: Bill Orcutt.

THIS PAGE: Joan Brown.
Family Portrait. 1960. Oil on canvas.
70 3/4 x 61 1/8 inches.

Joan Brown. *Self-Portrait.* 1970.
Enamel on canvas. 26 x 26 inches.

Joan Brown. *Portrait of a Girl*. 1971. Enamel on Masonite. 96 x 48 inches.

Joan Brown. *After the Alcatraz Swim #3.* 1976. Enamel on canvas. 96 x 78 inches.

Joan Brown. *The Dancers in a City, #2.* 1972. Oil enamel and fabric on canvas, 84 x 71 3/4 inches.

Joan Brown. *Harmony.* 1982. Enamel on canvas. 96 x 60 inches.

FOLLOWING PAGE: Joan Brown. *Year of the Tiger.* 1983. Oil enamel on canvas. 72 x 120 inches.

Christina Ramberg.
Wired. 1974–75. Acrylic on
Masonite. 48 x 36 inches.

Christina Ramberg.
Hexagons, Number 1. 1984.
Cotton. 68 x 102 inches.

Christina Ramberg. *Hermetic Indecision.* 1977. Acrylic on Masonite. 49 x 37 inches.

Christina Ramberg. *Sedimentary Disturbance.* 1980. Acrylic on Masonite. 49 1/4 x 37 inches.

Christina Ramberg. *Freeze and Melt.* 1981. Acrylic on Masonite. 47 9/16 x 35 5/8 inches.

Christina Ramberg. *Untitled (#126).* 1986. Acrylic on linen. 22 x 18 inches.

Lenore Tawney. *Jupiter.* 1959. Silk, wool, wood;
woven. 53 x 41 inches.

Lenore Tawney. *Jupiter* (Detail). 1959. Silk,
wool, wood; woven. 53 x 41 inches.

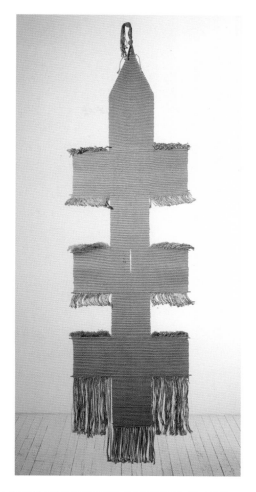

Lenore Tawney. *The Path.* 1962.
Linen, 24k gold. 90 1/2 x 24 1/2 inches.
Photographer: George Erml.

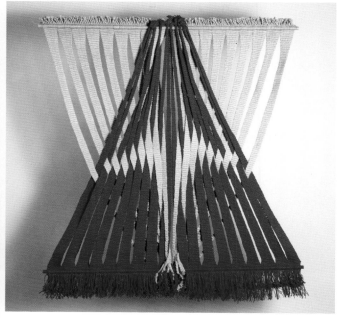

Lenore Tawney. *Union of
Water and Fire.* 1974.
Linen. 36 x 36 inches.
Photographer: George Erml.

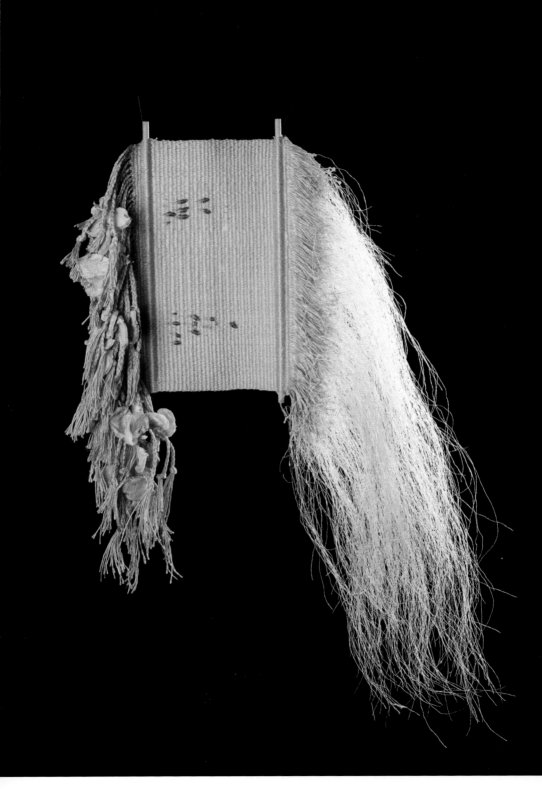

Lenore Tawney. *Shield.* Begun ca. 1967, completed 1985. Linen, horsehair, feathers, whelk egg cases. 15 1/2 x 14 inches. Photographer: George Erml.

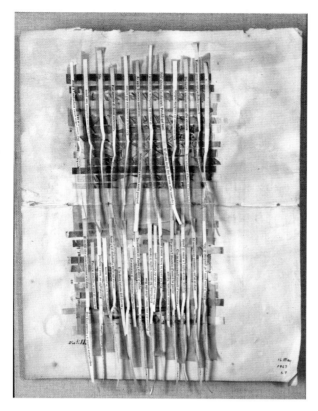

Lenore Tawney. *Distilla.* 1967.
Collage. 10 1/2 x 8 1/4 inches.
Photographer: George Erml.

Lenore Tawney. Postcard collages.
1973–1987.

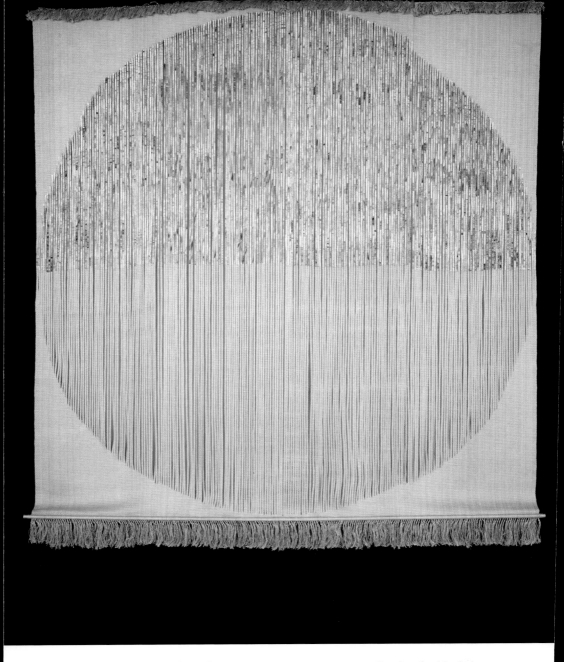

Lenore Tawney. *Waters above the Firmament.* 1976. Linen, warp-faced weft-ribbed plain weave with discontinuous wefts; 18th/19th century manuscript pages cut into strips, attached, and painted with Liquitex acrylic paint; braided, knotted, and cut warp fringe. 56 1/2 x 145 1/4 inches.

upbeat little stories about how to be a glamorous wife, mother, and full-time housewife. Perturbed by this editorial dumbing-down, Friedan began to dissect what she termed the "feminine mystique." She writes, "The feminine mystique says that the highest value and the only commitment for women is the fulfillment of their own femininity," and that fulfillment can only be found "in sexual passivity, male domination, and nurturing maternal love." No matter how smart, curious, and well-educated a woman is, "she exists only for and through her husband and children."

Ramberg also came of age in the time of *Playboy*, founded in Chicago in 1953 by native son Hugh Hefner. With Marilyn Monroe on the cover, the first issue sold more than 50,000 copies. On these glossy pages, nubile female beauty was displayed in all its fleshy pulchritude, with lingerie serving as enticement, enhancement, and titillation, not as corrective intervention or armor—no unsightly flaws, bulges, or sags allowed. By 1960, when Ramberg was fourteen, the magazine was attracting a million readers a month. Hefner opened the first Playboy Club on Chicago's lakefront, and the Playboy Bunny was born. Three years later, intrepid freelance writer Gloria Steinem went undercover, working as a Bunny in New York City's Playboy Club for seventeen days. She then wrote "A Bunny's Tale," a scathing two-part diary-form article for *Show* magazine about how badly the women in the too-tight bunny outfits were treated. It still makes for to-the-barricades reading.

But open the December 1972 issue of *Playboy*, and you'll see what appears to be a sexy intellectual with a come-hither look. Her dark hair is slightly mussed; her large, round glasses are just one more item to remove; her mouth is slightly open in a saucy half smile. But she is not a centerfold, nor a Bunny. She appears on the "Playbill" page, where the editor previews the articles within. She shares the two-page spread with writers Lawrence Durrell, Robert Graves, Ralph Nader, Woody Allen, Nelson Algren, Ray Bradbury, and Bernard Malamud. She is an artist. She is Christina Ramberg, who found a different way from Steinem's to infiltrate Hefner's world.

When Ramberg began exhibiting her elegantly erotic paintings in the late 1960s, Chicago artist Kerig Pope was working for *Playboy* as an associate art director. He astutely and generously recruited some of Chicago's

most daring artists as well-paid freelance illustrators, including Don Baum, Ed Paschke, Karl Wirsum, and Christina Ramberg. Ramberg's polished work reproduced spectacularly well. In 1972 she illustrated "Love Lines," two pages of "amorous poems" by novelist, travel writer, and poet Lawrence Durrell, renowned for his *Alexandria Quartet*, and Robert Graves, England's poet laureate. The poems are printed in dark purple against a mauve background on one page, lavender on the other, and the two-page spread is bookended by two Ramberg paintings that create a saucy visual push-pull. On the left is a close-up of a perky-breasted woman's torso in profile pointing left and wrapped tight in a richly patterned black lace and satin bustier with a row of little nipple-shaped studs running up the front edge, a thick black ribbon undulating down the side, and a knotted black lace hankie arcing from the pointy bra cup like filigreed butterfly wings. On the right-hand panel, where Robert Graves's poems appear, we see the figure's derriere, pressed against the mauve edge as the torso, clad in shiny black bikini panties, tilts to the right. Is it pure chance or a visual pun that this taut posterior is aligned with the word *posterity* ("Let me put on record for posterity / The uniqueness of her beauty")?

Each page is graced with more of Ramberg's enticing images. Above Durrell's poems, we see a romantic, fairy-tale illustration of a purple hand holding a rose, while the first poem, "Spring Song," delivers these clunky lines: "And all this nonsense about women's liberation / Will fade into the fifty-fifty of kisses shared." Durrell's second throwaway effort is titled "Hey Mister, There's a Bulge in Your Computer." Robert Graves's rather morbid love poems ("And she is also the dark hidden bride") are accompanied by two Ramberg paintings. Seen through a screen or scrim, a woman's hand reaches below a strange, hanging shape rendered in the black-blue pattern Ramberg used for hair. It could be a rolled ponytail and the back of a head; it could be a weird penis and scrotum. Beside it stands a swollen ankle and foot jammed into a high-heeled shoe. The curvy flesh in Ramberg's torso paintings is glowing and perfect: as immaculate and regal as French master Jean-Auguste-Dominique Ingres's odalisques, as machined as Fernand Léger's Cubist figures, and as delectable as the pinups of *Playboy* favorites Alberto Vargas and Mel Ramos. And might not *Playboy*'s airbrushed centerfolds also have inspired Ramberg's polished style?

In the March 1974 issue we read in "Playbill": "Joyce Carol Oates, with the help of artist Christina Ramberg, adds a pinch of incest in 'The Golden Madonna.'" National Book Award winner Oates, a writer of delving social and psychological insight and mind-whirling creativity and productivity who often writes with fierce explicitness about the vulnerabilities and strengths of women, has had many stories and articles published in *Playboy*. But this particular tale is a curious choice, given that the sexual tension is not only taboo but also terribly sad. Here desire is a malady. Ramberg perfectly captures the dynamic of Oates's queasy tale in portraits of the two protagonists. One shows Alexander, the twentysomething nephew, from the back. We see his denim jacket and the bristling pelt of his hair, half combed into a loose ducktail. His vampy aunt, Eunice, is portrayed in profile from just below the waist to just above her lush, very plump, very red lips.

In November 1978 Ramberg illustrated Barbara Rochelle's "Perfect Match," an unsettling short story with an arsonist theme that, likes Oates's tale, runs contrary to *Playboy*'s casual-sex-is-fun message. Ramberg's painting is of a sexy woman's torso, leaning forward. She's attired in a black lace bustier and panties, and her long red dress is thrown back to reveal her hip and thigh, with the leg closest to us bent and raised, her high-heeled foot firmly planted. Her arm reaches between her legs, and her hand holds a lit match, its little flame making her body glow.

In January 1979 the Chicago Public Library Cultural Center, an architectural jewel on Michigan Avenue, mounted *The Art of "Playboy,"* an exhibit that celebrated the hometown magazine's twenty-fifth anniversary. In the *Chicago Sun-Times* review, David Elliott expresses surprise at how varied the artwork is. He notes that *Playboy*'s art director "has been a godsend to Chicago artists," and he singles out Ramberg's illustrations for Durrell and Graves's poems, displayed in large reproductions. Elliott offers this startling assessment: "Christina Ramberg's 'Love Lines' may be the kinkiest, oozingest-with-sin thing ever to appear in *Playboy*."

In her 1969–70 journal, Ramberg wrote, "For a while I've been thinking about some paintings I'd like to make, but I've tried to ignore the thoughts because the paintings sound so sick . . . An item in the newspaper brought my latent desires to the fore once again. The headline was something to this

effect: 'Semi-invalid drops cigarette to lap: dies in fire.' The father of the victim tried unsuccessfully to put out the burning clothing with water. Another article a few months ago also fascinated me. It was on the obituary page and told of a nun participating in a celebration and bonfire who suddenly took off her sweater and shoes and leaped into the flames. Observers said she had been in good spirits and could supply no motive. The nun was 43." Ramberg made a little sketch of this baffling and horrific scene.

Ramberg's parents grew up in Wisconsin. Her father, Vernon, was of German and Norwegian descent; her mother, Norma, was German and Scotch-Irish, and somewhere along the line there were also Dutch and Swedish ancestors. An army colonel, Vernon served in Italy in World War II; he then brought his growing family along on subsequent postings. Norma had hoped to study music at a conservatory and pursue a musical career, but this was during the Depression and necessity won out, leading her to attend a "normal school," that is, a small local college. Charles was the firstborn, followed by Christina, who was born on August 21, 1946, in the recently opened military base Camp Campbell, which became Fort Campbell in 1950. When Christina was four, Vernon began a two-and-a-half-year stint in Japan as a member of the American occupying force. Debbie was born there. This sojourn in Yokohama left an indelible impression on Christina, and Japanese crafts and art profoundly influenced her work. In a 1983 interview, Ramberg says of this interlude,

> I remember it quite vividly . . . My father did logistics work, and we lived in military housing but at that time, the Americans were employing a lot of Japanese and we had a Japanese maid for each child; we had a cook, you name it . . . It was very nice, because each maid kind of adopted a child of the family, and I can remember being taken to my maid's home, and I remember the rice paper on the screens, the smells, and what it was like to take your shoes off at the door, and the cherry blossoms.

This idyllic memory is particularly interesting in light of the fact that Yokohama, the second largest city in Japan, was hit by more than two dozen

air raids, including a catastrophic attack in May 1945, in which nearly half of the city was pulverized into ruins, and at least seven thousand people were killed.

When Jane, the youngest, was three, Vernon was sent to Germany, and Christina attended third and fourth grades in Heidelberg. This was their last overseas posting. Back in the States, they lived in Kansas, Virginia, and, when the army sent Vernon to Chicago, in Highwood, Illinois, which is twenty-four miles north of the city. Norma chose Highwood for the excellent schools in the area, and Christina attended Highland Park High School during her junior and senior years. When Jane entered first grade, Norma returned to her first love, music, and began teaching piano, becoming an in-demand instructor for serious students. Jane recalls,

> When we came home from school, we would be on our own until our mom was done with her piano students, about supper time every day. We were all required to study piano until we got to a certain level of proficiency and then we were off the hook.
>
> Christina was very musical. She was good at piano and she had a good voice and she was wonderful at harmony. We spent a lot of time on family trips, singing in the back seat of the car, and Christina always did really good harmonies. Our singing was torture for our brother. That was the real purpose of it. He hated it.

Classical music and show tunes provided the sound track for the Ramberg home. Christina, who came to love opera, eventually had a piano in her studio, and she would work on mastering classical pieces. She also played the recorder with friends and fellow artists Gladys Nilsson and Jim Nutt.

Christina was always very close to her mother. When Vernon was serving in Vietnam, Norma ran every aspect of their household. Once Vernon returned for good, she wasn't about to step back and relinquish her control. This led to some friction, and Vernon could be difficult. Christina told her close friend Rebecca Shore that Bull Meecham, the fighter pilot and abusive father played by Robert Duvall in the movie *The Great Santini* (1979), based on the autobiographical novel by Pat Conroy, reminded her of

her father. Yet Debbie remembers Vernon coming home from work and joining them in their paper-doll sessions. "He would sit down on the floor with us and make a paper doll outfit. And they were pretty funny and pretty good. I remember they always had a lot of buttons on them, and pockets and stuff. And Christina was just so encouraging."

Jane explains that Vernon, who sported a full silver beard in his later years, was very depressed when he returned from Vietnam in 1962.

> The war there really changed him. He continued to forge his military career and was promoted and everything, but he thought the Vietnam War was a huge mistake, and he was pretty disillusioned with American foreign policy. He became a real liberal, and I think this made it hard for him to be successful in his work, given his antipathy toward the military. He was in his mid-forties when he came back from Vietnam and he didn't retire until he was in his sixties, so that was a long time. To say that he was a very difficult person is putting it mildly. He embarrassed poor Christina so many times with the things he would do at her openings.

"Christina had a lot of friends growing up," Debbie reports. "Everybody wanted to be her friend because she was such a good person, such a nice person. She didn't have as many boyfriends as she would have liked because she was so much taller than all the boys. Her height was always such an issue for her. But everybody adored her."

Christina learned to sew and sew well because she had such a hard time finding clothes she liked that fit her. She developed a great passion for fabric, stitching, sewing patterns—all the tools and practices of making clothes, and that passion had a profound effect on her artwork.

Ramberg's ongoing quest for shoes was traumatic, Debbie recalls:

> It was hard to be tall when Christina was growing up, and her feet were really big. She used to draw a lot of shoes. She was pretty fascinated with feet. I remember when she was in tenth grade, and I was in eighth grade, she would get these catalogs in the mail, special catalogs for people with big feet. The shoes would look so pretty and cute. And then the shoes

would come and they wouldn't even look remotely like the catalog and she would cry. It was awful; it was horrible. Because she wanted to wear those cute shoes just like everybody else did.

Jane adds, "There are really tall women in our family. Christina was six-one; I'm six feet, my dad's mother was five-nine, which was really tall for her generation. I don't think Christina liked being so tall, but that was the way it was going to be. She had really long feet. It was just ridiculous, what she had to go through."

Ramberg's husband, Philip Hanson, remembers, "Finding shoes: it was awful. She had to go to this place downtown, on the eleventh floor. A place for women who needed sizes larger than ten. She'd try to find shoes she could bear; there wasn't much to choose from in her size. Maybe only two styles. And the guy says, 'Well, lady, it's either those or you wear the shoe boxes.'"

Christina was so tall and had such disproportionally long limbs, fingers, and toes that her parents worried that she might have Marfan syndrome, a disorder that afflicted Abraham Lincoln, and that affects the body's connective tissue. Marfan can also weaken the heart and blood vessels. Later, Christina and Phil worried that their son had it.

Shore thinks that Ramberg was acutely self-conscious about her body, but she would joke about it, too, such as when she realized, much to her amusement, that cross-dressing men ordered shoes from the same catalog she used. She told Becky that, with her build, "clothes that looked good on a hanger looked good on her." While Ramberg could laugh about how difficult her wardrobe challenges were, she did get tired of people forever staring at her and making remarks about her height. No doubt her conspicuously different physique fueled her imaginative, daring, and provocative artistic inquiry into the absurdities and mysteries of the human body.

According to Jane, "Christina was always drawing. She had a room on the top floor at the front of the house in Highwood, and whenever I went up there, she'd be drawing, working on something." She was also an excellent student. Highland Park High School, which has honored Ramberg as a Distinguished Alum, had an exceptional art department, and Jane

notes that the art teacher at the time, Mrs. Esserman, "recognized that Christina had a lot of ability. She had a lot of influence on Christina, and encouraged her."

During the summer between her junior and senior years, Christina took an art class at the Art Institute of Chicago, thus launching a life-shaping association with the museum and its school. The School of the Art Institute of Chicago became Ramberg's artistic wellspring. Not only did she study with inspiring and insightful teachers, she also made close friends and met her husband there. The school became the source of her livelihood as she worked in the school store as a student, then joined the faculty once she earned her degrees. After her nomadic childhood, she seemed happy to put down roots, and she chose her holdfast wisely. SAIC was fizzing with radical, mischievous, inquisitive ideas, and the painting department attracted an extraordinarily gifted and adventurous group of students during the 1960s. These aspiring painters veered away from the Abstract Expressionist movement then ruling the more prominent New York City art world to create surreal, cartoony, risqué yet meticulous figurative art shaped by American pop culture and the art of diverse indigenous cultures. The instigators for this voracious sensibility were three innovative and influential art historians.

The first was Helen Gardner. Born in 1878 in Manchester, New Hampshire, Gardner arrived in Chicago with her family in 1891. Having earned degrees at the University of Chicago in Latin, Greek, and art history, she began lecturing at the School of the Art Institute in 1920, and two years later become a very popular full-time member of the faculty, creating an innovative art history curriculum while working on her landmark book *Art through the Ages: An Introduction to Its History and Significance*. First published in 1926 and revised in subsequent editions, *Art through the Ages* became a keystone work. Not only did Gardner guide readers through the centuries but she also widened the scope to illuminate non-Western traditions and modern art, emphasizing universal principles found in diverse cultures and aesthetics. Gardner's pioneering and profoundly enriching approach to art history extended its reach far beyond the classroom.

Enter Kathleen Blackshear. Born in Navasota, Texas, a town founded by her grandfather, young Blackshear became friends with the children of

the African Americans who picked cotton on her family's plantations, an experience that she revisited in her drawings and paintings. Blackshear began taking art lessons early, but she earned a degree in modern languages at Baylor University before she went to New York to study at the famed Art Students League. A free spirit, she traveled across America, Mexico, and Europe, taking photographs and making art. She came to Chicago in 1924 to study at the School of the Art Institute, where she became Gardner's protégé. Blackshear began teaching art history in 1926, and kept at it until 1961. As Susan Weininger and Lisa Meyerowitz observe, Blackshear "sent students to explore not just the galleries of the Art Institute, but the Field Museum of Natural History, the Shedd Aquarium, the Oriental Institute, and the local zoos for inspiration. In this way, she influenced generations of students at SAIC to discover idiosyncratic sources and connections with cultures other than their own, laying the groundwork for later Chicago artists of the Monster Roster and Imagist movement."

Whitney B. Halstead is the third of the open-the-doors-of-perception art historians. Halstead earned degrees at SAIC, then developed an expertise in primitive art while working in the Field Museum's anthropology department, the subject of one series of courses he taught at SAIC. Art historian Robert Cozzolino writes, "Halstead's image-proliferative art history classes could incorporate up to two-hundred and fifty slides as he made stunning cross-period and cross-cultural comparisons based on visual evidence."

Blackshear and Halstead were significant influences on artist, collector, and teacher Ray Yoshida. Soft-spoken, keenly observant, and impish, Yoshida, the son of a Japanese immigrant father, was born in Hawaii in 1930. He attended the University of Hawaii, then earned his B.F.A. at the School of the Art Institute in 1953 after a stint in the army, and his M.F.A. at Syracuse University. He returned in 1960 to teach at SAIC, where he stayed for some forty years, encouraging students aesthetically and engaging them in "a vigorous intellectual exchange." While developing his own pulsating, patterned, and cartoony work, Yoshida also elevated the collecting, scrutiny, and curating of objects and comics to the height of an art form. He encouraged his students, including Ramberg, to do the same, directing them to Chicago's vibrant outdoor market on the Near South

Side, the famous Maxwell Street, where all sorts of junk, goods, clothes, tools, parts, furniture, bootleg recordings, funky crafts, oddities, and treasures were set out for perusal and haggling over while blues musicians played, food sizzled, and people strolled, meandered, loitered, looked, listened, teased, flirted, fought, and harangued. This gritty weekly carnival of castoffs and discoveries, this living street exhibition, fed the imaginations of Chicago's aspiring artists. Yoshida explained, "I was interested in students beginning to work on iconography or ideas that were not necessarily art school things."

Ultimately Yoshida amassed an eclectic collection of 2,600 items, from African art to toys, folk art, and bent-wood furniture, all of which was carefully documented after his death in 2009 and bequeathed to the John Michael Kohler Arts Center in Sheboygan, Wisconsin, where Yoshida is revered as a "collector of all things interesting and undervalued."

In a video about Yoshida's astonishing collection, Kohler curator Karen Patterson explains that his students who became Chicago Imagists "credit Yoshida with this idea of metamorphosis. So that you look at an object, you see it for what it was; you bring it into your home, you place it next to something completely different, and the identity changes. Looking at these objects triggers something in you. You're undoing an identity that this object previously had, and in that liminal space is where creativity lives."

Ramberg collected dolls—more than 350 dolls, which she and Hanson displayed on the walls of their apartment. Odd, used and abused, discarded, disreputable, funny, deformed, cute, demonic, obscene, and creepy dolls. These battered dolls comprise yet another complex facet of Ramberg's surpassingly complex study of the figure and how we imagine and represent it.

She and Hanson kept scrapbooks of comic book panels. Ramberg systematically gathered and archived source material, evincing a passion for categorizing that seems to run in her close-knit family, where order and organization were essential to the lives of an often on-the-move military household. The embrace of orderliness inspired Charles to become a lawyer, Debbie a librarian, and Jane a scientist, while Christina brought a love

of research and classification to her study and practice of art, along with the inclination to work with a subject over and over again, as though she were conducting lab tests, trying out different variations and watching for transformations. In one of her notebooks she wrote, "Investigations of growth." Hers was an art of morphology, a sustained inquiry into structure and form.

Though this pursuit is manifest most often in her drawings, an occasional painting reveals this scientific fascination. *Cross Breeding* (1978) is a double panel on which she painted two women's heads seen from the back, each with blue-black comic-book hair expertly coiffed into elegant chignons. But the hair only grows down from the level of the ears, while the fleshy top of each head opens out into a genitalic bud or bloom. The painting looks like a botanical illustration of the monstrous outcome of a cross-breeding between humans and an alien, carnivorous plant.

Ramberg had remarkably clear and graceful handwriting. She almost never had to cross out or erase a word in either her carefully preserved school papers or the smallest of her notebooks, even when she was writing while standing in museums, sketching and commenting on paintings and other artworks she found illuminating. She used her own style of shorthand ("ptg." for painting, "dr." for drawing). She maintained extensive files of all kinds of clippings, photocopies, brochures, newspaper ad supplements, and other printed materials. The subject headings include "Anatomy," "Armor," "Art Brut," "Baskets," "Body: Human Figure," "Chinese paper cut-outs," "Clothing," "Furs," "Gardens," "Hardware," "Insects," "Italian primitives," "Jewels," "Knots," "Odd Newspaper Stories," "Persian Indian," "Pets," "Rousseau," "Script—Writing," "Sports Photos" (shots that capture athletes in action with their bodies contorted and colliding), and "Structures." Her "Beauty" file was filled with magazine clippings of ads for foundational garments that look like torture devices or chastity belts, all sorts of absurd so-called beauty treatments, including chin straps, blindfolds, and bizarre contraptions to keep skin taut, and oddly composed how-to photographs for cutting hair.

Ramberg kept a page from a wrestling magazine, now yellowed. On one side we see small head shots of cute kids accompanied by their age, name, address, and sports enthusiasms, including, of course, their favorite

wrestlers. It's a pen pal program, with a coupon to sign up. On the reverse side is a full-page ad for sex dolls:

> Life Size—Life Like Instant Action
> Lowest Ever Sale, with prices marked down from $29.95 to $9.95.
> "Thousands sold"
> 6 new designs So Flexible
> Comes Complete With Built In Female Organ Human-Like Hands—
> With Electronic Fingers Open Mouth Deep Throat Action

Nothing Ramberg drew or painted was any weirder than real life.

Chicago was not only home to Maxwell Street, a collector's paradise, it was also headquarters for the legendary Sears catalog. The addictive Sears "Book of Bargains" and "Wish Book" began modestly in 1888 with a small edition devoted to watches. It then ballooned into an enormous "everything" compendium, the pre-Internet shopper's virtual emporium, offering page after page of small, detailed drawings of jewelry, clothing, shoes, tools, bicycles, books, cameras, carpets, china, pianos, organs, and sewing machines. Sears sold the earliest home entertainment centers in the form of magic lanterns. Wallpaper, paint, furniture, office machines, sports equipment, wigs, firearms, appliances, and entire houses were for sale. The drawings were captivating, and everyone pored over them in a state of covetous bewitchment. The catalog came out in various iterations until 1993. Ramberg had to have been entranced by the Sears catalog as a girl, and she even worked for a spell at the Sears Roebuck Commercial Paper Company.

The artist had a forensic bent. She collected old, elegantly explicit medical illustrations and shockingly graphic medical photographs. In 1970 she wrote in her diary, "On my wall I put up pages from the medical scrapbook which Phil can't bear to look at—the diseased skins and the organs being operated on—all very beautiful. As in the Rousseaus, the forms, the nameless organs being sewn, cut, tied, are all ptd [painted] so carefully, smoothly, caressedly."

These artistically rendered medical illustrations figure prominently in her late 1970s work, as did her attraction to expressive paintings of the crucifixion. In a 1983 interview with Morgan Spangle, who was then working for the Richard Gray Gallery in Chicago, Ramberg described her undergraduate paintings as "quasi religious." She explained, "I was thinking about hierarchical religious paintings that I liked in the museum, hierarchical arrangement." She also had an abiding formal interest in the shape of Christ's body on the cross, a focus aligned with her perception of the beauty of medical illustrations and her aesthetic perspective on images of suffering. As for potential religious intentions, her sister Jane thinks not. Their parents were both Methodists, she explains, who were active in the church while she and her siblings were growing up. "They were very popular Sunday school teachers," Jane says. But there were no images of the crucifixion in their churches. "In the Methodist church there was a picture of Jesus and a plain cross and that was about it."

Christina saved a black-and-white group photograph from Fort Leavenworth, Kansas, of a group of neatly groomed kids, tagged "The Bible Advancers." Young Christina, her smooth hair held back with a barrette, braided, and beribboned, is standing in the last row just in front of the teacher, her gaze intent yet dreamy.

After their father returned from Vietnam, Jane continues, he "lost interest in the church. So it was right around that time that we didn't do

Christina Ramberg. The Bible Advancers.
Unidentified photographer.

that so much anymore. And I think my mother lost interest, too. Years later, they became Unitarians." Christina didn't attend church as an adult. Yet the crucifixion paintings she studied profoundly informed her paintings.

The Rambergs are a family of list makers, and Christina's list-making mania produced notebooks laddered with lists: practical lists for the daily routines of household chores, appointments, shopping, and cooking; art-oriented lists of artists, ideas, objects, and subjects. These lists are inadvertently poetic as they accompany her methodical yet cryptic drawings, and offer clues to her mysterious paintings:

> back to same shape
> head—vase—shirt
> flower hat, a
> cross breeding
> Glowing area where fabric is pressed against body.

Critic and gallery owner John Corbett describes Ramberg as a "nocturnal painter," and her notebooks suggest that she was an avid late-night radio listener. In one she seems to be educating herself in the blues, diligently listing songs she's heard on a Chicago Public Radio station show, Steve Cushing's *Blues before Sunrise*. One can surmise that she found these blues titles inspiring, since she co-opted some for her paintings: "Date Bait," "Cut You Loose," "Tight Like That," "Give Me Back My Wig," "Girl Gone Him No Gone," "Screamin + Cryin," "Key to the Highway," "No Regrets," and "Freeze + Melt."

In a sketchbook now housed at the Art Institute of Chicago, Ramberg made a list of actions and elements in her paintings. Again, some of these also became painting titles: "Stroked, Glimpsed, Bridged, Tight-hipped, Gloved, Influenced, Wired, Netted, Encased, Tucked, Embedded, Wrapped."

Following Ramberg's example, we might list the themes, objects, and actions that stoked her imagination and often appear in her drawings and paintings: African American quilts, African textiles, amputation, aprons,

armor, bandages, beauty aids, blindfolds, bondage, candy, carapaces, catalogs, chairs, clothing, comics, corsets, crutches, curtains, dolls, electrical towers, fabric, fences, fencing masks and protective garb, fetishes, flesh, fur, gardens, gates, hands, handkerchiefs, hair, hybrids, Indian and Persian miniatures, insects, Javanese batiks, kimonos, knots, lace, lattice, lingerie, magazine ads, mannequins, medical and scientific illustration, netting, nurse's hats, opposites, origami, paper dolls, prostheses, purses, ropes, samurai helmets, sewing stitches and patterns, shoes, urns, vases, weaving, wigs, wood.

Ramberg was preternaturally receptive to the world around her, Jane explains: "Christina had this amazing eye. She noticed everything. Riding with her on the subways in Chicago, she noticed so many things that I wouldn't have noticed. We talked about them. A sign she would see on a building, or an open window with somebody leaning out. It just seemed that her eye took in so much that most people don't see or notice." Debbie concurs:

> I love her take on the world. When she and Phil were first going out, she would talk about them going to some place like Woolworth's, and then she would sketch people she'd seen there, and I would think, these are so fabulous. She would just jot these drawings on envelopes and stuff. She loved to look at people and think about how they looked. It was never in a negative way; she was just curious. She might draw a picture of somebody who was odd-looking, or maybe had something funny on their face, but it wasn't that she thought they were gross; she thought they were interesting. She was interested in the quirky side of life, that's for sure."

Though Ramberg's exacting inquiries into form, femaleness, and morphology are strictly her own, she has always been included among the Chicago Imagists, and she did share certain interests and characteristics with other artists in that loosely associated group. She and Ray Yoshida were both devoted to strong black outlines and faceless figures. At times Yoshida worked with a palette almost as muted and selective as hers. He also assiduously created textures and patterns, and depicted strange hands, separated body parts, and wrapped heads. Some of his paintings generate a

menacing or teasing sexuality. Both Ramberg and Karl Wirsum created polished surfaces, transfixing patterns, and bold improvisations on the figure, and both were inspired by the art of Mexico, South America, Africa, and Asia, as well as robots and other mechanical toys. Roger Brown's use of a precise, controlled palette, strong lines, and silhouettes places him in Ramberg's zone, as do Jim Nutt's exacting paintings and outrageous sexual imagery.

Ramberg's most important collaboration was with her husband. Born in Chicago in 1943, Philip Hanson earned his bachelor's degree in the humanities at the University of Chicago, studied architecture at the University of Illinois at Chicago, and then enrolled at the School of the Art Institute of Chicago, where he, like Ramberg, studied with Yoshida. Hanson and Ramberg were both brilliant, tall, charming, hardworking, funny, and utterly committed to creativity and education. The art they made entwined and diverged, mirrored and opposed, balanced and clashed.

It was Hanson who suggested, during the first year of their marriage, that Ramberg keep a journal. Hanson also shared with her his passion for books. Debbie says that Christina wasn't a reader as a girl, but once she did become enamored of books, thanks to Phil, she read constantly and adventurously. She loved poetry and classic nineteenth-century novels, and she pored over arts and crafts books.

Ramberg found her half-time office job at Sears Roebuck Commercial Paper Company "very frustrating." She switched to teaching art two days a week to grades one through eight at a Catholic school in Evanston. That, at least, involved creativity. But as soon as Hanson secured a faculty position at the SAIC, she resigned, and they took off for Europe, traveling and painting for five months in England, France, Spain, Italy, and Germany. Ramberg recalls, "It was exciting; it was marvelous fuel for stuff that came later." One of the most inspiring collections they saw among many was Jean Dubuffet's appointment-only Musee de L'Art Brut. Ramberg was also taken by the Leger Museum outside Nice. She talked about their time in Italy with zest, clearly reveling in the exaltation of the experience: "Going to Arezzo and particularly going to Siena was very important to me because I have always been interested in primitive Italian painters. And to be able to see them. We went to Padua and saw the Scrovengi Chapel and to see the

Giottos really and truly and to see the Giovanni de Paolos and to see the Piero della Francesca."

The civil rights movement was underway in the South while Hanson and Ramberg were art students in Chicago, and Ramberg's brother, Charles, was in the thick of it. A former U.S. Army paratrooper with the 101st Airborne Division, he became an attorney and prominent First Amendment advocate. While serving as president of the ACLU's chapter in Jackson, Mississippi, he worked for equal voting rights with Charles Evers, who took charge of the local NAACP after his brother, Medgar, the former director, was murdered in 1963 by a Ku Klux Klan member. Christina admired her brother and was proud of his work, and she traveled to Mississippi to visit him. Dr. Martin Luther King Jr. brought his civil rights campaign north for the first time in January 1966, moving with his family into a poor black neighborhood in Chicago to protest the city's racially discriminatory housing and mortgage practices. King's efforts included demonstrations in all-white neighborhoods that ignited violence; King himself was struck by a hurled rock. Fifty years later, Chicago remains harshly segregated. Two days of deadly and devastating riots broke out again in the city after Dr. King's 1968 assassination, and that was just the start of a year of shocking bloodshed, which continued when the now infamous Democratic Convention came to Chicago that summer, along with crowds of people assembling to protest the Vietnam War.

Hanson and Ramberg supported the antiwar cause, donating work to a fund-raising auction, and participating in some of the earlier Chicago peace demonstrations. They ended up getting married during the convention at the peak of the massive antiwar protest in Grant Park, which culminated with appallingly, now infamously brutal attacks by the Chicago police. Ramberg and Hanson's wedding reception was held at the home of Art Institute curator James Speyer, and Hanson remembers guests arriving "with oil around their eyes, you know, to protect them from tear gas. It was a strange moment."

Nineteen sixty-eight was also the year in which Hanson and Ramberg, along with Roger Brown and Eleanor Dube, exhibited their work in the *False*

Image group show at the Hyde Park Art Center, thanks to Don Baum, an essential figure in the story of Chicago art. Baum has been called a "crusader for art," an impresario, and a "bird dog for artistic talent." Born in Michigan in 1922, Baum studied with Katherine Blackshear at SAIC and with László Moholy-Nagy at the School for Design and took art history courses at the University of Chicago, all while also making his own art, primarily collaged constructions, and teaching at Roosevelt University in Chicago's Loop and the Hyde Park Art Center on the Near South Side. Baum knew everyone. He became friends with Hyde Park painter Gertrude Abercrombie, curated her retrospective exhibition, and became executor for her estate. He turned the Hyde Park Art Center into headquarters for the Chicago Imagists, boldly inviting up-and-coming artists to show their work in innovatively conceived group shows. The first was the now legendary, rudely named *Hairy Who* exhibition of 1966, which featured work by James Falconer, Art Green, Gladys Nilsson, Jim Nutt, Suellen Rocca, and Karl Wirsum.

Baum explains the origins of the Hairy Who in a 1986 oral history interview for the Smithsonian Institute's Archives of American Art, noting that these artists, working in the early years of rock and roll, were

> very much interested in language and very much interested in this kind of satirical and ironic language . . . The idea of naming the show, or naming the group, was something which they were quite intent on . . . The name the Hairy Who was devised as a direct reference to Harry Bouras, who is an art historian. He taught in Chicago, and he has this radio [show] . . . He occupied this rather curious position at that time. He was very much admired and possibly still is by many people . . . But to this group, Harry was a kind of, well, a slightly amusing figure, in a way . . . There's a kind of a pretentiousness about the way he delivers the information . . . They responded to this on a sort of a humorous, ironic, and satirical level.
>
> Yeah. So anyway, it refers specifically to Harry . . . But of course, hair, as a symbolic material, is something which was very important in their work, too . . . It has a lot of different meanings. The idea of thinking of hair in a kind of an abstract way has slightly, I wouldn't say nasty, but possibly naughty connotations.

Group shows notwithstanding, and contrary to the lore that has accrued over the years, the Chicago Imagists were not in cahoots when it came to creating their work. In spite of friendships and marriages, they were not purposefully collaborating, and they did not see themselves as a movement. Ramberg did become close friends with Dube when they were art students together. She met Hanson in her sophomore year, and Brown a year later, but she was not acquainted with the Hairy Who artists; she didn't even see the Hairy Who shows. Don Baum came to see her work, as well as that of Brown, Dube, and Hanson, at the urging of Yoshida and Nutt, and that was how the first *False Image* show came about. For Ramberg, it provided crucial validation. She told Morgan Spangle that being in the Hyde Park show made her feel that "there was a place for us in the world."

Critic Franz Schulze, credited with coining the term *Chicago Imagists*, reviewed the *False Image* show in an article in the *Chicago Daily News* that featured silly photos of the artists mugging with their work: Ramberg rests her chin on the top of her panel of hair paintings. Schulze declares it "a very good show, one of the best teacher and painter Don Baum has assembled at the center in the last several years, and that is saying a lot." His article was, at heart, an argument in favor of recognizing and appreciating Chicago art as a major dynamic force. He writes rather bombastically, "Miss Ramberg paints nothing but the backs of heads, concentrating on the coiffures, which are as laboriously impeccable as they are vulgar." Schulze details the connections between the groups False Image and Hairy Who, and writes that the False Image members' work "is even more subversive, more laconically withdrawn." He continues, "And as people, the four painters are straighter than the Who. The statement by Christina Ramberg, 'We are interested in the effects gained by withholding information in a work,' is more rationally analytical than anything one could ever extract from the Who's flippy Jim Nutt."

This statement about withholding is key to the enigmatic content and power of Ramberg's future paintings.

The second *False Image* show opened a year later. Ramberg was also included in the much-celebrated exhibition at the Museum of Contemporary Art, *Don Baum Sez "Chicago Needs Famous Artists."* Ramberg remembered that this is when gallery owner Phyllis Kind "was just emerging on the

scene . . . At some point she came to me and said, 'You ought to think about showing some things at the gallery.' It made me very nervous . . . At that time I felt I wasn't ready." Ramberg and her False Image cohorts did sell some work at the Hyde Park Art Center. "The paintings were $100, $75, that kind of thing, but it was thrilling to sell your work because now you could make some more because you sold it."

When Kind approached her, Ramberg explained to Spangle, she "felt so uncomfortable. When I look back, now, it is kind of funny; it didn't even enter my mind that I might be losing all chances to ever show . . . I felt that I didn't have enough work . . . I always painted slowly . . . finally I said OK." Kind began showing Ramberg's paintings in group shows, and then mounted Ramberg's first one-person show in 1974. For thirty years, the Phyllis Kind Gallery was the epicenter of the Chicago Imagists.

Much has been written about what makes this group unique and provocative. According to Don Baum, sculptor H. C. Westermann was a godfather of the Chicago Imagists. A U.S. Marine turned artist, he believed in hard work, possessed a keen aesthetic, and succeeded brilliantly in transmuting deep emotion into a folksy surrealism. Westermann combined exceptional technical skills with a sardonic sense of humor and mystery in his death ships, mystery houses, secret-filled boxes, and machinelike variations on the human form that embrace both our quest for security and refuge and the unavoidable precariousness and absurdity of life.

Like Westermann, the emerging Chicago Imagists managed to be at once down-to-earth and outrageous. They had abiding respect for materials, tools, and techniques. And they cultivated a big-hearted love for the city in all its grit, bluster, and pragmatism, recognizing its prejudice, corruption, and violence, its rough beauty, bricked and littered absurdities, and persistent resourcefulness.

Chicago is a monotonously flat city gridded with car-lined streets fronting tiny houses, blocky two- and three-flats, and hulking apartment buildings, all cheek-to-cheek, punctuated by funky little storefront businesses of dubious standing; dark, stinky corner taverns; brash, sometimes illiterate signs; churches humble and aspiring; secretive alleys; and battalions of valiant trees, breathing, sheltering sentries that soften the blows and make the city livable. Potholed streets on which cars pound, buses

lumber and wheeze, and trucks lurch and rattle stretch for miles and miles. The el trains clatter, screech, and squeal on raised tracks that shadow the streets below, while granting riders illicit glimpses into windows and yards. The subway trains plunge down into the earth to tunnel below schools and parks and office buildings, rising up again into the light, performing clacking reenactments of the cycles of life and death. To the east, the great lake shimmers and glowers, a moody freshwater sea reflecting sky and cloud, dancing and raging beneath the commanding wind—a deep, cold, glorious body of water that keeps dreams afloat and secrets submerged.

The city's artists did not sequester themselves in repurposed lofts in an artists' enclave as their New York peers did. Chicago artists lived in the neighborhoods next to plumbers, teachers, policemen, nurses, waiters, taxicab drivers, parents, and bums, while making art in spare bedrooms, cramped back porches, whatever space they could claim. Art was life. And the Chicago Imagists were sober and disciplined, unlike New York's notoriously hard-drinking, combative, dramatic, self-destructive Abstract Expressionists, though Ramberg did have one known addiction: candy bars.

The work ethic of the Imagists did not preclude their rambunctious irreverence when it came to artistic pretension and society at large. The well-educated and highly skilled Imagists were ribald if not downright obscene, delighting in dirty puns and embracing the weird, the grotesque, and the unnerving. They sought sideshow extremes. If H. C. Westermann was one godfather for the loosely aligned group, Chicago painter Ivan Albright was another.

Singular, influential, and successful, Albright possessed the unusual distinction of having one of his paintings—*The Portrait of Dorian Gray* (1943), based on the novel by Oscar Wilde—star in a Hollywood film adaptation. Albright was a master technician who, though positive and fun-loving, painted dark and troubling portraits that focus on decay, aging, and death. Albright wrote, "The body is our tomb," and admitted that he liked to make viewers uncomfortable by challenging their notions of art, beauty, and life.

Ed Paschke—Chicago Imagist, SAIC alumnus, and member of the *Nonplussed Some* group exhibit at the Hyde Park Art Center, painted wrestlers, strippers, and freaks in blazing colors and hotrod styles. Jim Nutt

painstakingly rendered severed limbs and monstrous genitalia. Karl Wirsum's highly stylized figures vibrate with narcotic electricity. And they all revered self-taught artists, including Chicago's own Henry Darger, Lee Godie, and especially Joseph Yoakum, who created entrancing landscapes rendered in linear patterns that seem to depict the very life force itself. Ramberg and the other Imagists were deeply moved by these artists, with their authenticity of feeling, their inventiveness, and their profound sense of calling. This was soul art. This was visual blues.

Another distinguishing characteristic of the Chicago Imagists is the presence of women. As art historian Robert Cozzolino observes, women artists in Chicago were the unquestioned equals of male artists: "Chicago was a rare climate for artists who happened to be female. It fostered independence and encouraged the confident pursuit of personal, subjective vision." Married couples were a noticeable part of the mix, including Hanson and Ramberg, Jim Nutt and Gladys Nilsson, and Lorri and Karl Wirsum. In Leslie Buchbinder's documentary *Hairy Who and the Chicago Imagists* (2014), Nilsson says, "Amongst all of us in Chicago, gender was never an issue. It was 'how good is your work.'"

In the early years of their marriage, Hanson and Ramberg dissected gender expectations in works that shared imagery and themes, even as their painting styles and figuration were dramatically different, even oppositional. Hanson's opulent paintings, lush with organic and crystalline shapes in glowing tropical and jewel colors, are alive and in motion, romantic and mysterious, dreamy and surreal. He improvised on plants, flowers, seashells, fountains, curtains, folding fans, gloves, dresses, robes, ruffles, tassels, and caravan tents. His architectural interest inspired him to paint fanciful prosceniums, mezzanines, stages, staircases, archways, and doors. He also riffed on fancy candy boxes, comic books, and opera's lavish costumes and sets. Hanson's early paintings have the movement of undersea currents, breeze, and music. Like Ramberg, he was intrigued by women's attire and the ritual of grooming, a classic subject explored by such male painters as Edgar Degas and Pierre Bonnard.

Ramberg mused over her husband's work in a 1970 journal entry: "Seeing so much art I like lately is making it hard for me to get back into my own work. Phil's new paintings of women in front of mirrors—they're seen

from the back wearing slipping soft robes and are patting their hair—are very interesting. The robes are painted in a style that has fascinated me—like the garment in the Rufus Hathaway picture. [Hathaway was an eighteenth-century Massachusetts physician and folk painter.] Of course, compartmentalized hairdos are a long-held interest."

Hanson created a series of etchings of dancing couples, culminating in the painting *Country Club Dance* (1969), in which a woman stands facing the viewer, holding an open fan decorated with a large, blowsy red flower in front of her face, leaving only a bit of forehead and a nimbus of hair visible. She is wearing a lace-trimmed off-the-shoulder dress, long fingerless black-net gloves, and red nail polish. The background is blackboard black, and there is a chalkiness to the small figures that surround the central figures and dance in the void. In each couple, the woman is seen from the back in a backless dress, each skirt undulating like a sea anemone. The men are mere shadow figures, outlined in dusty white, like the figures drawn to mark the location and shape of a dead body in a crime scene. The black frame is painted with strange, suggestive orchids and seafloor flowers, some with eel-like stamens.

In Hanson's otherworldly *Purple Orchid* (1972), two outstretched arms reach into the painting, the fingers draped in a white cloth (an image Ramberg also used) and gently holding a large purple orchid that looks like a sea creature newly birthed from the stage-like opening behind it, from which pleated curtains reach outward.

Hanson ventured into sewing, a craft and art Ramberg excelled in, making painted, sliced open, folded, and sewn canvas wall hangings that vaguely resemble such sea creatures as skates and horseshoe crabs, or open-worked undergarments for no specific gender.

Compared to Hanson's prismatic, rococo, and kinetic paintings, Ramberg's were austere, exacting, and static. Her brushstrokes were painstakingly concealed, the surface resolutely flat and impenetrable, her patterns executed with antiseptic precision. The feelings her work evoked were ones of restraint, dark eroticism, and epic stoicism. She laments what she perceives as failings in her work: "My paintings seem such a dull bore. So few colors, so removed, and becoming so abstract and anti-anecdotal. The vague stories that used to hang around my older paintings have even been

removed from these new corsets. I'm itching for a reason to blend from red to green and on to another color. Maybe I've got to be telling more in these paintings." Responding to a 2013 exhibition of Ramberg's work at the Institute of Contemporary Art in Boston, Greg Cook wrote, "Hanson's work is gregariously florid, wildly patterned, while Ramberg's paintings have an interior, solitary, severe, bound-up hum."

Ramberg spoke to Spangle about her undergraduate days when everyone in the studio was working on "huge canvases dripping in oil paint . . . You'd go in there and all you'd hear were these canvases going whomp, whomp, whomp. There was this huge space and the easels were back-to-back and the air spaces between them were making them go back and forth . . . I tried to do big oil paintings and I could never finish anything."

Two discoveries put her on track. She was working in the school store, she explains, which was run by a real character who

> couldn't throw anything away . . . One time she had these scraps of 6 x 6 Masonite. They were the laughing stock of the store. She had this little sign: "Paint on it, use it for a palette," trying to get people's suggestions about ways they could use these things that cost only 10 cents. We all laughed, but I bought some and suddenly I realized that this is a perfect size for me. I don't know why I hadn't thought of it before. A lot of paintings that I've liked, that have moved me, are small. Suddenly I realized . . . that I would paint on it with acrylic and acrylic was magic for me . . . I could go through all the multitude of changes and finally finish it at least, instead of having to wait for things to dry because although the paintings don't often look it . . . I know that people are often surprised when I say I go through many changes before I arrive at the point where I am . . . So buying those 6 x 6 pieces of Masonite—nobody was really painting on Masonite at that point either . . . I really liked this kind of more resistant surface, a surface which didn't give so much and didn't have the texture of canvas in the way.

Ramberg was happiest talking about materials and technique, but she was comfortable enough with Spangle to broach her provocative subjects:

The first paintings that I did that I really liked and felt that were something very personal about me anyway were all these paintings of shirts being opened up and they were just the torso, neck to waist, all variations on how the shirt could be opened up . . . Then I did another whole series on the same size Masonite called "Backs of Heads" and that came out of an interest in comics, of comic conventions to draw hair, and hair still fascinates me in that it is supremely manipulative; it can take any form, it can be anything you want; you can make it so that it suggests a tree or arrange it so that it suggests food, the levels of meaning are just incredibly rich. So that's what interested me about that so I made sixteen paintings of hair . . . And those are the paintings that got me started and I always worked in series from that point on. Permutations of various ideas.

Ramberg talks about her interest in origami and how it influenced the shapes in some of her paintings. Then the conversation moves on to clothing: "One thing I've always been interested in about clothing is that it can talk a lot about the body. Whether about the outside or the inside, too."

Spangle talks about her lingerie paintings, saying, "They look like almost 1940s-type dresses rather than being real figures, in the way that those things kind of shape the figure. Which is a nice metaphor for things contained." Ramberg responds, "At one point the things that I was doing provoked the response, 'Oh, these looked like clothes from the forties.' And I didn't like that that was what was kind of happening. I didn't want to refer to kinky fashions of a particular time . . ." Spangle interjects, "The corsets." He asks if she was trying to get people to think about what was evoked when we look at corsets and other body-altering garments. Ramberg says,

That's not really what I intended, and that was the strange thing about doing all that. There were people who kind of raised their eyebrows, and responded to the kinkiness of it. To me it doesn't look kinky at all. I was interested in form . . . You talk about the paintings now being kind of vessel-like. In the early seventies there was a painting that I held onto

because it was very important to me, called *Corset-Urns*; [which depicts a set of shapes that] were like corsets but also like vessels . . . They were kind of abstract. So there was always a line sort of like the origami ones you just mentioned [that] fit into this more abstract vein that I followed. And, now at this point, the paintings I'm doing are sort of in-between. Few people have looked at them and said that this is not a figure. Which surprises me because that is what they are, they are figures, and I mean to make them be like vessels at the same time.

In her journal she writes,

Phil suggested a good idea for some ptgs [paintings] for me. The curious thing is that they could be very pornographic. The idea combines ideas from my recent drwgs [drawings], the hair/masturbation pictures and the early boxed series of a jacket being opened to reveal flesh. The ptgs would be creased garments being stretched and pulled by hands, sometimes male and sometimes female to reveal the body. The garment could be pulled back to expose hands feeling, caressing, masturbating the body. Transparencies, lace sections, shiny undergarments, cloth-wrapped hands, tight, fetish-like garments, too-small or too-big garments, sofa-like background. I'm very excited about this idea. I think the absence of the reference to masturbation is what makes some of the more recent fetish ptgs border on boring. How about implications of rape? Tattooed hands. Gloved hands. Man's tie binding girl's waist. Ripped clothing. Bruised skin. Masturbation? Direction from which hands come would be important. Non-aggressive, prowling hands.

A few pages later, Ramberg writes, "A second thing I looked at during Whitney's class was Esche's book on Erotic Art, in which I found the Chinese and Japanese examples the most beautiful . . . Included in the Japanese section were some close-ups that startled me in the likeness to my head caressed by hand series (about which Olaf always said fiendishly, 'We know what those are about, Chris' and then his crazy laugh). One of the Japanese close-ups was a hairy cunt probed by a finger. Over the cunt was a draped cloth. The format was square."

Istrian River Lady (1974) is a stunning and pivotal painting. A seismic shift occurred in Ramberg's work in the mid-1970s as she moved away from her complexly provocative images of voluptuous lace- and satin-adorned women. Here, in what curator Jenelle Porter describes as "a tour de force of illusionistic texture and volumetric edges," we see a woman from the side, neck to mid-hip, standing with her shoulder thrown back and her chest lifted with military rigor. She is wearing a tight long-sleeved, dark-seamed cropped top of fiercely detailed, nearly microscopically meshed black lace. It is slit here and there, and from some of these openings bulge strange epaulettes made of gleaming dark hair. One looks like a tongue, the others like tails or penises. Her hips are wrapped in a tight garment made of the same black lace. Odd little tufts emerge from the waistband at the sacrum. There is a stern beauty here, and a sense of valor.

In a series of sketches that appear to be studies for this painting, Ramberg took a more drastic approach to the pose. In one, a blindfolded woman's head is dropped way back to her shoulder blades; her arms seem to be tied behind her back. In others, the woman's arm is amputated above the elbow or at the wrist, the stumps wrapped in bandages or hair. One drawing has "splint" written below a headless figure's trussed waist. Yet the etching, *Back to Back* (1973), and the painted Istrian River Lady stand invincible, like a decorated combatant who has survived some sort of bizarre, intimate battle.

Christina Ramberg. Back to Back. *1973. Etching. 8 x 11 inches.*

The title is unique in Ramberg's work in its geographical reference, which, like so much else in Ramberg's oeuvre, is more puzzling than informative. The Istria River is in Romania, where traditional women's clothing includes elaborately pleated and richly embroidered blouses, vests, long skirts, and decorated aprons, just the sort of textiles and attire that caught Ramberg's eye and found their way into her imagery. Istria is a substantial peninsula jutting south of Trieste into the Adriatic Sea. It is shared by Italy, Croatia, and Slovenia, regions even more rife with potential sources of inspiration.

After exploring stylishly risqué variations on female sexuality as defined by bustiers and corsets, pulp magazines and consumerism, in figures seen in profile or from the back, Ramberg turned to fully frontal figures that are disconcertingly rigid and nearly robotic. *Stretch Her* (1974) is one of a select few works by Ramberg that has a Hairy Who vibe in its exaggerations and grotesqueness. It presents us with a broad-shouldered, tight-hipped torso that reads male, yet it is clad in black lace with a creepy-crawly insect-like pattern, and it has breasts, though they are wrapped in some tortuous hair-twist bandages that are pulling them down and cruelly stretching them. In place of a head, there's a handle. In place of hands, there are what look like large mattress coils or springs. A gaping space indicates a worrisome absence of organs and flesh, while a braided hair bikini bottom clutches the crotch.

Ramberg had embarked on a daring and disconcerting series of frontal torsos that possess both male presence and female attributes in forbidding and haunting variations on androgyny. These works are sexual either-or variations on the classic face-vase, figure-ground perception test at work in Ramberg's corset-urn paintings. Androgyny, ambivalence, ambiguity, uncertainty, hybridization—these amorphous states of being profoundly compelled Ramberg, in intriguing opposition to her penchant for order and categorization.

The headless figure in *Wired* (1974–75) holds its arms apart from the body, elbows bent and forearms plunged into shapes that resemble a disembodied woman's hips and footless legs. Like the larger figure, these little limbs are covered in black lace. The black lace on the torso is unraveling over the center of the chest and along the groin, while the core of the body is covered in a cummerbund/shield that looks like the back of a head with

long, bundled brown hair, the ends of which form two buns placed like testicles. Across the nipples stretches a bra made of hair. This is another aggressive, alien, obscurely obscene entity.

Glimpsed (1975) depicts a hulking torso with a braided, pleated, and folded hair bra and matching briefs or girdle. It is as much armature as body, with many portions shown only in outline, with no suggestion of flesh, while the skin on the chest and waist is folded and bunched by tight-fitting foundational garments made of hair. It's a spooky effigy.

Ramberg constructs her damaged torsos on structures that evoke skeletons, clothes hangers, sewing dummies, the poles used to display ceremonial kimonos, chair backs, and medical apparatus. These partial figures have a military erectness, correctness, and aura of invincibility. Do they in some schematic way portray Ramberg's colonel father and his upright posture? Christina's sister Debbie remembers, "We did see him in uniform a lot, and my father was very physically fit. It was very important to him to be neat, and so his hair was always right, his clothes always tucked in. I'm sure she had that sense of power from seeing him that way." And perhaps, given her father's post-Vietnam transformation, she also discerned the doubt and regret concealed by his uniform, fitness, and polish.

For many years the Art Institute of Chicago displayed its extraordinary collection of medieval and renaissance European armor in the central hall on the first floor, so that visitors threaded their way through a gleaming metal army etched in fine decorative detail. These showpieces were not for the crash and muck of battle, but rather for jousting tournaments and parades. Ramberg would have seen these empty suits of shining armor often, including richly patterned half suits hanging in their display cases much like her wide-shouldered, carapaced torsos. Armor is a hard, protective shell that also standardizes one's appearance and hides flaws. It is defense and disguise. Body armor conceals your true self and your individuality, while impeding movement and mobility. It protects and hobbles. Ramberg's fascination with opposites and ambiguity led her to appreciate armor's paradoxes, and to paint intimate armor in the form of corsets and other confining, protecting undergarments.

As in the funky, pseudoscientific drawings she made of her beloved chocolate bars sliced in half, revealing their gooey fillings, Ramberg saw

past our clothes and skin, our ineffectual everyday armor, to our soft centers, our malleable inner selves. She pondered the mystery of how the visible relates to the hidden, outer rigidity to inner receptivity. She was a connoisseur of disguise and dichotomy.

In 1975 Ramberg also painted *Broken* and *Strung (for Bombois)*, the latter a curiously reductive homage to the French self-taught artist Camille Bombois, who painted fleshy circus strong men in skimpy leotards, some made of fur, and cheerfully sexy, curvy women in dishabille. Ramberg's spare image is like an X-ray of one of Bombois's bouncy characters. It stands as evidence of Ramberg's far-ranging study of art and ability to simultaneously look within and without for inspiration.

Ramberg's iconic torsos are assiduously painted, evoking crucifixions, mournfully regal in their decimation, emaciation, and solitary confinement. In a notebook she carried with her on a European journey, she sketched crucifixions based on paintings she saw in museums, paying sharp attention to the rolled and draped loincloths, the lifted, spread, and pronounced rib cage, the hollowed stomach, and the sparseness of a starved body in extremis. She wrote, "*figure wrapped around cross*," perceiving a horrific merging of the body and the instrument of torture.

In her files, Ramberg kept a collection of "exquisite corpses," a mode of collaborative drawing adopted by the Surrealists, who based it on a group word game that yielded the phrase "the / exquisite / corpse / will / drink / the / young / wine." To create an exquisite corpse, a group of artists works on one long sheet of paper. Each artist draws one section of a body and then folds it over so that only a small portion of their contribution is visible for the next artist to improvise on, and so it goes until the end result is a crazy mutant giant. Ramberg's exquisite torsos look like survivors of injury, amputation, and hybridization gone wrong, occupying the interstices between animate and inanimate, human and mannequin, male and female, coherence and chaos, figurative and abstract. Truncated and damaged, each is sequestered in a bare cell. Specimens of medical disasters or monstrous experiments, they stand alone in a chilly void.

What do these silent survivors tell us about the artist?

Ramberg taught at the School of the Art Institute of Chicago for more than twenty years, served as chair of the Painting and Drawing Department, and brought her own very personal methodology to her classes. Her course notes offer illuminating insights into her habits of mind and artistic endeavor. Under "Suggested Problems," she lists two examples:

—The Object Transformed: drawings of objects in which the function is denied. How would a comb that cannot untangle hair look? You can make the object dangerous, humorous, useless, sinister.
—Ambiguity—make a series of drawings of grafted objects. A scissors/ shoe. A can-opener/clock.

On other sheets, she instructs, "Problems Involving Ambiguity and Contradiction; Assignment involving hybrids." Another assignment is titled "Shape Investigation," and it directs students to "Bring 20–30 newspaper photos of figures whose garments are wrinkled." Ramberg advises students: "As you look at more and more art, you may begin to recognize that artists often seem to have their own 'vocabulary' of forms. This vocabulary is usually developed over years of work and it can become a richer and more meaningful vocabulary as the artist matures." Students are to "adopt a vocabulary of forms," and the sources she tells them to use are "hair or muscle magazines" or "flower catalogues, Sears or Wards catalogue." She gives them lists of words to draw from, including pairs of opposite qualities: "even—jagged, sick— healthy," and objects: "Rope, Brick, Stone, Glass, Metal, Wood, etc.," "Lace, Cotton, Leather, Satin, Velvet, etc."

Another assignment, on pattern:

Problem: a drawing in which pattern predominates
Subject: a portrait of yourself present, past or future possessed by a specific emotion. Make the figures large. Do not include the face. Represent all or part of the figure.
Take every opportunity to use pattern. Make it express the emotion you've selected.
How can pattern be used on a figure?
—patterned garments

—folds, pleats, ruffles, etc. treated as pattern

—hair treated as pattern

—jewelry as pattern

—skin wrinkles as pattern

Ramberg was a much-beloved and admired teacher. Her sister Debbie observes, "Christina had what I would say was a nonartist personality. I don't mean to offend anybody who's an artist by saying this, but she was so kind, and so without an ego, it seems. I just felt like she was in it because she had to be and she was glad when people appreciated what she did but it really almost didn't matter; she was going to do it anyway. And she was always so happy for other people who were successful. It wasn't cutthroat for her at all. That was just her personality."

Hanson, who taught at SAIC for more than forty years, reflects: "Students liked her a lot. A good woman teacher was important to them, particularly in that time. It was much more dominated by men, so to have a teacher like Christina, who was doing her own work, that was a big deal. The men could be very nice, but it was really meaningful to learn from another woman." Shore remembers,

> She was a wonderful teacher. She was so solicitous. She wanted to know who you were; she was interested in your ideas. She was light-hearted in a way; she wasn't cross or correcting. I'm sure she had moments when she was frustrated or impatient, but I didn't see them. It seemed to me that there was a hunger for her attention. I took her Saturday class, for several semesters. You know, most people don't want to take a Saturday class, but people were happy to be in her class even though it was on Saturday.
>
> There's a funny story that Jackie Kazarian told at Christina's memorial service. She was in Christina's drawing class, and there was a guy in the class who never did anything. He never made drawings, and Jackie was super annoyed with him because Christina was always paying attention to him. She would listen to him and he would talk on and on and regale her with stories and she would laugh. It turned out he was David Sedaris. I love that example because I think Christina had good

instincts. She wasn't going to be cross with him because he wasn't making a drawing, she was nurturing his innate talent of being a great storyteller."

Thanks to Shore, Ramberg is still a guiding light for students, as she explains:

> For years I didn't talk to my students about her because I couldn't talk about her without sobbing. Now I can share who she was, and talking about her is an amazing teaching tool. I show students her drawings, and we talk about how you don't assume that the first thing that pops into your head is going to work out. Her drawings are a good example of trying so many iterations of, in her case, a figure or an object. You draw it and redraw it and draw it again. It's a great way to talk about how content comes out of form. With Christina's work you can say to students, be interested in something visual, but then play with it and see how the content changes. Like with her drawings of hands, you can say, look, she's wrapped the handkerchief around the hand in such a way and then in the next drawing she's shifted the finger up. Every little change makes for different content. I love showing students her work. I feel like it helps her brilliance live on by letting students know about how she thought and how she worked and how dedicated she was.

For Ramberg, her drawings were private investigations into the morphology of the forms that entranced her. She never meant to exhibit them. But they are powerful works of art in their own right, as proved in 2000 by *Christina Ramberg Drawings,* a substantial posthumous exhibition at Gallery 400 at the University of Illinois, Chicago.

The dramatic and mysterious shift in Ramberg's work from her erotic lingerie paintings to the schematic torsos occurred in the wake of two pregnancies. The first turned tragic: a baby boy was born nearly at full term but didn't survive. Grief may have given rise to her starker paintings. And this loss may have also intensified her already conflicted feelings about her body. Was Ramberg's sorrow exacerbated by a sense that she had been

betrayed by her physical self? Her torso paintings can be seen as emblematic of shock, bereavement, and emptiness.

Ramberg and Hanson's son, Alexander, was born in 1976. Thereafter, her incarcerated torsos grow more complicated, nuanced, elegant, and enigmatically beautiful. These injured entities, these disordered figures surreal in their suffering and desperately improvised repair, become more feminine, more richly layered, more fleshed and alive, even as Ramberg's titles become more medical and more alarming. In 1977, an astonishing year of artistic inquiry and accomplishment driven, perhaps, by fear and emotional upheaval as grief was paired with joy and fear remained undiminished, she painted a galvanizing series of divided torsos, stoic figures of trauma and triage.

Hereditary Uncertainty (1977) is a particularly striking heraldic piece. On the left side is a partially clothed female figure with a pleated white blouse and skirt, or tunic, shorn on the bias, revealing undergarments, while a white bandage, or perhaps the rest of the skirt, wraps around the legs at knee height. On the right, the figure consists of a skeleton of neatly textured bent-wood pieces that resemble those seen in her two-panel object portrait *Chairbacks* (1976), which introduces wooden chairs as another form of armature, figure, or vessel. The openwork torso in *Hereditary Uncertainty* is half human, half wood. What may have been inherited? What problematic transfiguration is underway?

In Ovid's *Metamorphosis*, angry Cupid has made Apollo fall in love with nymph Daphne, who is repulsed by the very thought of sex and love. Burning with desire, Apollo gives chase, and Daphne runs, her hair coming loose, her clothes torn, her legs exposed. The god is all but upon her when she calls out to her river-god father to save her, and he transforms her into a laurel tree. Her body instantly turns into bark, branches, wood. Is Ramberg's painting a modern, stop-action variation on this mythic process?

Hermetic Indecision (1977), a painting of uncanny poise, portrays another bifurcated human-wood figure. *Hermetic* is a loaded word for Ramberg. Did she feel hermetically sealed within her deepest concerns and darkest emotions? Did she feel isolated? Given her fascination with urns, might she have been intrigued by the source of hermeticism, the Gnostic writings attributed to Hermes Trismegistus and the story that he "invented

a magic seal to keep vessels airtight"? In this remarkable portrait, one half of the stalwart, gender-unspecified figure is tightly wrapped in a bandage, including the forearm, which is missing its hand. The other half of the body is built of wood chair parts stacked one upon another. These strips also look like black fabric woven with a pattern that resembles those of Navajo blankets. There is a gap where the heart should be. The hips and legs are covered in black lace with a biological, or cellular, pattern. There's something so powerful about this wrapped and unraveling figure with its lustrous whites, deep grays and blacks, something so refined in the formality of its stance, it feels like an extraction from a painting by Rembrandt, say *The Night Watch*, with its men in figured jackets wrapped in great sashes and wearing complicated collars. There is misery in Ramberg's mysterious figure, and dignity.

A statement of painter Ivan Albright's illuminates Ramberg's work: "We think of people as material beings. But the body is merely an outward or external shell. The ego, the essential ego, is what one is in ultimate reality . . . The physical and objective looked into deeply enough become spiritual and subjective and abstract . . . Every person sees things in a way unique and peculiar to himself . . . All that we perceive is a world of surfaces. The real center is never seen. But it is just that which the artist should strive to find and body forth."

What is it that Ramberg bodies forth in what stands as a bewildering and bewitching quartet? Her titles indicate epic inner conflicts—*Hereditary Uncertainty, Hermetic Indecision, Schizophrenic Discovery, Double Hesitation*. These are portraits of a divided self, a life riven by corrosive doubt and quandary. What is Ramberg grappling with? Fear and hope as a new mother? The conflicting demands of art and motherhood? The habit of withholding and the need to let go? The impulse to conceal and the desire to reveal?

The birth of Ramberg and Hanson's son changed everything. Christina, her sister Debbie recounts, loved children. She was torn between joy and the weight of responsibility, which turned deeply complicated as it became clear that Alex was not a typical child. At the time, such cognitive differences as his were not well understood or satisfactorily diagnosed (today these would be placed at the high-functioning end of the autism spectrum),

and how best to educate smart, funny, sweet, and energetic Alex was open to much interpretation and improvisation, accompanied by constant worry.

Debbie, herself the mother of three (Jane also has three children, as did Charles), remembers her sister's concern and struggle. "Oh, it was very hard for her. She talked about how difficult it was. But she was the kind of person who wasn't going to say this is terrible and not do anything about it. She immediately looked for clues that might lead her to a solution and she found a special school and she worked really hard to normalize life for Alex as much as possible. And he did really, really well. Christina loved the quirkiness of his mind. Alex was hilarious. He still is."

"Christina did a lot of trying to figure out what was going on and they saw a lot of specialists," Jane remembers. "You know in those days they didn't have a word for it. I think it caused a huge amount of anxiety in her life, worrying about him. Christina was completely, totally submerged for years, trying to figure Alex out and what to do. Then they enrolled him in the Cove School, which was a great place for him, and by the time he got to high school he was attending a regular school."

Motherhood precipitated another sea change in Ramberg's paintings. As the 1970s ended and the 1980s began, her torsos became more robust. Her palette embraced a broader spectrum, including greens and blues, warming earth tones and deep crimson. The figures become even more elaborate in their assemblage as they acquire architectural elements. The atmosphere and background shift from that of a medical torture chamber to a more serene space with flat backdrops resembling gray and muted blue skies. You can see the first movements away from amputated, bandaged, and crucified torsos to more vital figures in two transitional paintings, even though their titles still point to maladies of conflict, strife, mayhem, and rupture.

In *Layered Disorder* (1979), a torso is fitted tightly into the frame, its arms extending past the edge, and it has a head, of sorts, though not a face. Instead, it is draped in thick, segmented black-brown tresses that reach down behind the left shoulder, while on the right they turn into a muzzle, somewhat like a fox fur stole with the head still attached. The rest of the torso is solid and partially clothed in a stiff, ridged jacket on one side, a softly pleated blouse on the other. A woven shield-like covering in a multihued

herringbone pattern covers the vital organs, while a bit of white cloth wends its way down the side, and black lace in different patterns covers the rest of the body. It's all mismatched and curiously layered, symmetrical at base and asymmetrical in embellishment. There's perplexity and tension here.

Sedimentary Disturbance (1980) incorporates many of Ramberg's tropes in an unusually large and strongly built torso. A band of Ramberg's distinctive blood-vessel lace crosses the diaphragm area. The upper left of the torso is clad in a simply painted, femininely curved, burnt-sienna jacket; the other shoulder is swathed in blue fabric, over which lies a striped and patterned olive green vest. The shoulder and leg are built of wooden chair fragments. All this makes for an intriguing hybrid figure, but two elements push it into new territory. Where the heart would be, we see into a room where a mirror-like painting hangs on a wire on the wall. And between the legs, a small, complete upside-down version of the burnt-sienna jacket forms flowerlike genitalia.

Ramberg continued to worry that her stringent paintings were remote and boring. She was frustrated by the gap between her feelings and the cool detachment of her work, which seemed to strip away the warmth and motion of life. All was frozen there, she felt, while she was burning up with angst and stress over the unsought changes she was forced to face. On an undated drawing she wrote,

Wt is wrong w/ current ptgs? *so removed*
 so distant
 mr narrative mr about my life now?
 Theme of > whole
 > breaking apart
 > coming together
The shifting of gender roles, the containing within each of us what are defined as masculine and feminine qualities.
Symmetries shattered.
Birthing physically, psychically

Not only did Ramberg want and need to make paintings about birth and motherhood, she also felt compelled to artistically express her feelings

Christina Ramberg. Untitled (*Skirts Jackets Weaving*). *Graphite on paper, 11 x 8 1/2 inches.*

about the unraveling of her marriage. She and Hanson never stopped being close or sharing their love and care for their son, but Hanson felt an overpowering need for a separate life. So they began, with much anguish, to live apart. Their separation induced Ramberg to question the meaning of home, family, gender roles, and self, and her paintings express fracture, division, desperate regrouping, rejection, and loneliness.

Yet for all her agony, her paintings began to blossom in assertive and determined ways in 1980 as Ramberg created a series of dazzlingly complex torsos that take a completely different view of the body. Here the body, though still broken and patched together, has flesh, heft, and vitality. These oddly assembled torsos stand as vessel, house, giver of life: mother. Here clothes take on even more playful biological significance. Tiny jackets and pants not only serve, eye-poppingly, as genitalia but also represent the emerging child (or new self) at birth.

She wrote:

July '80 notes on 2nd inner jacket ptg.
small jacket glowing
red squared inside
a yellow grey waist cinch
on R, longer jacket?
green or red into blk striping

more blk chest
Italian primitive Christ chest
Shoulder pad or cage
cage over hips
cages coming
off other
body part
tattered hem
shape of edge coming
from fabric design
of jagged leaves

Ramberg continued to enliven her palette, reaching for coral, rose, and turquoise, though without giving up her thick black lines. In *Hearing* (1981), a rich, lustrous, and beaming painting, one half of the chest, which is made of planks of wood, is clad in a sporty, grid-patterned jacket, though no arm projects from the short sleeve. The collar of the shirt or vest is a miniature pair of inverted gold pants. The pointed end of a wire hanger sticks out of the other shoulder. A small pink jacket shaped to an absent woman's body and seen in profile is attached to the side of the torso as an odd little appendage. An ear, perhaps, given the title? Another little figure, clothed in a pink blouse and orange trousers, hangs down, its head still inside a large, notched black shield covering the lower abdomen and crotch. Is this a breech birth image? Or, given the gender ambiguity of the larger figure, does this handless body serve as male genitalia? Or a little alternate self?

Ramberg's enigmatic, oddly majestic series of resurrected-from-the-wreckage torsos reaches a crescendo in two paintings bearing push-pull, yin-yang titles with violent, emotional, and erotic connotations.

The figure filling the frame in *Black 'N Blue Jacket* (1981) is all woman, and she is girded for whatever comes. The figure has already survived the loss of a leg, and who knows what else, given her jerry-built construction and the fact that her sleeves hang empty, one in an iridescent striped weave of blues and greens, the other black lace over a tangerine glow. But her shoulders are broad, and two long blue-black braids hang down from an invisible head, carrying an aura of warrior strength. The curves of this

wide-hipped figure echo drawings Ramberg made of the figures in Indian art, as does the white sash around the waist. It lashes a small blue-black jacket against her diaphragm, while below the band, against a glowing blue pudenda, is a larger, upside-down black jacket with a burnt-sienna collar from which emerges a small pair of pale pink pants. Surely this is a pregnancy and birth painting. Or is the little black-and-blue jacket an interior memorial for the lost child? Or a lost self? Or maybe it's a future self, waiting to emerge. Or a core self, held close. Small jackets are similarly placed in *Interior Monument* (1980) and *No Regrets* (1980).

Freeze and Melt (1981) is a song title Ramberg wrote in her notebook while listening to the radio. It's a quick-stepping jazz composition written by Dorothy Fields and Jimmy McHugh and performed by Duke Ellington, among others, that builds on a thumping, slapping bass line in a call-and-response pattern with lots of trumpet and sudden slides and pauses. It's a grab-and-shake-you song, chopped up and reassembled, stop and go, up and down, clanging and crooning, and, yes, freezing and melting. Ramberg's painting is hardly this exuberant, but it is one of her jazzier and, yes, warmer, paintings. The brushstrokes are looser; the body is fairly solid, its skin intact. The colors range from cold to warm. And here a motif that has been slowly cohering in other paintings becomes explicit. In *Vertical Amnesia* (1980), we see a white rectangle marked with a few diagonal lines jutting off the left hip. In *Black 'N Blue Jacket,* what looks like a pocket with a black X hovers over the left thigh. In *Freeze and Melt*, overlapping white rectangles create a pattern on the left sleeve, while, in its final iteration, a white letter envelope sits on the right shoulder. Has Ramberg been moving toward some new form of connection, some indication that her figures are not utterly isolated? Communication has been established. A document of some sort has been received. Is it a love letter? A sentence-served confirmation? A passport, visa, or plane ticket? Whatever the private significance, Ramberg leaves fragmentation behind and begins creating small, more freely painted and irradiated images that ever more closely align body and urn, perhaps body and soul.

Untitled (Torso with Leaf) of 1980 portrays a solid female figure clad in a tightly fitted glowing-ember-orange dress with a black flare at the waist. The chest and abdomen are open in the shape of a large dark urn, and

within that green-blue chamber hovers a black leaf, while above the rim of the vessel the shadow between the breasts looks like a widening tendril of dark smoke. This body is a temple in which an offering has been made.

In a series of small untitled paintings, Ramberg depicts other similarly clothed torsos, some in pink and rose with contours lined not in black but in white. New apron-shaped shields appear. One small untitled 1982 painting presents a headless figure that resembles a doll, maybe a Barbie. It is wearing a dress with a tight bodice and a large, full, hoop-crinoline-supported skirt that reaches below the knees of stiltlike legs cut off by the frame at mid-calf. The skirt is black, with long brushy strokes of green along the outside edges and the bottom, shifting to an orangey, burning-coal red at the waist and down along the groin. From the waist hangs an odd apron: a pair of magenta pants that would cling tightly to a curvy female if someone was wearing them. It's almost as though these little pants represent a younger, perhaps freer self. Or maybe they signify a child and stand as another image of mothering.

Ramberg produced a great number of these small, searching, transitional paintings in the early 1980s, but other endeavors were commanding her attention. She had an activist impulse, inspired in part by her lawyer and ACLU-board-member brother. During the civil rights movement, she was involved with the Student Nonviolent Coordinating Committee (SNCC). She worked as a volunteer in George McGovern's unsuccessful 1972 presidential campaign. And in 1983 she became very active in the nuclear freeze movement, cofounding a local coalition, holding meetings at her home, and organizing signature drives and protests.

Everyone agrees that Ramberg was motivated by concern for her son's future. Her sister Jane says, "Christina felt really passionate about the nuclear freeze movement once she had Alex. She felt so protective of him, and wanted the world to be a better place for him. She was very idealistic. And she worked hard."

Ramberg had also run into an impasse with her paintings, though she never stopped making art. She kept drawing, and she took up an old pleasure, quiltmaking, in new and increasingly creative and dramatic ways. Quilting—the salvaging of remnants, the making of a whole from disparate parts, order from chaos, something new from something old, beauty from

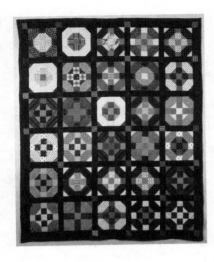

Christina Ramberg. Rolling Stone.
Cotton. 89 x 74 inches.

scraps—this was the methodology of her patched-together torsos, imagined processes she now performed in the real world. And just as she began conceiving of larger and more complex quilts than those she had made for fun in the 1970s, she found her quilting soul sister in Rebecca Shore.

Ramberg shared her memories of their mutual quilt mania when she filled out a questionnaire for a 1985 show of her and Shore's quilts at the Gallery Karl Oskar in Westwood Hills, Kansas. The show was curated by quilt historian Barbara Brackman, who invited pairs of quilting friends to exhibit their work together. Ramberg wrote, "I had been making quilts and quilted jackets and bags for about ten years and it was great to meet someone who was as crazy about quilts as I was." Shore remembers,

> We were both very engaged in the tradition of quiltmaking, and we were
> both repelled by the art quilt phenomenon that seemed to be so ashamed
> to have anything to do with tradition or with craft or with quilts based
> on geometry. One of the first things Christina either got for me or
> showed me was a line-drawing booklet that had all kinds of different
> quilt block patterns in it. She started out, as did I, making quilts based
> on traditional blocks. What she was really good at was thinking about
> how to use fabric to make those blocks formally different. So maybe in
> one, an X shape would be emphasized by the fact that she would use
> stripes. Or in another one she might break it up by having that be the

same value as the triangle. She was really thinking about them formally, as geometry.

One joy of quiltmaking is how the craft of stitching together pieces of repurposed fabric to create dynamic patterns also binds together friendships as women quilt side by side. Ramberg and Shore, alike in their ebullient intelligence, artistic intensity, and multiple talents and skills, took deep pleasure in sharing their enthusiasm for quilting, a very different endeavor than painting. Shore describes how avidly they studied established patterns and techniques: "We loved to get new books and quilt periodicals. We would go through them page by page and talk about what we liked and what was exciting and how we could do spin-offs. We really embraced the idea that in the world of quiltmaking it was legitimate to do a spinoff. That you were allowed and supposed to be inspired by other people's quiltmaking." Ramberg wrote,

> Becky and I used to laugh with embarrassment about how similar our work looked. Alone in our studios, we'd think "People will think I copied!" Or "People will think she copied me!" I remember catching myself thinking that I shouldn't pursue a certain idea because it resembled something Becky had done. Later Becky revealed she'd often worried about working on ideas if they resembled ideas she knew I was thinking about. Once we talked about this we realized such worries were only getting in the way of our excitement and the development of our work. Rationally, we knew it was counterproductive to let anything stop us from trying out ideas that excited us! We decided to agree then and there to copy each other every chance we got!

As quiltmaking strengthened their bond, it also offered a refuge as both women struggled to adapt practically and emotionally to the dissolution of their marriages. They spent a lot of time together, and their quilt fanaticism proved to be too much for Ramberg's son. Becky remembers, "Alex, at one point, looked at us in dismay and said, 'Quilts, quilts, quilts, that's all you ever talk about.'" Ramberg wrote, "Sometimes when we get together we talk so much about quilts that my son calls it a meeting of the

Quilt Club." Ramberg and Shore prowled through thrift stores, hunting down interesting fabric and generously sharing their treasures. They also helped each other with "problem" quilts. As their quilt portfolios grew, they each had quilts published in *Quilt Digest*, and continued to exhibit together to powerful effect.

In early 1989 Ramberg submitted an artist's statement to the Carl Hammer Gallery in Chicago:

> I have made quilts since the early 1970s but it was not until the early 1980s that I really became serious about them. Quiltmaking bailed me out at a time when I had reached a crisis with my major interest— painting. I was dissatisfied with everything about my paintings and all my experiments were yielding nothing. Quiltmaking was the perfect activity for me at that moment because I did not have to think about content.
>
> Afro-American quiltmaking was and continues to be a great source of inspiration to me—the disregard of rules, the willingness to try anything, and the exuberant results! Another important moment was the discovery, at a temple flea market in Kyoto, Japan, of stacks of remnants of everyday striped kimono material; I bought as much as I could carry home.
>
> Although I've found my way with painting again, my interest in making quilts has not subsided. I continue to make them and am noticing that they have begun to look more and more like my paintings; the same sensibility seems evident.

Ramberg had traveled to Japan in May 1984 after receiving her second grant from the National Endowment of the Arts. She kept a journal, chronicling her adventures and sketching the temples and art she saw, striking a skeptical note in her first entry: "Still can't believe I'm going, even now that I'm on the plane. In no mood to talk to anyone . . . Traveling light—one small suitcase and a carry-on travel bag. Feeling jaded, wondering if I will find anything truly exciting." She also wondered if she would be able to find a supply of Skor, the chocolate bar she was pretty much addicted to.

Her sister Debbie remarks, "Japan had a huge influence on Christina.

She lived there when she was four and five, and ever since she loved all things Japanese. Interestingly, both Jane and I are also very attracted to Japanese art. We really like it. And we will often choose an exhibit about that over anything else. My mother had a wonderful eye for Japanese art and she collected a lot of it, so we grew up with it in the home." Jane recalls that when Christina went back to Japan, "She loved the Japanese gardens with the raked gravel and the meticulous placement of every plant. She loved the textiles. She made jackets and other quilted things and used Japanese fabrics."

Ramberg, then thirty-seven, experienced wonder and excitement during her long journey, even as she had to cope with the dumbstruck awe, rudeness, and joking her towering height aroused. Bathing in communal baths was a constant source of discomfort and amusement. Her host kindly filled the tub with the amount of water a Japanese person would use without any spilling over, but when Ramberg immersed herself, she records, "I spilled a lot!!"

Journal excerpts:

Beautifully used wood everywhere.

 To Kinkaku-ji temple—gold pavilion over-run by school children gawking at my size.

 On to Ryoanji Temple—rock garden wonderful!

Two women come up to talk to her. "They laugh at my size."

 More walking—holes in stockings. Been wearing black shoes—feel less huge + more feminine in them—get stared at enough as it is . . . feeling templed-out . . . if I see one more sensitively used piece of wood I'll vomit.

Ramberg made many drawings of objects she saw and admired in the Kurashiki Folkcraft Museum, which was housed in an old rice granary.

"Almost deserted," she wrote. "Objects are on open shelves. You can touch! Haven't seen a guard yet." She listed and described many items; all were fascinating to her. *"Straw shoes!"*

She bought kimonos and cloth purses. She met a Japanese doctor in the nearby archaeological museum and spent a few hours with him:

> A [sic] first I wasn't sure Id enjoy it, then I decided to be bad + brazen and not be obsequious or mild or to treat him deferentially because he was a man—and it was fun. I think he would have preferred someone he could "show the town," explain things to, but I wouldn't play the ignorant tourist + once that was established we had interesting talk about his work, his time doing post-grad work 10 yrs. ago at Twin Cities + later teaching in Ann Arbor, his internship at U.S. V.A. hospital in southern Japan during the Viet Nam years, his interest in archeology . . . nuclear disarmament (Japan has 3-part policy: not to produce, have, or bring them in + question always is: does U.S. 7th fleet have nuclear weapons aboard its subs and ships in Jap harbors), my grant and report . . . I think I puzzle my hosts by not being interested in the usual tourist stuff. My "good girl" stuff gets kicked up when I realize I'm not acting the way they expect me to—I'm in the habit of wishing to please—a good habit to break!

Ramberg visited the Saihoji Temple, where people perform *shakyō*, a religious rite in which you trace a sutra by hand and include a wish. She wrote that her wish was "for the abolition of nuclear weapons." On the street, she "ran into anti-Tomahawk nuclear submarine demonstration—11-day hunger strike by young man—lying asleep on a tatami, a young girl there, too. Sat w/ them awhile. Touching but also discouraging—most passersby determinedly ignored them."

"Struck gold with Nara National Museum, an exhibit of Buddhas." This inspired notebook drawings in which one can sense her happy inquisitiveness, and understand exactly why she was captivated by what she drew and commented on, including "disciples of Buddha hands under sleeves," and a figure seated in the lotus position: "ascetic Buddha, skin + bones veins visible like rivers over ridged land / drapery over legs / long sleeves over folded hands."

Ramberg made many very fine and beautifully precise technical draw-
ings, accompanied by notes about how things were made, as she marveled
over everything from knotted cords to lunch boxes to wooden floor patterns.
She learned how to properly fold a kimono, and bought an additional suit-
case to hold everything she'd acquired.

The Japanese fabric she brought back supercharged her quiltmaking.
She chose very demanding patterns and reveled in their complexity.
She made brilliant use of bright plaid, polka-dot, floral, and other print
fabrics, juxtaposing them in unexpected combinations against a black back-
ground in bold, intricate, and masterful inquiries into the dynamics of color
and form.

Japanese Showcase (1984) is a relatively straight-ahead composition of
squares on squares, a subtle study in black, reds, yellows, whites, and traces
of blues and greens, all made of traditional Japanese striped cloth. *Hexagons
#1*, of the same year, is an entrancing variation on one of the classic quilt
patterns most in use over the past three centuries. Ramberg lined up a vital
array of radiant hexagons against a black background, each shining like a
crystal formation or a magnified diatom glowing against the dark of the
ocean deep. This is one of the artist's most cheerful and dazzling creations.

Ramberg made exhilarating use of the optical illusions created by such
traditional quilt blocks as the Rolling Stone (in a highly sophisticated varia-
tion), Patience Corners (using a delirious assortment of fabrics), and Double
T (in a potent, percussive interpretation). In 1987 she made the handsome
Open Box. With a light background and dramatic tension, this quilt clearly
relates to her paintings. This aesthetic connection is even more conspicuous
in *Showcase Spinoff* (1987), another quilt made of Japanese fabric in which
stacked urnlike shapes look like fat fish and finned bombs. She broke free
from the meshed connectivity of block patterns in *Columns*, another in a
series in which she used striped Japanese fabric to create stacked vessels
and architectural configurations.

It is impossible to overstate the impact of Ramberg's quilts. As with
her acutely detailed paintings, the pinpoint perfection of pattern and the
surprising matches and contrasts of colors and forms are arresting and
mesmerizing. And then there's the magic with which she summons her own
particular shimmering vibrancy, that mysterious inner luminosity, from

something as humble as everyday fabric, conveyed via her deep thought, concentrated gaze, and sure touch. Ramberg channeled so much of herself into everything she created, expressing visually feelings and realizations she did not communicate in any other way. Quiltmaking, a passion and an art she so happily shared with her dear friend and sister artist Shore, freed her from the content analysis her paintings provoked, and allowed her to work out complicated ideas. As it turned out, her needle-and-cloth geometric investigations were quietly fueling a series of new and very different paintings.

Looking back in 1987 to her profound immersion in quiltmaking, Ramberg replied to a query from curator Judith Russi Kirshner about her return to painting, explaining that she missed the "sensation of paint, the opportunity to control illusion and to describe atmosphere. I have always recognized two parallel strains in my work. One was the readable, recognizable-as-figure image, and the second was a more abstract, meta-phorical image often reading as torso/urn/?"

In one of her last notebooks, Ramberg was considering ideas for two distinct types of images. She had long loved the work of such European self-taught artists as Augustin Lesage, Dominique Peyronnet, Henri Rousseau, and Alfred Wallis, who painted with unfettered passion the glorious lushness of nature, from leaves and flowers to sky and sea. Ramberg had also become a spectacular gardener, and she began writing down ideas for paintings inspired by these artists and her gardening ardor, visions that, for the first time in her human- and vessel-focused oeuvre, would look out to the larger, living world.

She writes, "*Victory* garden shed . . . instead, just a wall red showing thru ptg: a collection of surfaces. a sampler. Shaker inspirational drwg. Organizational principles, a symmetrical garden . . . A hill? Shed fronts + roofs . . . Garden contrast—unruly + manicured. Chance for pattern in decorative features of terraces or tiles. Augustin Lesage. Garden ptg of many months ago. Chinese screen ptgs of temple complexes. fences. walls. benches. pedestals. pools. streams. plantings. arch. trellis Table."

But Ramberg was also thinking about more austere imagery, ideas for what she called her "satellite paintings," which involved far more abstract and poetically scientific concepts than gardens. Her notes read,

Meanderspiralbranch
water flow fast
deep shallow sediment pulls up
cabbage
octopus
rate of growth
gravity light weather ice
higher humidity temp range
snowflakes
succulent
explosion branches double explosion
"part as model of the whole"
helix coil polarity
patterns anticipate later emerging forms
form growth forces shapes molecular environment gravity arid weather
structure need to conserve energy—creates order

She also writes,

too many dif[ferent] ideas. what are they. thinking about past reputation
sneaks in + what people will think . . . Fear of making boring repetitive
work too many dif. ideas. What is relationship to image? Too many
sizes. What I make is boring looking. What I make is nothing new or
original or surprising. How to work painting into rhythm of my life.
Smaller things. Many parts. Don't think now if they add up. Many
masonite panels the same size. All the ideas on them then they add up
or don't. Too many ideas. Not only painted. Pencil, glued on. Like
sketchbook pages.

From this swirl of ideas, doubt, and worry, Ramberg chose not to
pursue her visions of verdant gardens but rather the measured "satellite"
motif. At first look, these new drawings and paintings appear to be radical
departures. For all the abstraction and incorporation of wood and metal into
her injured and reassembled torsos, there is still life there. Still something
human. Her new numbered abstractions refer to nothing living or even

Christina Ramberg. Untitled *(Satellite Sketches).* Graphite on *paper. 10 1/2 x 9 inches.*

earthly; they are elegant diagrammatic and geometric studies. Although Ramberg began making these spare images while she was still making quilts, none of the joyful colors of the fabrics she was using appear in these paintings. Instead, she returns to a palette of gray, white, blue, and black as limited as that of her 1970s torsos, using even more vehement black lines.

But for all their stark singularity, Ramberg's final paintings did evolve from her earlier work. You can see their origins in *Wired* and other fierce, robotic figures inspired by origami: metallic, futuristic, sexually aggressive, battle-ready entities that crouch menacingly against a sickly yellow background. Origami meets science fiction.

About her new, cosmic works Ramberg wrote,

surface
space
energy
glowing core

In these schematic works, Ramberg fits together circles, cones, triangles, and diagonal lines to configure what seem like astronomical, cosmological, mathematical, or meteorological phenomena. They also look like plans for radio telescopes, and, of course, satellites, as well as diabolic machines or weapons, the sort that would harm your mind more than your

body. The more polished drawings in this series have a lab-book look to them, and the paintings grow increasingly intricate in overlapping patterns not dissimilar to those in her quilts. These drawings could be the underlying framework, or skeletons, of the patterns the artist brought to life with cloth and thread. As spare as these images of menacing contraptions are, Ramberg does perform her usual morphological inquiry, drawing and painting numerous variations on a theme. And sure enough, these mechanized structures form conical vessels, linear variations on Ramberg's enduring form, the urn.

Ramberg was always feeding her imagination by looking at art and artifacts. She was quite taken with the work of German "asylum artist" August Natterer, a favorite of the Surrealists. Natterer was trained as an engineer and worked as a mechanic and electrician until he was assailed by apocalyptic hallucinations and delusions brought on by schizophrenia. His neatly executed and wildly imaginative technical drawings included studies of a pleated skirt that resonated strongly with Ramberg, as well as depictions of such threatening or fanciful machines as elaborated mechanized cannons and a strange flying warship in which Natterer's pleasingly precise rendering plays in provocative contrast to the troubling fantasies powering his visions.

Some of Ramberg's vortex paintings date back to 1980, when she was also painting those loosely brushed, brightly hued mother figures. Some were done with acrylic on Masonite, Ramberg's steadfast medium, but she also experimented with acrylic on linen and canvas, working with underpainting and transparent layers. She even returned to oils, which she hadn't used since she was a student. Though these paintings are small to medium in size, with dimensions under thirty inches, they feel enormous. That's due, in some instances, to their atmospheric, swirling layering of tones, which look like notations of celestial motion. There is a cool yet moody beauty to these machines taking measure of—or monitoring, or marshalling—tempestuous cosmic forces.

Ramberg and Hanson were part of a 1987 exhibit organized by Judith Russi Kirshner for the Terra Museum of Art, *Surfaces: Two Decades of Painting in Chicago, Seventies and Eighties*. Hanson's contribution, *Comedy of Art: Spring, Summer, Fall, Winter* (1985), was comprised of four panels,

each depicting a torso representing one of the seasons in the form of an empty yet body-contoured jacket, each a fantastically organic and baroque bit of otherworldly regalia made of finely layered leaves, vines, flowers, and crystals. Two are voluptuously female, and two are male, a large codpiece hovering before each. Ramberg chose to show *Untitled Installation, 1986–87*, in which two of her dramatic satellites create a somber, refined, and mysterious diptych. "Installation" actually describes the paintings themselves more relevantly than their display. Each portrays a monstrous device, some sort of open-work centrifuge or nuclear reactor or tractor-beam emitter, which appears to be housed, or installed, in a chamber, silo, or bunker. One is flatter and more frontal in orientation, and it has, as do other paintings in this series, elements that can be interpreted as cranial and facial. After years of drawing wrapped, bound, blindfolded, and gagged faceless heads and headless torsos, Ramberg just may have been constructing giant open-frame robotic faces and heads. As she wrote in a notebook in 1981 while looking at Karl Wirsum's show at the Museum of Contemporary Art, placement is all:

> *Any form can be anything.*
> eg: Given context of face, *any form* placed in eye's position is read as an eye!

These vortex paintings are commanding works of art. Composed with great balance and tension, richly painted, and tightly controlled in form and palette, they remain, as all of Ramberg's drawings and paintings do, wide open to interpretation.

Ramberg included a half dozen of these diagrammatic abstractions in her twenty-year retrospective exhibit at the Renaissance Society at the University of Chicago in March and April of 1988. In his catalog essay tracing the evolution of Ramberg's work, esteemed Chicago critic Dennis Adrian wrote,

> In her work Ramberg is dedicated to an uncompromising search for the fullest and clearest resolution of the formal and imagistic issues she chooses to address and to investing her art with the fullest measure of intense and utterly sincere feeling. This feeling is centered upon a

complex awareness of the range of variety of artistic functions, the artist's own role and personal identity and upon thorough-going and profound investigations of the mechanisms and interactions of different kinds of perception. Commitment to such demanding concerns is the vocation of the greatest artists, and Ramberg's accomplishments in her work have amply justified her decades of dedication, effort and resolve.

What a resounding accomplishment, for a forty-one-year-old woman artist to have a retrospective of such magnitude. Everyone believed this was a midcareer assessment, and looked forward to Ramberg's future creations. But the people closest to Ramberg found her new paintings off-putting and troubling, perceiving them as emblematic of a chilly withdrawal from life, from engaging with others. While her early works were unnerving in their fetishist sexuality, these seemed disturbingly detached and forbidding. The return to muted colors seemed to signal depression. The machines or aliens she summoned forth seemed hostile, their world empty, cold, and calculating. If some images do depict the underlying infrastructure for heads and minds, they map closed systems, vicious cycles of imprisonment. Hanson says that these late paintings were inspired by the huge electric power transmission towers that seem to march across the countryside like giant robots. Ramberg was fascinated by these metal entities, and would draw them in her notebooks while traveling. Hanson also feels that her diabolical mechanicals are terribly sad, "as though she was trying to send out a message."

This bleak reading of Ramberg's beautiful geometric and cosmological abstractions by her loved ones is because they cannot separate these puzzling works from the tragedy that put a halt to Ramberg's art and, after much suffering, her life. From this vantage point, we can't help but feel the cruel ironies of Ramberg's artistic obsession with heads muffled, opened, and dissected.

"Dedicated to my brother, Charles, whose life is an inspiration to me."

This is the dedication in the catalog for Christina's 1988 Renaissance Society retrospective. Her beloved brother, the valiant civil rights and free speech attorney and father of three, had been stricken with a fast-growing,

malignant brain tumor. Diagnosed when he was forty-three, he died at forty-four in May 1988, just after Christina's show closed. She was devastated. When she began to act a bit strangely in the aftermath, everyone assumed she was deeply depressed—so much so that she wasn't able or willing to paint or make quilts. And then things got worse.

Hanson says, "Christina began having problems. People would call, and she couldn't really talk, so she'd say she was tired and had to lie down. Once, in the middle of a meeting with the president at SAIC, she had to lie down. Everyone knew something was off. She couldn't manage to renew her driver's license. I took her and helped her do it, but then I worried about her driving."

Shore and Ramberg had work in an exciting international quilt show in São Paulo, Brazil, and they went down there together for what should have been a great adventure. Instead it turned out to be a confounding ordeal. Shore remembers, "Christina was acting so weird. Everyone else in the group was wearing summer clothes, it was hot there, and she was in silk and wool. We would all be walking together, for, like, five minutes, and she would say that she couldn't keep going. There was no logical explanation for her behavior. I didn't know what was going on."

Hanson recalls, "We thought maybe she would have to have electroshock therapy. Finally her mother begged her to check into the hospital for observation. She was there for five days or so before they diagnosed it."

Ramberg had Pick's disease, a rare, progressive, irreversible form of dementia that attacks the frontal and temporal lobes of the brain. The frontal lobe controls essential aspects of everyday functioning, from speaking and understanding speech to movement, emotion, judgment, and the ability to make plans. The malady is named after Arnold Pick, a professor of psychiatry at the University of Prague who, in 1892, discovered the disease and its cause: abnormal amounts or types of a nerve cell protein (tau) that causes nerve cells to degenerate and brain tissue to shrink. What instigates this abnormal protein presence is still not known, and there is no cure. Sufferers usually die from Pick's in six to eight years. Ramberg was forty-three when she was diagnosed. She died at age forty-nine in 1995.

When Ramberg could no longer live alone, Hanson, generous and loving, stepped in and took charge of her care. He brought her into his

home, tackled the financial complexities, and made sure she had everything she needed until there was no choice but to move her to an assisted-care facility.

Ramberg's father had developed Alzheimer's. Out of a family of five, three had neurological maladies. How to explain this cruel assault? Vernon and his two oldest children had lived in Japan immediately after the dropping of atomic bombs on Hiroshima and Nagasaki. Could there be a connection? Jane Ramberg has thought about this a lot.

> With Charles and Christina it was outside the box in terms of disturbing. Scary and tragic. Being the scientist that I am, I keep following the literature, trying to see if there's any association between these diseases. And if there was something going on in Japan when they were there. But my mother says that they did not eat any fresh food; everything was canned and their food came from the U.S. But I don't know about the water, I never asked about that. So who knows? Our parents were both from Wisconsin, so we would go up there on vacation, and everything was drenched in pesticides. This makes you wonder about playing around in the corn fields. They really don't understand Pick's disease at all. It's just a mystery. And Charles' death was a mystery, too.
>
> It was horrible for our mother. Christina's illness went on for so long. It was terrible; there really are no words for it. But our mother's grandchildren have made her really happy after those dark years. As for Christina, I've always been in awe of her. I've been in awe of her my entire life.

"Christina's illness was horrible," Debbie says, "and it was especially awful because it was soon after my brother's death. But honestly, Christina was beloved and revered by everybody who knew her and that has made it easier for us."

Hanson's most recent oil paintings bring together poetry, color, and form in resplendent, many-layered compositions best described as visual opera. He

Christina Ramberg. Photograph by William H. Bengston. c. 1970.

has had four solo shows at Corbett vs. Dempsey Gallery in Chicago, and his paintings were shown in the 2014 Whitney Biennial. Tech-savvy and community-oriented Alex is thriving.

After years in the shadows, Christina Ramberg's drawings and paintings are being rediscovered, reclaimed, and celebrated anew with wonder, curiosity, and enthusiasm. For an artist who claimed to work slowly, she completed a tremendous amount of consummate, unique, and complex work. Her drawn hands beckon; her bound heads warn. Her pristine sexy ladies remain seductive and disquieting. Her wounded torsos are as haunting as ever—maybe more so. Her birthing and mother paintings are still surprising. Her quilts are sheer joy. And her final cosmic paintings, her satellites and vortexes, her space heads and telescopes, put our minds in a spin and reconfigure our imaginations. No one who knew Ramberg will ever forget her radiance, and those new to her art will readily come under her transfixing spell. Ramberg remains extraordinary, enigmatic, and endlessly intriguing.

ALL OF A PIECE

LENORE TAWNEY

I become timeless when I work with fiber. Each line, each knot is a
prayer.
—Lenore Tawney

The artist stands high atop a scaffolding tower in a capacious interior
space, a diminutive figure in a white robe and snug white hat. Her head is
tilted back; both arms are raised. Above her hovers a bright rectangle from
which cascades a dazzling shower of white rain. A vast array of floating fila-
ments, slender tentacles sixteen feet long, each a linen thread meticulously
selected, measured, cut, knotted, rolled up, then released to create one of
the artist's breathtakingly delicate yet monumental *Clouds*.

Lenore Tawney was a small, lithe, photogenic woman who lived to be
one hundred years old and made enormous hanging sculptures out of thou-
sands and thousands of threads and strands painstakingly woven and
worked to form lushly textured tapestries, intricate, airy webs and nets, and
commanding totemic forms. She liberated tapestries from the wall to hang
freely in space, and she pushed beyond traditional straight edges to create
suspended sculptures that curve and bend and breathe and sway and
cast patterned shadows that transform ordinary rooms into mysterious
spaces enlivened by the interplay of transparency and opaqueness, weight
and buoyancy. These "woven forms," as she named them, are works of
radical vision, clever innovation, sophisticated composition, and complex,
assiduous, and contemplative execution. The pioneering Chicago-based art
gallery owner and curator Katharine Kuh wrote that Tawney "quietly devel-
oped a new vocabulary for fiber, a new freedom from conventional weaving
techniques. It is no exaggeration to claim her as very likely the earliest
animating spirit behind modern fiber art."

A strong spiritual current flows through Tawney's intrepidly imagined, evocatively elegant creations. The Catholicism of her youth is reflected in such works as *St. Francis and the Birds* (1954), *Nativity in Nature* (1960), and *Vespers* (1961). The first signals a key theme in Tawney's work, her love for birds, especially seabirds, which aligns with her passion for water, from springs to rivers, lakes, and the sea. In nearly every culture on Earth, birds and water have holy resonance. As Tawney's art evolved, so too did her metaphysical inquiry, which inspired her long and sustaining meditation practices, guided by her studies of Zen Buddhism and eventual commitment to siddha yoga.

Lenore Tawney's devotion to art and spiritual practices even kept her youthful. She never looked, felt, or acted her age, so she easily got away with claiming to be a good eighteen years younger than she was. She looked like a priestess with her poised, upright posture, expressive hands, the smocks she made of fine silks, and her hair gathered away from her strong-featured face. She radiated power. Her body language is prayerful as she works kneeling, seated on the floor, perched on a low stool, or standing. And indeed her techniques required phenomenal concentration, dexterity, precision, and respect for materials and the act of creation as she made complicated, unprecedented works thread by thread, line by line, knot by knot, feather by feather, word by word, breath by breath. For Tawney, making art was a meditative, mystical, and joyous experience.

Her immaculately clean and polished loft studios looked like sacred spaces, churches, temples, or cloisters, with their high ceilings and large windows, fresh flowers, and cherished collection of venerated objects. Curator and art writer Kathleen Nugent Mangan recalls her first unforgettable visit to Tawney's New York studio in 1987: "Quiet and light, the loft was imbued with an otherworldliness, a sense of spirituality reflective of Tawney's reverence for and poetic response to materials. The space was filled with time-polished pebbles, bleached bones, feathers and eggs, textiles and objects from her travels around the world, and chests in which each drawer contained a small assemblage. The studio itself seemed to be a kind of environmental autobiography, the collage of a lifetime."

Mangan was there to begin work on what would become Tawney's 1990 retrospective exhibition at the American Craft Museum in New York,

but sprightly Tawney, at age eighty, as Mangan recounts, "had other ideas. 'I thought we'd blow bubbles today,' she said, and producing a small vial of soap bubbles from the pocket of her smock, she began to twirl through the space, a cloud of bubbles trailing behind."

Leonora Agnes Gallagher was born on May 10, 1907, in Lorain, Ohio, on Lake Erie, not far from Cleveland. Her father, William Gallagher, was Irish American. She described her mother, Sarah Jennings, as "a farm girl from Ireland." In a 1971 Archives of American Art interview with Paul Cummings, Tawney wryly remembers her hometown: "It had a shipyard and a steel mill, and that was it." Tawney laughs as she reports that she "never had a touch of art in Lorain, Ohio." But she did vividly remember the blue of the great lake, the sky, and the many wildflowers.

In a not particularly cheerful 1913 photograph, Leonora, one of five children, stands with two of her siblings to the right of her seated mother. She is a pretty girl with dark bobbed hair, parted neatly in the center. She looks earnest and impish, sweet and intense, her eyes sharply focused and her lips compressed in a straight line. Her mother has a serious, if inquisitive, mien, her head slightly tilted, her gaze also penetrating. She holds her hands lightly clasped in her lap instead of reaching out to touch Leonora, whose left arm and hand rest close to her on the chair's arm, or the youngest child, a round-faced girl who is frowning sulkily, her mouth drawn firmly down. Only the boy has a slight hint of a smile, though he also looks cautious, skeptical. Mother and children are posed in front of the outside

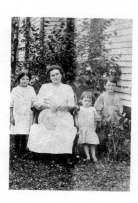

Lenore Tawney with her mother and siblings, Lorain, Ohio, ca. 1913. Unidentified photographer.

wall of a wooden shingled house cushioned by a sprawling bush and other exuberant greenery.

The artist claimed to have changed her first name around the time she entered first grade: "Why? Too many letters." Her mother taught her to sew and embroider and, as art writer Eleanor Munro reports, she

> became proficient enough to adorn the sleeves of her plain blue serge schooldress. But when she wore it to her convent school, the nuns disapproved. They preferred a modest conformity among their students, and Tawney thinks of that early flight of fancifulness as a first turn toward the life she would eventually make. The convent rigidity oppressed her in other ways as well. When a ballet teacher came and got the girls going in pliés and arabesques and then dressed them up in tutus for a show, the sisters shut the door on that activity. Dancing too was a release not to be enjoyed for a long time.

In 1971 Tawney became one of the approximately 250 artists, dealers, and collectors who spoke at length with art scholar and curator Paul Cumming while he directed the oral history project of the Archives of American Art from 1968 to 1978. She told him that after completing high school she went to work full-time at a factory. When Cumming asked what she did there, she replied, clearly aware of and amused by how revealing her answer would be, given her devotion to fiber art, "Well, it was sewing. Just sewing something on men's suits, you know. Nobody knows that."

When Lenore was twenty, she left Ohio for Chicago, where her older brother, Jimmy Gallagher, was a sportswriter who became general manager for the Chicago Cubs during the 1940s. Gallagher was widely criticized for strictly adhering to the dictates of the team's chewing-gum magnate owner, Phil Wrigley, whose destructively parsimonious budget kept the ballplayers' salaries problematically low. After Gallagher was fired, the man who briefly followed as manager, Charles Grimm, said, "He was the most honest man I ever knew." Jimmy may have ushered his attractive sister into the high-rolling Wrigley circle.

Lenore worked as a waitress, and began taking classes at the Art

Institute of Chicago. She then landed a job as a proofreader for a publisher specializing in court opinions. She stayed with the company for fifteen years and became the head of her department. This position required disciplined, meticulous, and relentlessly detailed and attentive work, for which she was well-suited, given her keen eye, high intellect, remarkable patience, and exceptional power of concentration. Her involvement with text would resurface in her art when she began using the pages of old books in collages, assemblages, sculptures, and tapestries.

At some point during the 1930s, this diligent yet fun-loving young Irish Catholic woman got married and promptly realized that she had made a mistake. Courageously bucking religious and social taboos, she managed to extract herself from this predicament, keeping the painful interlude to herself for most of her life. Later, friends introduced her to George Busey Tawney, a psychologist (as was his father) from a prominent family in Urbana, Illinois. He was five years younger than she. They married in 1941, and had a "happy yet tragically brief marriage," lasting only a year and a half before George became ill after the start of his military service. After spending two wretched months in the hospital, he died at age thirty-one. Lenore was "devastated," as were his parents. She moved to Urbana and lived with her grieving in-laws for two years. They were a powerful couple, whose wealth and standing provided Tawney with the financial independence that shaped the rest of her long, productive life.

Early settlers in Urbana-Champaign, Illinois, the wealthy Busey family had founded a bank. George Busey Tawney's maternal grandmother, Mary Elizabeth Bowen Busey, advocated for women's rights, served on many boards as a community activist, and ran her family's business for twenty years, after her husband, General Samuel T. Busey, drowned in 1909. Her daughter, Marietta Busey Tawney, was also an early feminist. She graduated from Vassar College in 1899 and married Professor Guy Allan Tawney in 1909. Marietta inherited the Busey properties and had three children, two daughters and a son, George. Like her mother before her, Marietta was very active in civic affairs.

Guy Allan Tawney, like Lenore, was born in Ohio. He earned his bachelor's and master's degrees at Princeton, and his Ph.D. at the University of Leipzig in Germany, studying with Wilhelm Wundt, remembered as the

founder of modern psychology. Tawney became the first psychologist to join
the faculty at Beloit College in Beloit, Wisconsin, where he was an erudite,
extremely popular, and famously absent-minded teacher. Dr. Tawney also
taught at Columbia University, the University of Illinois at Urbana-
Champaign, and the University of Cincinnati, where he was a professor of
philosophy and lecturer in biblical literature. After he retired, he and his
wife settled back in Urbana. While living with her in-laws, Lenore attended
the University of Illinois for a year and a half, studying occupational therapy
in a newly established program. Her studies, encompassing both art and
medical classes, were demanding. When she reached the part of the term
that required many hours in the hospital, an environment she could not
tolerate so soon after her hospital vigil beside her slowly dying husband, she
dropped out.

Lenore not only left the university but moved away from Urbana. Her
in-laws may have clung too tightly. Certainly she needed to retake charge of
her life; she was, after all, in her late thirties. Seeking a fresh start, she
went to Mexico for six months, the first of her many inspiring journeys to
other lands, then returned to Chicago. There, encouraged by friends, she
enrolled in the cutting-edge Institute of Design, hoping for "something
newer and more exciting, more vital." ID, as it was called, was an offshoot
of the Bauhaus, the progressive art school founded in Germany in 1919 by
the architect Walter Gropius. The school's mission was to unite art, design,
and crafts, aesthetics and utility, to foster a new form of art education that
would in turn generate a new more unified and positive way of living. The
textile workshop proved to be one of the most successful Bauhaus depart-
ments, thanks to the brilliant and innovative weaver Anni Albers. When
the time came to establish an American Bauhaus in Chicago, Gropius
chose László Moholy-Nagy as director.

An "enthusiastic and inspiring teacher," Moholy-Nagy "was aiming at
things of the spirit," according to Thomas Dyja in *The Third Coast: When
Chicago Built the American Dream*. "Art was all about the making, and in
Moholy's eyes it was now progressing past the easel, toward light, space,
and motion." Tawney found Moholy to be "quite marvelous," and said that
his "drawing class really released me from the feeling I couldn't draw." She
recalled that Moholy had the class "draw our names," an exercise that

resurfaced when Tawney turned handwriting into an art form. "The next time he came in," Tawney continued, "he had a piece of string. He held it up and dropped it and we were to draw it just as it fell. Those exercises were very freeing to me." Tawney also studied drawing and watercolor with Emerson Woelffer; weaving with Marli Ehrman, a Bauhaus instructor who also taught Chicago fiber artist Claire Zeisler; and sculpture with the Ukrainian artist Alexander Archipenko, who revealed to Tawney just how all-encompassing a commitment art requires.

Archipenko was a groundbreaking modernist, exploring the sculptural possibilities of Cubism and developing his own approach to form by concentrating on convex and concave shapes, paying as much attention to negative space as to mass. He practiced what he termed "sculpto-painting," seeking a fresh, dynamic, and unifying approach, while experimenting with new materials and techniques.

Perceiving Tawney's nascent gifts and potential, Archipenko invited her to spend the summer studying with him at his studio in Woodstock, New York. Tawney described the experience: "So I studied with him that whole summer and that was a real turning point for me because, working all day, you know, you really just thought about high points, when you're just completely with what you're doing. It's like almost ecstasy sometimes."

But as transforming as her summer immersion was, she found herself in a bind: "It seems that I had to devote my whole self to sculpture, I couldn't do it halfway, so I gave it up." Many would-be artists aren't able to make this total commitment because they have to work for a living. Tawney was spared that dilemma, having inherited farmland from her husband's family that supported decades of wholly independent art-making and travel. But at this juncture, she simply wasn't ready to radically change her life once again. She was happy within her social set, involved in a romantic relationship, and busy renovating a building she'd purchased in Chicago. She told Munro that while she was trying to decide whether to set aside a space for a studio there, she gave in to a curious impulse: "While the house was all torn up, I had a couple of wonderful parties with a famous jazz pianist. Everyone came and drank a lot. And I destroyed all my sculpture." When Munro expresses disbelief, Tawney elaborates,

It's true. There was a place where you'd open a door and there were no stairs. That's where I threw my sculpture. I threw it all down in the hole—just down into the cellar. I threw all my clay, everything. Out. I even destroyed the last sculpture I had made, a very strange one. One I couldn't understand. A figure, with a hawk's head—a Egyptian sort of head, with a large beak. I wasn't frightened by it. I just didn't understand. I was far then from knowing that something new can be marvelous. No. I just didn't want to face it.

"It" was the need to create, an alarming impetus Tawney tried to stave off as though it were a dangerous and illicit addiction. Realizing that she couldn't escape it altogether, she tried to ameliorate this compulsion by purchasing a secondhand loom. "I thought it was something I could just do while I was living my life. I thought I might be able to get away with that." She asks a friend to teach her how to use it and began weaving without any further instruction. She proved to be so adept that black-and-white table mats she wove out of jute and horsehair were selected for the "Good Design" show at the Merchandise Mart. Her fate seemed obvious, yet Tawney fled once again, decamping, this time, to Europe for a year and a half. She was not only fleeing her artistic imperative but also decisively ending a love affair with a married man. "I didn't want to go on with it, so I left and I just couldn't come back."

Tawney got to know other weavers, including Jack Lenor Larsen, who would become an exceedingly influential textile designer, writer, scholar, collector, and champion for fiber art. But just as she was welcomed into the weavers' circle, she once again turned everything topsy-turvy. Tawney felt compelled to create not functional pieces but rather more personal art. "My work had to begin to come out of the depths of myself, or it wouldn't be worth doing."

In pursuit of more advanced training, she went to the Penland School of Crafts in North Carolina in 1954 to study with the famed Finnish tapestry weaver Martta Taipale. Tawney was at Penland for nearly two months, working at the loom eight hours a day to make two tapestries of Taipale's design. A photograph shows Tawney at work at the loom. Wearing a white T-shirt and striped overalls and sitting ramrod straight, she looks

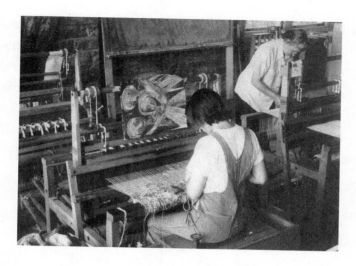

Lenore Tawney at the loom, Penland School of Crafts, Penland, North Carolina, 1954. Unidentified photographer.

like a college student. She was forty-seven. While working on the second piece, she recounted,

> I began to venture to mix my own colors. When I cut it off I couldn't look at it: I hid it for half a day, then took it to Martta's studio and we looked at it together. Martta is a warm and wonderful person and an inspiring teacher. She said, "Color is like music," and I could see color soaring like gothic arches in the sky.
>
> I brought home what was left of my warp, attached it to my loom and made the sketch for *St. Francis and the Birds* and began to weave my first tapestry alone. I was going to do it in dun colors but it didn't turn out that way. The red and yellow and pink crept in, the purple sidled up. My sketches are always black and white, the color is the freedom and the joy.

Tawney came to see this closely woven, chromatically lush tapestry as a reference to her father and a bid for some form of forgiveness that she needed if she were to feel free to proceed as an artist. This pivotal work echoes Taipale's style in its simple, elongated figuration, but the gestural simplicity and the drenched colors in unexpected combinations are Tawney's

own. She found herself spontaneously selecting colors and textures right on the loom, rather than working from a fully realized cartoon, as traditional tapestry weavers do. Later Tawney said, "Well, that was the beginning of my real career, I feel." At this crucial moment, she liberated herself from hesitation and doubt and gave herself over completely to her work. Yet she still had to undergo an even deeper transformation. She explained, "I became very sick, I nearly died. When I came out, it was like being a newborn. And only a few months after that I did the first piece of what is now called open-warp tapestry."

It was in 1955 that Tawney developed her inventive open-warp technique. She found herself working on a large piece called *Family Tree*, and only filling in "the part where there was a form, and all around it I left the warp threads open." *Family Tree* depicts two intertwined trees holding nests and birds in their branches. Like *St. Francis and the Birds*, it also had to do with reconciling her childhood with the present. This inaugural open-warp tapestry was also a "first" in Tawney's use of feathers in the weave.

She wasn't sure the open-weave experiment would work, but she suddenly understood that it didn't matter. "I had the freedom to do what I wanted. I didn't have to please anybody but myself." She told Cummings, "The trouble I feel with craftsmen, so many, is they look at other people's work instead of looking into themselves. So I'm not really interested in crafts because there's so much imitation and looking at other people's work so that it's very depressing."

In the midst of this creative self-liberation, Tawney went to visit friends at the American University in Beirut, and spent much of 1956 exploring Lebanon, Greece, Jordan, Syria, and Egypt, reporting at one point that she was "snowbound in Istanbul." All that she observed and experienced during her wanderings would surface in her work.

Meanwhile, Tawney quickly gained recognition for her expressive creations, which were "essentially paintings in thread." Her unique, intuitive approach to weaving inspired Chicago painter and art journalist Margo Hoff to write in a 1957 article, "the warp is her canvas." But this painterliness also proved to be controversial, as Tawney noted: "Weavers on juries have tended to reject my work—painters on juries have tended to like it." This was just the start of Tawney's bold departure from the craft tradition

on her way to becoming one of the first and most lyrical of a new breed, the fiber artist.

Tawney theorized that people objected so strenuously to her open-warp works because they seemed so fragile and tenuous. Perhaps her approach was seen as anti-weaving. As if her open-warp technique didn't elicit enough consternation, when Tawney was invited to be on a textile design panel at the first national conference of the American Craftsmen's Council (now the American Craft Council) in Asilomar, California, in 1957, she caused an uproar by telling the assembled craftspeople, "We had to follow our own inner being." She reported that "everybody got sore and angry and took sides." Somehow her embrace of emotions, thoughts, and intuition was threatening to these serious and traditional craftspeople. Tawney was speaking more like an artist, specifically the new and radical Abstract Expressionists and action painters who were attempting to commune with the dangerous realm of dreams, myth, and archetypes, plunging into what Jung called the collective unconscious. Tawney seemed to relish the brouhaha she caused, and offers a glimpse of the playful, sensuous self concealed behind her cool and collected exterior: "I did a wild dance around the pool one night, I do wild dances sometimes."

One can readily picture her performing "wild dances" along the shore of Lake Michigan. Tawney lived in one of the most beautiful spots in Chicago, a stately neighborhood along Oak Street Beach just north of the Loop. Over the moody lakescape, the sky is forever changing from bright, hard, enameled blue to muffled, downy grays and flat, milky whites. On sunny days clouds parade like great sailing turtles and flat-bottomed schooners, dragons and horses, sprays of feathers and leaves. Cold and warm fronts collide over the lake in furious battles, unleashing hard rain and whipping up surging, churning, towering, smashing waves. Winter delivers slow, silent, lacy snowfalls, vehement blizzards, and a thick armor of ice concealing the deep-breathing great lake. Tawney recounts,

The lake also was a great inspiration to me. I would get up early and run out to the lake before I had breakfast in the winter and run up and down there. It was wonderful . . . sometimes when I was over there and the snow was falling it was like I was in a world of my own. You couldn't

hear a sound, it was all white and there I saw the birds too. I saw many birds and then in the summer I saw three birds going as if they were on a ship, on this board.

Tawney's response to this mutable place is detectable in her exquisite open-warp pieces as she figured out how to make the curves of earth, leaves, and birds, her totem animal, in a medium of straight lines, perfectly evoking the exquisite lightness of feathers and clouds, dancing sunlight, breeze. Such fresh and translucent tapestries as *Red Celestial* (1960) are resplendent with tracery landscape elements and the colors of the ever-changing crepuscular sky at dawn and dusk. Threads sinuously bend and meander down the warp; all is gauzy, alive, and calligraphic. The ravishing *Yellow* (1958) is a floating dream of many hues of gold, orange, and ocher. It calls to mind the surface of sun-spangled, current-rippled water or a bright sky of cirrus clouds in flower hues. The detail, as always in Tawney's work, is extraordinarily sensitive, as she combined soft, lush yarn with slender thread in the loosely woven weft to add definition and texture. She even slipped in two small, downy gray feathers along one edge. One of the more figurative of her 1950s open-warp tapestries, *Lost and Proud* (1957), grace-fully portrays a nesting dove. This piece looks dauntingly complicated, and

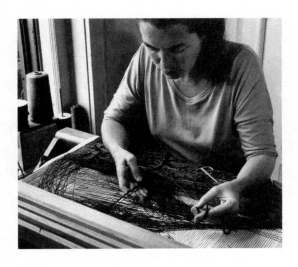

Lenore Tawney working on Lost and Proud, *Chicago, 1957.*
Photographer: Aaron Siskind.

a photograph by the renowned Aaron Siskind documents Tawney at work on it with serene concentration and agility. Of this and other early works, fiber artist Warren Seelig writes, "Tawney opened up the 'canvas,' filtering light that passed through . . . These works incorporate a fluidity of line, thickening and spreading across layers, unlike anything known before."

Tawney was inspired not only by earthly nature but also by the mystery and majesty of celestial forces. And she was as attracted to density as she was to openness, just as a painter might work in both oils and watercolors. *Jupiter* (1959) splendidly evokes the majestic planet with a rich palette of wool and silk yarns in violet, black, yellow, and ocher. The sphere appears three-dimensional as it hovers within a rectangle, a mesmerizing effect Tawney achieved by weaving in an extra layer of horizontal threads. This seminal work anticipates her profound engagement with the symbol of a circle within a square, a configuration she explored over and over again. This focus was inspired by reading Carl Jung, for whom, Tawney explained, the symbol signified "the Inner Self. The square means integration of the self—of course the circle means that, too. So the circle in the square is *really* integration."

A subtle variation on this theme is found in the elegant *Clothed in Memory* (1965), a linen piece in which the dark outline of a circle is woven into a light background, with darker threads reaching out along the circle's lower rim as though it were rising from churning dark clouds or a roiled sea. The monumental *Triune* (1961), a linen, wool, and silk tapestry more than eight feet tall and wide, depicts circles within circles in a square. Art and design historian Sigrid Wortmann Weltge writes, "Shimmering hues in *Triune* invoke the vastness of space, a moon partially obscured by clouds"; but Tawney was thinking about more than the beauty of the firmament. *Triune* means three in one, or threefold, and often refers to triple deities. This formation appears in many diverse mythological and religious traditions, going back to the very earliest polytheistic beliefs on to the Christian trinity. Jung identified the triad as a religious archetype. Tawney said of this piece, "Linear time and eternal time are the arms of the cross. Where the two meet in the middle is the moment of being. It's the moment of awareness if you are aware. Eternal time is always there."

Tawney seemed to be living an ideal life, snug inside her Gold Coast home and studio on the shore of her great muse, Lake Michigan, buoyed by

close relationships and growing recognition for her fresh and remarkable work; yet she renounced it all. In November 1957 she loaded up her stylish Daimler with essential belongings and, accompanied by her adored cat, Pansy, drove cross-country to New York City.

A dozen years later, Tawney reminisced, "I had a friend who had a sailboat and we were always out in the boat on weekends and sailed across the lake. He was a great cook and he'd make sandwiches, all different kinds, and we'd have aquavit, champagne, everything. Oh, it was quite a thing there. And I left all that, I left him, I left Chicago, my house. I just thought I can't let this house burden me."

Were the desires, needs, and expectations of this "friend" also a burden she needed to escape?

All those hours out on the cold, deep great lake, that ever-shifting, shimmering freshwater sea of grays and jades, silken gleam and frothing whitecaps, dark, surging waves. All that time beneath the ever-modulating palette of sky and cloud, within the scouring, thrilling wind. All those long, contemplative hours watching the gulls ride wind and wave. Was all this lake space and time stored in her brain, her psyche, waiting for her to situate herself in a place large enough to express it? Did she need solitude before she could take the next steps in her creative inquiry? Or did she need to be among other artists taking chances with their lives and their creations? Did she need to start fresh, casting off her identity as a creative craftsperson once and for all?

Tawney recounts, "I felt in Chicago I was sort of held. You know when you're in a place a long time, your friends hold you into the sort of mold, they think you're this and you can't drag yourself out of it . . . I didn't know what I wanted, it was a very vague and nebulous thing. I didn't know for a long time. I didn't have any real reason for leaving except it was an inner feeling that I wanted a higher goal, you know. My work is from that, the whole comes out through some kind of feeling."

Ten years later, reflecting back on her move, Tawney wrote in a journal: "I left Chicago to seek a barer life, closer to reality, without all the *things* that clutter and fill our lives . . . The truest thing in my life was my work. I wanted my life to be as true. [I] almost gave up my life for my work, seeking a life of the spirit."

Having grown up on the shore of Lake Erie, and reveled in the power of Lake Michigan, Tawney needed to be close to water—"you know water is fertilizing and water is dissolving and water is cleansing and water is life giving." She managed to find a loft on Lower Manhattan's historic water-front, shifting from life as the owner of a cozy, well-appointed private home to living illegally in a gigantic industrial space within a community of similarly dedicated and groundbreaking artists. This extreme alteration in domicile catalyzed a gloriously liberated change in her creations.

Tawney landed in a studio bereft of all amenities on a patch of New York known as Coenties Slip, which began as a manmade deep-water inlet for loading and unloading ships at the southern end of Manhattan on the East River near what eventually became the tourist-friendly South Street Seaport. Although in 1835 the slip was filled in, it remained part of the maritime world as home to businesses dedicated to the building and outfitting of oceangoing wooden boats. Coenties Slip was also the site of New York City's first publishers, which brought the likes of Herman Melville, Edgar Allen Poe, and Walt Whitman to the busy little neighborhood.

Art critic Nancy Princenthal describes Coenties Slip as full of "ware-houses, gas works, and ship supply shops, including stores for ropes, tackle, and netting. Many of the buildings retained pulley systems for hauling up goods, and many remained unchanged through the middle of the twentieth century . . . When visual artists began to congregate there in the 1950s, it was profoundly isolated from the rest of the city."

Robert Rauschenberg and Jasper Johns were among the first to find spaces in Coenties Slip. They and those who followed transformed raw commercial and industrial spaces still harboring abandoned equipment and materials into rudimentary homes and studios with spectacular river views. The group in place when Tawney moved in included Robert Indiana, Ellsworth Kelly, fellow weaver Ann Wilson, Agnes Martin, and Tawney's landlord, painter Jack Youngerman. She could have run into Youngerman in Paris in the late 1940s, when she rented an apartment and he was there studying on a GI scholarship. He and Kelly became friends there. But however and wherever Tawney and Youngerman met, she would have been intrigued by his dynamic, geometric paintings. Some from this period even

have a woven look, such as *Black Gray Yellows* (1951), *Paris Painting* (1951), and *Rochetaillee* (1953).

Like Tawney, Agnes Martin, who was five years younger, didn't come fully into her own as an artist until she reached her late forties. Neither had children, and both made Zen Buddhism part of their art-focused lives. Martin had lived in New York earlier, as a student at Columbia University. She then went to New Mexico, living primarily in Taos, where she got to know Georgia O'Keeffe, who encouraged her to paint. Martin returned to New York the same year Tawney arrived. Kindred spirits, they were soon "mutually affecting each other's artistic and personal lives," according to Sid Sachs, director of exhibitions at the Rosenwald-Wolf Gallery, University of the Arts in Philadelphia, who suggests that Martin's "reserved, romantic abstraction (a characteristic of many of the Coenties Slip artists) seems to have facilitated Tawney's evolution away from pictorially expressionist weaving." Sachs continues, "In turn, Tawney influenced Martin. Martin's rejection of impasto and adaptation of linear fields derived from Tawney's weaving, and in addition to a t-square and ruler, Martin used threads to track vertical and horizontal coordinates, a trick assimilated from watching Tawney dress her loom." In time, Martin would hotly deny this influence.

The Coenties Slip artists were highly intelligent, disciplined, inventive, and ardently protective of their privacy. As Agnes Martin said, "That's what's wonderful about the Slip—we all respect each other's need to work." Unlike the Abstract Expressionists just to the north, this group did not comprise a movement—each worked from her or his individual aesthetic. Nor did they congregate in bars to hash out and defend their artistic intentions. But they did support each other's quests, and they shared many affinities, even as they headed in opposite directions. Rauschenberg, Johns, Indiana, and later James Rosenquist played key roles in the development of Pop Art. Kelly, Martin, and Youngerman, with Tawney along the fringed periphery, helped develop minimalism. Tawney was fascinated by what the painters were doing, even as she expressed herself with lowly craft materials and techniques. Warren Seelig marvels, "How could she have the audacity to think of linen, silk and cotton threads, working through ancient processes on the loom, to be a viable means of art making in modern

times?" Tawney determinedly followed her muse and didn't allow herself to be concerned about what others thought.

In her biography of Agnes Martin, Nancy Princenthal notes another invaluable aspect of the Slip: it was a place where gays and lesbians "could be comfortable" in a time of intolerance even among straight artists, some of whom were outright hostile. Indiana, Johns, Kelly, and Rauschenberg were gay, and, as Princenthal notes, "Martin is said to have had romantic relationships with two women artists: Chryssa (who used a single name) and Lenore Tawney. Indisputably, she had close associations with both."

Tawney has said that she and Martin were not lovers, that their close relationship was rooted in their work. Tawney continued to be involved with men now and then, but once she made New York her home, she seems not to have entered into any committed romantic relationships. Perhaps she never wanted to suffer loss again. What is certain is that the more focused she became on following her spiritual path, the less inclined she was to get deeply involved with a lover, let alone consider another marriage.

Tawny described her first of several waterfront lofts:

So there I was right on the river, looking at the river and the boats and the lights of Brooklyn. Behind me there was only this wall and there all these pigeons and birds with wings flapping and outside were the gulls on the river. So I had birds all the time, the birds in the back and they were on the windowsills and then the gulls and the boats. It was as if New York was at my back. Then in the winter you saw every change of the weather down there, you were more aware of it than when you're uptown because you'd see the ice and the wind and it would come through my skylights some of it. I had a stove for heat and sometimes when the wind was blowing hard, I couldn't get the fire going and it was very cold. But it was beautiful. I had the floors sanded and it was like a dance floor.

Better off financially at this time than her fellow Slip artists, Tawney was able to fix up her lofts to achieve both creature comforts and visual unity. Fiber, after all, is a cleaner and neater medium than paint. Stylish Tawney, who designed and made her own clothes, maintained her loft

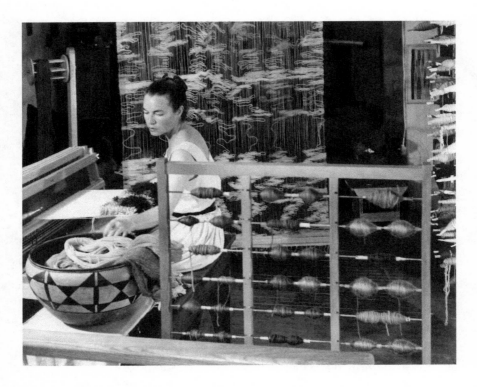

Lenore Tawney in her Coenties Slip, New York studio, 1958. Photographer: David Attie.

studios as pristine, meticulously ordered performance spaces. A friend of Martin's said, "Lenore was a sprite, very sophisticated and beautiful, and her loft was perfect, orderly and elegant. Utterly different from Agnes's."

David Attie took a series of beautifully composed photographs of Tawney in her Coenties Slip studio, images as perfectly staged as a fashion shoot. In one, the artist, her hair up in a dancer's twist, sits at her loom wearing a white sleeveless dress. Beside her on a small table is a handsome, strongly patterned ceramic bowl, a piece of Pueblo pottery, full of yarn. Beside it stands an open frame holding evenly spaced spools. Hanging behind her is one of her exquisite open-warp tapestries. In another photograph, Tawney sits cross-legged and barefoot on the floor between the spoolframe and the back of the loom. The large yarn-filled bowl is now on the floor, and beside it is a large ceramic dish holding a collection of water-smoothed stones.

The renowned photographer Yousuf Karsh, who took thousands of portraits of noteworthy individuals, from heads of state to scientists, entertainers, activists, and artists, photographed Tawney in 1959, the same year he made portraits of Jack Benny, Victor Borge, Bob Hope, President Dwight D. Eisenhower, Pope John XXIII, and Edward R. Murrow. As Tawney moved into even more spacious studios and began making her increasingly large sculptures, photographs of the artist at work became ever more dramatic.

Everything about Tawney seems self-possessed and in control, from her aplomb in traveling the world, to photographs that capture her serene concentration, poise, and strength, to her masterful, extraordinarily daring free-hanging improvisations on traditional textiles. But one can glean from her interviews just how intense her emotions were, how demanding her efforts, how sensitive she was. She gave herself over wholly to her work, and nothing mattered more, yet her sanguinity was hard won and zealously sustained.

Margo Hoff asked Tawney, just before she left for New York, how she felt about commissions. She replied, "I like commission, it is a challenge. But I usually have a fight with myself at the beginning. I want to please the customer, naturally, but I must first please myself. To free myself to do what I want with the work I must throw off the desire to please, then do what I want, and plan to keep it if the customer doesn't like it. So far I haven't had to keep any on this basis. Most of the time I simply work on my own ideas. I work all the time."

In 1959 Tawney was chosen for a major commission: a 10½-by-12½-foot tapestry for the chapel of the Interchurch Center on Riverside Drive in Manhattan. She worked without preliminary sketches and with the proviso that the client was in no way obligated to accept the piece. Traditional in technique and form, Tawney's tapestry was utterly unconventional in image and style. *Nativity in Nature* is a symphony of color in motion. There is a watery, rippling feel to it, and its most recognizable elements are waterbirds, including a heron and a duck. There is also an owl, a tree, and various plants. *Night Bird*, an earlier work, a tall, narrow tapestry depicting a

standing heron with its long neck stretched up, its slender beak pointing to the sky, its body pressing against the edge, with threads tufting and feathering out into space, foreshadowed the imagery and palette of this mysterious nativity. At the center stands an elongated female figure, the Virgin. But instead of holding her Child, her arms are at her sides, her palms facing the viewer, while the Child hovers, "represented simply as pure light." The building committee members deemed it to be "too abstract, too much in need of interpretation," and rejected it. But the architect, Frederick Dunn, ardently defended Tawney's approach, writing that "the tapestry . . . has all the dignity of a Byzantine mosaic, which dignity owes much to the simplified drafting of the figures . . . The concept to me is most poetic in that the Christ Child is shown only as a blaze of light. In the Bible, John (1:4–9) speaks of Jesus as 'light.'" Dunn prevailed upon the committee to take a second look, and then convinced Tawney, who was not anxious for another rejection, to permit a second viewing. While the committee deliberated, Tawney went shopping at Macy's and bought two hats, one of mink, on sale for $17. Her tapestry still hangs in the chapel.

Anni Albers fled Nazi Germany in 1933 with her husband, the painter Josef Albers, and both Bauhaus instructors joined the faculty at the newly opened Black Mountain College in North Carolina. Though short-lived, this now legendary school also attracted Bauhaus founder Walter Gropius, composer John Cage, choreographer Merce Cunningham, and painters Willem de Kooning, Jacob Lawrence, Franz Kline, and Robert Motherwell, as well as various poets and writers. Anni Albers became a guiding light for the emerging fiber art movement, writing a mission statement in a 1959 exhibition catalog, *Pictorial Weaves*, that reads, in part, "Let threads be articulate . . . and find a form for themselves to no other end than their own orchestration, not to be sat on, walked on, only to be looked at." In her technically exacting, richly philosophical, and immensely influential treatise *On Weaving* (1965), Albers both elucidates traditional craft techniques and celebrates the ways fiber artists are improvising upon them to invent fresh approaches and head in heretofore unexplored directions.

Albers perfectly describes Tawney's approach when she writes that it is

"thoughtfulness and care and sensitivity" that turn craft and design into fine art. Furthermore, she declares, "there are no exclusive materials reserved for art . . . Any material, any working procedure, and any method of production, manual or industrial, can serve an end that may be art." Among the works Albers chose to illustrate in *On Weaving* is *Dark River* (1962), one of Tawney's most majestic sculptures.

Tawney must have been struck by this passage in Albers's book about the subject of an ancient tapestry found in northern Peru in 1946: "One of the earliest pictorial works made of threads is a weaving in which floating warp threads set in a plain-weave field form the design . . . It shows a bird which is thought out in regard to form and structure with superior intelligence. We easily forget the amazing discipline of thinking that man had already achieved four thousand years ago." Albers dedicated her book to "my great teachers, the weavers of ancient Peru." And she writes that Peru has "one of the highest textile cultures we have come to know. Other periods in other parts of the world have achieved highly developed textiles, perhaps even technically more intricate ones, but none has preserved the expressive directness throughout its own history by this specific means."

Tawney found Peruvian gauze weave so compelling that she studied the method with New York weaver Lili Blumenau in 1961 when she was fifty-four, then promptly developed her own approach. She was also inspired by Peruvian feather art, in which feathers are finely woven and stitched to form gleaming headdresses, garments, ornaments, and ritual objects.

After spending eight months at Coenties Slip, Tawney moved to an extraordinary, "soaring" space nearby at 27 South Street, renting three enormous (25' x 80') floors of what used to be a sail maker's loft, crowned by a cathedral ceiling and framing what Mangan describes as "a magnificent view of the East River." In this exhilarating studio, which even had the luxury of hot and cold running water, Mangan writes, "Tawney worked incessantly, creating tapestries of tremendous scale, experimenting, and exploring new ideas."

After initial objections to her open-warp tapestries, these gorgeously transparent weavings, with their floating islands and clouds of lushly blended yarns of varying textures, these harp-string-delicate landscapes and magnetizing celestial images, became highly prized. Yet Tawney once

again declined to settle down. "I wasn't doing them and I couldn't do them anymore, I was on to something else." A hint about the nature of this "something else" is found in a June 1958 journal entry in which Tawney wrote, "The idea of weaving in volume floated up to consciousness this morning." This vision was the seed for a resplendent body of work unlike any ever created before.

Just as Tawney knew when to extract herself from relationships and situations that she felt were holding her back, she recognized that it was time to make a clean break from expressively figurative images and even color, with which she was so rhapsodically adept. She emptied her studio of her avidly assembled collection of colorful, plush, and knobby wool and silk yarns, so carefully spooled and organized on racks and piled in bowls and baskets. As she purged her studio, she ordered linen yarn to rigorous specifications: "Five strands of linen were specially cable-plied and polished satin-smooth . . . This yarn was sufficiently dense and hard that it would not change shape when tightly packed into the weft, and was smooth enough to allow the warp to be closely crammed together in the reed to produce a substantial, horizontally ribbed surface." Tawney's new spare palette held only natural and black, a tonal simplicity that freed her to work even more daringly with shaped weaving.

Tawney coined the phrase "woven forms" to describe her new hanging pieces, which required extraordinary technical skill and ingenuity as well as an unfettered imagination regarding the sculptural potential of thread. Tawney used established techniques, such as slit tapestry and double weft interlock, in fresh, complex ways and surprising combinations. She also invented a type of reed, or comb, that enabled her to control the tapering and curving shape of her weaving by either spreading or narrowing the warp. Tawney inserted rods into her weavings to maintain the shape. She also expertly used a technique called double wefting to create perfect, reinforced selvages, or warp-wrapped edges.

She explains, "Well, then when I began doing them more freely, without a cartoon and leaving things hanging off, it had to become three-dimensional. That's where my sculptural sense came in and then these big woven forms became sculptural, very tall, and then I used the metal to hold some of the forms and one day I just went over there without the

thought, I just touched it and I bent it so it was a rounded form. You know things just happen like that."

Tawney began making works of astounding height. Some evoke the majestic riggings of the grand sailing ships that were once roped to New York's many docks. Others are sleekly modern, veritable skyscrapers with light filtering through the patterned openings like rows of windows catching the sun. Some are subtly anthropomorphic and possess a timeless totemic presence. Constructed thread by thread, these large, intricate woven forms remind us that everything is made up of countless parts and particles held together in perpetual cycles of dark and light, open and closed, attraction and repulsion. In some latticed forms, the strips split into ever-more-slender verticals in configurations that suggest the Fibonacci sequence, in which each subsequent number is the sum of the previous two: 1 divides into 2, 2 into 3, 3 into 5, and so on. This is the pattern that determines how plants grow and how trees branch. Pulled by gravity and stirred by air, Tawney's breathtaking webs, nets, veils, and dreamcatchers project shadows and cast spells.

The sources for Tawney's works are diverse. Some were found in her immediate vicinity; others were discovered on her far-ranging travels. The arabesques of her loosely woven open-warp pieces echo the curves, swoops, and linear filigree of Arabic calligraphy, while her woven forms improvise on elements of Islamic architectural forms—arches, minarets, window

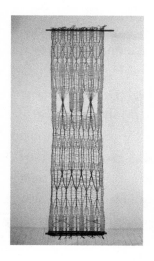

Lenore Tawney. Vespers. *1961. Linen, 82 x 21 inches. Photographer: George Erml.*

grilles, gates, doorways, beaded curtains. Tawney explained that her fiber art works were "constructed as expanding, contracting, aspiring forms . . . sometimes expanding at the edges while contracting in the center. The work takes its form through its own inner necessity."

With no particular ideas in mind, let alone any preliminary sketches, Tawney sat down at her loom and worked. Incessantly. She could only see a small portion of each enormous piece at a time, so she couldn't be sure that it would work in its entirety. "But the curious thing was," she told Munro, "there was some kind of knowledge here in my center, and in my fingers, of proportions and everything else." In a six-month spell, Tawney, with her smart fingers, created a revolutionary new body of work that erased the line between textiles and fine art and introduced a daring and demanding approach to geometric abstraction within a graceful and poetic style of minimalism.

"They just poured out like a fountain or a river. In fact, I did one piece called *Dark River*. And another called *Fountain*. And another *River*. The river was right out my window, and I looked at it every day. During that winter, Agnes Martin and I would talk on the phone, though we hardly ever saw each other. One day she said, 'I'm doing a river.' And I said, 'Oh, I'm doing a river, too!' She was painting a river, and there I was weaving a river. And mine was black."

Some of Tawney's pieces possess a regal aura, which inspired Martin to suggest appropriately royal titles. *The Queen* (1962), nearly thirteen feet in length and thirty inches across, woven in natural linen, is potently female in its strongly curved contours. *The King I* (1962) is a bifurcated hanging, half black, half neutral, its base a symbol of masculinity with its two anchoring "legs."

Some hangings evoke the broad, patterned collar necklaces of ancient Egypt, while the extravagantly knotted and braided warp threads at the top resemble elaborate Egyptian wigs and headdresses. Tawney pays overt tribute to the source of her inspiration in *The Egyptian* (1962); *Pharaoh* (1965–67), which takes the shape of a sarcophagus and incorporates a wooden collar; and *Pyramid* (1966), which contains an Egyptian funeral mask.

Tawney described this creative surge in a jazzy, free-association, Kerouacian riff:

You can't go back when you're in this . . . I mean the point of view of going on to what is happening to one's self. Well, anyway they all changed and it all became this black and white and it became the forms and they went up. They were going to great heights and I thought they'll never be shown because they're too high. I worked about six months, oh, I worked just day and night, it was just flowing like a river. So they were fifteen feet and I went up to twenty-seven feet high. I did one that I finished in a hoist, which was three floors.

In 1961 Tawney had her first major solo exhibition, filling the Staten Island Museum with forty works. Agnes Martin contributed an essay to the catalog, her first published writing: "To see new and original expression in a very old medium, and not just one new form but a complete new form in each piece of work, is wholly unlooked for, and is a wonderful and gratifying experience." Martin went on with rising, almost erotic fervor, "There is penetration. / There is an urgency that sweeps us up, an originality and success that hold us in wonder. / Art treasures indeed, this work is wholly done and we can all be proud."

Beyond Craft: The Art Fabric (1972), a big, ebulliently illustrated volume by curator Mildred Constantine, renowned for championing underappreciated art forms, and textile designer Jack Lenor Larsen, was the next major book, after *On Weaving*, to define and support fiber art, which the authors dubbed "Art Fabric." Looking back to this show, they recognized Tawney as the preeminent pathfinder:

Here for the first time was a major exhibit of American Art Fabrics, with enough work shown to make the cumulative impact one expects in a one-man show. The series of quietly, intimately scaled personal pieces created a thunderous response . . . That event on Staten Island was the point at which Art Fabric was healthfully and joyously launched in America. Tawney's breakthrough, her style and innovation, stimulated a small, then larger and international following of weavers, critics, and an influential coterie of patrons. She opened eyes and imaginations and pocketbooks: from this time, the Art Fabric was considered so seriously as to be acquired by private collectors and public institutions.

They then describe the "personal revolution" that radically altered Tawney's work:

At this time, she was subconsciously aware of the strong, hard forms around her—the winches and paraphernalia of a sail loft, the great iron spikes, the precision of old brass stencils (which she gave to Bob Indiana), the stark reality of river patterns and her own newly structured metaphysical reality. Then too there was her growing collection of works of art by her friends—hard-edge, strong works by Youngerman, Voulkos, Negret, and the abstractions of Agnes Martin . . . A change was brewing. And then she bolted, veering sharply away from the past, forgoing all the heady color and sensuous materials and sensitive drawings she had lived with for ten years.

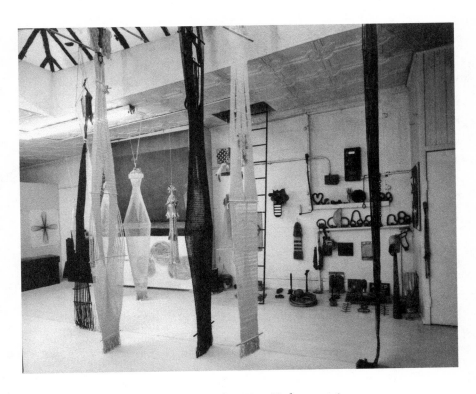

Lenore Tawney's Beekman Street studio, New York, ca. 1965.

Tawney created a number of fiber sculptures that scan as female entities, including the grandly complex *The Queen's Sister* (1962) and the dark and elegant *Black Woven Form (Fountain)* (1966) and *Inside the Earth, A Mountain* (1965). A number of these striking pieces contain boldly sexy vulval openings, some of which are spanned by loose, open weft threads or, more ornamentally, rods and braids, fringe and tassels, manifestations of Tawney's sensuous and earthy side, her pride in being female, and her fascination with the mythical and spiritual Great Mother as the source of life and all creation. She even paid tribute to belly dancers with *Little Egypt* (1964), a lithe and mischievous top-knotted, gauzy hanging with voluptuous, strategically placed fringe. Tawney also created a series of lyrically diaphanous works, evocative nets and veils. *Lekythos* (1963) is named after a Greek pottery vessel with a long neck and narrowing body that was used to store oil. Tawney's webby variation is a fine tracery, a thread-vessel holding light, air, thoughts. *The Whisper* (1962) is a gossamer, extended triangle, a gentle exhalation.

Ethereal Spirit; *Breath of Earth, Spirit River*; *Secret Path*—these are titles of works Tawney created in the early and mid-1960s while she and Martin were close. Art was a spiritual path for both artists, who also shared a devotion to serious books (though later in life Martin happily indulged in Agatha Christie novels). Together they read the writings of Saint John of the Cross and Saint Teresa of Avila, as well as *The Lives of the Saints* by Alban Butler, as they each radically altered their work in pursuit of new forms of clarity and essentiality.

In 1967 Martin left New York to go back to New Mexico, where she lived and painted until her death in 2004. She became and remains much more well known than Tawney. Painting, after all, is still considered the highest of the fine arts. Fiber has always been more of a curiosity than an established art form, a low status compounded by the inconvenient fact that large-scale works can be difficult to display and preserve. Another factor is consistency. While Martin steadily made and exhibited refined series of square, spare grid and stripe paintings, published her essays, and lectured, Tawney, a bit of a will-o'-the-wisp, danced away from fiber art and back

again, while veering in and out of the public eye. She made little effort to establish a career. She did not need to make art to earn her living; she was free to conduct her spiritual and artistic practices however she wished and at her own pace. As she told Cummings, "I just felt I had to go my way quietly."

But nothing could protect Tawney from the vicissitudes of New York City's ravening real estate market. In the most wrenching of far too many dislocations and disruptions, Tawney lost her sail-making loft. Before she was evicted, she made a twenty-seven-foot-high protest piece: "I made it that height because that was the number—27 South Street—and they were putting me out . . . I fought in the courts to stay there but they still put me out. That was before we were allowed to live in lofts." Forced to move from one studio after another in a bewilderingly short period, Tawney fled the chaos to travel for a spell in Bolivia and Peru.

Independent, resourceful, private, and resilient, Tawney was also a person of torrential emotions. In the midst of her phenomenally creative and productive Coenties Slip and South Street months, when she was creating the sculptures that hit with a meteoric flare and impact in her first solo show, she was secretly suffering. In an unpublished manuscript, "The Eyes of Death," dated 1987, she wrote,

> In 1959, 60, 61, I was in deep depression. I wandered through the city, stopping in churches just to sit, try to feel some comfort, I would sit at the Cloisters. I remember one very rainy day, sitting under the portico of a courtyard, watching the water as it met the ground, an unending, hypnotizing experience. Often went on the Staten Island Ferry, standing at the bow, watching the water being ploughed aside, watching drops rising and falling away.
>
> Sometime later, I went symbolically down, down, down into the earth. I stayed there a long time, months, years, I died there, became a seed, slowly, slowly. I became a new shoot, I rose slowly, slowly. New tendrils came out tender, new-born, that was in 1964. I began the boxes, collages, drawings. They were completely new. I became happy, for a time.

What caused her despair? A broken heart? Emotional and psychic exhaustion precipitated by the demands of such fervid creativity and

perpetual hard work? Was her crisis catalyzed by the loss of her dream studio? Whatever the source of her anguish, it propelled her on a new artistic path that she would follow for the rest of her creative life: she began to work with paper and found objects, both natural (stones and bones, feathers and eggs) and human-made, to construct witty, poetic, and evocative assemblages, most in wooden boxes, and collages, hundreds pasted on postcards.

Tawney describes the objects she uses and how she gathers them:

And then these little things I put in which I collect on the beaches in the summer. I use stones that are so small you can hardly see them to pick them up on the beach. Of course you can see them when I put them in a circle. Well, when I'm picking up stones on the beach, you know I'm down on my hands and knees and you can't imagine how many people come over and they look and they can't see and they say, "What is it?" They think I'm picking up something valuable and finding very marvelous things, which I am, but . . . And sometimes little children will help me when I'm picking up feathers and a whole crowd of kids . . . they look like delinquent kids, you know, they pick up feathers and they bring me all these. I really want to pick my own, you know but I take everything people give me because it's very nice.

In *On Weaving*, in a chapter titled "Tactile Sensibility," Anni Albers encourages readers to reawaken their sense of touch, their "tactile perception" of the texture of materials, the "qualities of appearance that can be observed by touch." She explains, "We will look around us and pick up this bit of moss, this piece of bark or paper, these stems of flowers, or these shavings of wood or metal. We will group them, cut them, curl them, mix them, finally perhaps paste them, to fix a certain order. We will make a smooth piece of paper appear fibrous by scratching its surface, perforating it, tearing it, twisting it; or we will try to achieve the appearance of fluffy wool by using feathery seeds. What we are doing can be as absorbing as painting."

This tactile approach is central to all of Tawney's art-making, as is her love of books. Her constant reading and writing stoked her spiritual and

creative energies and words and handwriting itself became intrinsic to her art. Her bookcases held many religious and mystical texts and poetry collections as well as books about birds, art, and anthropology, and titles by Carl Jung, Robert Graves, James Schuyler, John Cage, and Annie Truitt, along with Simon Ortiz's *Woven Stone*, *The Metamorphosis of the Circle* by Georges Poulet, *The Elegant Universe* by physicist Brian Greene, and Deborah Solomon's biography of Joseph Cornell. Books were essential to Tawney for their intellectual and spiritual illumination and inspiration, while the very acts of reading and writing are much like weaving as lines of words run back and forth across the page to gradually build a narrative, poem, or text. How entrancing the line-by-lineness of books is; how fitting it is that we weave a story or spin a yarn. Tawney lived within a grand and intricate web of language, and she loved the look of written and printed letters and words and the texture of paper. She filled notebooks, journals, and diaries, many pocket-size, all well-used, with musings, notes on her wide-ranging and demanding reading, and quotes she copied from the *I Ching* and the Upanishads, the poetry of Arthur Rimbaud and Rainer Maria Rilke, and books on Indian tantric philosophy, neuroscience, mandalas, the mystical power of numbers, Jupiter, and Taoism. Tawney found wisdom, beauty, and inspiration in religion, science, and poetry.

From the artist's notebooks:

5 AM 5/19/57 NYC
the over-flowing heart
sky landscape stream
Sky streaks
iced waves
depths of the sea

fine filaments like spider web spinnerel
picture hanging in ctr as in space
add fine silver thread here & there glint of rain
 spark of early morning
explosion of crystals inner & outer

sharp cries of birds
cooing soft of doves

the overflowing heart
June 6 flying over Colo
simplicity of conception & execution
the beautiful flowing line with much space around—Japanese drawings
cut shapes arrange & tear
seven fir trees all twisted some denuded branches
strips of dark & other strips built up in blocks shaded
thru all—birds
stalactites & stalagmites
octagonels of dif. size & colors—obscure design or owl or —
listening to the soft wind breathing
thru the grass
with a few touches indicate the spirit
of a face so that it needs no body
by speaking of the moor make the
wind blow & the thunder roar
Sacred Island of Miyajima, Japan
District of Darjeeling, gateway to Tibet & Himalayas
Athens to . . .

11/23/66 Midnight
What is there original in my mind. I feel fire & Flame, water & springing
of waters. Love & concupiscence.

Dec. 7, 1971 6 PM Zendo NY
What is my true nature?
I am the wind along the grass
I am the stream
I am the white clouds floating
across the blue sky
I am the ocean's roar
I am the cry of a bird

I am a waterfall
I am a tear
I am a river on its way
to the sea.

9.16.89
Contemplate the Truth.
Look at nature, the sages say.
A restless mind, look at the sky
When your heart is disturbed
look at water, flowing water.
When you don't know what to do,
contemplate the luminosity of Fire.
When you feel great & don't know
what to do., contemplate the wind.

2/12/89
"Nourish oneself & take care of others."
"No tree, it is said, can grow to heaven unless its roots reach down to
hell."
"All things are numbers." Pythagoras
"Time is nothing more than the measure of movement." Plotinus
"For it is secretly in the hidden depths of the spirit, that the soul of man
is joined to the word of God, so that they are two in one flesh." St.
Augustine
"Works of art are always the result of having been in danger." Rilke

Tawney was not only a passionate reader but also cherished books as
beautiful, infused, and generative objects, and used them in her art. As she
confesses to the consternation of her interlocutor, "I have a terrific collec-
tion of rare books. I'm sorry to say I tear pages out of them," explaining, "so
I bought an old, very beautiful old book, Italian, with beautiful paper, a rare
book, so I used those pages and made my drawings on these. That was the
beginning of my collages. They just began in this kind of way. Then I began
to cover boxes with this paper and put things in the boxes. And that's how

everything started and I worked a couple of years just doing these. I had hundreds of them."

Tawney drew and painted on these exquisite pages. She tore them into strips and made paper weavings and tiny scrolls. She sawed entire books into smaller rectangles and sliced windows into the pages to create marvelously layered cutouts that, as the pages are turned, present secret visual narratives; intimate, witty, and provocative hidden labyrinths. These are clever and wily variations on the old trick of using hollowed-out books to conceal money or flasks or other contraband and treasures. Who would see these hidden pieces? When? How? What Zen creations these are, made in the moment for the pleasure and challenge of the act itself, with no need for the reactions of others.

For Tawney, dismantling and cutting into old books was not desecration but rather revitalization. How carefully, tenderly, patiently, precisely she excised, reused, and transformed old books—volumes that had endured years of standing on shelves in dim places, tightly packed and forgotten, muffled and cloaked with a steady dust-fall until they were reclaimed, opened, and admired. Of Tawney's preference for using books in languages she could not read in her collages, art critic Judith E. Stein writes, "Perhaps perversely for a former proofreader, she reveled in not consciously knowing what was signified." Tawney told Stein that "an unconscious hand seemed to guide her choices—when foreign words on various collages were subsequently translated for her, 'they would mean just what I intended.'"

Curator Erika Billeter wrote that all the objects Tawney collected that "crowd her drawers, closets, her entire living space—have but one purpose: to be transformed into art. At some point, Lenore will pick up an object—after having stored it subconsciously in her mind for a long time—and start to work with it." Tawney explained, "I pick up what's near me. My desk is usually a terrible mess, with layer upon layer. When I'm working and I need something, my hand just goes to that place wherever it is—under whatever it is. That's why in my studio I have a *lot* of things around: yarn, bones, feathers, egg shells, stones, even the mail and magazines that come in, I use everything."

Tawney was small and deftly handled minuscule objects—tiny corks, delicate feathers, fine thread, little needles, narrow strips of fragile paper.

She also drew preternaturally precise lines in ink to form patterns so fine they seem beyond the capability of human touch. Tawney's tiny, graceful, threadlike script forms spirals, waves, knots, blocks, and circles. This flowing cursive is often too small to read, deliberately so: another form of hidden meaning, as in her book cutouts and her use of pages from books in languages she couldn't read. Her microscript formed "visual poetry."

Tawney's small, refined collages are lyrical and quietly bewitching. In *Chalcid* and *Round and Square*, both from 1966, she pasted carefully torn, sepia-tinged strips of printed paper, the text upside-down, to create a woven effect; then, in closely spaced lines drawn with black ink, she created a mandala. In a miniature paper echo of her long, flowing woven forms in tribute to rivers, Tawney created a collage series, as she said, "on that theme—all watery." In these seven pieces, including *Rivers in the Sea* (1968) and *Rebirth in the Western Sea* (1968), she drew on illustrated pages taken from books in Persian and Japanese. "All this had to do with water, too, these lines . . . I did a series from a quotation I read like 'from his footsteps flowed a river,' . . . all flowing lines like water. And they're also like threads, the lines, they're very like threads."

In other collages, such as *St. Francis* (1967) and *Distilla* (1967), she weaves together slender strips of paper with a lace maker's skill. Tawney painted some of her collages with watercolors, most often using blue. Sid Sachs writes, "Blue was Tawney's touchstone and signature; she used a celestial blue ink or paint so often as to become a hallmark. This hue was the blue of mystics and memories, the mark of the infinite sea."

Tawney used the pages of old books to cover small boxes she repurposed or constructed from scratch. She filled these secretive little vaults with found materials, creating works similar in approach to those made by the seminal box artist Joseph Cornell, who also loved birds and celestial themes.

A visit to a homeopath's office inspired *Médecins Anciens* (1966). Tawney recalled, "I saw all these little bottles and they had little corks. I just lost my head again. I thought they were so wonderful." A lidded box is covered in paper torn from old books. Little glass vials filled with golden pigment or sand stand up in close ranks from the base to the top rim of the bottom of the box, each stoppered with a tiny cork embellished with an

inked inscription. Another set of small glass vials projects down from the half-open lid, each filled with the same materials and sealed with a tiny cork. The vying rows of vials are like teeth that cannot meet, or micro stalactites and stalagmites. It's an astonishing piece of contained power, of symmetry and tension, enclosure and exposure.

Other boxes contain bones, eggshells, feathers, a pair of pale blue gloves, a nautilus shell, a tiny sarcophagus with the collaged image of an Egyptian cat mummy. Poet and art critic James Schuyler wrote, after visiting Tawney's studio in 1967,

> The work invites questions. One box contains feathers of some unflashy bird—wing feathers of a city pigeon, probably—put in on edge, as though filed. A similar one contains worn pages. Are the feathers shed, or on file for future reference and use? Which is finer: the feathers, the imprinted paper, the rough boxes, or the placing of them in conjunction? Or is each element a fact which, together, makes a new, nameless, delighting thing that shows each freshly—the soft resistance of paper, the blade-like hardness of the edge of the feathers? Certainly, to use a thing for a purpose beyond its intent gives it excess value, and excess is what art is made of.

Collage Chest, displayed in her studio, is a tall wooden cabinet with many small drawers, like the sort used for nails in old hardware stores or an old library card catalog. When eased open, each long, narrow drawer, its interior painted white or blue, reveals a small sculpture or micro installation made of thoughtfully arranged stones, scrolls, bones, a skull, a bowl, feathers, and "mended" eggs (empty, broken eggshells meticulously reassembled), some in nests of paper. Other drawers are spanned by thread webs. It is a cabinet of contemplative wonders, mysteries, and mischief.

Tawney's live-in studios were not only places to make art but also works of occupied art, and therefore every item had to be aesthetically pleasing. Tawney's acute need for beauty and harmony induced her to camouflage consumer items—her Band-Aid box, her jar of Vick's Vapo-Rub—with paper torn from old books. She simply could not abide the

jarring crassness of commercial products in her sacred place. It was also an impishly funny acknowledgment of her artistic obsession.

Tawney had a thing for wooden shoe forms, wonderfully evocative shapes that summon thoughts of balance and motion, of standing firm or making pilgrimages. Feet are fundamental to yoga and acupuncture. For Tawney, these forms were emblematic of her travels around the world as well as her step-by-step inner quest, her delight in dancing, and her overall surefootedness. She wrapped her foot sculptures in the pages of old books, creating walking stories, walking poems, walking prayers. *Persian Poet* (1984–86) is covered in calligraphic splendor. In a late piece, *Book of Foot* (1996), a foot form stands, sole out, in a narrow open box, the heel rested on a curving stack of pages, while a small open book affixed to the ball of the foot looks like a butterfly. *Celestial Messenger* (1978) is embellished with an animal jawbone affixed like wings; Tawney's feet can take flight.

Fond of hats, Tawney collected wooden hat blocks, lining them up on shelves and embellishing them with paper, cloth, nails, thread, and other materials to create clever improvisations on headdresses, wigs, caps, and other forms of adornment found in various world cultures. A hint of the sources of inspiration for these timeless, multicultural cranial sculptures is found in a photograph of a smiling Tawney looking thrilled and a bit nervous as she holds an African carved bust with a tasseled headdress on her shoulder like a second head.

As playful, poetic, enigmatic, even surreal as she could be in her collages, boxes, and head and foot sculptures, the format that truly liberated Tawney was the humble postcard. She explained, "actually the postcards came from wishing to communicate with friends but not knowing what to say. You know—you don't want to say anything but you want to be a friend. So I began making these postcards with messages that looked like writing but were just signs. There *was* a message but it was an invisible, unreadable message. People liked those cards . . . They are all over the world. I don't know who has them. They are like messages thrown to the winds."

These small traveling collages were compact vehicles for Tawney's satiric humor and succinct takes on serious matters pertaining to childhood, gender expectations, sexuality, the state of nature, politics, crime,

and spirituality. She had a sharp and discerning eye for printed images and type, and a keen sense of contrast, even dissonance. Made with specific recipients in mind, these inventive, subversive, alluring postcards, numbering in the hundreds, were completed artistically by the U.S. Postal Service. The stamps Tawney chose and affixed, along with postmarks and other signs of processing, were integral to the look and energy of these small art missives, these little miracles. How did these unusual, provocative, downright startling collages, some with tiny objects attached to them—feathers, thread, cloth, even the fragile carapace of a tiny hermit crab—make their safe journeys, unmolested, to their intended recipients? Clearly, they were handled with special care.

In *Lenore Tawney: Signs on the Wind*, a sumptuous book devoted to her extraordinary postcards, Pulitzer Prize–winning *New York Times* art critic Holland Cotter writes, "In Tawney's wide-ranging and welcoming work, paper encompassed photographs, newspaper clips, magazine ads, cosmological charts, tantric symbols, popular devotional pictures, musical scores, illustrations from art history books, and nature guides, antique manuscript pages in languages from French to Sanskrit to Chinese; letters from friends, postcards received and recycled, as well as drawings and notes written in her own hand."

As in her collages, Tawney's microscript was a form of drawing and a paradoxical form of commentary as she made words incomprehensible as though to mock our attempts to define or elucidate the inexplicable. "Words and letters can be compacted to a dense knot or draw out to great length," she mused. Just like thread.

Writing, individual letters and words, and the interface between image and text shaped the work of many of the Coenties Slip artists and their contemporaries, including Robert Indiana, Jasper Johns, Agnes Martin, Robert Rauschenberg, and Cy Twombly. Tawney's collages were very much part of this fertile line of artistic inquiry.

The artist herself appears on some of her postcard collages. She makes amusing use of one black-and-white photograph that captures her either in a studio or at an exhibit of her work. She is smiling, with her hair drawn up, and wearing a silken wing-sleeved tunic and a thick white necklace. She is captured mid-dance step, with one arm raised high, the other slanting low.

The pose has an Asian look. Beside it she has fixed a second copy of the same image, as though she and a twin are performing together—except that in the second iteration, her head has been replaced by a reproduction of a painting of a long-necked woman with her hair twisted up, posed before a red background. Three strips of printed paper are affixed to the card. Two contain typos: "'Yeah,' he said. 'A girl on the fifth floor has been molested'" and "The coldest Carlin-Sternhagen offspring is now 17, the youngest 7, and several have snowed some inkling of theatrical aspiration.— *Kalamazoo Gazette.*"

Surely Tawney was smiling as she added this floating line—"It's a wintry outlook at best"—in her own hand?

(Acclaimed actor of stage and screen Frances Sternhagen married actor and drama teacher Tom Carlin, and they had six children, several of whom did become performers.)

The third excerpt, pasted upside down, reads "A lady lifted the lid of her toilet tank and found a small yachtsman, on the deck of his boat, in the tank."

On another postcard, Tawney has pasted her own face onto a reproduction of an expressive Italian mosaic of Saint Agatha, the virgin martyr, who is depicted with greatly elongated fingers. An artist's hands?

In a postcard to a close friend, the ceramic artist Toshiko Takaezu, Tawney places her face on the body of an owl in an illustration captioned "New Zealand laughing owl or whekau." The message gives metaphysical resonance to the owl's laughter: "death is taking place constantly / birth is taking place constantly." On another card to Takaezu, Tawney wrote, "the worm turns / the earth turns / they push wide / particles too/ large to ingest." On a card sent to Katharine Kuh, Tawney painted a blue wash along one edge. Beside it is a cutout from an old drawing of a very muscular pair of men's legs, running. The top half of their owner's body is obliterated by a brown patch, and on his raised back foot balances a large oval stone or egg. Tawney wrote, "meteors were chips off the heavens / 'thunder stones.'" On another postcard she listed, in her itty-bitty script, the names of the "20 most brilliant stars" beside a yellowed newspaper photograph of a young girl in a white veil and white dress. The caption hovering off to the side reads "First Communion." A bird collage carries this lyrical message: "take your

wing & your flower & fly to that place of waterfalls, clouds, crystals, blue flowers, grass, tears, bells, violins, drums stars moon."

The more you look at these small works, the more you see. Tawney's postcard compositions are gems of canny discoveries, disarming juxtapositions, divining wit, abiding affection, and cosmic grace. In these deft collages, Tawney summoned the monumental from the infinitesimal.

Nineteen sixty-four, the year of Tawney's slow rise from the underground and rebirth at age fifty-seven, also brought into closer proximity her dear friend Toshiko Takaezu, whom she met seven years earlier at the ground-breaking craft council conference in California.

The sixth of eleven children, Takaezu was born in 1922 in Pepeeko, on the big island of Hawaii, to Japanese immigrants. She first became interested in making ceramics in 1940 when she moved to Honolulu after graduating from high school. While living with her older sisters, Takaezu worked for the Gantt family, owners of a commercial pottery company, the Hawaii Potter's Guild. There she met New York sculptor Carl Massa, who was serving with the Special Services Division of the U.S. Army. Massa became a mentor, encouraging and instructing her and recommending books, including *Lust for Life*, Irving Stone's novel about Van Gogh. Massa's influence gave her the confidence to enroll at the Honolulu Art School, then at the University of Hawaii, where she became technically proficient in ceramic techniques and studied weaving. Takaezu also began teaching, which would become an essential part of her life.

In pursuit of further instruction, Takaezu left Hawaii for the first time in 1951 to attend the Cranbrook Academy of Art in Michigan. In spite of feeling overwhelmed and discouraged, Takaezu excelled, working closely with Finnish pottery master Maija Grotell. She studied weaving with Marianne Strengell and, writes Paul J. Smith, director emeritus of the American Craft Museum (now the Museum of Arts and Design), "became interested in the creative potential of fiber. Responding to the texture of yarn and the rich color possibilities, she approached weaving as a different way of thinking and developing ideas."

Fiber artist Jack Lenor Larsen attended Cranbrook at the same time as

Takaezu, and they became good friends. Larsen observed of her teaching methods, "She did not suffer fools, nor did she try to be popular or high falutin. She tempered seriousness with a sly wit and a winning smile." Of her relationship with Tawney, Larson writes, "Toshiko's friendship with the weaver Lenore Tawney was a major influence on both their lives. At one point they shared a studio at Toshiko's home in New Jersey and often traveled together. Lenore was introspective and had a deep awareness of her own and Toshiko's art. They supported each other, which helped Toshiko gain a better understanding of herself." Photographs of Tawney's studios document the constant presence of her friend's beloved ceramic sculptures.

Both women were extremely disciplined, energetic, sensitive, and devoted to art. Both were reticent, though in different ways, as Janet Koplos, former staff editor for *Art in America*, elucidates: "Toshiko Takaezu is seen as a rather private person, although she has not cultivated a deep air of mystery like that of her close friend, the textile sculptor Lenore Tawney, and Tawney's close friend, the painter Agnes Martin." Both artists also transformed and elevated their crafts.

What Tawney did with fiber, Takaezu did with clay, improvising on traditional techniques and forms to striking effect. While Tawney created "woven forms," Takaezu made her signature "closed forms," organically round and domed cylindrical vessels with inaccessible interiors. Beautifully globular, fruit-, egg-, and seedlike shapes pierced at the top with mere pinholes, they are elegantly and expressively glazed with either subtle earth tones or painterly swathes, whirls, and dashes of bright color reflecting the brilliance of the verdant land, flowers, and sea of Hawaii. Observing that Takaezu's ceramics have a "ceremonial quality" and a "meditative presence," Smith writes, "The poetry of the outside evokes the mystery of the inside, an aspect of these works that the artist considers vital. Their dark interiors remain a secret space." Into these eloquently formed vaults Takaezu would drop small pieces of clay wrapped in paper, a ritual she called "sending messages." During firing, the paper burned away, and the small, now hard clay bead within turned the closed form into a sort of rattle, adding sound to its power. Takaezu's burned "messages" are a personal variation on the ancient Asian practice of burning joss paper at temples and shrines to honor

and protect the dead. They also play an intriguing counterpoint to Tawney's unreadable microscript.

Takaezu's interest in sound inspired her to make bronze bells similar to those used in spiritual ceremonies. Her family was Buddhist, and as an artist she visited religious sites in Japan, staying for a while at a Zen Buddhist temple, experiences that helped shape her personal philosophy, contemplative life, and nature-inspired art. Critic John Perreault observed that "some see her as a kind of priestess of clay, a nun of earth and fire, a female monk."

Takaezu claimed no specific spiritual orientation, but rather a deep and constant receptivity to a force she could not name: "What I don't know is what pushes me to work. It's intangible. Something that I didn't know came through this pot. It's not my power that made me do this. The power is somewhere else. So now I can say without boasting, 'My pot is beautiful,' because I am not responsible." She also said, "An artist is a poet in his or her own medium. When an artist produces a good piece, that work has mystery, an unsaid quality. It contains a spirit and is alive. There is also a nebulous feeling in the piece that cannot be pinpointed in words. That to me is a good work!"

Weaving provides a completely different tactile experience than clay, a contrast Takaezu must have found restorative. She created woven hammocks in which she suspended large, ceramic spheres. She wove rugs and plain-weave wall hangings that mesh organic forms with abstractions in the sumptuous colors she used in her glazes. *Magic Circle #1* (1974) is a tapestry in a Tawney mode, its grassy base merging into a black sky and the white outline of a circle. A photograph captures the two weavers in Guatemala, seated side by side on a tiled floor in what looks like a courtyard outside a simple building, each working on a backstrap loom, an ancient device. They even had a joint exhibition in 1979 at the Cleveland Institute of Art, *Form and Fiber: Works by Toshiko Takaezu and Lenore Tawney*.

The two friends, art sisters, reveled in the experience of creation, in the mysterious forces that ignited their thoughts and ideas and that propelled them through the demanding physicality involved in working with fiber, clay, paper, paint, and found objects, with light, friction, gravity, and space. Tawney was as poised and balanced as a dancer; Takaezu

developed a distinctive choreography for building her forms and applying glaze, and often said that working with clay is a form of dancing.

The year 1964 was a decisive one for both artists. Takaezu received a Tiffany Foundation Grant, and set up a home and studio in New Jersey. Tawney attended the First World Congress of Craftsmen in New York, and went with a group to a New Jersey factory to see a Jacquard loom in action.

Mechanized looms were already in use in the early 1800s when French silk weaver Joseph Marie Jacquard invented his system for creating such complexly patterned fabrics as brocade and damask via a "deck" or loop of cardboard punched cards that controlled the warp's configurations. So effective was this technology that pioneering computing innovators Charles Babbage and Ada Lovelace, considered to be the first computer programmers, used punched cards for their Analytic Engine, the first computer prototype.

The reaction of nature lover Tawney, who was dedicated to painstaking handwork, to the mechanized Jacquard loom was in keeping with her Bauhaus training: "Hundreds of warp threads trembling, in constant motion. It was absolutely enthralling, thrilling. It was music—the unstruck sound. The unheard music of the universe, yet heard and felt in some secret part of me. My spirit heard this music and I never forgot it." So entranced was she—and so relieved, one suspects, to find something new and wholly outside of herself to concentrate on in the wake of her depression—that she enrolled at Cooper Union in New York to closely study Jacquard patterns, then spent a year at the Philadelphia Textile Institute, learning how to make a loom harness.

The most obvious and immediate impact the Jacquard loom had on Tawney's work was not in woven forms but rather in a series of magnificently exacting ink drawings on graph paper that explore the phenomenal density of the Jacquard loom tie-up. As she said, "I did some of these drawings that look so much like threads that people think they are threads . . . But I didn't do them with that in mind . . . I'd spend the whole day doing one of these drawings. Sometimes it would take more than a day, but you could go on, very fine . . . I didn't do as much weaving. I did some, but it did slow my weaving down quite a lot and then for a while I

Lenore Tawney. From Its Center. *1964.*
India ink on graph paper, 11 x 8½ inches.
Photographer: George Erml.

wasn't weaving at all." But when Cummings asked, "Do you see any relationship between the two?" Tawney replied, "Yes, I think their whole thing is all one thing."

As Sigrid Wortmann Weltge succinctly writes, "The transmutation of line is Tawney's alchemy."

These abstract drawings, optical wonders, are alive with a diagrammatic energy and dazzling motion. Made of fastidiously ruled lines, they twist, curve, bend, radiate, and overlap, shimmering with moiré patterns and trigonometric glory. Works such as *Blue Fountain* and *Wings of the Wind* appear in reproductions to be computer-generated, so finely executed are they. But Tawney's hands were precision instruments, her vision laser-sharp, her penchant for detail and pattern uncanny. And yet, as mathematically predetermined as they look, this is how Tawney described her drawing process: "I start with the top and bottom angled lines. These are simply arbitrary lines. You begin to draw on the far left bottom and go diagonally up to the right on top, gradually coming toward the center to the other side. Every line is made with my mind being right with the line. The part in the center—it's like a funnel. You never know exactly how it will come out."

As always with Tawney's work, her influences are many. As her journals attest, at the time of this intense drawing immersion, she was reading Jakob Boehme, a seventeenth-century German mystic. Tawney wrote,

"All life is fire. For Boehme existence is a stream of fire. The fire is will." Boehme's writings are the source of the titles for some her cosmic drawings—*Ethereal Form, The Great Breath, Region of Fire, Union of Water and Fire*—and her use of black, red, and blue ink. Tawney noted, "For Boehme, a high deep blue means 'Liberty,' the inner 'Kingdom of Glory' of the reborn soul. Red leads to the region of fire and the 'abyss of darkness.'"

In the mesmerizing *Union of Water and Fire II*, Tawney created a hexagram comprised of two overlapping, opposing triangles. The downward-facing shape is blue, symbolic of femininity and water; the upward-pointing triangle is red, symbolizing masculinity and fire. This vibrantly layered trigonometric composition inspired her, in a dazzling feat, to weave two similarly intermeshed triangles.

In *The Art Fabric: Mainstream* (1986), Mildred Constantine and Jack Lenor Larsen continue the defining work they began in *Beyond Craft*, and celebrate Tawney's new work as a wave of younger fiber artists surges onto the field she opened. Noting that she made her Jacquard-launched drawings before the arrival of "the systemic expressions of such minimalists as Sol Lewitt," they write, "Tawney has always sought the essential *order* or *system* that is the wellspring of creativity and the confluence of art and metaphysics."

Tawney's Jacquard-based drawings gave rise to her remarkable threaded boxes, in which her taut lines take on three dimensions. The title of one early example, *Even Thread Had a Speech* (1966), expresses how alive thread was to her. Diminutive in size—5 by 5¼ by 2¼ inches—it is a simple, open, delicately papered wooden box through which a thick web of overlapping threads has been strung, creating a twisting vortex at the center as the threads spring out vigorously from each corner. The gift of a Plexiglas box inspired Tawney to create her stunning and sleek 1990s series *Drawings in Air*. Tawney used the clear boxes as frames within which she tightly wove multiple layers of threads to create her vibrating, vortical forms. With this innovation, her torqued line configurations occupy space and allow light to filter through them. Smartly displayed atop tall, square Plexiglas columns so that they appear to float, these vital, tensile sculptures seem to map the schemata of the universe.

The Crossing is a dramatic "drawing in air" strung in a large—eight by four by two feet—wooden frame. Tawney, looking every bit the holy sage in her silver-and-gold-patterned silk robe and white skullcap, was photographed in 1998, at the start of her ninth decade, standing behind this towering linear vortex, her strong-featured head held high, her gaze fixed on the distance (or, given her dimming eyesight, deep within), her arms extended as her hands grasp two of the vertical beams of the frame, the threads fanning tautly yet fluidly, generating moiré waves in a towering black-thread fountain, a black eternal flame.

Tawney had friends on Cape Cod, including her psychoanalyst, and so in the summer of 1966 she went to Truro for a visit. There her real estate escapades took a new turn as she looked for a place to stay. After renting a car, she went to a motel to rent a room, but realized that she was out of cash. When she asked if she could pay by check, she was told "No." An article about the new craft revival had just come out in the June 20 issue of *Life* magazine, and Tawney was prominently featured. "Well, if my picture is in *Life* magazine," she asked, "will you take my check?" This time the answer was "Yes." As Tawney told Cummings, "So she took it! I thought, well, it's worth something."

This was a financially tough time for Tawney. She sold her Chicago property and somehow lost all the money. Yet she couldn't resist the lure of Cape Cod's beach: "So I bought this little house, three and a half acres, surrounded by a National Park. It's a 1790 house and it had the wooden sink and no heat, no hot water, nothing. But it was adorable." Naturally it required a great deal of work and expense to bring it up to her pristine standards. She had it renovated and painted all in white.

In the early 1970s Tawney's passion for real estate inspired her to acquire, with a friend, the Samuel Tredwell Skidmore House, which had just been given landmark status. This Greek Revival townhouse was built in 1845 by dry-goods merchant Tredwell at 37 East Fourth Street on the Bowery, which was then a wealthy neighborhood. Tawney didn't stay long, and hoped to interest John Lennon and Yoko Ono in taking up residence there, but she and the couple never managed to meet. The building, which

had been divided into apartments, was later neglected by a longtime owner, and fell into ruin until it was renovated with much fanfare in 2010.

Tawney profoundly admired Native American art, as did Agnes Martin, and owned some fine Pueblo pottery bowls. Some of her tight, natural linen weaves resemble Indian baskets, and her adept use of braids, knots, fringe, shells, beads, and feathers evince a strong Native American influence. As the 1960s and her fifth decade unspooled, Tawney paid tribute to Native American art in a series of small (20 inches or less), densely woven "shields," striking works in radiant autumnal gold and mulberry.

In her journal, Tawney wrote, "In the world of the Indian the secular was sacred; even commonplace artistic practices, as decoration of utilitarian ware, repr.[esented] a celebration of man's unity w. nature. The designs & motifs of Indian art imply the spiritual import of earth & sky, sun & rain, flora & fauna. The use of fur & hide, feathers & quills, teeth & talons, rocks & clay, & body ptg. gives the message that the divine force imbues all natural forms." Elsewhere she wrote, "I made some very small shields with thousands of threads and thousands of feathers, one on the end of each thread—very tiny feathers, some of them. It seems shields are for protection—I didn't know what I was protecting myself from."

Some of Tawney's intricate, expressive shields are turned on their sides so that their long, cascading and draping warp threads form massed, knotted fringes. On one, owned by the Art Institute of Chicago, whelk egg cases have been carefully pierced and threaded into the long, braided and knotted fringe; at the opposite side, Tawney tied the golden linen warp threads to strands of white horsehair to create a fine froth that emanates in airy contrast to the flat, round, oval, stone-gray whelk cases. Woven into the belly of the shield are tiny dark sparrow feathers. Another shield in the Chicago collection is shaped like a cross, yet with its braided and domed topknot and window-like slits it looks like a temple or mosque, and generates a remarkably animated and joyous aura. Its bottom fringe, gathered in finely braided and wrapped tassels, is festooned with cardinal feathers.

The Art Institute acquired these two superb pieces, along with a small collage titled *Form Infolded*, in a dramatic rescue effort thirty years after

their creation. When they were shipped back to the States after appearing in an exhibition in Amsterdam, customs officials opened and examined the crate and became concerned about the origins of the feathers. Tawney's artwork ended up with the U.S. Fish and Wildlife Department. The feathers were identified as belonging to endangered species, and officials informed the artist that they were impounding the works. Even after Fish and Wildlife had been assured that the weavings and collage were made thirty years earlier and that the now-ninety-year-old artist had found the feathers in the woods, the officials would only release the art to an educational institution—no profit could be exacted from any use of imperiled species. Curators at the Art Institute of Chicago rushed through an emergency acquisition request and secured Tawney's exquisite artworks.

Tawney's admiration for Native American art may have sensitized her to the Native American struggle for equal rights, and her shields may have been spurred by the coalescence of the American Indian Movement in the late 1960s. Certainly political concerns, especially the Watergate scandal, jump-started her *Flag* series. Given the spiritual nature of most of her forms—her circles-in-a-square, her crosses, her symbolic rivers—her variations on the American flag, at first glance, are jarringly secular, almost folksy in their Americana vibe. The flag is a subject more in keeping with the iconography of Pop artists, and, indeed, Tawney's Coenties Slip neighbor Jasper Johns boldly painted an American flag as early as the mid-1950s. But why wouldn't Tawney be drawn to the flag? Flags are ancient heraldic objects, they're a form of textile art and craft, and Tawney was busy appropriating all kinds of existing imagery in her collages and boxes. As sequestered from the hurly-burly of public life as she seemed, she was no hermit. She was in no way out of touch. At age sixty-seven, Tawney felt compelled, along with so many other artists and writers, to protest the corruption and criminality of the U. S. government.

Tawney wove the large flag, *Untitled* (1974), in natural and red linen. To create the blue rectangle and its white stars, she used a new combination of materials, bringing together her love of both fiber and paper. She painted patches of book pages with her favorite transparent blue and covered the paper with Liquitex, an acrylic gel medium. Her stars are small, round white buttons. On the left edge, a red rod extends beyond the top

and bottom of the weaving, and the knotted warp threads create a lively, tousled fringe. On the right edge, the warp threads hang long and lush, a graceful sign of rebellion. Tawney also made "reversed" protest flags. In one small piece, the blue is denim.

Tawney spoke about one of her new flags at the Cleveland Art Museum: "For years, I had thought of flags and banners. So I finally did it . . . I felt our flag was being shamed, hence it is 'untitled.' It goes back to beginnings. Instead of Betsy Ross's petticoat, a friend gave me her bluejeans, and the bluejean buttons are the stars, dark and not proud. But still the sentiments of that early time are there, the 'true-blue,' the good and strong linen."

Adulterated Flag (1975) is constructed of horizontal strips of paper, a line of red watercolor painted down the center of each. The blue field is a torn piece of paper painted deep, dark blue; the stars are white dots. This slatted flag overlays a complexly layered mashup of different lines of printed type, some upside-down, some legible and quite stinging. At the top we read: "of the Decline and Fall," a phrase that is repeated along the right edge. Between the flag's stripes we find "some ruins are still visible" and "was received and dismissed."

Tawney was prodigious. While she was weaving shields and flags, she was also weaving majestic, tightly woven, opaque hangings infused with gravitas. One set of works in this august and spiritual series offered variations on the theme of the Path. In a journal Tawney wrote, "The Tao, a Path, the Way, the Absolute, the Law, Nature, Supreme Reason. Lao-tse says: 'There is a thing which is all-containing, which was born before the existence of Heaven & Earth. How silent! How solitary! It stands alone & changes not. It revolves without danger to itself & it is the mother of the universe. I do not know its name & so call it the Path.'"

An anchoring piece in this sequence is *The Path* (1962), a hanging tower woven in natural linen with a triangular peak and three horizontal fringed bars. At the very center is an opening laced with strips of twenty-four carat gold. *Path II* (1965–66) is the same shape, but it has a vertical opening at the center of the top crossbar, and a large square opening at the center of the middle bar. Buddhism's Noble Eightfold Path is sometimes divided into three basic categories, the Three Higher Trainings: wisdom, ethical conduct,

concentration. This trio would have resonated strongly with Tawney. Might Tawney's three crossbars represent this trio of "trainings"?

Tawney then began weaving monumental variations on the cross, called the Greek cross, an ancient symbol that often represents the earth, with four arms of equal length corresponding to the four elements (earth, water, air, fire) or the four directions. For Tawney, the cross also stood for "the meeting of opposites and the point at which linear and eternal time meet." Her stately and potent *Tau* (the Greek letter T) series was made up of large, compactly woven T-shaped hangings. Other woven forms from this time were simultaneously solid and open as Tawney made resounding use of slit tapestry techniques in works like *Four Petaled Flower II* (1974), an imposing piece of dignified black. The horizontal bar of the cross is thicker than the vertical, and bisects it at the midpoint. At the center, masterfully realized, is a slit pattern of a smaller cross of the same configuration, shown in reverse as the light filters through. In 1974 Tawney created *Dove*, another Greek cross, but this time woven in natural linen, with the horizontal bar divided into strips, so that the piece is softened and undulating.

As commanding as these hangings are, they are rendered with subtle and graceful detail, their pliability engendering a quiet vitality. Tawney brings color back to her large weavings as she returns to one of her signature motifs, the circle in the square, in two refulgent works. In *Red Sea* (1974), dozens of vertical red linen woven strips form a slitted circle that nearly fills the solid square. *In Fields of Light* (1974), a monumental piece in glowing gold, has a much smaller circle, making for a prairie of radiance.

Tawney continued to perfect her technique for uniting thread and paper to painterly effect in the calligraphic *Sphere of Moon* (1975–92). A slit tapestry from top to bottom, it is also an elongated variation on the circle-in-a-square format. The background is crimson, and the top half of the sphere—the illuminated half of the moon—is formed by white collaged handmade Japanese paper, specifically a seventeenth-century scroll on which the Heart Sutra, an essential Buddhist scripture, is written in thickly brushed black ink. The bottom of half of the sphere is red, and beneath it floats a curving shadow of black, forming a strange sort of lunar eclipse.

In 1976, at age sixty-nine, Tawney completed the last work she would create on the loom, the mighty masterpiece *Waters above the Firmament*

(1976), which measured thirteen by twelve feet. This collaged weaving is a monumental circle-in-a-square in which the enormous slit-tapestry circle is woven in sturdy natural linen and divided into more than two hundred slender strips. The top not-quite-half of each strip is covered with carefully applied lengths of paper torn from old books, some patterned with the black ink of various typefaces and languages, others serenely blank, most painted in varying densities of watercolor, in washes and dashes and accents of her signature transparent, spiritual blue. The paper is affixed with Liquitex. The effect is as grand and bewitching as a great lake breathing and ruffling and rippling, as a lake sky striated with thin passing calligraphic clouds. These collaged words, these sentence fragments, are like prayers sent out on waves and wind, currents and ripples. *Waters above the Firmament* is a gloriously atmospheric, floating, hovering piece, a work of transcendent intensity and unique and surpassing beauty.

A photograph captures petite Tawney at work on this mammoth collaged weaving, sitting cross-legged on a pillow on the floor, braiding and knotting the bottom fringe as *Waters above the Firmament* hangs from the ceiling of her Wooster Street studio, an astonishing, draping, light-filtering guardian entity.

Waters above the Firmament was acquired by the Art Institute of Chicago, which is also home to a kindred work by Georgia O'Keeffe, whom Tawney knew. O'Keeffe's immense oil painting *Sky above the Clouds IV* (1965) is a panoramic skyscape depicting a tightly packed array of white blocky clouds with rounded corners, a mosaic of levitating white stones against a blue sky, a vast blue sea, the horizon a blue line above which the sky is tinted with bands of peachy pink, white, and hazy blues. O'Keeffe wrote, "I painted a painting eight feet high and twenty four feet wide—it kept me working every minute from six am till eight or nine at night as I had to finish before it was cold—worked in the garage and it had no heat. Such a size is of course ridiculous but I had it in my head as something I wanted to do for a couple of years, so I finally got at it and had a fine time— and there it is. Not my best and not my worst."

Sky above the Clouds IV was the largest in a series of paintings inspired by what O'Keeffe saw outside the windows of planes during her world

travels in the 1950s. She was seventy-seven years old when she painted it. These two powerful women artists held the whole world, the very cosmos, in their minds' eyes.

In their 1971 conversation for the American Archives of Art, Paul Cummings asks Tawney when and how she became interested in Eastern thought and philosophy. Tawney replies,

> After my husband died I went down to Urbana, and I lived in my father-in-law's home. He had a big library, being a professor of philosophy, and in that library I found two books of [Swami] Vivekananda from that time when he was in Chicago at the Congress of Religions and out of that came many volumes of his talks. And these were two volumes that I read and that was the first time. I was brought up Catholic, very devout, and when I went to Chicago, after about a year of reading Schopenhauer one day the whole thing—it was as if I vomited it all and I was thrown into this sea with nothing to hold on to. It was a terrible loss and I felt as if I had nothing to hold to. I found nothing until I found that Vivekananda, that was some time later.

The interview continues:

MR. CUMMINGS: What about him appealed to you, what was it?
MS. TAWNEY: What appealed to me was that they didn't say we're right and everybody's wrong. They said all religions are going to the same place, they're simply on a different path. This appealed to me, they weren't exclusive in their right to God or whatever they were going towards.
MR. CUMMINGS: Well, that's a terrific spiritual change, isn't it?
MS. TAWNEY: Yeah. Well, I feel I had religious feelings of spirit but there was nothing to hold it to, to hold to until I found Vivekananda. I took those books and I stole them. He never looked at them. He later died, I know he never missed them, and the library was dispersed and I had those and I still have. Then in Chicago before I came here I used to

read this book every night before I went to bed. And I would read it in the morning too. It was a way of going into myself.

Tawney was certainly not alone in being an American Christian powerfully drawn to Indian spirituality. Many Westerners, including artists, musicians, and Hollywood stars, practiced meditation and yoga during the 1960s and 1970s as they sought alternatives to Western traditions that felt calcified and antithetical to genuine quests for meaning. The Beatles' avidly publicized involvement with the Maharishi Mahesh Yogi launched an era of the celebrity guru.

Tawney traveled throughout the Far East in 1969, exploring Japan and Thailand, then staying for an extended period in India. In 1970 she met Swami Muktananda, a spiritual leader who would profoundly change her life. "With his dark glasses, funky red ski cap, and scruffy beard, Swami Muktananda looked more like an edgy jazz musician than a standard-issue holy man," writes Philip Goldberg in *American Veda*. Named Krishna at birth in 1908 in southern India, Muktananda was a teenager when he met his guru, the loincloth-wearing, nearly silent Bhagawan Nityananda, then spent decades wandering on foot across India and studying with other yogic masters. Muktananda was almost forty when Nityananda finally accepted him as a disciple. In 1956 Nityananda gave him some land in Ganeshpuri, near Bombay, where Muktananda built an ashram "that was probably visited by more Westerners in the last quarter of the twentieth century than any other ashram in India." His teachings focused on awakening the kundalini, or *Shakti*, the life force that resides, coiled like a snake, at the base of the spine. This primal energy can be raised, via yogic practices, to charge the body's chakras, or centers, including the one located at the crown of the head, which ignites enlightenment. He came to the United States in 1970, appearing with the popular spiritual teacher Ram Dass (Servant of God), formerly Richard Alpert, an LSD pioneer along with Timothy Leary and the author of one of the era's most embraced books, *Be Here Now* (1971).

Tawney became a dedicated follower, her joy obvious in a photograph of her and her guru. Wearing a knit cap, a bindi, smoky-lensed aviator glasses, a stylish cardigan, and a high-collared shirt, Muktananda sits

Lenore Tawney and Swami Muktananda, ca. 1975. Unidentified photographer.

cross-legged in a well-cushioned rattan chair against a wall covered in wall-paper that looks like woven reeds. Tawney, clad in one of her handmade smocks, kneels on the floor as she leans in and embraces her guru, her head resting trustingly on his chest as both face the camera. The artist is smiling with open joy, her eyes glistening. The guru is smiling, too. Both are elated in their cozy, intimate snuggle.

The charismatic guru forged connections with other spiritual teachers, including the Maharishi Mahesh Yogi, Carlos Castaneda (whom Tawney read closely), and Werner Erhard, famed for his "est" training seminars. And Tawney was in elevated company as Muktananda attracted a roster of famous disciples, including California governor Jerry Brown, John Denver, Indira Gandhi, astronaut Edgar Mitchell (who went on to found the Institute of Noetics), Diana Ross, Isabella Rossellini, and James Taylor. By 1980 Muktananda had thousands of followers and established hundreds of ashrams and meditation centers around the world, with one of the largest located in upstate New York.

Then, in 1981, as chronicled by William J. Broad, a science journalist and yoga practitioner, in "Yoga and Sex Scandals: No Surprise Here," a 2012 article in the *New York Times*, "a senior aide charged that the venerated yogi was in fact a serial philanderer and sexual hypocrite who used threats of violence to hide his duplicity." As appalling as this disclosure was,

Muktananda was not the only guru accused of sexual impropriety and abuse. Broad cites several others whose sexual exploitation contradicted their teachings and betrayed their followers' trust. To understand this treachery, Broad looks to hatha yoga's origins in the tantric tradition, which "sought to fuse the male and female aspects of the cosmos into a blissful state of consciousness." In medieval times, this involved sexual rites, leading to tantric practices being condemned as mere debauchery masquerading as spirituality. Twentieth-century yogis, especially the adept and brilliant B. K. S. Iyengar, author of the greatly influential *Light on Yoga* (1965), focused strictly and chastely on yoga's health and fitness benefits, consigning its rapturously erotic past to a buried vault without a key. Yet scientific studies reveal, as Broad puts it, that hatha yoga can "fan the sexual flames," engendering guru sex scandals and all the confusion, anguish, and pain that follows. As for Muktananda, he "defended himself as a persecuted saint, and soon died of heart failure."

However Tawney felt about her guru's fall from grace and sudden death at seventy-four, she continued her siddha practice, and became close to Muktananda's successor, a woman named Gurumayi Chidvilasananda, whose parents were devotees of Muktananda. At the close of the acknowledgments in the 1990 catalog *Lenore Tawney: A Retrospective*, we read, "Lenore Tawney wishes to acknowledge 'with deepest appreciation and love' her meditation teachers, Swami Muktananda and Swami Chidvilasananda." The influence of her siddha meditation practice on her work and her life is incalculable.

Tawney may have stepped away from the loom for good after completing *Waters above the Firmament*, but she was not finished with fiber art. She was back in India in 1977 when she received an invitation from the General Services Administration to create a commissioned piece for the glass-walled lobby of the new Federal Building in Santa Rosa, California. When Tawney went there to scope out the space, she found herself contemplating a forty-foot open stretch with a twenty-five-foot-high ceiling. The director of the GSA's Art in Architecture program suggested a suspended piece. Tawney mused, "I could not see anything I had done hanging in this space. But I . . . knew that if I waited, without impatience, an inspiration would arise out of silence." And out of Tawney's growing awareness of the drought then afflicting the region, she found herself imagining a cloud, and so she created one. She

Lenore Tawney installing Cloud Series VI, *1981. Frank J. Lausche State Office Building, Cleveland, Ohio. Unidentified photographer.*

secured a thirty-by-five-foot sheet of canvas and painted it blue. A photograph documents Tawney outside on a vast, brittle lawn, bending over the cloth that she has spread out to dry beneath the sun, securing it with small pumpkins placed at the corners and along the edges. She then painstakingly attached 2,500 sixteen-foot-long linen threads in several shades of blue to this immense blue rectangle, arranging them in a neatly ordered grid. Each thread was "carefully measured, counted, knotted, rolled up, and finally rolled down." The threads fell like rain. *Cloud Series IV* was a sensation. It still is.

For the *Cloud* installation in her 1979 exhibit at the New Jersey State Museum, Tawney created four thread clouds and hung them in a cross formation. Each canopy had ten-foot-long threads attached every two inches within the grid. A dancer, Andy deGroat, performed within the "shower" of threads. Later, for her 1990 retrospective, the octogenarian artist reconfigured this work, stitching together two of the clouds, and deciding that each of the thousands of hanging threads needed to be twenty feet long, not ten. This meant that additional ten-foot lengths had to be tied onto the originals, and Tawney didn't have much time. So she recruited eight assistants, young women from the ashram she frequented in upstate New York. They helped her measure, tie, and roll up all the threads (for transport), an enormous undertaking that Tawney insisted be accomplished in meditative

silence. The result, Mangan recalls, was a "sea of knots" floating at eye level, always "slightly active" in the soft air currents of the gallery.

In the 1990s Tawney created smaller cloud sculptures, such as the 30-by-20-inch *Dark Cloudburst*, works that can hang in a room or gallery and possess a more concentrated, stormier energy.

Sigrid Wortmann Weltge writes, "Anyone who has walked beneath Tawney's Cloud series has experienced a magically transformed space. Thousands of threads, individually knotted and inserted into a linen background, cascade in bursts from the ceiling, environments that envelope the visitor as a participant in her creation." Constantine and Larsen observe, "There is a purity and nobility in her hanging strands that, in contrast to the concrete and glass, produces a sense of exhilaration." Tawney herself explained that "Clouds represent a clearing, allow me to be open and free and unencumbered." In a notebook she copied a line from Jung: "The struggle to express an inner vision of a reality greater than the individual self, a reality that transcends the mundane, is what lies at the root of a genuine artistic impulse."

Critics and viewers have marveled over the seemingly infinite patience required to perform the painstaking, repetitive work necessary for the creation of Tawney's free-floating, airy sculptures. Tawney objected: "Some people can only think of the patience. They say, 'How can you have so much patience.' It's *not* patience. I'm not just patiently doing it, because I love to do it. It's done with devotion. It's just working. My work is my pleasure, it's my life, it's what I live for."

These passionately precise works hold up remarkably well, but after several decades, they require care. By 2013, the Cloud installed in Cleveland's Frank J. Lausche Office Building in 1981 had accumulated so much dust that the sixteen-foot-long array of 4,000 linen threads was at risk of being taken down. Instead, the facilities manager contacted the Lenore Tawney Foundation for help, and a comprehensive preservation project ensued. Conservators carefully cleaned the painted canvas canopy and each and every thread. New lighting was installed, and now this cloud gleams and shimmers.

An exacting effort was also required to maintain an earlier work, *The Curtain of the Ark*, or *Ark Veil* (1963), a commissioned piece for

Congregation Solel in Highland Park, Illinois, north of Chicago. A finely woven and knotted work of linen and gold wire, it measures 120 by 54 inches. In the synagogue's newsletter, *Pathfinder*, of January 22, 1964, Harriet Ziff celebrates the "beautiful unusual curtain covering the ark. Its delicate loveliness is partially due to the openness of the woven strands, an original style in weaving that is Miss Tawney's own."

Ziff's write-up offers a look into the artist's tireless effort: "Miss Tawney arduously studied Torah curtains after she was commissioned by Solel. A great deal of her research was done at the Jewish Theological Seminary in New York . . . Like all true artists, Miss Tawney is a perfectionist. She started work on one curtain last summer, and discarded it when it was near completion. It was not as open or as perfect as she demanded. She is very pleased with this one. She received great satisfaction from weaving for religious edifices."

When Congregation Solel had *Ark Veil* cleaned in 2014, the conservator contacted the Lenore Tawney Foundation about the need to repair some inevitable wear and tear. The conservator was astounded to learn not only that the curtain had been made fifty years earlier but that the foundation still had a supply of the very linen thread Tawney used to create the piece.

Tawney wrote in a May 4, 1979, journal entry, "The work changes in form & even in content, but still it is the same. Like the ocean, the surface has waves & storms over it, but the depths remain always calm, dark, full of life & mystery. We know not what is in our depths. So our life, transmuted into our work."

As Tawney's work changed, yet remained the same, so too did the artist. Thanks in part to her healthy diet and yoga, meditation, and Pilates practices, Tawney remained vibrant and lithe. But age is sneaky and relentless. At eighty-four, Tawney, a master of fine detail, a hungry reader who wrote in tiny script, began to lose her sight. There was no way she could live without books, so she switched to books on tape, borrowing titles from the public library branch for the blind that just so happened to be right across the street from her loft. Her favorite was Richard Ellmann's enormous and definitive biography of James Joyce, a writer Tawney was passionate about, and who himself suffered from painful and debilitating problems with his eyes. She listened to Ellmann's book over and over again, ultimately refusing to return it. Because

no recordings were available for most of the esoteric books she was interested in, she had friends come to the loft and read them aloud.

Eventually the artist began to need assistance with many other aspects of her personal and professional efforts. Yet she remained undaunted in her creative and active approach to life and art. In 1989 she established a charitable and educational foundation to continue her long philanthropic practice by supporting the teaching and exhibition of visual arts with a craft connection. Her foundation would also ensure the preservation of her work, studio, and belongings, from her archives to her books, journals, and handmade clothes.

Tawney kept traveling as long as she could. In 1996, at age eighty-nine, she went to Seattle to visit a friend and to see an exhibition of the work of a textile artist she knew and admired, Jan Haag. Also a poet, writer, and activist, Haag, like Tawney, had traveled the world and maintained an Eastern spiritual practice. Haag was amazed and deeply touched by Tawney's visit, given her age and fading vision. Together they went to the Seattle Asian Art Museum. Tawney, her posture still upright and her mind sharp, was dressed elegantly as always, wearing white gloves, a white fur hat with a pompom, and one of her most resplendent handmade silk robes. The two artists sat down, facing each other, and Haag handed Tawney, one by one, her intricately patterned, lushly hued needlepoint pieces. *Kalachakra*, for example, a work inspired by Tibetan Buddhism, contains approximately 107,254 stitches. Tawney gazed at Haag's work, enjoying the rich colors; then, gloves off, she appreciated their finely detailed texture with her extraordinarily sensitive and knowledgeable fingertips.

Tawney continued to do Pilates, even after she lost her sight, until she was ninety-eight. She loved to throw big, festive birthday parties and continued to do so well into her nineties. She was even able to have a small gathering to celebrate her hundredth birthday, but her health declined rapidly after that landmark occasion, and she soon died peacefully in her loft. As she requested, she was cremated. Then, after more than sixty years of separation, Lenore Tawney was laid to rest with her husband and her in-laws in Woodlawn Cemetery in Urbana, Illinois, not far from the farm the Tawneys had given the newlyweds as a wedding present, property that supported Tawney during her extraordinarily creative life.

Lenore Tawney. Black Woven Form (Fountain). *1966.
Linen, expanded gauze weave, knotted, loom woven. 105 x
2 1/4 inches. Photographer: Sheldan Comfort Collins.*

Tawney traveled a long, winding path that led her from worlds in which artistic expression was suspect and censored and uniformity enforced to realms in which she was free to pursue her artistic and spiritual inquiry, a quest rooted in a profound sense of order, vitalized by a poetic sensibility, and sustained by meditation. She attained a modicum of fame as a fiber art pioneer, creating works of arresting presence and rare eloquence, while also making collages and assemblages of subtle beauty, reflection, and wit. But due to the unusual, often maligned medium in which she worked, as well as her inner-focused temperament, she was always underappreciated, unlike Agnes Martin and her other painter peers. Fiber art has never been fully embraced by the art world, and as Tawney's radical and majestic works were rolled up and put in storage, the medium itself seemed to fade away. But not for long; a decade after her death, the magic of Tawney's work is gathering strength once again as curators rediscover the allure and vibrancy of fiber art, and mount exhibitions that reclaim and celebrate the work of first-wave fiber artists, Tawney preeminent among them. Let this be the start of fresh and lasting wonder over this virtuoso of exquisite detail and sublime surprise. Let us marvel now and always over the accomplishments of this devoted artist of contemplation, vitality, daring, and vision who, out of thousands of threads, words, feathers, and knots, brought forth a profound and dancing unity.

CODA

PERPETUAL REDISCOVERY

What strange and formidable tasks artists assign themselves. Lenore Tawney sought to weave a great web of consciousness and continuity with her woven forms, and cut up the pages of old books to make small, enigmatic collages. Louise Nevelson built large, imposing sculptures out of wood scraps. Christina Ramberg made magnificently disquieting paintings of fractured, amputated, and flayed human bodies haphazardly patched together with cloth, wood, and wire. Ree Morton built mischievously provocative sculptures out of branches and found objects. Gertrude Abercrombie and Joan Brown confronted themselves and their predicaments over and over again in frank and fanciful self-portraits. World traveler Loïs Mailou Jones created unique and resounding multicultural juxtapositions. All seven of these twentieth-century artists dedicated their lives to making daringly original art without any guarantee that anyone else would ever appreciate any of it.

Where does this all-consuming need to create come from? This bizarre commitment to impractical, even implausible pursuits requiring enormous personal sacrifice? The compulsion to make art complicates every aspect of life, from personal finances to close relationships. The material, psychological, and metaphysical demands and the odds against attaining the sort of success that translates into a livelihood can plunge an artist into despair and lead to isolation and depression. The struggle to stay true to their calling was all the more daunting for these artists because they also had to face sexism and, for Jones, racial discrimination. Yet each persisted, affirming and defending her identity as an artist no matter the consequence. And as their stories attest, for all the doubt, fear, and deprivation they endured, their steadfast devotion to art proved to be transforming, transcendent, and profound.

Nevelson devised her own glorious mythos. Abercrombie imagined a fantasy realm in which her painted avatar acted out her psychic anguish in witty, surreal, and cathartic vignettes. Ramberg's forensic inquiry into the human form gave way to geometric abstractions of poignant emotional intensity as her own body failed her. Brown and Tawney's artistic quests and extensive travels led them to the teachings of charismatic Indian gurus. Jones embraced the spiritual traditions of Africa and Haiti. As an itinerant teacher, Morton made art all across the country, responding nimbly to new places, riffing on bows and beaux in Bozeman, and the ornamentation of architect Louis Sullivan in Chicago.

By virtue of their indefatigable work ethic, audacious originality, extraordinary talent, magnetic personalities, and blazing spirit, all seven artists attained success in their lifetimes, yet their hard-earned renown was of short duration. This book was catalyzed by my astonishment and outrage over how quickly Louise Nevelson was forgotten. I felt the same shock and indignation when I came upon the work of the six other over-looked artists. Yet as I delved into their lives and work, I was struck most not by injustice but rather by their conviction and discipline, concentration and effort. Their allegiance to art brought impetus, direction, order, and meaning to their lives, and their quests reveal that as much as creativity pulls you into your deepest self, it also connects you to the universal aspects of the human experience, from love to fear, anguish to joy, confusion to revelation. As each artist pursued her obsessions, fascinations, ideas, quests, and inquiries, psychological and moral, and set herself new aesthetic and technical challenges, her work evolved, often in startling directions.

I see something new and arresting every time I look at an Abercrombie, Brown, Jones, or Ramberg painting; every time I consider a sculpture by Morton, Nevelson, or Tawney. In the presence of their work, I undergo an illuminating frisson, an electrifying recalibration of my perception. Over the years I spent researching and writing this book, art historians, curators, and gallery owners were struck by that same radiant force, and they have been gradually reclaiming these underappreciated painters and sculptors. As works of these thrilling, provocative, and significant artists are retrieved from the dark chill of vaults and storage spaces and brought back into the

light, they will inspire not only other artists but everyone searching for the path to a genuinely engaged, expressive, and fulfilling life. As their identities become known once again and their works are made more accessible, there will be much more to discover and rediscover in rapt contemplation of these women's ardent and arduous lives, bold visions, and endlessly intriguing and resonant art.

ACKNOWLEDGMENTS

Writing about people's lives is a demanding and exhilarating undertaking that brings with it great responsibility. I was aided, guided, rescued, and inspired by many individuals who gave unstintingly of their time, attention, effort, and expertise.

I'm grateful for the assistance of Maria Nevelson, Lynn Gilbert, Dixie L. Guerrero, and Diana MacKown, as well as Sheryl McMahan at the Farnsworth Art Museum. During my Gertrude Abercrombie research I was warmly welcomed and generously assisted by the staff of the Illinois State Museum, and I want to thank Doug Carr, Carole Peterson, and Jim Zimmer for their above-and-beyond support, particularly when they were coping with extremely difficult circumstances. Collector Bernard Friedman was extraordinarily gracious in contributing images of Gertrude Abercrombie paintings. I'm grateful, too, to Nancy Roosevelt Ireland for permission to include Eleanor Roosevelt's *My Day* column. The Loïs Mailou Jones Pierre-Noël Trust was essential to my mission, and I thank Dr. Chris Chapman and Larry Frazier. Long ago I contacted Noel Neri, Joan Brown's son, with a request to reproduce a painting of Brown's on the cover of my first book; this time around he once again demonstrated remarkable and greatly appreciated kindness in supplying images of Brown and her paintings. Thanks, too, to Amy Mutza and the Joan Brown Trust, and Gus Wheeler at the George Adams Gallery. Ted Bonin at the Alexander and Bonin Gallery not only provided me with images of Ree Morton and her work but also played a key role in clarifying the book's stated mission. Thanks, too, to Kathryn Gile.

Special heartfelt gratitude to Philip Hanson and Alexander Hanson for so generously sharing family archives and Christina Ramberg's remarkable files. Deepest thanks to Jane Ramberg, Debbie Ramberg Blackwood, and Rebecca Shore for our illuminating and moving conversations. Corbett vs.

Dempsey graciously provided me with space in the gallery where I spent hours poring over Christina Ramberg's drawings; thank you, Benjamin Chaffee and John Corbett. I am also very grateful to Nicole Sachs, registrar and gallery manager, for her crucial help. Gratitude, too, to the Art Institute of Chicago's Drawings & Prints department, particularly curator Mark Pascale, who so patiently presented Ramberg's notebooks and drawings, and to Carl Hammer at the Carl Hammer Gallery.

I was warmly welcomed and munificently assisted by the executive director of the Lenore G. Tawney Foundation, Kathleen Nugent Mangan, who eloquently and sensitively shared her memories and perceptive insights, and allowed me to closely study Tawney's notebooks and many works of art. I'm immensely grateful to Mangan, too, for her meticulous work on the reproductions and on ascertaining that every detail in the Tawney portrait was correct. When research engenders a friendship, you know you're on the right track. The Textile Department at the Art Institute of Chicago expertly brought exquisite works by Lenore Tawney out of storage so that I could bask in their intricate splendor, including the enormous *Waters above the Firmament*, which has such a vital presence, and I am immensely grateful for their knowledge and support, with special thanks to Sarah Gordon and Isaac Facio.

We Americans are so very fortunate to have one of the world's most extraordinary public repositories, the Smithsonian Institute, which includes the wondrous Archives of American Art, a treasury of artists' papers, oral histories, and a mammoth collection of images, much of it digitized. This is democracy in action: the gathering, organizing, and sharing of historical information, the support of lifelong learning, and the valuing of art and the humanities as part of a free, evolving, and creative society. I feel proud of and reassured about our nation each time I access this resource, and I thank those I communicated with over the course of my research. I also benefited mightily from the Chicago Public Library, with its precious holdings and marvelous staff, and from the key assistance of Rebecca Gerber and Valerie Hawkins in the American Library Association library.

Very special and deep gratitude goes to my editor, Nancy Miller. As soon as we met, we began a conversation about books, art, and life that has

lifted, inspired, and sustained me ever since. Everything Nancy has contributed to *Identity Unknown*'s conception and creation has made it a far, far better book. I'm so grateful, too, to everyone else at Bloomsbury USA, including George Gibson, Lea Beresford, Callie Garnett, Laura Phillips, Jenna Dutton, Patti Ratchford, and Sara Mercurio.

I am infinitely grateful for my patient and ever-supportive family for their encouragement and understanding: my wonderfully giving and wise parents, Elayne and Hal Seaman, for sharing their passions for reading, art, and the world, and my wizard husband, David, for his help on so many levels and in so many imperative ways. I'm very grateful for my loving in-laws and my encouraging cousins. I thank dear friends and literary comrades who so profoundly bolstered, succored, and assisted me, including but certainly not limited to Randy Albers, Angela Bonavoglia, Nancy and Jon Fjortoft, Susan Hahn, Jayne Hileman, Sheryl Johnston, Craig Kois, Billy Lombardo, Steve Paul, Ellen Pettengel, Mark Stanley, Elizabeth Taylor, and all my smart, witty, creative, dedicated, book-loving *Booklist* colleagues on staff and beyond, past and present.

NOTES

Introduction: Telling the Stories of Seven Artists

p. xi **"while great achievement"** Linda Nochlin, "Why Have There Been No Great Women Artists?" in *Women Artists: The Linda Nochlin Reader*, ed. Maura Reilly (New York: Thames & Hudson, 2015), 67.

p. xii **"The unreliability of the classic references"** Germaine Greer, *The Obstacle Race: The Fortunes of Women Painters and Their Work* (New York: Farrar, Straus and Giroux, 1979), 4.

p. xiii **"Feminism cannot supply"** Ibid., 325.

p. xiv **"the first woman artist"** Whitney Chadwick, *Women, Art, and Society*, 5th ed. (New York: Thames & Hudson, 2012), 100.

The Empress of In-Between: Louise Nevelson

p. 1 **"My total conscious search"** Arnold B. Glimcher, *Louise Nevelson* (New York: Dutton, 1976), 79; reproduced in John I. H. Baur, *Nature in Art* (New York: Whitney Museum of American Art, 1957).

p. 3 **"Louise loved being provocative"** Pedro E. Guerrero, *A Photographer's Journey with Frank Lloyd Wright, Alexander Calder, and Louise Nevelson* (New York: Princeton Architectural Press, 2007), 196.

p. 3 **"I wanted a medium"** Louise Nevelson, *Dawns and Dusks: Taped Conversations with Diana MacKown* (New York: Charles Scribner's Sons, 1976), 78.

p. 4 **"I had all this wood"** Nevelson, *Dawns and Dusks*, 76.

p. 4 **"the original recycler"** Guerrero, *A Photographer's Journey*, 195.

p. 5 **"the total color"** Nevelson, *Dawns and Dusks*, 125–26.

p. 5 **"Without Picasso"** Ibid., 38.

p. 6 **"inner necessity," "Kandinsky's imaginative legacy"** Frederick Hartt, *Art: A History of Painting, Sculpture, Architecture*, 3rd ed. (New York: Harry N. Abrams, 1989), 890.

p. 7 **"more exciting"** Ibid., 890.

p. 7 **"who ranks"** Hartt, *Art*, 946.

p. 9 **"a modernist down"** Brooke Kamin Rapaport, ed., *The Sculpture of Louise Nevelson: Constructing a Legend* (New Haven, CT: Jewish Museum of New York/Yale University Press, 2007), 36.

p. 9 **"I trained"** Nevelson, *Dawns and Dusks*, 73.

p. 9 **"During the war"** Ibid., 81.

p. 10 **"When you do"** Ibid., 83.

p. 10 **"'built for greatness'"** Laurie Lisle, *Louise Nevelson: A Passionate Life* (New York: Summit, 1990), 18.

p. 11 **"WASP Yankee town"** Nevelson, *Dawns and Dusks*, 7.

p. 11 **"scavenging bottles"** Lisle, *Louise Nevelson*, 26.

p. 12 **"was her art"** Ibid., 30.

p. 12 **"a woman who"** Nevelson, *Dawns and Dusks*, 6.

p. 12 **"My mother"** Lisle, *Louise Nevelson*, 30.

p. 12 **"an extravagant"** Ibid., 40.

p. 12 **"Without drawing"** Nevelson, *Dawns and Dusks*, 64.

p. 13 **"I was never," "There but for"** Ibid., 37.

p. 13 **"Here I had"** Ibid., 35–36.

p. 13 **"I can't stay"** Ibid., 37–38.

p. 13 **"I said, oh"** Ibid., 43.

p. 14 **"I am closer"** Lisle, *Louise Nevelson*, 126.

p. 14 **"Fucking, dear"** Ibid., 125.

p. 14 **"slightly whorish"** Ibid., 126.

p. 14 **"if she revealed"** Ibid., 126.

p. 15 **"You know, Louise"** Nevelson, *Dawns and Dusks*, 69.

p. 15 **"We learned"** Lisle, 143.

p. 16 **"I think that"** Nevelson, *Dawns and Dusks*, 69–70.

p. 15 **"chronic stomach trouble . . . sick person"** Lisle, *Louise Nevelson*, 166.

p. 16 **"empress of art"** Ibid., 263.

p. 16 **"I love to"** Nevelson, *Dawns and Dusks*, 184–85.

p. 16 **"such esteem"** Ibid., 185.

p. 17 **"Well, don't forget"** Glimcher, *Louise Nevelson*, 190–93.

p. 18 **"a thousand destructions"** Lisle, *Louise Nevelson*, 222.

p. 18 **"sculpture-collage," "accumulation of thought"** Nevelson, *Dawns and Dusks*, 171.

p. 18 **"The World Trade Center"** Ibid., 112.

p. 19 **"I found that"** Ibid., 171.

p. 19–20 **"The very nature . . . of unity"** Lisle, *Louise Nevelson*, 191.

p. 20 **"I think often"** Nevelson, *Dawns and Dusks*, 167–68.

p. 20 **"Near the end"** Lisle, *Louise Nevelson*, 283.

p. 20 **"But the thing"** Nevelson, *Dawns and Dusks*, 177.

p. 21 **"the belief that"** Sharman Apt Russell, *Standing in the Light: My Life as a Pantheist* (New York: Basic Books, 2008), 2.

p. 21 **"Everything is"** Ibid., xi.

p. 22 **"a massive black"** Lisle, *Louise Nevelson*, 20.

p. 23 **"She was a bird"** Edward Albee, "Louise Nevelson: The Sum and The Parts," in *Louise Nevelson: Atmospheres and Environments* (New York: Clarkson N. Potter/Whitney Museum of American Art, 1980), 12.

p. 23 **"40's, pleasant"** Edward Albee, *Occupant: The Collected Plays of Edward Albee, Volume 3, 1978–2003* (New York: Overlook Duckworth, 2005), 625.

p. 23 **"encased," "Look dear," "Time passes"** Ibid., 626.

p. 23 **"You're kidding!"** Ibid., 627.

p. 23 **"All right!" "You're a very famous"** Ibid., 628.

p. 23 **"Pay no attention"** Ibid., 647.

p. 24 **"As big as *death*"** Ibid., 699.

p. 24 **"Due to illness"** Ibid., 624.

Girl Searching: Gertrude Abercrombie

p. 27 **"I paint the way"** Gertrude Abercrombie papers, 1880–1986, bulk, 1935–1977, Archives of American Art, Smithsonian Institution (hereafter cited as Abercrombie, AAA).

p. 28 **"very funny," "grouchy"** Don Baum, interview, in *Gertrude Abercrombie*, ed. Susan Weininger and Kent Smith (Springfield: Illinois State Museum, 1991), 67.

p. 28 **"very introspective," "She played the piano"** Ibid., 69.

p. 28 **"She was gay and radiant"** Dinah Livingston, interview by Susan Weininger, June 7 and 11, 1983, in Weininger and Smith, *Gertrude Abercrombie*, 17.

p. 29 **"It was wonderful"** Richard Stern, *What Is What Was* (Chicago: University of Chicago Press, 2002), 112.

p. 29 **"To Queen Gertrude"** Abercrombie, AAA.

p. 30 **"Surrealism is meant for me"** Ibid.

p. 31 **"I am not interested"** Ibid.

p. 31 **"I like to paint mysteries"** Agnes Lynch, "Art Critics Say Her Works Are 'Magic Realism,'" *Chicago Sun-Times*, September 14, 1952.

p. 31 **"something to do"** Ron Offen, "Artist's Eyes," *Southeast Economist*, March 8, 1972, 12.

p. 31 **"Everything is autobiographical"** Abercrombie, interview by Studs Terkel, WTTW (Chicago), January 28, 1977.

p. 31 **"I always paint"** Donald James Anderson, "Feeding the Artists Is Not Prohibited," *Chicago Magazine*, May/June 1972, 18.

p. 31 **"restrained palette"** Lynch, "Art Critics Say."

p. 32 **"She was no technician"** Baum, interview, 69.

p. 32 **"Something has to happen"** Abercrombie to Fred Sandiford, cited in "About Gertrude," *Chicago Photographic* 111 (1950): 13.

p. 32 **"recovering"** Abercrombie, AAA.

p. 32 **"It is a great pity"** Wendell Wilcox, "Remembrance," in Weininger and Smith, *Gertrude Abercrombie*, 86.

p. 32 **"Dear Karl"** Postcard from Dudley Huppler, Abercrombie, AAA.

p. 33 **"lovely," "Abercrombie's fascination"** Weininger and Smith, *Gertrude Abercrombie*, 9.

p. 33 **"Garbo was her ideal"** Wilcox, "Remembrance," ibid., 85.

p. 35 **"No one looked less"** Katharine Kuh, "Remembering Gertrude," ibid., 77.

p. 35 **"It's always myself"** Abercrombie, Terkel interview.

p. 36 **"Gertie already"** Abercrombie photo album, Illinois State Museum, Springfield.

p. 37–38 **"Virginia Bartlet," "I was twelve," "my seat felt," "crazy about . . . too nasty"** Abercrombie, AAA.

p. 39 **"she felt that"** Weininger and Smith, *Gertrude Abercrombie*, 11.

p. 39 **"I met all kinds"** Abercrombie, Terkel interview.

p. 40 **"dream of community"** Livingston, interview, 14.

p. 40 **"It makes me"** Karl Priebe to Gertrude Abercrombie, postcard, Abercrombie, AAA.

p. 40 **"smooth socialite"** Robert Cozzolino, *With Friends: Six Magic Realists, 1940–1965* (Madison: Elvehjem Museum of Art/University of Wisconsin, 2005), 83.

p. 41 **"developed personal iconography," "made art"** Ibid., 1.

p. 41 **"They established"** Ibid., 2.

p. 41 **"loosely based"** Ibid., 144.

p. 42 **"It was the closest"** Tyler Friedman, "Interview with Professor Curtis Carter on Milwaukee Artist Karl Priebe," *Shepherd Express*, November 6, 2013.

p. 43 **"The sight of"** Abercrombie, AAA.

p. 44–45 **"A seal and matches," "Light blue," "A peaceful life," "a table means,"** Gertrude Stein, *Tender Buttons: Objects, Food, Rooms* (1914; reprint, San Francisco: City Lights, 2014), 12.

p. 45 **"they are very pretty," "I knew I could"** Abercrombie, AAA.

p. 45 **"Everyone sees something different"** Anderson, "Feeding the Artists," 18.

p. 45 **"to use my head"** Abercrombie, AAA.

p. 45 **"Do you remember Gertrude"** Edward M. Burns and Ulla E. Dydo, eds., *The Letters of Gertrude Stein and Thornton Wilder* (New Haven, CT: Yale University Press, 1996), 99–100.

p. 46 **"Here's the cheque"** Ibid., 31.

p. 46 **"A man thinking," "I had grapefruit," "with a real life elephant"** Abercrombie, AAA.

p. 47 **"I met Livingston"** Ibid.

p. 48 **"*Jewishness*"** Ibid.

p. 48 **"My husband was Jewish"** Ibid.

p. 48–49 **"It had all," "They didn't look"** Ibid.

p. 49 **"When I'm not painting"** Anderson, "Feeding the Artists," 18.

p. 50 **"My Dear Thornton . . . show her off to you?"** Abercrombie, AAA.

p. 52 **"Bob let me slip"** Ibid.

p. 52 **"I think the real reason"** Baum, interview, 68.

p. 53–54 **"felt that long flutter . . . Dinah there"** Abercrombie, AAA.

p. 54 **"Sunday nite"** Ibid.

p. 56 **"Abercrombie claimed"** Ibid., 32.

p. 56 **According to Abercrombie** Weininger and Smith, Gertrude Abercrombie, 32.

p. 57 **"quite a *grande dame*"** Baum, interview, 70.

p. 58 **"Snared" and "Snagged"** Weininger and Smith, *Gertrude Abercrombie*, 32.

p. 58 **"project the same"** Ron Effen, "Artist's Eyes," *Southeast Economist*, March 8, 1972, 12.

p. 58 **"I want to make"** Florence Hamlish Levinson, "She Invented the Life She Wanted," in Weininger and Smith, *Gertrude Abercrombie*, 79.

p. 59 **"stands with her second husband"** Dinah Livingston, "For Gertrude," in Weininger and Smith, *Gertrude Abercrombie*, 73.

p. 59 **"playing solitaire"** Ibid., 21.

p. 59 **"Where the hell"** Offen, "Artist's Eyes," 12.

p. 60–61 **"The story . . . is overdone"** Erle Stanley Gardner, foreword, in Paul Warren, *Next Time Is for Life* (New York: Dell, 1953), 2–3.

p. 61 **"I knew I would never . . . each other"** Warren, *Next Time*, 9.

p. 61 **"the honest people"** Ibid., 96.

p. 62 **"phony . . . burglar"** Ibid., 100.

p. 62 **"Connections with"** Abercrombie, AAA.

p. 62–63 **"CHICAGO, Friday . . . attitude is"** Eleanor Roosevelt, *My Day*, January 16, 1954, Eleanor Roosevelt Papers Project/George Washington University.

p. 65–66 **"Adorable musicians," "Dizzy Gillespie," "Ted Friedman"** Abercrombie, AAA.

p. 66 **"In the 1950's"** Livingston, "For Gertrude," 75.

p. 67 **"jug sherry"** Baum, interview, 68.

p. 67 **"8:30 all at once"** Abercrombie, AAA.

p. 68 **"Her relationship with Frank"** Baum, interview, 69.

p. 68 **"Tuesday, 2 PM"** Abercrombie, AAA.

p. 69 **"did most of"** Baum, interview, 67.

p. 69 **"March 22, 1963"** Abercrombie, AAA.

p. 70 **"Frank you are"** Ibid.

p. 71 **"alienated, self-starting"** Paul W. Miller, "James Purdy's Gertrude: A Visit to Chicago Painter Gertrude Abercrombie (1909–1977) in Hades," *Midwestern Miscellany* 27 (1999): 30.

p. 71 **"autobiographical surrealism"** Ibid., 35.

p. 72 **"Malcolm was listening . . . everyday life"** James Purdy, *Malcolm* (1959; reprint, London: Serpent's Tail, 1994), 85–87.

p. 72 **"state pen"** Ibid., 88.

p. 73 **"I can't help . . . *life* with Jerome"** Ibid., 99.

p. 73 **"All of Eloisa's portraits . . . fine thing"** Ibid., 97–98.

p. 73 **"You are too ugly . . . drinking with him"** Ibid., 114–15.

p. 73 **"saw her former"** Ibid., 130.

p. 74 **"'Must my life'"** Ibid., 134.

p. 74 **"'You're all of a pack!'"** Ibid., 135.

p. 74 **"No woman ever loved"** Abercrombie, AAA.

p. 76 **"innocence and naïveté"** Ibid.

p. 76 **"May 28 71"** Ibid.

p. 76 **"I saw a sign"** Ibid.

p. 77 **"The husband Frank"** Ibid.

p. 77 **"Three years ago"** Ibid.

p. 79 **"the one about"** Ibid.

p. 79 **"Nowhere could I go"** Ibid.

p. 80 **"Frank—"** Ibid.

p. 80 **"Frances Sandiford"** *Rhinebeck (New York) Gazette Advertiser,* August 28, 1975.

p. 81 **"stage-Johnny"** Abercrombie, AAA.

p. 81 **"I had never intended"** Frances Sandiford, "Reflections of a Retired Prison Librarian," *Library Journal,* January 6, 2011.

p. 83 **"had been caught up"** James Purdy, *Eustace Chisholm and the Works* (1967; reprint, London: GMP, 1984), 3.

p. 83 **"Her face"** Ibid., 39.

p. 83 **"Old Maureen . . . in line"** Ibid., 40.

p. 83 **"kissing him"** Ibid., 41.

p. 83 **"unsold oils"** Ibid., 63.

p. 83 **"mentor for sexual freedom . . . old maid"** Ibid., 64.

p. 83 **"had been born"** Ibid., 66.

p. 83 **"she must give herself"** Ibid., 65.

p. 83 **"yesterday's queen"** Ibid., 86.

p. 84 **"her abdomen"** Ibid., 75.

p. 84 **"Be glad"** Ibid., 78.

p. 84 **"Dear Gertrude"** Karl Priebe to Abercrombie, postcard, October 21, 1964, Abercrombie, AAA.

p. 84 **"Dear Gertrude"** James Purdy to Abercrombie, July 17, 1965, Abercrombie, AAA.

p. 84 **"Don't give up"** Purdy to Abercrombie, March 2, 1971, Abercrombie, AAA.

p. 85 **"Write to me soon"** Purdy to Abercrombie, June 24, 1972, Abercrombie, AAA.

p. 86 **"Oh yes, Gertrude dear"** Sonny Rollins to Abercrombie, March 21, 1962, Abercrombie, AAA.

p. 86 **"Dear Friends"** Rollins to Abercrombie, July 12, 1962, Abercrombie, AAA.

p. 86 **"Gertrude (Precious stone that you are)"** Rollins to Abercrombie, September 7, 1962, Abercrombie, AAA.

p. 86 **"So how are things?"** Rollins to Abercrombie, December 20, 1962, Abercrombie, AAA.

p. 87 **"And Gertrude yes"** Rollins to Abercrombie, n.d., Abercrombie, AAA.

p. 87 **"Dearest Gertrude"** Rollins to Abercrombie, 1972, Abercrombie, AAA.

p. 87 **"Dear Gertrude— It was distressing"** Rollins to Abercrombie, n.d., Abercrombie, AAA.

p. 88 **"You have heard"** Abercrombie, album cover for *Orlando!* . . . (Chicago: Super Star Records, 1970), Illinois State Museum.

p. 88 **"Dear Painter"** Purdy to Abercrombie, June 8, 1976, Abercrombie, AAA.

p. 89 **"We never got on"** James Purdy, *Gertrude of Stony Island Avenue* (New York: William Morrow, 1997), 1.

p. 89 **"She was not"** Ibid., 2.

p. 89 **"Her paintings"** Ibid., 112.

p. 89 **"was not like"** Ibid., 11–12.

p. 89 **"go in search"** Ibid., 63.

p. 89 **"no one knew"** Ibid., 117.

p. 89 **"I saw I"** Ibid., 180.

p. 90 **"a ten-pound box," "been dead center"** John Waters, introduction to *The Complete Short Stories of James Purdy* (New York: Liveright, 2013), xiv.

p. 90 **"Her radical American vision"** Purdy, brief essay in the catalog *Gertrude Abercrombie: Retrospective Exhibition: A Tribute to Gertrude Abercrombie and Her Work* (Chicago: Hyde Park Art Center, 1977).

p. 90 **"Her work itself"** Dennis Adrian, "Abercrombie: Mentor of Art, Chicago-Style," *Chicago Daily News,* February 19–20, 1977.

Behind the Masks: Loïs Mailou Jones

p. 94 **"I discovered"** Charles H. Rowell, "An Interview with Loïs Mailou Jones," *Callaloo* 12, no. 2 (Spring 1989): 6.

p. 94 **"The Grande Dame"** Tracey Robinson-English, "Celebrating Loïs Mailou Jones: The Grand Dame of the Art World (1905–1998)," *Ebony* 61, no. 2 (December 2005): 124–28.

p. 94 **"the establishment"** "A Portrait of the Artist as an Elderly Woman," interview with Joel Siegel, *Good Morning America*, ABC, February 1, 1996.

p. 94 **"I went to 57th Street"** Ibid.

p. 98 **"As a child"** Rowell, "Interview," 1.

p. 98 **"ethnic heritage"** Chris Chapman, *Loïs Mailou Jones: A Life in Color* (Bloomington, IN: Xlibris, 2007), 1.

p. 99 **"I think that much"** Nancy G. Heller, "Loïs Mailou Jones: American Painter," *Museum & Arts Washington*, July/August 1988, 42.

p. 99 **"was really a very"** Chapman, *Loïs Mailou Jones*, 1.

p. 99 **"I was rather"** Loïs Mailou Jones, interview, Black Women Oral History Project, Schlesinger Library, Radcliffe Institute for Advanced Studies, Harvard University, 1977, sequence 19 (hereafter cited as BWOHP).

p. 99 **"What a joy"** BWOHP, sequence 14.

p. 99 **"My life"** Betty LaDuke, "The Grande Dame of Afro-American Art: Loïs Mailou Jones," *SAGE* 4, no. 1 (Spring 1987).

p. 100 **"My mother"** Mark Dorman, "Lois Mailou Jones: A Tribute to a National Treasure," *Washington View*, December/January 1991, 56.

p. 100 **"they would invite"** Heller, "Loïs Mailou Jones," 42.

p. 100 **"little Loïs"** Ibid.

p. 101 **"struck viewers"** Lisa E. Farrington, *Creating Their Own Image: The History of African-American Women Artists* (New York: Oxford University Press, 2005), 65.

p. 101 **"My child"** Ibid., 66.

p. 101 **"the achievements"** Ibid., 67.

p. 102 **"awakening"** Ibid., 70.

p. 103 **"take the long walk"** Rowell, "Interview," 357.

p. 104 **"artistic bent"** Kathleen Ayers, "U.S. Woman Wins Honors and Friends through Art," *USIS Feature*, 1955.

p. 104 **"her most intimate"** Edmund Barry Gaither, "Loïs Mailou Jones: Reflections on a Friendship," in Hanzal, *Loïs Mailou*, 18.

p. 104 **"working with"** BWOHP, sequence 20.

p. 104 **"happy art"** Ayers, "U.S. Woman."

p. 105 **"Even though I sometimes"** "Artist of Sunlit Canvases: Lois Pierre-Noël Explores Colors and Haitian Themes," *Ebony*, November 1968, 138.

p. 105 **"All of these activities"** BWOHP, sequence 21.

p. 106 **"references to"** Lowery Stokes Sims, "Loïs Mailou Jones: From Designer to Artist," in Hanzal, *Loïs Mailou Jones*, 38.

p. 106 **"During the drive"** Rowell, "Interview," 2.

p. 106 **"As I wanted"** Ibid.

p. 106 **"He very kindly"** Ibid., 3.

p. 107 **"We *need* you"** Ibid.

p. 107 **"She thought"** Tritobia Hayes Benjamin, *The Life and Art of Loïs Mailou Jones* (San Francisco: Pomegranate, 1994), 13.

p. 107 **"You understand"** Charlotte Hawkins Brown to Loïs Mailou Jones, July 23, 1928, Loïs Mailou Jones scrapbooks, 1922–1992, Archives of American Art, Smithsonian Institution (hereafter cited as Jones, AAA).

p. 107 **"snappy little sports-car"** Rowell, "Interview," 3–4.

p. 108 **"On learning"** Ibid., 4.

p. 108 **"I built up"** Ibid.

p. 108 **"We need you"** Ibid.

p. 108 **"I am free to admit"** Brown, February 1, 1929, Jones, AAA.

p. 109 **"sympathetic and dignified"** Benjamin, *Life and Art*, 25.

p. 110 **"My dear Miss Jones"** Valerie E. Chase to Jones, February 11, 1937, Jones, AAA.

p. 110 **"Talent is the basis," "You must love"** Benjamin, *Life and Art*, 15.

p. 110 **"Jones was zealous"** Ibid.

p. 111 **"gave Loïs"** Chapman, *Loïs Mailou Jones*, 25.

p. 112 **"the wonderful feeling"** Ibid., 26.

p. 113 **"It was something"** BWOHP, sequence 26.

p. 113 **"But," she related, "the spirit"** Rowell, "Interview," 5.

p. 113 **"Now, my dear Loïs"** Albert Alexander Smith, ca. 1939, Jones, AAA.

p. 113 **"It was ironic"** Chapman, *Loïs Mailou Jones*, 32.

p. 113 **"a very fine artist"** BWOHP, sequence 27.

p. 113 **"practically adopted"** Rowell, "Interview," 5.

p. 113 **"Céline and I"** BWOHP, sequence 27.

p. 114 **"magnificent"** Benjamin, *Life and Art*, 30.

p. 114 **"Gauguin!"** Chapman, *Loïs Mailou Jones*, 36.

p. 114 **"You are a remarkably gifted"** Ibid., 39.

p. 115 **"Paris so mystic"** Rowell, "Interview," 5.

p. 117 **"A keynote work"** Chapman, *Loïs Mailou Jones*, 33.

p. 117 **"if white painters"** Ibid., 32.

p. 117 **"proclaimed the existence"** Farrington, *Creating Their Own Image*, 90–91.

p. 118 **"I was rather young"** "A Portrait of the Artist," *Good Morning America*.

p. 118 **"simply must know"** "Miss Jones Spoke of the Inquisitive Temperament of the Italian People," *Vineyard Gazette*, 1939, Jones, AAA.

p. 119 **"Howard U. Art Instructor"** Clipping without attribution, 1939, Jones, AAA.

p. 119 **"The artist is a Boston"** *Chronicle* (no other information on clipping), Jones, AAA.

p. 120 **"Unbeknownst"** Benjamin, *Life and Art*, 50.

p. 121 **"It was a beautiful"** Rowell, "Interview," 8.

p. 123 **"a vigorous"** Benjamin, *Life and Art*, 50.

p. 123 **"he insisted"** Rowell, "Interview," 6.

p. 123 **"Can I have"** Tritobia Hayes Benjamin, interview by Carla Hanzal, "Remembering Loïs Mailou Jones," in Hanzal, *Lois Mailou Jones*, 87.

p. 123 **"Locke Period"** Chapman, *Loïs Mailou Jones*, 55.

p. 123 **"I was very much disturbed"** Rowell, "Interview," 6.

p. 124 **"He was one"** Ibid.

p. 124 **"I have to paint"** Ibid., 7.

p. 125 **"Loïs, don't"** Ibid., 9.

p. 125–126 **"a well-educated . . . to the States"** BWOHP, sequences 39–40.

p. 126 **"He didn't speak"** Ibid., sequences 38–39.

p. 126 **"I took him"** Ibid., sequence 39.

p. 127 **"And there stood"** Rowell, "Interview," 9–10.

p. 127 **"think about it"** BWOHP, sequence 40.

p. 127 **"civilly," "religiously"** Ibid.

p. 127 **"to be his guest"** Rowell, "Interview," 10.

p. 128 **"my love"** BWOHP, sequence 41.

p. 128 **"I was doing"** BWOHP, sequence 38.

p. 128 **"the man with the microscopic"** "Our Lois Jones," *Pot Pourri*, Haiti, ca. 1977–78, Jones, AAA.

p. 129 **"marriage to Pierre-Noël"** Benjamin, 79.

p. 130 **"After all"** Rowell, "Interview," 10–11.

p. 131 **"that was a very serious"** BWOHP, sequence 37.

p. 131 **"I'm a great"** Ibid.

p. 131 **"It kept me"** Ibid., sequence 38.

p. 132 **"concentrates on"** Clipping, info missing, *Washington Post* (?), circa 1965, Jones, AAA.

p. 132 **"I preferred to work"** LaDuke, "Grande Dame," 55.

p. 132 **"close and happy"** Chapman, *Loïs Mailou Jones*, 73.

p. 132 **"was especially well-suited"** Gaither, "Loïs Mailou Jones," 18–19.

p. 132 **"girlish excitement"** *Pot Pourri*, 1977–78.

p. 133 **"This talented"** America House, U.S. Information Service press release, May 25, 1970, Accra, Ghana, Jones, AAA.

p. 133 **"art is everywhere"** BWOHP, sequence 51.

p. 134 **"the distinguished"** "Concludes Eight-Day Research, Panoramic View, Country Life . . . ," *Ethiopian Herald*, Woman's Page, April 19, 1970, Jones, AAA.

p. 134 **"military zones"** Jones, AAA.

p. 135 **"an international event . . . Washington, D.C."** BWOHP, sequences 50–53.

p. 135 **"I'm not an African"** Ibid., sequence 56.

p. 136 **"a lifelong muse . . . possibilities"** Cheryl Finley, "The Mask as Muse: The Influence of African Art on the Life and Career of Loïs Mailou Jones," in Hanzal, *Loïs Mailou Jones: A Life in Vibrant Color*, 52.

p. 136 **"I feel"** Ibid., 63.

p. 136 **"what I marveled"** Rowell, "Interview," 11.

p. 137 **"I was so interested"** "American Artist Develops New Technique Using African Designs," *Amannee*, U.S. Information Service (USIS) IV, no. 6, 1973.

p. 137 **"explore on canvas"** Benjamin, *Life and Art*, 98.

p. 137 **"an overlapping"** USIS.

p. 140 **"Loïs argued:"** Gaither, "Loïs Mailou Jones," 15.

p. 140 **"Don't get"** LaDuke, "Grande Dame," 56.

p. 141 **"As an artist"** *Washington View*, December/January 1991, 58.

p. 141 **"the first African-American"** Farrington, *Creating Their Own Image*, 183.

p. 142 **"She leads me"** Heller, "Loïs Mailou Jones," 42.

p. 142 **"a well-rounded"** Hanzal, *Loïs Mailou Jones*, 76.

p. 143 **"You know I think . . . your disposal"** Ibid., 78.

p. 143 **"put [her] whole . . . to complete"** LaDuke, "Grande Dame," 56.

p. 143 **"reserved her . . . century"** Gaither, "Loïs Mailou Jones," 21.

p. 143 **"was at the forefront"** Finley, "Mask as Muse," 63.

p. 143 **"As students of"** Benjamin, *Life and Art*, vii.

p. 144 **"summer idylls"** Chapman, *Loïs Mailou Jones*, 103.

p. 144 **"physically"** Betty LaDuke, "Loïs Mailou Jones: The Grande Dame of African-American Art," *Women's Art Journal* 8, no. 2, Fall 1987/Winter 1988, p. 30.

p. 144 **"She felt that"** Chapman, *Loïs Mailou Jones*, 54.

p. 144–145 **"I might say . . . today"** BWOHP, sequence 46.

p. 145 **"the art department"** LaDuke, *Women's Art Journal*, 30.

p. 145 **"It was many"** Chapman, *Loïs Mailou Jones*, 16.

p. 145 **"I write . . . on Saturday"** Jones, AAA.

p. 146 **"Pierre was"** Jean & Dick Wolford, Jones, AAA.

p. 146 **"Dear Loïs:"** Ibid.

p. 147 **"Ours was"** Rowell, "Interview," 10.

p. 148 **"In grateful recognition"** Loïs Mailou Jones Foundation: www.loismailoujones.com/index .php?page=legacy

p. 148 **"gracefully passed"** Chapman, *Loïs Mailou Jones*, 111.

p. 148 **"Ms. Jones"** Holland Cotter, *New York Times*, June 13, 1998.

p. 148 **"Although I still"** LaDuke, *Women's Art Journal*, 32.

p. 149 **"Although she"** Dele Jegede, *Encyclopedia of African American Artists* (Westport, CT: Greenwood Press, 2009), 123.

p. 149 **"was never fully"** Benjamin, interview in Hanzal, *Lois Mailou Jones*, 91.

p. 149–150 **"Of my two handicaps"** Farrington, *Creating Their Own Image*, 155.

p. 150 **"We are deeply"** LaDuke, *SAGE* IV, no. 1, Spring 1987, 57.

p. 152 **"wee wooden schoolhouse"** W.E.B. Du Bois, *The Souls of Black Folk* (New Haven, CT: Yale University Press, 1903; rev. ed., 2015), 4.

p. 152 **"After the Egyptian"** Ibid., 5.

"The Rebellious Bravo": Ree Morton

p. 154 **"Thinking about art"** *The Mating Habits of Lines: Sketchbooks and Notebooks of Ree Morton* (Burlington: Robert Hull Fleming Museum/University of Vermont, 2155), 101 (hereafter cited as *TMHL*).

p. 155 **"The spaces are"** Lucy Lippard, "Ree Morton: At the Still Point of the Turning World," *Artforum* 12, no. 4 (December 1973): 48–50.

p. 157 **"Art can be"** *TMHL*, 32.

p. 158 **"My work is"** Ibid.

p. 158 **"too damned"** Ibid., 48.

p. 159 **"How to deal"** Ibid.

p. 159 **"The misinterpretations"** Ibid., 52.

p. 160 **"The point in"** Ibid., 3.

p. 160 **"Drawings based"** Ibid., 23.

p. 160 **"myth is"** Ibid., 92.

p. 160 **"Work of art"** Ibid., 24.

p. 160 **"'What a nice'"** Ibid., 25.

p. 161 **"REALITY"** Ibid., 64.

p. 162 **"I still was"** Lyn Blumenthal and Kate Horsfield, *Ree Morton* (Chicago: Video Data Bank, 1974; hereafter cited as Blumenthal/Horsfield).

p. 162 **"was something"** Ibid.

p. 163 **"Previous Accomplishments"** *TMHL*, 11.

p. 163 **"very serious"** Blumenthal/Horsfield.

p. 164 **"spiritual unfoldment"** Derrel B. DePasse, *Traveling the Rainbow: The Life and Art of Joseph E. Yoakum* (Jackson, MS: University Press of Mississippi, 2000), 17.

p. 165 **"There is hidden"** John Ashbery, *ArtNews Annual 1961*, reprinted in Raymond Roussel, *How I Wrote Certain of My Books* (Cambridge, MA: Exact Change, 1995), viii.

p. 165 **"everything appeared . . . hieroglyphics"** Raymond Roussel, *Impressions of Africa*, trans. Lindy Foord and Rayner Heppenstall (London: John Calder, 2001), 5–6.

p. 166 **"Then came"** Ibid., 11.

p. 166 **"To the question"** Ibid., 27.

p. 166 **"*Impressions of Africa* was"** Blumenthal/Horsfield.

p. 166 **"IT IS IMPOSSIBLE"** *TMHL*, 43.

p. 166 **"DO SOME PAINTINGS"** Ibid., 50.

p. 168 **"It seems to me"** Ibid., 98.

p. 168 **"Unamuno"** Ree Morton, Notebook, 1973–1974, in Allan Schwartzman and Kathleen Thomas, *Ree Morton: Retrospective, 1971–1977* (New York: New Museum, 1980), 39 (hereafter cited as Schwartzman/Thomas).

p. 169 **"I love to draw"** James Ensor, quoted in *TMHL*, 67.

p. 171 **"personality"** Ibid., 72.

p. 171 **"Women artists . . . is consistent"** Ibid., 58.

p. 172 **"Embossed Words . . . deciphering it."** Schwartzman/Thomas, 42–43.

p. 173 **"since i came . . . and regattas"** "Places: Ree Morton," originally in *Journal*, the Southern California Art Magazine of the Los Angeles Institute of Contemporary Art; reprinted in Schwartzman/Thomas, 56.

p. 174 **"a veritable"** Schwartzman/Thomas, 65.

p. 174 **"a mingling . . . his world"** Jed Perl, *Antoine's Alphabet: Watteau and His World* (New York: Knopf, 2008), 4–5.

p. 175 **"new decorativeness . . . body of work"** Judith E. Stein and Ann-Sargent Wooster, *Making Their Mark: Women Artists Move into the Mainstream, 1970–1985*, ed. Randy Rose and Catherine C. Brawer (New York: Abbeville Press, 1989), 155–56.

p. 175 **"seasets and sunscapes"** Schwartzman/Thomas, 58.

p. 176 **"i watched"** Ibid., 56.

p. 176 **"It seems to me"** *TMHL*, 117.

p. 177 **"an ex-Navy . . . worn off for me"** Peter Schjeldahl, *Columns & Catalogues* (Great Barrington, MA: The Figures, 1994), 92, 94.

p. 178 **"I look . . . household objects"** Blumenthal/Horsfield.

p. 178 **"loves the mystery . . . out of here!"** Ibid.

p. 178–179 **"The use of color . . . Just waiting"** Ibid.

p. 179 **"was founded . . . contact with them"** Marcia Tucker, preface to Schwartzman/Thomas, 3.

Swimming in Light: Joan Brown

p. 182 **"My work"** Karen Tsujimoto and Jacquelynn Baas, *The Art of Joan Brown* (Berkeley and Los Angeles: University of California Press, 1998), 18 (hereafter cited as *TAJB*).

p. 183 **"California Spanish . . . and that was it"** Oral history interview with Joan Brown, 1975 July 1–September 9, Archives of American Art, Smithsonian Institution, 3–4 (hereafter cited as Brown, AAA).

p. 184 **"Meanwhile . . . was killed"** Ibid., 5.

p. 185 **"It was all attitudes"** Ibid.

p. 185 **"There was a wall"** Ibid., 6.

p. 185 **"pointer"** Ibid., 1–2.

p. 186 **"He drank himself"** Ibid., 11.

p. 187 **"It was wacky"** Ibid., 9.

p. 187 **"very, very angry"** Ibid., 7.

p. 187 **"all kinds . . . particular people"** Ibid., 28–29.

p. 187 **"I would go"** Ibid., 25–26.

p. 188 **"It was tense"** Ibid., 9.

p. 188 **"So on the one hand"** Ibid., 13.

p. 189 **"pushed . . . artist"** Ibid., 14.

p. 189 **"I just picked"** Ibid., 13.

p. 189 **"I hated" "my immediate goal" "I like"** Ibid., 14–15.

p. 189 **"Be an artist"** Lynn Gumpert, interview with Joan Brown, in *Early Works* (New York: New Museum, 1982), 16.

p. 189 **"I loved"** Brown, AAA, 14.

p. 189 **"this brick patio . . . arty attire."** Ibid., 23–24.

p. 190 **"was going"** Ibid., 25.

p. 190 **"I'm in the wrong area"** Ibid., 33.

p. 190 **"Gee, he was"** Ibid., 26.

p. 191 **"But down deep"** Ibid., 29–30.

p. 192 **"I believe"** Online Archive of California, www.oac.cdlib.org.

p. 192 **"critical standard . . . financial success"** *TAJB*, 11–12.

p. 193 **"make a lot . . . which I liked"** Blumenthal and Kate Horsfield, *Joan Brown: An Interview* (Chicago: Video Data Bank, 1979; hereafter cited as Blumenthal/Horsfield).

p. 193 **"delighted in"** *TAJB*, 13.

p. 193 **"vivid study"** *TAJB*, 11.

p. 193 **"I got sick"** Brown, AAA, 27–28.

p. 194 **"Her reputation"** *TAJB*, 13.

p. 195 **"Undoubtedly"** *TAJB*, 17–18.

p. 195 **"whopping metaphor"** Michael Dunan, "Chancing the Ridiculous," in *Jay DeFeo: A Retrospective* (New York: Whitney Museum of American Art; New Haven, CT: Yale University Press, 2012), 68.

p. 196 **"ragged bits"** *TAJB*, 21.

p. 196 **"It was really . . . frankly"** Brown, AAA, 55–56.

p. 197 **"Right away"** Ibid., 37.

p. 197 **"So I worked . . . friendly"** Ibid., 29.

p. 197 **"after a point"** Ibid., 58.

p. 198 **"special rapport . . . materials"** *TAJB*, 24.

p. 198 **"a move"** Ibid., 26.

p. 198 **"Well, my family"** Oral history interview with Manuel Neri, conducted by Lynn Robert Matteson, May 6, 2008, Archives of American Art, Smithsonian Institution (hereafter cited as Neri, AAA).

p. 199 **"to make"** Ibid.

p. 199 **"wild as hell . . . big deal"** Ibid.

p. 199 **"Manuel"** Brown, AAA.

p. 201 **"I'm glad"** *TAJB*, 37.

p. 201 **"I was teaching"** Brown, AAA, 39.

p. 202 **"Then we got . . . and foot."** Ibid., 39–40.

p. 202 **"Okay. Come . . . every morning"** Neri, AAA.

p. 203 **"unbelievably moving"** Brown, AAA, 40.

p. 203 **"Because it was"** Ibid., 42.

p. 204 **"It had some"** Ibid., 43.

p. 204 **"His hardness"** Ibid., 37–38.

p. 204 **"I was very"** Ibid., 49.

p. 207 **"archetypal"** *TAJB*, 58.

p. 207 **"all of a sudden"** Neri, AAA.

p. 207 **"each vitally . . . of her medium"** *TAJB*, 59.

p. 208 **"feeling very"** Ibid., 65. Tsujimoto is quoting from Jan Butterfield, "Joan Brown in Conversation with Jan Butterfield," *Visual Dialog* 1, no. 2 (December 1975–February 1976): 15–18.

p. 208 **"immense happiness"** *TAJB*, 62.

p. 209 **"She was really"** Estate of Joan Brown website.

p. 209 **"a vividly"** *TAJB*, 65.

p. 209 **"whom Brown"** Ibid., 62.

p. 210 **"questioning"** Ibid., 75.

p. 211 **"When the pressure"** Blumenthal/Horsfield.

p. 211 **"I . . . decided"** Ibid.

p. 211 **"I felt"** Gumpert, interview, 17.

p. 211 **"I got the stars"** Claudia Steenberg-Majewski, "Joan Brown: One Stroke Ahead," in *Artbeat* (San Francisco), April 1981, 9.

p. 212 **"I really don't . . . is hooked into"** Ibid.

p. 212 **"thin layers . . . all but lost"** *TAJB*, 75.

p. 212 **"after I'd"** Brown, AAA, 19.

p. 213 **"from my childhood"** Ibid., 22–23.

p. 215 **"either deliberately"** *TAJB*, 85.

p. 216 **"I feel that"** Ibid., 86.

p. 216 **"absolutely panned . . . until 1974"** Blumenthal/Horsfield.

p. 217 **"a large, handsome"** Barbara Janeff, introduction to the online catalog for *Gordon Cook (1927–19850): A Retrospective of Real Magic* (Bolinas, CA: Bolinas Museum, 2010), bolinas-museum.org/exhibition10052.html.

p. 218 **"magnetic and . . . 'Get it right'"** Don Ed Hardy, "About Gordon Cook," in ibid.

p. 218 **"firecracker . . . and magical"** *TAJB*, 89.

p. 218 **"See, I've been"** Brown, AAA, 17–18.

p. 219 **"prodigious creativity"** *TAJB*, 191.

p. 220 **"a little doll"** Hayden Herrera, *Frida* (New York: HarperCollins, 1984; paperback edition, 2002), 120. Page reference is to the 2002 edition.

p. 221 **"in the air"** Ibid., 124.

p. 221 **"her feeling"** Ibid., 357.

p. 221 **"They might be"** Brown, AAA, 53.

p. 222 **"I feel most"** Ibid., 45.

p. 223 **"struck by their"** *TAJB*, 93.

p. 223 **"I felt a big"** Brown, AAA, 10.

p. 223 **"She hung herself"** Ibid., 9.

p. 224 **"real neat . . . of family life"** Ibid., 11–13.

p. 225 **"left, in cash"** Ibid., 6.

p. 226 **"I find it . . . things like that"** Blumenthal/Horsfield.

p. 226 **"And as the years"** Brown, AAA, 85.

p. 228 **"and when he"** *TAJB*, 202.

p. 229 **"I prefer to"** Blumenthal/Horsfield.

p. 231 **"Many people"** Andrée Maréchal-Workman, "An Interview with Joan Brown," in *Expo-see Magazine*, March–April 1985.

p. 232 **"a tremendous"** Brown, AAA, 39.

p. 232 **"It's one of my"** Ibid., 20.

p. 232 **"All these men"** Ibid.

p. 233 **"I think that"** Gumpert, interview, 21.

p. 234 **"appeared to her"** *TAJB*, 202.

p. 234 **"I trust the unconscious"** Brown, AAA, 98.

p. 235 **"I think my life"** Brown, AAA, 19.

p. 235 **"a natural, innate"** Ibid.

p. 236 **"the symbol of"** Gumpert, interview, 22.

p. 236 **"In Chinese culture . . . and vitality"** *TAJB*, 98.

p. 238 **"I like to leave"** Maréchal-Workman, "Interview with Joan Brown."

p. 238 **"modest, unassuming"** *TAJB*, 108.

p. 240 **"All of a sudden"** Brown, AAA, 97.

p. 240 **"These are among"** *TAJB*, 108.

p. 240 **"Brown was a child"** Ibid., xxxiv.

p. 241 **"maybe fifty times" "laying around"** Video interview, San Francisco Museum of Modern Art, Joan Brown Estate website, www.joanbrownestate.org (hereafter cited as SFMOMA/Brown Estate).

p. 242 **"There was a very . . . and authority"** *TAJB*, 113.

p. 244 **"Charlie Sava"** Brown, AAA, 95.

p. 245 **"It's been very hard"** Ibid., 92–93.

p. 246 **"I think it's a goddamn"** Ibid., 81.

p. 246 **"In terms of living"** Maréchal-Workman, "Interview with Joan Brown."

p. 246 **"I hope"** Brown, AAA, 76.

p. 247 **"They were never"** Ibid., 78.

p. 247 **"I was a little" "'Goddamn it!'"** Ibid., 77.

p. 247 **"The reason I taught"** Maréchal-Workman, "Interview with Joan Brown."

p. 248 **"I've always wondered"** Steenberg-Majewski, "Joan Brown."

p. 249 **"they're very quick"** Brown, AAA, 96.

p. 250 **"very nervous"** Ibid., 87.

p. 250 **"But this Alcatraz"** Ibid.

p. 250–251 **"Jesus, what misinformation" "We all got lost"** Ibid., 87–88.

p. 251–252 **"I didn't want . . . inside and out"** Ibid., 89.

p. 251 **"After the swim"** SFMOMA/Estate of Joan Brown website.

p. 252 **"very stylized"** Ibid.

p. 253 **"She painted"** Noel Neri speaking in a video, San Francisco Arts Commission website: www.sfartscommission.org/toursfo/Brown_Slideshow/.

p. 254 **"Hell, if I lived"** Brown, AAA, 101.

p. 254 **"Well I've asked"** Ibid., 53.

p. 255 **"was a terrible"** SFMOMA interview/Estate of Joan Brown website.

p. 255 **"Some have suggested"** TAJB, 138.

p. 255 **"was outgoing"** Abby Wasserman, "Into the Light: The Transformation of Joan Brown," *Museum of California Magazine* (Oakland Museum of California), 1998.

p. 256 **"rowed beside . . . mental therapy"** Ibid.

p. 258 **"As if by some," "Yet in spite"** TAJB, 152.

p. 258 **"the most humane"** Brown, AAA, 50–51.

p. 259 **"God, my favorite"** Ibid., 95.

p. 260 **"distressingly vapid"** TAJB, 153–54.

p. 260 **"I was sitting"** Fritjof Capra, *The Tao of Physics* (Boston: Shambhala, 2010), 11.

p. 261 **"highest aim"** Ibid., 24.

p. 261 **"be in perfect"** Ibid., 25.

p. 262 **"Your friends"** Wasserman, "Into the Light."

p. 262 **"I was a good"** Ibid.

p. 264 **"developed"** TAJB, 157.

p. 267 **"Where do you"** Steenberg-Majewski, "Joan Brown."

p. 268 **"scattered and racing"** TAJB, 185.

p. 269 **"was metaphorically"** Ibid., 163.

p. 270 **"there were fish"** Ibid., 218.

p. 270 **"'One of my main'"** Zan Dubin, "An Artist's Vision of Peace: In Paintings and Sculpture, Joan Brown Looks Back to Ancient Golden Eras, Ahead to the Dawning Age of Aquarius," *Los Angeles Times*, September 16, 1986.

p. 272 **"Her slightly faux-naif"** TAJB, 165.

p. 272 **"In past civilizations"** Ibid.

p. 273 **"These days"** Dubin, "Artist's Vision of Peace."

p. 275 **"Subjectively"** Maréchal-Workman, "Interview with Joan Brown."

p. 278 **"There's certainly"** Ibid.

p. 279 **"a golden globe"** TAJB, 170.

p. 281 **"frequently talked"** Ibid., 174.

p. 281 **"Words cannot"** Ibid.

p. 281 **"Before I left"** Wasserman, "Into the Light."

Freeze and Melt: Christina Ramberg

Excerpts from Christina Ramberg's diaries, notebooks, and sketchbooks are used with permission from Alexander Hanson, including works seen at Corbett vs. Dempsey and the Department of Prints and Drawings at the Art Institute of Chicago.

p. 284 **"The point is"** Christina Ramberg, Journal #2, 1970–71.

p. 289 **"sunny"** Debbie Ramberg Blackwood, interview with the author, June 9, 2014.

p. 291 **"Since I last"** Ramberg, Journal #2.

p. 291 **"She surprised"** Jane Ramberg, interview with the author, May 25, 2014.

p. 292 **"advent of the pill . . . feeling nothing"** Norman Cousins, "We Have Swept Away Too Many of the Old Taboos," Baltimore *Sun*, July 4, 1976.

p. 293 **"I remember . . . of self-doubt"** Rebecca Shore, interview with the author, May 19, 2014.

p. 293 **"Jim Speyer"** Ramberg, Journal #2.

p. 294 **"There is no real"** Carol Becker, "Christina Ramberg in Retrospect," in *Christina Ramberg: A Retrospective, 1968–1988* (Chicago: Renaissance Society at the University of Chicago, 1988), 19 (hereafter cited as Renaissance Society).

p. 294 **"My father"** Kerstin Nelje, "Christina Ramberg and Luce Irigaray: A Feminist Analysis of Ramberg's Female Figures" (master's thesis, School of the Art Institute of Chicago, 1990), 3.

p. 295 **"Christina always"** Blackwood, interview.

p. 297 **"The feminine mystique . . . and children"** Betty Friedan, *The Feminine Mystique* (New York: W.W. Norton, 1963; reprint, 2001), 91–92.

p. 299 **"has been a godsend"** David Elliott, "Show," *Chicago Sun-Times*, January 7, 1979, 8.

p. 299 **"For a while"** Ramberg, Journal #1, 1969–1970.

p. 300 **"I remember it"** Ramberg, interview by Morgan Spangle, Richard Gray Gallery, Chicago, 1983, 1–2.

p. 301 **"When we came"** Jane Ramberg, interview.

p. 302 **"He would sit"** Blackwood, interview.

p. 302 **"The war there"** Jane Ramberg, interview.

p. 302 **"Christina had"** Blackwood, interview.

p. 302 **"It was hard"** Ibid.

p. 303 **"There are really tall"** Jane Ramberg, interview.

p. 303 **"Finding shoes"** Philip Hanson, interview with the author, May 22, 2014.

p. 303 **"clothes that looked"** Shore, interview.

p. 303–304 **"Christina was . . . encouraged her"** Jane Ramberg, interview.

p. 305 **"sent students"** Susan Weininger and Lisa Meyerowitz, "Modernism in the New City, Chicago Artists, 1920–1950," www.chicagomodern.org/artists/kathleen_blackshear/.

p. 305 **"Halstead's image-proliferative"** Robert Cozzolino, "Chicago's Modernism," in *Art in Chicago: Resisting Regionalism, Transforming Modernism* (Philadelphia: Pennsylvania Academy of the Fine Arts, 2007), 21.

p. 305 **"a vigorous intellectual"** John Corbett, *Touch and Go: Ray Yoshida and His Spheres of Influence* (Chicago: Corbett vs. Dempsey, 2015), 3.

p. 306 **"I was interested"** Ibid., 59.

p. 306 **"collector of all"** "Ray Yoshida's Museum of Extraordinary Values," Kohler Art Center website, www.jmkac.org. Available October 2013–January 2014.

p. 306 **"credit Yoshida"** Karen Patterson, Ibid., video.

p. 308 **"On my wall"** Ramberg, Journal #1.

p. 309 **"quasi religious . . . arrangement"** Spangle, interview, 13.

p. 309 **"They were very . . . Unitarians"** Jane Ramberg, interview.

p. 310 **"nocturnal painter"** John Corbett, *Christina Ramberg: Corset Urns & Other Inventories, 1968–1980* (Chicago: Corbett vs. Dempsey, 2011), 5.

p. 311 **"Christina had"** Ibid.

p. 311 **"I love her take"** Blackwood, interview.

p. 312 **"very frustrating" "It was exciting" "Going to Arezzo"** Spangle, interview, 7, 8, 11.

p. 313 **"with oil"** Hanson, interview.

p. 314 **"crusader . . . artistic talent"** Tribute to Don Baum, Elmhurst College, 2011, video, www.elmhurst.edu/alumni/126124068.html.

p. 314 **"very much interested"** Oral history interview with Don Baum, Jan. 31–May 13, 1986, Archives of American Art, Smithsonian Institution.

p. 315 **"there was a place"** Spangle, interview, 6.

p. 315 **"a very good show . . . flippy Jim Nutt."** Franz Schulze, "The False Image and the Image of Chicago," *Chicago Daily News*, November 30, 1968.

p. 315–316 **"was just emerging . . . I said OK"** Spangle, interview, 7.

p. 318 **"Chicago was a rare"** Robert Cozzolino, *The Female Gaze: Women Artists Making Their World* (Philadelphia: The Pennsylvania Academy of the Fine Arts, 2012), 64.

p. 318 **"Seeing so much"** Ramberg, Journal #1.

p. 319 **"My paintings seem"** Ibid.

p. 320 **"Hanson's work"** Greg Cook on Boston's *WBUR's ARTery*, www.wbur.org/artery.

p. 320 **"huge canvases . . . in the way"** Spangle, interview, 13–14.

p. 321 **"The first paintings"** Ibid., 14.

p. 321 **"One thing . . . the same time"** Ibid., 15–17.

p. 322 **"Phil suggested"** Ramberg, Journal #1.

p. 322 **"A second thing"** Ibid.

p. 323 **"a tour de force"** Jenelle Porter, "Some Approaches for Exploring Collected Material," in *Christina Ramberg* (Boston: Institute of Contemporary Art, 2013), 48.

p. 325 **"We did see"** Blackwood, interview.

p. 328 **"Christina had"** Ibid.

p. 328 **"Students liked"** Hanson, interview.

p. 328 **"She was a wonderful . . . how dedicated she was"** Shore, interview.

p. 331 **"We think of"** Ivan Albright, *Art in Chicago*, 17.

p. 332 **"Oh, it was very"** Blackwood, interview.

p. 332 **"Christina did"** Jane Ramberg, interview.

p. 337 **"Christina felt"** Ibid.

p. 338 **"I had been"** Ramberg, questionnaire from curator Barbara Brackman for a 1985 exhibit at Gallery Karl Oskar, Westwood Hills, Kansas.

p. 338 **"We were both"** Shore, interview.

p. 339 **"We loved to"** Ibid.

p. 339 **"Becky and I"** Ramberg, Brackman questionnaire.

p. 339 **"Alex, at one"** Shore, interview.

p. 340 **"Japan had a huge"** Blackwood, interview.

p. 341 **"She loved the"** Jane Ramberg, interview.

p. 344 **"sensation of paint"** Judith Russi Kirshner, *Surfaces: Two Decades of Painting in Chicago, Seventies and Eighties* (Chicago: Terra Museum of American Art, 1987), 17.

p. 348 **"In her work"** Dennis Adrian, "Christina Ramberg," in Renaissance Society, 4.

p. 349 **"as though she"** Hanson, interview.

p. 350 **"Christina began"** Ibid.

p. 350 **"Christina was acting"** Shore, interview.

p. 350 **"We thought maybe"** Hanson, interview.

p. 351 **"With Charles and Christina"** Jane Ramberg, interview.

p. 351 **"Christina's illness"** Blackwood, interview.

All of a Piece: Lenore Tawney

Excerpts from Lenore Tawney's notebooks used with the permission of the Lenore G. Tawney Foundation.

p. 353 **"I become timeless"** Tawney, notebook.

p. 353 **"quietly developed"** Katharine Kuh, foreword, in *Lenore Tawney: A Retrospective*, ed. Kathleen Nugent Mangan (New York: American Craft Museum, 1990), 11 (hereafter cited as *LTR*).

p. 354 **"Quiet and light"** Kathleen Nugent Mangan, "Remembering Lenore Tawney," *New York Arts* 13 (March/April 2008), 70.

p. 355 **"had other ideas"** Ibid.

p. 355 **"a farm girl"** Eleanor Munro, *Originals: American Women Artists* (New York: Simon & Schuster, 1979), 326.

p. 355 **"It had a shipyard . . . Lorain, Ohio"** Oral history interview with Lenore Tawney, June 23, 1971, conducted by Paul Cummings, Archives of American Art, Smithsonian Institution (hereafter cited as Tawney, AAA).

p. 356 **"Why?"** Rita Reif, "ARTS/ARTIFACTS; Artistry and Invention Seamlessly Joined," *New York Times*, November 26, 1995.

p. 356 **"became proficient"** Munro, *Originals*, 326.

p. 356 **"Well, it was"** Tawney, AAA.

p. 356 **"He was the most"** Peter Golenbock, *Wrigleyville: A Magical History Tour of the Chicago Cubs* (New York: St. Martin's, 1999), 279.

p. 357 **"happy yet"** Kathleen Nugent Mangan, "Messages from a Journey," in *LTR*, 17.

p. 357 **"devastated"** Ibid., 18.

p. 358 **"something newer"** Tawney, AAA.

p. 358 **"enthusiastic and inspiring . . . and motion"** Thomas Dyja, *The Third Coast: When Chicago Built the American Dream* (New York: Penguin, 2015), 45–46.

p. 358 **"quite marvelous . . . couldn't draw"** Tawney, AAA.

p. 358–359 **"draw our . . . freeing to me"** Munro, *Originals*, 326–27.

p. 359 **"So I studied"** Tawney, AAA.

p. 359 **"It seems that"** Ibid.

p. 359 **"While the house"** Munro, *Originals*, 327.

p. 360 **"I thought"** Ibid.

p. 360 **"I didn't want"** Tawney, AAA.

p. 360 **"My work"** Munro, *Originals*, 328.

p. 361 **"I began to"** Margo Hoff, "Lenore Tawney: The Warp Is Her Canvas" in *Crafts Horizon* 17 (November/December 1957), 14–19.

p. 362 **"Well, that was"** Tawney, AAA.

p. 362 **"I became very sick" "the part where"** Munro, *Originals*, 328.

p. 362 **"I had the freedom"** Ibid., 329.

p. 362 **"The trouble" "snowbound"** Tawney, AAA.

p. 362 **"essentially paintings"** Munro, *Originals*, 329.

p. 362 **"the warp," "Weavers"** Hoff, "Lenore Tawney."

p. 363 **"We had to follow . . . dances sometimes"** Tawney, AAA.

p. 363 **"The lake"** Ibid.

p. 365 **"Tawney opened"** Warren Seelig, "Thinking Lenore Tawney," in *Lenore Tawney: Wholly Unlooked For* (Baltimore: Maryland Institute College of Art; Philadelphia: University of the Arts, 2013), 20.

p. 365 **"the Inner Self"** Jean d'Autilia, *Lenore Tawney: A Personal World* (Brookfield, CT: Brookfield Craft Center, 1978).

p. 365 **"Shimmering hues"** Sigrid Wortmann Weltge, *Lenore Tawney: Celebrating Five Decades of Work* (Wilton, CT: browngrotta arts, 2000), 8.

p. 365 **"Linear time"** d'Autilia, *A Personal World*.

p. 366 **"I had a friend"** Tawney, AAA.

p. 366 **"I felt in Chicago"** Ibid.

p. 366 **"I left Chicago"** LTR, 21.

p. 367 **"you know water"** Ibid.

p. 367 **"warehouses"** Nancy Princenthal, *Agnes Martin: Her Life and Art* (New York: Thames & Hudson, 2015), 65.

p. 368 **"mutually affecting . . . dress her loom"** Sid Sachs, "Lenore Tawney: Wholly Unlooked For," in Seelig, *Wholly Unlooked For*, 6.

p. 368 **"That's what's wonderful"** Princenthal, *Agnes Martin*, 68.

p. 368 **"How could she"** Seelig, *Wholly Unlooked For*, 20.

p. 369 **"could be comfortable"** Princenthal, 73.

p. 369 **"Martin is"** Ibid.

p. 369 **"associations with both"** Princenthal, *Agnes Martin*, 73.

p. 369 **"So there I was"** Tawney, AAA.

p. 370 **"Lenore was a sprite"** Princenthal, *Agnes Martin*, 74.

p. 371 **"I like commission"** Hoff, "Lenore Tawney."

p. 372 **"represented simply . . . speaks of Jesus as 'light'"** *LTR*, 22.

p. 372 **"Let threads"** Anni Albers, *Pictorial Weaves* (Cambridge: MIT, 1959); quoted in Elissa Auther, *String Felt Thread: The Hierarchy of Art and Craft in American Art* (Minneapolis: University of Minnesota Press, 2010), 18.

p. 373 **"thoughtfulness . . . may be art"** Anni Albers, *On Weaving* (Middleton, CT: Wesleyan University Press, 1965), 72.

p. 373 **"One of the earliest"** Ibid., 67.

p. 373 **"one of the highest"** Ibid., 68.

p. 373 **"a magnificent . . . new ideas"** Mangan, *LTR*, 80.

p. 374 **"I wasn't doing"** Tawney, AAA.

p. 374 **"The idea of"** Mangan, *LTR*, 22.

p. 374 **"Five strands"** Mildred Constantine and Jack Lenor Larsen, *Beyond Craft: The Art Fabric* (New York: Van Nostrand Reinhold, 1972), 267–71.

p. 374 **"Well, then when"** Tawney, AAA.

p. 376 **"constructed as"** Kathleen Mangan, *Lenore Tawney: Drawing in Air* (Wilton, CT: brown-grotta arts, 2007), 5.

p. 376 **"But the curious"** Munro, *Originals*, 330.

p. 376 **"They just poured"** Ibid.

p. 377 **"You can't go"** Tawney, AAA.

p. 377 **"To see new . . . be proud"** Agnes Martin, quoted in *LTR*, 22–24.

p. 377 **"Here for the first"** Constantine and Larsen, *Beyond Craft*, 45.

p. 378 **"At this time"** Ibid., 267.

p. 380 **"I just felt"** Tawney, AAA.

p. 380 **"I made it"** Ibid.

p. 380 **"In 1959"** Tawney, in Weltge, *Celebrating Five Decades*, 42.

p. 381 **"And then these"** Tawney, AAA.

p. 381 **"tactile perception . . . painting"** Albers, *On Weaving*, 64.

p. 384 **"I have a terrific"** Tawney, AAA.

p. 385 **"Perhaps perversely"** Judith E. Stein, "The Inventive Genius of Lenore Tawney: Reflections on a Lifetime of Art," *Fiberarts* 24, no. 2 (September/October 1997), 31–32.

p. 385 **"crowd her"** Erika Billeter, "A Very Personal World for L.T.," in *LTR*, 39.

p. 385 **"I pick up"** d'Autilia, *Lenore Tawney*.

p. 386 **"visual poetry"** Paul J. Smith, "A Tribute to Lenore," in *LTR*, 15.

p. 386 **"on that theme"** d'Autilia, *A Personal World*.

p. 386 **"All this had"** Tawney, AAA.

p. 386 **"Blue was"** Sachs, "Wholly Unlooked For," 9.

p. 386 **"I saw all"** Billeter, "A Very Personal World," 42.

p. 387 **"The work invites"** James Schuyler, "Lenore Tawney," in *Selected Art Writings of James Schuyler*, ed. Simon Pettet (Santa Rosa, CA: Black Sparrow Press, 1998), 248–49.

p. 388 **"actually the postcards"** d'Autilia, *A Personal World*.

p. 389 **"In Tawney's"** Holland Cotter, *Lenore Tawney: Signs on the Wind* (San Francisco: Pomegranate, 2002), 9.

p. 389 **"Words and letters"** Tawney diary, quoted in "The Art of Handwriting," an online AAA exhibition, www.aaa.si.edu/exhibitions/art-of-handwriting.

p. 390 **"'Yeah,' he said'"** Lines from Tawney's postcards are all from *Signs on the Wind*: 95, 27, 26, 28, 17, 81.

p. 391 **"became interested"** Paul J. Smith, "Toshiko Takaezu: Six Decades," in *In the Language of Silence: The Art of Toshiko Takaezu*, ed. Peter Held (New York: Toshiko Takaezu Book Foundation; Chapel Hill: University of North Carolina Press, 2010), 14.

p. 392 **"She did not suffer" "Toshiko's friendship"** Jack Lenor Larsen, foreword to Held, *Art of Toshiko Takaezu*, 12.

p. 392 **"Toshiko Takaezu"** Janet Koplos, "An Unsaid Quality," in Held, *Art of Toshiko Takaezu*, 19.

p. 392 **"ceremonial . . . secret space"** Smith, in Held, *Art of Toshiko Takaezu*, 16.

p. 393 **"some see her"** Ibid., 19.

p. 393 **"What I don't know"** Ibid., 38.

p. 393 **"An artist"** Ibid., 17.

p. 394 **"Hundreds"** Weltge, *Celebrating Five Decades*, 48.

p. 394 **"I did some"** Tawney, AAA.

p. 395 **"The transmutation"** Weltge, *Celebrating Five Decades*, 11.

p. 395 **"I start with"** Mangan, *Drawing in Air*, 16.

p. 396 **"All life is fire"** Ibid., 7.

p. 396 **"For Boehme"** Ibid.

p. 396 **"the systemic"** Mildred Constantine and Jack Lenor Larsen, *The Art Fabric: Mainstream* (New York: Van Nostrand Reinhold, 1981), 187.

p. 397 **"So she took it!"** Tawney, AAA.

p. 397 **"So I bought"** Ibid.

p. 398 **"In the world"** *LTR*, 67.

p. 398 **"I made some"** d'Autilia, *A Personal World*.

p. 400 **"For years"** *LTR*, 28.

p. 400 **"The Tao"** Ibid., 62.

p. 401 **"the meeting"** Ibid., 28.

p. 402 **"I painted"** Georgia O'Keeffe, Art Institute of Chicago website, www.artic.edu/aic/collections/artwork/100858?search_no=2&index=17.

p. 403 **"After my husband"** Tawney, AAA.

p. 404 **"With his dark"** Philip Goldberg, *American Veda: From Emerson and the Beatles to Yoga and Meditation; How Indian Spirituality Changed the West* (New York: Harmony, 2010), 182.

p. 404 **"that was probably"** Ibid., 183.

p. 405 **"a senior aide"** William J. Broad, "Yoga and Sex Scandals: No Surprise Here," *New York Times*, Feb. 27, 2012.

p. 406 **"sought to fuse"** Ibid.

p. 406 **"fan the . . . heart failure"** Ibid.

p. 406 **"Lenore Tawney wishes"** *LTR*, 9.

p. 406 **"I could not"** Ibid., 30.

p. 407 **"carefully measured"** Ibid.

p. 408 **"Anyone who"** Sigrid Wortmann Weltge, "Lenore Tawney: Spiritual Revolutionary." *American Craft* 68 (February/March 2008), 90–97.

p. 408 **"There is a purity"** Constantine and Larsen, *The Art Fabric*, 208.

p. 408 **"Clouds represent"** Weltge, *Celebrating Five Decades*, 36.

p. 408 **"Some people"** d'Autilia, *A Personal World*.

p. 409 **"The work"** *LTR*, 86.

SELECTED BIBLIOGRAPHY

General

Chadwick, Whitney. *Women, Art, and Society*. 5th ed. New York: Thames & Hudson, 2012.

Cozzolino, Robert. *Art in Chicago: Resisting Regionalism, Transforming Modernism*. Philadelphia: Pennsylvania Academy of the Fine Arts, 2007.

Farrington, Lisa E. *Creating Their Own Images: The History of African-American Women Artists*. New York: Oxford University Press, 2005.

The Female Gaze: Women Artists Making Their World. Edited by Robert Cozzolino. Philadelphia: Pennsylvania Academy of the Fine Arts, 2002.

Greer, Germaine. *The Obstacle Race: The Fortunes of Women Painters and Their Work*. New York: Farrar, Straus and Giroux, 1979.

Levin, Gail. *Becoming Judy Chicago: A Biography of the Artist*. New York: Crown, 2007.

Munro, Eleanor. *Originals: American Women Artists*. New York: Simon & Schuster, 1979.

Nochlin, Linda. *Women Artists: The Linda Nochlin Reader*. Edited by Maura Reilly. New York: Thames & Hudson, 2015.

Rosen, Randy, and Catherine C. Brawer, eds. *Making Their Mark: Women Artists Move into the Mainstream, 1970–85*. New York: Abbeville Press, 1989.

The Empress of In-Between: Louise Nevelson

Lisle, Laurie. *Louise Nevelson: A Passionate Life*. New York: Summit, 1990.

Nevelson, Louise. *Dawns and Dusks: Taped Conversations with Diana MacKown*. New York: Scribners, 1976.

Rapaport, Brooke Kamin, ed. *The Sculpture of Louise Nevelson: Constructing a Legend*. New Haven, CT: Jewish Museum of New York / Yale University Press, 2007.

Wilson, Laurie. *Louise Nevelson: Light and Shadow*. New York: Thames & Hudson, 2016.

***Girl Searching*: Gertrude Abercrombie**

Cozzolino, Robert. *With Friends: Six Magic Realists, 1940–1965*. Madison: Elvehjem Museum of Art / University of Wisconsin, 2005.

Purdy, James. *Eustace Chisholm and the Works*. 1967. Reprint, London: GMP, 1984.

———. *Gertrude of Stony Island Avenue*. New York: William Morrow, 1997.

———. *Malcolm*. 1959. Reprint, London: Serpent's Tail, 1994.

Behind the Masks: Loïs Mailou Jones

Benjamin, Tritobia Hayes. *The Life and Art of Loïs Mailou Jones*. San Francisco: Pomegranate, 1994.

Chapman, Chris. *Loïs Mailou Jones: A Life in Color*. Bloomington, IN: Xlibris, 2007.

Hanzal, Carla M., ed. *Loïs Mailou Jones: A Life in Vibrant Color*. Charlotte, NC: Mint Museum of Art, 2009.

"The Rebellious Bravo": Ree Morton

The Mating Habits of Lines: Sketchbooks and Notebooks of Ree Morton. Burlington: Robert Hull Fleming Museum / University of Vermont, 2000.

Roussel, Raymond. *Impressions of Africa.* Translated by Lindy Foord and Rayner Heppenstall. London: John Calder, 2001.

Swimming in Light: Joan Brown

Tsujimoto, Karen, and Jacquelynn Baas. *The Art of Joan Brown.* Berkeley: University of California Press, 1998.

***Freeze and Melt*: Christina Ramberg**

Corbett, John. *Christina Ramberg: Corset Urns + Other Inventions, 1968–1980.* Chicago: Corbett vs. Dempsey, 2011.

Christina Ramberg: A Retrospective, 1968–1988. Chicago: Renaissance Society at the University of Chicago, 1988.

All of a Piece: Lenore Tawney

Constantine, Mildred, and Jack Lenor Larsen. *The Art Fabric: Mainstream.* New York: Van Nostrand Reinhold, 1981.

——. *Beyond Craft: The Art Fabric.* New York: Van Nostrand Reinhold, 1972.

Cotter, Holland. *Lenore Tawney: Signs on the Wind.* San Francisco: Pomegranate, 2002.

Held, Peter, ed. *In the Language of Silence: The Art of Toshiko Takaezu.* New York: Toshiko Takaezu Book Foundation; Chapel Hill: University of North Carolina Press, 2010.

Mangan, Kathleen Nugent. *Lenore Tawney: A Retrospective.* New York: American Craft Museum, 1990.

Princenthal, Nancy. *Agnes Martin: Her Life and Art.* New York: Thames & Hudson, 2015.

LIST OF ILLUSTRATIONS (BY ARTIST)

Elayne Seaman

Elayne Seaman. *Anemone Quilt*, 1989. Incised ink painting, 20 × 24 inches. Used with permission of the artist. Photographer: Charles Carlson.

Louise Nevelson

Louise Nevelson (Profile) with artwork. Pedro E. Guerrero. © Pedro E. Guerrero Archives.

Louise Nevelson #4. Pedro E. Guerrero. © Pedro E. Guerrero Archives.

Louise Nevelson wood collection #5. Pedro E. Guerrero. © Pedro E. Guerrero Archives.

Berliawsky family portrait, ca. 1907. Unidentified photographer. Louise Nevelson papers, Archives of American Art, Smithsonian Institution.

Louise Nevelson, 1932. Unidentified photographer. Louise Nevelson papers, Archives of American Art, Smithsonian Institution.

Louise Nevelson © 1967. Lynn Gilbert.

Louise Nevelson, *The Endless Column*, 1969–85. Painted wood sculpture. Center: 128 1/8 × 59 1/16 × 11 1/6 inches. Left: 109 7/8 × 22 × 9 1/8 inches. Stand: 4 × 25 1/8 × 6 inches. Right: 114 13/16 × 21 1/2 × 5 1/4 inches. Stand: 4 × 18 × 6 inches. © Estate of Louise Nevelson / Artists Rights Society (ARS), New York. From the collection of the Farnsworth Art Museum. Bequest of Nathan Berliawsky, 1980.35.30.

Gertrude Abercrombie

Gertrude Abercrombie on couch. Unidentified photographer. Collection of the Illinois State Museum.

Gertrude Abercrombie, *Cat and I*, 1937. Woodcut. Collection of the Illinois State Museum. Gift of Gertrude Abercrombie Trust.

Gertrude Abercrombie, *Family Home in Aledo*, 1956–60 (unfinished). Oil on canvas, 20 × 25 inches. Collection of the Illinois State Museum. Gift of Gertrude Abercrombie Trust.

Gertrude Abercrombie sitting on steps with her artwork, 194–? Unidentified photographer. Gertrude Abercrombie papers, 1880–1986, bulk, 1935–1977, Archives of American Art, Smithsonian Institution.

Gertrude Abercrombie and friends, ca. 1950. Unidentified photographer. Gertrude Abercrombie papers, 1880–1986, bulk, 1935–1977, Archives of American Art, Smithsonian Institution.

James Purdy and Gertrude Abercrombie, ca. 1945. Unidentified photographer. Gertrude Abercrombie papers, 1880–1986, bulk, 1935–1977, Archives of American Art, Smithsonian Institution.

Gertrude Abercrombie in her bedroom. Unidentified photographer. Collection of the Illinois State Museum.

Gertrude Abercrombie and Sonny Rollins. Unidentified photographer. Collection of the Illinois State Museum.

Gertrude Abercrombie, *Girl Searching*, 1945. Oil on Masonite, 8 × 10 inches. Courtesy of the Pennsylvania Academy of the Fine Arts, Philadelphia. Art by Women Collection, Gift of Linda Lee Alter.

Loïs Mailou Jones

Loïs Mailou Jones, *Street Vendors, Haiti*, 1978. Acrylic, 53 × 40 1/4 inches. Courtesy of the Loïs Mailou Jones Pierre-Nöel Trust.

Loïs Mailou Jones, *Bouquet*, 1996. Watercolor, 17 × 23 inches. Courtesy of the Loïs Mailou Jones Pierre-Nöel Trust.

Ree Morton

Ree Morton in kindergarten, ca. 1941. Unidentified photographer. © Estate of Ree Morton. Courtesy Alexander and Bonin, New York, and Annemarie Verna, Zurich.

Ree Morton with her children, ca. 1964. Unidentified photographer. © Estate of Ree Morton. Courtesy Alexander and Bonin, New York and Annemarie Verna, Zurich.

Ree Morton, *Untitled*, 1972. Paint on paper, tape, felt, flour, and wood; studio of the artist. © Estate of Ree Morton. Courtesy Alexander and Bonin, New York and Annemarie Verna, Zurich.

Ree Morton in studio with Beaux paintings, 1974. © Estate of Ree Morton. Courtesy Alexander and Bonin, New York and Annemarie Verna, Zurich. Photographer: Becky Cohen.

Ree Morton, study for *Signs of Love*. Black sketchbook, 1976–77. © Estate of Ree Morton. Courtesy Alexander and Bonin, New York and Annemarie Verna, Zurich.

Ree Morton. Blank billboard. Sketchbook, 1976. © Estate of Ree Morton. Courtesy Alexander and Bonin, New York and Annemarie Verna, Zurich.

Ree Morton, *Untitled*, 1971–73. Gouache, pencil, and crayon on canvas; gouache on wood, 93 × 66 × 18 inches. © Allen Memorial Art Museum, Oberlin College. Photographer: Markus Wörgötter. © Estate of Ree Morton. Courtesy Alexander and Bonin, New York and Annemarie Verna, Zurich.

Ree Morton, *Sister Perpetua's Lie*, 1973. Fifteen works on paper and canvas: acrylic, ink, crayon, and pencil on paper; chalk on paper; acrylic on canvas; watercolor on paper; chalk, wood, and acrylic on wood. © Generali Foundation Collection, Vienna. Photographer: Markus Wörgötter. © Estate of Ree Morton. Courtesy Alexander and Bonin, New York and Annemarie Verna, Zurich.

Ree Morton, *To Each Concrete Man*, 1974. Acrylic, pencil, wood, paper, rawhide, vinyl, canvas, metal, light bulbs and electrical fixtures. Photographer: Markus Wörgötter. © Estate of Ree Morton. Courtesy Alexander and Bonin, New York and Annemarie Verna, Zurich.

Ree Morton, *Terminal Clusters*, 1974. Enamel and glitter on wood and celastic, lightbulbs, 48 × 48 × 8 inches. Photographer: Markus Wörgötter. © Estate of Ree Morton. Courtesy Alexander and Bonin, New York and Annemarie Verna, Zurich.

Ree Morton, *One of the Beaux Paintings (#4)*, 1975. Oil on wood and enamel on celastic, 24 × 24 inches. Photographer: Joerg Lohse. © Estate of Ree Morton. Courtesy Alexander and Bonin, New York and Annemarie Verna, Zurich.

Ree Morton, *Regional Piece*, 1975–76. Oil on wood and enamel on celastic in two parts, each: 17 × 50 inches. Photographer: Bill Orcutt. © Estate of Ree Morton. Courtesy Alexander and Bonin, New York and Annemarie Verna, Zurich.

Joan Brown

Joan Brown at age five, 1943. Unidentified photographer. © Joan Brown Estate. Image courtesy of George Adams Gallery, New York.

Joan Brown painting, 1962. Unidentified photographer. © Joan Brown Estate. Image courtesy of George Adams Gallery, New York.

Joan Brown in close-up, 1964. Unidentified photographer. © Joan Brown Estate. Image courtesy of George Adams Gallery, New York.

Joan Brown, *The Birthday Party*, 1971. Oil enamel on Masonite, 96 × 47 1/2 inches. Mr. and Mrs. Robert MacDonnell, Hillsborough, California. © Joan Brown Estate. Image courtesy of George Adams Gallery, New York.

Joan Brown and son, Noel Neri, 1976. © Joan Brown Estate. Image courtesy of George Adams Gallery, New York. Unidentified photographer.

Joan Brown in studio, San Francisco, 1986. © Joan Brown Estate. Image courtesy of George Adams Gallery, New York. Unidentified photographer.

Joan Brown, *Pine Tree Obelisk*, Sydney Walton Park, San Francisco, 1987. Ceramic tile and steel, 12 × 5 1/2 feet. Shorenstein Company, San Francisco. © Joan Brown Estate. Image courtesy of George Adams Gallery, New York.

Joan Brown, cat, monkey, ca. 1988. © Joan Brown Estate. Image courtesy of George Adams Gallery, New York. Unidentified photographer.

Joan Brown, *Family Portrait*, 1960. Oil on canvas, 70 3/4 × 61 1/8 inches. © Joan Brown Estate. Image courtesy of George Adams Gallery, New York. Mr. and Mrs. Harry Cohn, Hillsborough, California.

Joan Brown, *Self-Portrait*, 1970. Enamel on canvas, 26 × 26 inches. © Joan Brown Estate. Image courtesy of George Adams Gallery, New York. The Buck Collection, Laguna Hills, California.

Joan Brown, *Portrait of a Girl*, 1971. Enamel on Masonite, 96 × 48 inches. © Joan Brown Estate. Image courtesy of George Adams Gallery, New York.

Joan Brown, *After the Alcatraz Swim #3*, 1976. Enamel on canvas, 96 × 78 inches. © Joan Brown Estate. Image courtesy of George Adams Gallery, New York. Collection of the Palm Springs Art Museum, California; gift of Steve Chase in honor of the 10th anniversary of the Contemporary Art Council, 1994.

Joan Brown, *The Dancers in the City #2*. 1972. Oil enamel on Masonite, 84 × 71 3/4 inches. San Francisco Museum of Modern Art; gift of Alfred E. Heller. © Joan Brown Estate. Image courtesy of George Adams Gallery, New York.

Joan Brown, *Harmony*, 1982. Enamel on canvas, 96 × 60 inches. © Joan Brown Estate. Image courtesy of George Adams Gallery, New York.

Joan Brown, *Year of the Tiger*, 1983. Oil enamel on canvas, 72 × 120 inches. © Joan Brown Estate. Image courtesy of George Adams Gallery, New York.

Christina Ramberg

Christina Ramberg, *Black Widow*, 1971. Acrylic on Masonite, 31 × 18 1/2 inches. Collection of the Illinois State Museum. Courtesy of the Estate of Christina Ramberg and Corbett vs. Dempsey.

Christina Ramberg, *Untitled (Crying Women)*, 1968. Felt-tip pen on paper (double-sided), 6 × 3 1/4 inches. Courtesy of the Estate of Christina Ramberg and Corbett vs. Dempsey.

Christina Ramberg, *Untitled (Hands)*, c. 1971. Felt-tip pen, graphite, and colored pencil on graph paper, 8 1/2 × 6 1/2 inches. Courtesy of the Estate of Christina Ramberg and Corbett vs. Dempsey.

Christina Ramberg, *Waiting Lady*, 1972. Acrylic on Masonite, 22 3/4 × 34 1/4 inches. Collection of Anstiss and Ronald Krueck. Courtesy of the Estate of Christina Ramberg and Corbett vs. Dempsey.

Christina Ramberg, paper dolls. Courtesy of the Estate of Christina Ramberg and Corbett vs. Dempsey.

Christina Ramberg, The Bible Advancers. Courtesy of the Estate of Christina Ramberg and Corbett vs. Dempsey. Unidentified photographer.

Christina Ramberg, *Back to Back*, 1973. Etching, 8 × 11 inches. Courtesy of the Estate of Christina Ramberg and Corbett vs. Dempsey.

Christina Ramberg, *Untitled (Skirts Jackets Weaving)*. Graphite on paper, 11 × 8 1/2 inches. Courtesy of the Estate of Christina Ramberg and Corbett vs. Dempsey.

Christina Ramberg, *Rolling Stone*. 1983. Cotton. 89 × 74 inches. Courtesy of the Estate of Christina Ramberg, Corbett vs. Dempsey, and Carl Hammer Gallery.

Christina Ramberg, *Untitled (Satellite Sketches)*. Graphite on paper. 10-1/2 × 9 inches. Courtesy of the Estate of Christina Ramberg and Corbett vs. Dempsey.

Christina Ramberg. Photograph by William H. Bengston. c. 1970. Courtesy of the Estate of Christina Ramberg and Corbett vs. Dempsey.

Christina Ramberg, *Wired*, 1974–75. Acrylic on Masonite, 48 × 36 inches. Courtesy of the Estate of Christina Ramberg and Corbett vs. Dempsey.

Christina Ramberg, *Hexagons, Number 1*. 1984. Cotton. 68 × 102 inches. Courtesy of the Estate of Christina Ramberg and Corbett vs. Dempsey.

Christina Ramberg, *Hermetic Indecision*, 1977. Acrylic on Masonite, 49 × 37 inches. Courtesy of the Estate of Christina Ramberg and Corbett vs. Dempsey.

Christina Ramberg, *Sedimentary Disturbance*, 1980. Acrylic on Masonite, 49 1/4 × 37 inches. Courtesy of the Estate of Christina Ramberg and Corbett vs. Dempsey.

Christina Ramberg, *Freeze and Melt*, 1981. Acrylic on Masonite, 47 9/16 × 35 5/8 inches. Courtesy of the Estate of Christina Ramberg and Corbett vs. Dempsey.

Christina Ramberg, *Untitled (#126)*, 1986. Acrylic on linen. 22 × 18 inches. Courtesy of the Estate of Christina Ramberg and Corbett vs. Dempsey.

Lenore Tawney

Lenore Tawney with her mother and siblings, Lorain, Ohio, ca. 1913. Courtesy Lenore G. Tawney Foundation. Unidentified photographer.

Lenore Tawney at the loom, Penland School of Crafts, Penland, North Carolina, 1954. Courtesy Lenore G. Tawney Foundation. Unidentified photographer.

Lenore Tawney working on *Lost and Proud*, Chicago, 1957. Photographer: Aaron Siskind. Courtesy Lenore G. Tawney Foundation.

Lenore Tawney in her Coenties Slip, New York, studio, 1958. Photographer: David Attie. Courtesy Lenore G. Tawney Foundation.

Lenore Tawney, *Vespers*, 1961. Linen, 82 × 21 inches. Photographer: George Erml. Courtesy Lenore G. Tawney Foundation.

Lenore Tawney's Beekman Street studio, New York, ca. 1965. Courtesy Lenore G. Tawney Foundation.

Lenore Tawney, *From Its Center*, 1964. India ink on graph paper, 11 × 8½ inches. Photographer: George Erml. Courtesy Lenore G. Tawney Foundation.

Lenore Tawney and Swami Muktananda, ca. 1975. Courtesy Lenore G. Tawney Foundation. Unidentified photographer.

Lenore Tawney installing *Cloud Series VI*, 1981. Frank J. Lausche State Office Building, Cleveland, Ohio. Courtesy Lenore G. Tawney Foundation. Unidentified photographer.

Lenore Tawney, *Black Woven Form (Fountain)*, 1966. Linen, expanded gauze weave, knotted, loom woven, 105 × 2 1/4 inches. Museum of Arts and Design, New York, gift of the artist, through the American Craft Council, 1968. Photographer: Sheldan Comfort Collins.

Lenore Tawney, *Jupiter*, 1959. Silk, wool, wood; woven, 53 × 41 inches. Museum of Arts and Design, New York, gift of the Johnson Wax Company, through the American Craft Council, 1977.

Lenore Tawney, *Jupiter*, detail, 1959. Silk, wool, wood; woven, 53 × 41 inches. Museum of Arts and Design, New York, gift of the Johnson Wax Company, through the American Craft Council, 1977.

Lenore Tawney, *The Path*, 1962. Linen, 24k gold, 90½ × 24½ inches. Photographer: George Erml. Courtesy Lenore G. Tawney Foundation.

Lenore Tawney, *Union of Water and Fire*, 1974. Linen, 36 × 36 inches. Photographer: George Erml. Courtesy Lenore G. Tawney Foundation.

Lenore Tawney, *Shield*, begun ca. 1967, completed 1985. Linen, horsehair, feathers, whelk egg cases, 15½ × 14 inches. Photographer: George Erml. Collection of the Art Institute of Chicago, Gift of Lenore Tawney. Courtesy Lenore G. Tawney Foundation.

Lenore Tawney, *Distilla*, 1967. Collage, 10½ × 8¼ inches. Photographer: George Erml. Courtesy Lenore G. Tawney Foundation.

Lenore Tawney, postcard collages, 1973–87. Courtesy Lenore G. Tawney Foundation.

Lenore Tawney, *Waters above the Firmament*, 1976. Linen, warp-faced weft-ribbed plain weave with discontinuous wefts; eighteenth/nineteenth-century manuscript pages cut into strips, attached, and painted with Liquitex acrylic paint; braided, knotted, and cut warp fringe, 56 1/2 × 145 1/4 inches. H. L. and Mary T. Adams, Harriott A. Fox, and Mrs. Siegfried G. Schmidt endowments; restricted gift of Laurance H. Armour, Jr. and Margot G. Armour Family Foundation, Mrs. William G. Swartchild, Jr., Joan Rosenberg, Joseph W. Fell, and the Textile Society, 1983.203. The Art Institute of Chicago. Photography © The Art Institute of Chicago.

INDEX

A NOTE ON THE AUTHOR

Donna Seaman is an editor for *Booklist*, a member of the national advisory council for the American Writers Museum, and a recipient of the James Friend Memorial Award for Literary Criticism and the Studs Terkel Humanities Service Award. Seaman's writings have appeared in numerous publications, including the *Chicago Tribune*, the *Los Angeles Times*, *Creative Nonfiction*, the *Oxford Encyclopedia of American Literature*, and *American Writers*. She lives in Chicago.